SCULPTURE TODAY

JUDITH COLLINS

CONTENTS

Sculpture has probably changed more during the last thirty years than at any other time in its more than 30,000-year history, and it has changed because we have changed. The invention and complexity of the contemporary world is matched by the invention and complexity of contemporary sculpture. This book attempts to explain the major trends of contemporary sculpture, but the reader will ask: what is 'contemporary'? The dictionary defines it as 'of the present period', but in order to understand the present period, we need to know what causes brought about its trends. To do this, it is necessary to look back a generation or two, which takes us to the late 1960s and early 1970s.

Art historians, critics and curators tend to identify and label trends and 'isms', so that an unwieldy creative mass can be given some kind of order. Artists usually ignore these labels and carry on regardless, only watching each other to see what is happening. The last three decades have witnessed the rise and fall, and in some cases, the rise again, of modernism, postmodernism, Conceptualism, Minimalism, Post-Minimalism, Arte Povera, Neo-Expressionism, Land Art, Neo-Conceptualism, Dematerialization, Neo-Dada, Maximalism, Process Art, abstraction and figuration. Although these and other labels are discussed in the following chapters, *Sculpture Today* is not arranged according to isms or chronology. This means that in some instances divergent works by the same sculptor will appear in the context of different chapters.

We are living in a non-linear time, where things happen simultaneously in different places. We are also in what seems to be a period of transition, partly caused by the shift from one millennium to another. If one asks the question, what is sculpture today?, it is not possible to give a simple answer. Ernst Gombrich, in his enormously successful book *The Story of Art*, stated: 'There is no art, only artists,' so perhaps it is feasible to follow him and say, 'There is no sculpture, only sculptors.' The book's eighteen chapters and extensive illustrations offer an explanation that is plural, rather than singular, and provide a comprehensive overview of the activity of the last thirty years, celebrating both the vitality and diversity of sculpture made globally. The enormous array of materials, forms, techniques and concepts that have been presented under the term 'sculpture' indicate that the discipline is no longer an immutable art form with fixed boundaries and rules. Indeed, its success stems from the very opposite: it can expand its terms of reference with unflagging energy, and appear inexhaustible and capacious. Although almost anything can be brought into play to create sculpture, the use of video is not included here. Kinetic and lens-based works introduce more than can be dealt with in this volume. Installation/environmental art is included, however, since it is part of the expanded field of sculpture.

The most radical change worldwide since the 1970s has been the exponential increase in electronic and digital technology, the development of the internet, and the global increase in mobile communications. This has changed the way in which we think about ourselves as human beings, and about the concepts of space and place, factors crucial to the production of sculpture. There is a new sense of geography, which is more political and economic than physical, and less bound to maps, territories and boundaries. Additionally, the way in which we access knowledge has changed, and, for example, the history of international art is now instantly accessible to a worldwide audience. There is more source material and imagery than ever before, and this bewildering, unedited mass seeps into the unconscious and affects it. Artists are possibly more aware of this than the rest of us, and the sculpture they are making today reflects this.

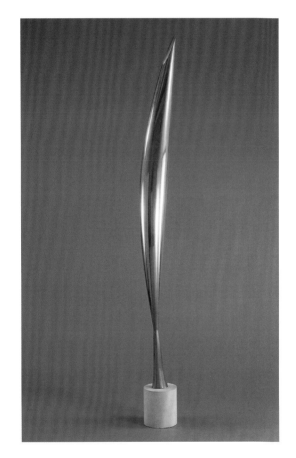

1

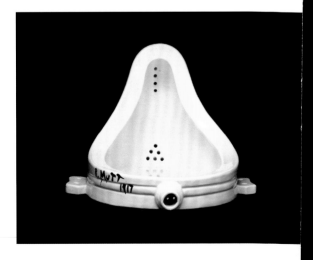

2

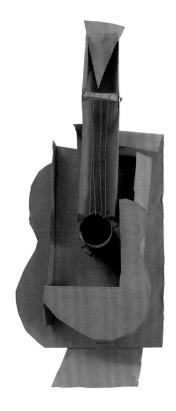

3

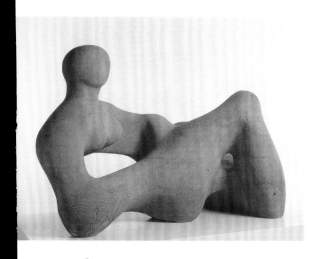

4

1 Constantin Brancusi, *Bird in Space*, 1927. Bronze.
118 cm (72 ¾ in) high. National Gallery of Art,
Washington, DC

2 Marcel Duchamp, *Fountain*, 1917. Porcelain urinal.
60 x 23.5 x 18 cm (23 ⅝ x 9 ¼ x 7 in).
Indiana University Art Museum, Bloomington

3 Pablo Picasso, *Guitar*, 1912-13. Sheet metal
and wire. 77.5 x 35 x 19.3 cm (30 ½ x 13 ¾ x 7 ½ in).
Museum of Modern Art, New York

4 Henry Moore, *Recumbent Figure*, 1938.
Green Hornton stone. 88.9 x 132.7 cm (35 x 52 ¼ in)
Tate, London

So in order to assess where sculpture is today, it is necessary to see where it comes from. There was a great shift in art at the end of the 1960s and early 1970s that, with hindsight, is seen as the end of modernism. This ism reigned supreme from the time of Cubism to the early 1960s. Modernism, which prioritized painting above sculpture, is characterized by a rejection of realistic and academic art, and a concentration on issues such as form and colour. Critics who promoted modernist views and ideas about art were British and American -- Roger Fry, Alfred Barr, Clement Greenberg and Michael Fried. When modernism collapsed, the emphasis shifted from painting to sculpture. Until then, sculpture had been overshadowed by a predominantly painterly aesthetic, which promoted as primary the idea of the coloured plane. The painter Barnett Newman described sculpture as 'what you bump into when you back up to see a painting'. Sculpture began to adopt the flat mode of painting, utilizing the wall and the floor as its new area of activity. In the mid-1970s, when this book begins, there was a surge of sculptural action, involving artists of different generations, nationalities and outlooks.

For want of a better title, the 'ism' that followed modernism was called 'postmodernism', and this term entered the lexicon of artistic practice and theory in the 1970s, originally used to describe a new kind of architecture. A significant book of that time was French philosopher Jean-Francois Lyotard's *The Postmodern Condition: A Report on Knowledge* (1979), which dealt with social rather than aesthetic matters. Lyotard suggested that contemporary society was rejecting its grand, universal and powerful structures, such as religion, gender and capitalism, in favour of more local, personal narratives and myths. His text described a world that was anti-establishment, fragmented and given to voracious borrowing from other cultures and ideologies. Certainly, the fragmentation, borrowing and collage elements cited in his book began to find their way into contemporary sculpture, where they still remain.

The art historian and critic Rosalind Krauss published the seminal essay 'Sculpture in the Expanded Field' in *October* magazine for spring 1979, which was one of the first texts to investigate postmodernism in sculpture. She described how, over the previous ten years, some 'rather surprising things have come to be called sculpture', and went on to rehearse what sculpture had been up until that date. Mostly it had been 'a commemorative representation' that 'sits in a particular place and speaks in a symbolic tongue about the meaning or use of that place'. This representation was 'normally figurative and vertical', and was sited on a pedestal. When she tried to define sculpture of the 1970s, and she was writing about American sculptors, she felt that they were the first to venture into the expanded field, and that their work was located somewhere between landscape and architecture, between nature and culture. Sculpture had come down off the pedestal and was no longer 'figurative and vertical'. The vertical axis that had predominated since the beginning of sculpture was being replaced by a horizontal one, by work that lay directly on the gallery floor or the earth. The traditional processes by which sculpture had been made -- modelling and carving -- were being rejected. The new orientation for sculpture and the lack of a base meant that different processes and presentations appeared, the most prominent of which were stacking and scattering, which needed no manual dexterity or craftsmanship to execute. Monolithic, solid forms gave way to more open, extended ones, and weight and mass began to lose their supremacy.

Krauss looked for the godfathers 'who could legitimize and thereby authenticate the strangeness' of these new sculptures, and she cited Auguste Rodin (1840-1917) and Constantin Brancusi, the latter artist being responsible for 'expressing parts of the body as fragments' and for transforming the way in which sculpture relates to its base. Brancusi made his bases as important as the sculptures they supported, and they were usually made from stacked pieces of rough wood, which were detachable, rearrangeable, and appeared improvised. He simplified his shapes and polished his bronze forms until they resembled machine-made industrial products, such as his *Bird in Space* (1). Equally important in Paris at the same time, though not mentioned by Krauss, were two other artists, Marcel Duchamp and Pablo Picasso, who introduced further new ideas, techniques and materials into the world of sculpture, and whose influences, like that of Brancusi, were still being worked out in the postmodern period and continue to cast their shadow even today.

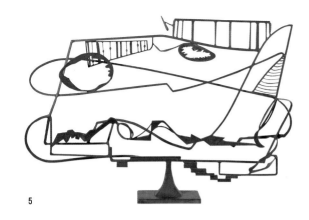

5

Duchamp gave up painting in 1912 and eschewed the shaping of materials in his studio in favour of choosing and exhibiting industrial or domestic manufactured objects, which he called readymades. The most celebrated and notorious of these works was *Fountain* (2), a white porcelain urinal bought from the Mott Works Company in New York. Duchamp's only interventions, after choosing it, were to turn it upside down and sign it with the fictional name 'R. Mutt' and the date. He submitted it to the jury-free 'Independents Exhibition', but it was rejected by the hanging committee. Duchamp's readymades challenged ideas about authenticity and originality in art. Picasso initiated opened-up constructed sculpture in 1912 with his two versions of *Guitar* (3), the first made from cardboard and the second from sheet metal and wire, both of which he hung on the wall like paintings. Picasso's materials and his methods were new in the history of sculpture. Carving and modelling were rejected in favour of rough constructions made from overlapping or intersecting planes.

Picasso's investigation into the interdependence of space and volume was carried forward by sculptors who dealt with the human figure, prominent among whom were Jacques Lipchitz (1891-1973), Alexander Archipenko (1887-1964) and Henry Moore. They all simplified and opened up the female human figure, notably by carving holes through the forms (4). They described this as allowing space to be enclosed by material, instead of the other way round. Moore began to break up the female figure into separate parts, which led him to make comparisons between human anatomy and the landscape. He also continued to work with the fragmentation theme that Rodin and Brancusi had begun.

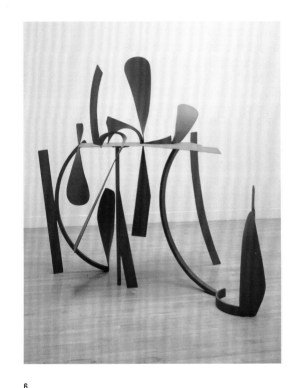

6

Moore worked with wood, stone and bronze, but a sculptor who returned to the sheet metal used by Picasso for his ground-breaking constructions was David Smith. He learned to weld and created his early sculptures of the 1940s from scrap iron and steel, often parts of agricultural implements. Smith turned away from figure sculpture and instead created welded abstract forms that were often equivalents for the landscape surrounding his rural studio in upstate New York, such as *Hudson River Landscape* (5). Welding introduces form without mass, a sense of strength allied to delicacy, and an even greater openness to sculpture. Smith's linear metal arabesques were described as 'drawing in air'.

Anthony Caro, who worked as an assistant to Henry Moore, changed his style after seeing some new sculptures by Smith in America, and he too made constructions from industrial metal offcuts, which he painted in bright, commercially available colours, disguising the reality of their heavy steel bars and girders and making them appear effortless and almost weightless, impervious to the power of gravity. Caro equally turned away from the figure, and his spare but elegant sculpture *Orangerie* (6) actually uses segments of metal ploughshares, which he purchased as scrap. An orangery is a greenhouse in which citrus trees are grown, and the title could well imply that this sculpture was inspired by forms in the natural world.

5 David Smith, *Hudson River Landscape*, 1951. Welded painted steel and stainless steel. 125.7 x 190.5 x 42.5 cm (50 x 75 x 16 ¾ in). Whitney Museum of American Art, New York

6 Anthony Caro, *Orangerie*, 1969. Steel painted red. 225 x 162.5 x 231 cm (88 ½ x 64 x 91 in). Collection Kenneth Noland

7 Arman, *Le Plein*, 1960. Mixed media. Dimensions variable. As installed at Galerie Iris Clert, Paris

8 Marcel Duchamp, *Mile of String*, 1942. String. Dimensions variable. As installed at 451 Madison Avenue, New York, 14 October-7 November 1942

During the 1970s a number of American artists produced substantial theoretical writings that have been more influential for new developments in recent sculpture than those of critics and historians, and the most significant cluster of them were coterminous with the collapse of modernism. Two sculptors -- Robert Morris and Donald Judd -- helped both in terms of practice and theory to effect a transition from the formality, purity and self-sufficiency of modernism to a new definition of what art was and how it could be interpreted. Between 1966 and 1968, Morris wrote four texts on sculpture under the general heading 'Notes on Sculpture', which were published in the American art magazine *Artforum*. The first -- 'Notes on Sculpture: Part 1' -- appeared in the February 1966 issue and mainly discussed simple, three-dimensional objects of the kind he had been making in painted plywood for a few years, in terms of viewer participation. Morris felt that the context in which the work was shown, the way light fell on it and the way the viewer walked around it, altered the perception of its shape. His focus on the relationship between the viewer and their experience of a three-dimensional object helped to introduce the concept of phenomenology into the world of sculpture.

The writings of a French philosopher -- Maurice Merleau-Ponty (1908-61) -- lay behind Morris's ideas. Merleau-Ponty's book *Phenomenology of Perception*, published in France in 1945, was translated into English in 1962 and quickly established itself as essential reading for artists and critics pondering the reception and appreciation of works of art. Phenomenology is a philosophical movement that stems from the writings of Edmund Husserl at the beginning of the twentieth century. It looks at what presents itself to us in conscious experience, and then at the essence of what we experience.

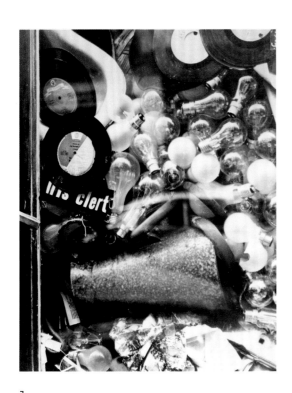

7

Sculptors in the postmodern period started to experiment with the various ways in which their work could be experienced. However, Marcel Duchamp was the first artist to manipulate the space of an art gallery with two interventions: *1200 Coal Bags*, 1938, and *Mile of String*. He hung the coal bags from the ceiling at a Surrealist Exhibition at the Galerie Beaux-Arts, New York. The *Mile of String* appeared at another Surrealist Exhibition held at 451 Madison Avenue, New York **(8)**; the string actually measured three miles in length and was strung in cobweb-like forms across the gallery and in front of the other exhibits. Duchamp's friend at that time, the art dealer Sidney Janis, recalled that Duchamp undertook this remarkable feat in order to 'symbolize literally the difficulties to be circumvented by the uninitiated in order to see, to perceive and understand, the exhibits.' Duchamp remembered that the string was gun-cotton, which burned in places under the light-bulbs -- 'it was terrifying, but it worked out alright.'

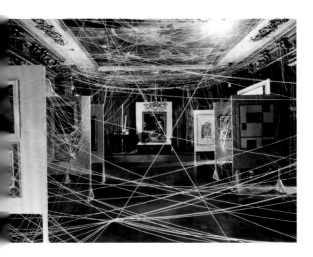

8

Yves Klein continued this idea of altering the experience of visiting an art gallery with his presentation *The Void* (*Le Vide*), at the Galerie Iris Clert, Paris, from 28 April to 5 May 1958, which consisted of a totally empty gallery, whose walls were newly painted with white gloss. Klein positioned himself in the empty space, only allowing ten visitors at a time, confining their stay to three minutes. Three thousand people came on opening night, and the police had to be called to control the crowds. The empty space of the gallery deeply affected its visitors both emotionally, aesthetically and viscerally. Arman followed with an exhibition entitled 'Le Plein' at the same venue in October 1960, the invitations for which were printed on sardine cans. He completely filled the gallery space from floor to ceiling with two truckloads of domestic rubbish. Visitors could only look at the show through the window, and from there they saw a bewildering conglomeration of crumpled paper, used light-bulbs, records, buckets and the like **(7)**. Klein said of Arman's installation that 'The universal memory of art was lacking his conclusive mummification of quantification.'

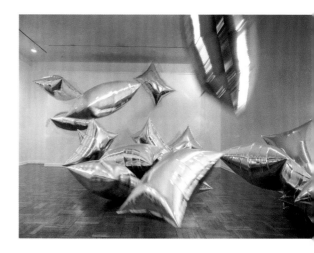

Six years later, Andy Warhol created an enchanting installation called *Silver Clouds* [9], which filled one room of the Leo Castelli Gallery in New York. The visitor was confronted by several large, pillow-shaped balloons, made of mylar and filled with a mixture of oxygen and helium, which were specially created with the assistance of engineer Billy Klüvur. The balloons floated around the gallery, moved by the air currents created by the visitors. Several recent gallery installations, notably one by Martin Creed, have revisited this idea. Warhol was also largely responsible for the introduction of popular and accessible imagery -- food, money, film-stars, publicity material, newspaper photographs -- into the canon of fine art. He turned to the everyday imagery of popular culture and invested his sculptures with instant realism. Like Brancusi earlier, Warhol was interested in a mass-produced look, and avoided the handmade character in favour of anonymous surfaces, with no evidence of the artist's hand. In 1964 he was included in an exhibition at the Bianchini Gallery, New York, titled 'The American Supermarket', and for this he created painted wooden replicas of the cardboard containers used by the American food and drinks industry, such as Coca-Cola cans, Heinz ketchup bottles and Campbell's Soup tins [10]. These were so life-like that the original designer sued.

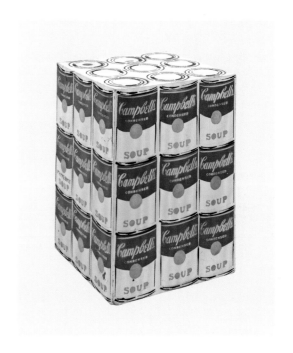

Richard Artschwager, who was included in the same exhibition, had previously worked as a furniture maker and designer and was inspired by the appearance on the market of the plastic laminate sheeting called Formica, which he described as 'a picture of a piece of wood'. Formica is a material that mimics another material, so Artschwager used it to make sculptures that mimic household furniture. His *Table and Chair* [11] comprises a pair of simple, generalized forms, and the artist has animated the surface by setting into it coloured and textured plastic laminate sheeting usually found on kitchen tables, where it is valued for its heat-resistant and wipe-clean qualities. The sides and top of the table are covered with pale Formica, while strips of wood-grained Formica illusionistically describe its legs; the chair is treated in the same manner. The irony here is that the table and chair are functionless, although visually they appear fully serviceable.

Tony Smith, who died in 1980, was given a major retrospective at MOMA, New York in 1998 and several reviews stated that his sculptures looked fresh and contemporary again. Smith's most famous work is *Die* [12], a large, six-foot cube of oiled steel, with a 'black and malignant' presence. It was fabricated for him by the Industrial Welding Company in Newark, New Jersey, and its dimensions were determined by the proportions of the human body. Its size and brooding presence require the viewer to walk around it and experience the relationship between himself, the object and the surrounding space, since no more than two of its sides can been seen at any one time. Although the work's form could not be simpler, its title invites many readings: the roll of a die, the name of a type of casting, or death. Smith did state that the dimensions bring to mind the colloquial phrase 'six feet under'.

9 Andy Warhol, *Silver Clouds*, 1966. Helium- and oxygen-filled metallicized plastic film. Each 91.4 x 129.5 cm (36 x 51 in). As installed at Castelli Gallery, New York

10 Andy Warhol, *Campbell's Soup Box*, 1962. Casein, paint, pencil on plywood. 55.9 x 40 x 40 cm (22 x 15 ¾ x 15 ¾ in)

11 Richard Artschwager, *Table and chair*, 1963-4. Melamine laminate, wood. 75.5 x 132 x 95.2 cm, 114.3 x 43.8 x 53.3 cm (29 ¾ x 52 x 37 ½ in, 45 x 17 ¼ x 21 in). Tate, London

12 Tony Smith, *Die*, 1968. Steel. 182.9 x 182.9 x 182.9 cm (72 x 72 x 72 in). National Gallery of Art, Washington, DC

13 Eva Hesse, *Contingent*, 1969. Cheesecloth, latex, fibreglass. 350 x 630 x 109 cm (138 x 248 ¼ x 43 in). National Gallery of Australia, Canberra

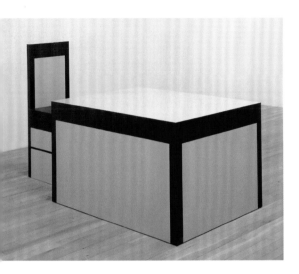

11

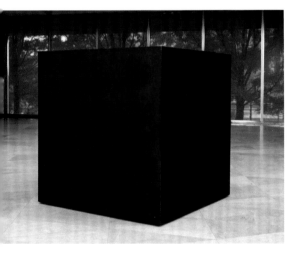

12

13

Among all these male artists working at the end of the 1960s, there was a distinctive female presence -- Eva Hesse, who achieved rapid prominence through her use of unconventional sculptural materials, such as latex, cheesecloth, rope, string and rubber tubing. These materials were soft and flexible and as a result her sculptures, such as *Contingent* (13), were given an amorphous air, dangling and wobbling from walls and ceilings. Hesse attempted to make something that was 'non art … from a total other reference point', and after her early death in 1970 her contemporary Carl Andre said: 'Perhaps I am the bones and the body of sculpture, and perhaps Richard Serra is the muscle, but Eva Hesse is the brain and the nervous system extending far into the future.'

Following on from these major discussions about form, material, subject matter and context, sculptors began, in the 1980s, to ignore their nationality in favour of an international sense of creativity. They came to regard themselves as citizens of the world, able to work anywhere and to speak the universal language of art, often describing themselves as itinerant workers or nomads. Yet only a decade earlier, nationalism played a part in the development of contemporary sculpture. In the mid-to-late 1970s, German and Italian painters, and a British group of sculptors, emerged to great acclaim, wresting the notion of the avant garde away from America. Subsequent hot spots were Latin America and Eastern Europe. During the same period, there was also a major shift in gender -- for the first time in the history of world art, many of the most significant artists working in three-dimensions were female. In 1997, the art critic Germano Celant stated that the 1960s and 1970s had been dominated by encounters between America and Europe, the 1970s and 1980s were characterized by a confrontation between male and female, while the 1980s and 1990s were defined by the celebration of multiculturalism. Although his assessment of these decades was somewhat glib, it was also largely accurate.

From the mid-1990s, modernist attitudes about form and content were revisited and opened up for lively renegotiation. There appeared the reinvention of popular or 'amateur' uses of material and technique, and an interest in disrupting the conventionalist distinction between representation and non-representation. Art exchanged much with the pop-media culture. There were reappraisals of older discussions and a strong nostalgia for the 'Swinging Sixties' and brightly coloured British New Generation sculpture. A vogue for kitsch Baroque emerged. Recently, there has been a shift to the handmade, to craftsmanship. At the end of the twentieth century, 'isms' were invented by the dozen, to try and catch hold of what was going on. But art is not now a sequential series of movements; it is more a network of artists, critics, dealers, curators, collectors, galleries and art magazines that all intertwine. Buzz words are 'interaction' and 'collaboration' between artists. The partnerships of Fischli & Weiss, founded around 1980, and Gilbert & George, established in 1969, have been the model for more recent partnerships. In the twenty-first century, there is no prevailing orthodoxy; artists are multi-taskers who work across categories and boundaries, and often do not have studios. As the art critic and philosopher Arthur Danto wrote in *After the End of Art* (1996): 'Ours is a moment, at least (and perhaps only) in art, of deep pluralism and total tolerance. Nothing is ruled out.'

For most of its long history, sculpture's primary concern has been the realistic representation of the human body, both naked and clothed, and at least nine-tenths of all the sculptures ever made have been devoted to this subject. Over the centuries, sculptures of the human body have been used to express abstract concepts, as well as particular narratives, emotions, aspirations and anxieties, which have been pressed into the service of religion, mythology, ideologies, politics and national identity. In the 1960s, the body lost its prominence as the prime subject for sculpture. This was the decade when simplified geometric sculptures began to appear in America and Britain, heralding the beginning of a new sculptural movement. It was also the decade that saw the proliferation of nuclear missiles developed by the two superpowers, Russia and America, which caused a widespread mood of anxiety. Artists in America and Europe began using their own bodies in performances and happenings, physically acting out issues involving the implications of nuclear war and global domination, sexuality, desire, identity, illness, gender inequality and homophobia, without feeling the need to make three-dimensional objects that would depict and concretize these concerns.

However, at the end of the 1970s and the beginning of the 1980s, there was a return to figurative art, both painted and sculpted. Initially, this may have seemed surprising, but on reflection it can be seen to have its reasons. The return was led by German and Italian painters, who paved the way for the sculptors. German painters, such as Georg Baselitz, Markus Lüpertz and Anselm Kiefer, turned to face their recent history and the way in which the Nazi regime had defamed the German Expressionist art of the early twentieth century. They started to work in a Neo-Expressionist manner, suggesting some kind of allegiance to their artistic forbears. Italian painters also looked at their history, and Sandro Chia, Enzo Cucchi, Francesco Clemente and Mimmo Paladino began to make sculptures of the human figure that had an archaic quality.

A huge range of approaches to figuration had been practised throughout the history of sculpture, and the sculptors who turned to the figure in the late 1970s were only too aware of what had been tried in the past. To most of them, it did not seem relevant to follow the tradition of working from a live model, or from other methods of mimicry, such as photographs. The few figural sculptures that were made at this time were stiff and hieratic in appearance, as though the body had to be reinvented.

Then, in the early 1980s, a romantic, mysterious or expressionist style emerged for a short period, inspired by the art and artefacts of a diverse range of cultures, mostly non-European. However, the AIDS epidemic, which surfaced at this time, had a powerful effect, causing the human body to be seen less as a conquering hero or embodiment of symbolic virtue, and more as a victim of global diseases and threats. A significant publication appeared in 1982, titled *Powers of Horror: An Essay on Abjection*, by the philosopher Julia Kristeva. This examined the concept of the abject, building on the earlier ideas of the Surrealist writer Georges Bataille, and it caused 'abjection' to become a buzz word in art circles from the early 1980s until the mid-1990s. Kristeva described the abject as the private and intimate aspects of the body, such as bodily functions and fluids, which are deemed inappropriate for public display. This book was widely read in art circles in the 1980s, and in 1993 the Whitney Museum of American Art, New York, organized an exhibition called 'Abject Art: Repulsion and Desire in American Art', which included, among others, the American sculptors Louise Bourgeois, Kiki Smith and Robert Gober. The body was presented as damaged, wounded, suffering, disordered and conveying political aspects attached to its sexuality, gender and ethnic identity. It was often accompanied by representations of body fluids, such as blood, semen, excrement and vomit. The suffering, semi-naked Christ, with his blood, sweat and tears, became a significant icon at this time, and many figural sculptures adopted a pose similar to that of the crucifixion.

14 Mark Wallinger, *Ecce Homo*, 1999.
White marbelized resin, gold leaf, barbed wire.
182 cm (71 ¾ in) high. As installed at Trafalgar
Square, London, July 1999 - February 2000

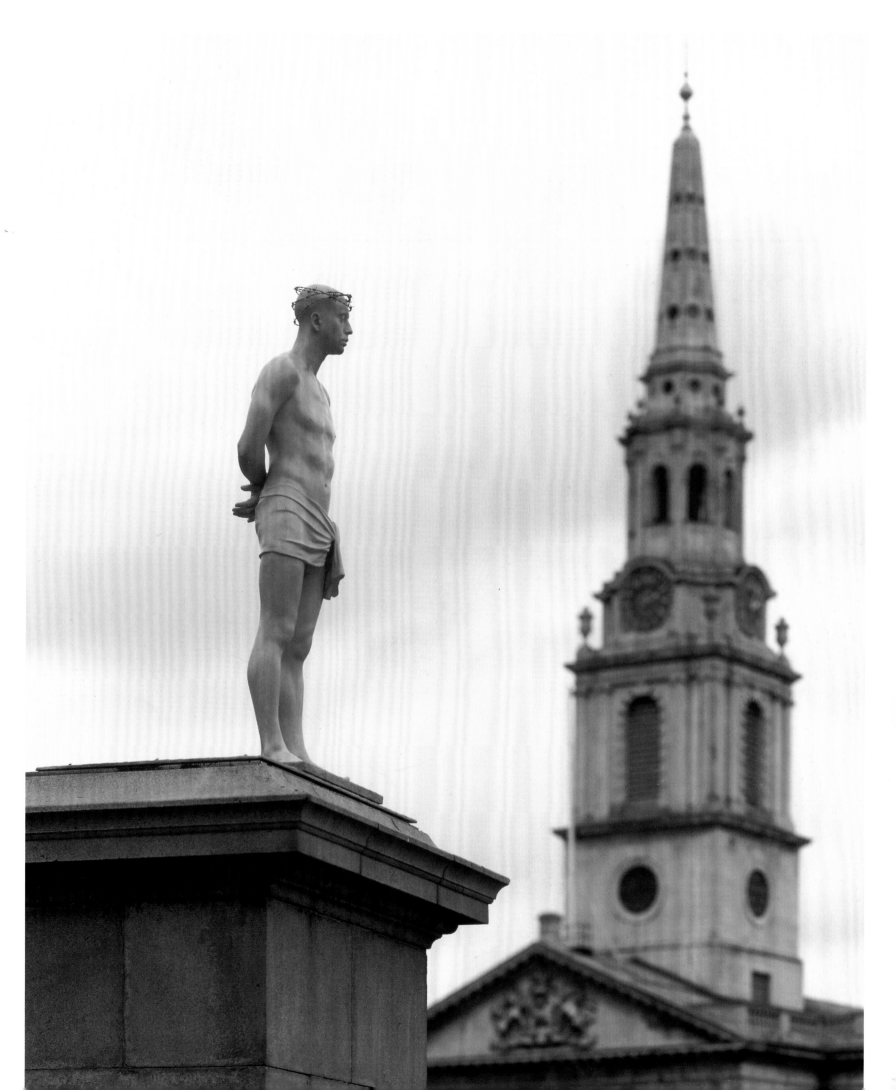

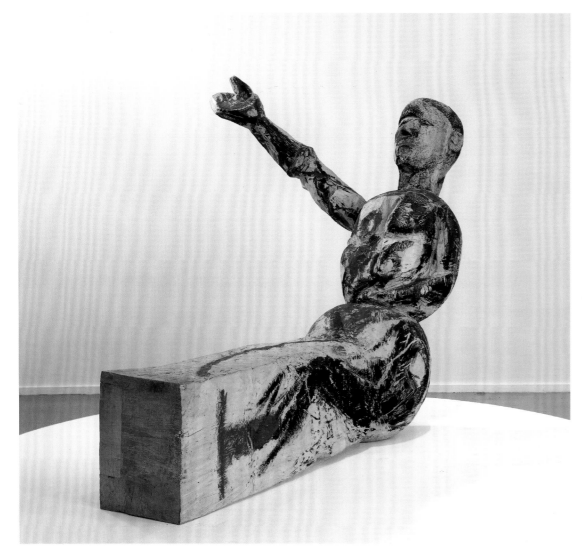

15 Georg Baselitz, *Model for a Sculpture*, 1979/80. Carved and painted limewood, tempera. 178 x 147.5 x 244 cm (70 x 58 x 96 in). Museum Ludwig, Cologne

There has been a second surge of figuration in sculpture since the late 1990s. This time, artists are not looking back to see what can be retrieved or modified from traditional symbolism, myth, or Expressionism. Now, the worlds that are plundered are those of the mass media and popular culture. Figuration is not the big issue it once was; it is just one choice among many. When contemporary sculptors address the human body, they use novel materials. In the 1980s, wood, stone, bronze and fibreglass had been employed, mostly traditional materials. Now these are eschewed in favour of plastics, lead, rubber, plaster, wax, ceramics, cement, sacking, sugar cubes, and even dust mixed with glue. And in an echo of the live performances of two generations ago, a handful of artists are working with the living body in all its ramifications. The Italian artist Piero Manzoni (1933-63) was the first in this field, signing the bodies of live people as living sculptures in 1960. Gilbert & George, the 'Living Sculptures', followed in the early 1970s. French artist Orlan plans to leave her surgically altered and mummified body to a museum. British artist Cornelia Parker arranged for the actress Tilda Swinton to sleep in a glass case for the duration of her exhibition 'The Maybe', held at the Serpentine Gallery, London, in 1995. The American Vanessa Beecroft organizes displays of living models in galleries and museums.

The first major manifestation of the return to figurative sculpture occurred when the painter Georg Baselitz surprised viewers at the 1980 Venice Biennale exhibition with his *Model for a Sculpture* **(15)**, a nude male figure, roughly carved from limewood and painted with forceful brush strokes. Baselitz's figure seems precariously held between falling and rising, in an uncomfortable pose. The raised arm is the most positive aspect of this awkward and constrained form, which has not fully emerged from the block of wood. There are not many poses that a figural sculpture can adopt, beyond standing, sitting, reclining and lying (although Rodin tried hard to extend the range), and Baselitz has chosen one that is unresolved, rather like the title of his work.

A younger artist, Stephan Balkenhol, began to make sculptures of the figure **(16)** a couple of years after Baselitz, of which *Man with White Vest* is a characteristic example. The pose of the figure is relaxed and unheroic, with one hand stuffed in his pocket and the mood reinforced by his undress. Balkenhol chooses soft woods, such as poplar or African wawa, as here, and uses a power saw followed by a chisel. The chisel marks are still visible through the painted surface, rendering the work's status as a sculpture undeniable.

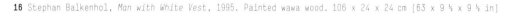

16 Stephan Balkenhol, *Man with White Vest*, 1995. Painted wawa wood. 106 x 24 x 24 cm (63 x 9 ½ x 9 ½ in)

In Italy in the early 1980s, a group of painters -- Chia, Cucchi, Clemente and Paladino [19] -- began to make figurative sculptures. The art critic Achille Bonito Oliva coined the term 'Transavanguardia' to describe and promote their new work. They mostly used stone and bronze, making silent, hermetic figures who gesture in the execution of obscure rituals. There is a suggestion of the classical antique style in their work, a cultural heritage with which Italian artists have to deal, as well as a hint of the smoothed-down, mysterious figures found in Italian Metaphysical paintings of the 1920s by Giorgio de Chirico and Carlo Carra.

Concurrently, two other Europeans experimented with the figure: Henk Visch and Martin Disler. Visch is a solitary figure who cannot easily be accommodated into any kind of grouping or category, although his figures shared many stylistic characteristics with Italian painters and sculptors. *Untitled* from 1981 [17] is arresting in both material and gesture, the pose having been inspired by an earlier drawing. In the early 1980s Visch resorted to the traditional techniques of carving and modelling, and *Untitled* is made from carved wood, onto which scraps of paper are attached. Its gesture is enigmatic, with the figure kneeling and appearing to throw two paper sheets upwards. The figure's face looks heavenward and seems to be smiling, as though it is capable of defying gravity.

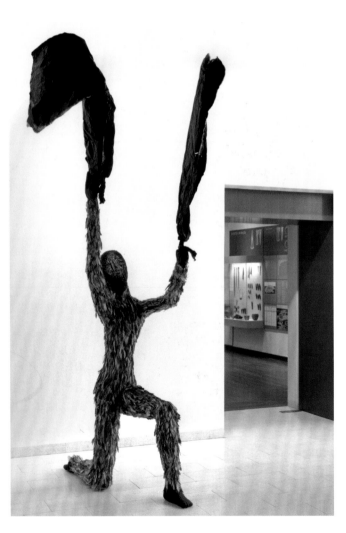

17 Henk Visch, *Untitled*, 1981. Wood, paper. 350 x 250 x 150 cm (137 ¾ x 98 ½ x 59 in). Groninger Museum, Groningen, The Netherlands

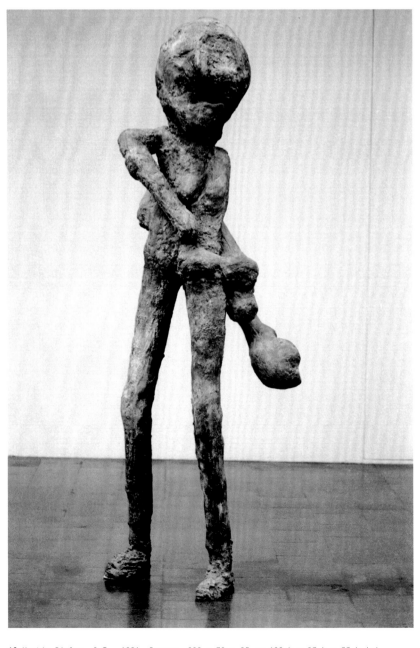

18 Martin Disler, *O.T.*, 1991. Bronze. 220 x 70 x 85 cm (86 ½ x 27 ½ x 33 ½ in)

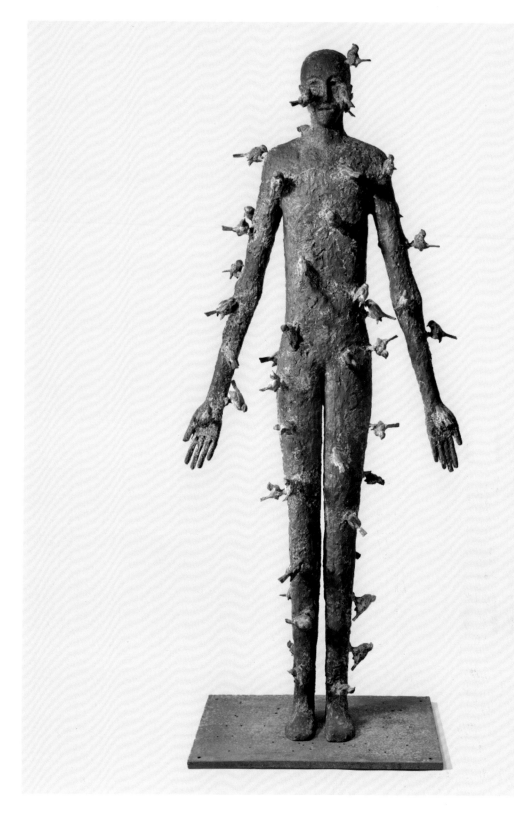

19 Mimmo Paladino, *Cadute a Ragione*, 1995. Bronze. 217 x 81.2 x 61 cm (85 ½ x 32 x 24 in)

It was executed in the same year as another carved wood figure called *Angel*, and both sculptures seem to express a desire to fly. By the mid-1980s Visch abandoned carving and began to make bronze figures with simple smooth contours and little detail, which have an echo of the art of the 1920s. Disler's figures, usually in bronze, shared stylistic characteristics with the wild, gesturing bodies found in German paintings. His androgynous creatures **[18]** have large heads on top of etiolated bodies and limbs, some of which are missing. They dance melancholically to their own music.

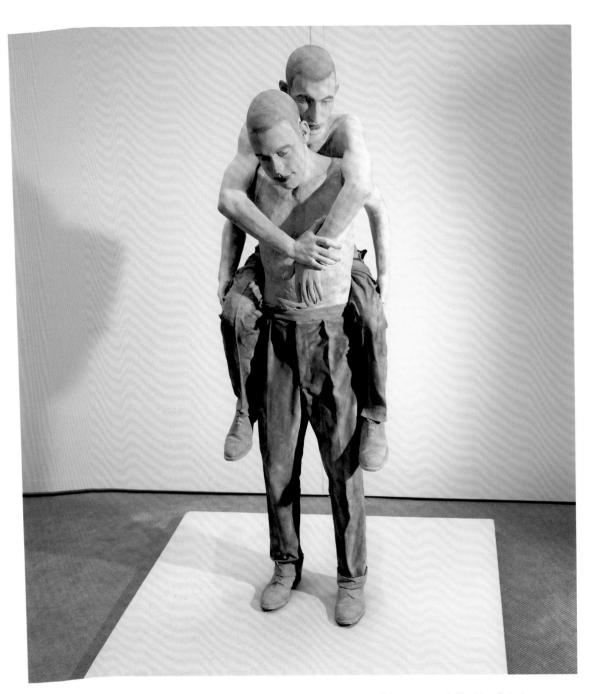

20 John Davies, *Two Figures (Pick-a-back)*, 1977-80. Mixed media. 180 cm (70 ¾ in) high. Collection Robert and Lisa Sainsbury, University of East Anglia, Norwich, UK

In the 1980s, Britain had few figurative sculptors of this expressionist or allegorical kind, except for John Davies, who stated that he wanted 'to make things that are like people, rather than like sculpture'. From the beginning of the 1970s, he has been making single, clothed figures, heads and enigmatic groups of men who look as though they are performing some kind of secret ritual. He models the bodies in clay, but casts heads and arms from life. The disparate parts are made of fibreglass, assembled and coated with a thick, dull, grey paint, which gives them the pallor of corpses, a quality completed by their expressionless glass eyes. The figures usually wear trousers and shoes, but are naked from the waist up and often seem vulnerable. The group sculptures frequently depict situations of dominance and subservience, such as *Two Figures (Pick-a-back)* **(20)**, although Davies sees such actions as ordinary, everyday gestures. The figures that he is making today have sloughed off their existential, lonely air, and are now more colourful and energetic, if less distinctive.

Antony Gormley started his career by covering small objects with lead sheeting, but in 1982 he abandoned this in favour of making sculptures of the human figure. He wanted to express what it feels like to be a human being, and he believed that the most direct way to do this was to have casts made from his own naked body, rather than modelling a figure from clay or other materials. He has asserted that 'to aspire to universality necessitates figuration'. He makes both single figures and installations involving large numbers of identical bodies. A fuller account of Gormley's process is found later in this chapter.

In Spain, the artist who reinvigorated figurative sculpture was Juan Muñoz. He began his career as a writer and curator before turning to sculpture in the late 1980s, when he made cast-resin figures, which he set in elaborate ensembles and installations, that exude a sense of melancholy and alienation. His figures are usually under life-size, and they are often set at a distance from the viewer, which increases their diminution. In the early 1990s, he made hundreds of grey, fibreglass figures of men in suits who chat, laugh and interact with each other -- many are titled *Conversation Piece* **(21)**; they are the more animated counterparts to John Davies's silent humans. Alongside these, Muñoz also made a series of strange, child-like figures, some of which were called *Dancers*, but whose bodies end in lumpy hemispheres instead of legs.

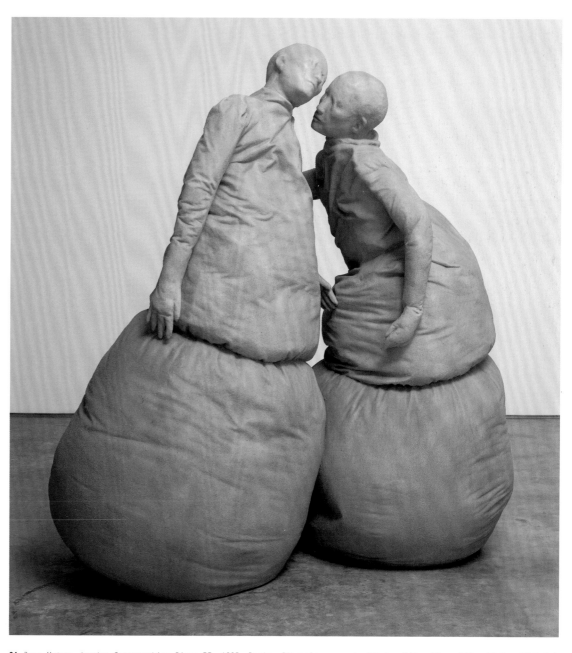

21 Juan Muñoz, *London Conversation Piece II*, 1993. Resin, fibreglass, sand. 157.5 x 144 x 70 cm (62 x 56 ¾ x 27 ½ in)

A few artists have ignored the changes in art fashions and continued with realistic figuration throughout their career, among the most prominent being Antonio López-García. Throughout a career spanning fifty years, López-García has kept to a traditional type of realism that harks back to the Italian Renaissance. An outstanding example of this is his major figure sculpture *Man and Woman* which he began in 1968 and worked on intermittently for twenty-three years. It is hard to believe that each figure started out as blocks of birch wood, which have then been meticulously carved and painted. He presents this austere naked couple very directly and nothing detracts from their materiality; the figure of the woman is more finished in appearance, while the surface of the man's body shows signs of manual activity. López-García has said, 'In the great Spanish art -- in Velazquez, Cervantes, Goya -- nothing interferes. They give you realism with a purity, with a tuning to reality not merely physical but psychological.' And in this impressive wooden meditation on time and mortality, he reveals that he too is capable of this.

Although López-García's figures display strong realism, they are outperformed in their artifice by the hyperrealist works of Evan Penny, who, as late as the mid-1970s, was taught academic figure-modelling at the art school in Calgary, Canada. Sensing that making figure sculptures in the mid-1970s was not the way in which to forge an artistic career, Penny started to make welded steel abstract shapes, but this did not satisfy his desire to work with scale, material, colour, and above all a surface filled with detail. He returned to modelling the figure in clay and chose people he knew as subjects, allowing them to find their own position and gesture so that all aesthetic decisions were avoided, and he was left to record his neutral version of everyman in the most lifelike manner possible. In order to avoid being accused of casting the figure from life, he works at four-fifths life-size, which puts the work at a slight remove from the viewer. Penny has executed several versions of *Jim* in a variety of materials **(22)**; the grey resin figure emulates the feel of a classical statue, but the surface detail is much greater than that found on an antique marble.

Penny's sculptures cause a shudder of unease, and have been described as 'uncanny'. This word appeared in art-critical circles during the 1980s, when it was used in discussions about the return of realistic figurative sculpture. The term derived from Sigmund Freud's essay 'The Uncanny' in 1919, which had been translated into English in 1959. In this text, he considered the paradox as to 'whether an apparently animate being is really alive, or conversely, whether a lifeless object might not in fact be animate'. The word 'uncanny' could be used of the silicone and fibreglass sculptures of Ron Mueck, who makes small and over-life-size figures that display obsessive surface detail and have a strong emotional charge.

A down-to-earth realism is found in the work of James Croak. Like Penny, he began as an abstract artist working with metal, but when he moved to Los Angeles in 1976, he started to make figures, both human and animal. He describes himself as 'a surrealist sculptor using conceptual figuration as his technique'. In 1984 he moved to New York, where he discovered his trademark material, cast dirt. He was looking for a neutral and cheap material, and dirt was readily available in the streets and gutters of Brooklyn. He models his figures in clay, using a live model as well as reference photographs. The clay form is cast, and Croak then mixes his dirt with a resin binder, which is poured into the cast. He is an admirer of the sculpture of López-García, and has stated that he wants 'to make art that has an uncanny presence'. In the mid-1980s he began a series of dirt babies, pitiful life-size creatures **(23)** that he often displayed hung on nails on gallery walls as though awaiting inspection or collection.

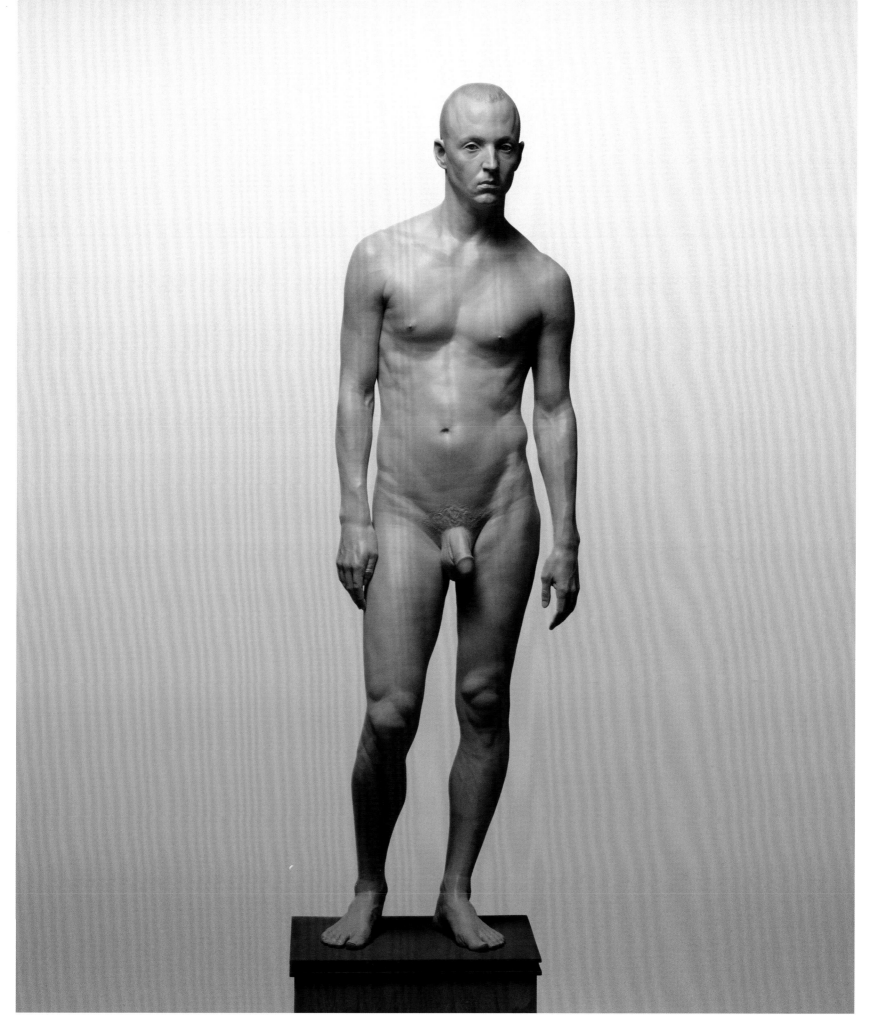

22 Evan Penny, *Jim*, 1985. Polychromed polyester resin. 140 cm (55 in) high

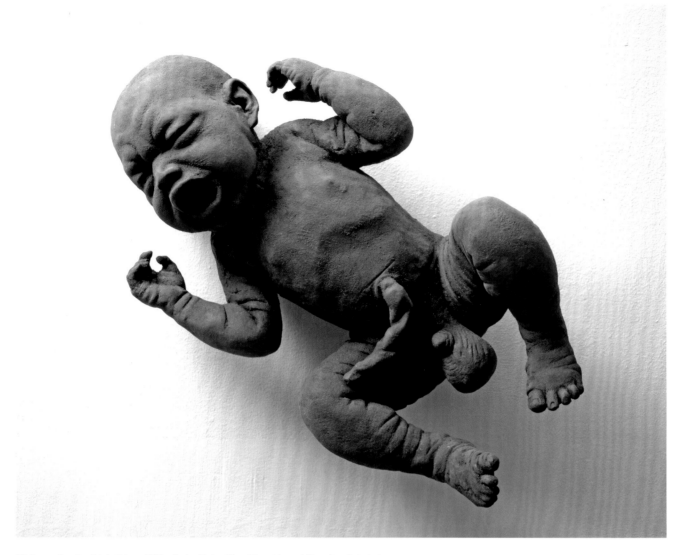

23 James Croak, *Dirt Baby*, 2003. Cast dirt. 38 x 23 x 14 cm (15 x 9 x 5 ½ in)

Since there is a strong emphasis in contemporary art on the idiosyncratic subjectivity of the artist, it follows that the gender of the artist will play a part in the formation of their style and content, particularly when dealing with the human figure. Do women sculptors work to a different agenda from those of their male counterparts? If anything, they could be said to veer a little more towards autobiographical introspection.

Kiki Smith presents the human body, usually female, as a battered subject, concentrating on its fragility and vulnerability, but also imbuing it with a sense of endurance. She states that her strong Catholic roots have affected her subject matter, and the pained endurance of some of her female figures have their counterparts in the suffering female saints and Christ figures of earlier religious art. Her training as an emergency medical technician at the Brooklyn Hospital, New York, in 1985, gave her first-hand knowledge of damage to the body. She uses a wide range of materials -- glass, plaster, ceramic, wax, bronze, fabrics, embroidery, clay and paper. She started with internal fragments of the human body (see Chapter 2), but by the beginning of the 1990s she was making complete figures, such as *Pee Body* [24], where long strands of yellow glass beads extend from the genital area of the wax figure of a naked woman, and *Untitled* (*Train*) [1994], in which strands of red beads stand in for menstrual blood.

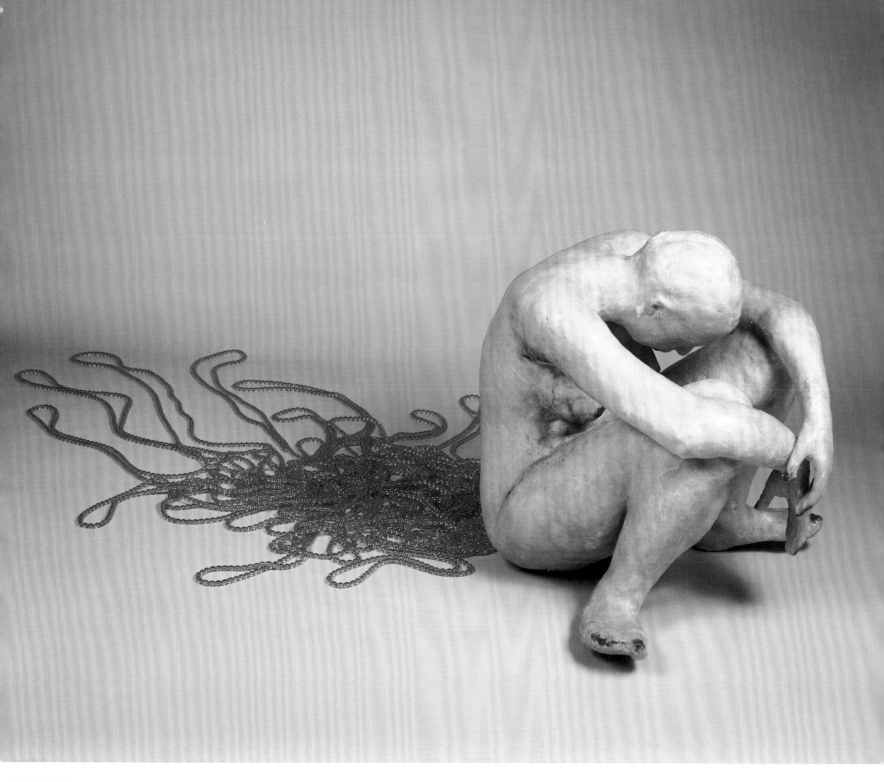

24 Kiki Smith, *Pee Body*, 1992. Wax and glass beads (23 strands of varying lengths). 68.6 x 71.1 x 71.1 cm (27 x 28 x 28 in).
Fogg Art Museum, Harvard University, Cambridge, Massachusetts

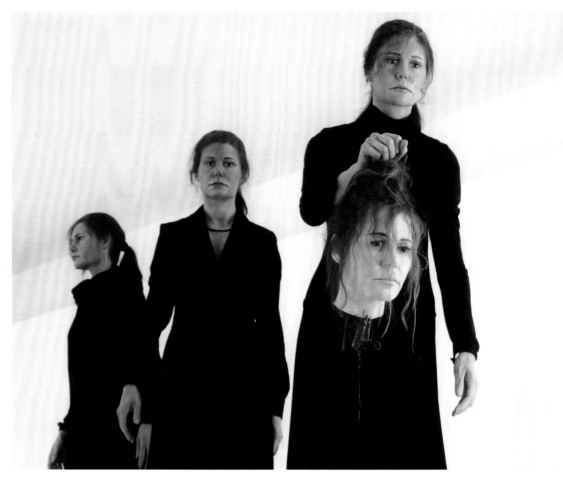

25 Mathilde ter Heijne, *Humans Sacrifice* (detail), 2000. Mannequins, clothes. Dimensions variable

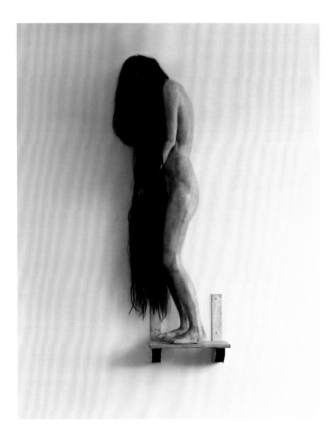

26 Berlinde de Bruyckere, *Hanne*, 2003. Wax, horsehair, iron coloured resin. 180 x 31 x 54 cm (70 ¾ x 12 ¾ x 21 ¼ in)

27 Miroslaw Balka, *The Salt Seller*, 1988-9. Wood, cement, fabric, salt. 122 cm (48 in) high. Art Institute of Chicago, Illinois

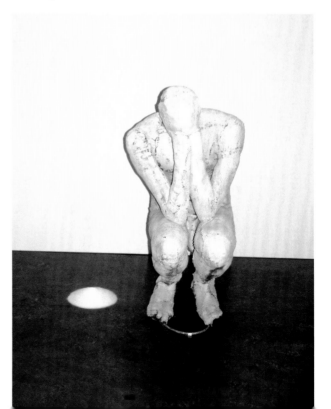

While Smith has been involved with the figure since the 1980s, Berlinde de Bruyckere and Mathilde ter Heijne have turned to this motif only within the last decade. De Bruyckere began her career in the early 1990s, making works with thick woollen blankets; the earliest consisted of a stack of these, set on a wobbly wooden stool. She has stated that her blankets symbolize warmth and protection, but also vulnerability and fear. The blankets then began to cover shapes such as cages, and progressed by the mid-1990s to her 'Blanket Women', female figures, usually made of plaster covered with a layer of wax, whose naked arms and legs are glimpsed under piles of woollen blankets, eluding the gaze of the viewer. More recently, she has worked with horse hide and casts of horses, and the women and horses have begun to intermingle; she has started to cover the bodies and faces of her nude female figures with long horsehair **(26)**, which acts as a protective veil.

Ter Heijne makes self-portraits, which she uses in installations and videos; these are life-size replicas incorporating casts made from her own hands and face, as well as false hair and clothes that are similar in style to the artist's own. In the installations, the figures **(25)** are usually accompanied by sound systems, such as CD players and radios, and appear lost in their own world. In the videos, the mood is one of violence and unrest, with ter Heijne taking her plots directly from contemporary news bulletins or old romantic films.

Miroslaw Balka graduated from art college in 1985 with a significant work, *Remembrance of the First Holy Communion* **(290)**, a life-size realistic sculpture of himself as an adolescent on the day that he joined the Catholic church. Poland was under martial law in the mid-1980s when Balka was studying to be an artist, and everything about his life was 'collectivized ... So I turned inwards to my own personal situation.' His work is always autobiographical, centring on the human figure and using humble materials to make powerful statements about human experience. In the late 1980s, he made some figures, such as *History* [1988] and *River* [1988-9], using poor materials like sack cloth. *The Salt Seller* **(27)** depicts a naked male figure in a crouching position, with his wrists pressed against his forehead in what looks like a gesture of exhaustion or despair. Beside the figure is a cone of salt, a material produced by both human tears and sweat, with which this figure appears to be all too familiar. But salt is also necessary for life; without it we die. In 1990, the human figure disappeared from Balka's work, and he began instead to make room-sized installations and objects -- like a bed or a coffin, based on the measurements of his own body -- and to work with materials such as soap, pine needles and ash. These works suggest a sense of corporeality felt through its absence.

Pawel Althamer, a slightly younger Polish artist, began his career staging performance events that subjected his body to various ordeals, such as submerging himself in water for three hours. When this phase ended, he started to make life-size, nude, standing figures from humble materials -- sewn and bound bundles of grass, which echoed the bundles of muscles. He also covered a nude male figure with pieces of animal skin sewn together, which gave it the look of a relic from prehistory. In 1993 he made *Self-portrait*, which built on these earlier works **(28)**. The figure was created from bundles of hemp fibres and coated with a wax skin, onto which real hair was applied. Althamer wanted every detail to be as lifelike as possible -- eyelashes, genitals, veins and fingernails -- and he employed a mirror and a camera as means to this end. He finished the work off by placing a pair of his own glasses on the figure, lending it a comic air.

All the artists mentioned so far live and work in America and Europe, and they unconsciously respond to their indigenous heritage and traditions. The figurative tradition has long been prominent in Japan and Africa, and some contemporary sculptors are consciously acknowledging their legacy. Katsura Funakoshi's father was a figurative sculptor,

28 Pawel Althamer. *Self-Portrait*, 1993. Hemp fibres, wax, hair, spices. 178 cm (70 in) high

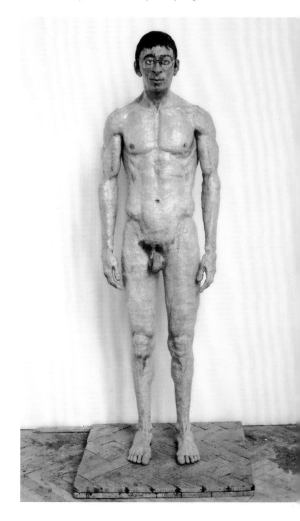

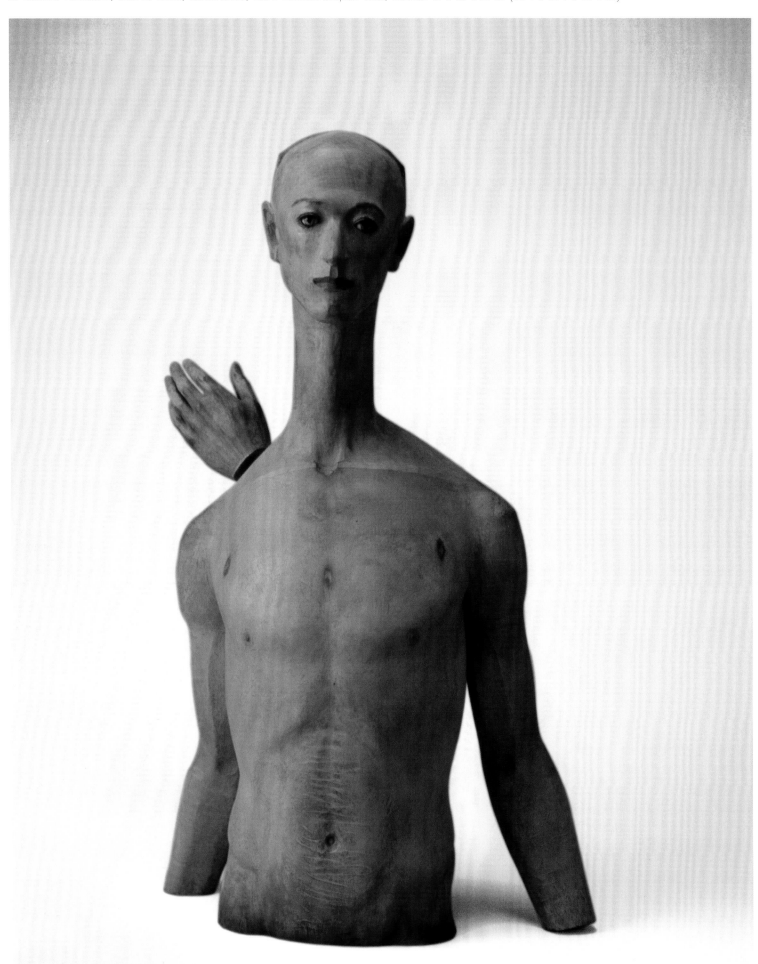

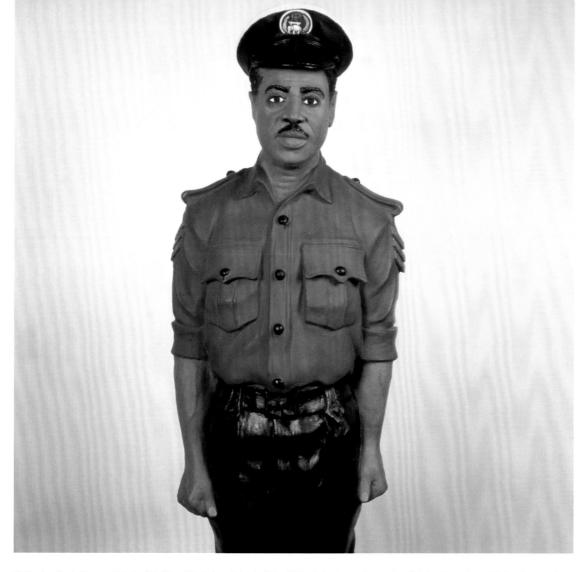

30 Sunday Jack Akpan, *Chief of Police (3 stripes)* (detail), 1989. Polychromed cement. 184.5 x 54 x 41 cm (72 ⅞ x 21 ⅛ x 16 in)

and Funakoshi's first work was a *Madonna and Child* for a Japanese monastery. Since then he has been carving serene figures from camphor wood, a traditional material that appeals to him because of its distinctive smell and the resemblance of the colour of the wood to human skin. The surfaces of his figures are varied, sometimes smooth and polished, sometimes with the small chisel marks showing. They are usually painted in subtle hues to enhance the connection between wood and flesh, and the eyes are marble. The figures are not portraits, but they have a tender yet assertive presence. Some of them have strange attachments, such as wings, parts of animals, or isolated body parts, as seen in *With no Horns, Herbivorous* (29).

Africa has its own traditions of carving and modelling the human figure in wood, clay, and more recently, in cement. Figural sculpture in Africa differs from that found elsewhere because most of it is commissioned and made to be used. It has its roots in the old religious practice of representing the deceased as a realistic standing effigy, made from wood or clay. Other figures represent divinities, guardians, statues of local chiefs and military men, as well as a range of Christian notables. Funerary and other sculpture in cement dates back to the 1930s, when that material became available along the west coast of Africa, from the Ivory Coast to Nigeria. Cement was imported from Britain for building purposes, and local sculptors turned to it since it was cheap and simple to use. The Nigerian sculptor Sunday Jack Akpan gave up his career in bricklaying in the 1970s to pursue a vocation making life-size funerary figures in cement (30). His business card reads: 'Natural Authentic Sculptor', and his works are life-size and painted to look as lifelike as possible.

The French art world was prominent in the showing of contemporary African figures in cement, exhibiting some by Koffi Mouroufie at the Pompidou Centre in Paris in 1977. In 1986 Akpan was given his own show in Paris and in 1989 was included in the ground-breaking Parisian show of artists from all over the world, 'Magiciens de la Terre'. Senegalese artist Ousmane Sow lived for a while in Paris, where he admired the work of Alberto Giacometti. Returning to Senegal in 1985, Sow has since devoted himself to making larger-than-life figure sculptures, primarily using plastic straw and jute over a steel armature with a final finishing layer of a secret substance that protects the work. It gives the figures a tarry, scarred look, which suggests both suffering and strength. He has also modelled figures in clay and had them cast into bronze [31], which he often paints in recognition of the body painting of African warriors. Sow was included in a group show of sculpture in Marseille in 1989; and when in 1995 the art historian Jean Clair put his figural work into his comprehensive show 'Identity and Otherness' at the Venice Biennale, Sow, like Akpan, entered the world of contemporary art. His highly successful retrospective show in Paris in 1999 included a thirty-five-figure piece, *The Battle of Little Big Horn*, sited at the Pont des Arts in front of the Louvre. Sow has since been commissioned to make large figural sculptures for his home city of Dakar.

In the last decade or so, there has been a rise of interest in figuration among male Belgian artists, following de Bruyckere. Their work pays a kind of homage to the Surrealist and Expressionist figuration practised by the Belgian painters René Magritte and Paul Delvaux, whose work was either dreamlike or sinister in tone. The somewhat disquieting side is to the fore at present, and is found in the sculptures of Wim Delvoye and Jan van Oost. In 1993, Delvoye made his bronze figure composition *Compass Rose of Wind*, which consists of four identical, nude, male figures on plinths in somewhat contorted poses [32]. They stop their ears with their thumbs and close their eyes with their fingers, so that they cannot see or hear. A large tube extends from their mouths and this is connected through their bodies to a smaller tube, which projects from their anuses. If one looks through the tube, one can see all the way through the body. The figures stand at the four cardinal points of the compass, hence the title. The same year, van Oost made *Black Figure in Corner*, a plaster figure of a female wearing black tights and dress, sitting hunched on the ground with her face covered by her long black hair [33]. Van Oost has said that he wants to work with the dark side of life, where death is ever present, and his swaddled figures appear to cower in fear or despair.

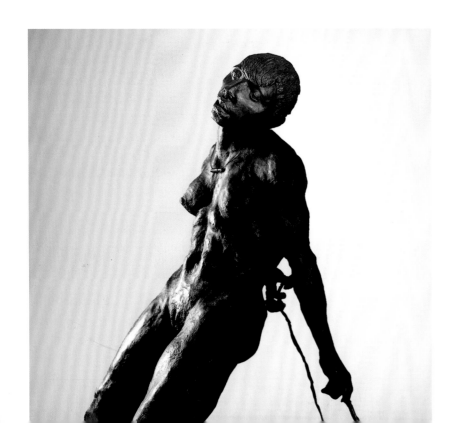

31 Ousmane Sow, *Dancer with Short Hair (Nouba)* (detail), 1985. Bronze. 92 cm (36 ¼ in) high. Fondation Jean-Paul Blachère, Apt, France

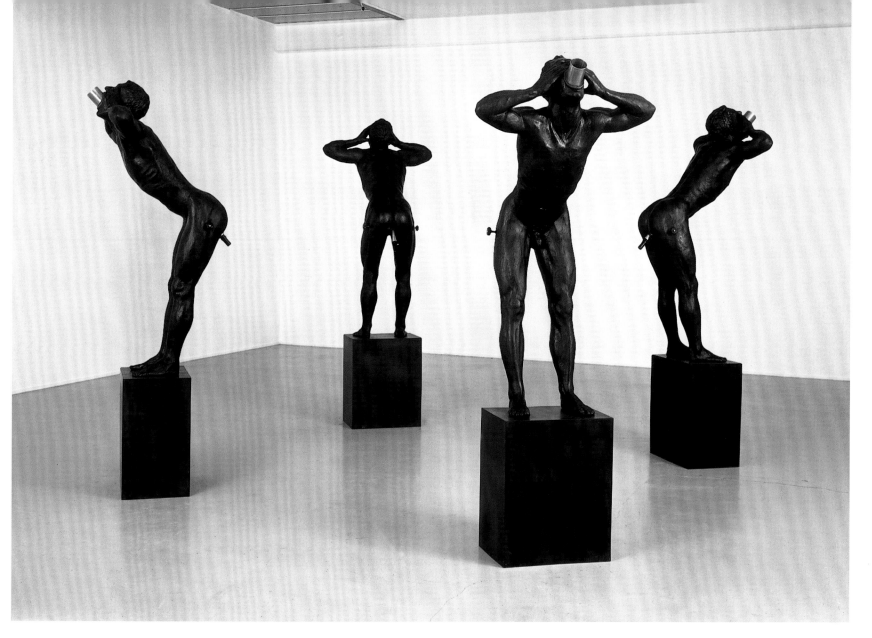

32 Wim Delvoye, *Compass Rose of Wind*, 1993. Bronze. Each figure 223 cm (87 ¾ in) high

Thomas Schütte likes to revisit and reinvigorate the canonical genres of sculpture, and there is none more central than that of the human figure. So it is not surprising to discover that at the very end of the twentieth century, he turned his attention to depictions of the nude female form. In New York in 1999, he exhibited four large sculptures of nude females, made from steel and set on tables of the same material. Since then, he has switched to having his modelled figures cast in traditional bronze, shiny aluminium and rusty cast iron. Schütte's nudes are pneumatic, with a slightly boneless feel, raising comparison with Aristide Maillol's heroic female nudes of the early part of the twentieth century. Besides a similarity in style and material, there is also a similarity in pose.

The younger American artist Steven Gontarski is also revisiting the human figure, using the style and content of those made during the Classical, Baroque and Romantic eras. However, he changes the proportions and the materials, casting his figures in fibreglass, which he finishes with a high-gloss sheen, and sometimes a bright colour, and he leaves some figures with parts of their anatomies missing **(34)**. Calling a group of them 'Prophets', he suggests an inner content. Like Schütte's, Gontarski's figures provocatively flaunt their odd corporality. (For further distortions of scale in the human body, see Chapter 16.)

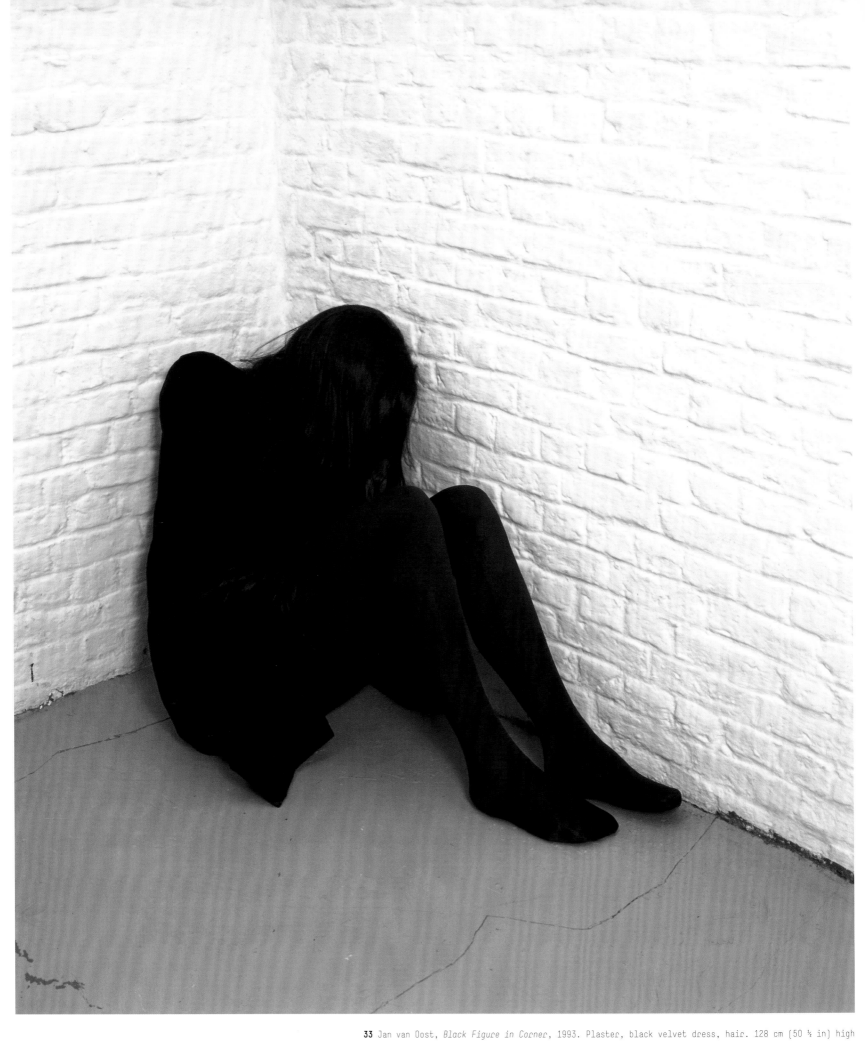

33 Jan van Oost, *Black Figure in Corner*, 1993. Plaster, black velvet dress, hair. 128 cm (50 ¼ in) high

34 Steven Gontarski, *Prophet*, 2001. Fibreglass. 215 x 75 x 60 cm (84 ½ x 29 ½ x 23 ½ in)

In the last few decades, casting from life has emerged as a popular method of making sculpture. At the beginning of the twenty-first century there has been a return to an interest in meticulous craftsmanship, and life-casting is a complicated and skilled process. Recent major retrospectives of artists who came to prominence in the 1960s and who used life-casting techniques, such as the Americans George Segal and Duane Hanson, have given younger artists a chance to look afresh at their work. The areas most involved in the current use of the life-cast are America, followed by Europe, with young British artists prominent in the field. Sculptors are looking at the machinations of representation and how to make a figure sculpture appear real or not real. There is always a dialectic between the authentic and the artificial; any sculpture has its own physical reality as an object, but when that object faithfully simulates something living, it then becomes artificial, simply because it is inanimate. The waxwork sculptures of famous people in Madame Tussaud's, which are not life-casts, play on this dialectic; they unsettle and deceive, as do several of the sculptures discussed below. Life-casts have the capacity to unnerve; the normal barriers between a piece of sculpture and the viewer are broken down due to the extreme similarity of the sculpture to real life. As mentioned previously, Sigmund Freud wrote how the uncanny, the eerie substitution of real life by simulated life, can cause the viewer to experience a shudder of revulsion.

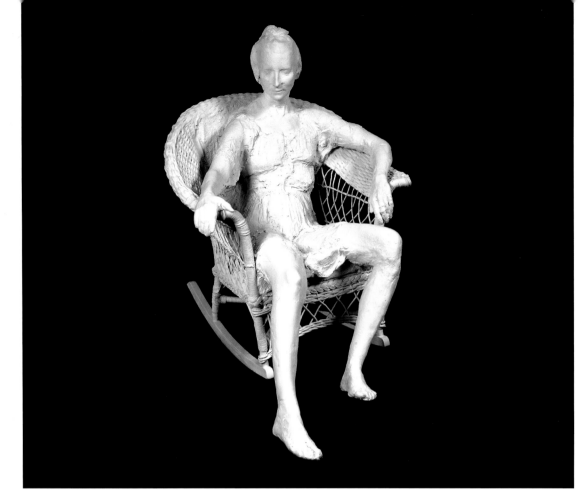

35 George Segal, *Woman in a White Wicker Rocker*, 1984-9. Bronze with white patina. 106.7 x 88.9 x 127 cm
(42 x 35 x 50 in). Frederick R. Weisman Art Foundation, Los Angeles, California

Although a high level of craftsmanship is needed to produce a life-cast, the path from live model to sculpture is extremely direct, and can be achieved by someone with no artistic leanings whatsoever. Plaster casts offer unmediated reality and show no evidence of an artist's personal style or signature. As a result, life-casts have often attracted the criticism that they do not classify as art. Actually, life and death masks -- a plaster or wax cast of a person's face -- have been made from the time of ancient Egypt to at least the nineteenth century, both as an aid to portrait sculptors and as objects of veneration. When a mask is made of the face, the eyes have to be closed against the molten plaster while it sets. 'Shake off this downy sleep, death's counterfeit', says Macduff in Shakespeare's *Macbeth*, and artists who use life-casts have explored this rich connection between sleep and death.

Life-casting on a larger scale emerged in Italy in the fourteenth century as a working tool for sculptors. As the term suggests, a cast or mould is made from a live subject, which can be human, animal or vegetable. Casts were made, usually in plaster, to create copies for further study, and they were private things, meant to stay in the studio so that their use might remain unrecognized in a finished work. Now, however, life-casts are found out in the open, in the public eye, and it is obvious that their function has changed. They are no longer an anonymous working tool, but are instead an expressive one, employed with humour and irony. Contemporary artists use the process to examine their presentation of self; some reveal themselves in a straightforward, self-portrait manner, while others make use of masks and disguises. Casting techniques have become more sophisticated, and the traditional use of plaster has been replaced by fibreglass, wax, alginate and cosmetic silicone.

Since the 1960s, a whole array of American and European artists, ranging from Yves Klein, Jasper Johns, Bruce Nauman, Paul McCarthy, Giuseppe Penone to Antony Gormley, have used life-casting in their work, but it was probably George Segal who used casting most prominently. In 1961, with the help of his wife, he covered himself with plaster-soaked medical bandages, used for broken limbs, to make his first figurative sculpture, a self-portrait. From then on, male and female models, nude and clothed, were encased in these bandages, which hardened on them. He set his figures in fragments of urban and domestic environments, such as *Woman in a White Wicker Rocker* [35]. The chair is not an arbitrary part of the composition, but serves to formally counter the pose of the woman, and the white paint that covers both the plaster figure and chair unites them even more. The monochrome coolness of the sculpture is warmed by the woman's slight smile, while her relaxed pose calls forth memories of luscious paintings by Matisse and Bonnard. In 1976, Segal started to cast his plaster figures in bronze, so that they were more durable and could be displayed outside. (For his *Holocaust Memorial for San Francisco*, using life-casts, see Chapter 13.)

Duane Hanson's work differs from Segal's in that he creates hyperrealist figures rather than rough, expressionist ones. Looking for a casting material that would enable him to make figures appear as real as possible, he found this in polyester resin and fibreglass. He was one of the first artists to employ this medium for figurative sculpture -- its more normal use was for boat hulls and the like. His first life casts in 1967 depicted figures that had undergone violence or suffering, such as rape, and Hanson doctored the casts to achieve these dramatic tableaux. But by 1970 he had found his main theme: the typical American involved in ordinary tasks, the same theme that had been adopted by Segal. A characteristic Hanson sculpture is *Old Man Dozing* [36]. Hanson chose his models with care, and he looked for people, like this man, who were a bit careworn and tired. He would have asked the man to adopt a pose that was natural for him and that was easy to maintain while the moulds were made of his body; the model possibly brought his favourite cushion with him while he rested. Then Hanson took the same care with the clothing, such as the old, polished shoes and the watch and wedding ring. Hanson's figures look so realistic in gallery environments that they constantly fool the viewer with their *trompe l'oeil* effects.

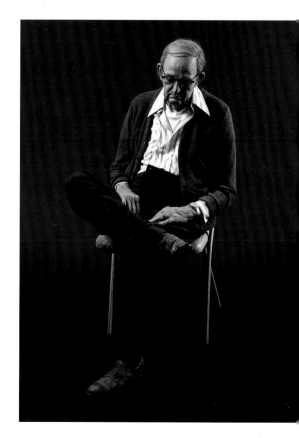

36 Duane Hanson, *Old Man Dozing*, 1976. Polyvinyl, polychromed in oil, mixed media. Life-size. Frederick R. Weisman Art Foundation, Los Angeles, California

37 John DeAndrea, *Diane*, 1987. Polychromed polyvinyl, mixed media. 78.7 x 99.1 x 71.1 cm (31 x 39 x 28 in)

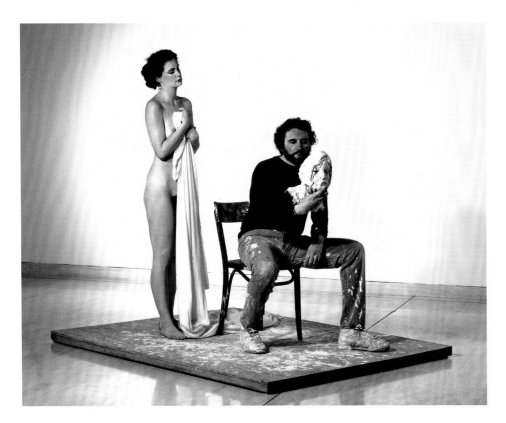

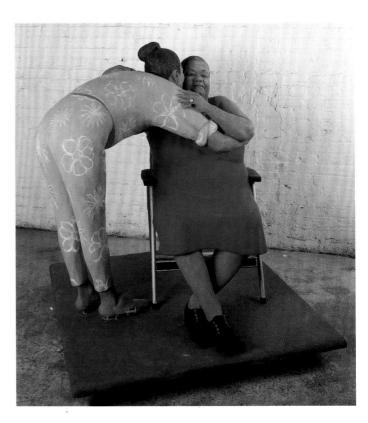

38 John DeAndrea, *Allegory: After Courbet*, 1988. Oil on polyvinyl, mixed media. 172.2 x 152.5 x 190.2 cm (67 ¾ x 60 x 75 in). Art Gallery of Western Australia, Perth

39 John Ahearn, *Maria and her Mother*, 1987. Oil on cast fibreglass. 132 x 132 x 123 cm (51 x 52 x 48 in)

John DeAndrea shares with Hanson the desire to deceive the viewer into believing that his figures are real. Although there are similarities in the means and materials by which these two artists arrive at their counterfeit representations of the body -- employing polyester, polyvinyl, fibreglass, oil paint, real hair and glass eyes -- they differ markedly in their aims and intentions. From the start of his career in 1970 until the present day, DeAndrea has concentrated almost exclusively on nude female models such as *Diane* [37]. He presents his naked women singly or in pairs, in twisted poses in which their limbs fold in on each other, emphasizing their introspective mood; their somewhat victim-like status keeps them in a 1970s time warp. His most significant statement is his tableaux *Allegory: After Courbet* [38], which depicts a self-portrait cast accompanied by a draped, nude female model. The title refers to a huge and controversial painting by the nineteenth-century French artist Gustave Courbet, *Interior of my studio, a real allegory summing up seven years of my life as an artist*, which showed Courbet painting, among a company of clothed men, attended by a draped, nude female model who appears as his muse. DeAndrea looks into a negative plaster mould of the model's face and muses on his own muse.

John Ahearn began making life-cast portraits of his friends when living and working in Manhattan in 1979; his aim was to produce art that was popular and accessible. He moved to the South Bronx and started to make life-casts of people whom he befriended among the Latino-American population of this neighbourhood; he creates two casts of each person, one of which is for sale and one for the sitter. He mostly casts half-length and full-length figures in relief, with only a few figures fully in the round, of which a major example is *Maria and her Mother* [39]. His life-casting takes place outside, usually on the pavement, so that it becomes part of the fabric of daily life, and recently he moved his studio to a storefront on East 100th Street. In order to make his figures more animated, he uses bright colours for their clothes and he paints their eyes open.

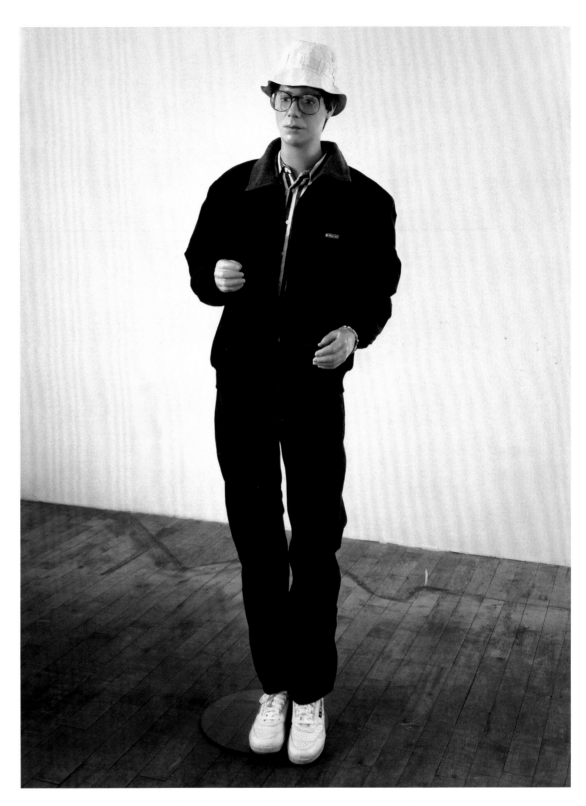

40 Charles Ray, *Self-portrait*, 1990. Mixed media. 190.5 x 167.6 x 50.8 cm (75 x 66 x 20 in)

Both Segal and Hanson were given major retrospective touring exhibitions in the 1980s and 1990s, and it is reasonable to assume that this exposure of their work, especially that of Hanson, has been a trigger for artists of the next generation. These include the Americans Charles Ray and Keith Edmier, and a group of European artists born in the mid-1960s: Olaf Nicolai, Gilles Barbier, Ugo Rondinone, Marc Quinn and Gavin Turk. Another influence was the work of Paul McCarthy, which emerged with his unsettling environment *The Garden*, installed at the Museum of Contemporary Art, Los Angeles, in 1992, where two life-cast male figures attempt to copulate with a tree and the ground.

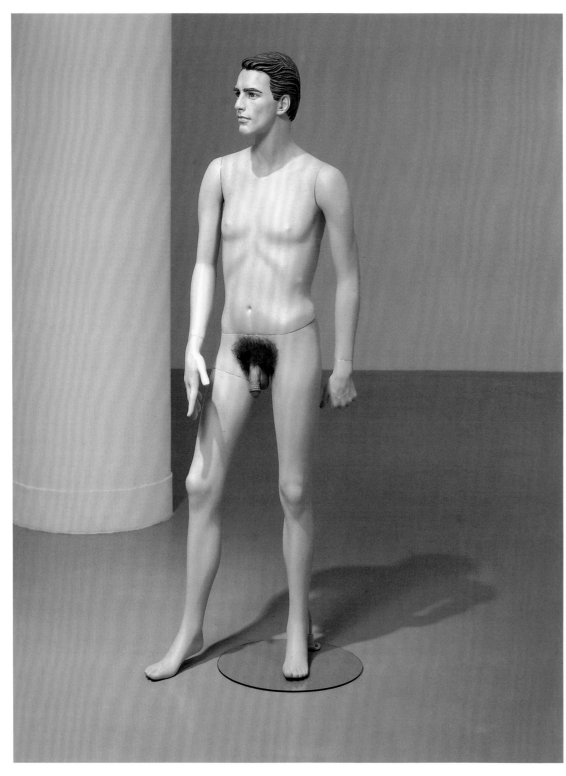

41 Charles Ray, *Male Mannequin*, 1990. Fibreglass, glass. 186.7 x 71.1 x 71.1 cm (73 ½ x 28 x 28 in)

Charles Ray adopts a variety of styles, materials and processes, and one of these involves life-casting. All of his activities examine what is real, what is literal, and he often uses the human figure to make the commonplace strange. His *Self-Portrait* **(40)** is a life-cast wax figure wearing his own tracksuit and trainers, hat and glasses. As an interesting complement, he made *Male Mannequin* **(41)**, which consists of a cast from a commercially available shop-window mannequin, onto which Ray has fixed a cast of his face and his genitals, surrounded by a halo of pubic hair. Male mannequins do not come equipped with realistic genitals, and Ray has transformed the bland ideal into the real with unsettling results.

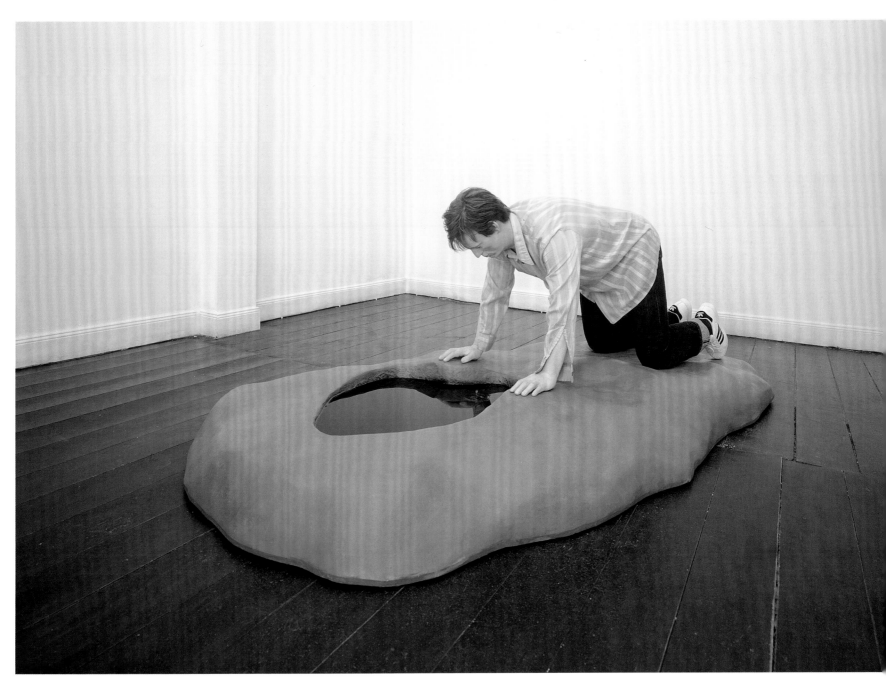

42 Olaf Nicolai, *Self-Portrait as a Weeping Narcissus*, 2000. Polyester, clothing, water, electric pump. 90 x 268 x 156 cm (35 ½ x 105 ½ x 61 ½ in)

Like Ray, Olaf Nicolai works in a variety of materials and styles, all of which play with levels of realism. In 2000, he produced a striking life-cast self-portrait, *Self-Portrait as a Weeping Narcissus* (42) -- an odd sculptural tableaux that is both formally striking and conceptually rich. Nicolai has chosen to create an amalgam of the everyday and the mythical. The artist, dressed in casual clothes, kneels on a grassy bank and gazes, enrapt, into a small pool. Every few seconds a concealed electric pump causes tears to fall from his eyes into the pool. This refers to the classical myth of Narcissus, a beautiful youth who falls in love with his mirror image reflected in water. This work is in keeping with a recent trend towards self-representation in painting, photography and sculpture, in which the protagonists role-play, presenting themselves in a range of bizarre situations and guises.

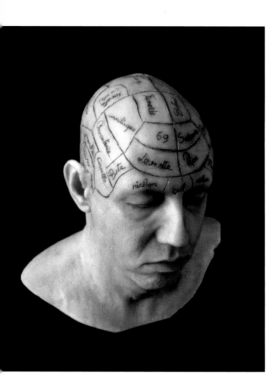

43 Gilles Barbier, *Trans-Schizophrenic Anatomy*, 1999. Wax, pigments. 40 x 35 x 35 cm (15 ¾ x 13 ¾ x 13 ¾ in)

Since 1994, French artist Gilles Barbier has embarked on a series of wax life-cast self-portraits in which he presents himself as both male and female, and, in one work of two figures, *My Conscience* (1996), as an angel in a long blond wig and an orange devil with a large erection. He describes his reason for turning to life-cast self-portraiture: 'I was totally lost, without any ideas, so I began looking for a type of work that was like a game -- something stupid or ridiculous. Copying in art is something stupid -- there is no invention, no genius, no pretension.' Apart from the angel figure in the wig, all other self-portraits are bald; Barbier has shaved his head for the past few years to facilitate the casting process. *Trans-Schizophrenic Anatomy* **[43]** is a wax cast of his bald head, sectioned and labelled with slang words for body parts jumbled up with corporate names. Barbier is parodying the death masks that were taken in the nineteenth century, from criminals and geniuses alike, for the study of phrenology, a branch of science that connected the shape of the skull and the parts of the brain to physical and mental faculties. These phrenological heads were inscribed with the names of the different brain parts.

Concepts of masquerade and disguise can be found in the sculptures of Ugo Rondinone, who has made a series of cast figures of plump clowns entitled *Bonjour Tristesse* (1997). He sources his models via advertising, asking for large, middle-aged men, whom he casts and reproduces in Styrofoam. He then paints and clothes the casts. In his installations, he places one or more of these figures as if sleeping on the floor **[44]** or slumped against the walls of the gallery, seeming quite content in their repose. On occasions, he has also presented himself as a clown, and as a straightforward self-portrait, leaning against a gallery wall. The condition of sleep that seems to overwhelm most of Rondinone's life-cast figures alludes to the fact that the eyes have to be closed when a cast is made.

44 Ugo Rondinone, *Bonjour Tristesse*, 1997. Mixed media, speakers, spotlights, sound. 300 x 500 x 270 cm (118 x 197 x 106 ¼ in)

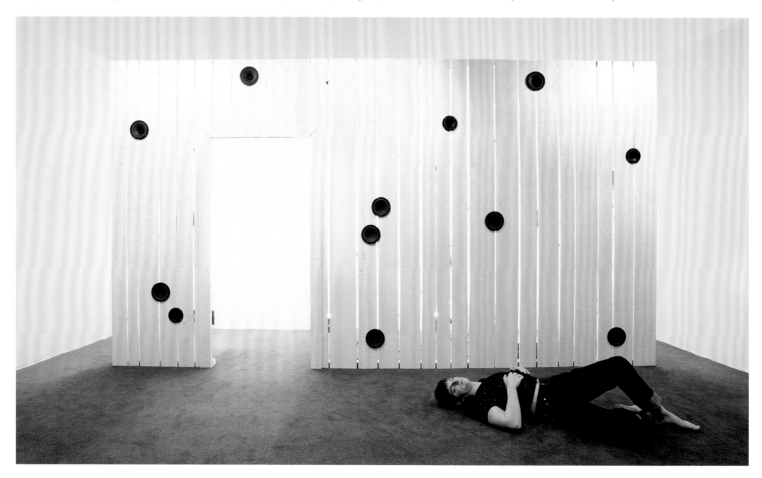

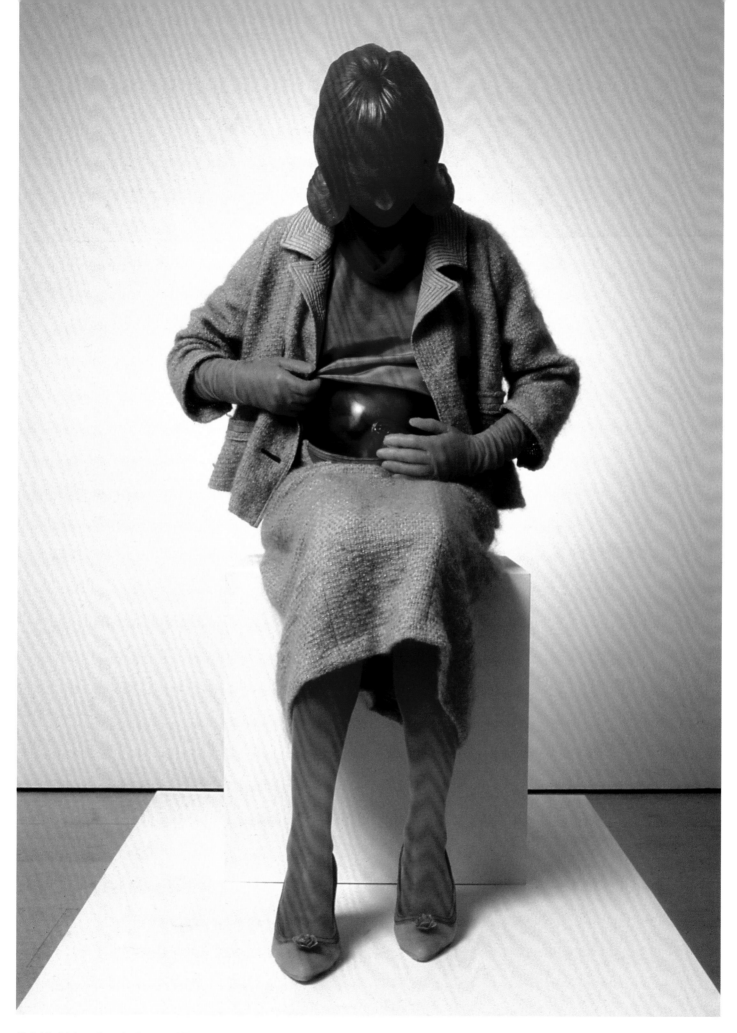

45 Keith Edmier, *Beverly Edmier 1967*, 1998. Cast resin, silicone, acrylic paint, fabric. 129 x 80 x 67 cm (50 ⅞ x 31 ½ x 26 ⅜ in). Tate, London

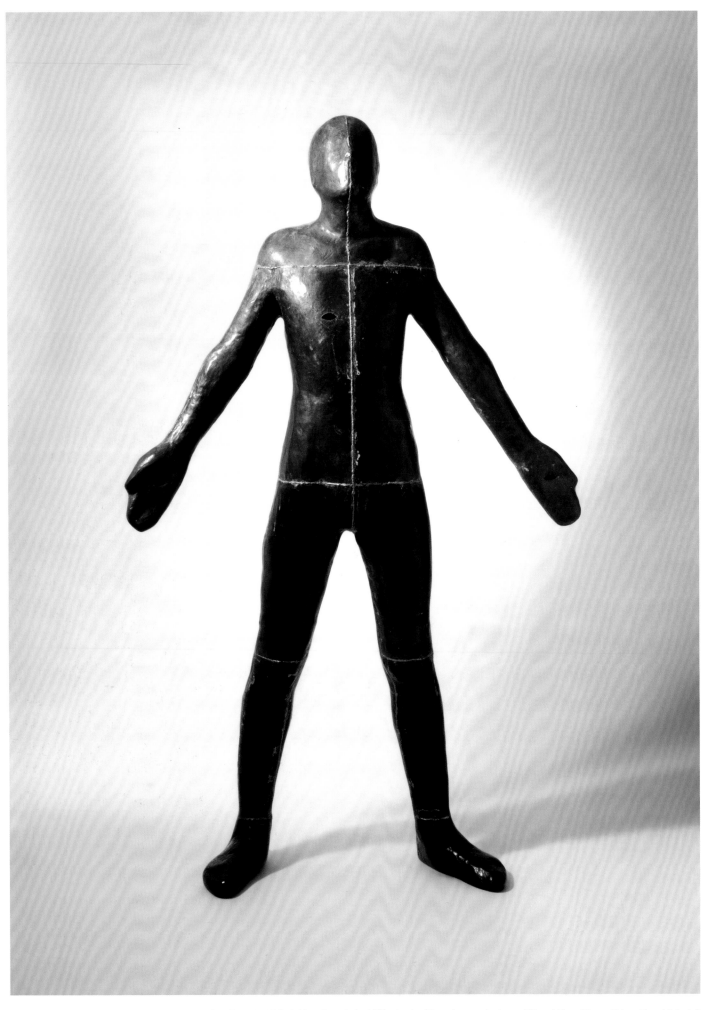

46 Antony Gormley, *Untitled (for Francis)*, 1986. Lead, fibreglass, plaster. 188 x 119 x 34 cm (74 x 47 x 13 ½ in)

47 Abigail Lane, *Misfit*, 1994. Wax, plaster, oil paint, human hair, clothing, glass eyes. 60 x 85 x 192 cm (23 ½ x 33 ½ x 75 ½ in)

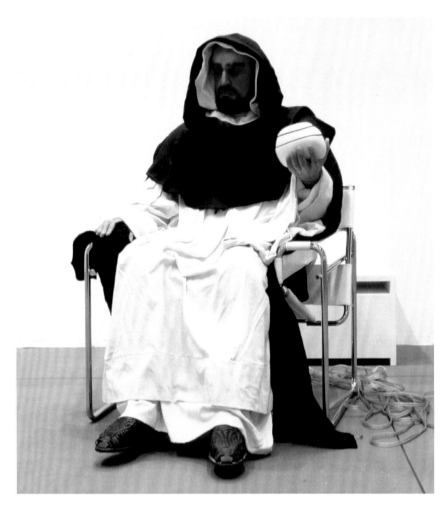

48 Siobhan Hapaska, *The Inquisitor*, 1997. Wax, synthetic hair, silk, oil paint, chair, audio components. 125.7 x 106.6 x 88.9 cm (49 ½ x 42 x 35 in)

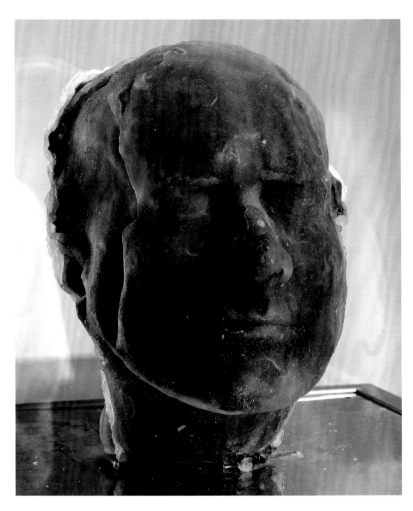

49 Marc Quinn, *Self*, 1991. Blood, stainless steel, Perspex, refrigeration equipment. 208 x 63 x 63 cm (82 x 25 x 25 in). The Saatchi Collection, London

Nostalgia for the popular culture of the 1960s and 1970s can be found in the sculpture of Keith Edmier, who worked on special effects in the American film industry before he became a sculptor. He now makes life-casts of humans and plants, using silicone, coloured polyester resin and his speciality -- coloured, translucent dental acrylic. He found a model to sit for a life-cast depicting his mother Beverly at the age of twenty-two in 1967, nine months pregnant with the artist himself as a foetus in her womb [45], making this one of the most unusual self-portraits in art. He clothed the figure elegantly in a pink Chanel suit, pink silk blouse and pink gloves, all from the mid-1960s, and gave her a stylish bobbed haircut. She lifts her blouse and gazes down at the child in her womb, and the pose carries allusions to that of the religious sculptural groups of the Virgin Mary and the Pietà -- motherhood and mortality, birth and death.

Antony Gormley's oeuvre is unique in that virtually all his work is based on casts taken from his own body. Even though each sculpture is a self-portrait, his casting process, which smoothes out all extraneous details, turns his figure into a universal everyman. To make a cast, the naked artist holds his chosen pose and is covered in plastic sheeting, Vaseline, and plaster-soaked cloth. Breathing tubes are inserted into his nostrils to keep him alive. Assistants, includ- ing his wife, cut him out of the cast, which has taken several minutes to harden, and the pieces of the mould are reassembled. A fibreglass figure is cast from the mould and this is then covered in sheets of lead, which are beaten into shape and welded, leaving the seams visible. The figure of the artist is schematically presented, submerged in a lead skin. Gormley thinks of this process as going to 'a place of darkness and of voluntary immobility.

It's death in a way.' His life casts differ in intention and look from all other artists in this chapter because he does not want to create a realistic illusion; his aims are more spiritual. *Untitled (for Francis)* **(46)** stands in the pose of St Francis of Assisi in Giovanni Bellini's Renaissance painting *St Francis in the Wilderness* (c.1480), receiving the stigmata, or wounds, from the crucified Christ, and Gormley's cast has matching holes at these particular points.

It is hard to tell whether Siobhan Hapaska had spirituality in her sights when she made *The Inquisitor* **(48)**. At any rate, it is not a self-portrait. It is a life-cast in painted wax of a man who has been dressed up in the habit of a Dominican monk and seated on a Marcel Breuer chair, an odd juxtaposition. It was not her first foray into life-casting; this came in 1995, when she exhibited her *St Christopher*, made from wax, human hair and fabric, in her first solo show in London. The figure of the saint with his beard and ragged clothing was in complete contrast to the other works in the show, which consisted of her signature biomorphic, opalescent plastic forms. Both Hapaska's life-cast figures are of religious figures, and the monk has a particularly stern and pedagogic manner befitting the title of the work. His right hand has a double set of fingers, while in his left hand he holds a strange white object, a little like an egg, which spouts a speech in Latin.

Abigail Lane's early work was concerned with physical evidence of the body. One installation consisted of wallpaper, printed with inked body parts such as buttocks, and others included casts of body fragments. *Misfit* **(47)** is a life-cast, wax, male figure, naked from the waist down, who rests uneasily on the floor. The sculpture was inspired by a similar figure seen in a London street, and to enhance his realism Lane has given him glass eyes, human hair and second-hand clothing. She likes to present odd tableaux, of which this is a prime example, and there is often the sense that something untoward has happened.

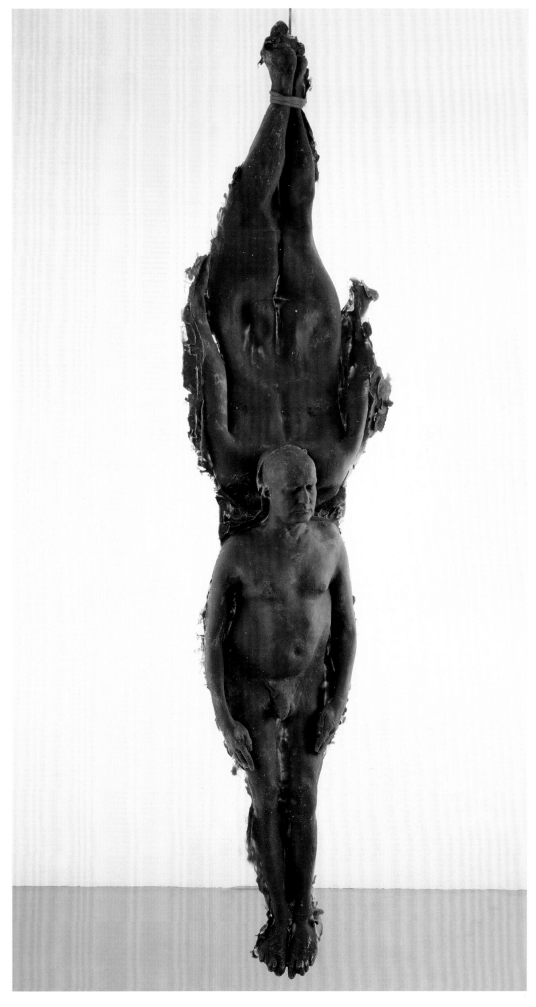

50 Marc Quinn, *No Visible Means of Escape XI*, 1998. RTV rubber, rope. 328 x 86 x 27 cm (129 x 34 x 10 ½ in). The Saatchi Collection, London

45

Like Gormley, Marc Quinn uses his sculpture to examine the condition of being mortal and all that this entails with regard to the human body. He has used himself as model for several works that address this theme. In 1991 he made *Self* **(49)**; over a five-month period he had eight pints of blood taken, which was poured into a cast of his head and kept frozen on top of a refrigeration unit. Inspired by a death mask of the mystical eighteenth-century poet and painter William Blake, *Self* is an extremely personal meditation on mortality, tenuously held in frozen animation and dependent upon a regular flow of electricity. The following year, Quinn made the first in a series of latex and rubber body casts of himself nude, several of which have the title *No Visible Means of Escape* **(50)**. In order for a cast to be made of Quinn's naked body, the material, alginate, is applied directly to his flesh when wet, and then peeled off in sections when set, allowing him to escape from its confines, in a contradiction of the work's title. Quinn has described this rubber cast as 'an extreme moment of transformation, a violent shedding of the skin', and by choosing to display it hanging from a rope, he alludes to death by hanging, an extreme moment of transformation of another kind.

Mark Wallinger looks at the 'politics of representation'. Invited to make an outdoor sculpture for a large plinth in Trafalgar Square, London, he surprised those who knew his work to date, which had largely concerned sport, by producing *Ecce Homo* **(14)**. This life-cast of a male figure was made of white marbleized resin, with a real barbed-wire crown coated in gold leaf. The figure's eyes are closed, his hands tied behind his back, and he is naked except for a loincloth. The Latin title -- 'Behold the Man' -- comes from the Bible and reveals the figure to be a representation of Christ, depicted at the moment when Pontius Pilate asked the crowd whether He should undergo crucifixion. Wallinger had the vulnerable figure set on the very edge of the large plinth, so that the contemporary crowd looking up at it was implicated, as in the biblical story. He commented: 'I think it was important that the figure was life-size, that it operated as a kind of inversion of all the other statues in the square. The latter are like trophies and triumphant scenes of empire, and they are huge and black and oversized.' *Ecce Homo* stood in Trafalgar Square from the summer of 1999 to the early spring of 2000, and was there for the revellers on millennium night, offering a silent reminder of what the millennium celebrated and was calibrated from.

In 1993, Gavin Turk showed *Pop*, a life-size, wax self-portrait dressed as Sex Pistol Sid Vicious, and appropriating the posture of Andy Warhol's painting of Elvis as a cowboy with a gun. This is a good example of the way in which contemporary figurative sculpture intertwines imagery from popular culture and the mass media. His *Death of Che* **(51)** is a waxwork recreation from the famous photograph of the dead body of revolutionary Che Guevara, lying on a stretcher laid on a cistern. But Turk has cast himself as Che, and thus as the martyred hero. Another artist who portrayed herself as dead, but without any trace of artifice or disguise, is Tracey Emin, who made her bronze *Death Mask* in 2002 **(52)**. Death masks were popular for preserving the features of the famous and the infamous, and Emin is famous for being infamous.

Gil Shachar is an Israeli artist who now lives and works in Germany. His signature work, *Nir* **(53)**, is a half-length bust of a figure with its eyes closed, made from synthetic resin and wax and painted to look as lifelike as possible. However, Shachar chooses to emphasize the closed eyes, thus bringing to the work a sense of suspended hibernation, deep sleep or even death.

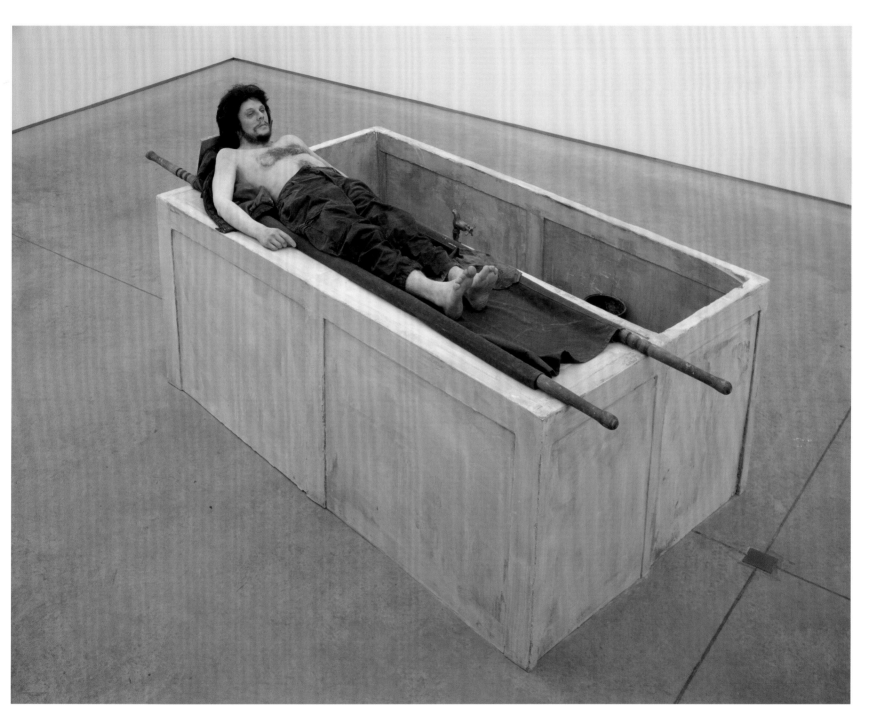

51 Gavin Turk, *Death of Che*, 2000. Wax, mixed media. 130 x 255 x 120 cm (51 ¼ x 100 ½ x 47 ¼ in). The Saatchi Collection, London

An artist who conflates the sleep/death dichotomy with extremely powerful results is Teresa Margolles, who trained as a forensic technician in a morgue in Mexico City, one of the world's most violent cities. There she finds evidence not only of acts of violence, but also failed organ transplants and botched cosmetic operations. She is a founding member of the multi-disciplinary group Semefo -- an acronym for the Forensic Medical Service -- who are devoted to exploring the aesthetics and taboos of death in Mexican society. Margolles achieves this by exhibiting real body parts, such as tongues, and by taking casts from dead bodies. Her *Catafalco* **(54)** is one such work; two plaster casts of autopsied male corpses are set upright, so that the viewer can look into the hollow mould and find bodily traces, such as hairs and particles of skin that have adhered to the plaster during the casting process. The stitching that follows the autopsy is also evident. These two figures may show some resemblance to medieval tomb sculptures or Egyptian mummies in form, but their raw presence is very much of our time.

52 Tracey Emin, *Death Mask*, 2002. Bronze. 19.5 x 23.5 x 17.2 cm (7 ¾ x 9 ¼ x 6 ¾ in)

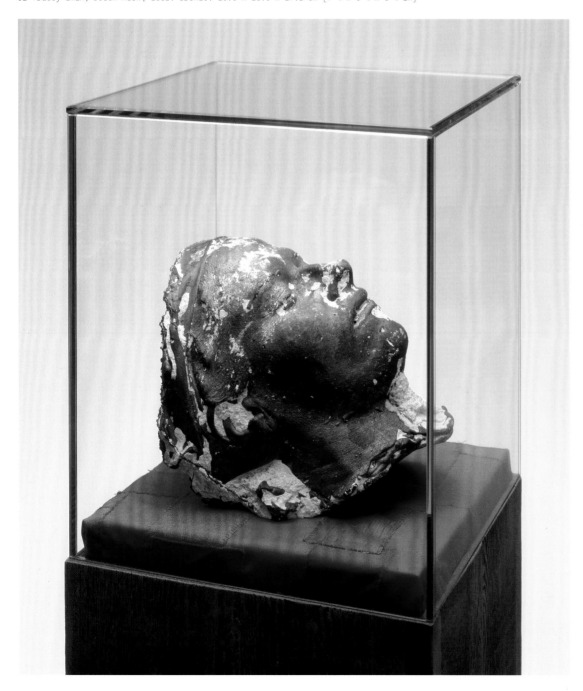

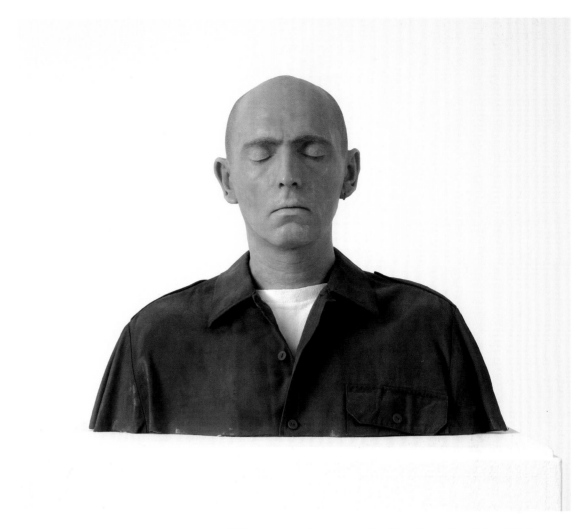

53 Gil Shachar, *Nir*, 2001-2. Wax, pigment, cloth, epoxy, earring, paint. 46 x 55 x 25 cm (18 x 21 ¾ x 10 in)

Tony Matelli, born in 1971, is a former assistant to Jeff Koons. He has become known for his hyperrealistic figurative sculpture, first emerging on the gallery scene with a tableau of three distressed boy scouts, *Lost and Sick* (1996). Most of his oeuvre since this date consists of self-portraits. His life-cast polyester figures are concerned with the troubled aspects of daily life. *Sleepwalker* **(55)**, for example, depicts a man dressed only in his underwear, fumbling his way across the floor.

McCarthy was mentioned earlier in this chapter as someone whose work with the body has been an influence on younger artists. He has two ways of working: he either makes sculptures and huge installations, or he acts out performances in galleries. He trained as a painter, and then enjoyed a seminal period of performance, where he developed his signature range of personalities -- cowboys and pirates among them -- as well as focusing on his own body, especially his genitals. Since the 1990s he has been making casts of his own body, and in his many gallery installations he often includes recycled moulds and casts of body parts, such as heads and hands. Life-casting can be a messy process, involving the painting of wet plaster or silicone onto nude and hairy flesh, and McCarthy is a sculptor who celebrates mess and materiality. A well-exhibited piece is a damaged plaster life-cast of himself with a black plastic rubbish bag on his head, but all previous life-cast work is surpassed by *Dreaming* **(56)**, a superbly detailed, semi-naked self-portrait of the artist asleep on a folding bed.

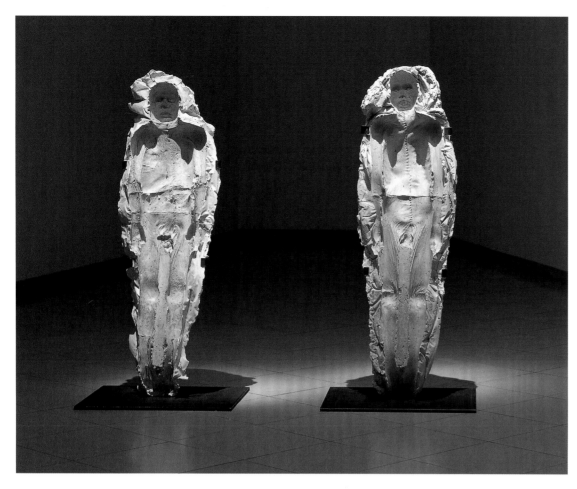

54 Teresa Margolles, *Catafalco*, 2000. Cast plaster. Each 170 cm (67 in) high. Museum für Moderne Kunst, Frankfurt

Two Chinese sculptors, Ah Xian and Zhang Dali, come to life-casting from a direction that is different from the Americans and Europeans. In their contrasting ways, both artists make strong statements about being Chinese at the beginning of the twenty-first century. Xian was born in Beijing but emigrated to Australia in 1990. He has, however, kept a close connection with the artistic heritage of his homeland, particularly in his choice of materials -- porcelain, lacquer and cloisonné enamel -- and his use of traditional Chinese decorative motifs. He began to make life casts in plaster but turned to working with viscous liquid porcelain instead. Figures of his family and friends, rendered in patterned porcelain, are depersonalized and burdened with the weight of Chinese history and culture, which in a sense obliterates them. His life-size nude figure *Human Human -- Lotus* **(57)** is made from lacquer and cloisonné, an expensive and hugely time-consuming process, first introduced to China in the thirteenth century.

During 2001 to 2002, Dali cast the heads of a hundred of his fellow men, as well as making a number of whole body casts **(58)**. He deliberately chose his models from among the temporary houses that have sprung up beside the Fifth Ring Road to the northeast of Beijing. These people have travelled from all over China to try and find work in the city, leaving their families in the countryside. Dali created a studio in an old warehouse next to a migrant community and worked on site, recalling the process of Ahearn. Before Dali made these body casts he was a graffiti artist and also made neon-light works, which he placed in urban streets. His urge to make art is based on his response to the dramatic changes happening in Chinese cities and society, where whole neighbourhoods are bulldozed in order to build high-rise towers. His life-casts of heads and bodies have the look of the morgue about them, and continue the sculptural theme of freezing the moment between life and death, between the animate and the inanimate.

55 Tony Matelli, *Sleepwalker*, 1997. Polyester, paint. 165 x 51 x 76 cm (65 x 20 x 30 in)

56 Paul McCarthy, *Dreaming*, 2005. Painted silicone, artificial hair, shirt, lawn chair, foam. 180 x 62 x 71 cm (71 x 24 ½ x 28 in)

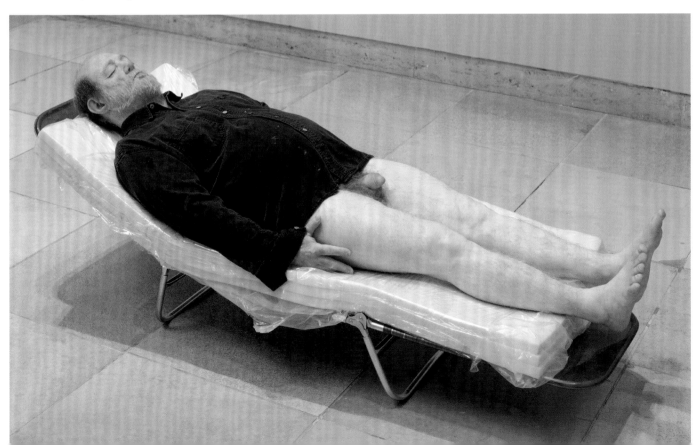

57 Ah Xian, *Human Human -- Lotus, cloisonné figure 1*, 2000-1. Hand-beaten copper, enamelled in the cloisonné technique.
158 x 55.5 x 32 cm (62 ¼ x 22 x 12 ½ in). Queensland Art Gallery, Brisbane

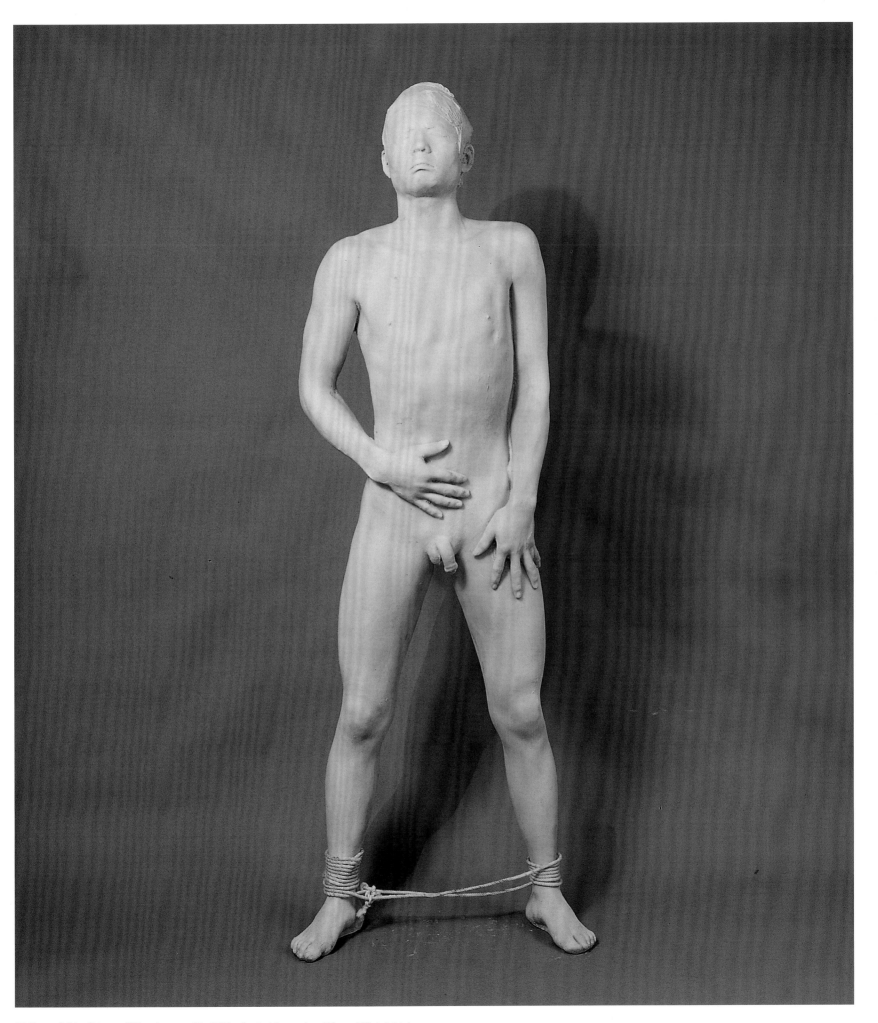

58 Zhang Dali, *Chinese Offspring no. 15*, 2003. Synthetic resin. 170 cm (67 in) high

THE BODY
FRAG-
MENTED

The ideas of completion and wholeness have been less common during the last fifty years than the idea of the fragment, the partial, the incomplete. Modernism promoted qualities of unity, wholeness and coherence, and with its fall in the 1960s these were deemed irrelevant to cutting-edge art. It could be said that the Cubist movement just before World War I introduced fragmentation, but American critic and art historian Linda Nochlin believes that the idea of the fragmented body emerged in Europe at the time of the French Revolution and the Napoleonic wars. This was a time of huge social disruption, when public monuments were torn down and people were beheaded by the guillotine; thus artists began to use the concept of the body fragment for allegorical purposes.

Two major artists of this era drew and painted body fragments -- Francisco Goya and Théodore Géricault. Goya made a series of powerful etchings entitled 'Disasters of War', while Géricault visited the morgue to study guillotined heads and severed limbs, which he then painted heaped together in gruesome and abject still-lifes. In this chapter, we see how corporeal integrity has been under threat in the last few decades, and how this has led to artists dealing with fragmentation and concomitant suffering. As a result, Goya and Géricault seem extremely contemporary.

The partial figure or isolated body part also made an appearance in late nineteenth-century European sculpture. Art students at that time were taught to sculpt by copying plaster casts of ancient Greek and Roman statues, many of which were fragmentary. By 1900, Auguste Rodin had appropriated the incomplete figure as his central theme; it allowed him to propel the body to speak in a new way. In the 1920-30s, the Surrealist artists used the partial figure to introduce ideas about the sexuality and psychology of the human body. These older concepts feed into the contemporary presentation of body fragments and are joined by such issues as quantum-physics research, where we learn that the world is made up of ever smaller and smaller particles, with nothing a solid whole. Duchamp's small plaster body casts made in the 1950s are significant precursors for some of the fragmentary pieces created during the last few decades. He cast erotic parts of the female body, such as the nipple and the genitals, as well as part of his face, to which he gave the marvellously literal title -- *With My Tongue in My Cheek* (1959). This colloquial phrase means expressing something ironically, and thus Duchamp's plaster fragment becomes a concise and witty amalgam of image and word. Other artists have followed suit, notably the American Bruce Nauman, who readily admits to being influenced by Duchamp. His fragment *From Hand to Mouth* (1967) is a wax cast of his wife's body from her lips to her fingertips, which is meant to be hung on the wall at body height. It has resonances of fragments of classical sculptures seen in museums, but also hints at a sense of violence done to the living body. It both fleshes out a colloquial expression and draws attention to the link between words and actions. Nauman has since made some dismembered heads cast in wax, the bright colour of which adds to their sense of violence, as in *Ten Heads Circle/In and Out* [60]. These disembodied heads hang from wires at the viewer's head height, so that their empty interior can be seen and the grimaces of their open mouths and protruding tongues are very visible. The thin, wobbly wires from which they hang contribute a sense of the precarious. The heads are displayed in pairs, yet each exists in its own solitariness. The spirit of Géricault's vivid imagination and the power of the guillotine are evoked in this work.

59 Robert Gober, *Leg*, 1990. Beeswax, cotton, wood, leather shoe, human hair. 27.3 x 52.1 x 14.3 cm (10 ¾ x 20 ½ x 5 ¾ in).
Hirshhorn Museum and Sculpture Garden, Washington, DC

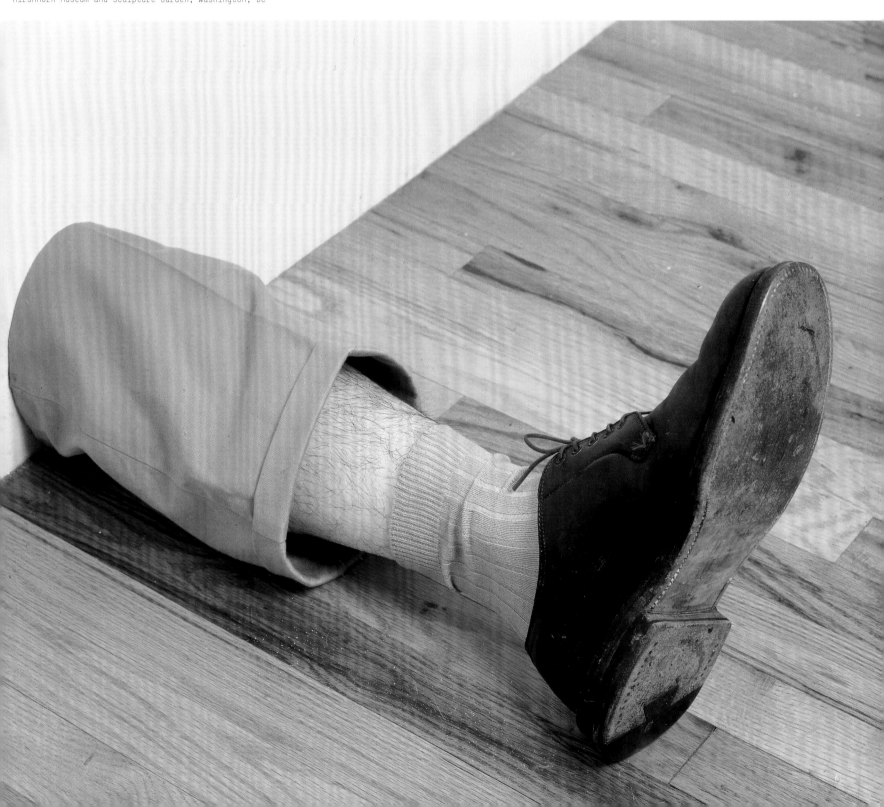

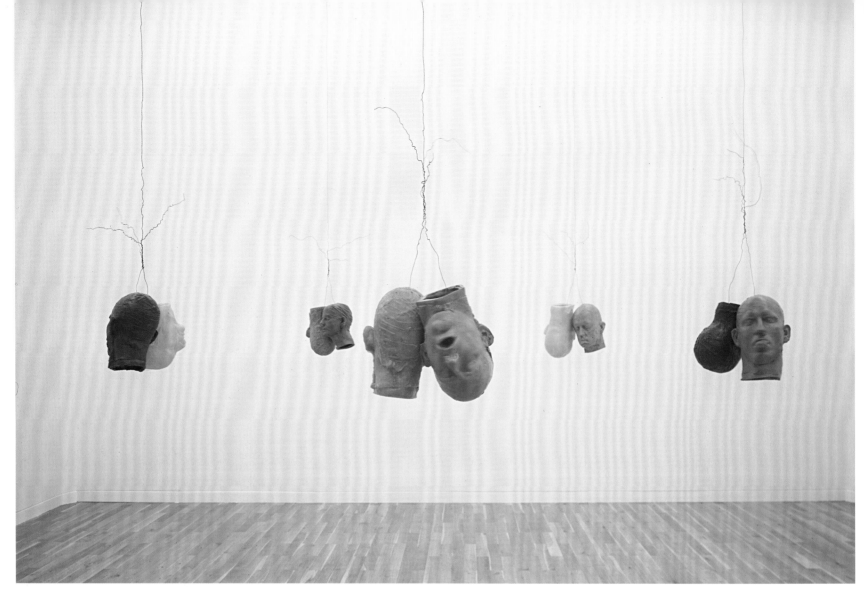

60 Bruce Nauman, *Ten Heads Circle/In and Out*, 1990. Wax, wire. Each head 30.5 x 22.9 x 15.2 cm (12 x 9 x 6 in). Kunstmuseum, Wolfsburg, Germany

Nauman is matched in his investigation of the dark and secret areas of the human anatomy and psyche by three female artists: Hannah Wilke, Louise Bourgeois and Kiki Smith. A seminal book on women's health and sexuality, *Our Bodies, Ourselves*, was published by the Boston Women's Health Book Collective in 1970. It was the first to stress that it was important for women to gain knowledge of their own bodies, suggesting for example that they become familiar with their genitals by examining them in a mirror. A large section of Hannah Wilke's small ceramic and rubber sculptures of her own genitalia look as though she took the book's advice to heart. Her small, modelled, white ceramic vaginas were made a decade or so after Duchamp's cast, and were among the first to present female genitalia in such an assertive way, only surpassed by the decorative vaginal ceramic plates of Judy Chicago's *The Dinner Party* (1974-9). Wilke's early death from cancer truncated her career and reduced her influence.

Bourgeois makes much grander statements than Wilke, and employs cast or crafted body parts -- hands, arms, legs and heads -- to express emotional states in abbreviated physical forms. *Untitled (with foot)* [61] is a disturbing work carved from her favourite pink marble. The smooth, polished sphere seems to have obliterated a small child, leaving only its left leg, which protrudes below; the rough hewn base appears to add to the discomfort. An inscription -- 'Do you love me?' -- runs repeatedly around this base, and the uncertain nature of this text fits well with the unsettling nature of the sculpture. Bourgeois has often stated how most of her work is about the relationship between parent and child, but equally she was a middle child, sandwiched unhappily between her brother and sister, so any number of family conflicts could well have inspired this piece.

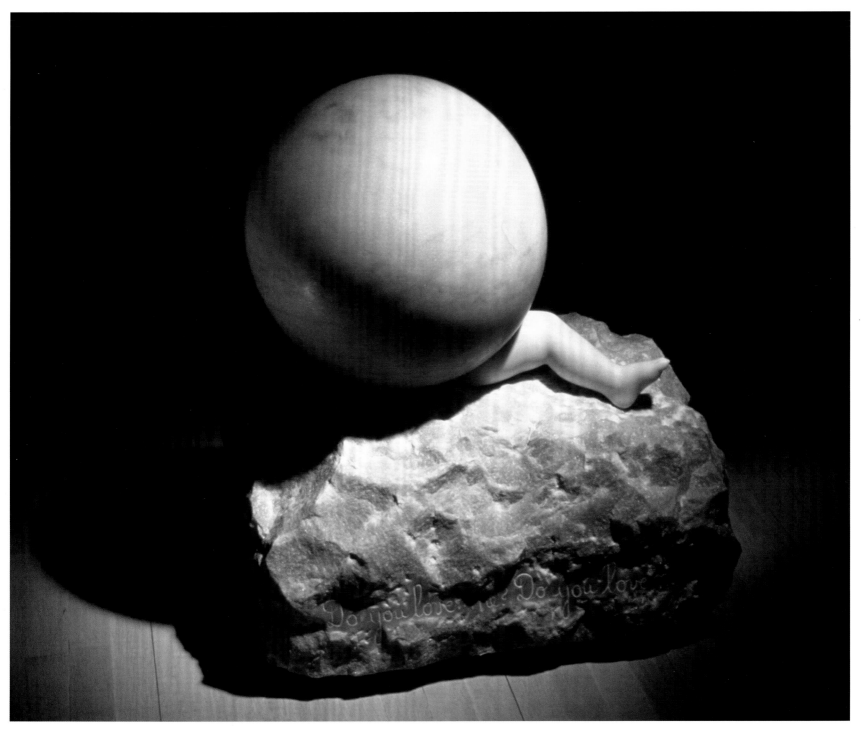

61 Louise Bourgeois, *Untitled (with foot)*, 1989. Pink marble. 76.2 x 66 x 53.3 cm (30 x 26 x 21 in). Corcoran Gallery of Art, Washington, DC

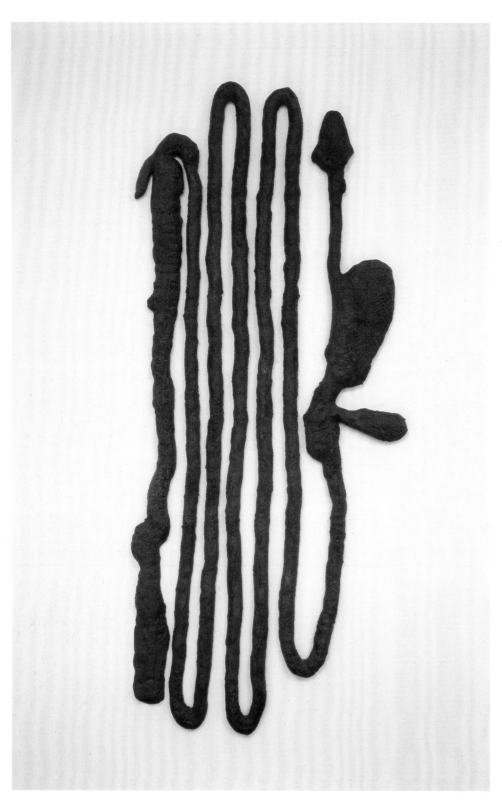

62 Kiki Smith, *Digestive System*, 1988. Ductile iron. 157.5 x 66 x 12.7 cm (62 x 26 x 5 in)

Kiki Smith takes a different stance regarding the body. Rather than working from personal memories, she looks outward and deals with the politics of the body, much in the way that Wilke did. The beginning of Smith's career coincided with the rise of feminism, which in art attempted to reclaim the female body from the strictures of patriarchy, religion and other kinds of institutionalized repression. In 1972, the critic John Berger produced the memorable phrase in his book *Ways of Seeing*: 'Men look at women. Women watch themselves being looked at.' The 1980s and 1990s response to Julia Kristeva's book on abjection (see Chapter 1) produced some significant body-part sculptures that dealt with issues such as violence, pain, passion and illness. A few artists, spearheaded by Smith, have given prominence to sculptures of internal organs, such as the stomach, and the endocrine and reproductive systems. Some of these works refer to the ancient theories that link emotions with specific internal organs. The ancient Greeks believed that there were four bodily humours -- sanguine, choleric, melancholic and phlegmatic, and that these were matched with four internal organs -- the spleen, liver, gallbladder and lungs. When AIDS and the notion of abjection drew attention to internal organs, disease, and exchanges of bodily fluids, the resonances of these ancient humours appeared in a wide variety of contemporary sculpture.

Smith and a fellow New York artist, Orsolya Drozdik, began to make sculpture that prioritized female body parts and set them in a new context. Smith made sculptures of arms, heads, hands and ears, as well as internal organs, revealing things that are normally hidden and mysterious. Her isolated body parts and internal organs **(62)** might speak of a scientific approach, but this is mitigated by their rough-and-ready domestic materials, such as clay, paper, glass, jewellery and embroidery, and their fragile appearance. Smith was one of the first to use glass as a material for body parts, attending the New York Experimental Glass Workshop; other artists, mostly female, have followed suit. She has made a glass *Womb* and glass *Sperms*, *Veins* and *Arteries* from coloured beads on wire, severed finger earrings, and an open mouth in bronze. Her *Ribs* **(63)**, which hang on threads from two nails on a wall, are a delicate construction revealing repaired breaks and disconnections that speak of wear and illness in the life of their fictive owner. They also act as a poignant reminder of the inhalations and exhalations that mark our journey from birth to death.

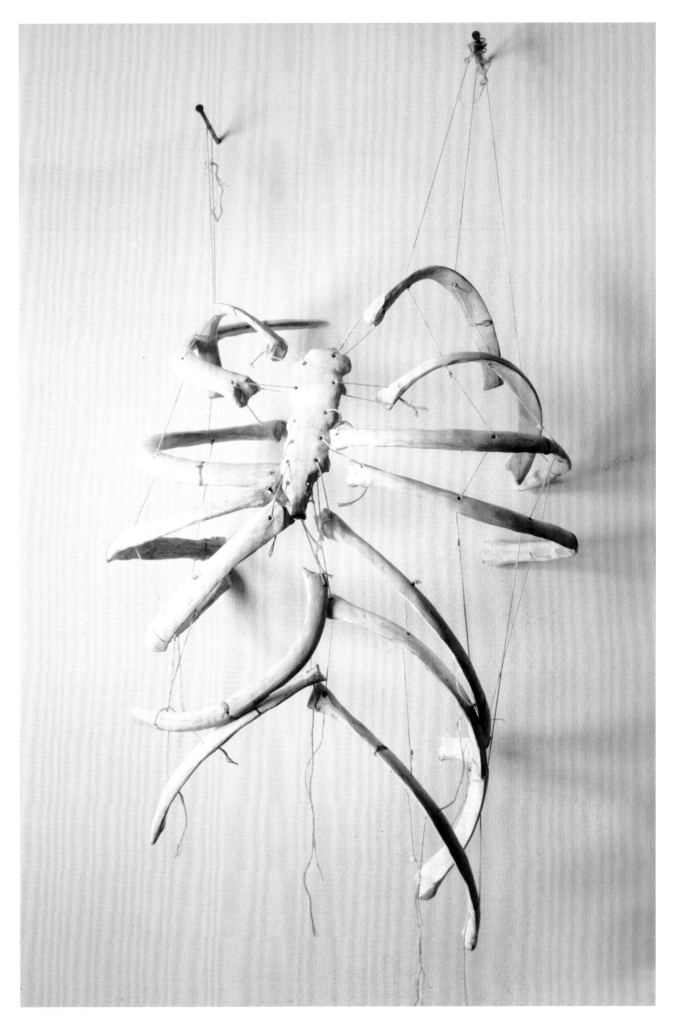

63 Kiki Smith, *Ribs*, 1987. Terracotta, ink, thread, nails. 55.9 x 43.2 x 25.4 cm (22 x 17 x 10 in)

Orsolya Drozdik began as a performance artist, firstly in her native Budapest and then in New York. Building on this work, she has used her own body to reveal how female identity is constructed by a largely patriarchal society. She employs a wide range of media including texts and photographs, and her most notable piece is a wax cast of herself naked, inspired by the medical dummies of Clemente Susini (1754-1814), who worked for the anatomical laboratory in Florence. This institution was provided with cadavers from the local hospital, most of which consisted of body parts, and Susini copied them before they rotted. Over 500 of these wax anatomical models still exist, and they have been an inspiration to several artists besides Drozdik. Her *Manufacturing the Self, Brains on High Heels* (64) appears as a light-hearted and witty work, even though it exemplifies the negative and patriarchal belief that female glamour and brains do not mix.

Another artist interested in human digestion as a subject is Jeanne Silverthorne, who makes reliefs and three-dimensional models of the organs that deal with sweat and bile. These are modelled in clay, cast in black rubber and displayed in rubber frames like pictures. Silverthorne has stated that she is not interested in making literal images of body organs; instead, she sees them as 'objective correlatives for emotional states. The ulcer has to do with anxiety, and the sweat pores have to do with labour.' She uses rubber because its tactile qualities render her sculptures more suggestively fleshy, and regards the walls of her studio as an extension of her body so that her activity inside it equals an investigation of her entrails. She has made some installations that involve fragments of the body surrounded by pipes, valves, joints and wires all cast in industrial black rubber (65).

64 Orsolya Drozdik, *Manufacturing the Self, Brains on High Heels*, 1992-3. Mixed media. Dimensions variable

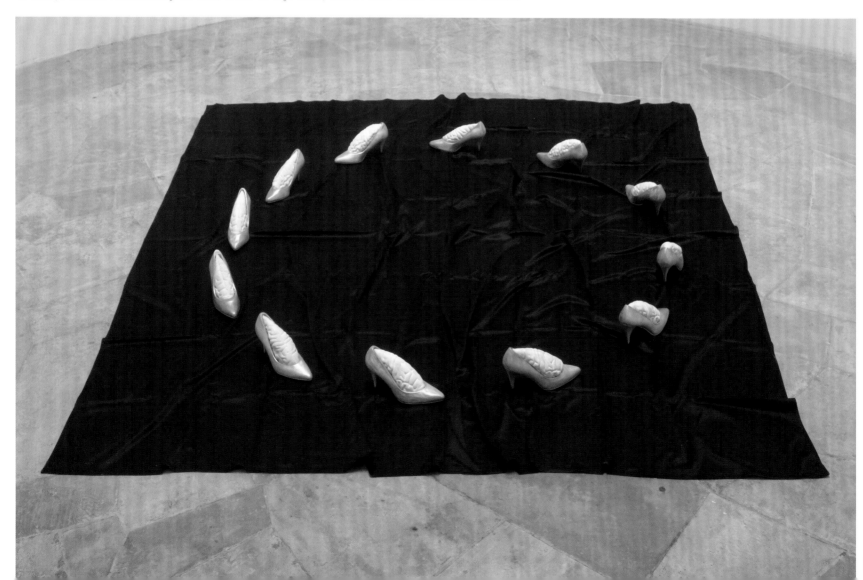

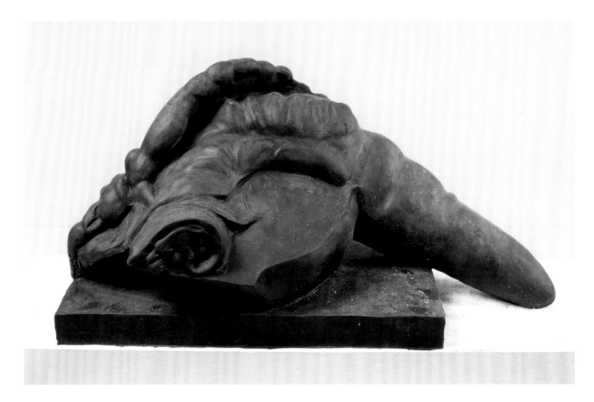

65 Jeanne Silverthorne, *Untitled, Fragment*, 1994. Rubber. 33 x 40.6 x 72.4 cm (13 x 16 x 28 ½ in)

At the end of the 1980s, Robert Gober began to make hyperrealistic casts of parts of his own body, after a decade of making sculptures that involved sinks, urinals and drains. The first of these body parts was a wax cast of his own leg, dressed in a trouser leg, sock and shoe **(59)**. In the gap between trouser and sock, Gober implanted the pale wax skin with body hairs. Then followed a series of increasingly fantastic yet utterly literal body fragments: a man's naked buttocks inscribed with a musical score; legs and bottoms pierced with drain holes; legs sprouting candles; and a hermaphroditic torso. More recently, Gober has made the upper thigh and lower torso of a naked female giving birth to an adult male leg and foot. These disturbing works all share an air of melancholy and sometimes a suppressed sexuality, which alludes in part to the devastating effects of the AIDS epidemic upon young Americans in the 1980s. There are also autobiographical impulses to Gober's work: his mother was a nurse whose first operation was an amputation.

Jana Sterbak was born in Prague and now lives and works in Canada. She emerged on the international art scene with her 1982 Toronto exhibition of a single, multi-part work: *Golem: Objects as Sensations*. It consists of several small sculptures of human body parts **(67)** laid in a line on the floor. There are eight lead hearts, a bronze spleen painted red, a lead throat, a bronze tongue, a bronze and a rubber stomach, a lead hand, a bronze ear, and a lead penis, the only piece to reveal its gender. In Jewish folklore, a golem is a creature created from inanimate matter, and the most renowned one was modelled from clay as a magic protection of the Jews in the city by a Jewish rabbi in sixteenth-century Prague. The subtitle *Objects as Sensations* implies that her human body parts stand as symbols for feelings. The material she chose in which to cast each piece adds to the psychological content of the work: lead is a toxic and heavy material often used by medieval alchemists, and the body parts fashioned in this material offer a sense of weighty profundity. The painted red spleen suggests anger and bitterness. Sterbak arranged the body parts on the floor as though they were the remains of a ritual dismembering. The work also calls up echoes of Surrealism and the weird bodily fantasies of Czech authors such as Franz Kafka.

66 Asta Groting, *Untitled*, 1990. Silicone, wood shavings. 590 x 190 cm (232 x 74 ¾ in)

67 Jana Sterbak, *Golem: Objects as Sensations*, 1979-82. Lead, bronze, painted bronze, rubber. 600 cm (236 ¼ in) long. National Gallery of Canada, Ottowa

68 Marc Quinn, *The Etymology of Morphology*, 1996. Silvered glass. 27 x 152.5 x 152 cm (10½ x 60 x 59 ¾ in). Tate, London

69 Isabel De Obaldia, *Fragments of Warriors*, 2002. Eight sand cast glass pieces. Dimensions variable

Asta Gröting matches Sterbak in making fragmentary sculptures that 'express concrete physical and psychological states'. *Untitled* **[66]** is one of a series of large pieces, two of which were made from clear glass, that describe the complicated twists and turns of the human digestive system from mouth to anus. This floor-based work measures over five metres long and is made from an unusual mixture of silicone and wood shavings. Gröting has isolated and enlarged this 'human conveyor belt' in order to draw attention to its function. It is something we overlook, rarely considering its constant functions, yet she finds that the way it processes and produces is similar to her own activity as a sculptor. Like Sterbak's *Golem* or Giacometti's *Woman with Her Throat Cut*, it lies prostate before the viewer on the gallery floor, looking like the remains of a dissected giant.

The same could be said of Marc Quinn's silvered glass fragments in his *The Etymology of Morphology* **[68]**, and he too is inspired by both the liquid and solid qualities of blown and cast glass. This work, which includes a cast head, hand and penis, among other more amorphous shapes, looks as though a figure has collapsed and dissolved as a result of some extreme condition.

Glass body fragments of a more colourful and decorative nature come from Isabel De Obaldia, who lives and works in Panama, although she has studied glass casting and glass engraving in America. Since 1987, she has made male body fragments from coloured glass [69], drawn to the medium because of its fragility, which she equates with the fragility of the human form. There is little in the way of a sculptural tradition in Panama, so she has looked elsewhere for inspiration, citing Rodin and the early Greeks as significant models. She embellishes her arms and legs with different decorative elements and themes; some are covered with snakes or lizards, while others have eyes. All these elements relate to the flora, fauna and rituals of her Panamanian culture.

Chen Zhen was born in Shanghai and moved to Paris in 1986, having spent his youth enduring the strictures of the Cultural Revolution. With his move to Europe, he attempted in his work to highlight the socio-cultural differences and similarities between East and West, using the human body and medicine as metaphors. One of the last works he made before his early death from a rare medical condition is *Zen Garden* (2000), a maquette for an unrealized public garden project, in which illuminated representations of body organs made from polished, white alabaster are pierced by sharp, metal medical instruments such as forceps, scissors and tweezers, and all are suspended over raked sand. Another late work is *Crystal Landscape of Inner Body* [70], in which several internal body organs are fashioned from clear, blown glass and laid out on a table.

70 Chen Zhen, *Crystal Landscape of Inner Body*, 2000. Crystal, iron, glass. 95 x 70 x 190 cm (37 ½ x 27 ½ x 74 ¾ in)

71 Giuseppe Penone, *Breath 5*, 1978. Fired clay. 154 x 83 x 84 cm (60 ½ x 32 ¾ x 33 in). Tate, London

72 Annette Messager, *Penetration*, 1993-4. Various fabrics, ropes. Dimensions variable.
National Gallery of Australia, Canberra

These artists who work with blown glass and use it to fashion body parts are all aware of the way in which glass forms are mainly created through the power of breath. In the 1970s, Giuseppe Penone made a series of clay forms called 'Breaths', of which the one shown is number 5 **(71)**. At first sight, it does not appear to have anything to do with body parts; on close inspection, however, the impression of the front of Penone's body, wearing shirt and jeans, can be seen captured in the clay, which is modelled as if it were the imagined shape of a large expelled breath of air exhaled from the artist's mouth. The small shape at the top is an impression of the interior of the artist's mouth from whence the breath came. Penone was inspired to make this series of works after admiring drawings made by Leonardo da Vinci of how he imagined the current of air emanating from a single human breath.

Work of a very different bodily kind comes from Annette Messager, whose art deals with issues of sexuality and the fragmentation of the body. Her large and impressive installation piece *Penetration* **(72)** includes internal organs such as hearts, ribs, lungs, the spine, intestines, stomachs, a womb and ovaries, along with a few substantial penises, all suspended from the ceiling. They are made from sewn and stuffed fabric and hang at various heights from soft pink angora wool lengths. Their shapes and colours may look arbitrary, but they are faithfully copied from medical illustrations. The result looks as though works by Bourgeois and Smith have collided and spawned something a little less sinister and more cheerful.

73 Mona Hatoum, *Entrails Carpet*, 1995. Silicone rubber. 198 x 297 x 4.5 cm (78 x 117 x 1 ¾ in)

The vogue for making body parts appeared to move from America to Britain in the early 1990s. Mona Hatoum's work proposes a relationship between internal and external, things hidden and things observed. She is Palestinian, born in Beirut and educated in London, and began her career making performances, which examined states and conditions of entrapment or confinement using cages and barricades. In 1994 she made *Corps étranger*, a video installation that showed an endoscopic film of her insides. She has long been interested in X-rays and how they reveal unexpected aspects of the body. Her most overt body piece is *Entrails Carpet* **(73)**, a piece that came about when she discovered a translucent, almost opalescent silicone rubber that was ideal for the subject; it is normally used to make breast implants. She wanted to create something that was both repulsive and seductive.

From the beginning of her career in the early 1990s, Sarah Lucas has dealt with contemporary attitudes to sex and gender differences, mostly culled from advertising and the media, especially British tabloid newspapers. She has made much use of her own body in her work, particularly a series of photographic self-portraits in various guises. She also utilizes buckets, toilets, fried eggs, melons, mattresses, beer cans and kebabs to stand in for body parts, often with reference to genitalia. Her first body part was *Where Does It All End?* of 1994, a cast of her mouth in red wax, with teeth and a real cigarette

butt, expressively displaying either aggression or insouciance. Later, she made *Get Hold of This* [75], a concrete cast of her forearms and clenched fists, making a gesture that is universally recognized as rude and aggressive, and usually made by men. The rest of the body was unnecessary since the content of the work was immediately obvious. Her most significant series of fragmentary bodies are her 'Bunny' girls, formed from a felicitous marriage between pairs of stuffed nylon tights and the back of a chair [76].

The painter and sculptor Markus Lüpertz has created several harsh fragments of the human body, that are cast in bronze and brightly painted. His whole figures are sometimes a bizarre agglomeration of badly matched parts. Many of Lüpertz's sculptures have a feel of battered archaeological remains, as though he wanted to demonstrate that artistic forms from the past still had authentic life in them [74].

74 Markus Lüpertz, *Standbein - Spielbein*, 1982. Painted bronze. 320 x 100 x 100 cm (119 x 39 ½ x 39 ½ in)

75 Sarah Lucas, *Get Hold of This*, 1994. Plaster. 29.8 x 36.8 x 30.5 cm [11 ¾ x 14 ½ x 12 in]

76 Sarah Lucas, *Bunny*, 1997. Tan tights, black stockings, chair, clamp, kapok, wire. 102 x 64 x 90 cm (40 ¼ x 25 ¼ x 35 ½ in)

STRANGE
CREA
TURES

In the last two decades, artists have increasingly concerned themselves with the influences and effects that microelectronic communications and biotechnologies are having on the human body, as well as on animals and plants. Boundaries between humans and animals are being transgressed; human babies have baboon hearts, pigs' valves are set into human blood vessels and human ears are grown on the backs of laboratory mice. Humans and machines are getting closer; hips and knees are made of Teflon, and prosthetic limbs are moved by microchips. The categories of human/animal/machine are steadily merging into one another, and it is not surprising that an inventive variety of cyborgs and hybrids has recently appeared in the art world.

Cyborgs -- human beings whose bodies have been taken over, wholly or in part, by electromechancial devices -- are not new to literature: science fiction has long devised both utopian and sinister man-made machines and altered humanoids. As early as 1818, Mary Shelley's book *Frankenstein or The Modern Prometheus* described the creation by Dr Victor Frankenstein of an amalgam of man and machine, and this seminal work has been an inspiration for writers, filmmakers and artists alike. In 1985, Donna Haraway, an American sociologist, wrote an essay entitled 'A Manifesto for Cyborgs: Science, Technology, and Socialist Feminism in the 1980s', in which she presented the cyborg as a transhuman and transgender entity. Haraway's ideas have reverberated through the art world, and recently she declared herself a cyborg, a fundamentally technological body plugged into the scientific power networks that control our world.

In 1988, Luciano Fabro made a prescient work, his *Ovaries* **(78)**, an elegant and diagrammatic floor piece made from shiny steel cables and white marble ovals. The title reveals that the ovals are to be read as eggs and the cables containing them as ovaries. The marble eggs are identical and infinitely reproducible, and call up ideas about mass production, genetic cloning, and fertility experiments. Fabro uses inorganic and industrial materials to make a statement about the reproductive capacity of a female body, not necessarily a human one. In fact, the scale and grandeur of the work turns the implied body into that of a mechanical giant.

There is a large gap between the cool and elegant minimalism of Fabro's work and the cartoon-inspired mutant figures made by Paul McCarthy, one of the most memorable being *Spaghetti Man* **(79)**, a ten-foot-high human figure wearing a furry bunny head and a fifty-foot plastic penis. The creature looks somewhat overwhelmed by the length of its organ and its apparent incapacity to do anything except lie coiled on the ground. The popular culture of Los Angeles has provided McCarthy with a wealth of material for his monsters, allowing him to amalgamate ideas from Hollywood movies, cartoons, Christmas kitsch and the multiple personas of Michael Jackson, for example. McCarthy is also the maker of large-scale, messy installations, some of which include robots.

Young Japanese artists seem to be naturally inclined to work with new technologies and materials, living as they do in one of the most advanced technological countries of the world. Momoyo Torimitsu, Takashi Murakami and Chiezo Taro, all born in the 1960s, make artificial creatures, taking their inspiration from Japanese youth culture and its obsession with animation, comic books and cartoons. Japanese animated cartoons first appeared in the 1960s, portraying an imaginary world filled with superheroes and cyborgs living a life of innocence and fun. In 1995, Nintendo launched their Pokemon video games, strategic battles to be played between hundreds of pocket monsters, followed in 1996 by the Tamagotchi, a virtual electronic pet. Japanese cartoons and comics were mainly inspired by American popular culture, such as Walt Disney's animated films, at a time when Japan fell heavily under American influence. However, contemporary Japanese artists turn the cute, innocuous quality of their source material into something darker and more anarchic, a trait that was actually present in many of the Disney films. They also add a touch of Andy Warhol and Jeff Koons to the mixture, in homage to these two masters of appropriated popular culture.

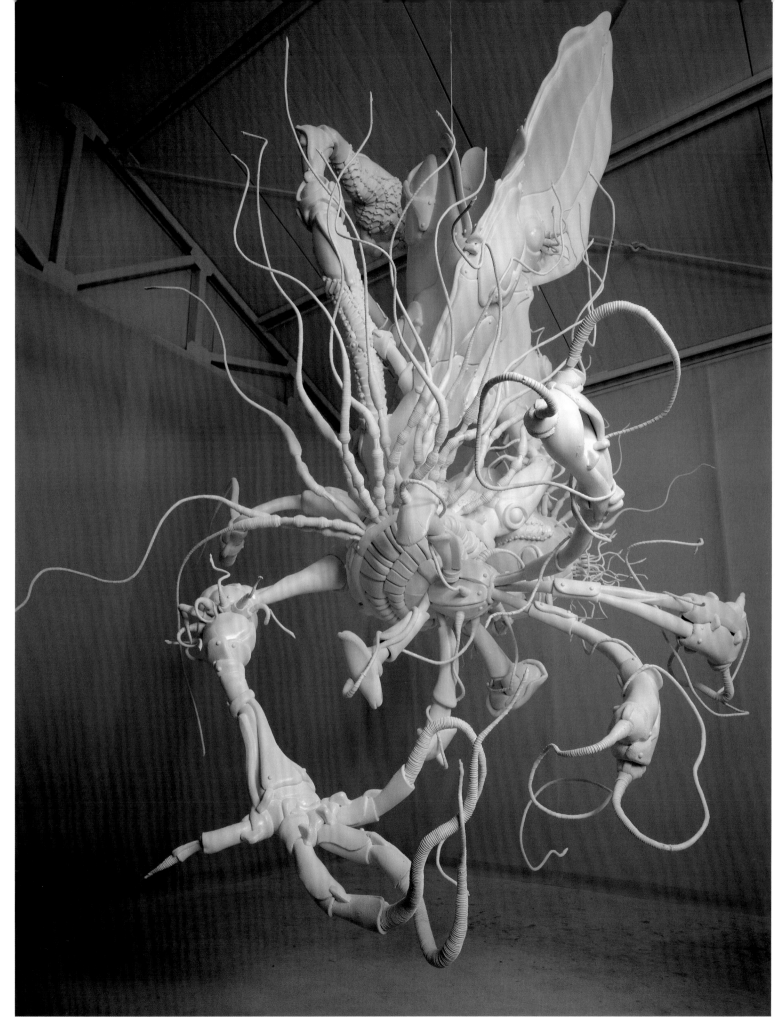

77 Lee Bul, *Amaryllis*, 1999. Hand-cut polyurethane panels on aluminium, enamel coating. 210 x 120 x 180 cm (82 ⅝ x 47 ¼ x 70 ⅞ in)

Torimitsu and her peers emerged on the art scene in the early 1990s, when they revealed their responses to these influences. Her robot Japanese businessman *Miyata Jiro* **(80)** is a realistic, life-size, battery-operated human figure, who crawls on the ground attended by the artist herself, dressed in a white nurse's uniform. He wears a typical business outfit of dark suit, white shirt and shiny silk tie. His thinning hair is combed to conceal his bald spot. He is incapable of standing and can only move on his elbows and knees. She has overseen his crawling in public streets in New York, Amsterdam, London, Paris, Rio de Janiero and Sydney. In 2004, at the Swiss Institute of Contemporary Art in New York, Torimitsu turned the gallery floor into a map of geographical territories over which an army of small-scale robotic businessmen invaded each other's land both physically and politically. By giving the businessmen the appearance of toys, she reduced their activities to play, and their source of power to others. Taro also makes robot figures; in 1993 at the Sandra Gering Gallery in New York, he showed a group of frilled, child-sized dresses mounted on battery-powered, wheeled chassis; the small headless robots were powered by a programme developed in a collaboration between the artist and the Massachusetts Institute of Technology.

In 1993, Murakami created Mr DOB, a cartoon-like figure with huge head, hands and feet, who appears in disquieting tableaux. An example is *DOB in the Strange Forest* (1999), where DOB is surrounded by coloured, anthropomorphic mushrooms with green eyes. He looks disturbed, his mouth is open and his hands are outspread, but the nature of his distress in unclear. Less cute was Murakami's life-size female figure, *Hiropon* (1997), and her counterpart, a 3-metre-high male figure titled *My Lonesome Cowboy* (1998). The male figure looks like an innocent anime character, except that he is frozen in the act of masturbating while spiralling a lasso of his own semen around his head, not something to be found in a Disney cartoon.

79 Paul McCarthy, *Spaghetti Man*, 1993. Fibreglass, metal, urethane rubber, acrylic fur, clothing. Body 254 x 84 x 57 cm (100 x 33 x 22 ½ in); penis 1270 cm (500 in) long. Fonds Régional d'art contemporain (FRAC) Languedoc-Roussillon, France

78 Luciano Fabro, *Ovaries*, 1988. Italian white marble, stainless steel. 7.5 x 1125 x 150 cm (3 x 443 x 59 in). Tate, London

80 Momoyo Torimitsu, *Miyata Jiro*, 1994. Battery operated polyester resin dummy, acrylic paint, clothing. 60 x 80 x 70 cm (23 ½ x 31 ½ x 27 ½ in). Performance in Graz, Austria.

Lee Bul's practice embraces sculpture, performance, video and interactive media. In the early 1990s she worked as a performance artist, and for some of these events she wore outfits with odd appendages, reminiscent of Yayoi Kusama's knobs and soft phallic sculptures of two decades earlier. Since the 1990s, Bul has been making a series of sculptures that merge the female human body and technology. These 'Cyborgs' and 'Monsters' **(77)** are constructed from white cast silicone, of a kind used in cosmetic plastic surgery, an area that brings together the female body and technology. They usually consist of fragmented pieces of a young female figure, clothed in a kind of body armour, and held up by a steel armature. Female in appearance, with their rounded hips and breasts, they often lack heads and have only one arm or leg. They are inspired both by contemporary technology and archetypal images of femininity from Western European art history. Although it is not always obvious, their poses are copied from paintings by Botticelli and Manet.

It is quite a jump from the baroque flamboyance of Bul to the repetitive power of Yue Minjun, who uses his own likeness in his paintings and sculptures. Most of the latter consist of massed, identical self-portrait figures, who smile broadly as they go about their exercises **(81)**, recalling a sight visible every day in Chinese cities. In 2003, the worldwide Human Genome Project announced the discovery of all the genes that make up human DNA, and this has opened the door to the possibility of cloned humans. Perhaps works like Minjun's reflect this new way of imagining the world. Minjun's work is taken one stage further by American artist Ken Feingold, who has made a series of robotic talking heads and puppets, interactive artworks that deal with language and communication technology. In 1998, he took up a residency at the Centre for Art and Media Technology in Karlsruhe, Germany, where he learnt the technologies necessary for his speaking heads. The first of these was *Head* (1999), which he describes as follows: 'A very realistic animatronic human head sits on a small table, looking into space and blinking its eyes as if it might just be conscious ... what is most remarkable about this head is that it is able to understand spoken English, and it is able to engage in something like conversations.'

In 2001, Feingold made *Sinking Feeling* **(82)**, a self-portrait head composed of silicone, pigments, fibreglass, software and electronics, which sits bewildered in a large flowerpot, making scrambled statements. *If/Then* followed shortly afterwards, and this allowed Feingold to dispense with the head/viewer conversation in favour of two disembodied identical heads in a cardboard box that talk to each other in an attempt to determine who and what they are: 'I wanted them to look like replacement parts being shipped from the factory that had suddenly gotten up and begun a kind of existential dialogue right there on the assembly line,' the artist said.

Los Angeles appears to be the leading centre for the production of artistic cyborg/hybrids, and this may be related to the fact that artists and technicians are hired by the film industry to produce special effects. Tim Hawkinson, who lives and works in Los Angeles, makes odd, unwieldy automatons and organisms, which, like the works of Minjun and Feingold, are based on his own body. Recycled domestic items are his favoured material and he reuses these in mechanical constructions that mimic the workings of various machines or bodily functions. Although these works look rough-and-ready, and a little Heath Robinson, they harbour deep metaphysical and sometimes religious ideas. *Penitent* **(83)**, for example, depicts a kneeling human skeleton, made from rawhide dog chews, whose ribcage is fitted with a mechanism operated by an air pump and valves, which whistles and wheezes when in action. The title describes a person who repents his or her sins and seeks forgiveness, and the figure does appear to be trying to communicate, but the artist states that it whistles 'as if calling for a dog'.

81 Yue Minjun, *The Last 5000 Years*, 1999. Synthetic resin, acrylic. 163 cm (64 in) high

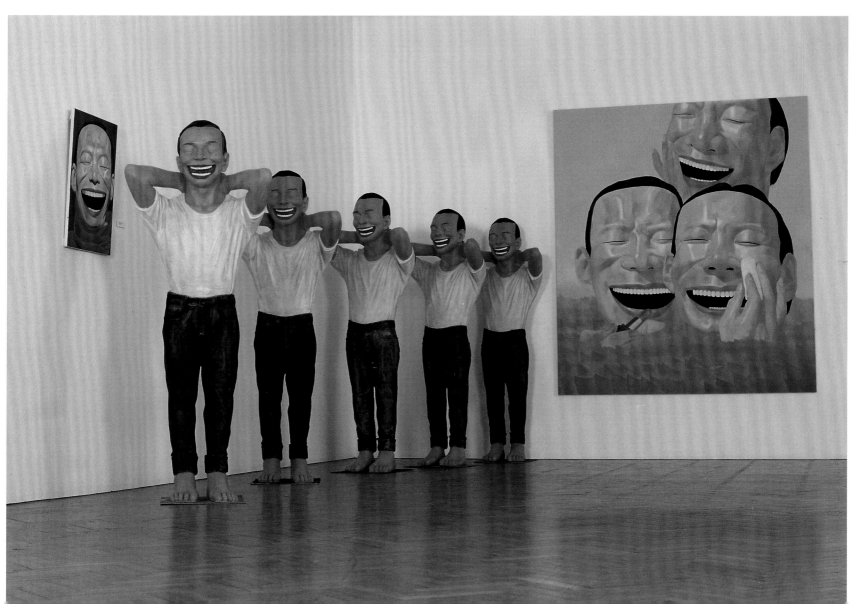

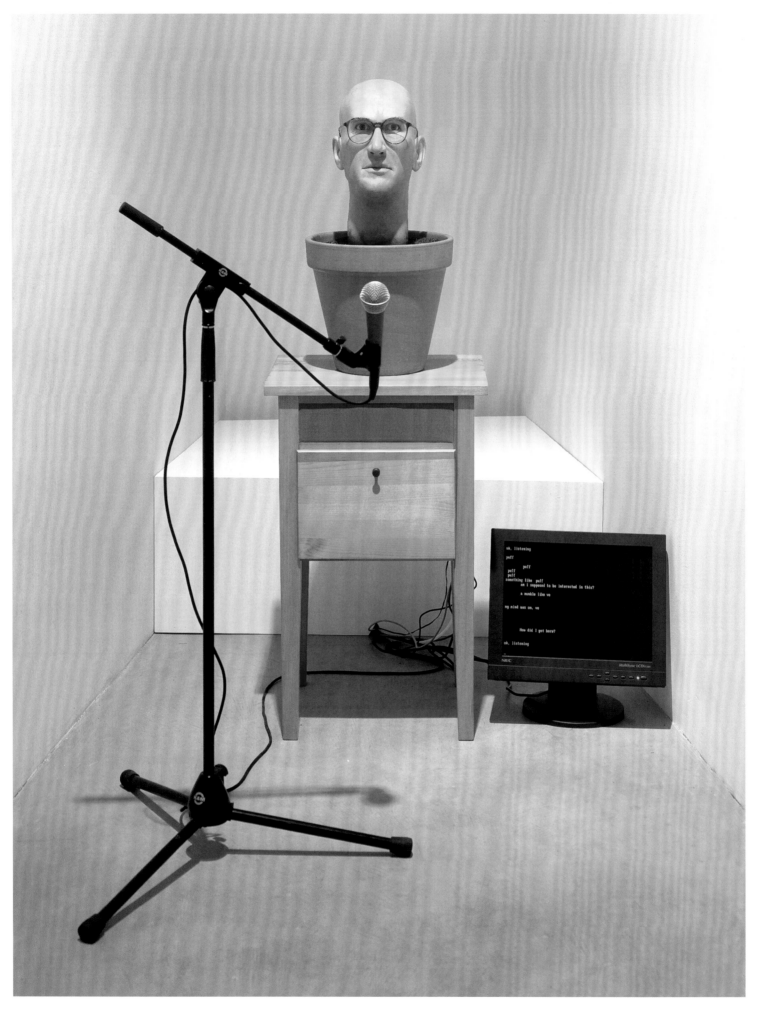

82 Ken Feingold, *Sinking Feeling*, 2001. Silicone, wood, flowerpot, computer, electronics. 132 x 38 x 46 cm (52 x 15 x 18 in)

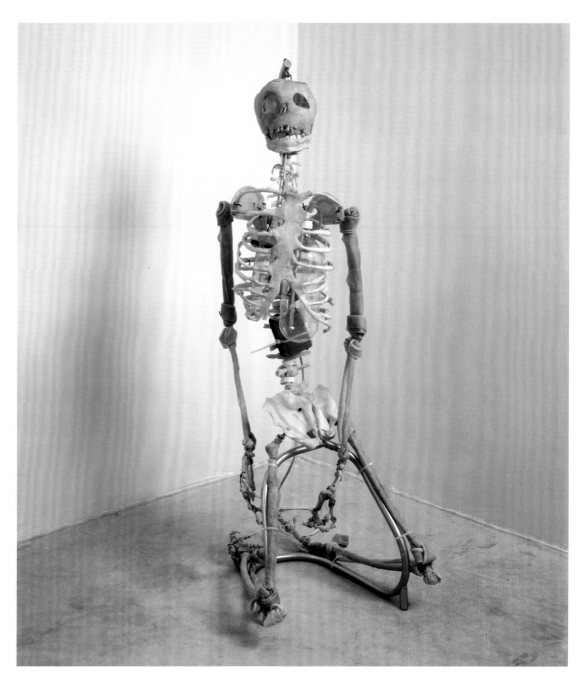

83 Tim Hawkinson, *Penitent*, 1994. Rawhide dog chews, slide whistle, motor, sound. 121.9 x 45.7 x 45.7 cm (48 x 18 x 18 in)

Conversely, the work of Paloma Varga-Weisz seems to have nothing to do with modern technology. She carves wooden figures and animals from limewood, an act that harks back to her predecessors in the world of medieval religious German sculpture. Initially her figures look like players in a religious narrative, but their titles -- *Dogman*, *Bumpman* -- belie this. *Bumpman sick* **[84]**, who sits in calm contemplation, is covered in mysterious swellings, and Varga-Weisz states that her inspiration was found on medical websites and in childrens' stories. Her afflicted men are an unusual amalgam of ancient and modern.

Some artists are looking at the latest developments in genetic engineering and presenting creatures that appear to display the unpleasant side-effects of these developments. Patricia Piccinini showed a range of such creatures in the Australian Pavilion at the 2003 Venice Biennale, and all the works reflect her interest in the ways that recent medical interventions have affected human life. In *Still Life with Stem Cells* **[85]**, a life-like child sits among grotesque, embryonic lumps with veined and hairy skin.

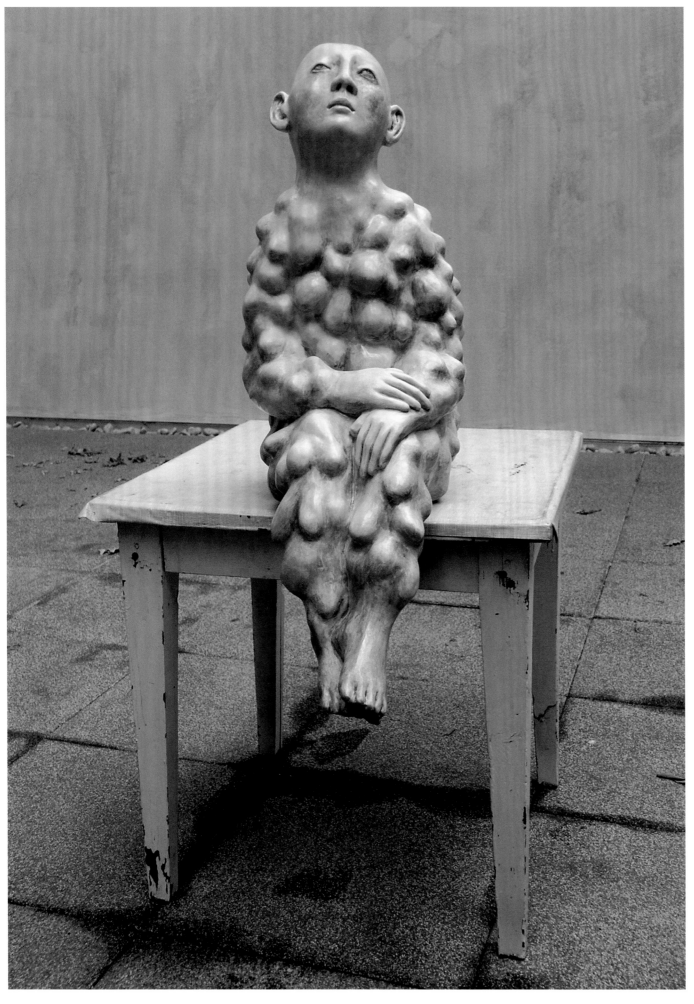

84 Paloma Varga-Weisz, *Bumpman sick*, 2002. Limewood, painted. 70 x 26 x 45 cm (27 ½ x 10 ¼ x 17 ¾ in)

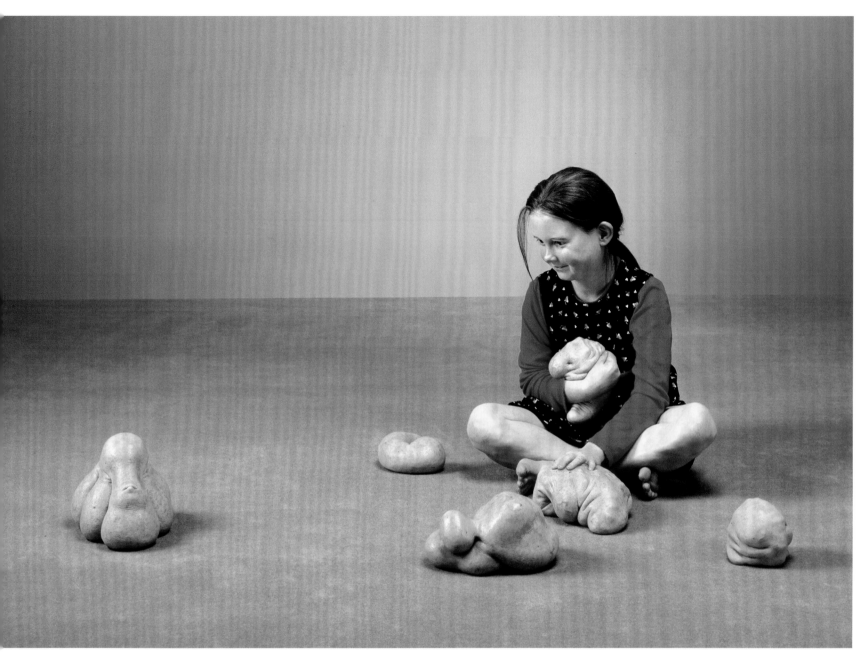

85 Patricia Piccini, *Still Life with Stem Cells*, 2002. Silicone, acrylic, human hair, clothing, carpet. Dimensions variable

'Dysfunctional' is an adjective that has often been applied to the mutated bodies made by brothers Jake and Dinos Chapman, who often reconfigure shop-window mannequins in their work. In 1994 they utilized two of these figures for *Mummy Chapman* and *Daddy Chapman*. The shiny plastic body of *Mummy Chapman* is punctuated by vaginas and penises, while her partner is covered with a rash of anuses. Although the Chapman brothers make obvious references to genetic engineering in works of this kind, they are also aware of the way in which the Christian Church has commissioned from artists millions of mutilated and wounded bodies, most notably that of Christ himself. In 1995, the Chapmans made *Zygotic acceleration, Biogenetic de-sublimated libidinal model (enlarged x 1000)* **(86)**, a ring of naked, conjoined shop-window mannequins of children, all wearing identical brand-new trainers. Some have anuses and penises where their mouths and noses should be, and most have no arms. This looks like a nightmare scenario of one of society's current fears, where an experiment to clone or genetically manipulate children has gone seriously wrong.

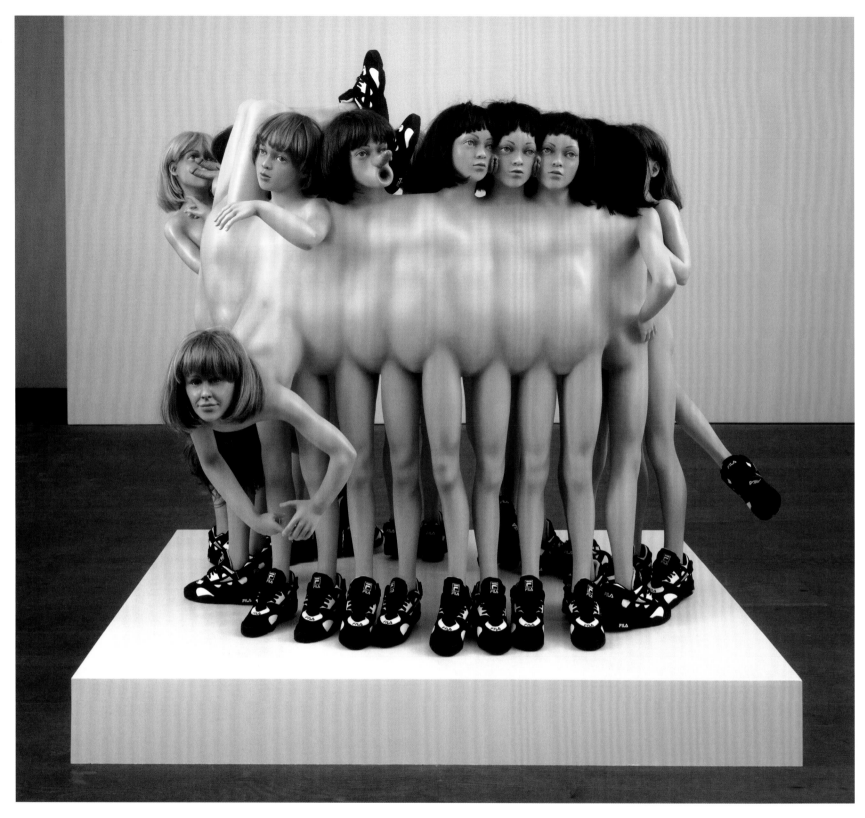

86 Jake and Dinos Chapman, *Zygotic acceleration, Biogenetic de-sublimated libidinal model (enlarged x 1000)*, 1995. Mixed media. 150 x 180 x 140 cm (59 x 70 ½ x 55 in)

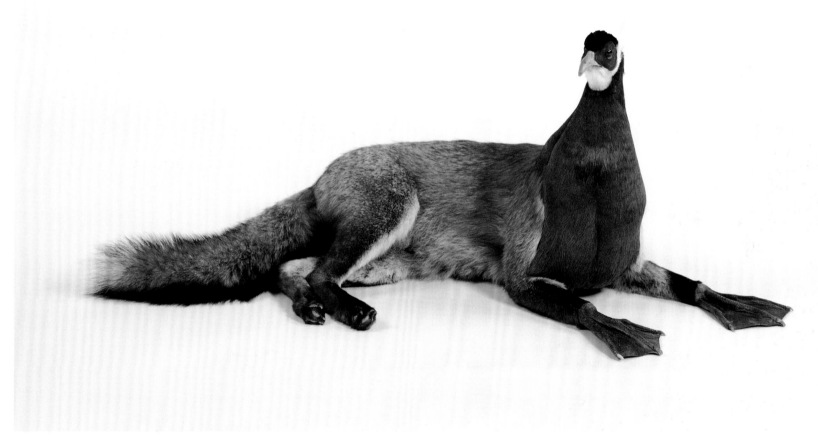

87 Thomas Grünfeld, *Misfit*, 1990. Taxidermic animals. Approx. 50 cm (20 in) high

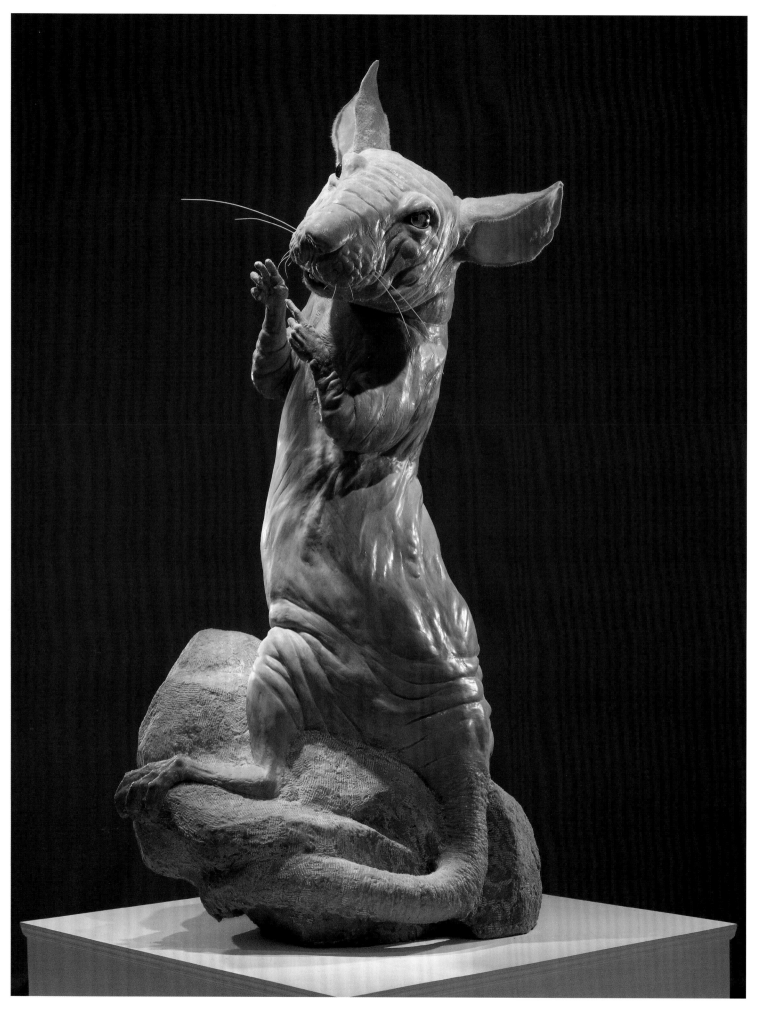

88 Bryan Crockett, *ecce homo*, 2000. Marble, epoxy. 274.3 x 106.7 x 106.7 cm (108 x 42 x 42 in)

Monsters of an animal kind populate the world of German artist Thomas Grünfeld, who combines taxidermied animals in unlikely and grotesque configurations. In 1990, he began a series of fantastic hybrid animals entitled 'Misfits'; this example (87) is a special one in that it combines three different species; the hind quarters of a fox, together with a pheasant head, and the webbed feet of a duck. Grünfeld morphs the disparate creatures together so seamlessly that they look as though they could generate a new and lively species, capable of surviving in a changing world.

The first notable hybrid in world sculpture appeared as long ago as circa 5,000 BC, the Egyptian Sphinx, with the body of a lion, female breasts and the head of the ruling pharaoh. Then followed centaurs, minotaurs, fauns, satyrs, all hedonistic creatures who live by their instincts. In medieval times, sculptors carved numerous anthropomorphic creatures to help promote moral virtues. And in more recent times, cartoon figures of rabbits, mice, dogs and cats have enlarged the repertoire of the human-animal amalgam, one of the most notable being Mickey Mouse. Another kind of mouse, the 'oncomouse', a patented creature bred in an American laboratory and given a human immune system for the purpose of cancer research, served as the inspiration for Bryan Crockett's large marble sculpture *ecce homo* (88), a life-size amalgam of man and mouse. Crockett made the work in 2000, the millennium year, and decided to 'reinterpret the ultimate figure of salvation, Christ, through the ultimate actor of contemporary science, the oncomouse'. The creature, rendered in great detail, sits on a rock and raises its paws as though in prayer. Referencing classical statuary, Crockett's sculpture looks as though it has been carved from the traditional material of pink marble. The medium is actually pink-tinted crystalline marble dust cast with a polymer binding, another nod towards modern technology.

Like Grünfeld, Carlee Fernandez uses taxidermic animals, altered in various ways so that they function as weird household objects, such as a deer/laundry basket, a deer/ice-cube tray, and a stuffed rhino converted into a stepladder. These are the types of animals that indigenous peoples ate, or trophy hunters shot, stuffed

89 Carlee Fernandez, *#7100-Goat*, from 'Carnage II 7000', 1999. Taxidermic animal, synthetic materials, 91.4 x 40.6 x 30.5 cm (36 x 16 x 12 in)

90 Alain Sechas, *Hugh, the Guitarist Cat*, 1997. Polyester, cellulose paint. 100 x 60 x 60 cm (39 ½ x 23 ½ x 23 ½ in)

91 Rona Pondick, *Monkey with Hair*, 2002-3. Stainless steel, modacrylic hair. 36.8 x 111.7 x 81.3 cm (14 ½ x 44 x 32 in)

92 Liz Craft, *Foxy Lady*, 2003. Brushed stainless steel. 188 x 160 x 140 cm (74 x 63 x 55 in)

93 Rosemarie Trockel, *Creature of Habit - Drunken Dog I*, 1990. Bronze. 12 x 68 x 32 cm (4 ¾ x 26 ¾ x 12 ½ in). De Pont Museum of Contemporary Art, Tilburg, The Netherlands

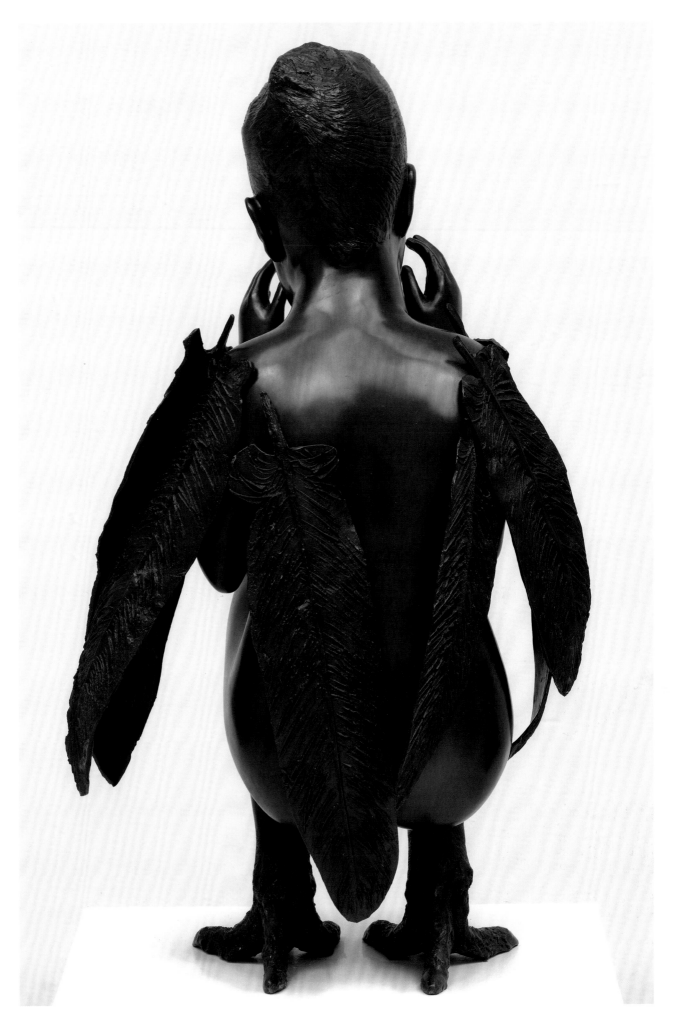

94 Kiki Smith, *Harpie*, 2001. Bronze. 78.7 x 58.4 x 43.2 cm (31 x 17 x 20 in)

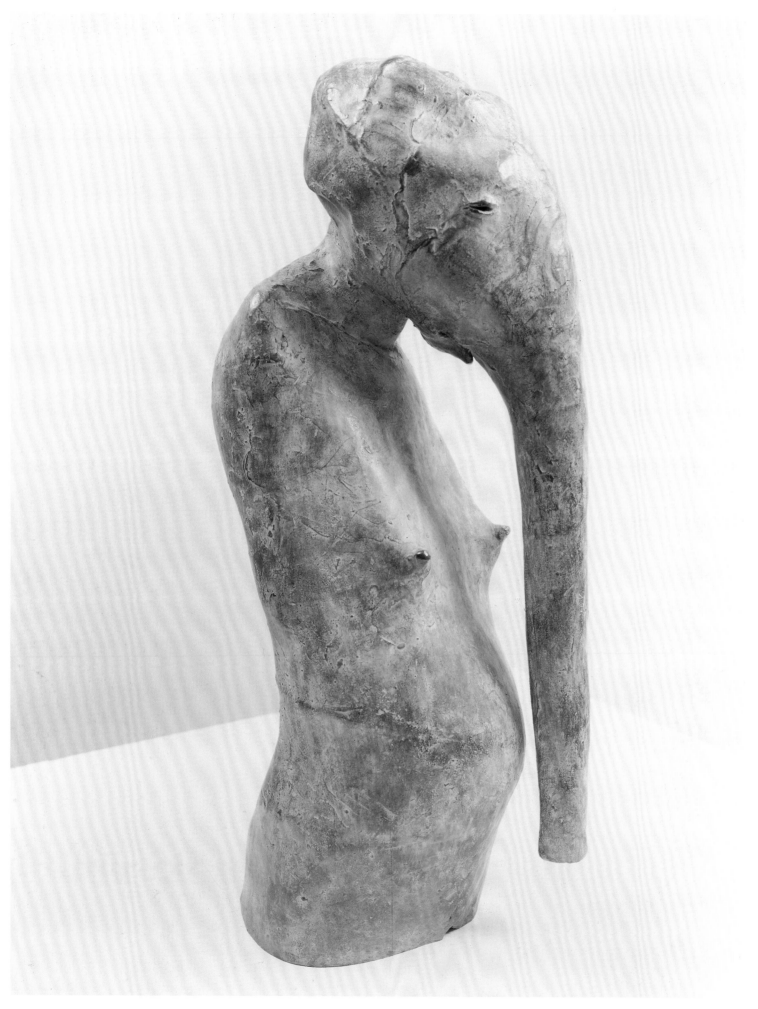

95 Daisy Youngblood, *Romana*, 1987. Bronze. 53.3 x 21.6 x 25.4 cm (21 x 8 ½ x 10 in)

and displayed in their homes. Fernandez brings human and animal into a more sympathetic relationship by turning them into useful domestic items; animals have long been regarded as the servants of man, and this artist puts them to good use. She has even utilized their skins, along with industrial materials, to make a range of luggage to which she gave the title 'Carnage II 7000' **(89)**, unveiled in 2000.

Alain Sechas has produced a bestiary of weary animals, most notably cats, which he explains stem from a play on his name. Works such as *Hugh, the Guitarist Cat* **(90)** is a characteristic example in which the monochrome animal stands on a platform and performs for his public. He wears an inscrutable look and is prepared to carry on regardless of his prowess or the audience. Although Sechas's cats have an allegiance to the cartoon characters found in *Tom and Jerry*, he also imbues them with a gentle existential air.

Kiki Smith stated in 2002:
When I first started making figurative work ... I was interested in the symbolic morphing of animals and humans. I found this anthropomorphizing of animals interesting; the human attributes we give to animals and the animal attributes we take on as humans to construct our identities ... [W]hat do animals mean to us in terms of the construction of our own identity, our well-being, our environment?

Several artists, mostly female, have conflated human and animal imagery for just these reasons. For them, turning a human into an animal is a powerful way of looking at ourselves from another viewpoint. Alongside Smith are Rona Pondick, Rosemarie Trockel, Liz Craft, Daisy Youngblood and Jane Alexander. In recent years, Smith has made small bronze figures of Harpies and Sirens, seductive figures from Greek mythology that combine the head of a woman with the body and claws of a bird. The Harpies were known for their destructive qualities and the Sirens were the malevolent monsters of the sea, luring sailors to their death with their beautiful songs. Extracted from their ancient world and created in the present, these metal hybrids **(94)** carry a message of potent femininity and archetypal power.

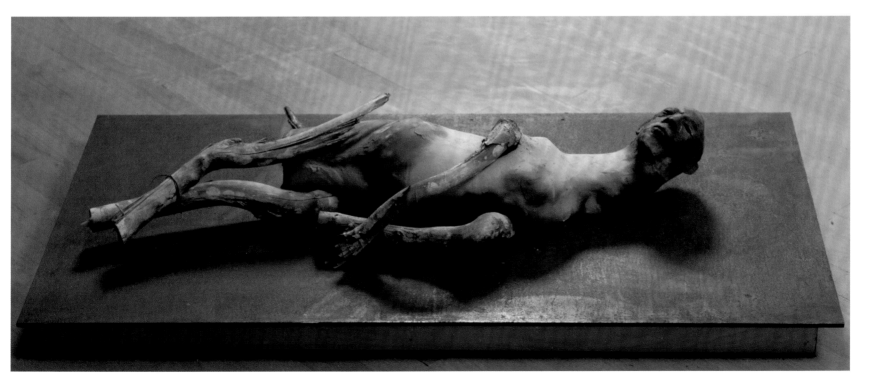

96 Daisy Youngblood, *Tied Goat*, 1983. Low-fired clay, wood. 15.2 x 80 x 28 cm (6 x 31 ½ x 11 in)

Rona Pondick began her career with scattered assemblages of body parts and gradually moved to making hybrid creatures, animals with human features. She has since started to work in stainless steel and bronze, making sculptures that combine her face and hands with that of a monkey [91], a dog, a marmot and a cougar. These bizarre beings not only address genetic engineering, but take a skewed look at the self-portrait, calling up psychological comparisons between human and animal, between consciousness and instinct. She also made a self-portrait by entering a cast of her head into a computer programme that allowed her to scale it up or down with complete fidelity. In such works, Pondick combines the cyborg with the hybrid.

Liz Craft, who lives and works in Los Angeles, also created a hybrid self-portrait with *Foxy Lady* [92], an amalgam of her own body with a dog's head, presented with multiple arms that twirl the lead attached to the collar around its neck. The figure is both controller and captive on its lead. The many arms link it to Indian deities such as Kali. Craft has said that she wanted to make a confrontational sculpture 'using myself and the dog next door to create a bitch -- in all the meanings of the word'.

In 1989 Rosemarie Trockel began to make works that were collages or new configurations of things; one was a hybrid, a disembodied human-animal head. In 1990 she made three animal bronzes -- two dogs and a deer. The most expressive is *Creature of Habit -- Drunken Dog I* [93], which lies on the floor in an alcoholic stupor, still wearing its party hat. The dog appears to be either deeply asleep or even dead, and in fact, it was cast from an actual dead dog. What Trockel has done here is to give the dog human traits, to anthropomorphize it, and to lend it a tender vulnerability. It is subject to the gaze of any viewer, and in its drunken state appears to have no control over its situation.

Daisy Youngblood's low-fired clay sculptures conflate human and animal imagery, and her common subjects are gorillas, goats and horses, usually with male faces, and elephants and hawks with female attributes. Works such as *Romana* and *Tied Goat* [95, 96] hark back to an archaic world of centaurs and fauns. Their small scale and their twisted poses give her works a strong sense of vulnerability or melancholia, as though they had been forgotten or rejected by the world. She herself works far away from the mainstream art world, recently in South Arizona and now in Costa Rica.

Jane Alexander is also very much a product of her environment. Her hybrid creatures relate to the social politics of the southern part of the African continent where she lives and works. She began to combine human and animal forms at the beginning of her career in the early 1980s, and her major presentation of this mode is the group called *Bom Boys* [97], created from a variety of materials -- fibreglass, synthetic clay, wood, acrylic paint and clothing. In most cases, an animal's head is transposed onto the figure of a boy, thus hiding his race and personality. She deals with binary oppositions in her work: good versus evil, strength and weakness, children and adults, oppressors and victims, and these children are a mix of confidence and vulnerability.

Erick Swenson makes hybrid baboons, deer and sheep from rubber and polyurethane, and acknowledges that his work is inspired by his fascination with dioramas, special effects in films, and prosthetics. He anthropomorphizes his animals, with the result that they resemble a cross between an escapee from a science-fiction film and a reject from a natural-history museum diorama. *Edgar* [98] looks like an amalgam of a large poodle, a sheep and a small horse, posing in a soulful way on a snow-covered, rocky outcrop.

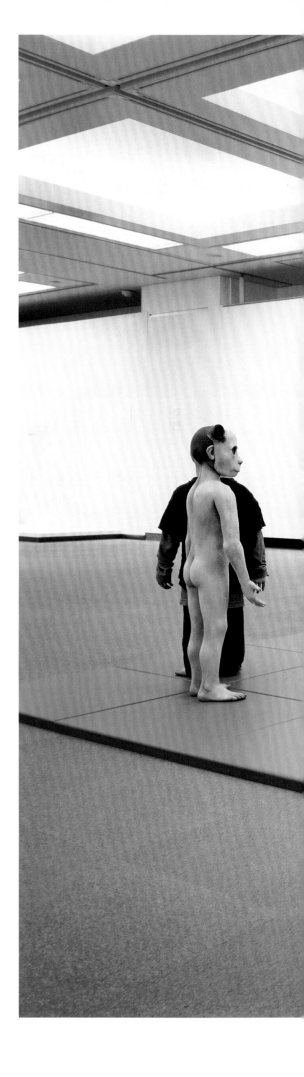

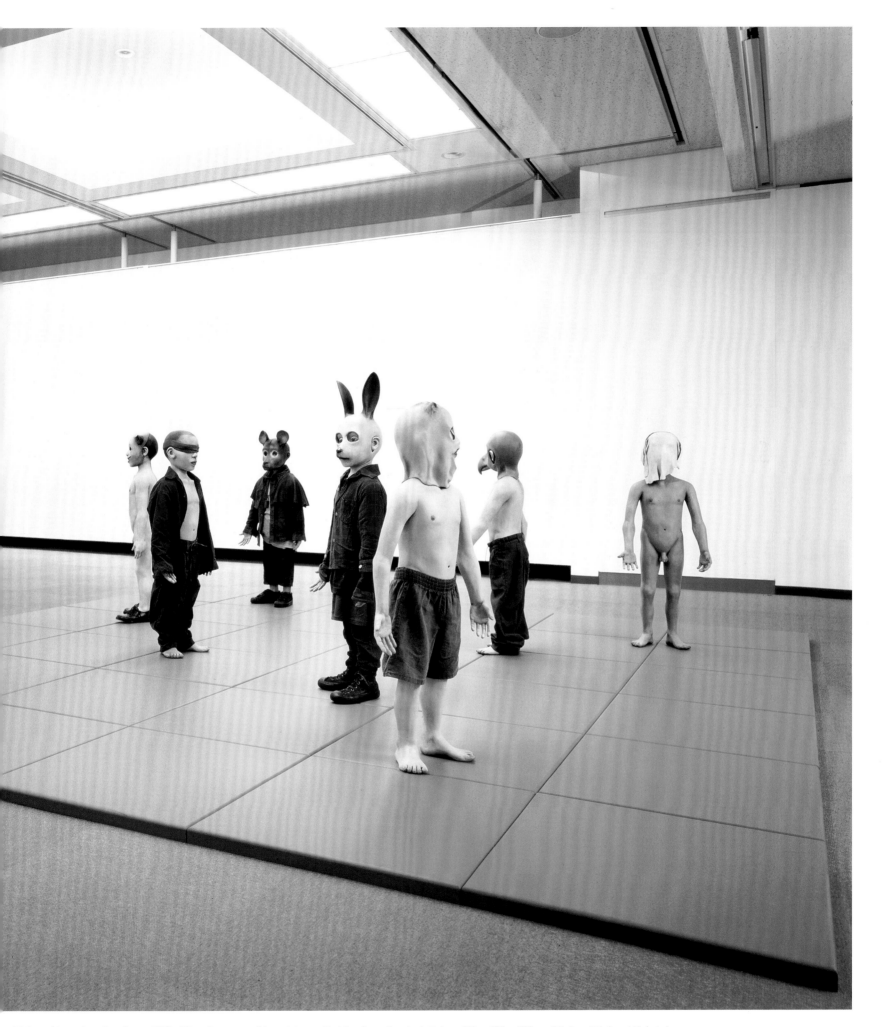

97 Jane Alexander, *Bom Boys*, 1998. Fibreglass, acrylic paint, synthetic clay, found clothing. 105 x 360 x 360 cm (41 ¼ x 141 ¾ x 141 ¾ in)

98 Erick Swenson, *Edgar*, 1998. Mixed media. 152.4 x 122 x 174.3 cm (60 x 48 x 108 in)

99 Young Sun Lim, *Room of the Host*, 2000. 200 glass jars, silicone, sound. Dimensions variable

Melancholic and comical scruffy little figures that resemble cats, dogs, birds and other animals come from the studio of Jon Pylypchuk. Spouting pitiful phrases, hand-written onto pieces of fabric, they interact with each other in tender or aggressive tableaux. They look a little like recycled old toys, dressed up with a bit of glitter and reanimated to propose meditations on violence and caring. *Hey, don't fuck with the pipsqueak!* [100] comprises a dog in boxing gloves punching an angry tiger, while protecting a frightened cat who wears white ankle socks.

Young Sun Lim showed *Room of the Host* [99] in the exhibition 'Unnatural Science' at the Massachusetts Museum of Contemporary Art in February 2000; this work consisted of 200 imaginary zoological specimens, such as a fish and human body parts, made from opaque silicone foam, suspended in illuminated glass jars filled with translucent gel, which hung from the ceiling of a darkened room. Each specimen moves in its jar, emitting chirps, squeaks and snippets of song that stop when a visitor approaches. It is as though the viewer has disturbed them, and they have reverted to the pretence of being dead. The artist has described the sounds as 'an angel departing the Earth'.

100 Jon Pylypchuk, *Hey, don't fuck with the pipsqueak!*, 2004. Mixed media. 198 x 91.5 x 122 cm (78 x 36 x 48 in)

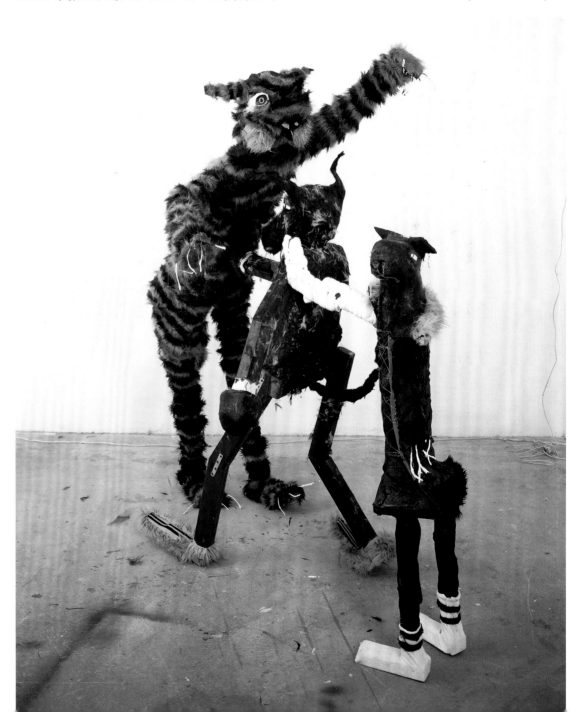

POST POP OBJECTS

Object sculptures incorporate, utilize, transform or mimic everyday domestic items for both aesthetic and socio-cultural reasons, and are the lively offspring of Marcel Duchamp's 'readymades'. As discussed in the Introduction, Duchamp invented this new category of sculpture when he took ordinary manufactured objects out of daily life and placed them in the art gallery. One of these was a snow shovel that he exhibited at the Bourgeois Gallery, New York, in April 1916, and another was a white porcelain urinal **(2)**. They were basic rather than luxury goods, and they were an intrinsic part of the social reality of the world. They drew attention to the gulf between the unique object, a work of art, and the mass-produced object found in the home of everyman. Notions of craft and the creativity of manual dexterity were undermined by Duchamp's act, while notions of choice and the use of the intellect were elevated.

Countless sculptures have been made along the same lines in the nine decades following Duchamp's lead, and his influence is particularly strong today in a world dominated by mass-production and multiples, with questions about high and low art, uniqueness and the 'aura' of the artwork being hotly debated. In 1936, two decades after the introduction of the readymade, the intellectual Walter Benjamin (1892-1940) wrote a seminal essay, 'The Work of Art in the Age of Mechanical Reproduction'. In this, he defined the unique quality pertaining to a work of art, conferred by its originality and authenticity, as its 'aura'. This aura was eliminated by mechanical reproduction. Benjamin recognized that the new idea of mechanical, rather than manual, reproduction of a work of art was likely to affect both cultural thought and production. Rediscovered in the 1960s, just when artists were seeking to widen the reach of art by extending its communicative and reproductive possibilities, the essay has become a canonical text in the art world. The Pop Art movement of the 1960s appropriated images from the mass-produced world, while the Minimalist movement that followed adopted elements such as repetition, the series and work made anonymously by fabricators and machines.

There is an interesting variety of contemporary responses to the concept of the readymade: some artists appropriate and present their materials virtually unaltered; some find and modify them, while others invent objects to look like mass-produced items. Both rare and utterly commonplace ingredients are used. All are done with a touch of irony, reflecting on Duchamp's legacy as well as commenting on the power and ubiquity of global marketing and the world of consumer goods. These new forms of readymade sculptures emerged in Britain and America at the same time, the beginning of the 1980s, but from different standpoints. In Britain, critics coined the term 'object sculpture', while in America the more common description was 'commodity' or 'appropriation sculpture'. British object sculpture diverges radically from its American counterpart in that UK artists were less interested in working with new, branded commercial goods. The British preferred the worn, discarded, anonymous item, which rarely carried a maker's label. The artist Richard Wentworth has described the British approach as 'the archaeology of the dustbin'. The American approach had its Pop Art precursors: in New York in 1960, Jasper Johns made two Ballantine beer cans in painted bronze, and in 1964 Andy Warhol began to produce silk-screened wooden sculptures mimicking the trademarks and packaging used in the American food and drinks industry **(10)**.

In the late 1970s, in the United States, Haim Steinbach began to work with everyday objects and initiated his series of 'Displays' in the early 1980s; these consisted of shelves on which he set objects borrowed from friends. He was interested in the way the context of the object changed when it was moved from a private to a public sphere. Around 1984, Steinbach began to make his signature, wedge-shaped shelves, on which he placed brand-new objects purchased from department stores and supermarkets. He looked for objects that conveyed 'typological character and cultural resonance', and his work made reference to

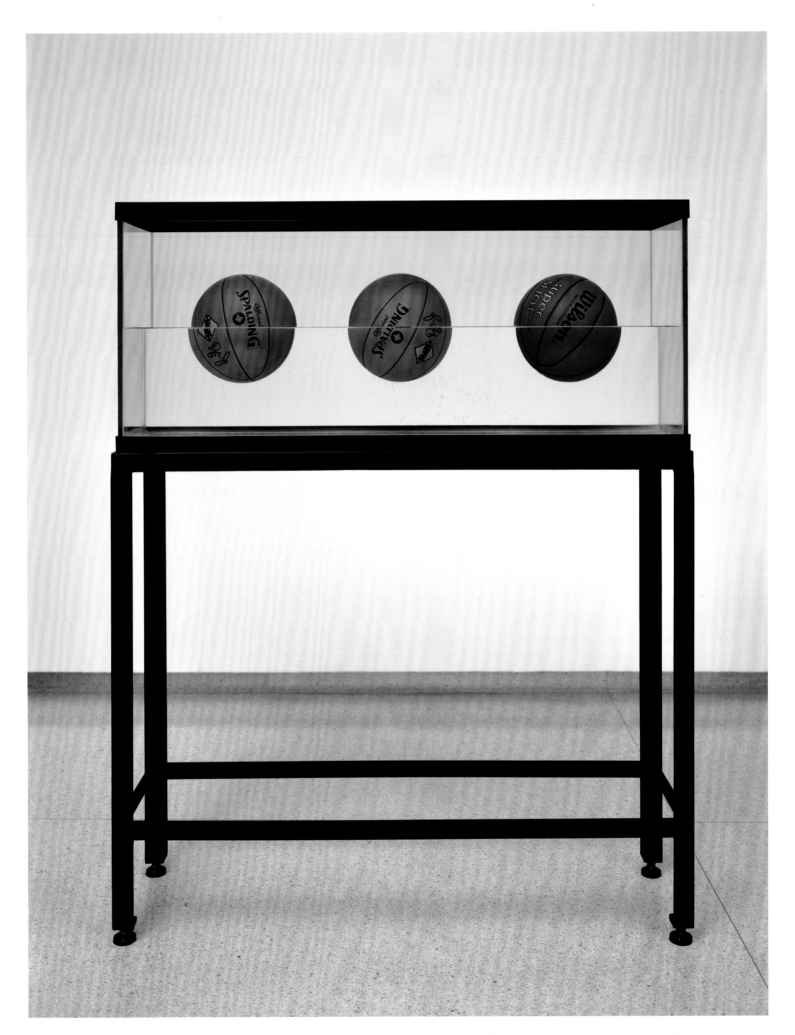

101 Jeff Koons, *Three Ball Total Equilibrium Tank (Two Dr. J. Silver Series, Spalding NBA Tip-Off)*, 1985. Mixed media. 153.6 x 123.8 x 33.6 cm [60 ½ x 48 ¾ x 13 ¼ in]. Tate, London

102 Haim Steinbach, *ultra red #2*, 1986. Wood, plastic laminates, lava lamps, enamel pots, digital clocks. 170 x 193 x 48 cm (67 x 76 x 19 in). Solomon R. Guggenheim Museum, New York

the way in which objects are selected, arranged and displayed in a commercial retail context. A typical Steinbach from the mid-1980s is *ultra red #2* **(102)**, which consists of four red and gold lava lamps, nine red, stacked cooking pots and six digital alarm clocks with flashing red numbers. The title draws attention to the colour shared by all the objects, with the prefix 'ultra' lending it extra radiance.

Jeff Koons is another appropriation/commodity sculptor, who found his source material in American kitsch. In 1979, he presented the first of his 'Inflatables' -- giant, blow-up plastic flowers or animals of the sort bought in toy-shops, such as his enormous silver *Rabbit* of 1986. He then moved on to brand-new domestic appliances such as electric kettles, toasters, vacuum cleaners and floor polishers, which he showed in Plexiglas cases, lit by fluorescent light, mimicking the way in which they are displayed in shops. In 1980, one of these sculptures was shown in the street window of the New Museum of Contemporary Art, New York, thus completing the ironic circle. Five years later, he unveiled his 'Equilibrium Tanks' series, basketballs suspended in liquid **(101)**. Keeping the balls in place required the help of a Nobel Prize physicist, Dr Richard Feynman. At the same time, Koons began to cast found objects in bronze and stainless steel, or had them modelled in porcelain or carved in wood. To begin with, both Steinbach and Koons allowed each object, usually a branded good, to preserve its original identity even though they gave it a new context. But when Koons started to have the items cast in editions, or manually copied by craftsmen, he brought a twist to the idea of the original 'aura'.

103 Allan McCollum, *Over Ten Thousand Individual Works*, 1987-8. Enamel on solid-cast hydrocal. Each 5 cm (2 in) diameter; dimensions variable

104 Josiah McElheny, *An Historical Anecdote About Fashion*, 1999. Blown glass, two glass and metal display cases. 183 x 305 x 71 cm (72 x 120 x 28 in)

Although the hallmark of Allan McCollum's practice is his mass-production and bulk repetition of forms, which reveal no trace of the artist's hand or style, it is easy to recognize his work. He has made two series: 'Plaster Surrogates', begun in 1982 and 'The Perfect Vehicles', begun in 1985. These are mass-produced vessels cast from moulds, which he displays in large groups. 'The Perfect Vehicles' were generic, Ming-style vases, which carried implications of taste and class. Artists of the 1980s were drawn to French sociologist Jean Baudrillard's 1968 book *The System of Objects*, which offered a cultural critique of the commodity in consumer society and identified the fact that every object has two functions: 'to be put to use and to be possessed'. McCollum's multiple sculptures are witty and clever responses to Baudrillard's thesis. His largest work to date is his *Over Ten Thousand Individual Works* [103], comprising that number of small plaster objects all painted the same aquamarine colour. McCollum lays them out in serried ranks so that their differences and similarities can be appreciated. Each object is unique, but all are cast in combinations of up to eight from a total of 150 moulds, and this lends them a strange family identity. The moulds were made from familiar domestic objects such as yoghurt pots, door handles, bottle caps and kitchen implements. Their small scale invites handling, and indeed, the original models were intended to be picked up. They raise many reactions in the viewer because they look useful and intimate, yet are actually functionless. McCollum's small plaster objects have their antecedents: the OHO group of Slovenian artists made plaster casts of everyday plastic bottles in the mid-1960s, which were inspired by the notion of 'reism', a philosophical term derived from the Latin word *res* for 'thing' and also the chosen name for their new artistic movement. OHO artists decided to work in a conceptual way, looking at the identity and function of art and its objects; this led them to believe that there was no difference between a human being and a plastic bottle, and that both should be treated equally.

Josiah McElheny trained as a glass blower in Europe and America. He makes elegant glass objects such as plates, vases and beakers, which he displays in specially designed vitrines. Each one is an exact replica of an item that McElheny has chosen from design history, and he writes explanatory captions for them that marry fact and fiction. One series of remade works copies the glasswork of the Austrian architect and designer Adolf Loos, a highly influential figure in the development of twentieth-century European industrial design. McElheny is fascinated by historical context and how objects accrue meaning, and his glass objects, captions and special display cases pose questions about the relationships between the original object and the copy. *An Historical Anecdote About Fashion* [104] comprises small glass copies of the haute-couture 1950s dresses of Christian Dior.

It is quite a leap from the elegance and craftsmanship apparent in the glass sculptures of McElheny to the plain plaster forms made by British artist Edward Allington. However, Allington also uses his work to question the relationship between object and copy, between originals and reproductions. At the beginning of his career he looked to the civilizations of ancient Greece and Rome as his inspiration, making copies of fragments of classical sculpture and architecture. He also read the Greek philosopher Plato (c.428-347 BC), whose most famous doctrine was his theory of forms. Plato believed that ordinary objects were imperfect copies of original ideal forms, which were ethereal and unavailable to man, timeless and unchanging, unlike the quotidian objects of the transient material world. Allington's *Ideal Standard Forms*, a collection of nine different geometric plaster shapes [105], is an ironic reference to Plato's ideal forms, although these are rough plaster moulds made from moulded clay originals.

105 Edward Allington, *Ideal Standard Forms*, 1981. Cast plaster. 47.5 x 300 x 228 cm (18 ¾ x 118 x 89 ¾ in). Tate, London

106 Tony Cragg, *Canoe*, 1982. Mixed media. 70 x 600 x 100 cm (27 ½ x 236 x 39 ½ in)

Allington's work stands somewhat alone in the British object sculpture scene, as a consequence of his references. The more familiar and typical pieces were made by his fellow sculptors Tony Cragg and Bill Woodrow. At the beginning of their careers, in the late 1970s, these two artists drew on the surplus and waste of the modern city, their local everyday urban reality. They were not the first sculptors to do this: Picasso and the Surrealists had incorporated the found object into their sculpture, and the German Dada artist Kurt Schwitters had used rubbish in his constructions.

Cragg began to collect discarded household objects, scavenging them from London streets. In 1977 he moved to Germany and looked for similar items in local industrial zones, on wasteland and around riverbanks and roadsides; he found that the predominant waste material was non-degradable coloured plastic items. Partly as a result, he turned from employing natural elements in his multi-part sculptures to using plastic. He began by arranging the found plastic pieces into formal ensembles that concentrated on their shape, size and colour, which he presented on gallery floors. Later, he made a series of self-portraits, such as *Self-Portrait with Sack*, setting wall-mounted, two-dimensional representations of himself alongside the scraps that he was collecting and sorting. He also made some more substantial pieces with plastic waste, like *Canoe* **[106]**, which often involved curves or spiral forms. Cragg's plastic sculptures of the 1980s can be seen in opposition to Plato's theory of timeless, indestructible forms, replacing them with synthetic polymer items that are non-degradable and everlasting.

Around 1980, Woodrow began to make sculptures from discarded white goods that he found on London streets -- domestic appliances such as washing machines and fridges, vacuum cleaners, heaters and televisions. He performed a sort of origami procedure, cutting and folding the thin metal skin of the host domestic object to produce a new and inventive parasitic offspring, still attached by a metal umbilical cord to its parent. Thus he left evident the original identity of the host as well as the mode of transformation, using a witty and skilful manipulation of the raw material into a kind of three-dimensional drawing **[107]**.

107 Bill Woodrow, *Car Door, Ironing Board, Twin Tub and North American Headdress*, 1981. Mixed media. 186.5 x 283 x 157 cm (73 ⅜ x 111 ⅜ x 62 in). Tate, London

He also made several works with car doors and bonnets, having found them to be readily available and cheap, and his work throughout the 1980s dealt with big subjects like religion, violence, politics and the media. The issue of the found object, the readymade, is played down in Woodrow's work in favour of imparting messages about the polarities of life, such as rural versus urban, savage versus civilized, present versus past.

Richard Wentworth manipulates tables, chairs, buckets, plates, light bulbs, garden implements, shoes, books and other ordinary domestic objects by joining, cutting, inserting and pairing them. Some of the objects are bought in hardware shops or builders' merchants -- he is particularly fond of galvanized steel buckets and baths -- while others are found in city streets. He works economically, making small, simple gestures that alter his found objects only in a minor way. His poetic, allusive titles play with language, and add another layer to the appropriated object. With *Shrink* **(108)**, the title could refer to the different sizes and shapes of the containers and their contents, but the word is also an informal term for a psychiatrist, a head-shrinker.

In 1982, Richard Deacon made the first in a series of small sculptures called 'Art for Other People' **(109-14)**; the group continued until 1998 and numbers forty-six pieces. It comprises several awkwardly scaled floor-based objects in a variety of materials, textures and colours, many of which have the look and feel of small industrial fabrications that could be handled and possibly put to some obscure use. The title given to them appears to imply that they have popular appeal. Deacon's works in this series belong to their own class of object sculpture, in that they do not cannibalize or mimic everyday objects, although some of them look oddly familiar.

108 Richard Wentworth, *Shrink*, 1985. Galvanized steel, brass. 45.7 x 137.2 x 91.5 cm (18 x 54 x 36 in)

109-14 Richard Deacon, *Art for Other People*, 1982-5. (clockwise from top left) *No 10*. Galvanized steel, linoleum. 40 x 90 x 90 cm (15 ¾ x 35 ½ x 35 ½ in); *No 13*. Stainless steel, linoleum. 47 x 96.5 x 9 cm (18 ½ x 38 x 3 ½ in); *No 17*. Galvanized steel, linoleum. 122 x 152.2 x 46 cm (48 x 60 x 18 in); *No 1*. Stone, leather. 30 x 90 x 30 cm (11 ¾ x 35 ½ x 11 ¾ in); *No 14*. Brass, mixed media. 50 x 150 x 70 cm (20 x 59 x 31 in); *No 12*. Marble, leather. 15 x 30 x 15 cm (6 x 11 ¾ x 6 in)

While primarily an American/British genre, object/commodity sculpture has also been made by artists from Germany, South America, France and, most recently, Mexico. Between 1979 and 1984, Katharina Fritsch made works which focused on consumer goods and their modes of presentation, but in the early 1980s she picked the nineteenth-century sculpture of the Madonna from the French pilgrimage centre of Lourdes as a significant consumer item, and *Display Stand with Yellow Madonnas* followed **[115]**. Lourdes is visited by over 5 million catholic pilgrims annually, and it is full of gift shops selling tacky holy souvenirs. Fritsch's endless yellow Madonnas, which are small-scale replicas of the nineteenth-century figure, look as though they are ready for purchase by the faithful masses.

115 Katharina Fritsch, *Display Stand with Yellow Madonnas*, 1987-9. Aluminium, glass, plaster, paint. 270 cm (106 ¼ in) high

116 Tobias Rehberger, *One*, 1995. Plaster, ceramic, wood, glass, plastic. Dimensions variable. As installed at Galerie neugerriemschneider, Berlin

Tobias Rehberger uses his sculpture to examine the role of the artist in contemporary production. To do this, he mixes up art-historical and domestic-consumer styles; he is particularly drawn to 1960s and 1970s design, and he could be seen as a descendant of both Steinbach and McElheny. Some of his objects are new, while others, such as his proposal to turn a Donald Judd metal sculpture into a working bar, modify existing ones. For a solo show in Berlin in 1995, he designed different vases for the gallery's nine contemporary artists in a variety of materials -- wood, plaster, plastic, ceramic and glass -- and in styles ranging from the minimal to the baroque, which he felt embodied the personalities of the artists [116]. He asked the artists to send flowers to fill them. Another Rehberger show consisted of nine tiny replicas of extant works of public sculptures by well-known artists; seven were real replicas, while two were made up by Rehberger. He withheld the information as to which were the originals and which were the fakes.

117 Sylvie Fleury, *Prada Shoes*, 2003. Chromed bronze. 16.5 x 20 x 25 cm (6 ½ x 8 x 4 ¼ in)

Sylvie Fleury's work of the 1990s has been called 'post-appropriation'. Her work *Platinum* (1995) consisting of three pairs of transparent plastic Karl Lagerfeld boots floating in a fish tank with blue lighting, which was shown in the Galerie Art & Public, Geneva, made strong allusions to Koons's floating basketballs of ten years earlier. She has made other pieces that refer back to Koons, but unlike his works, Fleury's goods come from the realms of fashion and product design: silver-polished bronze casts of a 1962 Hermes Kelly bag, a 1924 Chanel No. 5 perfume bottle, a pair of high-heeled Prada shoes **[117]** and a bottle of Evian water set on pedestals. She has produced several works that consist of shopping bags bearing the logos of famous designers and top stores, and has recently made editions of twenty-four carat, gold-plated *Shopping Trolley* and *Dustbin*. All these works refer to art as a kind of luxury consumerism and appropriation. Advertising plundered the styles of twentieth-century art, and now art is plundering the strategies of advertising. Fleury is responding to the way in which the barriers between art, design, fashion and commerce have folded in on themselves.

Mathieu Mercier is nine years younger than Fleury, and his career only started a few years ago. He employs common household and industrial objects and materials [118], rather than luxury goods, to explore the relationship between contemporary, mass-produced consumer objects and their aesthetic origins in early twentieth-century art and design. He admires and also parodies the work of the painter Piet Mondrian and Russian Constructivists such as Alexander Rodchenko, European artists who believed in utopias and the cross-fertilization between design disciplines. His *Glad (after Rodchenko)* consists of boxes of Glad rubbish bags, stacked according to the pattern of Rodchenko's *Spatial Construction, No. 30* (1920-1).

118 Mathieu Mercier, *Glad (after Rodchenko)*, 2003. Mixed media. 43 x 23 x 23 cm (17 x 9 x 9 in)

decades earlier, particularly Warhol's work. The Mexicans are responsive to the history
and politics of labour and craftsmanship. Orozco makes many of his sculptures from found
objects, and he turns them into games or puzzles. He cites Duchamp and the writer Jorge
Luis Borges as two of his major influences. In 1996, he designed an oval billiard table
(119), describing it as 'a speculation related to space, topography, mathematics, and the
logic of the object itself'.

Ortega also utilizes and transforms everyday objects in a witty way. He first worked as
a political cartoonist, and the art of caricature, or the manipulation of something well
known, has moved from cartooning to sculpture. He likes to tinker with ordinary things
such as tools **(120)**, gadgets, toys and furniture, and global products like the Coca-Cola
bottle. Kuri is drawn to the world of packaging, advertising, distribution and exchange of
consumer commodities **(122)** and is described by his friend Orozco as a 'Poetical Activist'.
Abraham Cruzvillegas, who studied with Orozco, uses both natural and manufactured items,
and has a penchant for arranging his material in large clusters. Although much of his
work displays tenderness and a light, playful approach to his recycled materials, some
pieces impart a sense of violence. *Aeropuerto alterno* **(121)**, for example, comprises over
two-dozen assorted knifes stuck into a wooden kitchen block.

José Hernández-Diez has rejected his colourful baroque Latin American heritage in favour
of the international vocabulary of Pop Art and appropriation sculpture. He works with
commonplace, everyday objects such as spoons, battery covers and clothing, and places
his chosen items in unexpected and witty juxtapositions, much in the manner of the
Surrealists. Using quartets of trainers bearing makers' symbols, Hernández-Diez spells
out the names of some of the most influential Western thinkers: Hume, Kant, Marx, Kafka
and Jung **(123)**. He thus employs elements from popular culture to point to figures from an
elite culture. These readymades reflect our fascination with consumerism, materialism
and consumption, globalization, technology and identity.

119 Gabriel Orozco, *Oval Billiard Table*, 1996. Wood, slate, mixed media. 89 x 309 x 229 cm (35 x 120 x 90 in)

120 Damian Ortega, *Sanding Duck*, 1997. Modified electric sander. 30 x 30 x 15 cm (11 ¾ x 11 ¾ x 6 in)

121 Abraham Cruzvillegas, *Aeropuerto alterno*, 2002. Knives, wood. Dimensions variable

122 Gabriel Kuri, *Carretilla 1*, 1999. Wheelbarrow, popcorn. 55 x 140 x 66 cm (21 ½ x 55 x 26 in). Museum of Contemporary Art, Chicago, Illinois

123 José Hernández-Diez, *Kafka*, 2002. New trainers, mixed media. 65 cm (25 ½ in) high

124 Choi Jeong-Hwa, *Plastic Paradise -- Vision of Happiness*, 1997. Plastic colanders. Approx. 200 cm (78 ¾ in) high

Alexandre Da Cunha lives and works in London and carries on Woodrow's tradition of making series of sculptures from domestic and found materials. He chooses to work with items that refer to sporting activities or to the repetitive chores of housework, utilizing cleaners' mops, rubber plungers and found plastic bottles; such items playfully turn themselves into other things through a game of 'dressing up' and make-believe (125). The playful element is further emphasized by the cheap, hand-crafted assemblage, which unashamedly exposes the material and the simple techniques.

Even though he lives on another continent, being based in Seoul, Choi Jeong-Hwa works in a similar way, using coloured plastic as a material, as first seen in the work of Cragg during the 1970s. Choi is inspired by Warhol and Koons, and has a particular liking for inflatables and kitsch artefacts. He utilizes multiples of domestic kitchen objects, made from brightly coloured plastic, which are sold in Korean markets (124). There is, of course, nothing specifically Korean about these items; they are ubiquitous and universal, and thus serve to point out how interchangeable are the market goods of Seoul and any other city.

125 Alexandre Da Cunha, *Terracotta Ebony 2*, 2003. Rubber toilet plungers, wooden plinth. 127 x 40 x 40 cm (50 x 15 ¾ x 15 ¾ in). Galeria Luisa Strina, São Paolo

In the early 1980s, when some artists turned to expressionist figuration and the human body, others sought a cooler alternative in the three-dimensional territories of architecture and furniture, where man's physical measure is implicated but not represented. American and German artists led the field, with the cities of New York, Los Angeles, Cologne, Stuttgart and Dusseldorf as important centres. Several sculptors in these cities cannibalized ideas and materials from architecture and furniture for their work. The Bauhaus school of art and architecture still casts its shadow on artists who choose to work on the frontiers of architecture and design. Founded in Weimar in 1919 by Walter Gropius, the Bauhaus proposed a unity of art, craft, design and architecture, and a marriage of art and technology, which it believed would lead to an amelioration of urban social conditions and the possibility of a utopian lifestyle. It moved to Dessau, and then Berlin in 1932, where it was led by the architect Mies van der Rohe. In 1933 the Nazi regime caused its closure and the dispersal of its staff, with many moving to America, including Mies, who emigrated to Chicago in the late 1930s. Thus the hard-edged, mechanistic Bauhaus style made its mark on both German and American soil. This was supplemented by the cool, linear shapes of the Russian Constructivists, such as Vladimir Tatlin and Naum Gabo, and the Dutch De Stijl Group, which included the painter Piet Mondrian and the architect/designer Gerrit Rietveld. Equally influential is a softer, more curvaceous style that emanated from Scandinavia from the 1930s to 1950s with designers like Alvar Aalto, Eero Saarinen and Arne Jacobsen. Now, the Swedish furniture and home goods store IKEA is a fruitful source of inspiration.

The manipulation of space and material, and issues around shape, colour, texture and gravity, are common to architecture, furniture and sculpture. The notion of form following function, a motto invented by the architect Louis Sullivan around 1900 and applied to his designs for the first steel skyscrapers, was jettisoned by architects and designers around the 1970s, and this earned them the epithet of 'postmodern'. Contemporary sculptors had no function to adhere to, and in their works they began to exploit the oscillation between form and function, which makes for unsettling viewing. Do you sit on a sculpted bench by Scott Burton, for example, or just walk round it and look at it? For their materials, sculptors turned to mass-produced, readymade stuff, the kind available at builders merchants, such as ladders, clamps, wood, plasterboard, bricks, Formica panels, sheets of glass and lighting units. This lent their sculpture a raw, anonymous feel, as well as an aesthetic of do-it-yourself, with these humble, almost poor materials.

In the early 1960s, New Yorkers Claes Oldenburg and Richard Artschwager were the first sculptors to take their inspiration for their non-functional forms from the world of domestic furniture. Among Artschwager's furniture pieces (11) are some that resemble church furniture, such as lecterns and confessionals. He has said: 'Furniture in its largest sense is an object which celebrates something that people do -- or sanctifies it.'

Burton, another New Yorker, began as a performance artist, presenting tableaux in which people and objects, usually furniture, interacted. In 1977 he exhibited two functional chairs and two tables as autonomous objects at a gallery, describing them as 'pragmatic structures'. He later said of his furniture/sculpture that he wanted it to be 'not in front of, but around, behind, underneath the audience -- in an operational capacity.' His granite Settee (127) is one of his most stylish 'pragmatic structures'. It comprises six different interlocking blocks of polished pink granite that fit snugly together. Burton made preparatory models, and it was then fabricated in Italy by craftsmen who work especially with granite. He considered granite 'the greatest natural material' and liked the fact that it has a long history of use, mainly for monumental sculptures, but occasionally for ceremonial chairs. This settee functions as both furniture and sculpture, and it can be set indoors in the gallery or outside in the garden. Donald Judd

126 Franz West, *Test*, 1994. Steel, metal, fabric
28 parts, each 100 x 240 x 85 cm (39 ½ x 94 ½ x 33 ½ in).
As installed at Museum of Contemporary Art,
Los Angeles, California

127 Scott Burton, *Settee*, 1982. Polished Milford pink granite. Six parts; 92 x 165 x 85 cm (36 ¼ x 65 x 33 in). Dallas Museum of Art, Texas

made real functional furniture -- as did Joel Shapiro and Sol LeWitt -- that was extremely close in appearance to his sculpture. The art critic Clement Greenberg contended that Minimalist sculpture was not actually sculpture, but good design. A group of younger American artists -- Jim Isermann, Roy McMakin, Rita McBride, Clay Ketter, Jorge Pardo, Joe Scanlan and Franz West, also make objects that are functional, but these have not received the same kind of criticism.

From the beginning of the 1980s, Jim Isermann has been making both two-dimensional and three-dimensional work from ordinary household and craft supplies, and his bright, patterned geometrical sculpture seems more at home in living rooms and bedrooms than in galleries. Many pieces are extremely labour-intensive, particularly his shag-pile rugs, and all his techniques have been learnt from do-it-yourself craft manuals. His sculptures tend to be large foam-rubber cubes, covered in hand-loomed cotton woven by the artist, exhibited singly or in series. *Untitled (0597)* **(128)** is a prime example. Isermann's hard-edge colour-field abstraction is derived from Bauhaus colour theories and the Op Art movement, and he claims Bauhaus-like utopian ambitions.

128 Jim Isermann, *Untitled (0597)*, 1997. Hand-woven cotton, foam cubes. Each 61 x 61 x 61 cm (24 x 24 x 24 in)

129 Roy McMakin, *Refrigerator, table, shelving unit*, 2000. Maple, plywood, enamel.
178 x 79 x 76.2 cm (70 x 31 x 30 in)

Roy McMakin's career has similarities both to those of Artschwager and Burton. Like Artschwager, McMakin works as a furniture designer, having established his own firm in Los Angeles and Seattle called Domestic Furniture, which supplied office furniture to the J. Paul Getty Museum in Los Angeles. And like Burton, McMakin makes no distinctions between furniture and sculpture. His work, however, could not be confused with theirs because it has a slightly unfinished, eccentric air. Each piece, such as *Refrigerator, table, shelving unit* **[129]**, is usually multi-purpose, bestowing it with a complex identity as befits a work that straddles furniture and sculpture.

For her subject material, Rita McBride is drawn to unassuming industrial products and unappreciated parts of the constructed urban environment -- high-rise car parks, ventilation systems, seating in sports grounds. She admires the work of the Swiss architect Le Corbusier as well as the space-frame systems invented by American designer Richard Buckminster Fuller; much of her work shares their minimal aesthetic. *Arena* **(130)** is both an autonomous sculpture and functional wooden seating unit like that found in sports arenas. In those environments people sit on such benches to watch a spectacle, and with McBride's sculpture the same can happen in an art gallery, except that the public who use the seating become the spectacle themselves. McBride likes to manipulate scale in her work, and *Arena* fits rather uncomfortably in interior gallery spaces, deliberately so.

130 Rita McBride, *Arena*, 1999. Twaron, wood. Approx. 4 x 20 x 30 m (13 ft 1 ½ in x 65 ft 7 ¼ in x 98 ft 5 in)

Like Isermann, Joe Scanlan designs and makes objects according to what he himself needs at home, usually modular forms, and this goal is above and beyond whether or not what he makes is art. He has made items for his bedroom, wardrobe and library, and is especially known for his *Nesting Bookcase* **[131]**. This can function just as happily in a home as in an art gallery, although it looks a little uneasy in the latter. Scanlan keeps a set of photographs of how collectors of his work both use and display the bookcase in their homes. In 2002, he produced a book called *DIY*, the cover of which carries the familiar blue and yellow logo of IKEA. The manual gives instructions on how to convert a flat-pack shelf unit into a coffin. Scanlan is interested in 'the relationship between craftsmanship and death', and why, for example, man expends time and effort designing a box that is never to be seen again once buried.

IKEA's products have also served as an inspiration for Clay Ketter. He worked in New York in the 1980s, but now lives in Malmö, the home of IKEA. He trained as a carpenter, and his work, which is a mix of painting, sculpture and installation, pays homage to Malevich, Mondrian and Judd, as well as to IKEA. With his series 'Surface Composite', made 1995-6, he remodels readymade IKEA kitchens and shelving units, appropriating the aesthetics of the building trade with commercially available flatpacks from IKEA and animating them with the language of Constructivism. He works at the frontier between the readymade and the flat pack -- the ready to be made. His *Billy Bob* [132] is a set of IKEA 'Billy' shelves to which he added new elements; yet the work does not lose sight of the original, even embellishing the name.

132 Clay Ketter, *Billy Bob*, 1998. MDF board, paint. 134 x 160 x 25.4 cm (52 ½ x 63 x 10 in)

The Dia Art Foundation in New York commissioned Cuban-born artist Pardo to design its lobby, bookshop and gallery, thus merging art with functionality [133]. He covered the floor and walls with bright ceramic tiles and designed shelving and seating, his colourful curvaceous style inspired by design from the 1950s and 1960s. This commission was not out of place in Pardo's oeuvre, since he designated his Los Angeles home a sculpture, titling it *4166 Sea View Lane* and opening it to the public for a six-week period, the usual duration of a gallery show. He also created the reading room for the Boijmans Van Beuningen Museum in Rotterdam in 1996 and a café-restaurant for gallery K21 in Dusseldorf in 2002. His most recent foray into design, a large-scale plywood structure that can be adapted for a variety of functions, was again commissioned by Dia. Here is a form that waits for its function: it was laser-cut from plywood following instructions from a computer.

133 Jorge Pardo, *Dia Bookshop Project*, 2000. Mixed media. 32.9 x 32.9 m (108 x 108 ft). Dia: Beacon, New York

Alexandre Arrechea, Marco Castillo and Dagoberto Rodríguez, three artists based in Havana, formed themselves into a collective group in 1991, which they later titled Los Carpinteros (The Carpenters). Their aim was to renounce individual authorship, referring back to the time of artisans' guilds. They make wooden objects that walk a tightrope between the functional and the non-functional, drawing inspiration from the built environment of Cuba. One of their witty and arresting pieces is *Russian Embassy* (134), a cedar chest of drawers in the shape of the Russian Embassy in Havana, once a formidable symbol of Soviet power in Cuba and now virtually abandoned.

134 Los Carpinteros, *Russian Embassy*, 2003. Solid cedar, cedar plywood. 300.4 x 109.9 x 109.9 cm [118 ¼ x 43 ¼ x 43 ¼ in]. Solomon R. Guggenheim Museum, New York

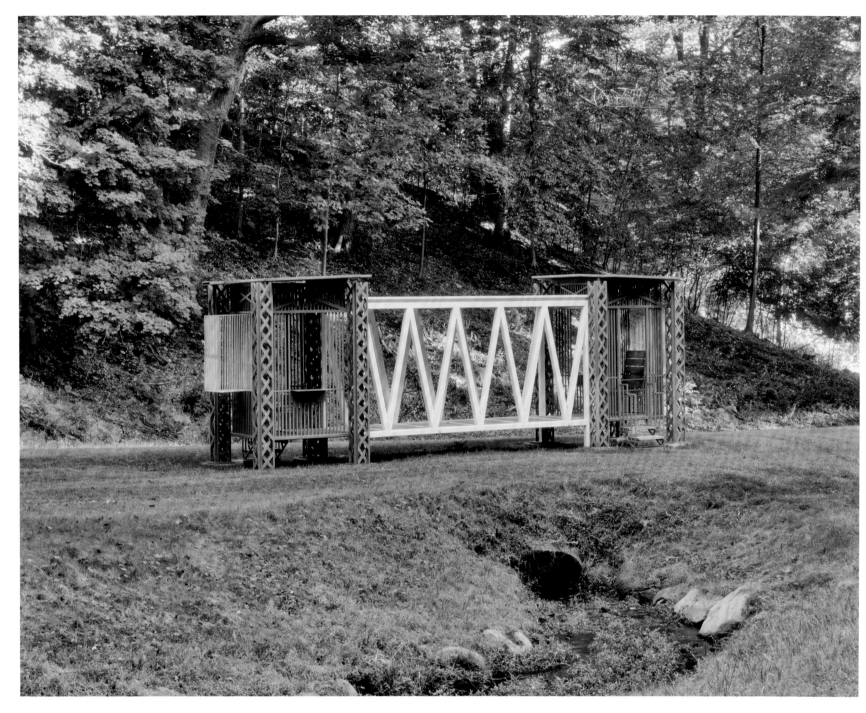

135 Siah Armajani, *Gazebo for Two Anarchists: Gabriella Antolini and Arberto Antolini*, 1992. Painted steel. 320 x 990.6 x 256.4 cm (126 x 390 x 101 in). Storm King Art Center, Mountainville, New York

In 1979, Siah Armajani invented his 'archi-sculpture', a series of abstract sculptures that are based on a range of architectural elements, mainly doors, windows, closets and staircases; many of his works play with the opposition of open and closed forms. He is interested in structural techniques of architecture while at the same time wresting them from their proper function. The architectural models and sculptures of the Russian Constructivists, such as El Lissitzky, have influenced him. He has designed 'archi-sculpture' for outdoor sites, bridges that go nowhere, glass and metal reading rooms and gazebos, which are usually dedicated to European anarchists **(135)**.

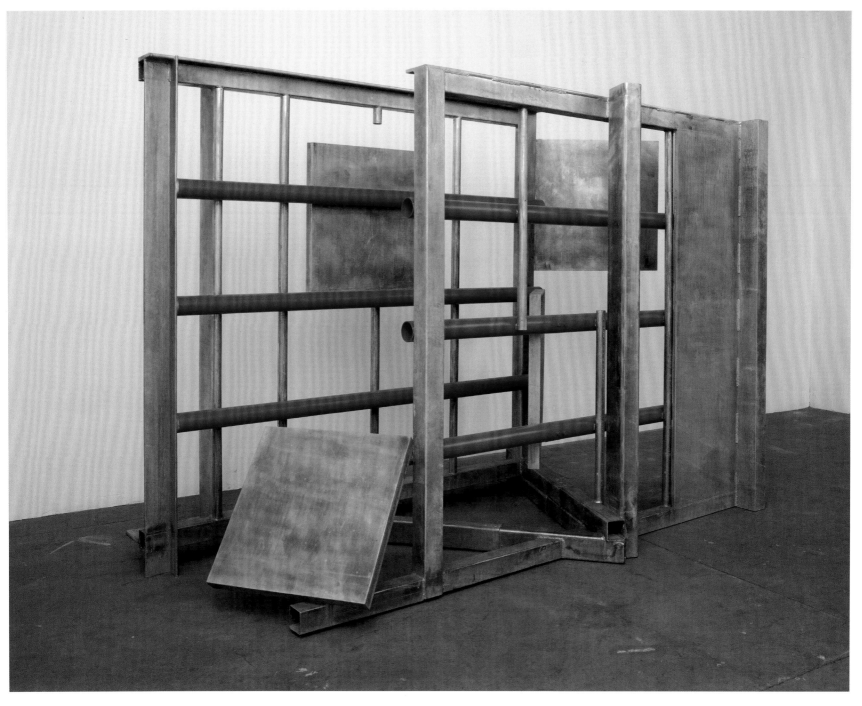

136 Anthony Caro, *South Passage*, 2005. Steel, galvanized and painted red. 231 x 346 x 173 cm (91 x 136 x 68 in)

Several artists in central Europe have occupied themselves with the vocabulary of architecture and furniture, the most senior being Anthony Caro, and it is one of the strongest trends in sculpture at the present time. Caro trained as an engineer before becoming a sculptor, and in the 1980s invented the term 'sculpitecture' to describe certain of his works that have an architectural aspect. These works, such as his recent *South Passage* **[136]** bear a strong resemblance to functional structures, since the forms look like doors, windows and inviting thresholds. These large steel structures, with their painted components, evoke a strong physical and emotional response from the viewer. 'Bodilyness is what you are, in fact, experiencing through your eyes when you look at a sculpture', Caro has said.

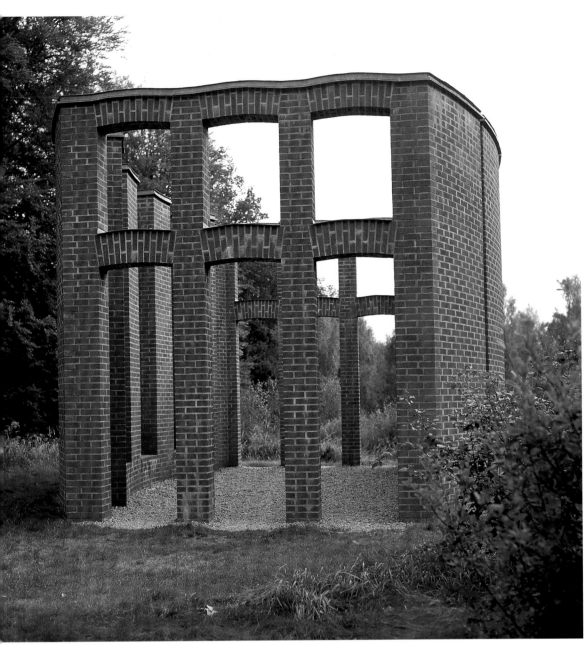

137 Per Kirkeby, *Wanås*, 1994. Bricks. 10 x 5 m (32 ft 9 ¾ in x 16 ft 5 in). Wanås Sculpture Park, Knislinge, Sweden

Per Kirkeby is both a painter and a sculptor, and his sculptures are either modelled in clay for casting in bronze, or they constitute strange, ambiguous structures in brick. His first brick pieces were low-lying structures like rudimentary bridges, but then they grew in size, with works such as *Wanås* (137) revealing the influence of European Neo-classical architecture. Their scale locates them between models and actual buildings, and they remain baffling, enigmatic objects.

In 1985, Reinhard Mucha made a site-specific installation for the Württembergische Kunstverein Stuttgart. *The Figure-Ground Problem in Baroque Architecture (For You Alone Is The Grave)* was made entirely from furniture, devices and tools he could find in the museum's storage and workshop. It was supposed to be a temporary installation and most items went back to their original functions in the Kunstverein. By creating a fragile image of circulation and rotation, the work reflected the mechanisms of the art world as fairground carousels: the big wheel and the wall of death. At the same time, all functional items of the work could be recognized visually in their original form.

Since the 1970s, Franz West has been making plaster objects, which he calls 'Fitting Pieces' that can be worn by viewers. He extended this engagement between artwork and public in his furniture sculptures of the 1990s, which function simultaneously as seating in galleries and as discrete works of art, like those of Burton two decades earlier. In 1994 West made *Test*, twenty-eight welded steel sofas, for the entrance of the Museum of Contemporary Art, Los Angeles (126). The sofas were covered with textiles from the various ethnic groups living in the area. The work was reincarnated later the same year as *Rest*, on the roof of the Dia Center for the Arts, New York. West wishes to change the roles of artist and viewer, inviting the public to manipulate his sculptures in the gallery just as he manipulates them in the studio.

Stefan Kern studied under both Kirkeby and West. His objects possess the characteristics of furniture; in form they resemble chairs, benches, shelves or lecterns, and they can be used as such. Yet their abstractness lends them a strong sculptural value -- the objects are usually monochrome, white or black and symmetrical. Their shapes are based on a precise analysis of the place for which they are created. This relationship to a specific location affects the work, but not to the extent that it could not be exhibited in another context. The character of Kern's sculptures owes much to the achievements of the Minimalists, and to their notion that a work of art is perceived not only for its formal characteristics but also in the context of the space in which it is shown (138).

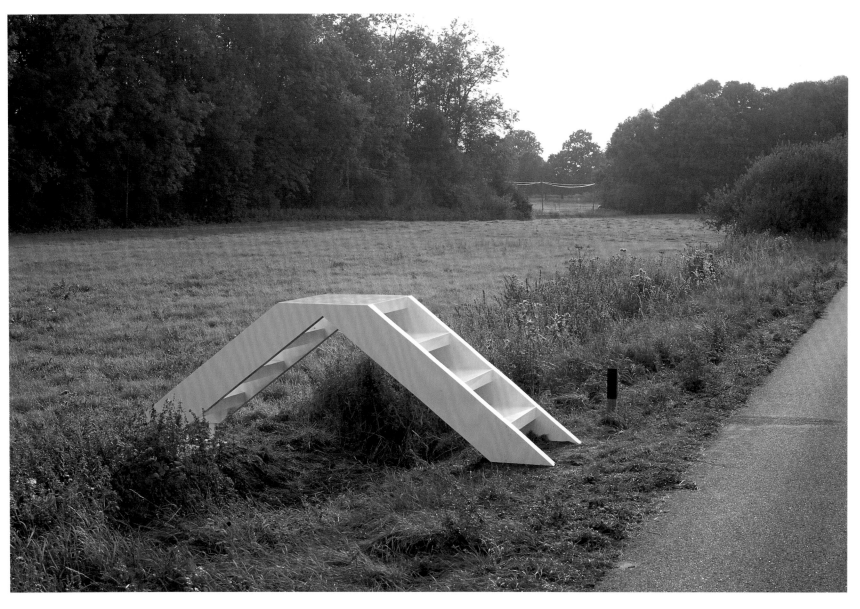

138 Stefan Kern, *Treppe*, 2003. Varnished steel. 68 cm (26 ¾ in) high. Neuenkirchen, Germany

Manfred Pernice makes sculptures from simple materials such as wood, plywood and chipboard, which give the impression that they are either provisional or somewhat unfinished. Small cardboard models precede most of them. Like McBride's work *Arena*, Pernice's pieces are often large, sometimes oversized for the space in which they are displayed, and thus they take on an architectural aspect in their ambiguous relationship with both the gallery and the viewer [139]. Pernice is fascinated by boxes and containers, and was particularly struck by ship containers while living in the German seaport of Bremerhaven. He built abstract plywood imitations of these containers, some with their sides painted the usual red or blue, and arranged them in gallery displays so that the viewer's path was hampered by their obdurate unwieldiness.

In the last decade or so, sculptors of all nationalities have been drawn to the aesthetics of the favelas or shantytowns found on the edge of third-world cities, informal structures made from recycled material -- architecture without architects. The first artist to look at these structures and their context was Hélio Oiticica, who was inspired by the shantytown of Mangueira, in the hills above Rio de Janeiro, especially the homes made from discarded materials such as large hoardings for products like Coca-Cola. He described his work *EDEN* [1967], consisting of six cells or cabins, as an experimental campus 'for making things and constructing one's own interior cosmos'.

139 Manfred Pernice, *Grosse Dose*, 1998. Mixed media. 600 cm [236 ¼ in] high

140 Mario Merz, *Fibonacci Igloo*, 1972. Metal tubes, cloth, wire, neon tubes. 100 cm [39 ¼ in] high, 200 cm [78 ¼ in] diameter

A year later, Mario Merz made his first igloo. These signature works refer to traditional types of Inuit or Native American housing, whose structure is determined in the most direct way by what nature provides in the form of either ice and clay; they are both permanent in that their form endures across generations, and temporary in that the ephemeral materials decay. Merz's igloos eschew ice and clay in favour of modern materials, for example metal, wood, twigs and electric light [140]. Traditional igloos provide security for their makers, but Merz's structures are unstable and insecure, and often dangerous, sometimes incorporating sheets of broken glass. He works with the emotional nature of habitation, and this is also true of a number of other artists.

Georg Herold, who lives and works in Cologne, regularly uses bricks, blocks of wood and construction techniques. He spent a year in an East German prison for an escape attempt to West Germany, where he was allowed to settle in 1973. In 1986 he made *X.Baracke* [141], a simple structure composed of grey pumice blocks and a wooden lath framework, through which the viewer can wander. It has no doors or ceiling, and looks as if it is either unfinished or a ruin. Its title designates it as a barracks, a temporary house for soldiers. Herold has explained that the 'X' at the start of the title refers to the tenth Station of the Cross, and inside the structure is a photograph that the artist took in a delapidated Belgian church, of a notice announcing that the tenth Station of the Cross had been removed for restoration. Herold makes the comparison between the decaying Station of the Cross and the Baracke, which looks ruined, though in fact it was never completed.

141 Georg Herold, *X.Baracke*, 1986. Pumice, wood, photograph. 190 x 700 x 200 cm (74 ¾ x 275 ½ x 78 ¾ in)

142 Pedro Cabrita Reis, *Favorite Places No. 6*, 2004. Aluminium, MDF, glass, wood, fluorescent lamps, hardware.
250 x 121 x 130 cm (98 ½ x 47 ½ x 51 ¼ in). Kunstmuseum, Winterthur, Switzerland

Pedro Cabrita Reis plays with ideas about the house and the city, and the way in which they
represent private and public space. He uses recycled building materials such as bricks,
metal girders, doors, plaster, glass, electric cables and fluorescent strip lights, and
his work often looks like a slice of an abandoned building site. Like Armajani, he creates
forms that hide or reveal, using oppositions of transparency and opacity, light and space,
and the interior/exterior dichotomy. His works of the late 1980s and early 1990s were
usually small, tableau-like stages with a sense of narrative and of memory, which was
hinted at in their poetic titles, but he has since extended his scale **[142]**.

More reflections on public and private space come from Callum Morton, who studied architecture and urban planning in Melbourne, where he lives and works. With the aid of a computer, he has designed and built elaborate scale models of iconic works of 1960s domestic architecture (see Chapter 16). But another part of his oeuvre comprises full-size copies of architectural forms such as balconies and awnings -- non-specific and familiar items that are found on city streets. His *Liminal No. 2* **(143)** is a glass door and balcony, made for display in an indoor gallery and utterly non-functional; the dictionary definition of the word 'liminal' states that it pertains to a threshold or the initial stage of a process. In Morton's hands, this odd structure satisfies both definitions.

Before his early death in 1993, Absalon's last major work was his *Six Cellules* (1992), which comprise half a dozen dwellings made to the artist's own scale. Combining the square, circle, cube and cylinder, they draw their inspiration from the spare aesthetic of the monk's cell, distilled through the reductive vocabulary of Le Corbusier. Like others who have worked with the idea of utopia, he proposed to alter personal behaviour by redesigning all aspects of the built environment; he created a total artwork, geometric, abstracted and unified by the colour white. His cells are fabricated from polystyrene, cardboard, wood and fabric and contain all the necessities for living -- a door, a window, a table, a chair, a bed, a bookshelf and a kitchen area **(144)**. He has also made other work similarly concerned with the relationship between architecture and design, and the way in which they affect and control our daily lives. The titles -- *Arrangement, Order, Compartments, Departments and Proposals for Everyday Objects* -- indicate formal, bureaucratic procedures, while their use of flimsy materials and prototype/model status give them an unsettled, fragile quality.

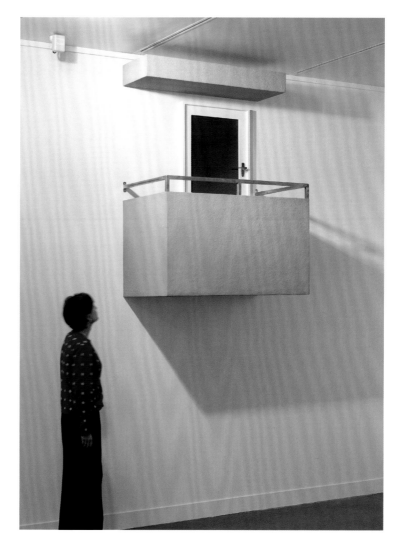

143 Callum Morton, *Liminal No. 2*, 1994. Wood, steel, concrete, glass, synthetic polymer paint. 105 x 65 x 35 cm (41 ¼ x 25 ½ x 13 ¼ in)

144 Absalon, *Cellule No.1*, 1992. Wood, cardboard, white waterproof paint. 255 x 490 x 250 cm (100 ½ x 193 x 98 ½ in)

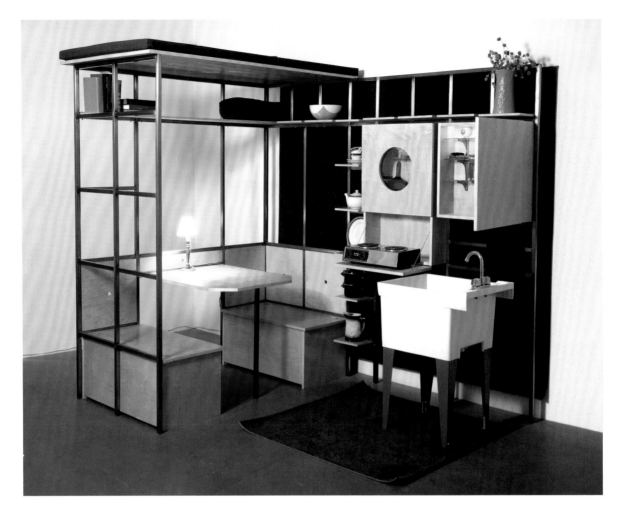

145 Andrea Zittel, *A-Z Management and Maintenance Unit Model 003*, 1992. Steel, wood, carpet, plastic sink, glass, mirror. 218.4 x 238.8 x 172.7 cm (86 x 94 x 68 in)

146 Krzysztof Wodizcko, *Homeless Vehicle 3*, 1988. Aluminium, Lexan, plywood, plastic, fabric, steel, rubber. 182.9 x 233.7 x 101.6 cm (72 x 92 x 40 in) (when extended). Fifth Avenue, New York.

147 Won Ju Lim, *Elysian Field North*, 2000. Plexiglas, foam core, still image projection. 182.9 x 518.2 x 365.8 cm [72 x 204 x 144 in]. Vancouver Art Gallery, British Columbia

Andrea Zittel has designed both clothing and small living units. She founded her A-Z Administration Services in 1994 and this produces an annual edition of a 'Living Unit', as well as 'Comfort Units' and 'Breeding Units' for rearing chickens. A-Z Administrative Services describes itself 'as a descendant of early twentieth-century modernist ambitions to redesign the facets of our environment ... the designer is empowered by the moral obligation to society. By assuming the role of destiny we have embarked on an eternal search for the ultimate system to cure our ailments.' Her *A-Z Comfort Unit* **(145)** can be customized on demand. The unit illustrated has a bed at its top, with a kitchen/ diner area below, and it provides the inhabitant with 'comfort, protection, shelter, isolation, intimacy, fantasy'.

Won Ju Lim's sculptures look at the projection of fantasy and desire into architectural spaces. The formats of her large-scale sculptural installations are copied from model floor plans of houses that can be ordered from Home Depot catalogues. With names like 'Fairy-Tale Feel' and 'Showy One-Story', these prefabricated dream homes promise to fulfil the class aspirations of the potential owners, yet in fact they all look virtually the same. Lim fabricates her three-dimensional structures out of white foam core or translucent, jewel-coloured Plexiglas, which adds to their fantastical nature. For a recent exhibition in Vancouver, she came up with *Elysian Field North* **(147)**, a utopian cityscape, transposing the idealistic space of the paradisical Elysium onto a contemporary city, such as Vancouver.

148-9 Marjetica Potrč, *Hybrid House: Caracas, West Bank, West Palm Beach*, 2003. Building materials, electricity, communication infrastructure. Dimensions variable. As installed at Palm Beach Institute of Contemporary Art, Florida

A handful of Eastern European artists borrow from the architectural vocabulary to deal with the emotion of space, both social and personal. For a number of Polish artists, who lived in a country only recently relieved of Soviet domination and martial law, this is not surprising. The eldest is Krzysztof Wodizcko, who now lives and works in New York. In the 1970s he began his series of 'Homeless Vehicles', portable cylindrical structures on wheels that could be moved by a single person, its occupant, which he first tried out on the streets of Paris. His *Homeless Vehicle 3* (146) is a cross between a missile and a large iron lung, with a hint of a street vendor's hot-dog wagon thrown in. These works have a social content, since Wodizcko saw them as the prototype for a kind of street living, offering the basic necessities of survival. The occupant of the metal capsule could live by collecting and recycling urban waste.

Wodizcko's Slovenian counterpart, Marjetica Potrč, takes her sculptural investigations into the notion of shelter in the city a stage further. She showed *Hybrid House: Caracas, West Bank, West Palm Beach* at various international museums during 2004 (148-9), and this complex structure was inspired by the gated communities, trailer parks and shanty towns found at the sites listed in the title. Potrč finds 'primitive beauty' in the way both high and low cultures construct 'unplanned' urban shelters, and her composite and brightly coloured construction, made from recycled materials, celebrated this. With help from others, Potrč actually built a smaller but similar house at a shanty town in Caracas.

In the mid-1990s, Katarzyna Jozefowicz made *Habitat*, a stacked agglomeration of 1,000 differently sized modules made from cardboard and paper that resembled tiny shelves and cupboards (150). Several contained drawers and compartments, private spaces for personal secrets. Previously she had made a dense and detailed work from the same materials, *Cities* (1989-92), a miniature shantytown, with units squashed into whatever space was available, a comment on the heartless urban planning so evident in rapidly growing cities in the third world.

150 Katarzyna Jozefowicz, *Habitat* (detail), 1993-6. Approx. 1000 items, paper, cardboard. Approx. 220 x 220 x 290 cm [86 ½ x 86 ½ x 114 ¼ in]

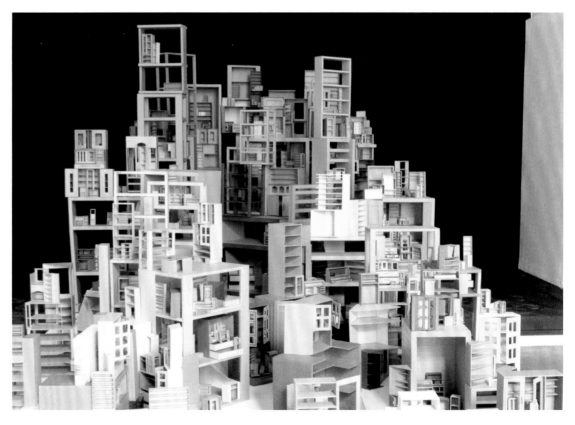

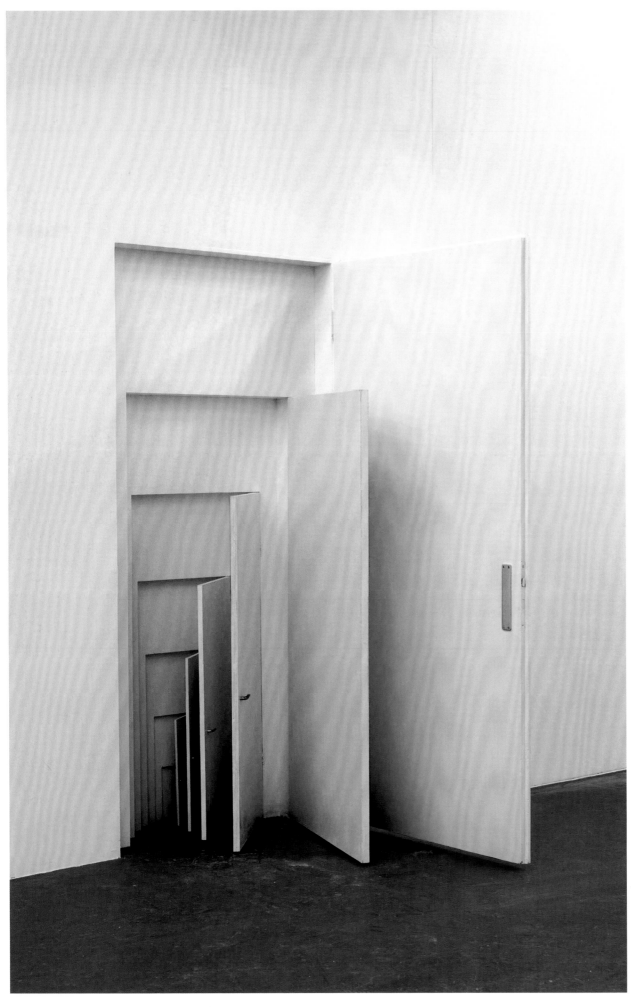

151 Monica Sosnowska, *Entrance*, 2003. MDF, white wall paint, handles. 200 x 100 cm (78 ¾ x 39 ½ in)

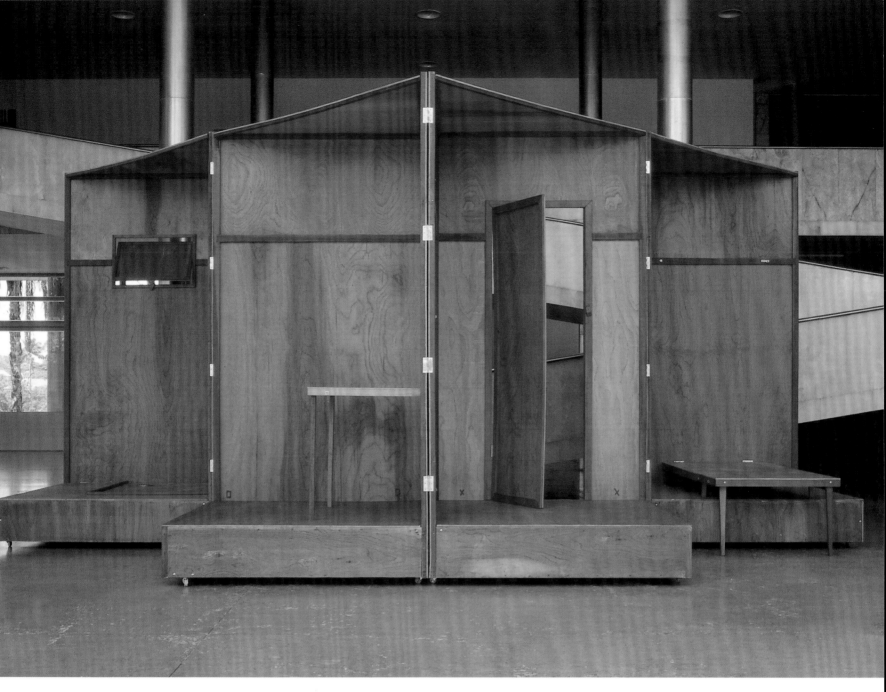

152 Marepe, *Embutido Reconcavo*, 2003. Wood, hinges. 300 x 600 x 300 cm (118 x 236 x 118 in) (open as above)

A generation younger than Potrč and Jozefowicz, Monika Sosnowska creates disorientating, claustrophobic structures **(151)** through which the viewer can walk or squeeze themselves. They recall the anonymous utilitarian public architecture built in Eastern Europe during the Soviet era. Sosnowska has acknowledged the influence of an earlier twentieth-century Polish sculptor, Katarzyna Kobro (1898-1951), who was born in exile in Moscow and only moved to Poland in 1924, where she made innovative, small, spatial compositions in painted steel, and taught the 'Aesthetics of Interiors' in the Economic College in Lodz.

Marepe -- real name Marcos Reis Peixoto -- continues in the same vein as his compatriot Oiticica in the 1960s, taking his subject matter and his materials from the urban life of northern Brazil, an area of material poverty, and making temporary shelters like those found in shantytowns. *Embutido Reconcavo* **(152)**, for example, is a large-hinged, wooden structure that can be open or closed, and comprises a small room for living, with a collapsible bed and table.

CULTURAL
DIVER-
SITY

The history of avant-garde twentieth-century art records how Henri Matisse, Pablo Picasso, André Derain and Maurice de Vlaminck discovered African and Oceanic masks and figures in the Musée d'Ethnographie du Trocadéro and the Musée Colonial in Paris in 1906-7. This helped to move their art away from the representational to the conceptual, and set in motion many of the significant changes that have occurred in avant-garde art since. These Parisian artists were deeply impressed by the formal inventiveness of the work of anonymous African and Oceanic sculptors, but cared little about its provenance or function. Museums of Ethnography were set up in the eighteenth century as the result of colonial conquests, for the collection of 'primitive' and 'savage' artefacts. Explorers and colonists brought masses of material back, not for aesthetic reasons, but to reveal evidence of how 'primitives' and 'savages' lived. Display cases in ethnographic museums were crowded with objects massed together according to ethnic or tribal origins, and offered as evidence of the vast cultural differences between the colonizers and the colonized. Today, many sculptors are looking again at such sculptures, not primarily for the formal qualities that so affected Picasso and his contemporaries, but to examine the relationship between the colonizers and the colonized.

During the last few decades, many sculptors have adopted processes, materials and methods that are more likely to be found in the disciplines of anthropology and ethnography. These disciplines function through an active material engagement with the world, studying its societies, tribes, races, institutions, social relationships, beliefs and artefacts. The artist working as a surrogate anthropologist or ethnographer has been a noticeable and growing phenomenon from the early 1990s. The culture they choose to study is not the 'primitive' or 'savage', but the powerful bourgeois-capitalist institutions of art, such as the museum and the gallery, in some senses the descendants of colonialism, and the way in which museums and galleries acquire, present and classify the objects in their care. Attention has also turned in recent decades to the ecological problems of the indigenous cultures of North and South America, and the insidious influence of corporate global power. The work produced has more the flavour of an installation, usually complex in content, sprawling in composition and often imitating museum displays. It is generally made from the appropriation of found objects, which are sometimes museum objects, combined with popular artefacts and handicrafts. Rarely do artists present a single object created in the solitude of a studio. In fact, they work in the way that Duchamp invented, choosing and selecting items for display that already exist and that they have not personally made. Some of the artists in this chapter, particularly the Americans Mark Dion, Fred Wilson, Renée Green and Indonesian Heri Dono, use their work to focus attention on the cataloguing and presentation of anthropological and ethnographical material in museums in America and Europe. In their different ways, they have examined the premises that led to the foundation of ethnographic museums. These had their origins in the European Renaissance practice of creating *Wunderkammern* or 'Cabinets of Curiosities', when kings, princes and rulers collected and displayed objects both 'natural' and 'artificial' -- coins, architectural fragments and other souvenirs from expeditions to remote parts of the world -- to educate and astound viewers. These items began to be grouped and categorized according to taxonomic schemes, the most prominent of which was that devised by Carolus Linnaeus, an eighteenth-century Swedish botanist, the first person to classify all living things in a hierarchical structure; his scheme is still used worldwide for plants. 'Natural' and 'artificial' taxonomic schemes purport to be objective, but they are a product of their times, and reveal how curiously men have ordered and disordered the world since the eighteenth century.

153 Jake and Dinos Chapman, *The Chapman Family Collection* (detail), 2002. 1 of 33 hand-carved wooden items, mixed media, paint. 68.5 x 14 x 13 cm (27 x 5 ½ x 5 ¼ in). The Saatchi Collection, London

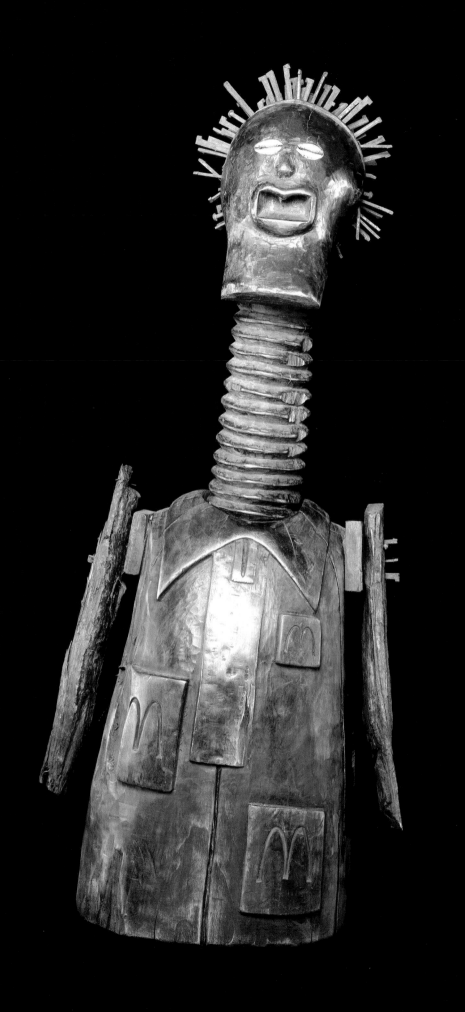

154-5 Mark Dion, *The Department of Marine Animal Identification of the City of New York (Chinatown Division)* [left: in progress; right: final stage], 1992. Mixed media. Dimensions variable. As installed at American Fine Arts, New York

From the 1980s, Mark Dion has made artworks that explore scientific, social and cultural taxonomies and the way in which these classifications shape knowledge, and therefore power. He has done this through two methods: either he uses an ethnographical museum collection as his material, rearranging it to fashion a new taxonomy or Cabinet of Curiosities for our times **[154-5]**, or he conducts an archaeological dig in an urban area. One of the most recent in the latter category was in the garden of the Museum of Modern Art, New York, in 2000, where he found historical artefacts from the foundations of the demolished brownstone townhouses of John D. Rockefeller, Senior and Junior. Dion does not work in a studio or make objects with his hands, but sets up a laboratory and employs volunteer assistants wherever he is invited to explore a collection or a site.

Fred Wilson is one of a number of African-American artists, mostly based in New York, who have used their work to address stereotypical images of their race and culture. On the evidence of his work over the past fifteen years, it could be said that he has assumed the role of an ethnographic ambassador for neglected or repressed African-American communities. In 1991 he made *Guarded View* **[156]**, dressing and painting four dark-skinned, headless mannequins in the uniforms worn by security guards at four major New York museums, including the Whitney Museum and the Museum of Modern Art. Wilson had himself worked as a guard at the Museum of Natural History, New York, and learned first-hand how guards in museums, usually people of colour, become invisible when on duty. Colonialism is still around in the art world, where top jobs are usually taken by white-skinned races. In a nice ironic twist, the work was bought by the Whitney Museum for its permanent collection. Wilson was then invited to make a show for the Museum of Contemporary Art, Baltimore, in 1992, using the collection of the Maryland Historical Society. In this exhibition, entitled 'Mining the Museum', he juxtaposed items used by white people with those used by or for people of colour. The most memorable of his juxtapositions was four wooden parlour chairs set facing a wooden whipping-post.

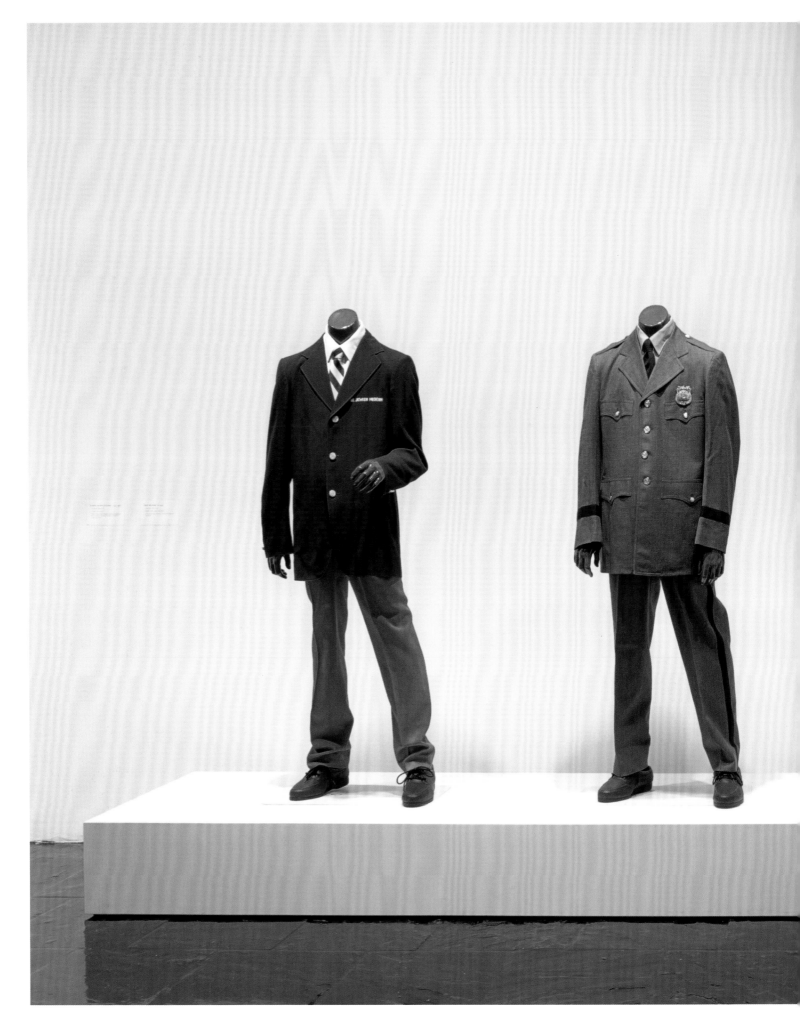

156 Fred Wilson, *Guarded View*, 1991. Wood, paint, steel, fabric. Dimensions variable. Whitney Museum of American Art, New York

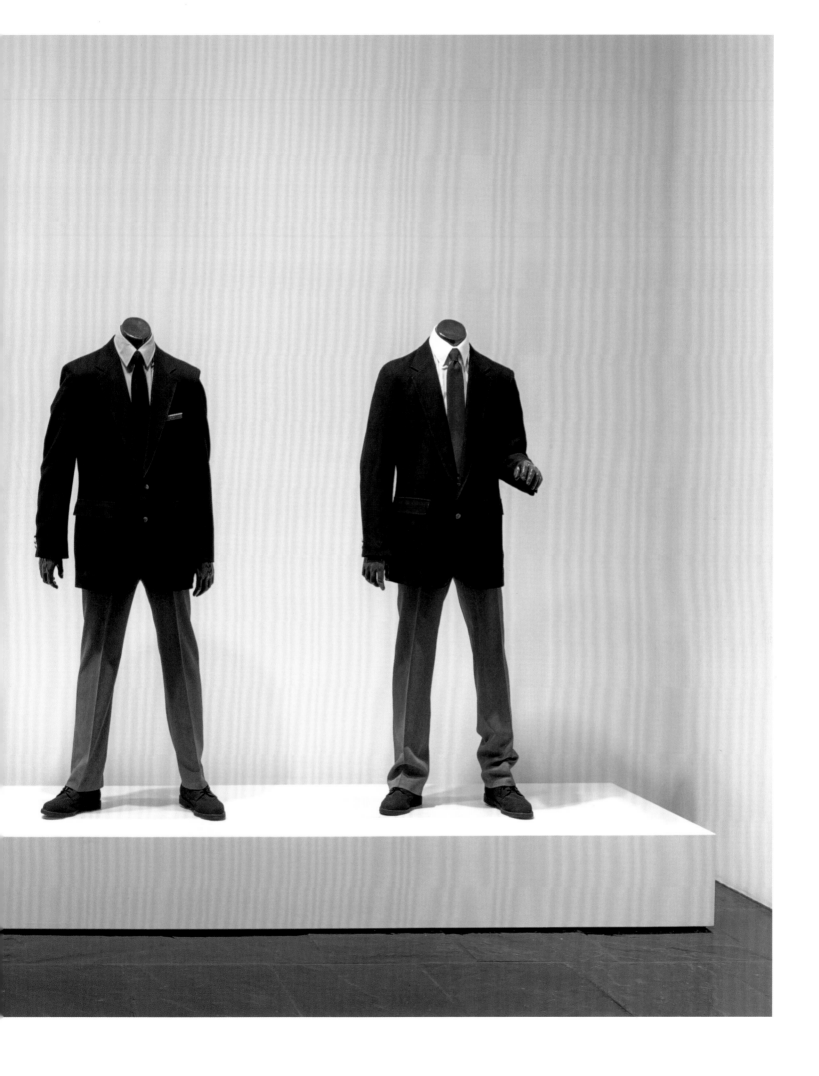

157 Renée Green, *Sa Main Charmante*, 1989. Stage light, paper, paint and ink on wood. 177.8 x 223.5 x 161.3 cm (70 x 88 x 63 ½ in).
Allen Memorial Art Museum, Oberlin College, Ohio

Renée Green makes mixed-media, museum-like installations, rich with texts and photos, and sometimes uses period furniture and historical objects to drive her message home. She tackles the historical and social aspects of ethnic and gender identities, concentrating mainly on representations of the black female body. In *Permitted* (1987), she contrasted the lives of two 'performers', the black American jazz singer and dancer Josephine Baker and the Hottentot Venus, using texts and photographs. She returned to the topic of the Hottentot Venus again with *Sa Main Charmante* (157). Hottentots are a race of black people from South Africa, now virtually extinct, and the so-called Venus was a woman called Saartjie Baartman from Cape Town, who was brought to London in 1810 and displayed as a sideshow to demonstrate what were perceived as her enormous buttocks and pronounced genitals. On her death aged twenty-five she was subjected to an infamous dissection in Paris, after which the French anatomist described her bodily features as having 'animality', but allowed that she had 'a charming hand'. *Sa Main Charmante* consists of a wooden structure stamped with texts describing Baartman's ordeals, a soapbox with footprints, a peep show box and theatre lights. The work serves as a poignant memorial.

Heri Dono studied painting and traditional shadow puppetry, and he creates his own versions of the flat puppet figures from Javanese folk art to make subversive comments about the current political state of Indonesia. Like Dion, he uses his work to reveal how knowledge equals power. 'A part of my work is about history, colonialism. People talk about post-colonialism, but colonialism is not gone -- another kind of colonial system is still controlling our activities. The United Colours of Benetton wants to make people think there is no more discrimination, but this is not reality.' Dono's work since 1982 comprises paintings and multi-media installations made from everyday materials, with parts moved by simple electric motors [158]. In the third world, electrical appliances are not thrown away, as in the West, but sent to local repair shops. Dono makes reference to the social implications of this kind of low-tech labour in his works, contrasting it with the high-powered information technology available in the developed world.

An engagement with the cultures of the countries of South America -- Venezuela, Brazil, Argentina, Uruguay, Puerto Rico and Colombia -- is usually the preserve of indigenous artists, but one European, Lothar Baumgarten, is notable for his involvement in this area. He followed in the footsteps of social anthropologist Claude Levi-Strauss (born 1908), who has had a major influence on contemporary anthropological and cultural studies. Levi-Strauss spent thirty years studying the behaviour of North and South American Indian tribes before he arrived at his conclusions, presented in such books as *Structural Anthropology* (1958) and *The Savage Mind* (1962). He insisted that Western civilization should not be honoured above others, and that the 'savage' mind is equal to the 'civilized' mind. Artists have embraced his ideas, and his influence can be felt in several of the works discussed in this chapter.

158 Heri Dono, *Glass Vehicles* (detail), 1995. 3 of 15 items. Glass, fibreglass, cloth, lamps, sable, iron, toy carriages. Each 125 x 40 x 40 cm (49 ¼ x 15 ¾ x 15 ¾ in). Queensland Art Gallery, Brisbane

159 Lothar Baumgarten, *Terra Incognita*, 1969-84. Wood, porcelain plates, light bulbs, electrical cable, machete. 74 x 885 x 1236 cm (29 ¼ x 348 ½ x 486 ¼ in). Tate, London

160 Laura Anderson Barbata, *Thought, word, deed (and-O-mission)*, 1999. Bibles and New Testaments in different languages, wood, rose branches, gold leaf. 137 x 82 x 33 cm (54 x 32 ⅜ x 13 in)

Between 1978 and 1980, Baumgarten spent eighteen months living in a Yanomamo village in the Upper Orinoco region of southern Venezuela, an experience that has infused his work. The Yanomamo are the indigenous people living in an area that spans parts of the Amazonian rainforest. They are virtually a stone-age tribe, and their isolation, both mental and physical, has proved a magnet for anthropologists and artists alike. Gold was discovered in their territory in the mid-1980s, and since then over ten percent of their population has been killed by massacres and diseases brought by invaders. In a number of works made in the 1980s and 1990s, Baumgarten inscribed the names of indigenous societies of North and South America, often imposed by explorers and ethnographers, in such settings as the dome of the Museum Fridericianum, Kassel, 1982, and the spiral of the Guggenheim Museum, New York, in 1993. *His Terra Incognita* **[159]** (the title is a term given by European explorers five centuries ago to the vast spaces of the Amazon basin) consists of pieces of Presil wood (from which Brazil took its name), a machete, blue and yellow light bulbs, electric cables and white china plates with added decoration. The cables stand for the dense network of rivers in the Amazon basin, several of which are poisoned by mercury used in gold prospecting; the blue lamps represent the magical and natural phosphorescence glowing in the night on the forest floor, while the yellow stand for the diseases brought by European settlers and gold hunters.

Two further Yanomamo enthusiasts are Laura Anderson Barbata, who studied sociology as well as sculpture, and Meg Cranston, who read anthropology. Barbata draws inspiration for her work from the materials and social conditions of the indigenous cultures of the Yanomamo Ye'kuanan and Quechua villages along the Venezuelan Amazon, the same region visited a decade earlier by Baumgarten. She spent seven years recording and preserving the languages of this area, and she taught the Yanomamo natives to manufacture paper from a local fibrous plant and to use this paper to draw and write their history and traditions. Barbata was moved by the lasting effects -- pollution, new diseases, deforestation and indignity -- caused by explorers and missionaries in attempting to convert the native population to Christianity. Her *Thought, word, deed (and-O-mission)* **(160)** consists of three columns of Bibles and New Testaments used for converting the Yanomamo, topped by forms made of wood and gold sheet found in native villages.

Meg Cranston created a show at the Rosamund Felsen Gallery, Santa Monica, in 2002, called 'Magical Death', which consisted of five life-sized, papier-mâché effigies of herself, hanging on ropes from the gallery's ceiling **(161)**. The title of the exhibition was borrowed from an award-winning film made in 1973, which recorded shamanic activity and death and rejuvenation rituals in Yanomamo culture. Cranston's effigies, which were made to her specifications in Guadalajara, Mexico, were related to Mexican papier-mâché piñata figures; these are filled with trinkets and sweets and hung on strings at festivals and celebrations, then destroyed by blindfolded players wielding sticks. The fragility and vulnerability of Cranston's figures, buffeted and damaged by gallery visitors, married the Mexican festive figures with shamanic rituals.

161 Meg Cranston, *Magical Death (with striped trousers)*, 2002. Papier mâché, coloured tissue, pastel. 183 cm (72 in) high

162 Luis Benedit, *Perón, Perón*, 1996. Drawing, pencil on paper, copy of an etching (1950) of Perón's face, wooden base and board, plaster of Paris, acrylic, epoxy, projected light and image. 250 x 500 x 250 cm (98 ½ x 197 x 98 ½ in)

Besides commenting on ecological and other problems, some artists have taken the subjugation and rape of the native population as their theme. In countries like Argentina, Uruguay and Colombia, thousands of people have been subjected to torture, gone missing, or had their lives ruined by ruthless dictators and military repression. The subject of torture is perhaps the main theme that unifies the experience of the majority of countries in the Latin American continent over the last four decades. Luis Benedit, Luis Camnitzer, Cildo Meireles, Pepon Osorio and Doris Salcedo have made significant works that address these outrages.

Benedit lives and works in Buenos Aires, and one of his major works, *Perón, Perón* **(162)**, alludes to Argentina's controversial three-time president, Juan Domingo Perón, whose tomb was defiled in 1987 when the dead leader's hands were cut off. Benedit's sculpture combines a drawing -- of Perón's favourite pinto horse and a city apartment block -- with a cast of a hand and a rough approximation of a wooden horse.

Camnitzer was born in Germany, raised in Uruguay and has lived in New York since the mid-1960s, which gives him his own particular stance on transcultural life. He makes works that allude to acts of imprisonment, torture and murder that have occurred in periods of military repression imposed by Latin American dictators. His installations have a sparse and fragmentary feel, but their elegance belies their content; *The Hall of Mirrors* **(163)** refers, with its slop bucket, to life in a prison cell, while the tied-up newspapers speak of information that is inaccessible or denied.

163 Luis Camnitzer, *The Hall of Mirrors*, 1997. Stretched rubber tubes, metal bucket, newspapers, 4 engraved glass panels, 4 brooms, 4 playing cards. Dimensions variable

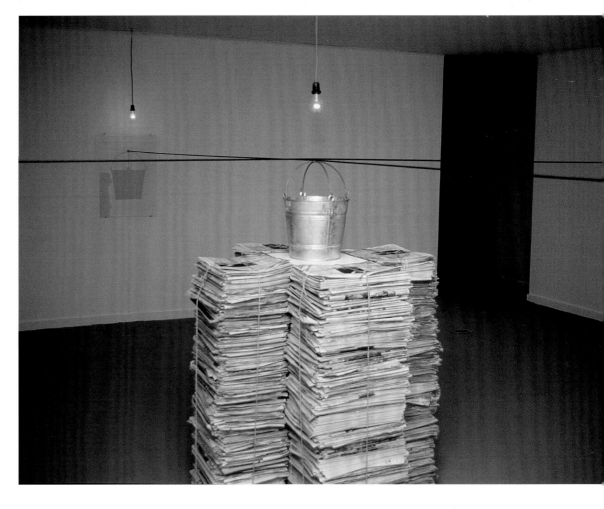

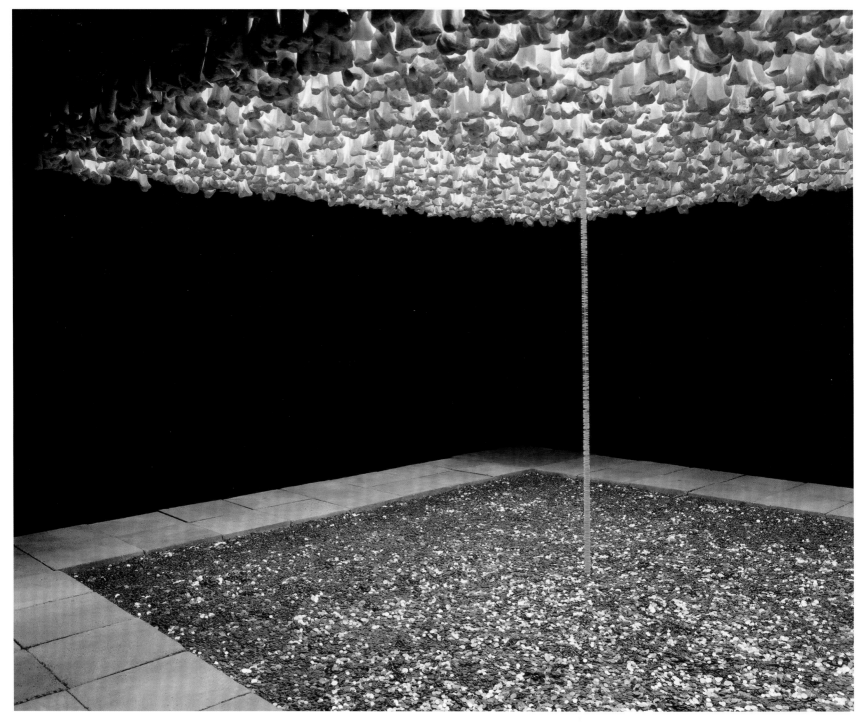

164 Cildo Meireles, *Missao/Missoes (How to Build a Cathedral)*, 1987. 600,000 coins, 2000 bones, 800 communion wafers, light, 80 paving stones, black fabric. Approx. 300 x 600 x 600 cm (118 x 236 ¼ x 236 ¼ in). Collection Daros-Latinamerica, Zurich

One of Meireles's most spectacular installations is his *Missao/Missoes (How to Build a Cathedral)* **[164]**, where the floor, covered with 600,000 coins, and the ceiling, built from 2,000 bones, are joined together by a delicate column of 800 communion wafers. The title gives a clue to the content, which touches on the Jesuit missions in Brazil in the seventeenth and eighteenth centuries, when attempts were made to convert the indigenous peoples away from cannibalism to embrace Christianity, but since the central act of the Christian Eucharist is the eating of Christ's flesh, symbolized by the communion wafer, the path was from one form of cannibalism to another.

165 Pepon Osorio, *The Bed*, 1987. Mixed media. 190.5 x 170.2 x 198.1 cm (75 x 67 x 78 in). El Museo del Barrio, New York

The Puerto-Rican-born artist Osorio makes sculptures that refer to the violence and upheaval suffered by his people over 500 years of colonial rule. He has left his native country and now lives and works in Philadelphia, after spending time as a social worker in the Bronx. He makes colourful objects and installations [165] out of kitsch and sentimental knickknacks, which he says refer back to 'the over-accumulation and transformation of mass-produced objects' found in Latino households, an outlook that Osorio sees as a way of dealing with imposed domination by another culture.

Doris Salcedo, a Colombian artist, has witnessed friends and neighbours being arrested and in some cases killed, and she has interviewed relatives of the dead and 'disappeared'. She therefore has much personal evidence of the suffering caused by Colombia's civil war. For her sculptures, she uses second-hand wooden or metal furniture, to which she adds clothing or organic material such as hair and bone. She cuts, fragments and recombines this furniture, and then drills tiny holes into the wooden surfaces, into which she and her assistants sew filaments of hair and thread **(166)**. Salcedo has said that she wanted to find a way of working that would seem like a huge expenditure of energy and effort, almost like a waste of time, in order to evoke the extreme conditions and waste of life that occur in violent and deprived parts of the world. Another series of sculptures of furniture encased in concrete acts as a protest against the mass disappearance of ordinary people in Colombia.

166 Doris Salcedo, *Unland audible in the mouth*, 1998. Three tables; front one: wood, thread, hair. 80 x 75 x 315 cm [31 ½ x 29 ½ x 124 in]. Tate, London

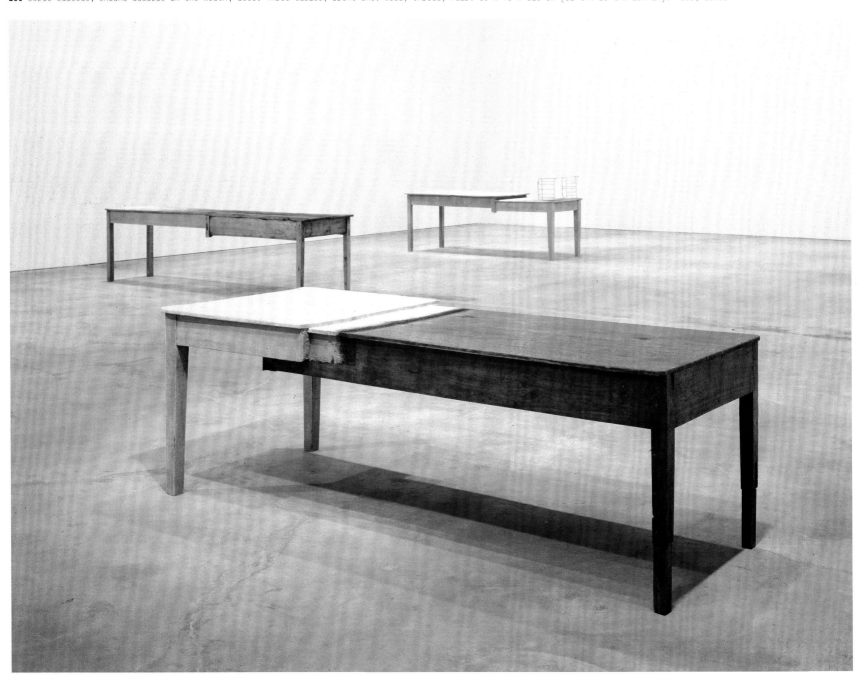

167 David Hammons, *Untitled*, 1992. Copper, wire, hair, stone, fabric, thread. 152.4 cm (60 in) high. Whitney Museum of American Art, New York

Hair is an emotive material and is also used in the sculptures of David Hammons, an African-American artist who lives and works in Harlem. Hammons creates his work from the debris of African-American life, often using puns and metaphors to help viewers to reflect on cultural stereotypes and racial issues. His career began in the early 1970s, and his materials have included grease, hair, cheap wine bottles, dirt and barbecued spare ribs. *Untitled* **(167)**, made from African-American hair wound round wire, looks like out-of-control Rastafarian dreadlocks, or a large predatory spider. Hammons likes to use materials that are free, that are thrown away, and for this work he collected hair from his local barbers' shops. Even though the material might seem worthless, he has explained how hair has magical properties in many cultures and stories.

168 Jimmie Durham, *La Malinche*, 1988-91. Mixed media. 168 cm (66 in) high. Stedelijk Museum voor Actuele Kunst, Ghent, Belgium

Jimmie Durham was a political organizer in the American Indian Movement between 1973 and 1980, and Director of the International Indian Treaty Council and representative at the United Nations. His spurious ethnographic displays deliver an ironic assault on the colonizing procedures of Western culture. In the 1980s in New York, he made animal-skull works and fake Indian artefacts from car parts. His sculptures flaunt the rawness of their materials, and they often have an air of incompleteness **(168)**.

Two contemporary artists consider the tribal masks that influenced Picasso and his contemporaries in the context of the communities who made them, and how they have been exploited and devalued, especially since they played a major role in sacred communal rituals. They respond by making their own versions of tribal masks from common everyday objects. New York artist Willie Cole recycles materials found in his New York neighbourhood into all kinds of sculptures, some of which are wry copies of African artefacts, while others address current topical issues, such as terrorism. Cole has made a series of elegant animal-head sculptures from recycled bicycle parts, and their titles, such as *Speedster tji wara* **[169]**, draw attention both to the bicycle brand from which they were assembled and the type of antelope headdresses made by the Bambara tribe of Mali for agricultural and fertility rites. Bambara sculptors are known for their delicate and minimal ironwork, and Cole shows with works like this that he is their equal.

Brian Jungen belongs to the Dunne-za First Nation of northern British Columbia, an aboriginal race who produces ritual masks among other artefacts. He has made a series of simulations of First Nation masks, which he calls 'Prototypes for a New Understanding' **[170]**, by dismembering and rearranging Nike Air Jordan trainers; his copies look closer to souvenir versions on sale at tourist venues than the original masks. These expensive trainers were the choice of the American basketball star Michael Jordan, and their status is therefore an elite one, yet they are made in sweatshops in the third world.

169 Willie Cole, *Speedster tji wara*, 2002. Bicycle parts. 118.1 x 56.5 x 38.1 cm [46 ½ x 22 ¼ x 15 in]. Albright-Knox Art Gallery, Buffalo, New York

170 Brian Jungen, *Prototypes for a New Understanding*, 1998. Disassembled Nike Air Jordan sneakers, hair. Dimensions variable

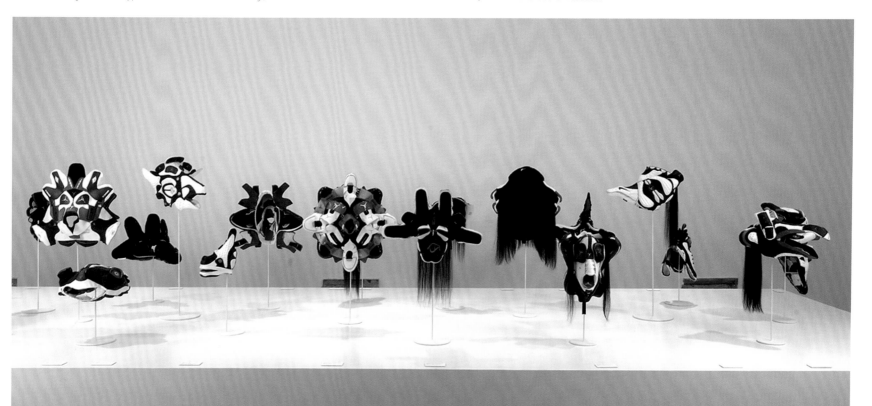

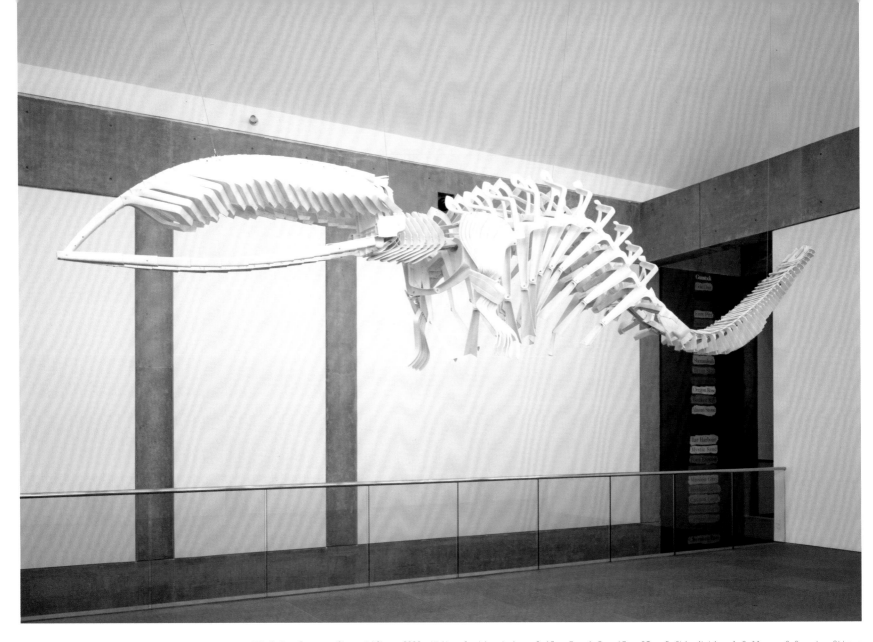

171 Brian Jungen, *Shapeshifter*, 2000. White plastic chairs. 2.13 x 7 x 1.5 m (7 x 23 x 5 ft). National Gallery of Canada, Ottowa

Jungen's most spectacular transformation of given material is his *Shapeshifter* (171), an enormous and very realistic skeleton of a whale, which is displayed hanging, copying the conventions of showing skeletons in natural history museums, but is made entirely from cheap, white-plastic garden chairs. It is a neat metaphorical trick to use such common consumer items, of the kind found littering the environment worldwide, to fashion the form of an endangered bowhead whale.

Ann Hamilton represented America at the 1999 Venice Biennale, where she devised an installation that dealt with slavery and oppression in American society. In the American Pavilion, built in a 1920s classical style, she had the false ceilings removed and opened four closed skylights, allowing more air and space into the building. Then she lined the four gallery walls with enlarged Braille dots; a deep pink powder continually dropped from the ceiling and gathered on the Braille characters (173). The texts and a soundtrack of whispered words revealed extracts from the poem 'Testimony' by Charles Reznikoff, who used American legal and historical records of social and racial injustice as his subject. Viewers found it difficult to avoid being stained by the coloured powder while walking through the galleries, so that all present became implicated in some way.

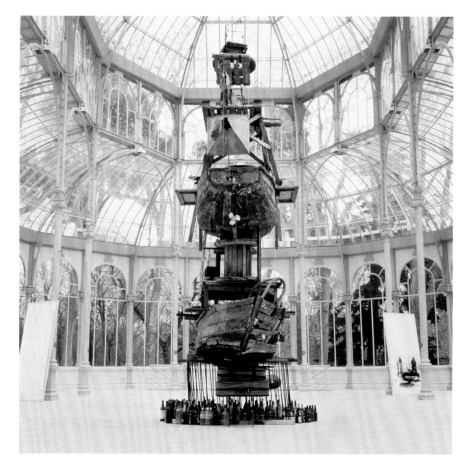

172 Alexis Leyva Machado (Kcho), *In My Mind*, 1995-7. Mixed media. Approx. 800 x 500 x 300 cm (315 x 197 x 118 in). As installed at Palacio De Cristal, Madrid, 2000

173 Ann Hamilton, *Myein*, 1999. Walls covered with Braille dots, red pigment, sound. Dimensions variable. As installed at American Pavilion, Venice Biennale

Alexis Leyva Machado, also known as Kcho, takes as his central theme the subject of the boat and the concept of migration. He was born on Isla de la Juventud, off the south coast of Cuba, and his father was a carpenter. For Cubans, boats represent both a common mode of transportation and the chance to escape the confines of their island nation. They regularly attempt to escape in small, unseaworthy vessels to a new life in America, because after the collapse of the Soviet Union and the loss of its support for the Cuban economy, food and fuel have become very scarce. Kcho often makes his rowing boats from textbooks covering a wide range of topics, from politics, natural sciences, maths and geography. Because of their material, his boats would quickly sink. Several rest on a sea of used bottles (172). Kcho prefers to work with old materials 'because they hold great energy'.

Georges Adéagbo was born in Cotonou, Benin, Africa, where he still lives and works, although he studied law and business administration in Paris in the late 1960s. Back in Cotonou, he began to assemble found objects and self-composed texts, which he put on display, and these were noticed by a travelling curator, leading to Adéagbo's first show in 1994 and the label of 'artist'. He was then invited to make a large installation for the Documenta exhibition in Kassel in 2002, which he entitled *The explorer and the explorers confronting the history of exploration! The world theatre* (174). It comprises more than 1500 objects assembled by the artist in both Benin and Germany, including traditional African art, four wooden carved totem poles, a fishing boat, two Persian rugs, books, magazines, flags, a variety of devotional aids and portraits of leading art-world figures such as Joseph Beuys, James Lee Byars and Harald Szeemann. Its central theme was to examine what effort was made by explorers to understand and integrate the material they brought back home. Adéagbo's temporary wayside booths of flotsam and jetsam are strangely reminiscent of those erected from similar material by German artist Thomas Hirschhorn, although they come from an entirely different direction.

Corporate global companies and the power of their products is the focus of many artists. In 2002, Jake and Dinos Chapman unveiled at White Cube Gallery, London, an exhibition of thirty-four carved and painted wooden sculptures. At first sight, this work, *The Chapman Family Collection*, appeared to be a range of ethnographic wooden sculptures from Africa, collected in Victorian times by a Great White Hunter, and brought back to be displayed as trophies in an ethnographic museum. On prolonged looking, certain motifs carved into the figures began to stand out, particularly an incised form shaped like a large M (153). The wooden sculptures in fact pay ironic homage to a conquering colonialist, that of McDonald's, the hamburger chain.

At the other end of the world, Fiona Hall has also used the brand imagery of a global icon, Coca-Cola, for a small but strong piece, her *Medicine Bundle for the non-born child* (175), a baby's layette that she knitted from strips of recycled Coca-Cola cans. In this and other works, Hall examines the part that has been played by plants in the history of colonization and the development of global economics; Coca-Cola was originally made from coca leaves from South America and cola nuts from Africa, and the ubiquitous drink is used today as a spermicide in some third-world countries.

A piece by the French artist Annette Messager returns to the African sculptures in Parisian ethnographic collections that so inspired Picasso and his colleagues. Messager, who describes herself as an artist and collector, has since the late 1980s accumulated used stuffed toys as her primary material. The generic title for her stuffed-toy pieces is 'Mes Petites Effigies', and these clusters of works are usually pinned to the gallery wall, accompanied by small, framed photographs and texts. She reshapes and modifies her multi-part works, altering them each time they are displayed. When invited to take part in a mixed show called 'Histoires de Musée' at the Musée d'Art Moderne de la Ville de Paris in 1989, she combined her 'Effigies' with small African figural sculptures (176). Messager felt that they had much in common, being fetishist and magical trophies of both innocence and experience.

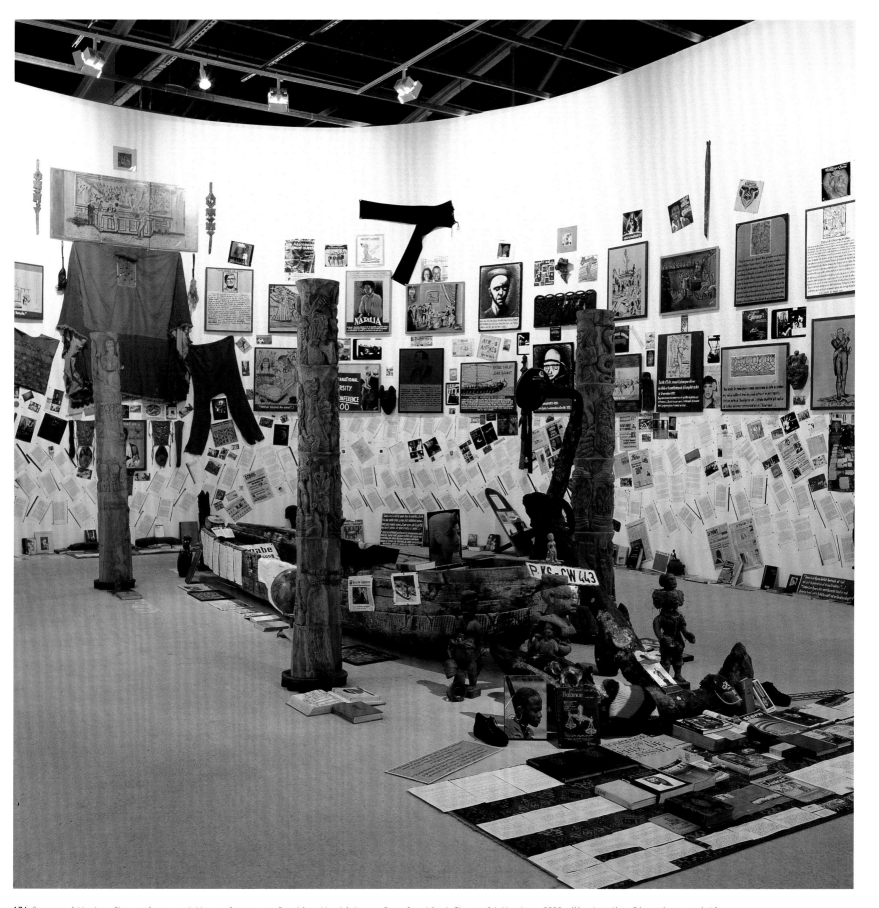

174 Georges Adéagbo, *The explorer and the explorers confronting the history of exploration! The world theatre*, 2002. Mixed media. Dimensions variable.
Museum Ludwig, Cologne

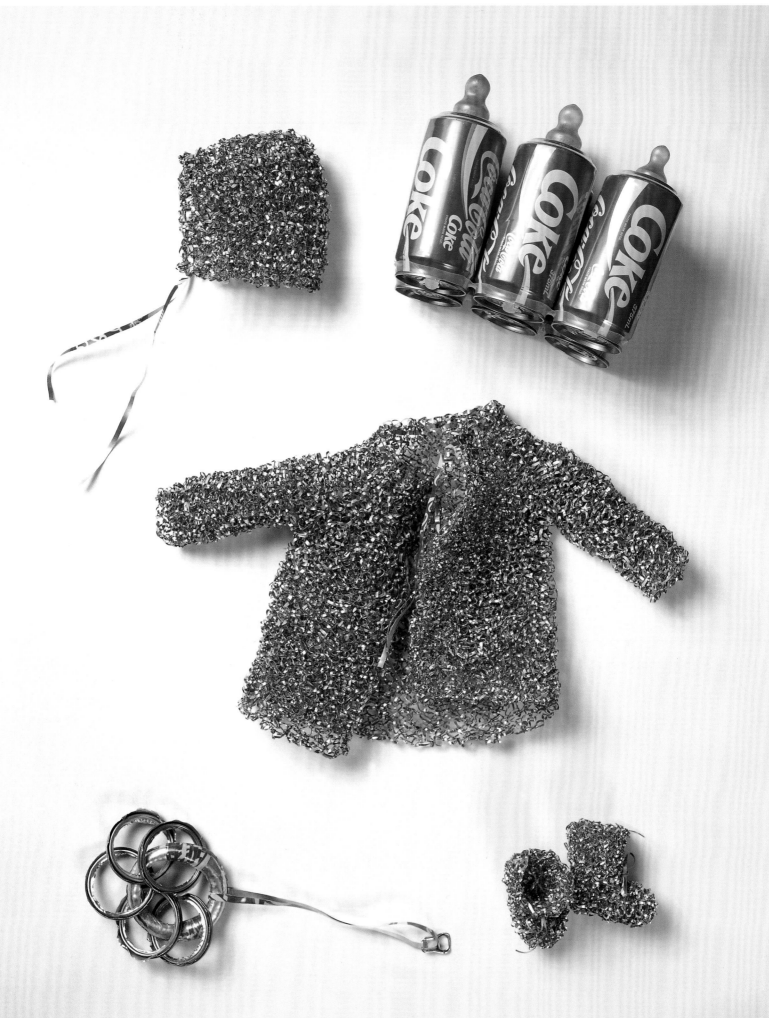

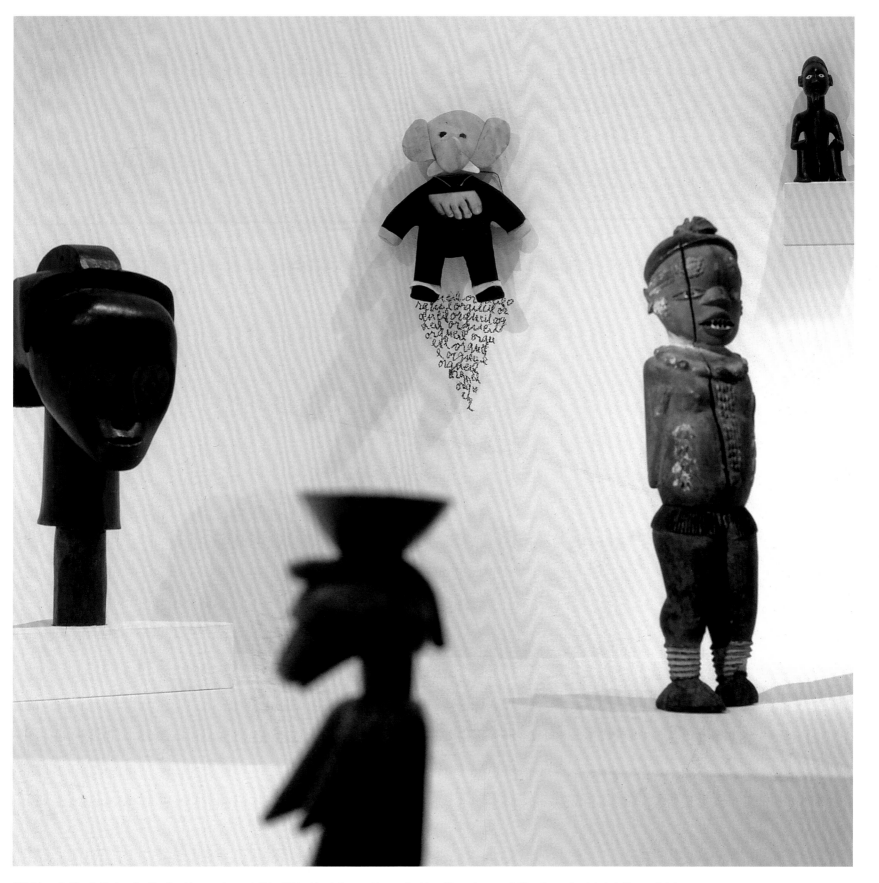

175 Fiona Hall, *Medicine Bundle for the non-born child*, 1994. Aluminium, rubber, plastic. Dimensions variable. Queensland Art Gallery, Brisbane

176 Annette Messager, *Mes Petites Effigies*, *Sculptures africaines*, 1989. As installed at Musée d'Art Moderne de la Ville de Paris, Paris

TRADITIONAL MATERIALS

In 1970, Robert Morris published his essay 'Some Notes on the Phenomenology of Making' in the magazine *Artforum*. It argued that the form of a sculpture arrives through the procedures and processes of its creation, of which the choice of material is the most significant. Thus the properties inherent to a specific material dictate the way in which the work is conceived and executed, and the way it looks. Each material comes with its own processes and techniques, and its own peculiarities of language and vocabulary. When Morris was writing his essay, a formalist way of making and looking at sculpture, seeing only the shapes, their relationships and nothing else, was predominant. Plastics and metals and their associated industrial fabrication techniques were the favoured materials and methods. 'What you see is what you get', a slogan of the 1960s and early 1970s, was about to be replaced in the 1980s by a partial return to traditional materials and techniques, ushered in by a phase of expressionism that employed figurative, symbolic and metaphorical imagery. Poetic and narrative statements could not easily be conveyed via sheets of plywood, Plexiglas or rusted steel, so the substances had to change. The traditional materials of stone, clay, wood, plaster, wax and bronze were revisited to become vehicles for new modes of expression. And the fortunes of these traditional materials have fluctuated quite widely since then, with one or another being favoured in certain geographical centres for specific periods of time. The moulding materials of clay and wax are currently enjoying a popularity not seen for quite a while.

The materials of sculpture have, through the centuries, been subject to a system of hierarchies, based on social, political and aesthetic factors; the two materials that sat at the top for the longest periods are bronze with a dark brown patina and white marble -- the bronze used for heroic male nudes and the marble for sensual female nudes. As early as 1912, the Futurist sculptor Umberto Boccioni, in his 'Technical Manifesto of Futurist Sculpture', wrote: 'Destroy the literary and traditional dignity of marble and bronze statues', but his order was not followed for some decades. The literary critic Roland Barthes (1915-80), whose writings examined the signs and symbols of mass culture, wrote a series of influential essays in the late 1950s, one of which was devoted to the subject of plastic: 'In the hierarchy of the major poetic substances, it figures as a disgraced material ... it embodies none of the genuine produce of the mineral world: foam, fibres, strata. It is a "shaped" substance: whatever its final state, plastic keeps its flocculent appearance, something opaque, creamy and curdled.' With plastic, Barthes felt that the hierarchy of substances had been abolished, to be replaced by a single one that could mimic them all. If that seemed the case in 1957, it is much more pronounced today.

Stone is a solid, recalcitrant material that carries associations of durability, history and monumentality. Besides being commonplace and utilitarian, it has great age, and this lends it a sense of power and mystery that contemporary sculptors have exploited to a variety of ends. It used to be shaped laboriously by hand, but now there are computer-directed carving devices. Throughout the long history of sculpture, stone was used to represent something other than itself; white marble, for example, was chosen to simulate nubile female flesh, and was often painted to enhance the illusion. Today, the stoniness of stone, its colour, geological quality, granular consistency, layering and weight is given top priority. Basalt and granite, both igneous, volcanic rocks of great hardness and intractable resolution, are favoured. Now, stone is not carved into shapes that resemble figures or other objects from daily life; instead, it is left almost untouched from the quarry or given minimal cuts with saws. A rare exception is the work of Louise Bourgeois, who uses luscious pink or white marble in its traditional mode, especially favouring pink because 'its colour suggests flesh'. Her stone carvings depict body parts **[61]**, and the marble, because of its traditional and historical associations, emerges as a material forceful enough to deal with her imagery.

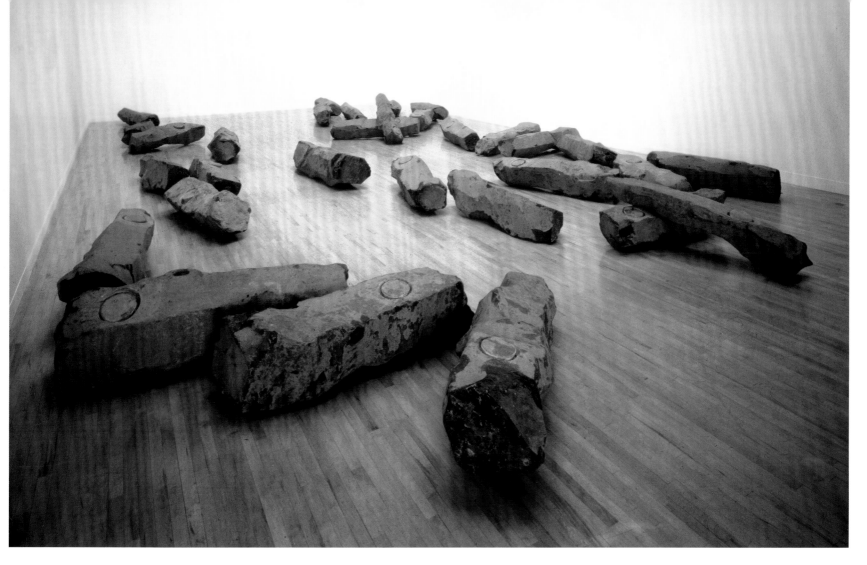

177 Joseph Beuys, *The End of the Twentieth Century*, 1983-5. 31 blocks of basalt, clay, felt. 7 x 12 m (23 ft x 39 ft 4 ¼ in). Tate, London

In the early 1970s, Joseph Beuys visited Scotland and Ireland to see two well-known geological formations -- Fingal's Cave on the Scottish island of Staffa, and the Giant's Causeway on the North Antrim coast of Ireland, both of which have extraordinary outcrops of basalt. The Giant's Causeway is composed of over 40,000 hexagonal basaltic columns, resulting from the cooling of lava from a volcanic eruption around sixty million years ago. The way in which these outcrops were made, formed by dynamic and dramatic activity, appealed to Beuys, who, from the early 1960s promoted energy as a significant creative power and used a wide variety of materials to parade its potency. In 1982, at Kassel's seventh Documenta exhibition, Beuys unveiled his *7,000 Oaks* **(235)**, a massive, multi-part sculpture that comprised 7,000 oak saplings coupled with 7,000 basalt columns, obtained from a quarry in the Eifel mountains near Kassel. The following year, Beuys created the first in his series of works titled 'The End of the Twentieth Century' **(177)**, this one consisting of thirty-one hexagonal basalt columns from the same German quarry. Beuys had no need to carve his stones since the basalt columns came readymade by nature. The columns can be installed on the floor of a gallery in any configuration, and at first sight look like the ruins of some temple after the gods have left. However, they have also been likened to the spent fuel rods from a nuclear reactor (basalt contains traces of radioactive material), or hibernating pupae waiting to emerge into new life. Close inspection reveals that Beuys drilled a small, circular plug in each stone, lifted it out, and then fixed it back in place using clay and felt. These odd intrusions give the stones an anthropomorphic character, alluding to a face or an eye, and could be read as breathing life into something ancient, a suitable metaphor for working again with stone.

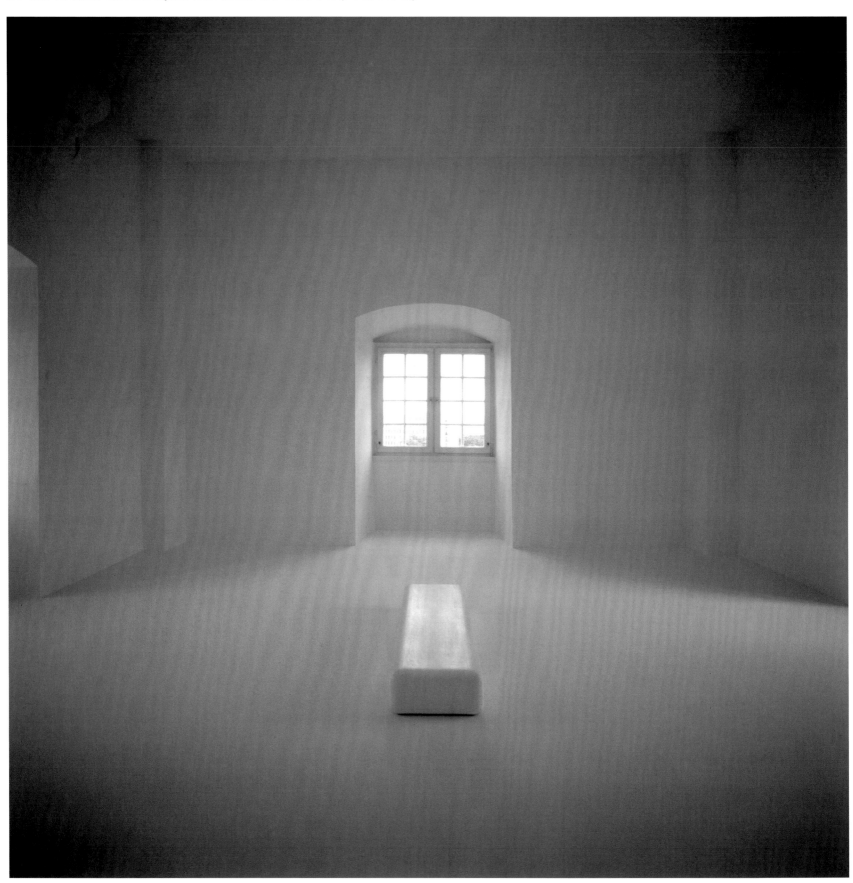

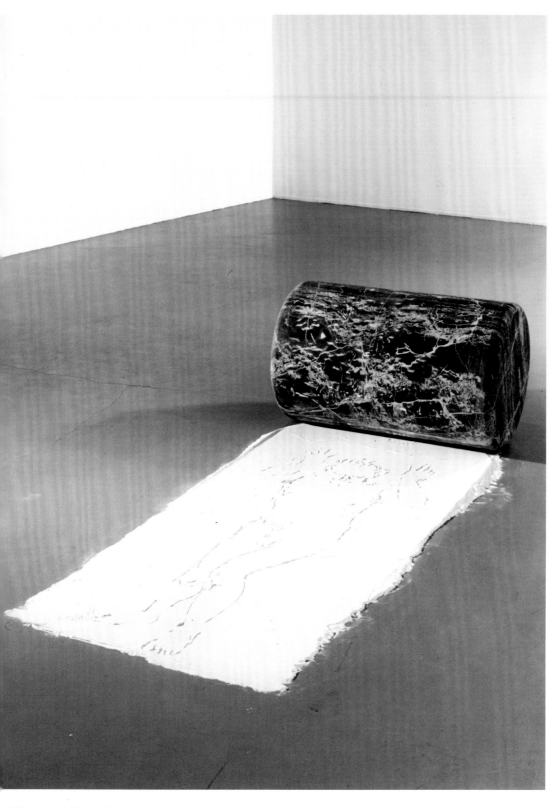

179 Luciano Fabro, *Sisyphus*, 1994. Engraved marble, gold leaf stars, flour. 50 x 100 x 50 cm
(19 ¾ x 39 ½ x 19 ¾ in). Walker Art Center, Minneapolis, Minnesota

James Lee Byars was born in Detroit, lived for periods in Japan, and died in Cairo, in the shadow of the Pyramids. During the early years of his career, he made performances using a variety of props, deeply influenced by Japanese Noh theatre and Shinto religious rituals. His solid, three-dimensional work evolved from these performances, the objects gradually becoming autonomous. From the 1960s, Byars worked in marble, granite and basalt, creating spheres, cubes, pyramids and columns. Although his clear geometric forms can look like the simple primary shapes made contemporaneously by American artists such as Donald Judd and Carl Andre, Byars's content is quite different; he was interested in the transcendent and the numinous rather than the phenomenological, and spent his life in pursuit of the Perfect. He travelled to Egypt and Greece in search of flawless stones and discovered a white marble capable of a high polish at Kavala quarry, on the island of Thassos, Greece, which he used for several carved and burnished marbles such as *The White Figure* [178].

Luciano Fabro also has a relationship with marble; reflecting on the legacy of its use during Italian history, he utilizes it precisely because it is a 'conduit' of tradition. In 1985, he began to produce stone, usually marble, sculptures that contrasted, dressed with unworked surfaces. The rough-hewn surfaces of these works declared the material as ancient, as did the titles, which referred to characters from Greek and Roman myths, such as Demeter, Prometheus, Kronos and Sisyphus. Sisyphus is a particularly apposite figure in any consideration of working with stone, since he was condemned by the gods to roll a large boulder up a mountain to its peak, only to have it roll back down into the valley again. For the work called *Sisyphus*, Fabro incised a self-portrait outline into a cylinder of black marble, which is revealed when the cylinder is rolled over a bed of flour [179], an act that gallery staff have to repeat once a week, when the work is on display, to keep the image crisp. This curatorial labour is a small homage to the labour and muscular effort that used to be

180 Ulrich Rückriem, *Untitled*, 2003. Rosa Porinjo granite. Four parts, each 69.9 x 77 x 499.7 cm (27 ½ x 30 x 196 ¾ in)

involved in stone-carving, a sculptural task that is now often considered unnecessary. The high finish of Fabro's marble greatly contrasts with the way another Italian artist, Giovanni Anselmo, handles stone. He has a preference for slabs of granite, which he leaves rough and undressed, so that they can clearly speak of the material from which they were formed **(380)**.

Minimal intervention when working with stone is the hallmark of Ulrich Rückriem and Richard Long. Rückriem worked as an apprentice stonemason from 1956-9 and then continued his training for another two years at the restoration workshop of Cologne Cathedral. He acknowledges that this period of his life has had the most influence on his work. He made some carved figurative work in the 1960s, but abandoned that approach in 1968 in favour of his current process of splitting stone. He selects his stones in the quarry or a saw mill, and gets them split or cut into sections dependent on the stone's inherent characteristics, which are then placed back together in their original positions, thus adding a temporal as well as a spatial dimension to the work **(180)**. He was impressed by the way in which Serra and Andre defined sculpture as a 'cut in space' during the late 1960s, and states: 'the process is more important than the result'.

181 Richard Long, *Red Slate Circle*, 1988. Slate. 37 x 400 x 400 cm [14 ½ x 157 ½ x 157 ½ in]. Tate, London

Richard Long discovers his stones when on his walks in remote locations around the world. While outdoors, he arranges improvised sculptures from what is at hand, but in order to make a stone line or circle in an indoor venue, he orders quantities of stones from a quarry that he has either noticed on his walks or is near to an exhibition venue. Having ordered them, Long does not alter the stones, except sometimes to have a flat plane cut for the purpose of stability. He has said: 'I like the idea that stones are what the world is made of.' *Red Slate Circle* [181] is made from pieces of slate from the border of Vermont and New York State in America, which have had a flat underside cut, enabling them to sit evenly on the gallery floor within the four-metre diameter of the circle. No piece of slate touches another piece.

In 1979 Stephen Cox began to work stone, particularly Italian marble and travertine, and seven years later he set up a studio in South India to carve the local black granite. Armed with a sense of history and tradition, Cox went in 1988 to the porphyry quarries in the mountains of Egypt's Eastern Desert, abandoned since the fifth century AD, and containing the hardest stone in the world. He obtained a consignment of this special material and carved several works from it, including *Chrysalis* [182]. The stone had been partly shaped by Roman stone cutters, and Cox has retained their marks, combining them with his own. The title gives the piece a sense of metamorphosis: something is dormant, waiting to emerge, and yet it also looks like a tomb. It also has echoes of Beuys's *The End of the Twentieth Century* [177].

The youngest artist to work with stone is Iran do Espírito Santo, who, like other contemporary artists from Brazil, is fascinated by the physical properties of certain materials. For his first solo show in America, Espírito Santo presented a piece called *Corrections B* [183], which consisted of ten green and grey granite stones with irregular polished surfaces, the cut shapes of which had been determined by their veining. Besides granite, he also likes to work with black and white marbles, in much the same manner as Byars, creating simple shapes with a high polish.

182 Stephen Cox, *Chrysalis*, 1989-91. Porphyry. 92 x 285 x 100 cm (36 ¼ x 112 ¼ x 39 ½ in). Tate, London

183 Iran do Espírito Santo, *Corrections B*, 2001. Granite (10 stones). Dimensions variable

Around 1975, Carl Andre was the first to use wood in a new, unadulterated way. He had begun to carve wood at the end of the 1950s, but only making minimal interventions into its surface to reveal its particular fibrous form and colour. Of an early carving he later said: 'The wood was better before I cut it than after. I did not improve it in any way.' Andre then ceased to alter the wood at all, eschewing the romanticism of manual labour; he spoke of ridding himself 'of those securities and certainties and assumptions' and getting down to something that 'resembles some kind of blankness'. *Sulcus* [184] is made from his favourite wood: eight blocks of rough-milled western red cedar, stacked in a geometrical configuration that naturally stresses horizontals and verticals. 'Sulcus' is Latin for 'furrow' or 'fold', and the centre of the sculpture does describe such a shape. The rough wooden blocks, with their splits and fissures, have a powerful visceral effect as well as a strong sense of order.

184 Carl Andre, *Sulcus*, 1980. Western red cedar. 150 x 90 x 90 cm
(59 x 35 ½ x 35 ½ in)

185 Martin Puryear, *The Nightmare*, 2001-2. Red cedar, painted black. 136.5 x 189.5 x 129.5 cm (53 ¾ x 74 ¾ x 51 in).
Sheldon Memorial Art Gallery, Lincoln, Nebraska

186 Ursula von Rydingsvard, *Doolin, Doolin*, 1995-7. Cedar, graphite. 210.8 x 538.5 x 195.5 cm (83 x 212 x 77 in)

Andre emptied wood of its long history of use, its loaded and established contexts and meanings, but some other contemporary sculptors want to preserve inherited sculptural traditions and techniques, and transmit these into the present. An American sculptor who likes to work with wood in this way is Martin Puryear, who served with the Peace Corps in Sierra Leone in the mid-1960s, where West African craftsmen taught him traditional carpentry. His career began at the time of Minimalism, with its industrial materials and smooth machined finishes, and he chose an opposite route that emphasizes a sense of craft. His African experience led him to make work with wood that has suggestive references to basic things like vessels, huts, furniture and boats (185). A contemporary of Puryear, and a fellow American, Ursula von Rydingsvard began her career at the same time, and like him, she makes reference in her works to everyday objects and architectural constructions. She has a fondness for milled cedar beams, which she shapes with a circular saw (186).

Japan has a long tradition of wooden sculpture, and it is not surprising to find that several contemporary Japanese sculptors work with the material. A group of them emerged in the 1980s; they used carving as well as construction, and colouring as well as charring. Perhaps the best known in the West is Shigeo Toya. His signature form is the upright trunk, and his preferred tool is the chain saw. He coats the finished carvings with an ash wash, which lends them an antique air [187].

Two British artists who work with wood, but in different ways, are David Nash and Richard Deacon. Nash explores the physical substance of wood, working intensively with its resistance and its vulnerability, to carve geometrical shapes reminiscent of tables, thrones, boxes, vessels and boats. He only uses felled or dead trees, and his forms are determined by the material. *Mizunara Bowl* [188] is carved from a large piece of Mizunara oak, which is found mainly in Japan and Korea. Two oak trunks from this tree were found for Nash in a forest area of northern Hokkaido, Japan, and he carved the bowl in situ while preparing for a major show there; a new twist on the concept of site-specific artwork.

187 Shigeo Toya, *Woods*, 1987. Wood, acrylic. Each piece 213 x 30 x 30 cm (84 x 12 x 12 in)

188 David Nash, *Mizunara Bowl*, 1994. Oak. 137 x 155 x 210 cm (54 x 61 x 82 ¾ in)

Deacon, on the other hand, dictates the forms of his material. His sculptures from the early 1980s were made from strips of wood glued together in a rough-and-ready way, often given permanence by the addition of rivets. He prefers sheet or strip material to massed, monolithic forms, and works with suggestive, open curves rather than flat, planar surfaces. More recently, he has used steam heat and lamination to mould his planks of ash, making a series of works with the generic title 'UW84DC', which look like the three-dimensional equivalent to Leonardo da Vinci's drawings of storms and rain clouds and waves beating onto the land. When spoken, the title reveals its watery allusion: 'You wait for the sea.' The ash planks lie around the gallery like shavings from a giant's plane **(189)**.

189 Richard Deacon, 7 pieces from the *UW84DC* series, 2001. Ash, aluminium.
Piece at left 84 x 300 x 132 cm (33 x 118 x 52 in). As installed at Dundee Contemporary Arts, UK

Tony Cragg, like Deacon, is interested in the physics of materials. Throughout his career, he has worked with a huge variety of both natural and synthetic materials, but since the late 1990s he has made much use of wood and stone, stacking and layering these substances into tall columns. His columns are usually centred around variable axes, which gives them an animated, twisted energy that is in complete contrast to the inert matter from which they are composed (190).

190 Tony Cragg, *Here Today, Gone Tomorrow*, 2002. Stone. Each 450 cm x 120 cm x 120 cm (177 ½ x 47 ¼ x 47 ¼ in). Cass Sculpture Foundation, Goodwood, UK

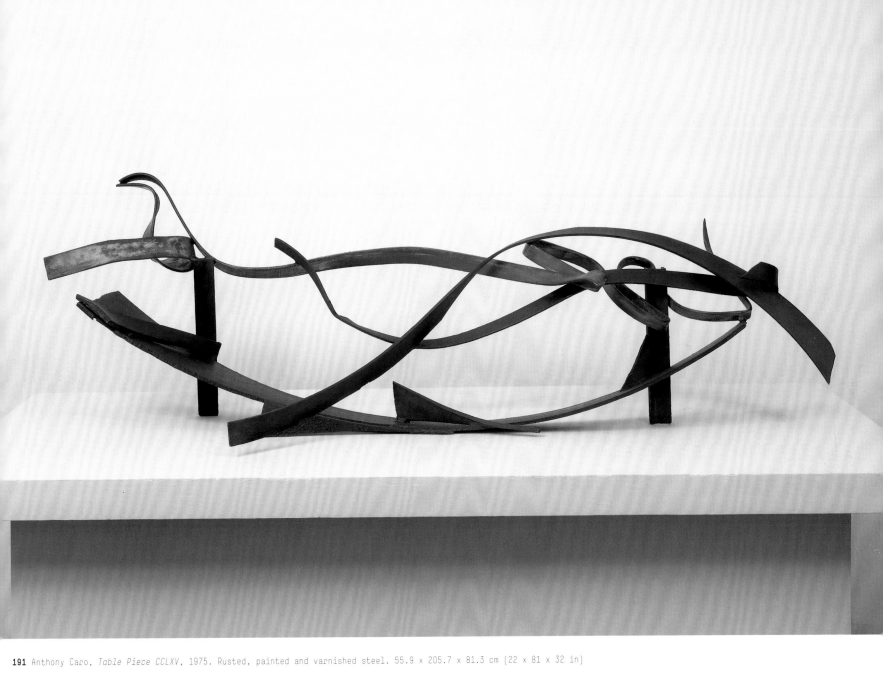

191 Anthony Caro, *Table Piece CCLXV*, 1975. Rusted, painted and varnished steel. 55.9 x 205.7 x 81.3 cm (22 x 81 x 32 in)

When Robert Morris wrote his essay on materials in 1970, pre-fabricated sheets of wood and steel were the avant-garde materials of the time; modular and planar, they led to simple flat, closed sculptures. Steel is a material that is used only by a few contemporary sculptors, who either work with its material presence, emphasizing its weight and strength, or make open forms in defiance of its gravitational pull. During the 1950s, David Smith created iron and steel drawings in space, and followed these with his series 'Cubis' (1961-5), made from sheets of polished stainless steel. Anthony Caro also uses steel in a very free way, most notably in his table sculptures, a series begun in 1966 and conceived on a scale related to that of a table, hence their name. Voluptuous or airy steel forms rest on the horizontal surface and often hang over the edge, introducing a dynamic of tension and repose **(191)**. Here the curvilinear forms were inspired by the waves breaking over the rocks near his studio in Dorset.

192 Eduardo Chillida, *Monument to Tolerance*, 1985. Steel. 94 x 264 x 220 cm (37 x 103.9 x 87 ½ in).
Museo Chillida-Leku, Hernani, Spain

Two sculptors who have used steel to convey weight are Eduardo Chillida and Richard Serra. Chillida discovered the ancient traditions of ironmaking in his native Basque region, and as early as the 1950s began to forge iron, giving him an insider's feel for the intractability of the material, and how slowly and laboriously forms are created from it. When he began to design sculptures on a larger scale, he had to turn to the steelworks at nearby Reinosa, which forged massive iron and steel sculptures, some weighing 60 tons, under his direction. As in *Monument to Tolerance* [192], Chillida favoured shapes that curved around an empty centre, describing himself as 'an architect of the void'. Serra worked in steel mills to pay his way through college, and learnt the potential of the metal. In an oft-quoted statement, he said: 'The models I have looked to have been those who explored the potential of steel as a building material: Eiffel, Roebling, Maillart, Mies van der Rohe.' Serra's steel sculpture is unique in that the sheets of metal are not fixed, bolted or welded together in any way; they are held in place by balance [377]. Ellsworth Kelly is another American artist with a fondness for flat, steel forms, which are either freestanding or wall-based [446].

As a material for making shapes, clay has a long history. A primal material, messy, sensual and readily available, clay is the universal language of vessels and vases -- shapes with a hollow centre. Until recently, clay was seen as too low a material for fine art, and artists who use it were classified as digressing from their major activities, playing like children making mud pies. An extreme example of this is art critic Hilton Kramer's description of some clay sculptures by Isamu Noguchi as the works of 'an inebriated pastry cook'. Working in clay made a comeback in the 1980s and 1990s, partly due to the globalization of the crafts of third-world countries, and a desire to make work that taps into the qualities of early and ethnographic art.

193 Antony Gormley, *European Field*, 1993. 40,000 hand-sized fired clay figures. Each figure 8-26 cm (8-10 ¼ in) high. As installed at Galerie Nordenhake, Berlin

Probably the most ambitious sculptural project to be made with clay is Antony Gormley's *Field*, a global initiative whereby thousands of tiny clay figures are made from the earth of a particular region by the people living there, following instructions from the artist. The figures are hand-sized, have two holes for eyes, and are kiln-fired in local brickworks. *Field* began in a small way in 1989, with 150 figures shown at the Salvatore Ala Gallery, New York; in October 1989 an Australian version numbered over 1,000 figures; in 1991 a Mexican *Field* was made in collaboration with the Tekca family of brickmakers in San Matias, Cholula, where sixty people used 25 tons of local clay to make 35,000 figures; this was followed by an Amazonian *Field* in 1991, a *Field for the British Isles* in 1993 and *European Field* in 1993 **(193)**. The latter involved 100 people from St Helens, Merseyside, 25 tons of local clay, and resulted in 40,000 figures. The largest Field to date is Chinese: 300 people from the Hudau District of Guangzhou made 190,000 figures in 2003.

As well as working with steel, Chillida used terracotta from 1973 until his death in 2002, and what makes his clay sculptures significant is their compact mass. *Lurra G-1977* **(194)** is one of a series of compact cubes of terracotta, into which Chillida has cut interlocking grooves before firing. Lurra is the Basque word for earth, and Chillida has described his Lurra pieces as somewhere 'between bread and brick'. Each has a different colour range depending on whether they were fired in a wood-burning or electric kiln.

Gabriel Orozco, who rarely uses clay, recently made some pieces working in the same way as Chillida, when he learned of a terracotta brick factory in France, which mechanically produced standard units of clay. He spoke of focusing on the material's sense of compressed mass, and the combination of its geometry with the organic gestures of his hands and body when manipulating it. He moulded a series of unpremeditated shapes, which he then fired and displayed on tables **(195)**. He also shaped around 150 pounds (his own body weight) of non-hardening clay into a huge ball, which he pushed around his neighbourhood streets of New York. One version, from an edition of three, complete with urban accretions, is in the collection of the Walker Art Center, Minneapolis, where it sits in all its obdurate physicality.

Anna Maria Maiolino started working with clay in 1989, and now makes large-scale gallery installations of repeated ribbons of unfired clay set against walls, on table tops and shelves. Like Orozco, Maiolino is interested in the results of repeated gestures, and her works consist of simple forms, such as balls and loops of clay, like those made by ceramicists when first creating a vessel **(196)**. Since they are not fired, her works dry out during the course of the exhibition; later, they can either be recycled by mixing with water, or swept away as dust.

194 Eduardo Chillida, *Lurra G-177*, 1990. Fired terracotta. 26 x 28 x 26 cm [10 ¼ x 11 x 10 ¼ in). Museo Chillida-Leku, Hernani, Spain

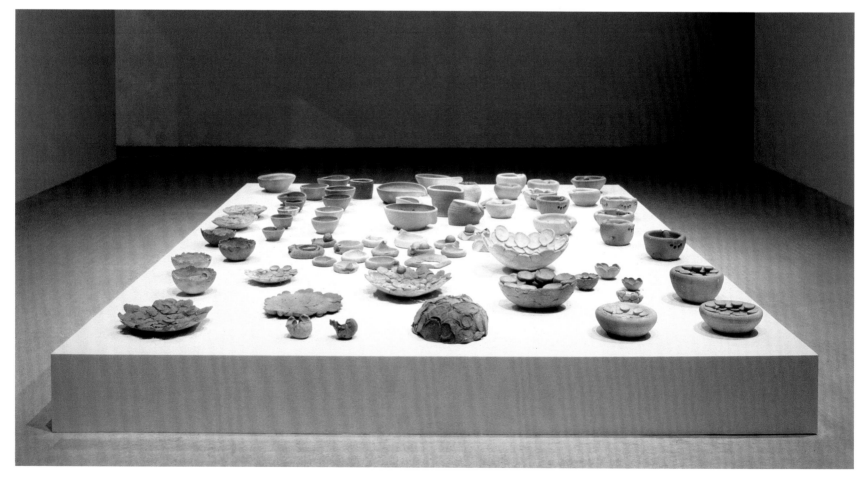

195 Gabriel Orozco, *Beginnings*, 2002. Fired clay. 350 x 450 x 35 cm (137 ¾ x 177 ¼ x 13 ¾ in)

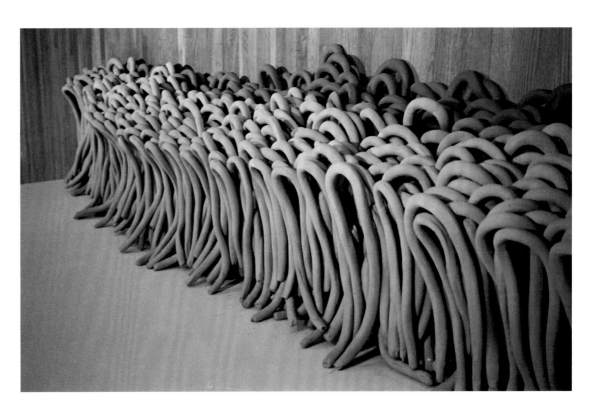

196 Anna Maria Maiolino, *More than One Thousand*, 1995. Unfired clay. Dimensions variable

Probably the most gestural and finger-printed of all recent clay sculptures are those made by Rebecca Warren, who made her debut on the London art scene in 1998 with a rough clay sculpture of a headless woman wearing high heels, full of energy and raw power. The vitality of Warren's work stems both from the quality of its material -- self-firing clay -- and from her vigorous manipulation of that material, where handprints and gestures are left visible (197), in much the same way that the French sculptor Rodin attacked his clay over a century ago.

Guido Geelen has devoted several years to working with clay. Between 1989 and 1992, he made large, fired-clay sculptures that shared an affinity with the austere and geometric forms of Minimalism. But in 1992, he created *Untitled (R.K.015)* (198), a tall wall composed of dozens of discrete clay elements. Close examination reveals shapes that, although slightly squashed, are recognizable as television sets, keyboards, vacuum cleaners, clogs, tyres, straw baskets and china animals. These configurations were made by taking moulds of the original objects, pressing soft clay into them and then firing it.

If clay is a material that looks fresh today, despite its extensive history, the same can be said of wax, which also has a long tradition of use by sculptors from the times of ancient Egypt, Greece and Rome. It was the material by which models were cast into bronze, using the lost-wax process. But it was also used to make effigies of the deceased, since its translucence makes it an ideal medium to replicate flesh. This sepulchral mode was the one exploited by wax museums, which were set up in the eighteenth century, the most famous and enduring being Madame Tussauds in London. It was also used by the medical profession from the seventeenth century to make anatomical teaching models, usually for dissection demonstration. Two European sculptors at the end of the nineteenth century worked with it, and both men appear to have some influence today among sculptors. Edgar Degas's wax sculpture *Little Dancer Aged Fourteen*, which was shown at the sixth Impressionist Exhibition in Paris in 1881, appalled visitors with its realism, while Medardo Rosso's fragmentary figurative images emphasized the fragility and mutability of wax.

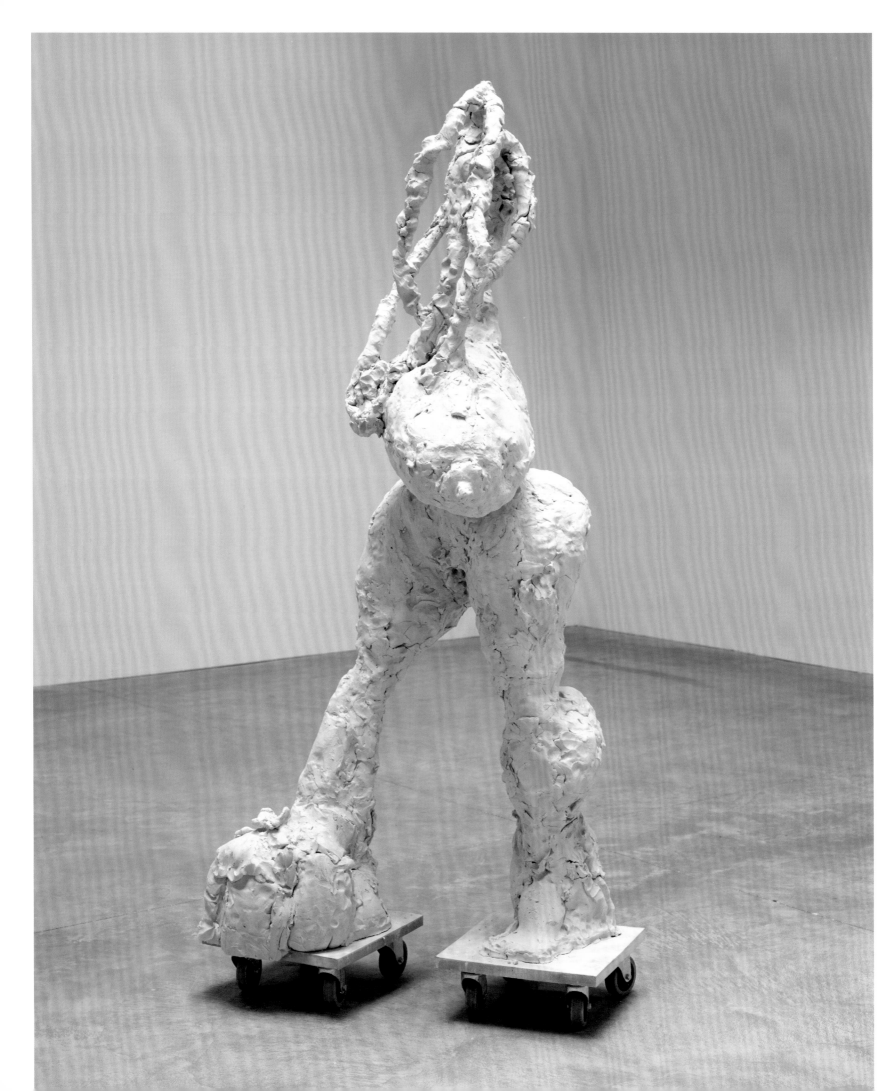

One of the first contemporary sculptors to use wax was Kiki Smith, who in the early 1990s employed coloured wax to make life-size figures of naked female bodies in poses that recalled both the anatomical and the funereal uses of the material **(24)**. The hyperrealism of Degas's young dancer set in a glass case inspired the work of Gavin Turk, a Londoner, who has created five life-size dressed wax figures -- *Pop* (1993), *Death of Marat* (1998), *The Last Bum* (1999), *Another Bum* (2000) and *Death of Che* **(51)** -- all of which are self-portraits. Other sculptors such as Gilles Barbier and Pia Stadtbaumer favour wax for their figurative works. Urs Fischer likes to work with candle wax, and has modelled the figures of several naked women as life-size candles **(221-2)**; he also creates portraits with several layers of wax until they become disfigured and blurred, rather like the impressionistic figures of Rosso.

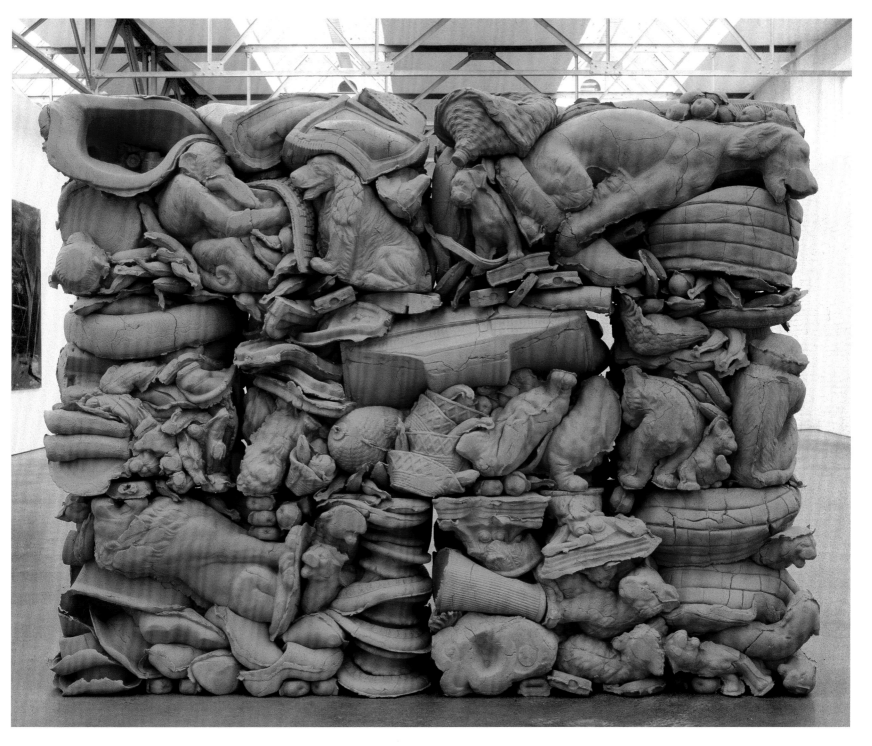

197 Rebecca Warren, *Teacher (M.B.)*, 2003. Reinforced clay, MDF, wheels. 214.6 x 102.9 x 74.3 cm (84 ½ x 40 ½ x 29 ¼ in)

198 Guido Geelen, *Untitled (R.K.015)*, 1992. Fired red clay. 175 x 230 x 55 cm (69 x 90 ½ x 21 ¾ in). De Pont Museum of Contemporary Art, Tilburg, The Netherlands

199 Jake and Dinos Chapman, *Death I*, 2003. Painted bronze. 73 x 218 x 95 cm (28 ¾ x 86 x 37 ½ in)

When bronze is chosen by younger sculptors as a casting material today, it is usually disguised with painted surfaces or misleading textures. For their Turner Prize exhibit at the Tate Gallery in 2003, Jake and Dinos Chapman made two figural compositions -- *Sex*, which comprised a painted bronze sculpture of a blasted tree bearing the skeletal remains of three bodies, copied from an image in Goya's etchings 'The Disasters of War', and *Death I*, a painted bronze sculpture of two inflatable sex dolls lying on top of one another **(199)**. The first work made a strong reference to art history in its narrative content, while both made use of the traditional material for figural sculpture: bronze. Dinos Chapman explained their reasons for the choice of material: 'We've reached the bronze age. Once you pass forty, you're allowed to use bronze. It's just a reproduction technique, but it's incredibly versatile.'

200 Mark Manders, *Fox/Mouse/Belt (fragment from Self-Portrait as a building)*, 1993. Bronze.
16 x 110 x 40 cm (6 ¼ x 43 ¼ x 15 ¾ in)

Fox/Mouse/Belt [200] is a work made by Mark Manders ten years earlier that is enigmatic both in terms of content and material. The title tells us what we see, but it is an unusual conjunction -- are both creatures dead, and why is the mouse strapped to the fox? Manders explains that the mouse could be eaten by the fox and thus become part of its body, undergoing a physical change. And physical change is what he has wrought upon the sculpture: he modelled the fox and mouse in clay, had them cast into bronze and then covered the bronze with a textured and coloured layer to make it look like moist clay, subverting the hierarchy of materials in a thought-provoking manner.

Glass is an ancient material, like clay, and the pioneer in the use of glass for large-scale sculpture is Dale Chihuly, who studied glass-blowing in the late 1960s at Murano, Italy. He designs both small and large works, and the bigger ones are often four or five metres high, composed of up to 1000 separate pieces. They can be free-standing, hung, set in the landscape or floated on water, and Chihuly's forms are suggested by flowers and ocean creatures. His glass sculptures impress by their scale, their material, their formal inventiveness and their brilliant colours [201], and he has exploited the tension between the fragility of the glass and its permanence as a material. The colours will not fade, nor the forms flag, and as if to reinforce the durability of the substance, he designed a glass pedestrian bridge for his home town of Tacoma, Washington.

201 Dale Chihuly, *The Sun*, 2006. Handblown glass, steel. 442 x 411.5 x 411.5 cm (174 x 162 x 162 in). New York Botanical Garden, Bronx, New York

EPHEMERAL EFFECTS

202 Roman Signer, *Water Boots*, 1986. Rubber boots and water. Performance in Weissbad, Switzerland

For certain contemporary artists, the famous dictum of the Roman philosopher Seneca, *'Vita brevis, ars longa'* -- (Life is short, art is long), is inapplicable. Their works deal with transience and decay, themes that underscore the provisional nature of our lives, our homes and our possessions. The range of organic, ephemeral, fugitive materials with which they choose to work is varied and inventive, from the evanescence of perfume to the extremity of gunpowder. They use these materials to draw attention to the transience of earthly pleasures and the inevitable decay of all things. Artists have turned their attention to these matters before, but not usually in the world of sculpture. The transience of pleasure was a favoured subject in European still-life painting from the fifteenth to the seventeenth century, especially among Dutch artists. The term 'vanitas' was used to describe memento mori of this kind, in which a range of objects -- broken pottery, flowers, fruit, flickering candles and shiny bubbles -- served as allegories of human frailty. The ultimate motif evoking the fragility of human existence was the skull. The theme of Vanitas has now returned, and is being explored through symbols more appropriate to our time, although some of the traditional ones are still in use. The turn from one millennium to another may have given the theme its contemporary impetus.

If it is popular to work with organic, ephemeral materials today, it is done in the spirit of revisiting the work of artists from the 1960s, such as the Italian Arte Povera group and Gordon Matta-Clark (1943-78), who were among the first to use fugitive, natural materials for sculpture; the Italians used fruit, vegetables, animals, fire and chemical elements, while Matta-Clark employed only food. They did this mainly for subversive reasons, to make art that could not easily be conserved or sold. Today, favoured substances are also those of a preservative kind, such as sugar, salt, wax, ice and spices, as well as those that provide energy and nourishment, such as chocolate, fat, rice, meat, honey, herbs, bread and flour. A work of art made from organic materials addresses a raft of ideas about time, chance, growth and decay, ethics and commerce, consumption and conservation issues. It has a life of its own beyond that of its maker, who cannot accurately determine its progress or prolong its presence. It undermines the role of the museum, set up to preserve the artworks in its care in perpetuity. It also undermines the commercial aspects of the art world, since fragile and entropic works cannot easily be sold.

In the 1960s, the Arte Povera group was interested in the way in which medieval alchemists had experimented with the physical transformation of matter, bringing about encounters between different elements. They were preceded in this interest by two other European artists, Yves Klein and Takis, who both used fire as a sculptural and pictorial element in the late 1950s. In 1957 Takis started making his *Fireworks*, explosive rods that were let off in the Luxembourg Gardens in Paris, while Klein created *Fire Fountains* for the Museum Haus Lange, Krefeld, Germany in 1958. In Rome in 1967, Jannis Kounellis incorporated a gas flame in the centre of a wall-hung metal sculpture of a flower. Many of his subsequent sculptures also incorporated a burning gas flame, or soot and smoke marks like *Untitled* **(204)**. Each time works like these are displayed, the viewer is reminded that the element of fire, dangerous and usually prohibited in the confined spaces of an art gallery, has been present and then removed. Kounellis also pioneered the use of another kind of subversive and more extreme material: animals. His *Untitled (12 Horses)* of 1969 was just what the subtitle stated: twelve live horses tethered, fed and watered in a Rome gallery for several days.

203 Gilberto Zorio, *Acidi*, 1985. Copper, metal, vase, rubber, copper sulphate. 277 x 279 x 244 cm (109 x 110 x 96 in)

Gilberto Zorio makes work that exploits alchemical transformations such as evaporation and oxidation. He creates fragile and precarious constructions from different materials, usually metal, rubber, neon lights, terracotta and containers with chemicals -- *Acidi* (203) is a typical example. Like Zorio, Pier Paolo Calzolari includes electricity in many pieces, and has used a wide variety of media including a live dog, tobacco, banana leaves, musk, gold, lead, copper, neon lights and refrigeration units. His *Untitled (Homage to Fontana)* (205), is composed of a sheet of lead and another metal surface covered with frost, created by a refrigeration unit.

204 Jannis Kounellis, *Untitled*, 1980. Stone, pallet, traces from a fire. 260 x 66 x 35 cm (102 ½ x 26 x 13 ¾ in). Stedelijk Museum voor Actuele Kunst, Ghent, Belgium

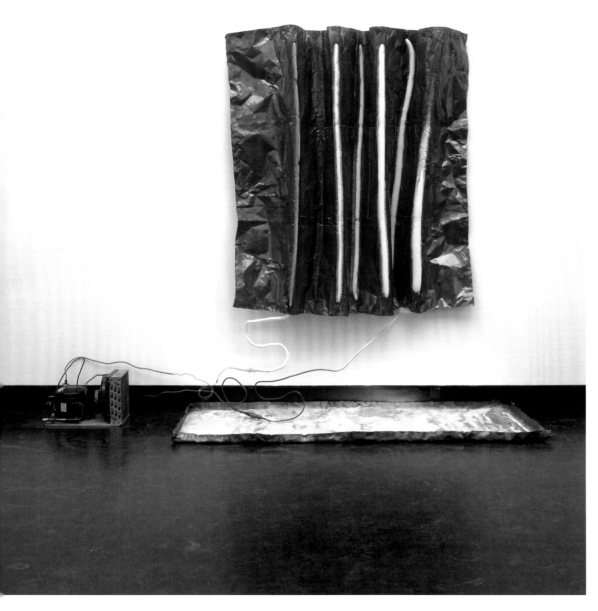

205 Pier Paolo Calzolari, *Untitled (Homage to Fontana)*, 1990. Lead, copper, refrigeration unit. 238 x 290 x 90 cm (93 ¾ x 114 ¼ x 35 ½ in). Stedelijk Museum voor Actuele Kunst, Ghent, Belgium

The young artist Roger Hiorns has taken up the alchemical path favoured by the Arte Povera artists, but not their socio-political stance; he quietly grows copper sulphate crystals on his forms. He also made *Vauxhall* **(206)**, a minimal work that consists of a rectangular sheet of steel that leans against the wall and is anointed with a dash of Van Cleef & Arpels scent 'First'. For the purchaser of the work, a bottle of the perfume is included so that the fragrance can be reapplied each time the work is shown.

When Kounellis showed his work in New York in the early 1970s, Dennis Oppenheim was interested in his use of energy. Since the 1980s, Oppenheim has incorporated fireworks and fire into his sculptures, a notable example being *Digestion: Gypsum Gypsies* **[207]**, a group of fibreglass deer from whose antlers burn flaming gas-jets. He described this work as turning 'the deer into furnaces, they're burning themselves up. In doing so they're digesting the room.'

Some of the Arte Povera protagonists, including Mario Merz **[208]**, have used food in their works. Food was first proposed as a subversive art material by the Dadaists in the 1920s, and was taken up again by European and American artists in the 1960s. Dieter Roth (1930-98) worked with various foodstuffs in the 1960s, including sausages, cheese, bananas and chocolate. Also in Dusseldorf at the same time, Joseph Beuys was interested in the essential energy inherent in organic materials, particularly fat, butter, margarine and honey, which he began to incorporate into his work. In America, in 1969-70, Gordon Matta-Clark worked with agar, a gelatine-like base usually used for bacterial growth, into which he introduced anti-sculptural materials such as milk, honey and chicken broth. A year later, he helped to found the restaurant Food in Soho, New York, where artist friends were guest chefs and performances involving food were presented.

206 Roger Hiorns, *Vauxhall*, 2003. Steel, Van Cleef & Arpels 'First' perfume.
145.5 x 26 x 9 cm (57 ¼ x 10 ¼ x 3 ½ in)

207 Dennis Oppenheim, *Digestion. Gypsum Gypsies*, 1989. Pigmented fiberglass, gas, wax, rubber hose, cast resin, regulator, jeweller's torch tips, steel bolts. 487.7 x 487.7 x 487.7 cm (192 x 192 x 192 in)

208 Mario Merz, *Spiral Table*, 1982. Mixed media. Dimensions variable

One of the largest and most striking sculptures made from food is Antony Gormley's *Bed* (209) constructed from layers of sliced white bread. Over a period of weeks, Gormley ate his own shape out of the bread, leaving a negative impression as though he had lain there. He preserved the stacked slices by soaking them in wax, although this has not prevented the growth of mould. Bread is one of the staple foods of many countries of the world, and it is a commodity that comes with its own particular social, political, economic and religious resonances. The Christian Eucharist, for example -- the sacrament in which Christ's Last Supper is commemorated by the consecration and consumption of bread and wine, representing His body and blood -- is brought to mind by Gormley's act of eating bread to represent a body. The significance and symbolism of the Christian ritual resonated with Gormley, who had a catholic upbringing and later studied Buddhism in India and Sri Lanka.

Besides bread, another basic universal foodstuff is the potato, a vegetable indigenous to South America and introduced to Europe as a result of conquest and colonization. In the 1970s, the Argentinian artist Victor Grippo made a series of works called 'Analogies' that examined the symbolic significance of the potato (210). He was trained as a chemist, and in this series, he arranged potatoes on tabletops, chairs and in boxes, connecting them to electrodes and a voltmeter, which measures the electrical charge that they produce. Sometimes he included glass flasks full of coloured liquids, which lent the works a stronger alchemical air. Like the Arte Povera group, Grippo believed that the artist should act like a medieval alchemist, working to transform substances and, ultimately, societies.

There is a long tradition of making ephemeral sculpture from sweet ingredients, such as sugar, caramel and chocolate, for special occasions like royal, religious or state ceremonies. At lavish banquets in Tudor England, for example, and in seventeenth-century Rome, sugar models of buildings were displayed. Chocolate is made from roasted, ground cacao seeds, native to Mexico and South America. It reached Europe in the seventeenth century as an exotic commodity with a supposed aphrodisiac power. Like Grippo's potato, it is potent edible matter with a strong social and emotional history, and it has made an appearance in several works in recent years, mostly executed by female artists.

In 1992, Janine Antoni produced *Gnaw* (211), which consisted of a large cube of chocolate weighing 300 kilograms and a cube of lard of the same size and mass, both set on marble bases. The cubes were nibbled at their corners by the artist, and the regurgitated chocolate was then recycled to make boxes of candy creams, while the chewed lard was reused to make 300 red lipsticks. Antoni's act of gnawing aped the more traditional sculptural practice of carving, which removes material little by little. With this work, she was as interested in the sculptural process as much as the material.

However, two other female artists have produced chocolate works that are somewhat radical in content. Jana Sterback's *Catacombs* (1992) is a partial human skeleton cast in high-grade chocolate that is displayed scattered on the gallery floor. She said of the work: 'It renders [transient] the only part of our being that survives long beyond our life ... It also raises the spectre of cannibalism or necrophilia.' In 1996 Egle Rakauskaite staged a gallery installation of multiple small chocolate depictions of the Crucifixion in her *Chocolate Crucifixes* (213). She cast them from an existing crucifix and then laid over two thousand of them head-to-toe in a striking, formal pattern along the walls. These little chocolate figures of Christ provocatively merge the central icon of Catholic culture with that of Western hedonism, and make reference again to the Eucharistic practice of eating morsels of the body of Christ during worship.

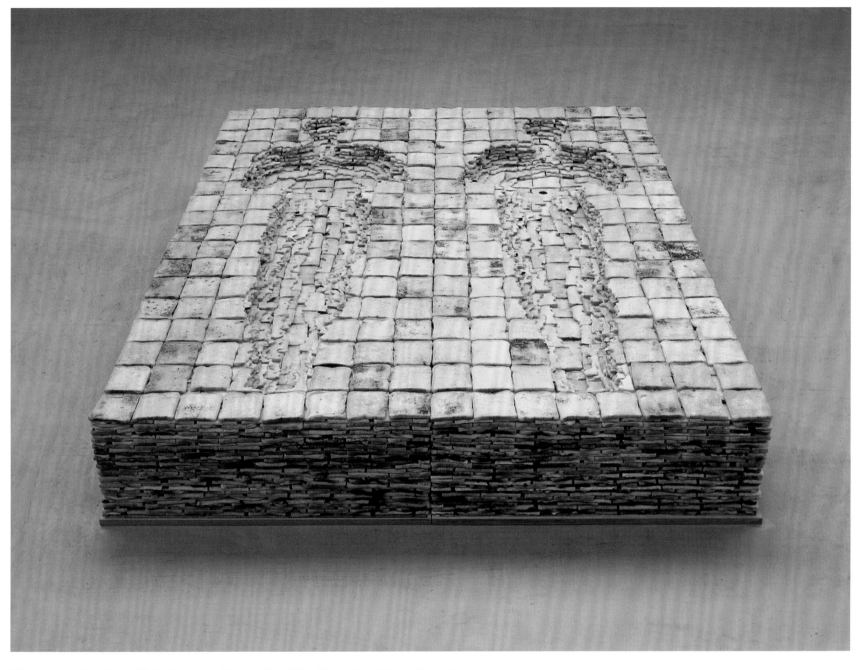

209 Antony Gormley, *Bed*, 1980-1. Bread, paraffin wax. 28 × 220 × 168 cm (11 × 86 ½ × 66 in). Tate, London

210 Victor Grippo, *Analogy I*, 1970-1. Electric circuits, electric meter and switch, potatoes, text, paint, wood. 47.4 × 156 × 10.8 cm (18 ½ × 61 ½ × 4 ¼ in)

211 Janine Antoni, *Gnaw*, 1992. 600 lb chocolate gnawed by the artist, 600 lb lard gnawed by the artist, lipstick display case with 45 heart-shaped packages for chocolate made from chewed chocolate removed from the chocolate cube and 400 lipsticks made with pigment, beeswax and chewed lard from the lard cube. Each cube originally 61 x 61 x 61 cm (24 x 24 x 24 in)

212 Thomas Rentmeister, *Nutella*, 2000. Nutella chocolate-nougat spread. Approx. 30 x 350 x 150 cm (11 ¾ x 138 x 59 in)

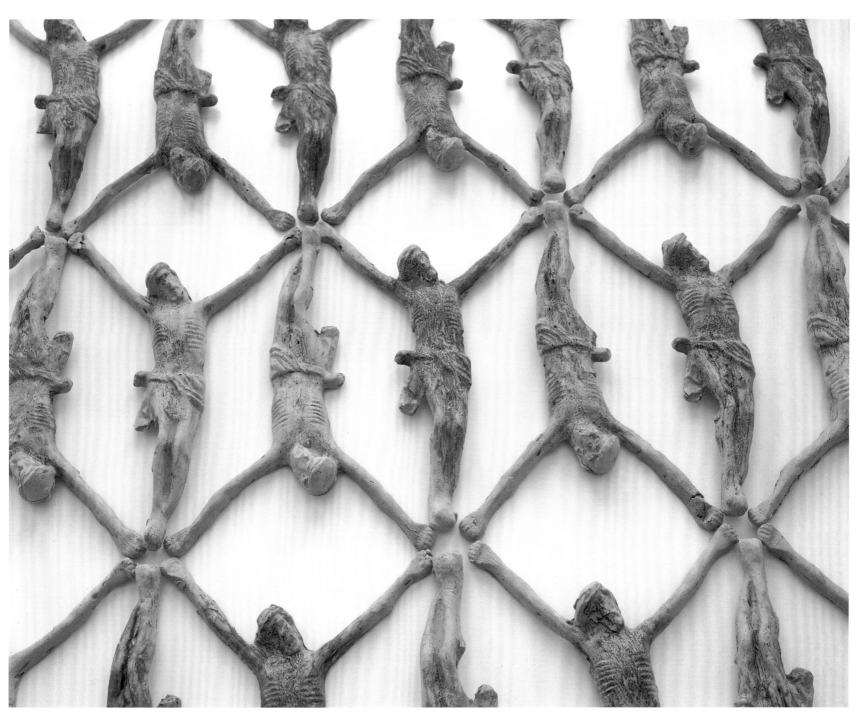

213 Egle Rakauskaite, *Chocolate Crucifixes* (detail), 1995. Cast chocolate. Each 42 cm (16 ½ in) high

Meanwhile, Thomas Rentmeister works with sugar, chocolate and baby lotion, but since 1999 his favoured material has been Nutella, a brown, glutinous, chocolate-nougat spread. In 2000 at the Kunstverein in Cologne, he poured the contents of 100 large buckets of Nutella directly onto the gallery floor, where the material slowly made its own amorphous shape, an unsettling and calorific landscape (212). The reaction of visitors to the work veered between attraction and repulsion, because although it was made of something sweet, its form and colour recalled a mound of excrement.

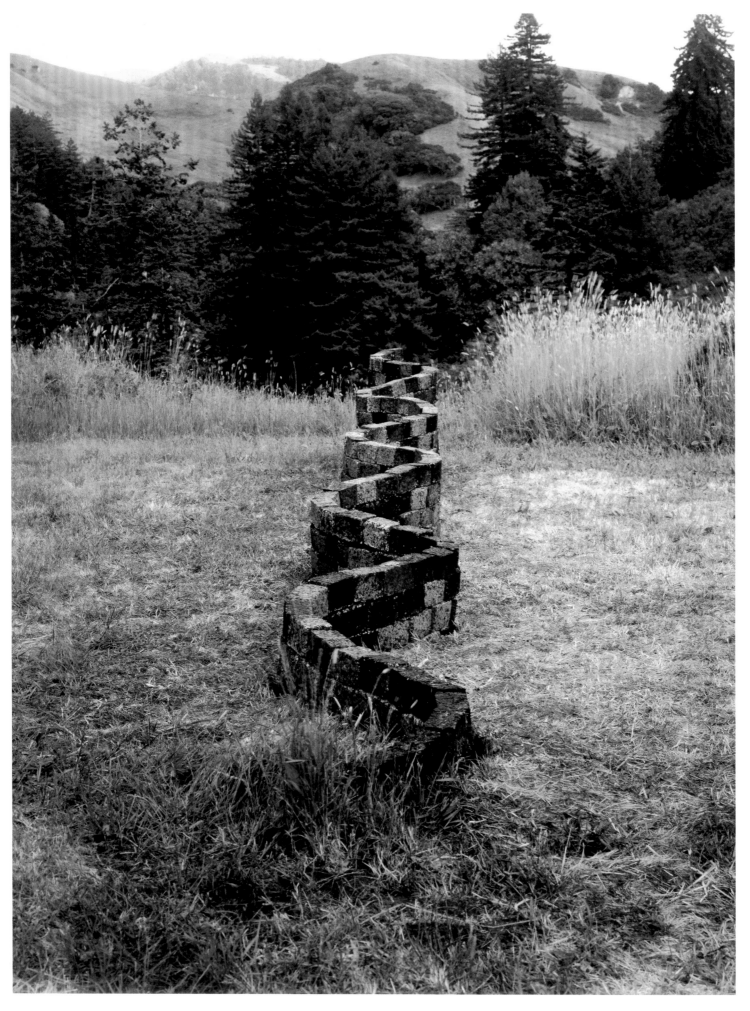

214 Gay Outlaw, *Dark Matter Redux*, 1998. Fruitcake, trench. 101.6 x 61 x 1036.3 cm (40 x 24 x 408 in). As installed at Djerassi Foundation, Woodside, California

Gay Outlaw took a course in French cooking and has used this training to explore ideas about materiality and mutability, working particularly with pastry and caramel sculptures. *Tinned Wall/Dark Matter Redux* was a 34-foot-long, serpentine wall constructed from 700 fruitcakes, which was cased in aluminium and sited in the Yerba Buena Gardens in San Francisco, where it lasted for two years. In 1998, she made another version of the piece, uncased and called *Dark Matter Redux* [214]; this was placed in the grounds of the Djerassi Foundation at Woodside, California, where it was eaten by the local wildlife.

Nayland Blake showed *Feeder 2* [215] at the Matthew Marks Gallery, New York, in 1998, a seven-by-ten-foot house made from slabs of gingerbread, which made reference to the gingerbread house in the fairytale of *Hansel and Gretel*, and to *Uncle Tom's Cabin*, both stories that he treasured from his childhood. Visitors to the gallery were overwhelmed by the sensual and olfactory experience of the work; they were unable to stop themselves from breaking bits off the house and eating them.

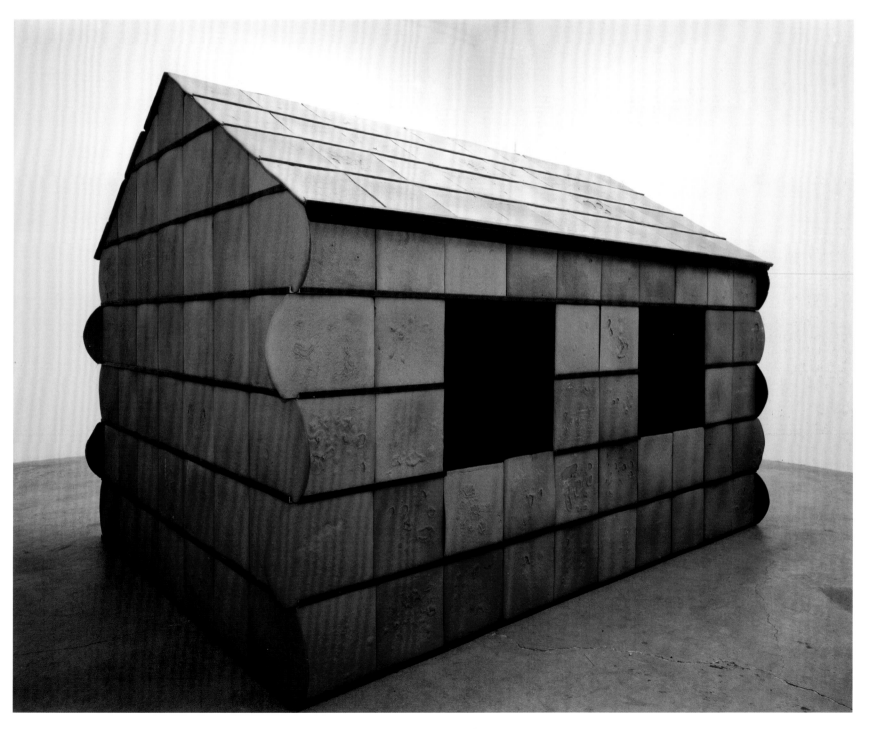

215 Nayland Blake, *Feeder 2*, 1998. Steel, gingerbread. 213 x 305 x 213 cm (84 x 120 x 84 in)

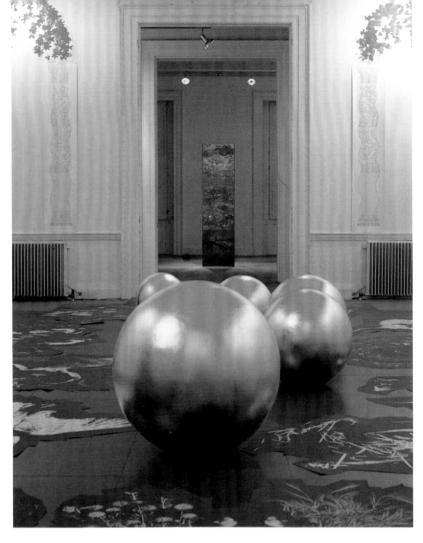

216 Helen Chadwick, *Of Mutability & Carcass*, 1986. Mixed media. Dimensions variable

217 James Lee Byars, *The Rose Table of Perfect*, 1989. 3333 red roses on Styrofoam ball. 100 cm (39 in) diameter. As installed at Castello di Rivoli Museo d'Arte Contemporanea, Turin

Recently, artists have prepared and given away food at exhibitions, challenging the role of museums and galleries as places where art is preserved inviolate and untouched, and using the notion of generosity and the interaction of eating to erase the boundaries between the audience and the artwork. In 1990, Felix González-Torres led the way, exhibiting his piles of sweets, which can be taken away by the viewers. In 1991, the Thai/Argentinian artist Rirkrit Tiravanija exhibited in a Warsaw gallery two suitcases of bacon-flavoured crisps, and invited the public to eat the work. In his *Untitled (View)* (1993) at the ICA, London, he cooked and served curry to the crowds who attended, selling vacuum packs for those who wanted to take the artwork home. Tiravanija has made other exhibitions that consist of free meals. Visitors are welcome to enjoy his food throughout the duration of the show. Because the artist was not always present, visitors were encouraged to cook for themselves and others. For his exhibition 'Untitled (Free)' (1995) at the 303 Gallery, New York, he transformed the back room of the gallery into a kitchen with a refrigerator, tables and chairs, electric hot plates, cutlery, cutting boards, woks and teapots. Bags of rice, spices and packets of bouillon cubes were the basic ingredients of a meal that was served to all who came during the seven-week exhibition. In accordance with Tiravanija's wishes, the uneaten meals, the plates and cutlery remained unwashed and piled up in the gallery, and these deteriorated into a pile of smelly garbage. For her show at the ICA, London, in 1986, Helen Chadwick made a complex installation that she called *Of Mutability* (216), a phrase from Edmund Spenser's *The Faerie Queene* (1590), in which the poet writes about how all things are subject to change. Chadwick stated: 'My work is to do with the

burden of physicality and sentience, and how desires and pleasures are very fleeting. How all human experience seems to be very frail, like a bubble', recalling the idea of the vanitas. A large glass column, *Carcass* (visible behind the golden spheres), was filled daily with food waste from her own street in East London. The column sprang a leak, flooding the gallery with foul-smelling fluids.

At much the same time, in California, Liz Larner experimented with sculpture that would make its own form, without her intervention. At the Tropicana Motel, West Hollywood, in 1987, she showed works including *Whipped Cream, Heroin, and Salmon Eggs*, collations of disparate elements suspended in agar, and allowed to act on each other. These works revealed Larner's interest in instability and change, and harked back to similar experiments by Matta-Clark.

James Lee Byars was as much a performance artist as a sculptor, and he made both stable and 'performable' sculptures, the latter proclaiming his abiding interest in the transient and ephemeral. In 1989, he showed *The Rose Table of Perfect* at the Galerie de France, Paris, 3,333 fresh and perfect red roses set in a Styrofoam ball **(217)**. As discussed in Chapter 7, most of his work was directed at examining the 'Perfect', probably an unattainable state on this earth, and works like this give evidence of this as they decay.

Anya Gallaccio has also looked at the spectacle of entropy, and has come to the same point as Byars, but from a different path. She, too, uses seductive objects like roses to demonstrate this. In works such as *Red on Green*, she arranges a large number of brightly coloured flowers in a geometrical formation on a gallery floor, sometimes covering them with a sheet of glass. Initially, the sculpture looks like a colour-field painting laid on the floor, but it gradually loses its hard-edge form and chromatic radiance. The flowers progress from florist-fresh to shrivelled stalks, losing their colour and becoming smelly and mouldy, revealing the 'physical transformation of matter from artificial symmetry to artless disorder' **(218)**. Gallaccio has also worked with fruit, sugar and ice.

218 Anya Gallaccio, *Red on Green*, 2002. 10,000 red roses. 260 x 550 x 6 cm (102 ¼ x 216 ½ x 2 ½ in). As installed at Kunstmuseum, Wolfsburg, Germany

219 Damien Hirst, *A Thousand Years*, 1990. Steel, glass, flies, maggots, MDF, insect-o-cutor, cow's head, sugar, water. 213 x 427 x 213 cm (84 x 168 x 84 in)

Another British artist concerned with the transience of life and the permanence of death is Damien Hirst, who launched himself into the London art scene in 1988 by curating 'Freeze', an exhibition of his own and fellow artist's work. A work of 1990, *A Thousand Years* **(219)**, uses living and dead material to make its point about the life cycle; within a divided glass-and-steel vitrine lies a rotting cow's head infested by a colony of maggots, which hatch into bluebottles, only to be immediately electrocuted by the insect-o-cutor that hangs above.

Wim Delvoye is interested in the scatological nature of man. In 2000, he collaborated with scientists at Antwerp University to construct a machine that he called *Cloaca* **(220)**, which replicates the functions of the human digestive system, producing human-like excrement after being fed two cooked meals a day. Piero Manzoni, regarded as a precursor to the Arte Povera

220 Wim Delvoye, *Cloaca*, 2000. Step ladder, food mincer, glass containers, stainless steel strands, tubes, tank of carbon dioxide, peristaltic pumps, electrical system, wires, circular tray. 12 m (39 ft 6 in) long

Movement, took the subversive step in 1961 of tinning his own excrement and offering it for sale by the ounce, and works involving ideas about excrement usually pay homage to this. Two sculptors who deal with the vanitas theme by using the form of the human body are Urs Fischer and Tom Friedman. Fischer makes life-size wax candles in the form of unfinished female nudes, which self-destruct during their display as the wax melts and their limbs fall off (221-2). He feels that this is the age of a 'meltdown' of information, and his work in a way mirrors this feeling; he has spoken of wanting to make work 'that disappears into its surroundings'. He is also pleased to allow his work to escape from his control and follow its own path. Earlier in his career, he made some still-lifes using fruit and vegetables whose decay he held in check by coating them in a layer of silicone. Most recently, he made a *House of Bread* (2005), which decayed while on show and was eaten by twelve colourful parrots.

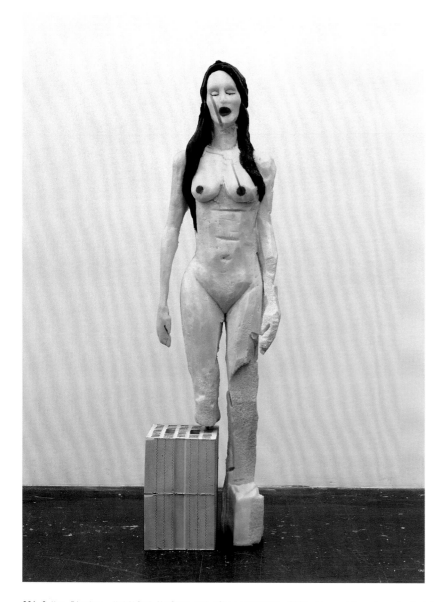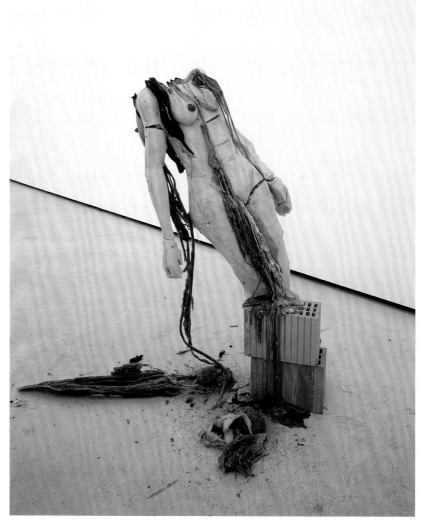

221-2 Urs Fischer, *Untitled* (before and after burning), 2001. Wax, wick, pigment, brick, and metal. 170.2 x 45.7 x 29.3 cm (67 x 18 x 11 ½ in)

The human figure is only a small part of Friedman's oeuvre, but one of his more memorable works is his three-quarter size self-portrait, *Untitled* **(223)**, made entirely from stacked white sugar cubes which crumble slightly during display, causing a white penumbra to form around the figure's feet. The crystalline nature of the sugar is an ironic allusion to the crystalline nature of white marble, the material used by classical sculptors for heroic male nudes.

Other sculptors who work with animals and insects often come from the Far East. Xu Bing employs pigs, sheep and silkworms. He was born in Chongqing, China, and now lives and works in New York. He began by exploring calligraphy and woodblock printing -- skilled crafts with a long history in China. Bing then extended his repertoire of artistic practices to include pig farming and silkworm cultivation, also both traditional Chinese activities. For his work *Panda Zoo* **(224)** he chose a male pig, an American York, and a female pig, a Chinese Changbai. The animals were breeder stock and, wearing panda masks, they were put in a pen and displayed. Bing intended the work to be a metaphoric manifestation of the differences between East and West, and the ways in which the opposing cultures try to interact.

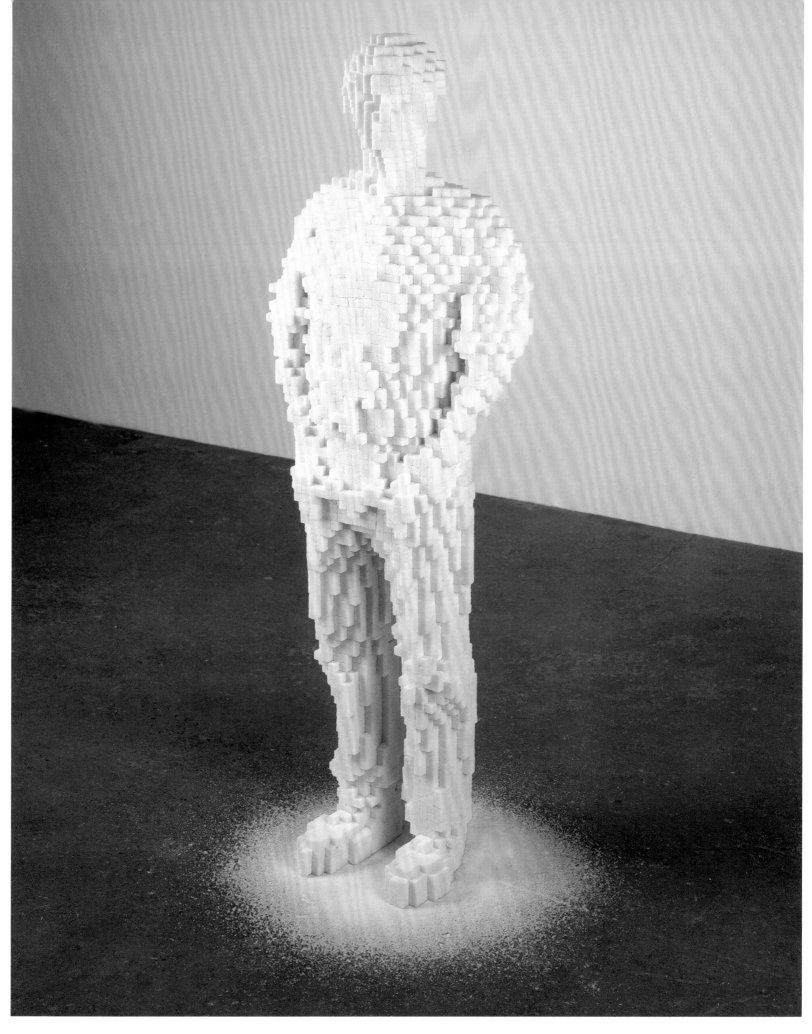

223 Tom Friedman, *Untitled*, 1999. Sugar cubes. 122 x 43 x 25.5 cm (48 x 17 x 10 in)

224 Xu Bing, *Panda Zoo*, 1998. Mixed media installation and performance: pigs in masks, bamboo, rocks, classical Chinese paintings. As installed at Jack Tilton Gallery, New York

One Dollar by Yukinori Yanagi, consists of a US dollar bill sculpted in coloured sand, held inside clear plastic boxes **[225]**. When the work goes on show, a colony of live ants is introduced to the boxes and for the duration of the exhibition they tunnel through the sand, gradually destroying the image. The ants' tireless labour undermines the symbol of American might, power and money. When the image has virtually disappeared, Yanagi releases the ants outdoors.

Ants and beetles have found their way into several of Rivane Neuenschwander's works. Her interest lies in the life-cycles and behaviour of a wide range of materials including snails, goldfish, flowers, fruit, spices, seeds, dust and soap bubbles, a link back to the vanitas still-life paintings of the seventeenth century. She brings to her work a delicate balance between the fragile nature of the material and the geometric, repetitive aesthetic order she imposes on it [226]. This structure helps counterbalance the evanescence of the materials. For a handful of shows, she has spelt out the alphabet, filling the letters in with spices, from acafrao to zatar, and suffusing the gallery with a mingled aroma.

Probably the most transient matter is that used by Cai Guo-Qiang, who now lives and works in New York. He was born in Quanzhuo, and as a child witnessed air-attacks on both sides of the Taiwan Strait during the war between the Mainland Chinese army and Taiwanese troops. This memory was interlaced with his childhood penchant for fireworks, and since the late 1980s, he has responded to his Chinese heritage and made a variety of works using gunpowder, which was invented in China as a by-product of alchemy. He was attracted to the unpredictable energy of the medium, with its destructive and constructive natures, and probably had little knowledge of Takis's work with fireworks when he began his own experiments. He has used gunpowder to make paintings -- marks on walls or on canvas -- and also huge outdoor projects. One of the most noted of these to date is his *Project to Extend the Great Wall of China by 10,000 Metres* [227], which took place on 27 February 1993 at the western end of the Great Wall in the Gobi desert. A 10,000-metre-long fuse snaked from the end of the wall, with smaller charges placed at intervals of 10 metres, and larger ones at 1,000 metres. Fifty thousand local people watched the series of successive explosions, which lasted approximately 15 minutes.

225 Yukinori Yanagi, *One Dollar*, 1999. Plexiglas, sand, ants. Each box 24 x 30 cm (9 ½ x 11 ¾ in)

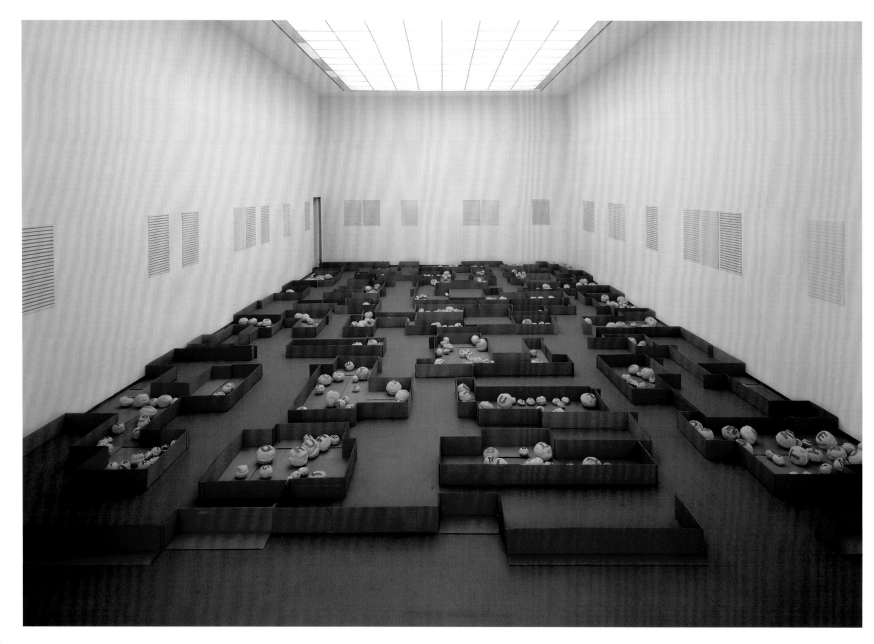

226 Rivane Neuenschwander, *Spell*, 2001. Cardboard boxes, tape, peeled and dehydrated grapefruits and oranges with carved alphabet. Dimensions variable. As installed at Portikus, Frankfurt, Germany

Almost twenty years before Guo-Qiang, Roman Signer began to work with explosive materials, having got to know volatile combustible matter as a child, like his Chinese counterpart. Signer's great-grandfather owned a match factory, which exploded twice and burned to the ground, while his grandfather managed a store that sold gunpowder. In order to record his transient and self-destructive works, he has resorted to recording them on video since 1972. His favoured materials are water, fire and air, as well as time, and he is a master in working with dynamite. One of his most impressive performances in a gallery is the presentation of an exploding umbrella, which shoots up to the gallery ceiling and remains there without blowing up the rest of the building; the power of the explosive charge and the dimensions of the room having been very carefully calculated. In keeping with his Swiss background, his works and events are scrupulously prepared, even though they only last for a few seconds [202]. These two artists could be said to exemplify what Rosalind Krauss called 'the extended field of sculpture'.

A different approach towards the transitory is pursued by Giuseppe Gabellone. He makes both cool, minimal structures and earthy, biomorphic sculptures, which he photographs, but after clicking the shutter he usually destroys them. The photograph on the gallery wall records the absence of a presence. *Untitled* (228), an image of a large plywood construction, is an example. Gabellone denies the viewer a direct encounter with the work, offering instead a flat image, which is more often the way in which we experience sculpture. In this time of virtual reality, he asks the gallery viewer to consider which work is more real: the photograph or the non-existent sculpture.

227 Cai Guo-Qiang, *Project to Extend the Great Wall of China by 10,000 Metres*, 1993. Fireworks. 10,000 m (32,800 ft). Jiayuguan, China

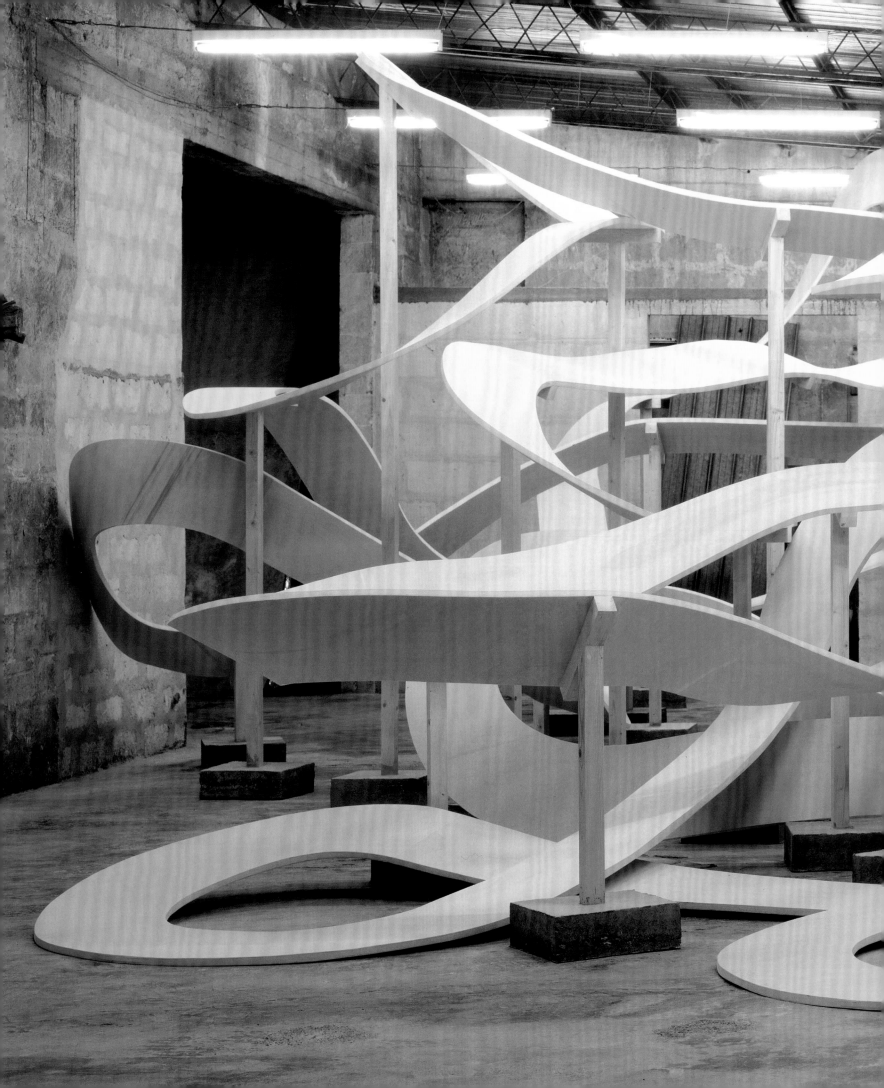

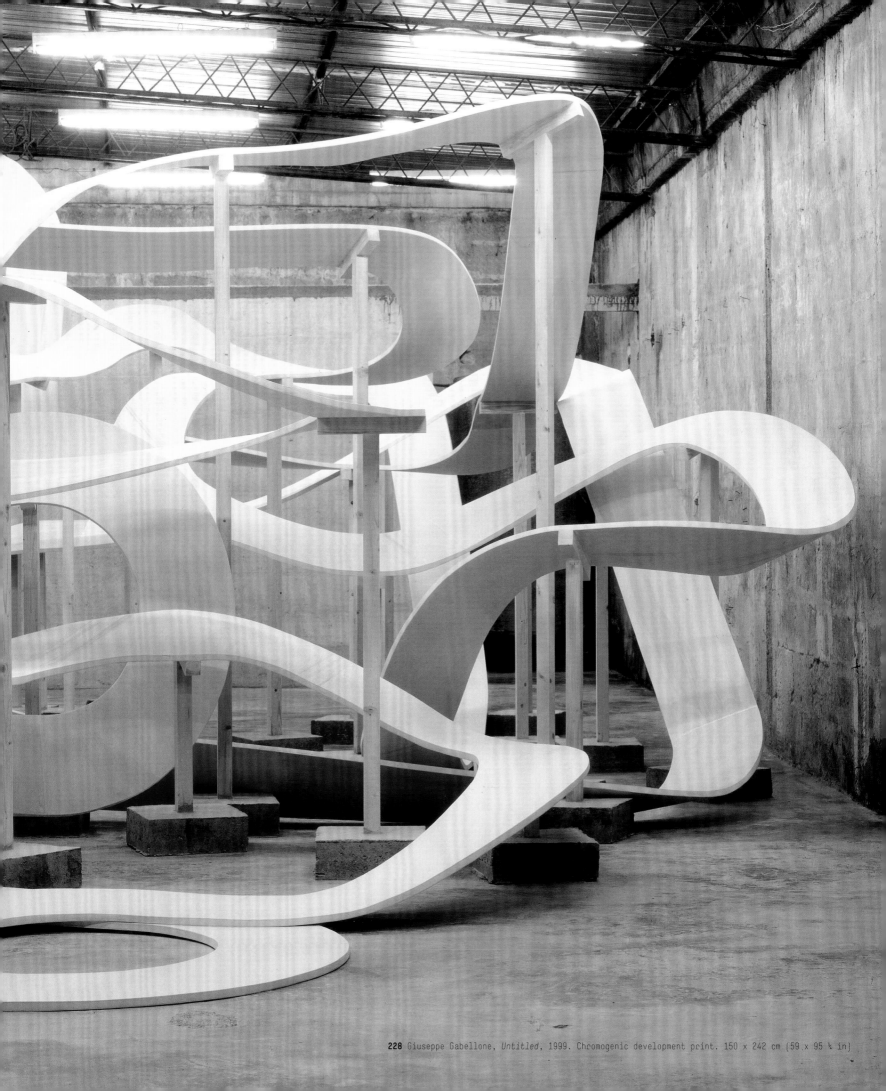

228 Giuseppe Gabellone, *Untitled*, 1999. Chromogenic development print. 150 x 242 cm (59 x 95 ½ in)

'Nature' is a loaded and complex word, with numerous meanings. Here, it refers to the material world that surrounds humans, to manifestations such as mountains, deserts, trees, rivers, plants and clouds. Not made by man, they can be modified by him. A poem written in 1923 by Wallace Stevens -- 'The Anecdote of the Jar' -- deftly captures this relationship:

I placed a jar in Tennessee
And round it was, upon the hill.
It made the slovenly wilderness
Surround that hill.
The wilderness rose up to it,
And sprawled around, no longer wild.
The jar was round upon the ground
And tall and of a port in air.
It took dominion everywhere.
The jar was gray and bare
It did not give of bird or bush,
Like nothing else in Tennessee.

'Nature' is often paired with 'culture', with the former standing for things that are innocent, sprawling, nurturing and pure -- the wilderness -- and the latter for those that are developed, cultivated and refined -- the gray jar. The dominion achieved by the placement of this round jar is one that is exploited in various degrees by several artists in this chapter. Nature is usually seen as feminine in gender, and this widely held belief strongly identifies women and their bodies with the natural world. As a result, culture is seen as male, as husbandry and cultivation, and usually superior. Several contemporary artists have made works in response to this somewhat rigid dichotomy.

At the beginning of the twenty-first century, it is increasingly difficult to discern exactly what constitutes the natural world. The seam between the natural and the artificial is unravelling, in a world filling with genetically modified plants and products. Also, climate change, the exhaustion of fossil fuels and global warming have appeared as major threats to our environment, and these circumstances have affected the way in which artists deal with the natural world. The options available to sculptors are basically three-fold: they can rearrange the materials of nature within their indigenous habitat outdoors, or present them indoors in a gallery environment, and this can be done either in all its earthly reality or they can simulate it. In 1968, a handful of male artists in America began to practice what quickly came to be labelled 'Land Art'; they were Dennis Oppenheim, Michael Heizer, Walter De Maria, Robert Morris and Robert Smithson. They turned to working outside in the land, rather than in their studio, partly as a reaction to the urban materialist Pop Art that was prevalent at the time and partly to present the viewer with a stronger sense of the physicality of matter. Although basically urban artists, they travelled to remote rural places in America to oversee monumental acts of earthmoving, imposing simple shapes such as rectangles, squares and circles on the land, the most famous of which was Smithson's *Spiral Jetty* of 1970, set into the Great Salt Lake in Utah. These artists were aware of the Neolithic stone and earth monuments in Europe, such as Stonehenge in England, and the stone temples and pyramids of the Pre-Columbian Aztec and Mayan cultures of Central America, which used the same simple formal elements -- circles, lines, spirals -- and displayed evidence of massive physical labour.

229 Yoshiro Suda, *Weed*, 2005. Carved and painted magnolia wood. Dimensions variable

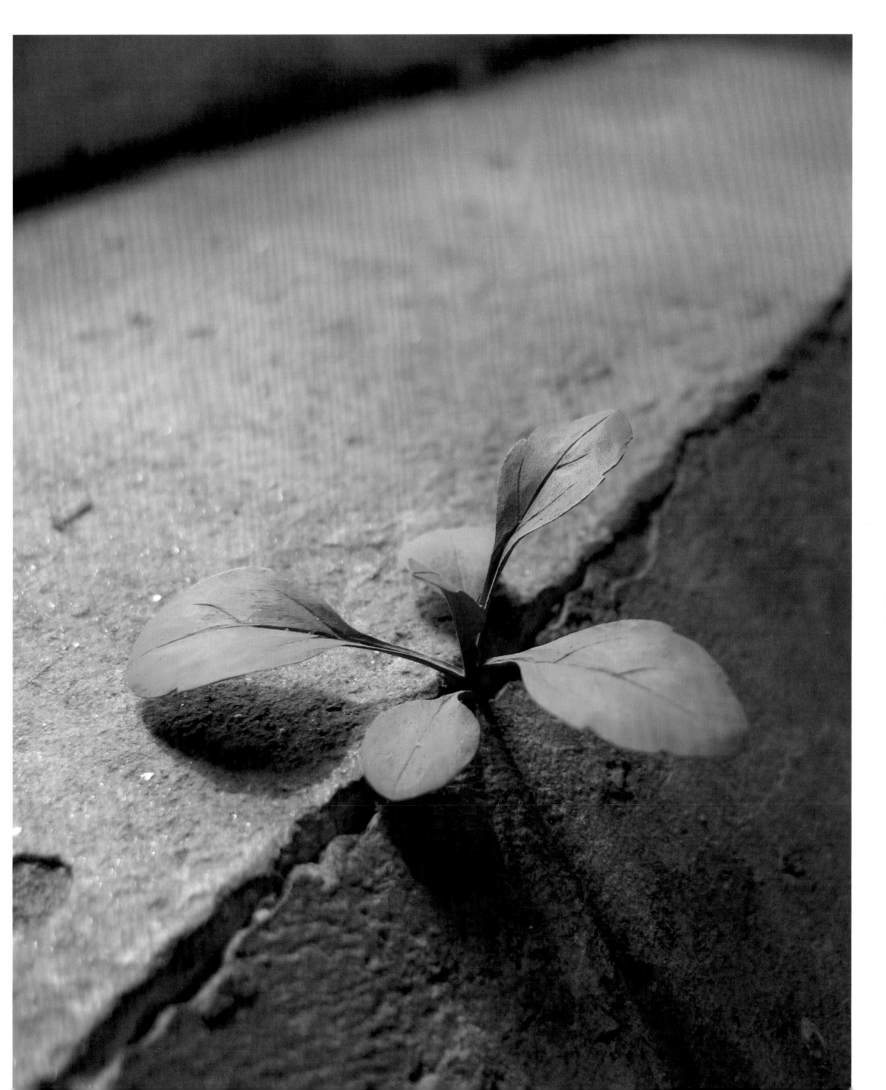

230 Walter de Maria, *The New York Earth Room*, 1977. 250 cubic yards of earth. 56 cm (22 in) high.
Dia Art Foundation, New York

Besides their earthmoving schemes in the desert, the Americans began to transport raw natural materials back to urban spaces, introducing into galleries an interchange between outdoors and indoors that continues to the present day. Walter De Maria had 250 cubic yards of earth moved to the Heiner Friedrich Gallery, New York, in 1977, and spread over the floor to a depth of about 2 feet. Two other 'Earth Rooms' preceded this, the first in Munich in 1968 and a second in Darmstadt in 1974, but these no longer exist. *The New York Earth Room* is now permanently installed in a room in Wooster Street, New York, which is closed off by a glass wall just higher than the earth **(230)**. All a viewer can do is look empathetically at the trapped soil and reflect on its location in an alien environment. It is still one of the most poignant importations of raw material into the clean, white space of an art gallery.

At the same time that American Land Art was exercising its muscles, European artists began to address the natural world in a different way. They tended to make smaller changes to it, and more temporary ones. Since 1967, Richard Long has been walking through remote landscapes all around the world, and as part of his walk, he makes a simple, ground-based sculpture in the open air, using locally found stones or sticks and eschewing tools or machinery. He is aware of the temporal nature of his work; what has been borrowed from nature will return to it in time. He chooses simple forms when he arranges these materials, such as circles and squares, which are sometimes concentric lines, spirals and crosses, the same forms used by the American artists, and our Neolithic ancestors. Long, however, distanced himself from American Land artists when he stated in 1984: 'My interest was in a more thoughtful view of art and nature, making art both visible and invisible, using

ideas, walking, stones, water, time, etc, in a flexible way ... It was the antithesis of so-called American Land Art, where an artist needed money to be an artist, to buy real estate to claim possession of the land, and to wield machinery. True capitalist art.' In order to make a work permanent, he takes a photographic record that can be displayed in a gallery or published. He also brings stones and sticks, and sometimes river mud, into the gallery, and makes the same shapes indoors that he makes outdoors.

Long's practice prepared the way for a younger British artist, Andy Goldsworthy, who prefers ephemeral natural materials such as leaves, sand, feathers, water, ice and snow. He makes works, usually one a day, that have a minimal and temporary impact on their surroundings, and he tends to work alone in the landscape, using only the natural materials found immediately to hand at the site, and working with the current weather conditions. Where necessary, he employs tools and motorized vehicles, and not all his works are made in remote places; some are in public urban areas. Keeping to a certain vocabulary of forms -- arches, circles, spheres, holes, lines and spirals -- Goldsworthy differs from other Land artists in that he incorporates colour, utilizing bright leaves and petals. He has made a series of forms of leaves held together with thorns, each form dictated by the architecture of the leaf -- *Thirty-two Leafworks* [231].

231 Andy Goldsworthy, *Thirty-two Leafworks* [detail], 1988-9. 1 of 32. Various leaves, thorns. Dimensions variable. Leeds City Art Gallery, UK

232 Giuseppe Penone, *Tree of 7 Metres*, 1986. Wood. 350 x 30 x 30 cm (138 x 12 x 12 in)

Giuseppe Penone, a significant member of Arte Povera, was born two years after Long. He, too, works in the landscape, as well as introducing natural objects, such as stones and plants, into galleries. Penone's relationship with nature concentrates on the temporal growth process of plants and trees. *Tree of 7 Metres* **(232)** is one of a series of 'Alberi' ('Trees') sculptures that he began in 1969. To create the form, Penone scraped inwards from the surface of a rough block of wood -- he calls this activity 'flaying' -- to reveal the tree's internal structure of core and branches. Here he has left the top and bottom ends of the block undiscovered. The result is that the viewer sees the tree at an earlier stage in its life. In the 1970s he often used his body to leave an imprint on nature as part of a 'transfusion of energies', e.g. he placed casts of his ears, lips and nose over vegetables, which then grew into the moulds, taking on the shape of his features.

Long and Goldsworthy do not impose any personal autobiographical aspects on the landscape, but Ana Mendieta chose a similar approach to Penone, leaving the imprint of her naked body on a variety of landscape elements. She was born in Cuba and sent to an orphanage in Iowa at the age of twelve to escape Fidel Castro's Revolution. This traumatic experience informed her art; she wrote of attempting to fuse her native land with that of her new home, and of fusing her body with the natural world. She took photographs of silhouettes and impressions that her naked body made with the earth in soil, clay, grass, sand, and so forth. The result was her 1970s 'Silueta' (Sihouette) series, which she created on location in Iowa and Mexico.

In a move away from the formal aesthetics of the generation of Land artists in the United States, another group of American artists emerged two decades later, whose aim was to work with living natural materials. In April 1982, Agnes Denes made one of the best-known environmental art projects, *Wheatfield -- A Confrontation* **(233)**, when she planted a two-acre field of wheat in a vacant lot at Battery Park landfill, among the skyscrapers of downtown Manhattan. Volunteers helped her remove trash from four acres of land, spread

225 truckloads of topsoil, and plant the wheat. The field was maintained for four months, irrigated, weeded, and on a hot Sunday in August, the grain was harvested, almost 1,000 pounds of it. Some was sent on exhibition to twenty-eight cities worldwide, some was fed to horses stabled by the New York City Police Department. The wheatfield was two blocks from Wall Street and the World Trade Center, and facing the Statue of Liberty, a site that constituted its 'confrontation'. In 1996, Denes initiated *Tree Mountain - A Living Time Capsule* in Finland, a massive reclamation project involving the construction of a mountain on the site of an old gravel quarry and the planting, by volunteers from all over the world, of 11,000 Finnish pine trees in an intricate pattern on its slopes. She expects it to come to fruition in about 400 years. This work is one of several by female artists who are working with the landscape and taking a nurturing and redemptive approach to the natural world.

Like Denes, Meg Webster works with living plants, creating planting schemes for both rural and urban sites. She also collects ingredients such as earth, moss, flowering plants and hay, which she places in shaped receptacles in temporary gallery installations, accompanied by small waterfalls, fountains and pools. During the 1980s and 1990s, Webster was commissioned by several American museums and universities to make living artworks for their gardens and campuses. *Glen* (1988) was a 42-foot-square temporary planted work for the Minneapolis Sculpture Garden at the Walker Art Center. *Kitchen Garden* (234) was for the Contemporary Arts Museum, Houston, Texas, and consisted of a running stream and 250 varieties of vegetables, herbs, fruit trees, grasses and native plants. These were planted for consumption by local residents or whoever passed by, and the garden was tended by staff members of the museum. Webster's gardens, particularly this Houston example, draw attention to the economy and consumption involved in the production of food, and the need to be ecologically aware of one's surroundings.

233 Agnes Denes, *Wheatfield - A Confrontation*, 1982. Wheat. As installed at Battery Park City, New York, 1 May 1982-30 September 1982

234 Meg Webster, *Kitchen Garden*, 1992-4. Approx. 100 species of native Texan plants, water, straw pathways. Approx. 371.6 m² (4000 sq ft). Planted at the Contemporary Arts Museum, Houston, Texas

Joseph Beuys made several passionate defences of the environment during the 1970s with well-publicized performances that signalled a new artistic approach to nature linked to the rise of the ecology movement of the 1970s, of which he was a seminal mover. In June 1982, while Denes's *Wheatfield* was growing in Manhattan, he launched his *7,000 Oaks*, a social sculpture project to plant seven thousand oak trees in the German city of Kassel. A photograph taken in March 1982 shows the artist planting the first sapling himself, wearing his usual waistcoat and felt hat **(235)**, and watched by interested observers. He specified that each tree was to be accompanied by a columnar basalt stone about four feet high, dug from a local quarry in the Eifel mountains. Later that year he talked of his feeling for the oak: 'I think the tree is an element of regeneration which in itself is a concept of time. The oak is especially so because it is a slowly growing tree with a kind of really solid hard wood. It has always been a form of sculpture, a symbol for this planet.' He also explained why he chose the number 7,000: it was the seventh Documenta exhibition and he discovered that oaks were often planted in groups of seven. However, seven trees would have made too small an impact, so Beuys multiplied this number by 1,000 in order to produce 'a very strong visible result in 300 years'. The project reached completion when the last oak tree was planted at the opening of Documenta 10 in 1997. Beuys had intended that this Kassel project would be the first stage in a mission to set up similar planting schemes around the world; extensions to *7,000 Oaks* can be found outside the Dia Foundation, New York, the Henry Moore Institute, Leeds, and in front of the Art Academy in Oslo, for example.

235 Joseph Beuys planting the first oak tree for *7000 Oaks* at Documenta 7, Kassel, Germany, 1982. 7000 oak trees, 7000 blocks basalt.

One of the most ecologically aware works of recent times was designed by Mel Chin, although the theory behind it was adumbrated by Beuys in the 1960s and 1970s. A strong concern for the earth's endangered ecology underlies much of Chin's sculpture and installations; in the late 1980s he read an article on the use of plants as remedial agents, and began using them as sculptural tools capable of restoring life to a devastated landscape. He also felt that plants could 'carve' away pollution from the earth, so that they worked like a sculptor, with Chin as their director. He located a research scientist, Dr Rufus Chaney, who wanted to use plants in this way, and in June 1991, after looking at sites all over the USA, they chose Pig's Eye Landfill in Saint Paul, Minnesota, as the site for *Revival Field* [236]. There they planted cadmium and zinc hyperaccumulators -- plants that pull heavy metal toxins from the soil, purifying it through a sort of natural alchemical process. Chin arranged the site as a circle within a square, divided into quarters by two elevated walkways. Theoretically, in a few years the hyperaccumulating plants will not only clean the soil but also turn the toxic metals into resources that can be recycled and used. Another plot was planted at Hohenheim University, Germany, in 2001.

Ian Hamilton Finlay lived and worked away from metropolitan art centres, cultivating his private garden as a temple to the intellect, balancing nature with culture. In 1964 he bought a disused farm at Stonypath in the Pentland Hills in Scotland. Up until this time, he had worked as a shepherd and a poet, but with the acquisition of Stonypath, all his unrealized ideas about art and nature were made concrete. In 1980 he named his house and grounds Little Sparta, in honour of the uncompromising militaristic ideals of that Greek state, and the works he made for the garden combine the pastoral, the classical, the military and the polemical [237]. Freestanding sculptures in stone and wood combine with numerous texts from various sources, mostly classical authors and thinkers from the time of the French Revolution such as Louis de Saint-Just.

236 Mel Chin, *Revival Field*, 1991. Landfill, chain link fence, six varieties of plants. 5.6 m² [60 sq ft]. Pig's Eye Landfill, St. Paul, Minnesota

237 Ian Hamilton Finlay, *The Present Order is the Disorder of the Future. Saint-Just*, 1988. 11 stones with carved letters. Dimensions variable. As installed at Little Sparta, Stonypath, UK

238 James Turrell, *Roden Crater* (detail of sky tunnel), 1977-present. Volcanic crater near the Painted Desert, Arizona, partially remodelled by the artist, including underground chambers and the crater bowl.

239 Marc Quinn, *Garden 2*, 2000. Approx. 1000 botanical specimens, 25 tons of liquid silicone, stainless steel refrigerator. 3.2 x 12.7 x 5.4 m (10 ft 6 in x 41 ft 8 in x 17 ft 9 ¾ in)

There is one huge earth moving project that harks back to the 1960s and Land Art, and also to eighteenth-century England, when the moneyed classes were engaged in vast landscaping projects around their stately homes. In 1977, James Turrell bought an extinct volcano in the middle of Hopi Native American territory in Arizona as a place for his largest artwork **(238)**. He has said: 'There is no nature unless we enter it, and it is through art that we can do so and become conscious of this relationship.' Turrell is altering the internal shape of Roden Crater so that it will comprise four spaces or rooms for viewing the sky, the sun, the moon and the stars. More than just an experience of nature, these spaces will offer a revelatory experience of light (see Chapter 10).

If the 1980s revealed strains of a Rousseau-like naturalism, the 1990s ushered in a more artificial outlook, exemplified by the work of Marc Quinn, who began a series of sculptures using fresh flowers in full bloom immersed in liquid silicone, and then set in glass display cases wired to freezer units, which keep the temperature in the cases at around minus 20 degrees Celsius. In 2000 he received a commission from the Prada Foundation in Milan to enlarge the series and create a frozen garden of flowers, titled *Garden 2* **(239)**. In a large glass tank, and using 25 tons of liquid silicone, Quinn fashioned a colourful garden of around 1,000 flowers from all countries of the world, including cacti, roses, tulips, desert orchids, banana trees, tropical fruits and exotic vegetables. No plot in the world could sustain such a mixture of plants growing together, except in this artificial environment, a contemporary Garden of Eden. But if the electric power or the refrigeration unit fails, the flowers blacken, wither and die.

Tania Kovats is fascinated by rocks and geology, and how geological forms reveal the powerful and hidden forces that created them. Since the mid-1990s, she has been making a series of sculptures with the generic title of 'Coast', fibreglass models of sections of British coastal topography, which are either freestanding or hung on the wall. Her work memorializes the forces that created the geology, but she sometimes adds inventions of her own. Additionally, a handful of the reliefs add the ingredient of nostalgia through titles such as *Vera* and *Blue Birds II*, referring to Vera Lynn's wartime song 'The White Cliffs of Dover'. In 2001, Kovats made a different kind of work when she commissioned a copy of a Victorian mountain-making machine invented by a nineteenth-century geologist, who used it to demonstrate his theory of tectonic plate movements **(240)**. *Mountain* was placed in a gallery, where it created contorted geological-like strata from a mix of modern materials, and the results were exhibited as sculptures.

240 Tania Kovats, *Mountain*, 2001. Steel, wood, foam, glass, wax, lead shot. Dimensions variable

241 Jennifer Pastor, *Spring* from *The Four Seasons*, 1994-6. High-density polyurethane foam, brass, hair, paint, copper, plastic, polyurethane paint, oil paint. 7.6 x 15.2 x 3.8 cm [3 x 6 x 11 ½ in]

The Four Seasons [241], by Jennifer Pastor, is a four-piece tableau; a giant moth represents *Spring*, large seashells stand for *Summer*, a life-size corn plant for *Autumn*, and a miniature copse of snow-covered fir trees for *Winter*. They are made from a mix of materials, including polyurethane foam, brass, copper, wood, pipe-cleaners, hair, plastic and oil paint, but these are disguised by Pastor's meticulous craftsmanship. Her first appearance in the art world with *Christmas Flood* in 1994 created a strong impression; it was a tableau of five artificial decorated Christmas trees, carried aloft on a wave of clear cast plastic.

242 Mark Dion, *Vivarium*, 2002. Maple log, soil, aluminium, tempered glass, wood, ceramic tiles. 213 x 152.5 x 762 cm (84 x 60 x 300 in)

In the last two decades, the tree has emerged as the focus for several other artists, either used as a specimen and brought into the gallery, or cast in metal and set outdoors. As an example of the first approach, Mark Dion exhibited a 22-foot-long fallen tree, harvested from a local forest at Redding, Connecticut, and placed in a large, glass greenhouse along with the moss, lichen, fungi and insects that still inhabited it **[242]**. The work's title, *Vivarium*, means a place where live animals are kept under natural conditions for the purposes of study, and Dion's greenhouse provided a stable environment for the continued growth of the rotting tree's vegetable and insect life, allowing viewers to observe both its decomposition and the new life that fed on it. Dion examines the role that museums play in the presentation and interpretation of both the cultural and the natural world in a wide-ranging and inventive series of installations.

For an exhibition in Luxembourg, a living olive tree was set in a large cube of soil at the casino. The artist responsible was Maurizio Cattelan, who had the tree transported from Italy and kept alive by a watering system concealed in the large soil base, which sat directly on the elegant parquet flooring **[243]**. Cattelan presented the tree as a readymade, a thing in the world that already existed and that he had chosen. It was also an act of homage to an unrealized work by an earlier Arte Povera artist, Alighiero Boetti (1940-94), who, in 1970, proposed the planting of a living apple tree on a column of soil 25 metres high, in front of the Fiat headquarters in Milan.

243 Maurizio Cattelan, *Untitled*, 1998. Olive tree, earth, water, wood, metal, plastic. 850 x 500 x 500 cm (334 ¾ x 197 x 197 in).
As installed at Castello di Rivoli Museo d'Arte Contemporanea, Turin

Tony Tasset has made many structures that are rigorously simple and formal in appearance, but in recent years he has moved away from this direction towards one that is autobiographical in content. In an exhibition at the Feigen Gallery, New York, in 2001, he showed the 12-feet-high, painted-wax and steel *Cherry Tree*, a realistic copy of one in his own back garden. The sculpture depicts the tree just beginning to blossom.

An even larger tree was the 50-foot *Bluff* (244), made out of stainless steel by Roxy Paine for the Whitney Biennal of 2002, for which it was temporarily sited in Central Park, New York, boldly announcing its artificiality. Paine has made six large, stainless-steel tree sculptures, between 1999 and today, the first of which was titled *Imposter*. His trees assume naturalistic forms and are placed in naturalistic settings, but their shiny, reflective material and their barren look do not allow them to blend in with the surrounding landscape.

244 Roxy Paine, *Bluff*, 2002. Stainless steel. 15.2 m (50 ft) high. As installed in Central Park, New York

245 Roxy Paine, *Amanita Field*, 2001. Polymer, steel, lacquer, oil. Dimensions variable

In contrast to his trees, Paine has been making trompe l'oeil sculptures of plants and fungi; his meticulous craftsmanship brings to mind the work of model-makers employed by natural-history museums in didactic displays. He concentrates on poppies and mushrooms, plants from which hallucinatory drugs are made. In *Puffball Field* (1998) and *Fungus Formica Field* (1998), various fungi, both deadly and beneficial, stick to a Formica surface. In *Crop (Poppy Field)* (1997-8), a realistic section of earth, 58 x 72 inches, is planted with beautiful poppies. His most spectacular presentation is *Amanita Field* **(245)**, shown at the Galerie Thomas Schulte, Berlin, in 2001, which consists of a realistic-looking collection of the most deadly of the mushroom species. Each is modelled, cast and hand-painted with breathtaking realism, equal to that practised by the Pre-Raphaelite painters of the nineteenth century, or the more recent modelled and painted plant and vegetable sculptures of Italian artist Piero Gilardi.

Hyperrealistic, life-size flowers and plants are created out of carved and painted wood by the Japanese artist Yoshiro Suda. He might show four in a gallery, placing them discreetly so that they could be overlooked **(229)**. One show of four pieces represented the different stages in the life cycle of the magnolia tree -- a dry twig, a fallen brown leaf, a new branch with bright red berries, and a branch with luxuriant white blossoms. Suda explains why he works in this traditional manner: 'A plant can only live by adapting itself to the environment when its seed is first planted in the ground somewhere. If the seed is dropped in myself, then it must acclimatize to the environment that is me. It just so happened that I was a person who sculpted wood.'

Zhan Wang was born in Beijing. Since the mid-1990s he has been working on his series of 'Artificial Rocks'. In 1995, he had a mould made from a rock and then had this cast in stainless steel; he exhibited the stainless-steel rock along with the scattered fragments of the original rock that had served as the model. 'Placed in a traditional courtyard,' he stated, 'rockery satisfied people's desire to return to Nature by offering them stone fragments from nature. But huge changes in the world have made this traditional ideal increasingly out of date. I have thus used stainless steel to duplicate and transform natural rockery into manufactured forms. The material's glittering surface, ostentatious glamour, and illusory appearance make it an ideal medium to convey new dreams.' Interestingly, the Chinese call natural rockeries *jia shan shi*, which means 'fake mountain rocks'.

Jason Middlebrook uses painted wood and Styrofoam to make sculptures that imitate both organic and man-made structures, both nature and culture. In *Strata Garden 2000*, created for the Whitney Museum of American Art, New York, he constructed a fifty-three-foot sculpture that ran along the window of the gallery that faces Park Avenue. On the side visible through the gallery window, the painted sculpture looked like layers of earth from which silk flowers bloomed. On the face visible inside the gallery, it was painted to resemble stone blocks, matching those with which the building was constructed.

One aspect of the natural world that is easier to deal with in painting rather than sculpture is the ephemeral and transient world of climate and weather conditions; John Constable's oil sketches of cloud formations are a notable example. However, two young artists have been making works that deal with atmospheric conditions. Olafur Eliasson, a Danish-Icelandic artist, employs ice, steam, running water and natural effects such as sunlight and rainbows, both outdoors and in the gallery to acknowledge a bridge between nature and culture. Many of his works use the construction of natural effects as a display concept (see Chapter 10).

Inigo Manglano-Ovalle was born in Madrid, raised in Bogota, and educated in America, where he now lives. He has made several videos and sculptures that draw attention to climate and weather, forces that extend beyond political and geographical boundaries and affect everyone living on the planet. His recent weather sculptures include a cluster of clouds and a large iceberg. Both the clouds and the iceberg were based on reality, scanned and scaled down by computers. A 50-metre cumulo-nimbus was the model for his largest cloud sculpture, which measures over 14 feet across, and is made from fibreglass covered with titanium-alloy foil. It is displayed hanging a few inches off the floor, where it looms over the viewer, dominating the gallery space with its shimmering curves **(246)**.

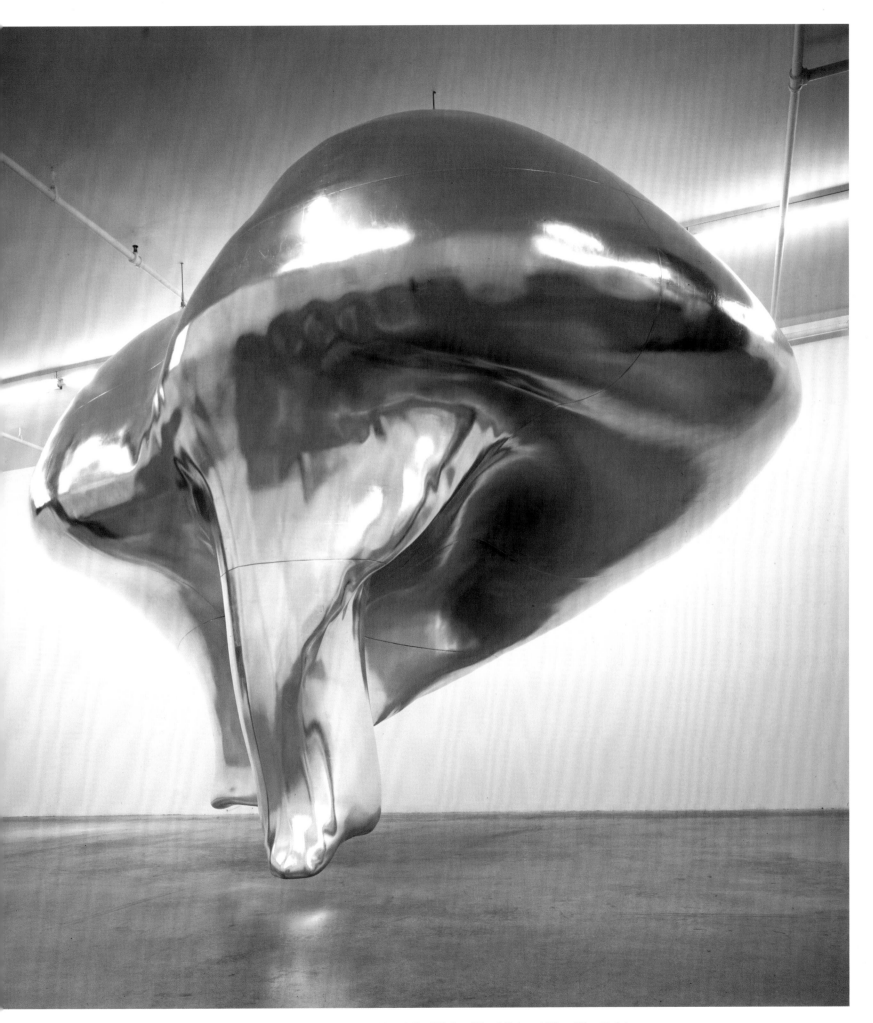

246 Inigo Manglano-Ovalle, *Cloud Prototype No 1*, 2003. Fibreglass, titanium alloy foil. 335.3 x 447 x 243.8 cm (132 x 176 x 96 in)

Colour is optical, formless and created by light. Without it, painting could not exist. Its relationship with sculpture is not so fundamental, but sculptors have applied colour to the surface of their forms for thousands of years. With figurative sculpture, colour decorated and glorified the piece so that it became more realistic and life-like. In abstract sculpture, colour is used to deceive the eye, to flout a sense of gravity or to take attention away from the material of the form. Colour has been the subject of much study since the time of Aristotle, who thought that objects emitted colour. It was not until 1676, when Isaac Newton discovered that sunlight could be passed through a prism to produce the spectrum of colours, that colour was seen to be created by light. Over 130 years later, in 1810, J.W. von Goethe wrote his 'Theory of Colours', which disregarded Newton's findings, and discussed colour in philosophical, moral and sensual terms, using words like 'powerful', 'noble', 'cold', 'gentle' and 'radiant'.

All these discoveries have some bearing on the sculptures discussed in this chapter, which looks at the interrelationships between colour, surface and light, and at the ways in which sculptors use matte, saturated, or refracted colour, choosing whether they want their forms to be reflective, diffractive, absorbent or dematerialized. Sculptors have also used glass, resin and acrylic sheeting, which can be transparent, translucent, opaque, or coloured all the way through, to create other kinds of form and space. Some artists manipulate light in order to create or dissolve form. American James Turrell is one of the foremost artists working with light today, and he has said: 'When you reduce light and the pupil opens, feeling comes out of the eye like touch.'

Donald Judd gave a lecture in 1993 entitled 'Some aspects of colour in general and red and black in particular', the opening line of which was 'Material, space and color are the main aspects of visual art.' Judd came to regard colour as 'the most powerful force' in the world of art, and shortly before his death he was experimenting with it more boldly than ever. In the early 1960s he painted his simple wooden pieces with an unmodulated cadmium red because he felt it made the forms sharper and more vibrant. He moved from using metallic automobile and motorcycle paint to a material that was ready-coloured -- Plexiglas -- an American trade name for extruded acrylic sheet. This was reflective and came in a huge range of colours, both transparent and opaque, and Judd employed it singly and also in layered combinations, so that his use of colour never became obvious or predictable. He paired it with wood, Cor-Ten steel and with aluminium as in *Untitled* **(247)**, but here Judd has chosen to colour the aluminium rather than the acrylic. The luscious colour is countered by the rigid logic of the boxes. In the early 1980s Judd began to make sculptures consisting of bolted aluminium boxes, at first on the wall and then free-standing. He had by this time discovered a factory in Switzerland that could enamel thin sheets of aluminium in a wide variety of colours. *Untitled* **(248)** is a freestanding piece, whose sheets are coloured before being bolted together. The combinations of colour in this work are striking and uncommon, because Judd was determined to avoid obvious harmonies or contrasts, seeking 'a multiplicity all at once'.

Judd's immaculate monochromatic surfaces are matched by those found on the sculptures of John McCracken, whose rigorous working practice has remained unaltered since the early 1970s, when he first emerged on the art scene. Unlike Judd, who employed fabricators, McCracken undertakes all the processes himself: woodworking, resin application and then endless polishing. He makes simple rectangular, vertical forms, which are painted a single colour; the materials are plywood covered by a highly polished fibreglass skin, so that the form seems entirely composed of colour, and the surface appears to shimmer and reflect what is around it. Aristotle's belief that objects emit colour can almost be justified by McCracken's sculptures **(249)**. Some of the dark-hued pieces have an almost supernatural presence, and call to mind the shiny black monolith in Stanley Kubrick's 1968 film *2001: A Space Odyssey*.

247 Donald Judd, *Untitled*, 1990.
Orange anodized aluminium with clear Plexiglas.
457.2 x 101.6 x 78.7 cm (180 x 40 x 31 in);
10 units, each 23 x 101.6 x 78.7 cm (9 x 40 x 31 in)

248 Donald Judd, both works *Untitled*, 1989-90. Enamelled aluminium, galvanised iron. Front piece 150 x 749 x 162.5 cm (59 x 295 x 64 in).
Kunstsammlung Nordrhein-Westfalen, Dusseldorf. As installed at Tate, London

249 John McCracken, *Dimension*, 2004. Polyester resin, fibreglass, plywood. Front piece 243.8 x 76.2 x 36.8 cm (96 x 30 x 14 ½ in)

Judd admired the painted sculpture of John Chamberlain, whose signature works are large sculptures constructed from crushed car parts covered in bright, patterned colours. Although their works do not share a resemblance, both sculptors were searching for the same thing from their materials: Judd sought surfaces and materials that were inherently coloured, and Chamberlain turned to car parts because they were basically a sheet of metal that 'already had a coat of paint on it'. Later on, he applied colour to the metal by stencilling, spraying and dribbling paint in brilliant hues, often incorporating repeated patterning. Although the metal parts that make up the sculpture are heavy and sometimes have jagged edges, Chamberlain diverts the viewer's attention away from such matters with an inventive choreography of forms and ornamentation. More recently, he has started to cut sheet-metal into long, thin, twisted strands; hundreds of these combine to make *The Privet* (250), over 61 feet long, is one of the largest of his works and a supreme example of his newer and lighter phase of sinuous, ribbon-like compositions. The metal forms wriggle upwards like a plant seeking the sun. Elements of the organic and the mechanical intertwine.

250 John Chamberlain, *The Privet*, 1997. Painted mild steel, chromium-plated steel. 3.81 x 18.75 x 0.8 m [12 ft 6 x 61 ft 6 x 30 in]. As installed at Dia: Beacon, New York

251 Frank Stella, *La Colomba Ladra*, 1987. Oil, urethane enamel, fluorescent alkyd, acrylic and printing ink on canvas, etched magnesium, aluminium and fibreglass. Approx. 500 cm (197 in) high

Chamberlain is a decade older than Frank Stella, who began his career as a painter, producing works that stressed their form more than their content. His work gradually became more three-dimensional, including shaped canvases and collages, until he started to produce wall-hung and freestanding flamboyant constructions composed of paint applied to a honeycombed aluminium support; *La Colomba Ladra* is an impressive example (251). It is one of a series of works named after exotic birds, although there are no specific links between the bird and the forms and colours of the relief. The metal relief was fabricated in a factory and delivered unpainted to the artist's studio, where he used a wide variety of colours and finishes to obtain his decorative effects. Stella has spoken of his desire to offer equivalents in his work for the 'chaos and turmoil that are part of the human personality', so his coloured works fit more into Goethe's outlook on colour.

In London in the early 1960s, Anthony Caro began to paint his steel sculptures with very bright colours -- red, yellow, orange and purple. He did this in order to disguise the reality of their heavy steel bars and girders so that they looked effortless and almost weightless, impervious to the power of gravity. Caro's painted sculptures are less solid and monolithic than those of his American counterparts, and seem more like drawings in space (6). His coloured phase did not last long, however, because he felt that it was too easy to make striking and seductive work that was in danger of becoming decorative. He makes the odd coloured work now, stating, 'certain sculptures need it'.

A group of young British sculptors employ colour in their work; the most colourful of them all are the works of Gary Webb, which tread a line between representation and abstraction. He plays with transparency and reflection, and creates vivid juxtapositions of colour, using acrylic sheeting, resin, neon, glass and wood [252]. His inspiration comes from contemporary 'indoor' culture, meaning restaurant decor, shopping malls and advertising, and several of his works include sound as a component part. Webb's contemporary, Jim Lambie, gives great prominence to surface, since his work mainly consists of sticky coloured tape applied to gallery floors, in rhythmic waves or sharp-edged patterns.

If Judd and others cared about the formal tension between colour and surface, Anish Kapoor, Wolfgang Laib, David Nash and Katharina Fritsch, all European artists, look more in the direction of Goethe's researches and use colour for emotional and symbolic reasons. All four usually keep to single colours, which gives their work a strong optical impact, lending it a powerful physical presence. Fritsch applies her colour monochromatically to figurative images. She uses matte, saturated colour, evenly distributed over the chosen form. Her palette is restricted to yellow, black, white, green and red. Between 1999 and 2001, she created three larger than lifesize figures: *Doctor* in dazzling white, *Monk* in matte black, and *Dealer* in rich scarlet [253-4]. He stands before the viewer, aloof in his suit, tie and pony-tail, ready to undertake any financial transaction. But close examination of the figure reveals that one of his feet is replaced by a cloven hoof, a feature traditionally associated with the Devil.

Kapoor was born in Bombay and studied in London, but a visit to India in 1979 reawakened cultural memories that were to inform a body of his work that dealt with colour. In the early 1980s, his sculptures consisted of simple forms covered in dry, loose pigment in saturated colours such as red, yellow and blue [255], and he has stated that 'The act of putting pigment on these objects removes all traces of the hand. They are not made, they are just there.' His use of dense, pure pigments tends to dematerialize his forms, making them harder to read as solid shapes. In several works, the pigment falls off the form, leaving a penumbra of colour on the floor around it, rather like a halo.

Laib uses the unique material of raw pollen as a substance for making sculpture, both as a coloured pigment and as a structural material. He lives near a small village in southern Germany whose inhabitants traditionally spend from February to September every year collecting pollen from blossoms in the surrounding meadows and woods, usually pine, hazelnut and dandelion. Laib finds pollen beautiful, ephemeral and dense. He made *The Five Mountains Not to Climb On* (1984) from dandelion pollen, small pyramids of orange-yellow, 7 centimetres high, placed directly on the gallery floor. They are extremely vulnerable and fragile, as their title hints, but also very strong in their chromatic intensity. Besides making tiny pollen mountains, Laib spreads large carpets of pollen on the gallery floor, and these ephemeral rectangles recall American colour-field paintings [256].

The question of whether black and white can be considered colours has occupied theorists since the time of Newton; he thought not, while Goethe proposed that they can, and used them to make moral comparisons between darkness and light. The social philosopher Rudolf Steiner (1861-1925) edited Goethe's papers and believed that black carbon was the primary matter from which everything else comes, and he backed up this belief by invoking the biblical statement about God creating the world by separating light from darkness, which implies that darkness precedes light. David Nash, who works with wood, is an admirer of the work of Steiner, and he began in 1975 to char the surface of some of his pieces, either by placing them in a fire or stove, or using a blowtorch, changing the surface layer of the wood from a vegetable material into a mineral -- carbon. *Vessel and Volume* [257] is a charred sculpture comprising two parts, the smaller of which has been cut out of the

252 Gary Webb, *Miami Gold*, 2005. Steel, Q-Cell, glass, electronics, speakers. 167 x 104 x 90 cm (65 ½ x 41 x 35 ½ in)

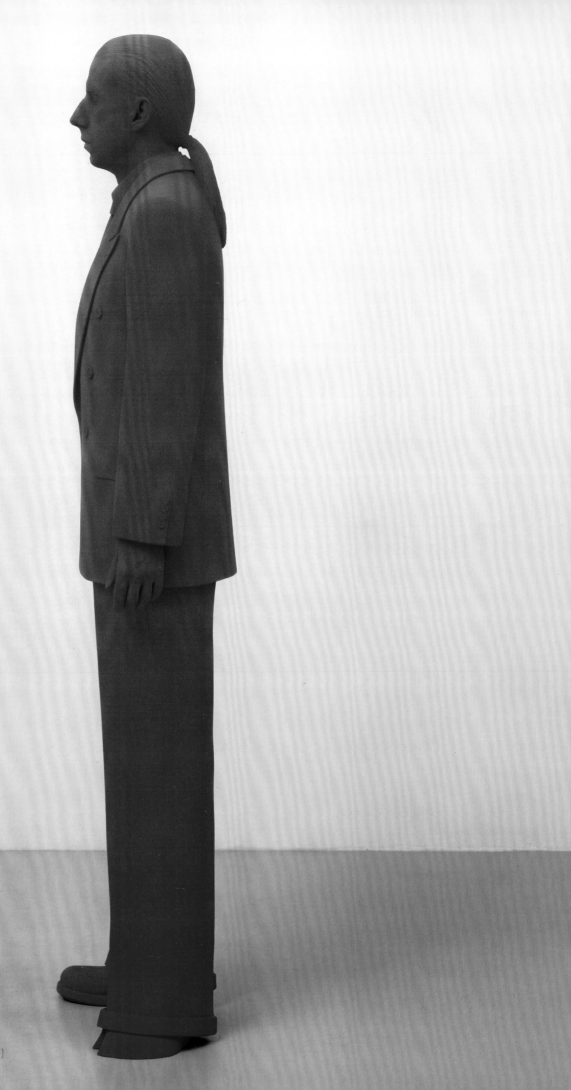

253-4 Katharina Fritsch, *Dealer*, 2001.
Polyester, paint. 192 x 40 x 59 cm (75 ⅝ x 15 ¾ x 23 ¼ in)

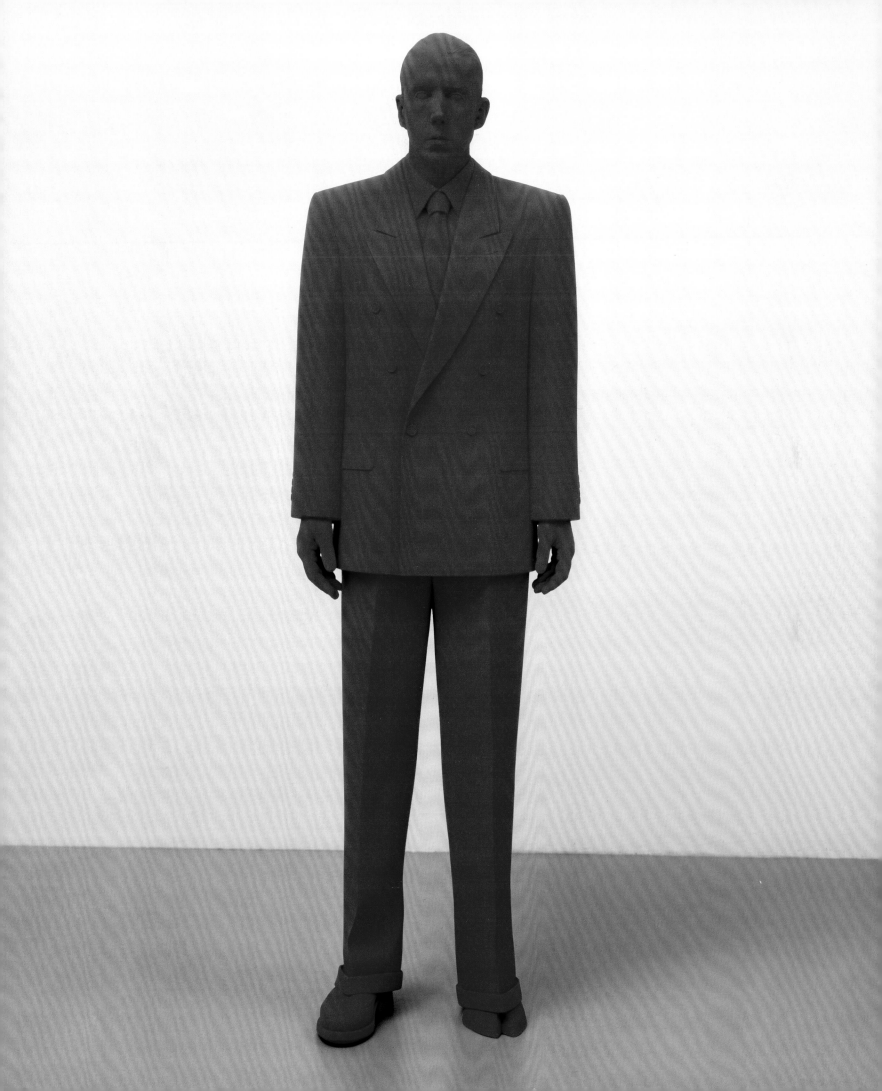

255 Anish Kapoor, *White Sand, Red Millet, Many Flowers*, 1982. Wood, cement, pigment. Dimensions variable

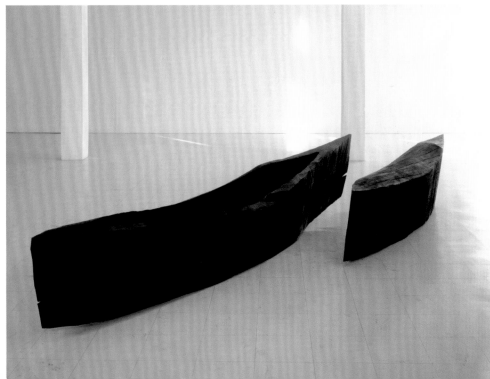

256 Wolfgang Laib, *Pollen from Hazelnut*, 1993. Pollen from hazelnut tree. 320 x 360 cm (138 x 141 ¾ in)

257 David Nash, *Vessel and volume*, 1988. Burnt oak wood. Dimensions variable. Musée des beaux-arts et de la dentelle, Calais, France

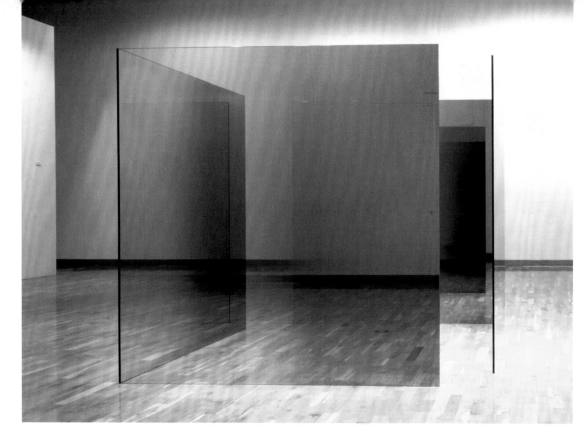

258 Larry Bell, *6 x 6 x 4 AB*, 1995. Four panels of 12 mm glass coated with nickel chrome. 182.9 x 182.9 x 1.2 cm (72 x 72 x ½ in)

larger. Nash has discovered that the black surface distances the viewer so that they experience the shape of the sculpture before they acknowledge that it is made of wood. The smell of the charring lingers, and provides the viewer with another sensory experience.

In complete contrast to this chromatic display are works using glass and mirrors, transparent and translucent panels and polished surfaces, which reflect, diffuse and transmit light. Many of the artists who work in this way are based on the West Coast of America, centred around Los Angeles, and this area, with its plentiful sunlight, has long been associated with experiments in luminosity. The California Light and Space group of artists emerged in the 1960s, and included Larry Bell, Robert Irwin, James Turrell and Bruce Nauman. Bell began to use refractive and reflective materials such as mirrors and tinted glass, and in doing so introduced a new ingredient into his sculpture: the viewer, whose image was combined or superimposed on that of other viewers and reflections of the surrounding environment. Viewers thus became aware that they were the primary objects of perception, and could see themselves caught in the act of looking at a work of art. This slightly unnerving condition altered their experience of the work of art and drew them unwittingly into a web of phenomenological ideas. Maurice Merleau-Ponty's 1962 book *Phenomenology of Perception* was popular reading among the California Light and Space group.

Bell started as a painter, but since 1962 has made glass and mirrored sculptures of refined simplicity. He began with boxes and cubes, and then moved on to making works of an environmental nature. These, including *6x6x4 AB* **(258)** usually consist of between four and ten panels placed at right angles to each other. Some panels are transparent, while others are coated with a thin film of quartz, silver or nickel-chromium. Bell has also made glass boxes for outdoor display, such as *Made for Arolsen* (1992), a piece that was set in a pool in the garden of the museum at Mönchengladbach, bringing the element of water into the equation, and enriching the perceptive experience.

259 Robert Irwin, *1234*, 1992. Three voile tergal (scrim) walls, violet, green, black acrylic laque, front to back. Three walls, each: 4.27 x 11.58 m (14 x 38 ft)

Irwin began to use new materials in order to work with light and space. He, like Bell, was interested in materials that possessed the capacity to dissolve form and eliminate the object. He too began as an Abstract Expressionist painter, but gave it up in 1970 in favour of environmental works that manipulate and augment the viewer's apprehension of the space in which he stands. In works such as *1234* **(259)** Irwin works with ephemeral and transparent materials, such as nylon scrim, nylon organza, tape and string, creating veils and wall divisions that alter the viewer's experience of light and space. Existing windows, doors and lights offer a soft, diffused light onto the space, so that this atmospheric work appears as though seen through a gentle fog.

Turrell is fascinated by the effect of light on space and how this affects the viewer's perception. He studied perceptual psychology and mathematics at college, and became interested in Merleau-Ponty's exploration of the relationship between perception and illusion. His career began with gallery installations in which light was perceived as a physical, almost tactile presence (260), but, following his *Skyspaces*, he moved on to working with natural light, out of doors. He is also a pilot, and in the early 1970s he flew over the western states of America, looking to purchase a volcanic crater in which to create his masterwork. In 1974 he bought Roden Crater, an extinct volcano in the Arizona desert, and the work that he is creating there is probably the most ambitious work of art ever undertaken by a single artist (238). Inside the crater, Turrell has gouged out underground tunnels leading to observation chambers, where the viewer can scrutinize the various qualities of sunlight, moonlight and starlight. Turrell deals in geological and astronomical magnitudes; he is harnessing red-shifted light that comes from outside our galaxy and is at least three and a half billion years old by the time it reaches our eyes; the light from the sun, in comparison, is only eight-and-a-half minutes old.

Dan Graham has been making a wide variety of works since the 1960s that deal with the mechanisms of perception. Like Bell, Graham uses two-way mirrors and transparent glass to make indoor and outdoor cubicles or pavilions, onto which he projects videos, multiplying the possibilities of reflection and overlay of imagery (261).

Robert Morris also made regular geometrical forms such as cubes, using glass and mirrors. *Untitled* (262) consists of four identical cubes made from mirror plate glass over board, first made in 1965 and remade in 1976 with more stable and permanent materials. When he first exhibited *Untitled*, 'the space between the boxes was equal to the combined volume of the 4 boxes' but this rule does not have to be followed. When his large cubes of mirrored glass are placed in a gallery, their forms are interrupted by the reflections of the architecture of the gallery, the viewers and the other cubes, making it impossible to see the work independently of the space, light, and the viewer's field of vision. 'Simplicity of shape does not necessarily equate with simplicity of experience,' states Morris.

More recently, a handful of female sculptors have employed mirrored and coloured glass, foremost of which are Katy Schimert and Roni Horn. (As we saw in Chapter 2, Kiki Smith, Jana Sterbak and Asta Groting use cast glass to make body parts.) Horn's work takes water as its theme, while Schimert's themes are mythological, involving both real and imaginary characters from the past and the present. The sun and the moon are symbols that she regularly uses, and her sun works are related to the story of Icarus. *The Sun* (263) is composed of numerous yellow and gold, blown-glass shapes, which are arranged in a loose circle on the wall. Early in her career, Horn made a series of coloured glass wedges -- six chromatic variations from yellow through red to blue -- resting on small shelves above head height, called *Untitled* (1974-5). Fascinated by stained-glass church windows -- both the chemical process of their creation and how they imbue the purely visual phenomenon of illuminated colour with palpable presence -- she decided to study chemistry at university before going to art school, where she learnt how to make coloured glass. Her *Gold Field* (1980-2) presented a quantity of pure gold in all its spectacular quiddity. A sheet of gold leaf, 5 x 4 feet, rests on the floor, devoid of image, form or mass. Its appearance is its substance. *Untitled (Flannery)* (264), whose title refers to the American novelist Flannery O'Connor, consists of a pair of solid, blue-glass shapes. The blocks were cast in moulds, but the top surface was not in contact with the mould when cast, and has a different finish; it is transparent compared to the translucent sides.

260 James Turrell, *Catso, Red (1967)*, 1994. Drywall, paint, xenon projector. Dimensions variable. The Mattress Factory, Pittsburgh, Pennsylvania

261 Dan Graham, *Two Different Anamorphic Surfaces*, 2000. Two-way mirror, glass, stainless steel. 250 cm (98 ½ in) high. Wanås Sculpture Park, Knislinge, Sweden

262 Robert Morris, *Untitled*, 1971. Plexiglas mirrors on wood, four units. Each 53.3 x 53.3 x 53.3 cm (21 x 21 x 21 in)

263 Katy Schimert, *The Sun*, 1998. Blown glass. 243.8 cm diameter x 45.7 cm (96 in diameter x 18 in)

264 Roni Horn, *Untitled (Flannery)* (detail), 1996-7. Optically clear blue glass, two units.
Each 28 x 84 x 84 cm (11 x 33 x 33 in). Solomon R. Guggenheim Museum, New York

265-6 Anish Kapoor, *Cloud Gate*, 2004. Stainless Steel. 20.12 x 10.06 m (66 x 33 ft). Millennium Park, Chicago, Illinois

Since the 1990s, Kapoor has moved on from his powdered pigment shapes to working with shiny surfaces and transparent resins, some of which are monochrome while others are bright in colour. One of his most impressive pieces, amongst the largest sculptures in the world, is his *Cloud Gate* (2004), sited in Chicago's Millennium Park **(265-6)**. It took fabricators in Oakland, California, over two years to make it, and it stretched their technical capabilities to the limit. The 110-ton elliptical shape, 66 x 33 feet, with a central depression through which the public can walk, is made of forged stainless-steel plates. These were rolled by hand, plasma-welded and then hand-polished to give the work a mirror-like surface, which reflects not only the city's architecture and the passing clouds, but also the viewers.

Highly polished surfaces are a hallmark of the sculptures of Shirazeh Houshiary. She is a follower of the Sufi religion and introduces its spiritual beliefs into her work, particularly the idea of the dematerialization of form. She works in a wide range of materials such as copper, zinc, brass, tin, lead, gold and silver, all of which have seductively shiny surfaces. Her early work was biomorphic in shape, but she progressed to complex geometrical structures in the 1980s. In 1992, she produced a major work, *Isthmus* **(267)**, a large, shallow, rectangular box made of burnished copper, split in two, with a narrow path between the two sections that viewers could traverse. The outer walls of the box are burnished copper, as are the inner walls, which reflect the ambient light with a surprising and rich intensity, causing disorientation to the person who walks through the work.

267 Shirazeh Houshiary, *Isthmus*, 1992. Patented copper, aluminium and polished copper. Two parts, 340 x 220 x 90 cm (133 ¾ x 86 ½ x 35 ½ in) and 340 x 500 x 90 cm (133 ¾ x 197 x 35 ½ in)

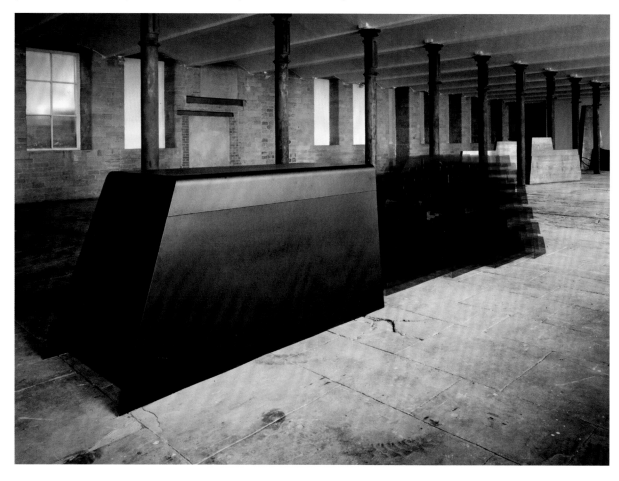

268 Alison Wilding, *Assembly*, 1991. Mild steel, brown PVC sheet. 123 x 174 x 547 cm (48 ½ x 68 ½ x 215 ½ in)

Alison Wilding is a contemporary of Houshiary, and both women passed though a phase where they patinated or burnished the reflective surfaces of their metal sculptures to increase their intensity and dissolve their materiality. In works such as *Receiver* (1988), Wilding uses copper, brass, galvanized and leaded steel, along with wood, usually oak, rubber sheeting and stone. Her titles reference water, fluidity and light, and her materials contrast transparency and opacity, light and shadow, weight and immateriality. In 1990, she introduced sheets of semi-transparent polypropylene into her vocabulary, setting these against stone and metal, and allowing the denser material to insinuate its presence into its neighbour in a symbiotic relationship. *Assembly* **(268)** comprises a steel container and a complementary shape made from slotted sheets of coloured PVC; according to the artist, the steel is a 'tunnel with no light at the end, while the other form is light, liquid and life'.

Rachel Whiteread worked as Wilding's assistant for a while, and they share some sensibilities with regard to choice of materials, particularly a desire to experiment with transparency as a quality. In 1998, Whiteread was commissioned by New York's Public Art Fund to create a sculpture for the city. She came up with *Water Tower*, a sculpture for the rooftops made from a translucent, glass-like resin that is so clear that at times it is almost invisible against the sky, while at other times it captures and intensifies the changes of light. She had a cast made from a wooden water tower sited on a rooftop at East 79th Street, 4 metres high and 3 wide, and into this was poured 4 ½ tonnes of clear polyurethane resin. In its pure transparency, it is reminiscent of both glass and water **(269)**.

There is another band of artists who use light in formal, literal and phenomenal ways, both in its natural state -- sunlight -- and in its artificial state -- electricity. Among the first to use electric light at the beginning of the 1960s were Chryssa, Dan Flavin, Keith Sonnier, Bruce Nauman, Joseph Kosuth and Brigitte Kowanz; all experimented with neon and fluorescent tubes, introducing a radical new material into sculpture. To begin with, these artists utilized neon in a way that mimicked its use in advertising signs. The first neon sign in America appeared in a car showroom in San Francisco in 1922, and by the 1950s, Times Square was a psychedelic riot of coloured signs. Flavin served in the meteorological branch of the US Air Force and then at the National Weather Analysis Center. This training, dealing with space, atmospheres and changing light conditions, may have had a bearing on his pioneering work, which used electric light and colour. From 1963, he confined his practice to standard, commercially available fluorescent light fittings, which come in four lengths (2, 4, 6 and 8 feet), five colours (red, pink, yellow, green, blue) and four kinds of white. *Untitled (for Ellen)* **(270)** comprises two pink eight-foot tubes that face the viewer, while hidden from view a blue and green tube face the wall and flood the corner with colour, merging blue with green. Works like this one, permanently illuminated when displayed, have a haunting presence in themselves, as well as affecting the viewer's perception of the space in which they are placed. The colours wash the walls and spill onto the floors and the bodies of the viewers.

In the 1990s, Brigitte Kowanz made a series of fluorescent light works entitled 'Light Is What We See', which incorporate Morse-code signals. In the nineteenth century, Samuel Morse invented this method, whereby letters could be transmitted via a system of electrical impulses. Kowanz has translated these signs into light impulses -- circles and lines -- so that the medium of light becomes intertwined with the medium of language, although unless viewers are conversant with the Morse code, they will not receive the message. *Lumen* **(271)** is a wall piece consisting of five fluorescent light tubes which spell out the work's title in Morse code. As well as being formally attractive, this piece is an elegant meditation on codes of knowledge, with light as both subject and material.

269 Rachel Whiteread, *Water Tower*, 1998.
Translucent resin, steel. 340.4 cm (134 in) high;
243.8 cm (96 ft) diam. Originally sited on roof
at 60 Grand Street & West Broadway,
New York; now sited on roof at The Museum of
Modern Art, New York

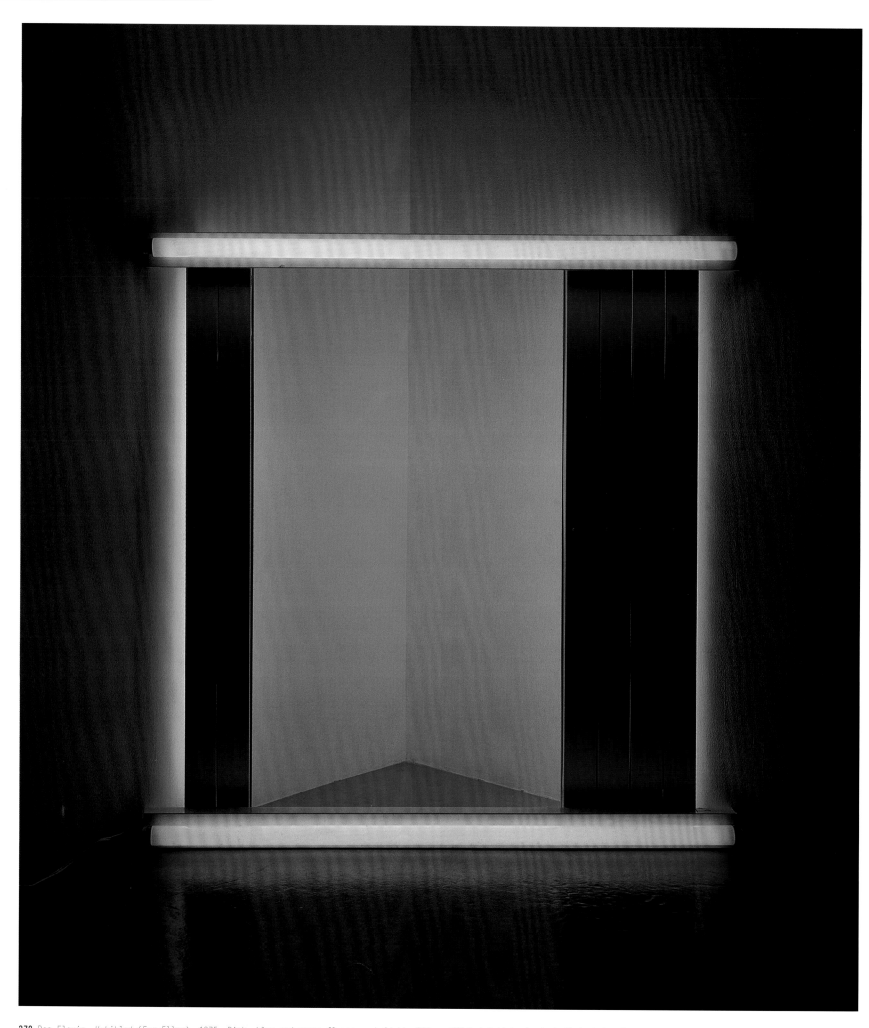

270 Dan Flavin, *Untitled (For Ellen)*, 1975. Pink, blue and green fluorescent light. 224 cm (88 ¼ in) high. As installed at Donald Young Gallery, Seattle, Washington, 1994

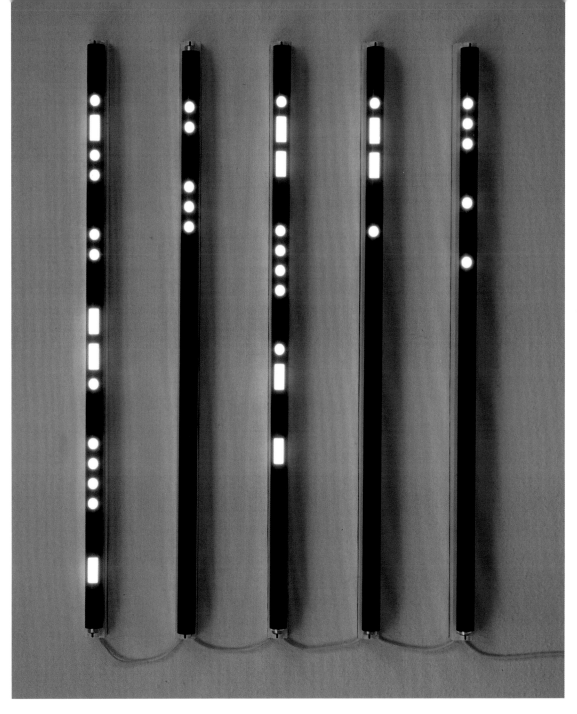

271 Brigitte Kowanz, *Lumen*, 1997. Fluorescent lights, fixtures. Dimensions variable

Bruce Nauman started to make figurative and textual neon works in the early 1970s; these were brightly coloured as well as full of content, usually of a sexual or violent slant, as in *Run From Fear/Fun From Rear*, 1972. A later neon work, *White Anger, Red Danger, Yellow Peril, Black Death* [272], is a powerful quartet of statements that touch on our fears and prejudices concerning racism, xenophobia and illness. The strength of the message is enhanced by the formal arrangement on the wall, with two phrases set upside down, all opposing one another while vying for our attention.

Another thinker who uses neon is the Conceptual artist Joseph Kosuth. He was one of the first to employ it as a material, realizing its communicative potential. *Wittgenstein's Colour* [273] is both an object and a concept. It is red in colour and it informs you of that fact by also forming the word 'red'. For Kosuth, art is self-reflective; its objective is to question what art is.

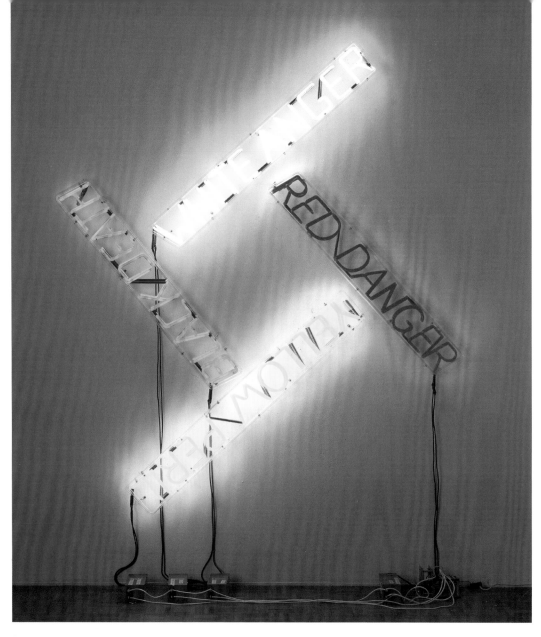

272 Bruce Nauman, *White Anger, Red Danger, Yellow Peril, Black Death*, 1985. Neon, glass tubing. 203.2 x 219.71 cm (80 x 86 ½ in)

273 Joseph Kosuth, *Wittgenstein's Colour*, 1991. Neon, glass tubing. 16 x 38 cm (6 ¼ x 15 in)

A younger generation of artists has followed these neon pioneers. David Batchelor's book *Chromophobia* discusses the attraction and fear of colour, and posits that it is seen to be superficial, feminine, cosmetic, dangerous and alien. Armed with this information, Batchelor goes in search of discarded metal boxes that housed signs, such as exit, shop or road signs, and uses them in his work. He also buys old metal office shelves and trolleys. He fits colourful acrylic sheeting and neon tubes into the boxes and makes untidy chromatic towers, behind which are cascades of looped and twisted black electrical cords (274).

Erwin Redl's art is concerned with 'how abstraction becomes a physical sensation'. He works with lines and grids, and recently has been exploring LEDs as a sculptural medium. These tiny, bright lights are commonly used in digitally programmed arrays to create simple repeating texts, usually of welcome or warning. Redl liberates the electronic components from their communicative function to create large-scale architectural installations. Stringing together thousands of LEDs, he creates walls of light (275), transforming a medium best known for conveying ephemeral, digitized information into powerful visual interventions.

Probably the most formless of all the dematerialized works in this chapter are Ann Veronica Janssens's sculptures made from coloured fog. She has written of her work as 'places for the capture of light', and states that she wants to push back the limits of perception. When viewers enter one of her coloured fog installations, which take place both indoors and outdoors, they are immediately aware of the precarious position of their bodies in space, not being able to see fully the confines of the gallery or the position of other viewers. Her *Blue, Red and Yellow* (276) is a cuboid measuring 3.5 x 9 x 4.5 metres, with translucent walls covered in transparent films of colour. The cube was filled with a dense mist, which altered as the viewer moved through it 'in a dematerialized coloured abstraction'.

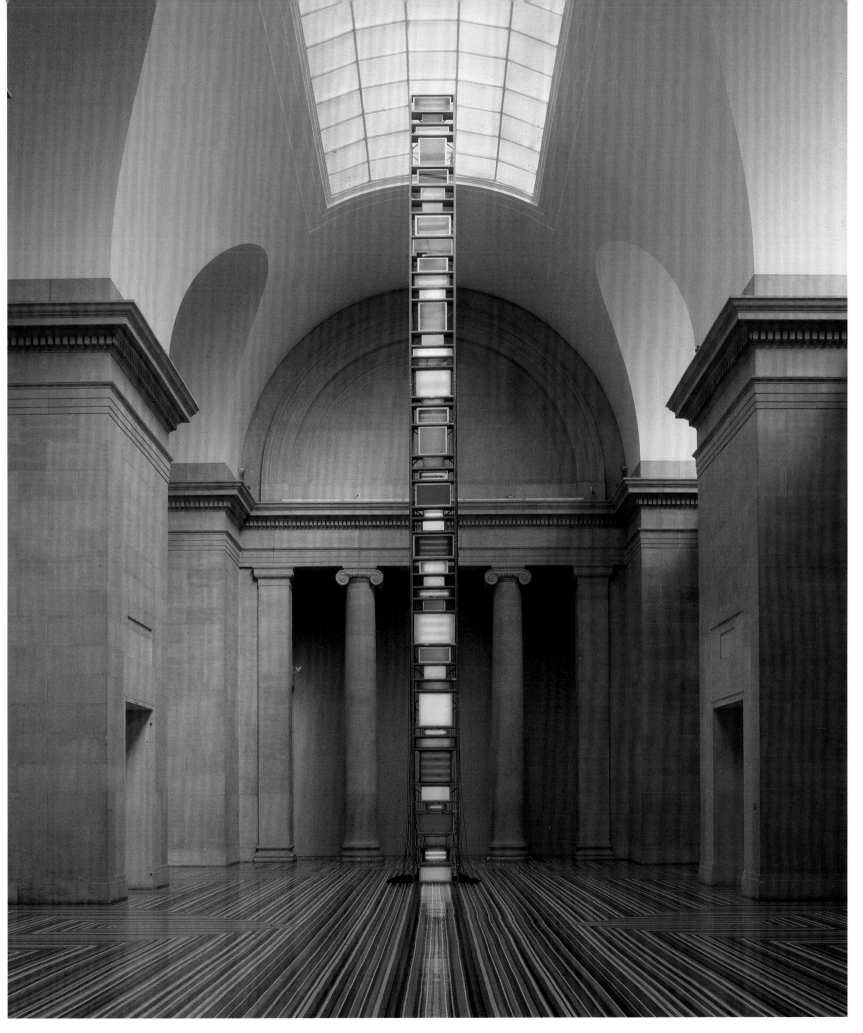

274 David Batchelor, *The Spectrum of Brick Lane*, 2003. Mixed media. 1497 x 91 x 31 cm (589 ¾ x 35 ¾ x 12 in). As installed at Tate, London (floor: Jim Lambie, *Zobop*, 1999–2003)

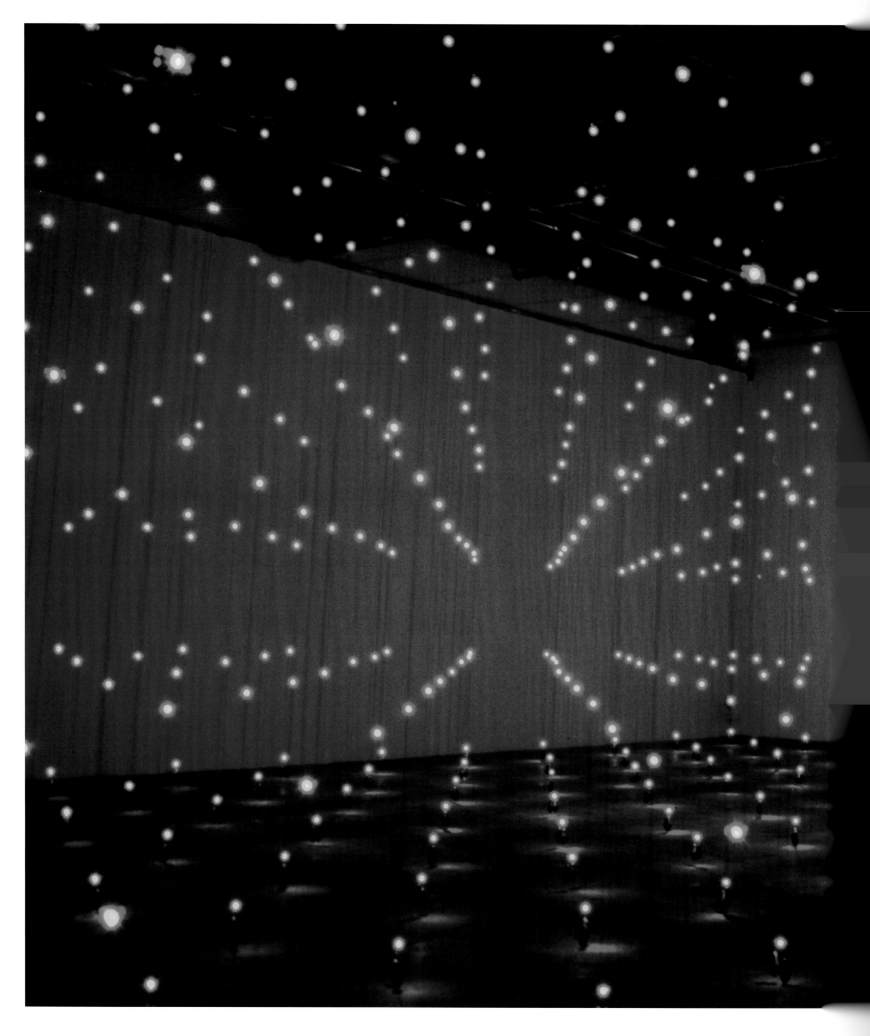

275 Erwin Redl, *Matrix II*, 2000-3. LED, mixed media. Dimensions variable. As installed at Riva Gallery, New York

276 Ann Veronica Janssens, 16 views of *Blue, Red and Yellow*, 2001. Pre-fabricated greenhouse, coloured glass panes, artificial fog. 350 x 900 x 450 cm (137 ¾ x 354 ¼ x 177 ¼ in). Neue Nationale Galerie, Berlin

One of the most popular installations in the vast Turbine Hall at Tate Modern in London was *The Weather Project* by Olafur Eliasson, made during the winter of 2003 (277). He has a similar aesthetic outlook to Janssens, and uses light, heat, wind, fire, steam and ice -- basically natural phenomena -- in urban settings. His ongoing preoccupation is the study of ways in which humans perceive natural phenomena, and his intriguing large-scale works allow the viewer to examine what they are experiencing: 'The benefit in disclosing the means with which I am working is that it enables the viewer to understand the experience itself as a construction and so, to a higher extent, allow them to question and evaluate the impact this experience has on them.' High up on the end wall of the Turbine Hall, which is over 500 feet long, Eliasson set a representation of the sun, composed of hundreds of mono-frequency lamps, the kind used in street lighting, and he clothed the ceiling with mirrors. A fine mist hung in the air, which added to the intensity of the experience, lifting the spirits of Tate's winter visitors.

277 Olafur Eliasson, *The Weather Project*, 2003. Mono-frequency light, reflective panel, hazer, mirrored foil, steel. 26.7 x 22.3 x 155.44 m (87 ft 7 x 73 ft 2 x 509 ft 11 ½ in). As installed at Tate, London

The poet Guillaume Apollinaire described memories as 'hunting-horns, whose noise dies away in the wind'. Tender, ephemeral memories do disappear if they are not revived and preserved, and art is possibly the most potent vehicle to deal with collective and personal memories in a direct and physical manner. Art offers an opportunity to reflect on the major facts of our lives both ordinary and extraordinary: love and death, sexuality and spirituality, the innocence of youth and the wisdom and experience of old age. Much contemporary sculpture deals with these emotional and psychological states in a rich diversity of ways.

Childhood and adolescent memories have been the springboard for many artists; one who has probably mined the seam of childhood memories the deepest is Louise Bourgeois, who has said: 'The artist remains a child who is no longer innocent yet cannot liberate himself from the unconscious.' Her work and interviews have revealed much about her childhood emotions and the role played by her parents in her psychological development. She made a series of room-like installations called 'Cells', and probably the most powerful pair are *Red Room (parents)* and *Red Room (child)* **[279]**. In the latter work, the various red items placed on the furniture, including casts of intertwined hands and arms, and large reels of yarn, evoke a sense of danger, blood and violence, yet there are hints of tenderness. She has spoken of her need to make these large-scale enclosures of sections of her past, and how her reconstructions act as exorcisms: 'I have paid my debt to the past and I'm liberated.'

Edward Kienholz also makes environments, more often with a strong view on social inequalities, but one of his most unusual works is a multi-layered reflection on his childhood. *Mine Camp* **[280]** is a tribute to his father, who took him camping as a child. The figures in his complex sculptures were often cast from life, from relatives and friends, and the figure of his father was taken from the artist himself, since his father was dead by the time this work was created. *Mine Camp* is the largest and most complex casting in bronze of his career, and possibly for Kienholz, like Bourgeois, it works as a mix of memorial tribute and exorcism. But the work is not purely autobiographical, since its punning title has a wider meaning. Ricky Swallow, an Australian artist living and working in Los Angeles, found that the geographical distance from his homeland caused him to turn his attention to 'the conditions and traditions I was brought up around'. The work that resulted from this internal investigation was *Killing Time* **[282]**, a still-life tableau of marine items on a table top, all carved with virtuosic ability. Swallow's father was a fisherman, who caught the kind of sea creatures that are arranged on the table; the work celebrates Swallow's family and the traditional profession of fisherman, as well as the art-historical genre of the still-life, which as we have seen, is often used as a memento mori.

Since the early 1980s, Martin Honert, who lives and works in Dusseldorf, has been inspired by his childhood memories to make single- and multi-part sculptures that call up a world unruffled by psychological damage. His work has a formal simplicity and purity that relates both to children's drawings and illustrations found in children's books. For his sculpture *Foto* **[281]**, he used a photograph taken on holiday of the Honert family seated round a table, but the artist has excluded his parents and brothers from the composition so as 'to isolate this brief contact between the camera and me'. He remembers being fascinated by the whirring of the camera's self-timer, and was the only one to look directly at it; this is the moment captured in the sculpture.

278 Christian Boltanski, *Monument*, 1985. Photographs, metal frames, light bulbs, wire. Dimensions variable

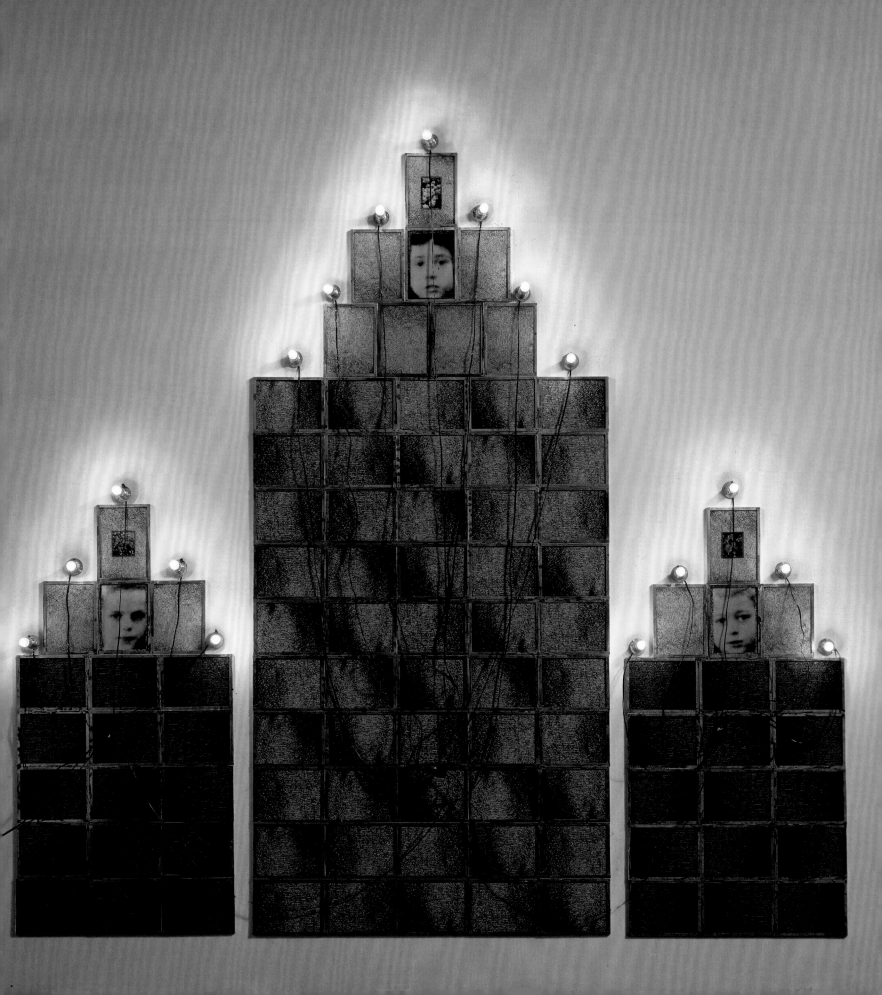

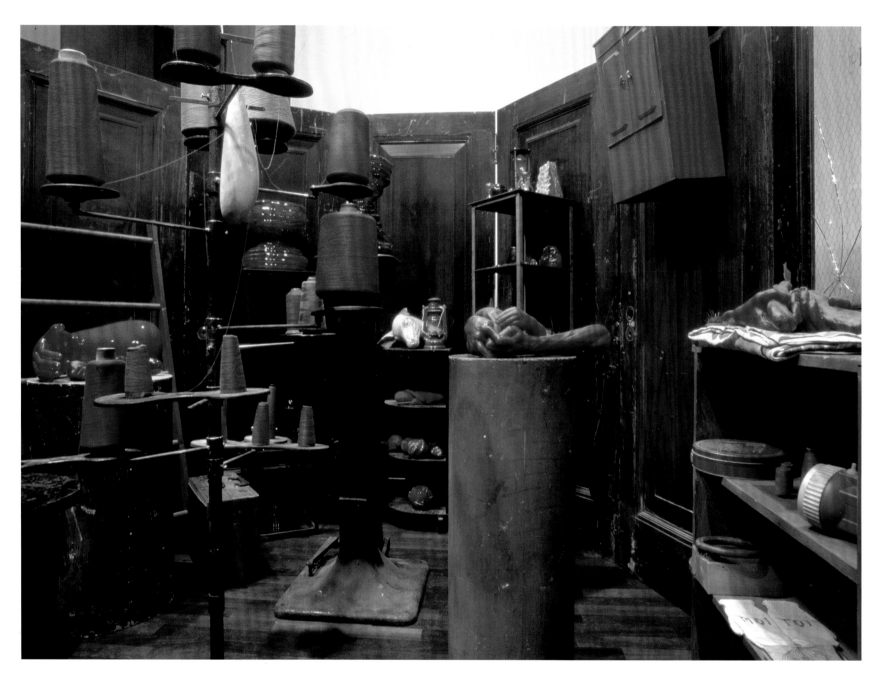

279 Louise Bourgeois, *Red Room (child)*, 1994. Mixed media. 210.8 x 353 x 274.3 cm (83 x 139 x 108 in). Musée d'Art Contemporain de Montréal, Quebec

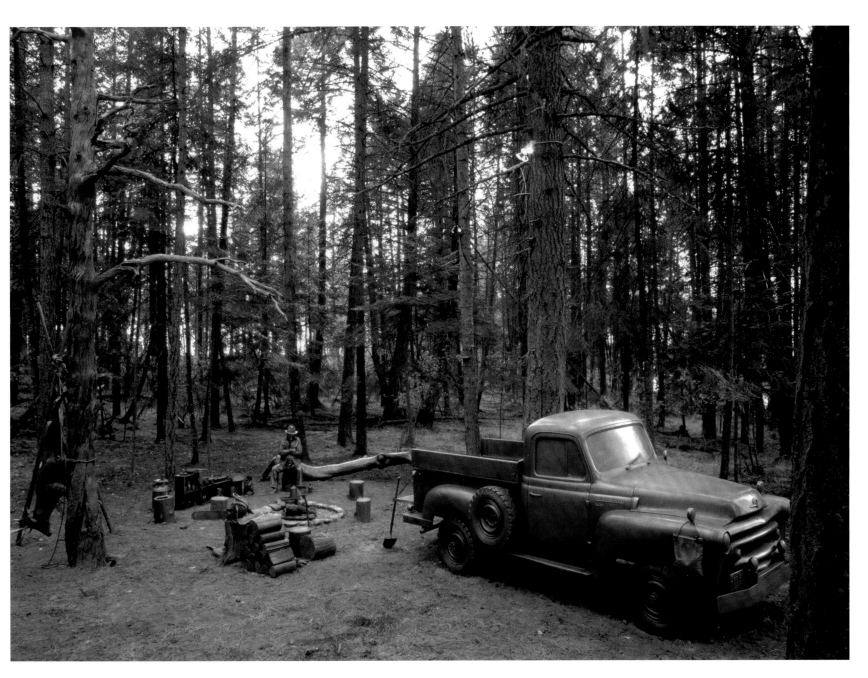

280 Edward Kienholz, *Mine Camp*, 1991. Life-size bronze casts including seated figure of hunter (portrait of Edward Kienholz), pickup truck, dead tree with hanging slain deer, campfire, cooking utensils, guns, tools. 9.1 x 14.0 x 10.9 m (30 x 46 x 36 ft)

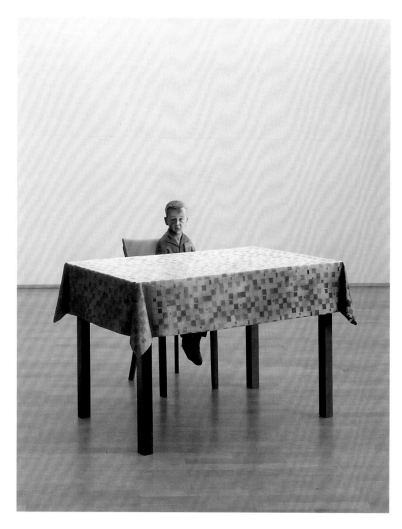

281 Martin Honert, *Foto*, 1993. Polyester, wood, paint, chair.
107 x 133 x 86 cm [42 x 52 ½ x 34 in]

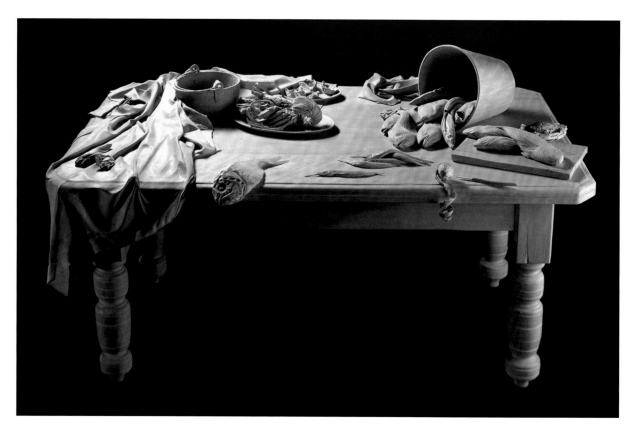

282 Ricky Swallow, *Killing Time*, 2003-4. Laminated jelutong, maple. 108 x 184 x 118 cm [42 ½ x 72 ½ x 46 ½ in]

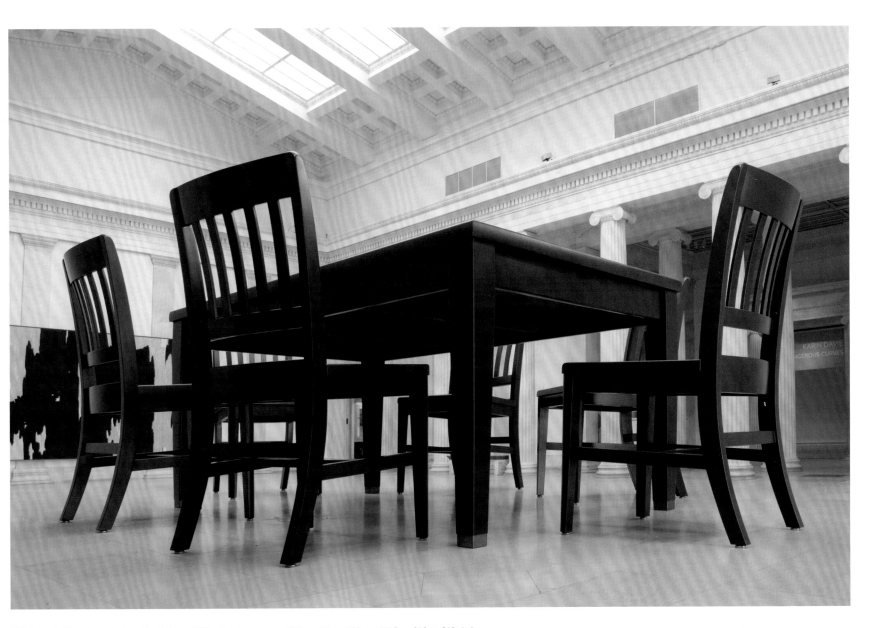

283 Robert Therrien, *Under the Table*, 1994. Wood, enamel. 297 x 549 x 793 cm (117 x 216 x 312 in)

Across the world in Los Angeles, Robert Therrien made a complementary piece that related back to his childhood: *Under the Table* **[283]**. He prepared himself by taking hundreds of photographs of the undersides of his own kitchen table and chairs, and then he made a sculpture that doubled the size of the furniture in order to evoke an emotional response in the viewer. It succeeds because the viewer can either see it as belonging to a race of absent giants, or as a reminder of their own childhood memories, since their head will only reach to the height of the chair seats.

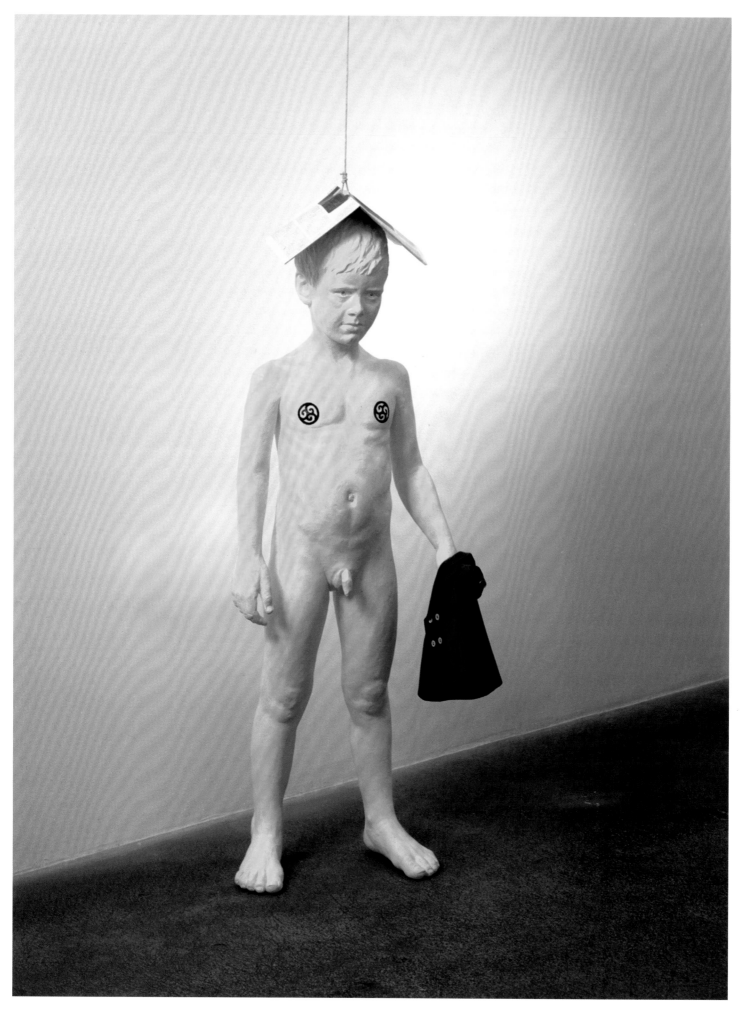

284 Pia Stadtbäumer, *Max, newspaper, tattoos, pistol, puppet-coat*, 2000. Zellan, yellow pigment, acrylic, newspaper, metal, fabric, rhinestones, string. 120 x 42 x 33 cm (47 ¼ x 16 ½ x 13 in)

285 Laura Ford, *Headthinker*, 2003. Steel, plaster, ceramic, fabric. Dimensions variable

286 Lia Menna Barreto, *Inside Out Rabbit*, 1995. Stuffed rabbit, lamp. 34 x 64 x 90 cm (13 ½ x 25 ¼ x 35 ½ in)

287 Xavier Veilhan, *The Republican Guard*, 1995. Polyurethane, resin, painted polyester. One of four items, each 280 x 280 x 70 cm (110 ¼ x 110 ¼ x 27 ½ in). Fonds Régional d'Art Contemporain (FRAC), Languedoc-Roussillon, France

Homemade fairy tales lie behind the figurative installations of Jan-Erik Andersson. His works are usually about love, longing and nostalgia. The intention is to create sculptures and installations that inspire children and adults to create their own fantasies and stories, and to this end he uses bright colours, simple shapes and cartoon-like figures. *The Dream of the Ice Princess* (1993), set on a floor of ice, illustrates a story invented by the artist in which a small girl falls in love with an ice-hockey player. In contrast to Honert and Andersson, both of whom make images that appeal to children, Pia Stadtbäumer depicts the children themselves. She has made several sculptures of naked young children known to her, a boy, Max, and a girl, Clara; these are traditionally modelled life-size figures, which she casts into wax coloured with an acid-yellow paste. The six-year-old *Max* **(284)** stands lost in concentration, with a strange array of objects, the most disturbing of which is a pistol covered by a small coat. A string runs from the ceiling to the top of his head, which either holds him up or curtails his movements. Stadtbäumer has avoided defining the child's specific emotion, and leaves the viewer room to conjure up their own narrative.

Quite a different approach is found in the work of Laura Ford. Her renditions of children are not realistic; they consist instead of aggressive, sightless little girls with frilly dresses and guns, pensive hooded boys sporting animal heads **(285)**, and animals such as moose, donkeys and camels, many of which stand silently in Eeyore mode. The support for all these figures is a plaster base, which is then clothed in blankets or, in the case of the little girls, patterned chintz. Her creatures are neither toys nor dolls, and she describes the clothes of the animal boys as 'bandages', implying that there is a sense of repair and recuperation. She is also aware that the felt wrappings of her boys and animals recall the holistic wrappings of Joseph Beuys (see Chapter 12).

The materials that Lia Menna Barreto uses for her meditations on childhood are dolls, puppets and rubber animal toys. She subjects these to awkward dismemberments and amalgamations, mindful that such transformations, which occur in fairy tales and monster stories, can also be found in the sculptures of Hans Bellmer and Mike Kelley. Her toys are not second-hand, but newly bought at markets near her home, and thus they have no emotional history or memory for the artist. In some works, such as *Inside Out Rabbit* **(286)**, her toys are accompanied by lamps and lights, or display burn marks, suggesting a sense of danger.

A different kind of unease is found in the work of Xavier Veilhan, who trained as a painter and now works in a range of media. In 1995, he produced four life-size horses and uniformed riders, *The Republican Guard* **(287)**, made of painted polyurethane and resin. They stand stock still with raised swords, as their real counterparts do, as though guarding a building or a VIP. Each has been separately modelled so that its anonymity and uniformity are modified by a tiny touch of the personal, and Veilhan sites them in a range of public places, where they both amuse and trouble the tourists.

Yoshitomo Nara's work causes no disquiet; rather, it veers close to sentimentality. *Dogs From Your Childhood* **(288)** comprises two small fiberglass dogs, peacefully facing each other. He also makes figures of pensive or malevolent children, as well as docile dogs, usually with their eyes closed and rendered in white fiberglass, lending them a somewhat ghostly air. He has said: 'My art represents my childhood experiences. It is not influenced by Japanese pop culture. I played with sheep, cats and dogs when I came home from school.' By an ironic twist, his figures and animals have entered the fabric of American popular culture, appearing on t-shirts, posters, mugs and so forth.

288 Yoshitomo Nara, *Dogs From Your Childhood*, 1999. Fibreglass, lacquer paint, nessel, felt with acrylic paint. 106 x 59.5 x 220 cm (41 ¾ x 23 ½ x 86 ½ in)

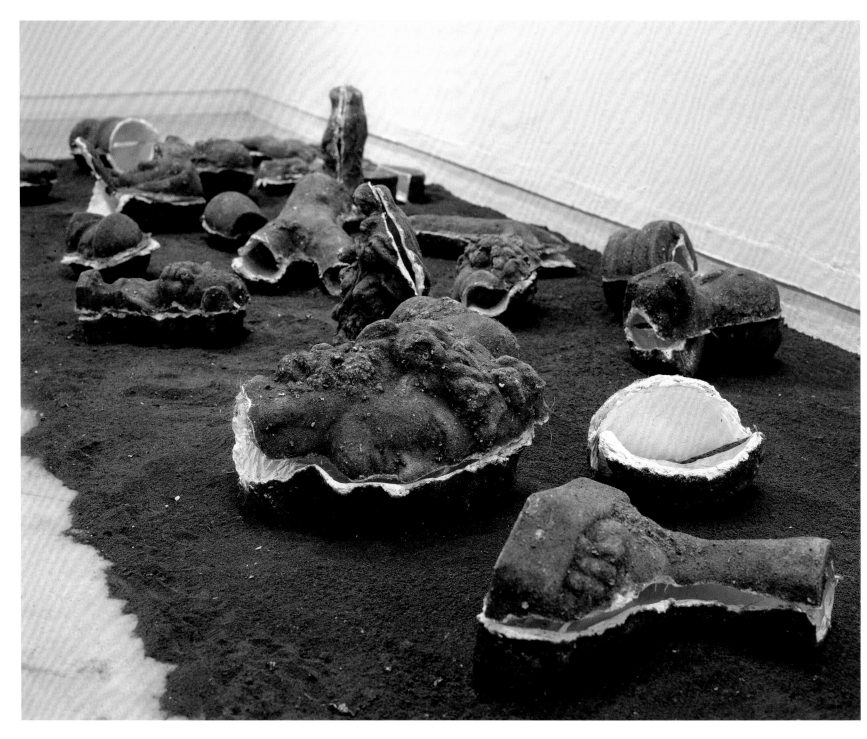

289 Antonio Sosa, *Seeds on the Right Bank of the River Guadalquivir*, 1992-3. Plaster, burlap, ashes. 130 x 40 x 600 cm (51 ¼ x 15 ¾ x 237 in)

Two European artists of the 1950s were born and brought up in rural areas, and both make work that keeps them in touch with the emotions and objects of their early years. Antonio Sosa was born in a little village in Andalucia, beside the river Guadalquivir, and he uses natural materials that are found locally, such as the river sand, as well as recycling the toys of his childhood. His *Seeds on the Right Bank of the River Guadalquivir* (289) consists of moulds of objects from his childhood and youth that have been meaningful to him -- a papier-mâché horse, a tree trunk that looks like a human body, a leg that he modelled at art school, a small Chinese figure. The moulds lie open like empty seed pods on a bed of ashes, indicating that something has been removed.

Miroslaw Balka lived as a child in a small town near Warsaw, and his family home is now his studio, with all its attendant memories, particularly of his Catholic upbringing under martial law in Poland. *Remembrance of the First Holy Communion* **(290)** depicts a boy standing beside a table covered with a lace cloth. Set into the cloth is a photograph of a child. Two spots of red enliven the mostly monochrome sculpture: one is a bloody spot on the boy's knee, while the other is a red fabric heart on his left breast, pierced by a pin. This is borrowed from the iconography of the Sacred Heart of Jesus, while the other is an ordinary boyhood occurrence. Balka's father and grandfather were monument masons, creating memorials in a traditional way for individuals. Balka has shifted the focus of this family profession so that he makes memorials for a wider public.

Memory can be invoked by more senses than just the visual one, and Valeska Soares creates works that activate a range of bodily sensations, notably the sense of smell. She has made much use of fresh flowers in her work, as well as perfume. In 1998 she made *Vanishing Point*, a large work consisting of fifteen shaped, stainless-steel containers, which were laid out in a maze-like order **(291)**. These were filled with a solution of oil and perfume, which eventually impregnated the host gallery with an intoxicating smell. The shapes of the containers are inspired by French and Italian garden designs, and their cool minimalism contrasts strongly with the sensuality and sense of memory invoked by the heady perfume.

Other artists who incorporate the sense of smell into their sculptures include Ernesto Neto and Montien Boonma. From 1996, Neto began to fill his soft, hanging sculptures with spices such as saffron, cumin, clove and aniseed; they had previously been filled with lead weights. These spices not only bring with them smells, but also strong colours and a sense of exotic travel and trade. Boonma was born in Bangkok, and spent time as a monk. He was a devout Buddhist and he used his work, which combined heavy industrial materials along with ephemeral materials like spices and perfumes, to draw attention to the fragility and impermanence of human life, and the concept of the transcendental; this turned out to be highly relevant, since he died aged forty-seven. Several of his sculptures are coated with herbs and spices, such as red sandalwood, cinnamon, turmeric, citronella grass and Indian pepper. His most significant piece is *Arokhayasala: Temple of the Mind* **(292)**, a tower-like structure composed of wooden boxes that are filled with medicinal and aromatic herbs.

One way of indicating the passing of time is to make a sculpture that diminishes in size while on public display, and this was the strategy of Felix González-Torres. He moved from Cuba to New York in the 1980s, and had a short career, from 1986 to his death from AIDS in 1996, but in those ten years he made several elegant statements about love and loss. The materials with which he chose to work were pre-existing, mundane objects such as light bulbs, clocks, stacks of paper and, most notably, wrapped sweets. In 1990, he began a series of work comprising piles of coloured sweets wrapped in cellophane, sometimes set in a pile in the corner of a gallery space. The sweets are commercially made and thus of an unlimited supply. The public is encouraged to take them away and eat them, rendering the work consumable and transient. The ideal weight of the sweets is given as part of the information on the work. Although always variable, it can relate to the named person indicated in the parenthetical title, as in *'Untitled' (Ross)* **(294)**, one of a handful of works that refer to his lover Ross Laycock, who also died of AIDS. González-Torres spoke of wanting to make a sculpture that disappeared: 'Freud said that we rehearse our fears in order to lessen them ... [and] this refusal to make a static form, a monolithic sculpture, in favour of a disappearing, changing, unstable and fragile form was an attempt on my part to rehearse my fears of having Ross disappear day by day right in front of my eyes.' However, although such works contain the possibility of disappearing, they equally have the possibility for being endlessly replenished.

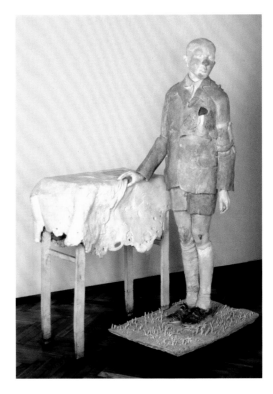

290 Miroslaw Balka, *Remembrance of the First Holy Communion*, 1985. Steel, cement, marble, textile, wood, ceramic, photograph. 170 x 90 x 105 cm (67 x 35 ½ x 41 ¼ in). Muzeum Sztuki, Lodz, Poland

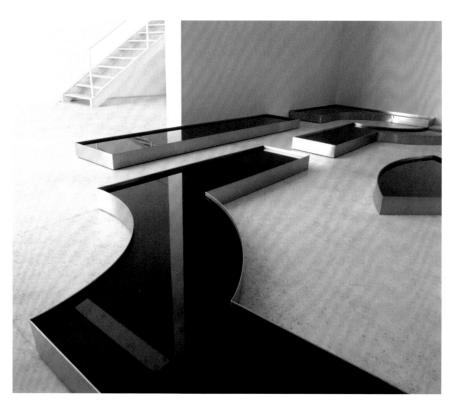

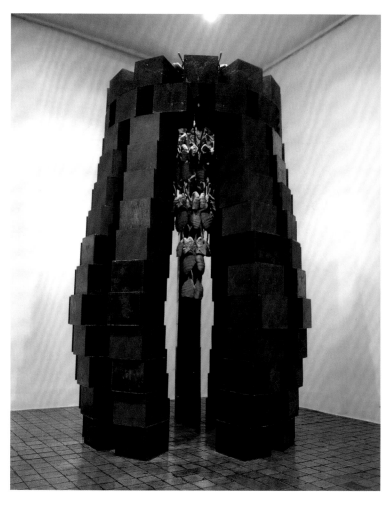

291 Valeska Soares, *Vanishing Point*, 1998. Stainless steel tanks, perfume. Dimensions variable. Collection Daros-Latinamerica, Zurich

292 Montien Boonma, *Arokhayasala: Temple of the Mind*, 1996. Steel, aluminium, herbs. 370 x 250 x 250 cm (145 ¾ x 98 ½ x 98 ½ in)

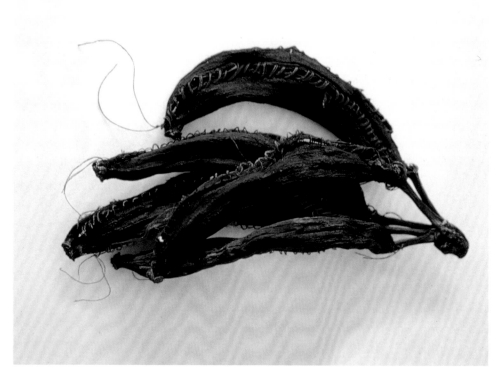

293 Zoe Leonard, *Strange Fruit (for David)* (detail), 1992-7. 302 Elements: orange, lemon, grapefruit, avocado and banana peel, thread, needles, zippers, buttons, wax, plastic, hooks, twine, fabric. Dimensions variable. Philadelphia Museum of Art, Pennsylvania

Another New York artist, Zoe Leonard, has worked in a parallel way to González-Torres; she has been active on behalf of feminist and AIDS issues, producing photographic images that get their message across in a direct, if sometimes blunt, manner. Her most celebrated meditation on the subject of the death is her installation *Strange Fruit (for David)*, which was created between 1992 and 1997 as a memorial for her friend, the artist David Wojnarowicz, who died of AIDS.

It consists of the skins of 302 fruits and vegetables -- avocados, oranges, lemons, grapefruits and bananas -- which lie scattered on the gallery floor. When the contents had been eaten, Leonard sewed the skins together again with large red stitches, or, in the case of some bananas, with zips or buttons **[293]**. She has said: 'The act of fixing something broken, repairing the skin after the fruit is gone, strikes me as both pathetic and beautiful.' The extended date of the work reveals that it was worked on over several years, and by the time that Leonard considered it finished, it had already changed in appearance. The Philadelphia Museum of Art has acquired it for its permanent collection, and this raises huge questions about its long-term life and conservation; the subject of the sculpture is death, and the work itself faces a slow death from the inevitable decay of the organic material.

Another tribute to love and loss comes from Tracey Emin. In 1995 she bought a small camping tent and embellished it with collaged and embroidered letters, listing the 102 names of everybody she had slept with in the thirty-two years since her birth in 1963, which included not only lovers but also family members, platonic friendships and her aborted fetuses **[295]**. Emin was given her first solo show in 1994 in London, which she wittily called 'My Major Retrospective'; the title has a double meaning since all her work to date has been a memorial of her past life. In an ironic twist, her embroidered tent was destroyed in a warehouse fire in East London in May 2004, and now only exists in the form of photographic illustrations and personal visual memories.

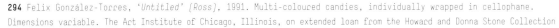

294 Felix González-Torres, *'Untitled' (Ross)*, 1991. Multi-coloured candies, individually wrapped in cellophane. Dimensions variable. The Art Institute of Chicago, Illinois, on extended loan from the Howard and Donna Stone Collection

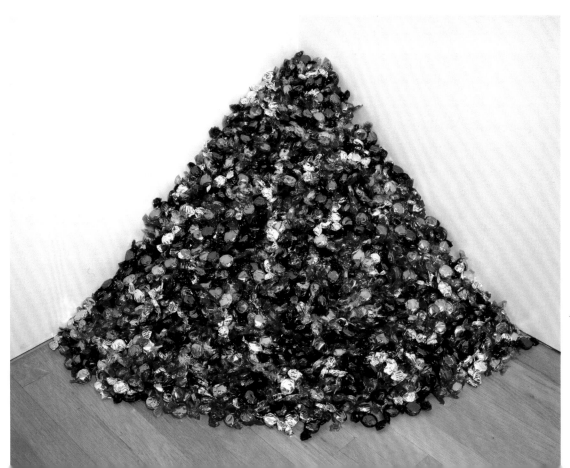

295 Tracey Emin, *Everyone I Have Ever Slept With 1963-1995*, 1995. Appliquéd tent, mattress, light. 122 x 245 x 215 cm (48 x 69 ½ x 84 ½ in). The Saatchi Collection, London, destroyed by fire 2004

The amalgamation of personal memories with public histories to create narratives relating to their homelands is the path taken by Ilya Kabakov and Christian Boltanski. Kabakov was born in the Soviet Union and worked as an illustrator of children's books. He left Russia in the late 1980s, first living in Europe and then settling in New York in 1992, and as an exile, he examines what it means to be Russian. In collaboration with his wife, Emilia, he makes large theatrical installations that take the viewer into a world filled with signs, sounds and symbols from the past, some real and others fictitious.

School No. 6 **[296]** is a recreation of a typical village school from the former Soviet Union, which fills several rooms of a building at the Chinati Foundation in Texas. The peeling walls are painted an institutional green and cream, some of the furniture is broken and dead branches lie on the floor. In faded red, glass-enclosed vitrines, Kabakov has placed Russian and English texts that recount the recollections of students. Kabakov's re-creations include corridors, since these structures, he wrote, 'have persecuted me all my life'.

Boltanski made his debut in the art world in 1969, in his words: 'by publishing a book of photos representing all the things that inhabited my childhood (sweaters, toys, etc.). That was a sort of search for a part of myself that had died away, an archaeological inquiry into the deepest recesses of my memory.' Since then, he has explored how we hold on to memories in the face of death, and the objects he employs to perform this task are well-worn, having already experienced a previous life. He creates room-sized and wall-based memorials to unknown people, and *Monument* **[278]** is one of these. Black-and-white framed photographs of anonymous children are set among empty frames, as if to emphasize a sense of loss. All are illuminated by small wall lamps, the wires of which trail untidily across the work. The photo frames stand on towers of rusting biscuit tins, and with their stepped tops form little altars of remembrance, to which the viewer can bring their own childhood past. Much of Boltanski's work is bleak in character, and poor in materials, and critics often discuss it in terms of the Holocaust. He is Jewish and was born during the Second World War, but he stresses that his memorials are for everyman, and for every death.

296 Ilya Kabakov, *School No. 6*, 1993. Several rooms of faded posters, flags, emblems, bookcases, desks, vitrines, Russian notebooks, memorabilia. Dimensions variable. The Chinati Foundation, Marfa, Texas

The memory of recent German history is one of the powerful threads running through the oeuvres of Joseph Beuys and Anselm Kiefer. Beuys was old enough to have belonged to the Hitler youth movement, and to have served as a pilot for the Luftwaffe. In 1958, at the beginning of his career, he entered a sculpture in a competition for a monument for the former Auschwitz concentration camp. In 1976, for the German Pavilion at the 37th Venice Biennale, he made the work *Tram Stop* [297]. This sculptural installation dealt with childhood memories of his home town of Kleve, situated on the Dutch border of Germany;

297 Joseph Beuys, *Tram Stop*, 1976. Cast iron. 376 x 45 x 29 cm [148 x 17 ¾ x 11 ½ in]. As installed at German Pavilion, Venice Biennale

it comprised casts of a field cannon and four seventeenth-century mortar shells, along with a segment of railway track: items that stood alongside his tram stop when he spent many hours waiting as a child. The only alteration that Beuys made to the casts of this historic material was to cast a male head and set it into the top of the cannon. Beuys had a borehole made in the gallery floor, and displayed its contents, which included bones and sediment dug up from Venice's lagoon. His childhood experience of the metal objects at his tram stop awakened his desire to become a sculptor.

298 Darren Almond, *Bus Stop*, 1999. Two bus stops: aluminium, glass, paint, plastic. Each 303 x 603 x 243.8 cm [119 ¾ x 237 ½ x 96 in]

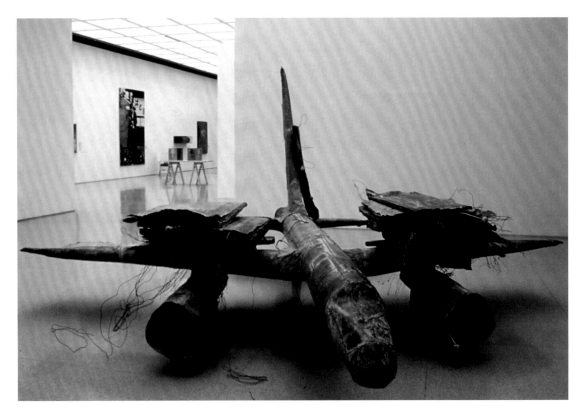

299 Cy Twombly, *Thermopylae*, 1991. Plaster on wicker, cloth, graphite, wooden sticks, flowers on plastic stems. 137 x 89 x 66 cm (54 x 35 x 26 in). Cy Twombly Gallery, The Menil Collection, Houston, Texas

300 Anselm Kiefer, *Angel of History: Poppy and Memory*, 1989. Lead, glass, poppies. 540 x 500 x 243 cm (212 ½ x 197 x 95 ¾ in) The Israel Museum, Jerusalem, permanent loan from Friends of the Israel Museum in Germany

301 Jannis Kounellis, *Untitled*, 1986. Steel, lead, plaster. 600 x 900 cm (236 ¼ x 354 ¼ in)

A more recent artist, Darren Almond, deals with similar material, although his work *Bus Stop* **(298)** is not autobiographical. In 1997, he made a film about the two bus stops outside Auschwitz, in Poland, and two years later he received permission to exhibit them in the Max Hetzler Gallery in Berlin, while replacements made by Almond were installed at the original sites. The bus stops were readymades that came with their own history of use: there were still cigarette butts in the waste bins. Their cool metal form has echoes of minimal sculpture, but their emotional content is high.

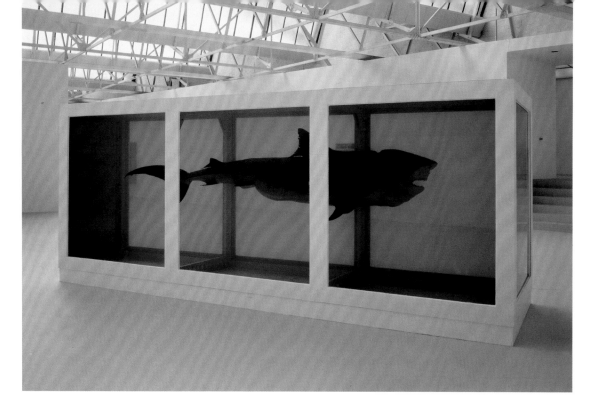

302 Damien Hirst, *The Physical Impossibility of Death in the Mind of Someone Living*, 1991. Tiger shark, glass, steel, 5% formaldehyde solution. 213 x 518 x 213 cm (84 x 204 x 84 in)

The paintings and sculptures of Anselm Kiefer deal with German heroic epics and German history, particularly National Socialism and the Nazi era. In his paintings, he uses natural materials such as soot, ash and straw, and since 1985, many of his sculptures and even some paintings incorporate lead, an old, heavy material -- a metaphor for the weight of history. Some of these lead sculptures depict books on shelves and on lecterns, and these suggest texts of great age and mystery.

His 1989 sculpture *Angel of History: Poppy and Memory* **(300)** consists of an aeroplane, whose wings and tail fin support lead books from which dried poppy stalks protrude. The title of the work alludes to a volume of poems by Paul Celan with the same name, published in 1952, which attempted to deal with the Holocaust, and Kiefer has made use of Celan's language and imagery in other works. To Celan, the poppies stand for forgetfulness, due to their opium content (in Britian they have been utilized as a symbol of remembrance for the war dead), and Kiefer employs them to refer to absence and death.

Italian artists also make works that reflect on the concept of history, but in a cooler, more elegant manner. Jannis Kounellis was born in Greece, but left his home country when he was twenty, at the time of its civil war, to live and work in Rome, where he came to regard himself as an Italian artist. The motif of shelves, used in his work since 1969, where books and objects accumulate over time and can be reassembled in different ways, is intended as a metaphor for history **(301)**.

Cy Twombly moved from America to Rome in 1957 and has lived there ever since, creating paintings and sculptures that respond to the palimpsest that is Italian history. He began to make modest and fragile assemblages from found objects and scraps of wood in the 1950s, which he coated in white paint. He called the result 'my marble', referring to the material of classical sculpture that confronted him everywhere in Rome. Onto these white forms, Twombly inscribed phrases from dead poets, some from Greek and Roman times, and some more recent, such as Rilke. Several forms resemble small chariots or boats, plants and palm fronds, mixed in with unidentifiable shards that look as though they come out of an archaeological dig **(299)**.

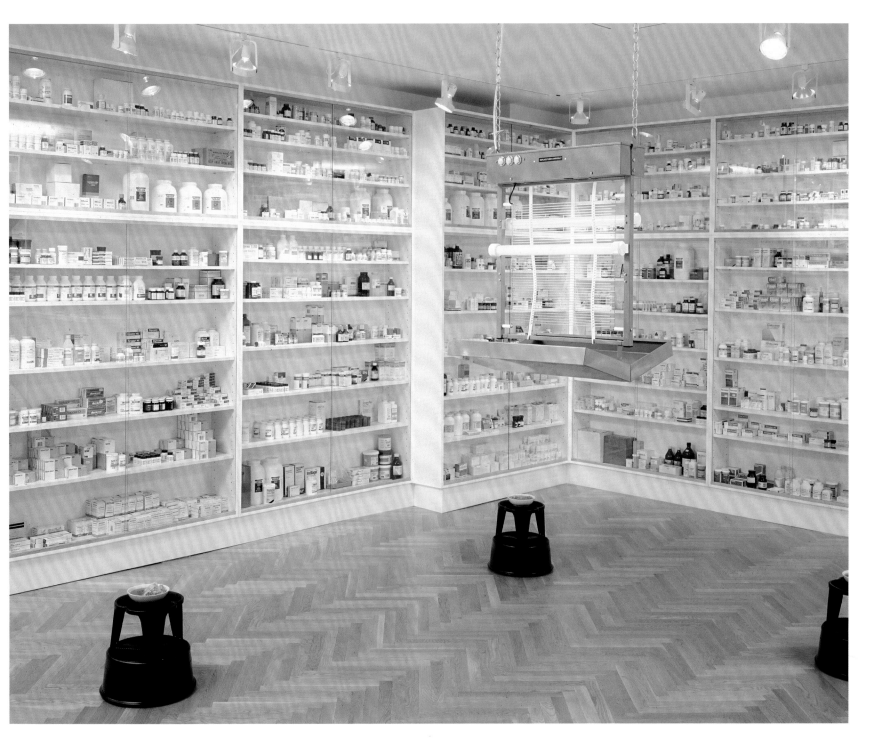

303 Damien Hirst, *Pharmacy*, 1992. Packaged drugs, 4 apothecary bottles filled with coloured liquids, counter, 3 desks, 3 chairs, 4 bowls containing honeycombs, 4 footstools, electric-o-cutor. Room-sized installation. Tate, London

Damien Hirst is obsessed with how to convey the transience of life and the permanence of death; his famous work *The Physical Impossibility of Death in the Mind of Someone Living* **(302)** transposes human emotions onto a dead beast, which once was a frightening killing machine. Most of Hirst's work deals with mortality, death, religion and drugs. One of the largest works of this kind is his room-sized installation *Pharmacy* **(303)**, which includes glass-fronted cabinets containing pharmaceutical drugs, apothecary bottles filled with coloured liquids, a desk and chairs, and an electric insect-o-cutor hanging from the ceiling. He has spoken of contemporary reliance upon drugs as a belief system, equivalent to religion, but a flawed system, since it is both seductive and illusory.

This chapter looks at the work of artists who use clothing as a means of artistic expression. The fabrics and substances with which they choose to work are very diverse, ranging from human hair to metal, and the processes are also multifarious; traditional crafts such as sewing, embroidery and knitting are employed, as well as computer-controlled industrial fabrication. Sculptors work with clothes because they are interested in their psychological, social, political and gender connotations, as well as their shapes, colours and textures. There are references to national, ethnic and religious costumes and uniforms, gender and sexual imagery, and work, play and comfort. Consideration of the production and consumption of clothing, and the way in which the fashion industry deals with notions of class and power, also play their part in the conception and execution of clothing sculptures.

The women's art movement of the 1970s helped to dismantle cultural hierarchies, and as a result ushered in processes like embroidery and knitting into fine art practice, which were used with innocence or irony. The gay liberation movement that followed also helped to shift these processes and practices into the male arena. The pursuit of fashion and the manufacture of clothing are usually identified with the feminine, but this clichéd concept has recently been demolished. Most of the artists in this chapter design or make their own forms of clothing, some of which are process-oriented, especially the labour-intensive knitting of Oliver Herring and the exquisite tailoring and embroidery of Charles LeDray. Bojan Sarcevic and Tobias Rehberger utilize commercially available new clothes of an internationally branded kind, while Erwin Wurm turns his attention to the humble sweater.

Earlier in the twentieth century, artists designed and made clothes -- Vladimir Tatlin in Russia, Sonia Delaunay in France and Oskar Schlemmer at the Bauhaus in Germany -- but these clothes were made either to be worn as high fashion or seen as utopian social statements. It was not until the performance-art events of the 1960s that clothing entered the art world as an aesthetic category. Items that were made to be worn in performance sometimes assumed their own autonomous existence. This is the case with the garments associated with Hélio Oiticica, Lygia Clark, Louise Bourgeois, Rebecca Horn and Joseph Beuys.

In 1970, Beuys made an edition of 100 felt suits [305], which were copied from one of his ordinary suits, but the sleeves and legs were lengthened, and no buttons were attached. This gives it the look of a prison uniform, although it also alludes to the work clothes designed by Tatlin and Schlemmer. The edition numbers appeared on a label sewn inside the jacket. Beuys decreed that it could be displayed directly on the wall, or hung either from a nail or on a wooden hanger, as here. He was not keen that the suit should be worn, as it would lose 'the character of the felt'. He regarded grey felt, one of the most basic fabrics, as a protective and magical material, offering both physical and spiritual comfort. He told the story that, as a pilot in the World War II flying over the Crimea, he was shot down and discovered badly wounded by a tribe of Tartars, who saved his life by wrapping him in a cocoon of fat and felt.

Lygia Clark (1920-88) made unusual costumes as part of her performance actions from the mid-1960s onwards. The costumes, such as fabric tunnels and conjoined plastic overalls, caused the participants to interact closely with one another, which Clark believed had a strong therapeutic effect on them; her performances and objects were made with this aim in mind. She equalled Beuys in her interest in fabric's power to nurture and heal.

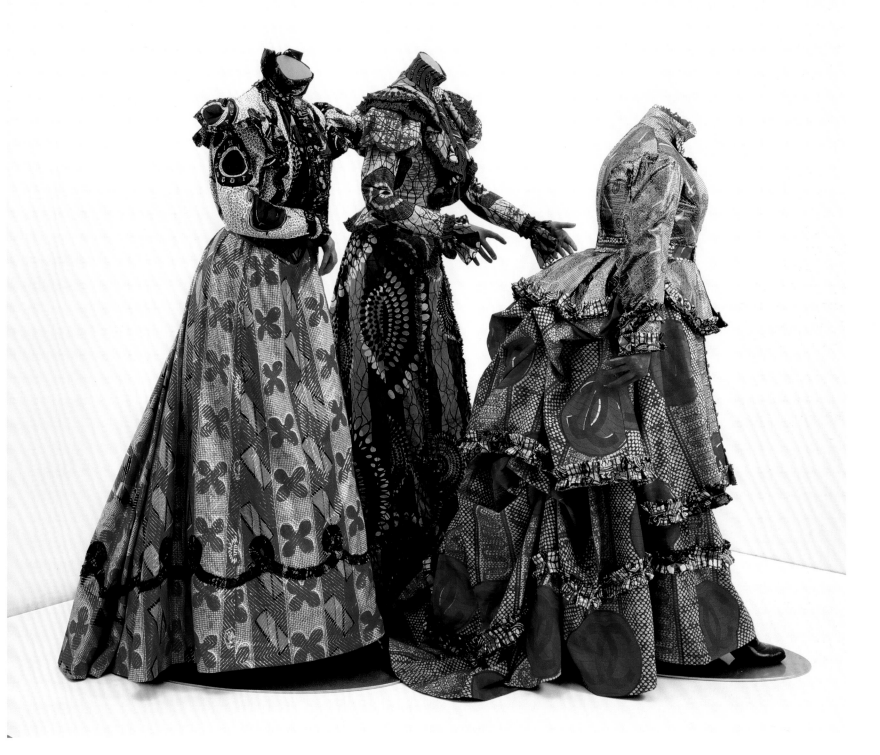

304 Yinka Shonibare, *Three Graces*, 2001. Three mannequins, Dutch wax-printed cotton. Dimensions variable

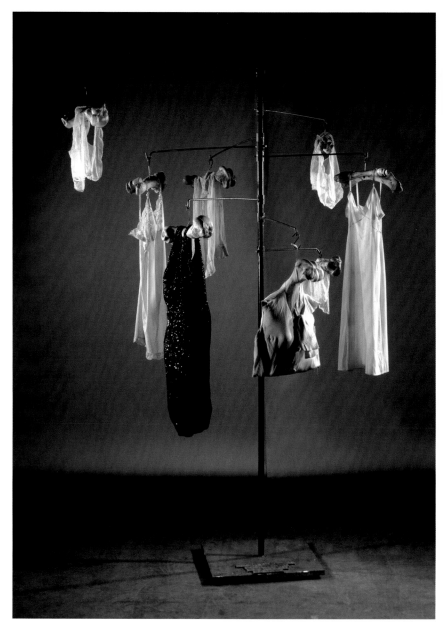

305 Joseph Beuys, *Felt Suit*, 1970. Felt. 170 x 60 cm (67 x 23 ½ in)

306 Louise Bourgeois, *Untitled*, 1996. Cloth, bone, rubber, steel. 300.3 x 208.2 x 195.5 cm (118 ¼ x 82 x 77 in)

A similar belief lay behind the creation of many of Bourgeois's fabric works. She first showed a kind of clothing at a performance in 1978, entitled *A Banquet/A Fashion Show of Body Parts* at the Hamilton Gallery, New York. For this, she made transparent garments of latex, onto which were fixed lumps that could be read as multiple breasts or a kind of body armour. Her mother and grandmother worked in the French textile industry, her father had a tapestry restoration business, and sewing and repairing fabrics was a major part of her childhood experience. She has said that when she was growing up 'all the women in my house were using needles.... The needle is used to repair damage. It's a claim to forgiveness.' *Untitled* (306) is a more unusual example of her fabric sculptures, and comprises several items of womens' attire suspended from large bones, which are hung from meathooks. Most of these garments were saved from her childhood home, and this adds a flavour of history and memory.

307 Rosemarie Trockel, *Balaklavas*, 1986-90. Knitted wool. Each 34 x 21.8 cm (13 ½ x 8 ½ in)

308 Sui Jianguo, *Legacy Mantle*, 1997. Painted fibreglass. Each 240 x 190 x 160 cm (94 ½ x 74 ¾ x 63 in)

Away from the world of handicraft, Rosemarie Trockel established her reputation in 1985 with her 'Knit Pictures', coloured woollen rectangles that she hung on the wall so that they looked like colour-field paintings. Based on a hand-made design, all Trockel's knitted works are professionally made by a computer-controlled knitting machine. She then branched out into making pullovers for two people, and what looked like functional knitted woollen items, such as socks, underwear, a dress and balaclavas, which she exhibited either singly or in groups displayed on mannequin heads in a Perspex box. Her *Balaklavas* (307) sport repeated patterns on neutral backgrounds, and although these lend a jaunty air to the garments, the absence of apertures for the mouth hints at suffocation or the impossibility of communication. The idea of the balaklava as an item of headgear that offers warmth and protection is subverted. Others in the series are decorated with different repeated patterns, such as the swastika and the hammer and sickle motif, and these blend the worlds of decoration and social systems in a perverse kind of anthropology.

309 Do-Ho Suh, *Some/One*, 2001. Stainless steel military dog tags, nickel-plated copper sheets, steel structure, glass fibre reinforced resin, rubber sheets. 205 cm (80 ¾ in) high; 320 cm (126 in) diam. Whitney Museum of American Art, New York

310 Kimsooja, *Encounter -- Looking Into Sewing*, 1998-2002. Korean bedspreads. Dimensions variable

In this time of polyculturalism, two sculptors have turned their attention to the form and content of national and ethnic costumes, examining how loaded they are with cultural and political implications. Yinka Shonibare, born in London and raised in Nigeria, creates costumes that interweave these two nationalities. The outfits are made from 'African' batik fabrics, which are not actually African in origin, although they present the identity of that continent to Western eyes. Batik fabrics originated in Indonesia, were imported to Holland, then exported to West Africa, and at the beginning of the twentieth century they were copied in factories in England, again for export to West Africa. When Nigeria gained its independence in 1960, such fabrics virtually became the national dress. Shonibare's costumes are based on Victorian models, and he sets them on headless mannequins **(304)**, often borrowing the pose of figures from famous eighteenth- and nineteenth-century paintings by artists like William Hogarth or Jean-Honoré Fragonard.

Since 1997 Sui Jianguo has been working on a series of large-scale sculpted jackets in bronze and fibreglass that depict the garment that for most of the twentieth century was the uniform for both men and women. In China the jacket is known as the Sun Yat-sen, the name of the revolutionary who was the first to wear it, whereas in the West, it is called the Mao, after Mao Tsetung **(308)**. Jianguo states that none of the Chinese have truly taken off their Mao suits, even though the revolutionary era is over, and his larger-than-life-size jackets can be read as symbols of restriction and limitation. Jianguo is using national clothing to re-evaluate an established political symbol, aware that he can do so in the freer climate of modern China. He has also made works in fibreglass depicting copies of famous Graeco-Roman and Renaissance marble sculptures of nudes -- such as Michelangelo's slaves -- clothed in the Mao Suit, perhaps implying that Eastern influences will overwhelm the culture of the West.

Two Korean-born artists, Do-Ho Suh and Kimsooja, who now live and work in New York, respond to their cultural displacement by creating pieces that relate back to the fabrics and sewing techniques of their native country. Suh sees the crafts of sewing and dressmaking as allied to architecture: 'When you expand this idea of clothing as a space, it becomes an inhabitable structure, a building, a house made of fabric.' His *High School Uni-form* of 1997 consists of 300 Korean schoolboys' jackets on hangers, sewn together into a submissive, regimented grid as though standing to attention for scrutiny by an authority figure. His *Some/One* **(309)** is a huge metal robe composed of thousands of stainless steel army-style dog tags. These allude to the military, while the large tent-like structure could be seen as a shelter; domination versus protection. Kimsooja does not design or make clothing, but instead creates performances, sculptures and installations using a familiar and ubiquitous piece of household fabric: the traditional Korean bedspread. Embroidered with symbolic patterns, these are traditionally given to newly married couples, and thus signify a human relationship. She has displayed them on the ground, hung like laundry on a clothes line, placed in layers veiling a figure, *Encounter -- Looking Into Sewing* **(310)**, and knotted into bundles filled with personal household items, as though ready for travel.

A trend that emerged during the late 1980s was for artists to get involved in social projects, and this extended to working with fabrics and garments. Since the early 1990s, Lucy Orta has been making unusual items of clothing to which she has given the generic term 'Body Architecture'. From 1993 she began to make 'Refugee Wear', partly in response to the homeless who featured in global news stories -- earthquake survivors, civil-war victims, the unemployed -- and these garments amalgamated sleeping bags with integrated medical supplies and personal waterproof shelters. The following year, she moved from making items for individuals to 'Collective Wear' **(311)**, stating that the physical links brought about by her clothing could assist social links, and help to ameliorate the condition of the homeless and the isolated. In this, she is an heir to Lygia Clark.

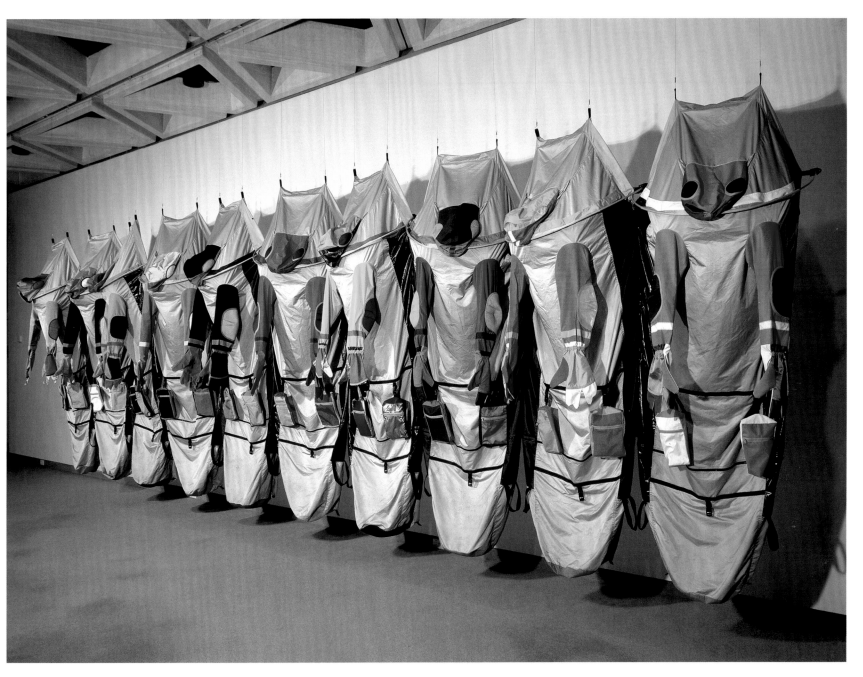

311 Lucy Orta, *Modular Architecture -- The Unit x 10*, 1999. Microporous polyester, mixed media. 2.1 x 10 x 0.5 m (6 ft 10 ¾ in x 32 ft 9 ½ in x 1 ft 7 ¾ in). Art Gallery of Western Australia, Perth

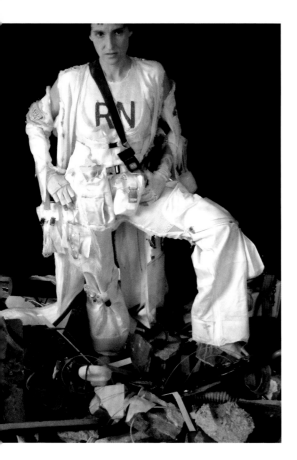

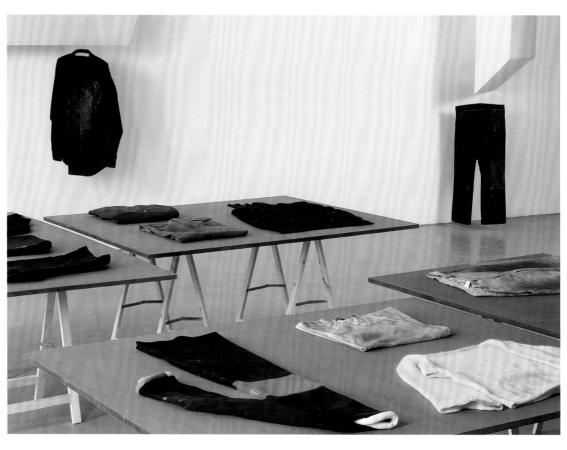

312 Mark Dion and J. Morgan Puett,
The Post-Apocalyptic Nurse, 2003-4. Mixed media.
Dimensions variable

313 Bojan Sarcevic, *Workers' Favourite Clothes Worn While S/He Worked*, 1999/2000. 23 items of clothing,
10 presentation tables. Dimensions variable

Another angle on protective clothing is provided by Mark Dion, who, with his partner
J. Morgan Puett, collaborated with The Fabric Workshop, Philadelphia, in 2003, to create
an exhibition of nurses' uniforms. The Fabric Workshop is a pioneering institution
in America that encourages the creation and exhibition of new work in fabrics and
experimental materials by contemporary artists. Dion and Puett proposed an exhibition
that traced the 150-year-old history of nurses' uniforms, and they combined historical
items from museums alongside their proposals for contemporary and future Nurses' Uniforms,
which included the *Bio-Terror Nurse*, the *Diagnostic Nurse*, the *Post-Apocalpytic Nurse* and
the *Intergalactic Nurse*. Dion used materials strong enough to stop bullets, and the
Bio-Terror Nurse would render its wearer capable of carrying on her duties in the event of
a chemical terrorist attack **[312]**. The uniforms owe as much to science fiction as they do
to new technologies, yet if put into commercial production, they could play a functional,
if somewhat decorative, role. Another artistic and social project involving workwear and
its ramifications was initiated by Bojan Sarcevic. In 2000 he presented *Workers' Favourite
Clothes Worn While S/He Worked* **[313]**, which involved the assistance of fifteen male and
female manual workers, including a garage mechanic, a carpenter, a building worker, a
kitchen assistant and a baker. Sarcevic gave the workers stylish clothing provided by
the fashion designer Agnès b, and asked them to wear it continuously for a period of two
weeks, as they went about their daily work. He wanted the loaned clothing to reflect the
traces of their labour, both their habitual movements and the materials they regularly
used, samples of which were likely to fall onto the clothes. At the end of this period,
he exhibited the soiled and stained clothes on tables in a gallery at the Gesellschaft
für Aktuelle Kunst, Bremen, as an act of homage to manual labour and its grimy traces,
evidence not usually set on public display.

Sarcevic is matched in his use of readymade, commercially available clothing by Tobias Rehberger, who makes installations that mimic fashion, design and boutique presentations. He uses designer clothing from the collections of Helmut Lang, Martin Margiela and Walter Van Beirendonck, which he sets in displays that ape designer boutiques, causing the viewer to oscillate between reading the work as fashion or art. Rehberger's most conceptual clothing piece was his underwear design for the security guards at the Venice Biennale exhibition of 1997, a set of which is preserved in the Biennale Archives. His flesh-coloured underwear could be found on sale at the Biennale shop, with the proceeds benefiting an Italian AIDS support organization.

There are numerous artists who use unusual materials or make dramatic changes in scale in their works featuring clothes. Jana Sterbak heads this list with her full-length wire-mesh dress, which is encircled by an electric filament plugged into the mains: *I Want You to Feel the Way I Do* (1984-5). This was the first in a series of sculptures that use clothing to explore troubled states of mind. Two years later, Sterbak showed *Vanitas: Flesh Dress for an Albino Anorectic*, a low-necked clinging dress made from 60 pounds of raw beef steaks sewn together **[314]**. The meat, which had been salted and allowed to air-dry, changed in texture and colour during the duration of the exhibition and ended up with the appearance of dry leather. The title of the piece refers to the eating disorder of anorexia. In a provocative photographic work, *Absorption: Work in Progress* (1995), Sterbak also cast herself as a moth whose ambition is to eat all of Beuys's felt suits.

314 Jana Sterbak, *Vanitas: Flesh Dress for an Albino Anorectic*, 1987. Mannequin, flank steak, salt, thread. Dimensions variable. Walker Art Center, Minneapolis

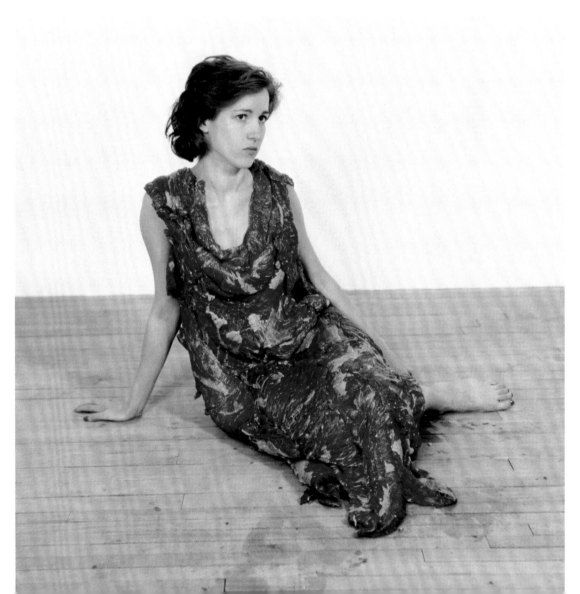

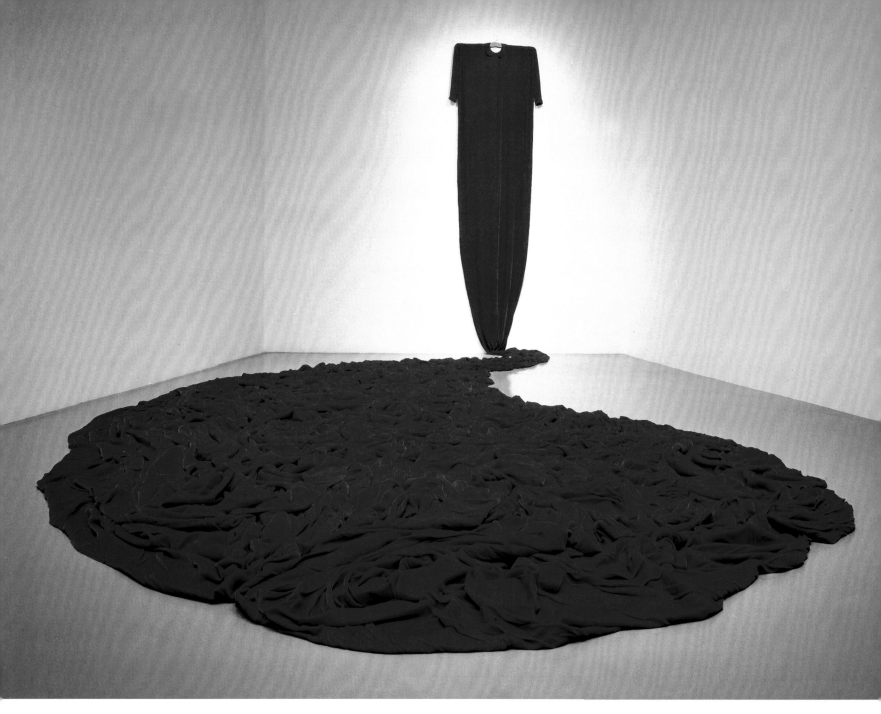

315 Beverly Semmes, *Red Dress*, 1992. Velvet, wood, metal hanger. Dimensions variable. Hirschhorn Museum and Sculpture Garden, Washington, DC

Beverly Semmes and E.V. Day combine glamour with a sense of menace in their garments. Semmes creates exaggerated clothing forms that merge social commentary with a formal investigation of texture and colour through her choice of material, which is often luxurious, such as silk, velvet or organza. She creates enormous versions of cocktail dresses and ball gowns, expensive attire with a social meaning, and she hopes to make a link between the viewer's body and architecture. She is well aware that in Greek and Roman classical art, the human figure was the prototype for the proportions and measurements of architecture. The massive scale and sumptuous material of some of her dresses recall the thirty-three-foot dress of gold sheets made for Pheidias' 40-foot statue of Athena for the Parthenon in Athens. Her *Red Dress* **(315)**, made of velvet, is displayed on a wooden hanger 12 feet from the floor and has the capacity to expand up to 50 feet in length, depending on the gallery space in which it is shown. It can look monumental, but the overwhelming colour and shape also suggest flowing blood and a sense of violence or damage.

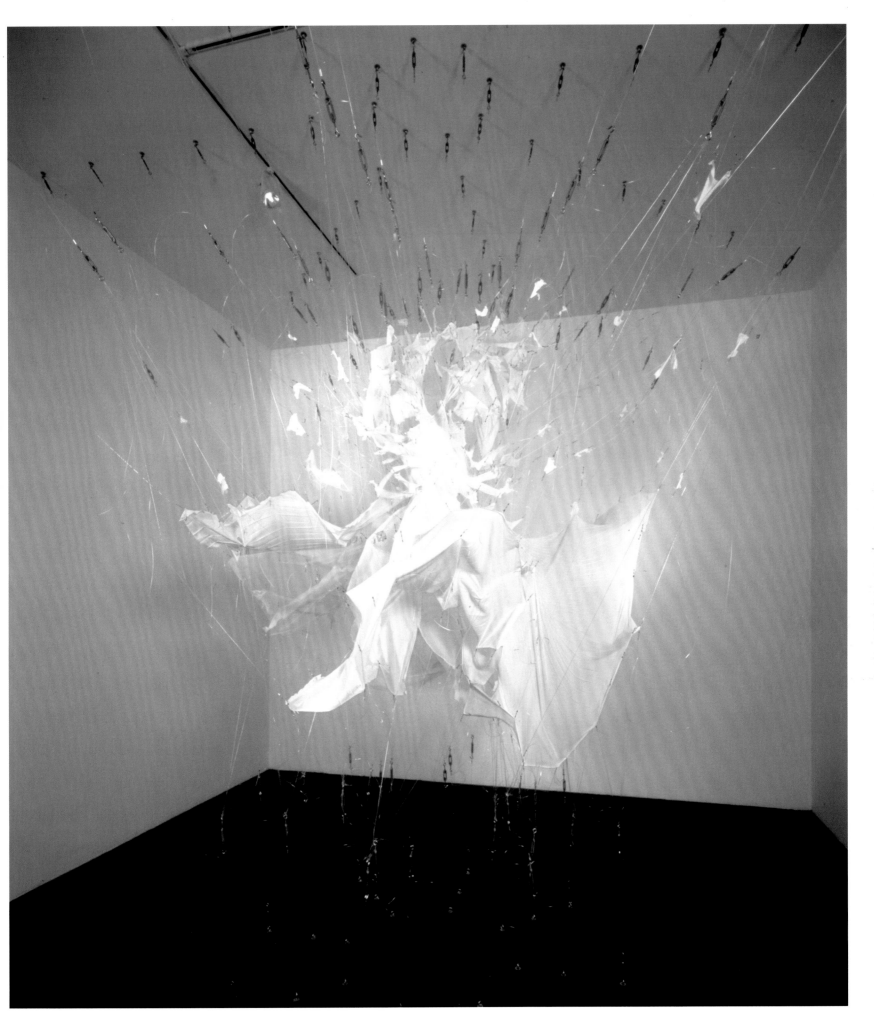

316 E.V. Day, *Bombshell*, 1999. White crepe dress, monofilament, turnbuckles. 487.7 x 609.6 x 609.6 cm (192 x 240 x 240 in)

Day cuts up and expands dresses and wetsuits. Her series 'Exploding Couture' began in the late 1990s; in each of these works, she creates then cuts up a huge dress into hundreds of different sized pieces and suspends them in mid-air on wires attached to the floor and the ceiling, so that the garment appears to have been caught in a violent explosion. For *Bombshell* [316], she created an 8-foot-high reproduction of the white dress worn by Marilyn Monroe in the film *The Seven Year Itch*. It conflates sex and the military, orgasm and detonation, and responds to the term 'blonde bombshell', which was used as an epithet for Monroe in the 1950s.

Ghada Amer makes tracings from pornographic magazines of women in provocative poses and embroiders these in repetitive patterns onto painted canvases or cloths. She also selects texts for her embroidery. For her sculpture *Private Rooms* [317], which consists of a rack of highly coloured satin clothes-covers and shoe racks, she embroidered onto the surfaces excerpts from the Qur'an that deal specifically with women and their correct apparel. Amer followed the strict rules about quoting from the Qur'an, but also chose to work from a French translation of the Qur'an rather than the Arabic itself, so that she was at one remove from the problem.

317 Ghada Amer, *Private Rooms*, 1998. Embroidered sculpture, satin. Dimensions variable

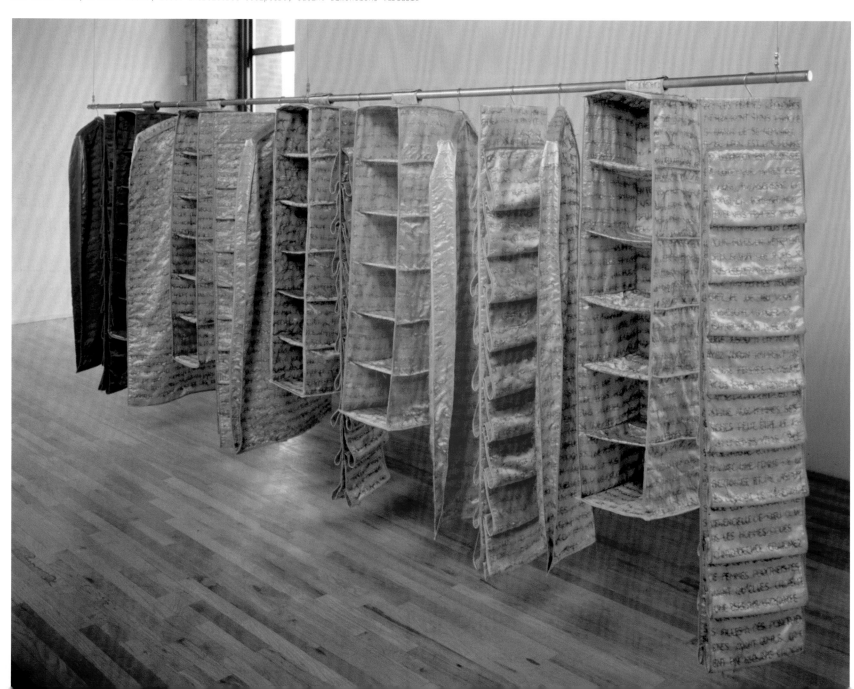

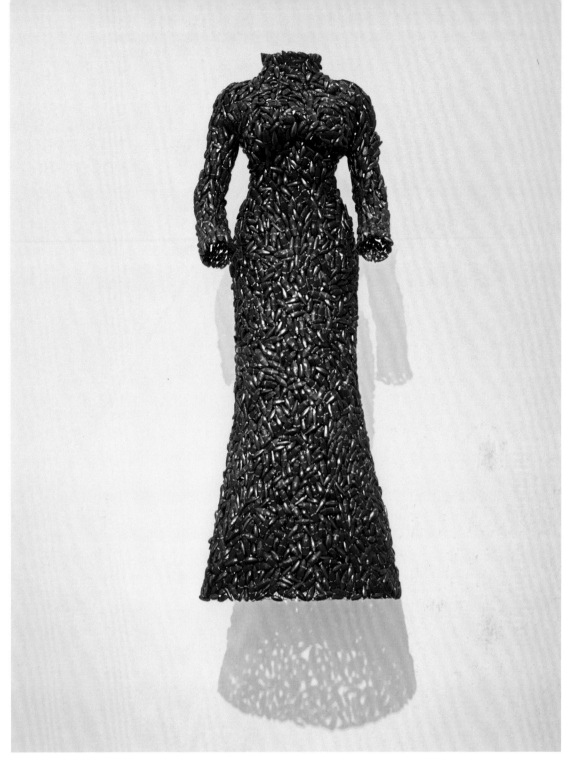

318 Jan Fabre, *Wall of the Ascending Angels*, 1993. Beetles on iron wire. 160 x 50 x 50 cm (63 x 19 ¾ x 19 ¾ in)

The Belgian artist Jan Fabre is the great grandson of the famous nineteenth-century French entomologist Jean-Henri Fabre, and he has inherited his ancestor's interests. He is obsessed with beetles, with which he has covered skulls, ceilings and balls, and numerous garments. *Wall of the Ascending Angels* **(318)** is a long dress made from thousands of iridescent green jewel beetles stitched together over a wire mesh support. These beetles are found in abundance in Australia and Indonesia, where they are fried, eaten and their shells discarded. Fabre considers that man should look to angels as role models, and he seeks to make sculptures that 'render the body spiritualized'. He views beetles as a metaphor for adaptability and resurrection, and is also attracted by the fact that, unlike man, a beetle's skeleton is external; a dress like this one is built up of thousands of exoskeletons.

319 Nicola Costantino, *Peleteria*, 2000. Chalk-coated silicone

Leather is one of the oldest of clothing materials, and sculptors often use it today for its animal qualities. It also comes with its own content of sensuality and sacrifice. Nicola Costantino worked in her mother's clothing factory in her late teens, helping with design and production matters. In her early sculptural works she made dresses from unorthodox animal skins such as chickens. She also makes stylish garments such as *Peleteria* **[319]** that resemble pale suede, but on close inspection reveal themselves to be made of silicone, which carries in its surface the casts of human nipples, navels and anuses. She edges the garments with fringes of human hair. Costantino deals with controversial subjects in her work; she has made sculptures cast from the stillborn fetuses of calves, reminding us that expensive coats are made from such material.

Dorothy Cross arrives at the use of animal skins from quite a different angle. In the 1990s she produced two large series of sculptures, one using cured cow skins and cow udders and the other employing stuffed snakes, which drew on both creatures' rich store of symbolic associations across cultures, to investigate issues of sexuality and religion. *Virgin Shroud* (1993) is an amalgam of her grandmother's silk wedding dress and a cow skin complete with udder. Cross recalled that Sigmund Freud described cows' udders as 'intermediate between a nipple and a penis', lending them a cross-gender identity. The cow skin covers the figure's head, preventing communication and making it seem like a dumb animal. The title of the work alludes to the Virgin Mary and the teats of the udder around the head can be read as a crown.

A group of gay male artists deal with sexual identity in their clothing pieces; gay codes and cross-gender apparel are found in the work of Charles LeDray, Robert Gober, Nayland Blake and Oliver Herring. LeDray was taught to sew by his mother when he was four, and he made his own puppets and toys. At the time he moved to New York in 1989, he was making worn and weathered velvet teddy bears, which he regarded as self-portraits but did not exhibit. He revealed his tailoring skills in the early 1990s, when he began a series of men's suits and uniforms, made to around one-third human scale. Several can be read as self-portraits, since they carry an embroidered name patch with the word 'Charles' or its derivations. LeDray either displays his clothes on hangers on the wall, on a handmade tailor's dummy, or on an armature within a Perspex case. His tiny outfits are fashioned with tenderness, but *Chuck*, a sport-fisherman's outfit, looks as though it has been savaged by a shark, and *Torn Suit* might have been through an industrial shredder. However, LeDray underplays this disarray and implied violence by stating that such works are exercises in adding and subtracting materials.

320 Oliver Herring, *Raft*, 1995. Knitted transparent mylar. 213.3 x 235 cm (84 x 88 in)

Charles [321] comprises a worker's short blue jacket of a kind worn by gay men in the 1970s, with navy trousers and a blue shirt. Dangling from the hem of the jacket and trousers are small garments, both male and female, including underpants and a patterned bra. There are many ways of reading this device: the smaller clothes could imply offspring, and there is also the possibility of cross-dressing.

Robert Gober has written about how the AIDS epidemic in New York in the late 1980s re-ordered the way in which he saw the world, and not surprisingly, his work reflects this. He lithographically doctored a page from *The New York Times*, so that the majority was taken up with a large Saks Fifth Avenue advert for bridal wear, showing a photograph of Gober in a long white wedding dress. The headline of the article above read 'Vatican Condones Discrimination Against Homosexuals'. The wedding dress, handmade by Gober, assumed its own autonomous state as a sculpture, and became the central feature in a gallery installation at the Hamburger Kunsthalle, along with printed wallpaper and handmade bags of cat litter [323]. The empty dress speaks of absence and loss; the bride stands alone without her groom.

321 Charles LeDray, *Charles*, 1995. Fabric, thread, metal, plastic, paint. 48.2 x 35.5 x 11.5 cm (19 x 14 x 4 ½ in)

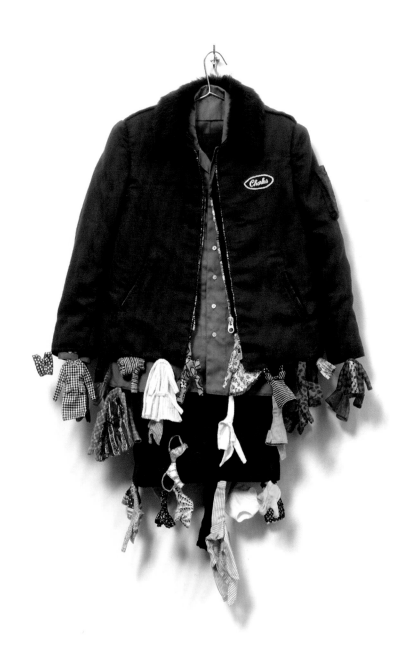

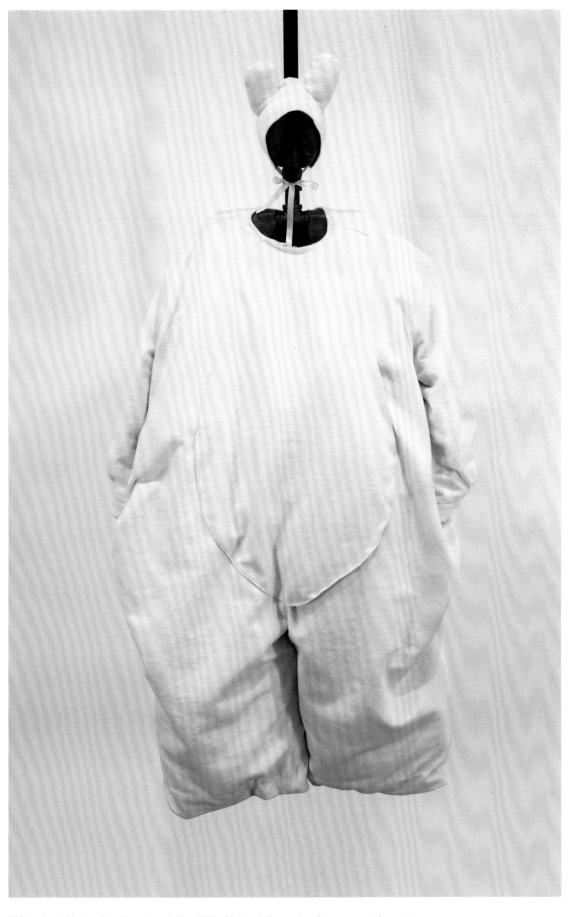

Nayland Blake is a gay artist who draws attention to his size and his sexuality through his work. In the early 1990s, he created a performance piece wearing a rabbit suit hired from a costume shop, and since 1994 his sculptures and some videos have focused on rabbits, an animal that has become a surrogate figure for the artist. He has made works using toy rabbits, chocolate rabbits, rabbit pelts and images of well-known rabbit characters from folk tales and cartoons, such as Brer Rabbit, Bugs Bunny and Uncle Wiggily. In 2000, Blake appeared in his own video *Starting Over* wearing a specially made rabbit suit of white flannel padded with 140 pounds of dry beans, the weight of his partner. He attempted to tap dance, but the heavy suit impeded his movements. The suit then became an autonomous work, the *Starting Over Suit* **[322]**, and was shown displayed on a metal armature, along with its accompanying rabbit hat and ears.

Oliver Herring appeared on the New York art scene in 1993 with his knitted outfits, which were offered as memorials to the performance artist and drag queen Ethyl Eichelberger, who committed suicide in 1990 while suffering from AIDS. Eichelberger performed his own plays, which celebrated the lives of strong women such as Cleopatra, while wearing long gowns, elaborate wigs and high heels. Herring's dresses and coats are immensely labour intensive, since he knits them himself using strips of reflective and transparent mylar, a synthetic material. He has employed other non-traditional knitting materials, such as paper, Sellotape and wood veneer, but the silvery pale, ghostly mylar garments such as *Raft* **[320]** are more successful in conveying a sense of emptiness, absence and loss, a fitting tribute to a fellow gay artist. Herring's knitting makes a strong statement about a traditionally female activity being taken over by a male for expressive purposes.

322 Nayland Blake, *Starting Over Suit*, 2000. Cloth, 140 pounds of beans, metal armature.
211 x 117 x 56 cm (83 x 46 x 22 in)

Wiebke Siem looks at how garments are presented in shops, and how they are perceived in relation to each other, as though they were a series with variations. Starting as a painter in the 1980s, she also made functional clothes for herself and her friends, onto which she sewed lop-sided stripes and checks. In 1989 she made a series of unwearable hats from foam rubber, and by the 1990s she was beginning to make collections of unwearable dresses, furs and hats, as well as shoes carved from wood, and wigs made out of plaster. Her favourite material is jersey, and she lines her garments with foam rubber or wire mesh to render them stiff and volumetric; their look is anonymous and impersonal even though their dimensions derive from her own body measurements. They hang on the wall stiffly, 'like medieval armour', and they speak of emptiness; no body has been near them [325].

Quite the opposite is found in the sweater sculptures of Erwin Wurm. *Untitled* [324] is a photographic record of six of his 'One Minute Sculptures', where he invites members of the public to become a sculpture for that length of time, providing them with the materials to do so, in this case a large red sweater. They were asked to hold a pose within the sweater, thereby bringing into play sculptural matters such as shape, colour and texture, stability and equilibrium. As Wurm has said: 'When the sweater is stretched so that the body of the wearer can find its way into this envelope ... an essential plastic process takes place.' In the early 1990s Wurm also exhibited some of his own sweaters, hung from nails directly onto gallery walls.

323 Robert Gober, *Wedding Gown*, 1989. Silk satin, muslin, linen, tulle, welded steel armature. Dimensions variable

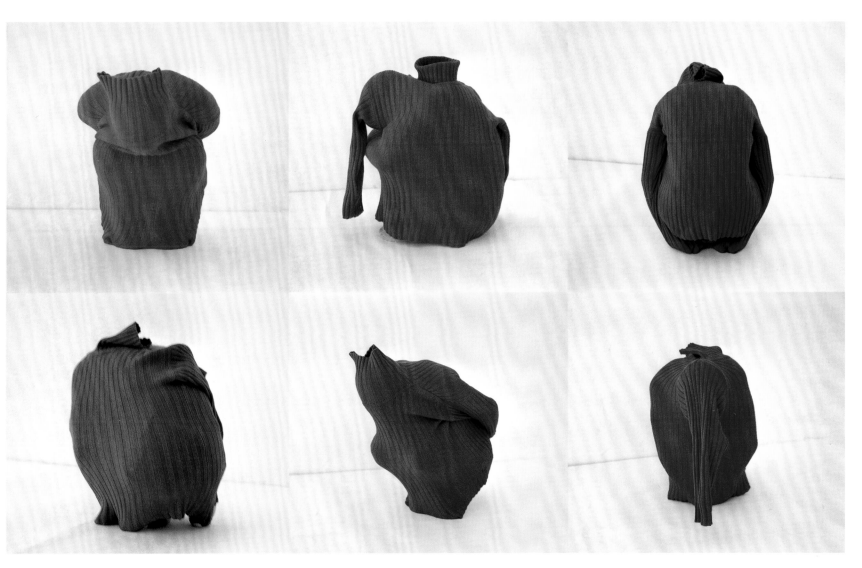

324 Erwin Wurm, *Untitled*, 2000. C-prints on PVC. 200 x 300 cm (78 ¾ x 118 in)

325 Wiebke Siem, *Work Group - Dresses*, 1991-4. Wire mesh, fleece, jersey. Dimensions variable

The *Oxford English Dictionary* defines a monument as 'something that reminds, a memorial'. Aldo Rossi, the Italian architect, stated that a monument 'is a sign upon which one reads something that cannot otherwise be said'. As art has ceased to be controlled by church, state or nobility, and lost its historic public role, monuments to power, conquest and sacrifice are no longer commissioned from artists. However, in the second half of the twentieth century, a new source of revenue appeared, specifically for the production of large-scale public sculptures, so that the monumental came to replace the monument.

In America during the late 1960s, state and city mandates required new government buildings to include commissioned artworks, both paintings and sculpture. The Art-in-Architecture Program of the General Services Administration -- GSA -- was set up in 1963; the Art-in-Public-Places Program of the National Endowment for the Arts in 1967; and local and state Percent for Art programmes started around the same time. Philadelphia, as America's first capital city, commissioned works to commemorate heroic figures, patriotic ideals and historic events, and as a result it has perhaps the largest collection of public sculpture (of variable quality) of any city in the world. In the mid-1960s, coinciding with these commissioning bodies, new production techniques and materials, such as Cor-Ten steel, made it possible for sculptors to work on a much larger scale. Sculptures of this era were used to create a significant focus in a public space, and to encourage a sense of urban pride and regeneration. They cover a wide variety of subject material, and are substantial in scale, qualifying them for the adjective 'monumental', but that does not mean that they are also monuments. In many cases, they do not fit the definition offered by Rossi. Yet there are contemporary monuments and they speak of many things; some deal with events that have occurred in the second half of the twentieth century: the war against Fascism, the Holocaust, natural and man-made disasters, while others deal with timeless aspects of the human condition such as heroism, sacrifice and achievement. The last twenty years have seen more sculptural memorials to the Holocaust than any other subject, commissioned mostly in Germany and America.

Claes Oldenburg's *Clothespin* [327], made for Philadelphia, is 45 feet high and made from Cor-Ten and stainless steel. Oldenburg has made a series of monumental sculptures, scaled-up versions of humble objects, for several cities worldwide, that are immediately recognizable to the general public, even though they are out of context and often have no relationship to their site, as is the case with Philadelphia. Oldenburg is known for his attempt to democratize art, and since commonplace, mass-produced objects dominate contemporary life, he finds it logical to make them the subject of his sculptures. European curator and critic Rudi Fuchs believes that Oldenburg's public sculptures act as collectors rather than projectors of meaning.

Tom Otterness also makes large-scale public sculpture, and like Oldenburg, his work, which is figurative and often humorous, appeals to a broad public. In 1977, Otterness was a founding member of COLAB, a New York artists' collective that pressed for art to become more accessible and less gallery-bound. In 1978, he received his first major public commission from the Art-in-Architecture programme of the GSA and produced a 300-foot-long, cast-stone relief filled with his trademark cartoon-like figures. Otterness is inspired by the content and style of fairy tales and comics, although his burlesque figures often have a subtext related to money and power. These figures are composed of simple geometric shapes and are cast in smooth, polished bronze. The World Trade Center attacks in 2001 prompted Otterness's sketch showing a 'Gulliver' figure, based on the character in Jonathan Swift's story *Gulliver's Travels*, lying in Manhattan, observed from across the Hudson River by the monumental *Crying Giant* [328], a memorial for the World Trade Center; but his idea, which represented the USA as a helpless giant held prisoner by other forces, was not accepted by the committee responsible.

326 Paul McCarthy, *Blockhead*, 2003. Vinyl-coated fabric inflatable. Approx. 35 m (115 ft) high. As installed at Tate, London

327 Claes Oldenburg, *Clothespin*, 1976. Cor-Ten steel and stainless steel on concrete base. 13.72 m (45 ft) high. Centre Square Plaza, 15th and Market Streets, Philadelphia, Pennsylvania

328 Tom Otterness, *Crying Giant*, 2002. Bronze. 335.3 x 198 x 439 cm (132 x 78 x 173 in)

A third American artist commissioned to make a monumental public sculpture for an urban site was Richard Serra, and he took a very different stance from Oldenburg and Otterness, stating: 'My sculptures are not objects for the viewer to stop and stare at. The historical purpose of placing sculpture on a pedestal was to establish a separation between the sculpture and the viewer. I am interested in creating a behavioural space in which the viewer interacts with the sculpture in its context.' He was commissioned by the Art-in-Architecture programme to make a work for Federal Plaza, New York, the city's legal and administrative centre; he proposed *Tilted Arc* [329], a solid sheet of rusted Cor-Ten steel 12 feet high, 120 feet long, 2 ½ inches thick and weighing 73 tons, which was set in place in July 1981. The sculpture was site-specific, meaning that its proportion, scale, material and form had been carefully judged so as to measure up to its setting. Serra wanted the sculpture 'to alter and dislocate the decorative function of the plaza, to redefine the space' both conceptually and perceptually. From the strength of the opposition to this work, it appears that he succeeded. Two months after *Tilted Arc* was installed, a petition with 1,300 signatures of employees working in office buildings overlooking Federal Plaza requested its removal. One employee described it as looking 'like a tank trap to prevent an armed attack from Chinatown in case of a Soviet invasion'. There was a three-day hearing in March 1985, which resulted in a vote for the removal of the sculpture. On hearing this, Serra sued the American government for forty million dollars for a violation of his contract, but was unsuccessful. On 15 March 1989, *Tilted Arc* was cut into pieces and removed to a scrap metal yard. Serra continues to create monumental steel sculptures for significant city sites such as London and Berlin, but no more works have been commissioned in America.

In Europe during the 1980s, several cities decided that a public art programme was an important factor in the revitalization of their environment. In Britain, these cities

329 Richard Serra, *Tilted Arc*, 1981. Cor-Ten steel. 3.7 x 36.5 m (12 x 120 ft). Federal Plaza, New York, destroyed 15 March 1989

330 Raymond Mason, *A Tragedy in the North. Winter, Rain and Tears*, 1975-7. Epoxy resin, acrylic. 287 x 321 x 134 cm (113 x 126 ¾ x 52 ¾ in)

included Birmingham, the City of London and the North-East conurbation of Newcastle and Gateshead. This latter region has an extensive range of large-scale public sculptures, including major works by Juan Muñoz, Mark di Suvero, Alison Wilding, David Mach, Tony Cragg, Richard Deacon and Claes Oldenburg. The largest work of all is Antony Gormley's *Angel of the North* [332], sited beside the A1 on the outskirts of Gateshead, which stands 20 metres high with a wingspan of 54 metres. The borough council had decided in 1994 to commission 'a millennial image that would be a marker and a guardian for our town.' Gormley described the intention behind his *Angel*: 'I want to make something we can live with and that becomes a reservoir for feelings -- feelings that perhaps we hadn't known about until this thing was there, or feelings that couldn't arise until it was.' His giant figure is rare among contemporary monuments in that it is a representation of a human body, albeit with aeroplane wings. Is it just monumental, or is it also a monument? The artist sees it as a memorial to the iron and steel industry of the area.

Two other British sculptors, Raymond Mason and Michael Sandle, also make figurative monuments and memorials, but are less well known than Gormley, partly because they have made their careers outside the country. Both look back to earlier art for their inspiration, and this situates their realistic figurative work outside the contemporary cutting edge. Mason has lived and worked in Paris since 1947, and he made his large painted fibreglass relief *A Tragedy in the North. Winter, Rain and Tears* [330] in response to a newspaper article on a mining disaster in Lievin, northern France. Mason altered the title and the content so that it was no longer specific to Lievin, allowing it to speak to a wider audience, although a black slag-heap can be seen in the background, and the industrial buildings are copies of those at the mine. The outstretched hand of the man left of centre serves to draw the viewer into the work, as well as formally balancing the weeping woman at the front who walks out of the relief. The content is accessible and obvious -- a powerful display of communal and public grief and suffering.

331 Michael Sandle, *A Twentieth Century Memorial*, 1971-8. Bronze, brass, wood. 126 x 522 x 522 cm (49 ½ x 205 ½ x 205 ½ in). Tate, London

332 Antony Gormley, *Angel of the North*, 1998. Weather resistant Cor-Ten steel. 20 m (65 ft 6 in) high, wingspan 54 m (177 ft). Gateshead, UK

333 Maya Lin, *Vietnam Veterans Memorial*, 1982. Two polished black granite walls, with engraved names. Each wall 75 m (246 ft 9 in) long, 3 m (10 ft) maximum height. Constitution Gardens, Washington, DC

Sandle has spent a large part of his career making figurative sculpture on the themes of war and death, the major subjects of memorials and monuments. Two recently commissioned public works are the great *Siege-Bell Memorial* (1989-93) for the island of Malta, and the *Seafarer's Memorial* (unveiled 2001) in the City of London. But long before he realized these, he made a large and complex bronze sculpture -- *A Twentieth Century Memorial* [331] -- in response to the America-Vietnam war. The central figure, a skeleton with a Mickey Mouse head and sightless eyes, mans a larger-than-life replica of a Browning machine gun. The gold patination of most of the bronze lends it a glamorous and precious air, out of keeping with the subject matter. The Disney cartoon character of Mickey Mouse gives the piece its American flavour, but the skeleton and weaponry make it speak universally.

In complete contrast to the hard-hitting, personal nature of Sandle's anti-Vietnam work, Maya Lin's Official *Vietnam Veterans Memorial* **(333)** wall in Constitution Gardens, Washington Mall, Washington, DC, unveiled on Armistice Day, 11 November 1982, is cool and elegant. The idea for an official American memorial to the Vietnam War was first mooted in 1979, and two acres of land in Washington were put aside for it, although there was no concrete idea of what it should be. A competition raised 1,400 entries and Maya Lin, a young architecture student of Asian-American origin, won. She proposed two polished black granite walls, 10 feet high and 250 feet long, set into a grassy slope and carved with 58,000 names of the Americans who died fighting in the Vietnam War. Lin chose black granite from India as her material because it turned 'into a mirror if you polished it. The point is to see yourself reflected in the names ... The Vietnam Veterans Memorial is ... formed from the act of cutting open the earth and polishing the earth's surface -- dematerializing the stone to pure surface.' To some critics, it seemed too minimal, and in 1984 a concessionary bronze figurative sculpture of three soldiers by Frederick Hart was added, followed, in 1993, by a bronze group of women soldiers.

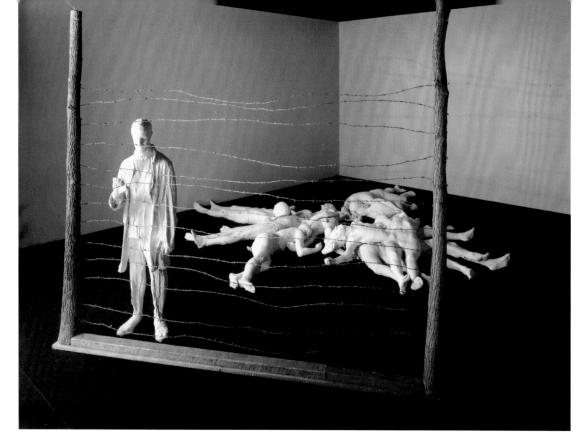

334 George Segal, *Holocaust Memorial for San Francisco*, 1984. 11 bronze figures with white patina, wood, barbed wire. Dimensions variable

In the past few decades, a growing number of Holocaust memorials and monuments have been commissioned across Europe and America. One of the first was by George Segal, who in 1984 won a competition to make a *Holocaust Memorial for San Francisco*; there are other Holocaust memorials in Miami and Philadelphia. Segal's sculpture **(334)** consists of naked body casts spread out on the ground to form the shape of a Jewish star. One of the male figures adopts the pose of the crucifixion, while a female figure holds an apple, alluding to Eve. A clothed male figure stands alone by a barbed-wire fence. The figures are made from bronze, painted white. This is the most literal of all Holocaust memorials; the figure of the man by the fence even derives from a 1945 *Life* magazine photograph of the camp at Buchenwald, taken by Margaret Bourke-White, yet in the San Francisco setting he gazes out over the ocean.

The artists Esther Shalev-Gerz and Jochen Gerz won a competition to make the *Monument Against Fascism, War and Violence, and for Peace and Human Rights* for the city of Hamburg-Harburg, which lasted as a public sculpture from 1986 to 1993, when, faithful to their concept, it was lowered into the ground and disappeared from view. The monument consisted of a lead-covered hollow steel tower 1 metre across and 12 metres high, which was sited on a platform close to Harburg Town Hall, near to the entrance of the commuter station. The inhabitants of the town were invited, through a text in seven languages, to engage in a public statement against fascism by indelibly engraving their names; 'In the long run, it is only we ourselves who can stand up against injustice', reads the last sentence of the invitation text. Steel styluses were attached so that the public could write their names and comments on the lead fabric of the monument; there were 60,000 responses. It was announced that the work would undergo eight staged lowerings, allowing the upper reaches of the pillar to be utilized and filled with messages, and each lowering was a public event with discussions about the memorial. At the final lowering, all that was left of the monument was the top of the pillar, and a small window at the level of the pedestrian subway below, revealing the shaft of the buried pillar, covered with its written contributions.

335 Sol LeWitt, *Black Form*, 1987. Concrete blocks, paint. 2 x 5.5 x 2 m (6 ft 7 in x 18 ft x 6 ft 7 in). Platz der Republik, Altona-Hamburg

A year after Gerz's Hamburg-Harburg monument, Sol LeWitt made two large complementary works for the 1987 sculpture exhibition in the German city of Munster: *Black Form* and *White Pyramid*, both composed of stacked concrete blocks. *White Pyramid* was set in the Botanical Gardens while *Black Form* **(335)** was sited in front of Munster University and consisted of concrete blocks painted black, stacked in a rectangular form and measuring 2 x 5 ½ x 2 metres. While the work was on display, LeWitt, a Jewish artist, added the subtitle *Dedicated to the Missing Jews*, turning it from a massive formal presence into a memorial. City officials requested that it be moved, on the grounds that it obstructed the flow of traffic. The city of Altona-Hamburg had long been considering erecting a memorial to the Jewish communities that suffered under Nazi rule, and in 1989 LeWitt offered *Black Form* to that city, where it was gratefully accepted and sited in front of Altona Town Hall in the Platz der Republik. In accordance with LeWitt's wishes, the sculpture has no inscription, but two plaques nearby give the history of the Altona-Hamburg Jewish community, which originated in the sixteenth century and was eradicated in 1941.

336 Hans Haacke, *Standort Merry-Go-Round*, 1997. Wood planks, barbed wire, carousel with lights and music. Approx. 700 cm (275 ⅝ in) high. As installed as part of the Skulptur Projekte Münster, Germany, 1997

One of the most active artists in the political arena is Hans Haacke, who was commissioned by the Austrian city of Graz in 1988 to make a piece to commemorate the fiftieth anniversary of Hitler's Anschluss. Haacke was asked to 'confront history, politics and society', and not surprisingly, he obliged. In the centre of Graz is a large statue of the Virgin Mary on top of a tall column, and in 1938 Hitler had a temporary truncated obelisk constructed, obscuring it with the slogan *Und Hir Habt Doch Gesiegt* (And you were victorious after all), referring to a recent Nazi victory. Haacke recreated this, copying both obelisk and text, which were open-ended enough to seem contemporary and to carry a different meaning in this context. In 1997, he made an uncommissioned counter-monument to German history for the sculpture exhibition in Munster, his *Standort Merry-Go-Round* [336]. He sited this piece next to a prominent nineteenth-century stone war memorial, known locally as the 'Monument of Asses' that commemorates the wars waged by Bismarck against Prussian neighbours, his victories and the establishment of the Reich. Haacke erected a closed form of the same height and diameter, made of rough wooden planks topped by barbed wire. Through chinks in the planks can be viewed a fairground carousel with wooden horses and lights, while music can be heard playing the German national anthem. The juxtaposition of the two memorials made a powerful and moving statement.

A younger German artist, Olaf Metzel, also makes art that has a political and social bent, often dealing with public outrages and violence. His career was launched in 1987, when he contributed a large, tower-like structure to the sculpture exhibition celebrating the 750th anniversary of the founding of Berlin. The work bore the title *13.04.1981* [337] and commemorates the debris left in Berlin's main shopping street, the Kurfurstendamm, after a violent battle between left-wing radicals and the police, following a false report of the death of a member of the Baader-Meinhof group in prison. Although Metzel's sculpture looks as though it is composed of the debris from the street battle, all the pieces are replicas of real police barriers, concrete blocks and a shopping trolley which the artist had simplified and enlarged. The form of the tower recalls that of Tatlin's famous model for a *Monument to the Third International*.

337 Olaf Metzel, *13.04.1981*, 1987. Steel, chrome, concrete, pigment. 11.5 x 9 x 7 m (37 ft 9 in x 29 ft 6 in x 23 ft).
Westfälisches Landesmuseum für Kunst und Kulturgeschichte, Munster, Germany

In Britain, one of the most famous public monuments was made by Rachel Whiteread in October 1993 **(338)**. *Untitled (House)* was a cast of a Victorian terraced house whose address was 193 Grove Road, Bow, in the East End of London. Whiteread had lived and worked in the area since 1989, and had been looking for a suitable condemned domestic building to memorialize, since these were being demolished in their thousands, authorized by the government of the day. The money for the project was provided by Artangel, a London-based art-commissioning body, who dealt with all the legal and planning problems. Whiteread used the house as a mould; technicians went inside and sprayed liquid concrete onto all its interior surfaces. They then carefully removed the structure, brick walls, roof, windows et al, to reveal a new concrete skin that retained the shape of the old house's interior life. The negative space inside the house was transformed into something solid, and the solid walls and roof of the house disappeared. Artangel had only organized a short-term lease on the site, and *House* was demolished on 11 January 1994 amid huge publicity. Artangel then turfed over the site, and no visible signs of the sculpture remain on Grove Road. Like Jochen and Esther Shalev-Gerz's monument for the city of Hamburg-Harburg, *Untitled (House)* now exists in the memory of the visitors and through numerous illustrations.

Whiteread was then commissioned to make the *Holocaust Memorial* for Vienna in 1997, which was unveiled in 2000. She commented: 'The difference between *House* ... and the Judenplatz monument is that *House* was in effect a private sculpture being made public "by default" (as a result of its scale and visibility). The Judenplatz monument is from inception bound up in history and politics.' The *Holocaust Memorial* resembles an inverted library; it is a concrete cast of rows of books with their spines turned to the inside, with two handle-less doors at one end. The viewer cannot enter the room, nor read the books. Around the base of the work are the names of the Nazi concentration camps in which 65,000 Austrian Jews died. It is located in the Viennese square, Judenplatz, and sits over the remnants of a Jewish synagogue that was burned down in 1421. Simon Wiesenthal, who initiated the memorial, said that the symbol of the book was highly significant and apposite: 'We are a people of books. We didn't build our monuments out of stone and metal. Our monuments were books.' With her Judenplatz memorial, Whiteread has conceived a sculpture that is an antidote to the heroic monument. Through its associations with a humble tomb, a grand mausoleum and an empty cenotaph, it commemorates and embodies loss; indeed, a memory of things now irredeemably lost resonates through all Whiteread's work. In some ways, her sculptures encapsulate the quintessence of what we mean by a memorial.

Thomas Schütte has proposed a series of memorials, commemorating a wide range of people, ranging from the sailor Alain Colas in 1989 to Hitler in 1991, conceived in naive, childlike forms, as if to counter the staleness and vapidity of naturalistic representation. 'In my eyes,' states the artist, 'the figurative tradition failed at the point when the artist had to create heroes in a democratic system, which nowadays is something television networks can do much more effectively.... Power is no longer represented by a king or a single figure; it operates through a system or many, many different, overlapping nets which tend not to be visible but to be hidden away. So the power structure is basically anonymous and it's impossible to give it a face or even a body.'

One of Schütte's early anti-monuments was his *Cherry Column* **(339)** for the sculpture exhibition in Munster, which looks as light-hearted as Oldenburg's *Clothespin* made eleven years earlier, but contains a thread of irony. Classical Corinthian columns have acanthus leaves at the top, so why not fruit in this context? The two enamelled aluminium cherries sit on top of a sturdy, 4-metre-high column of local sandstone, which is so oddly proportioned that it looks like a pepper-grinder. Such tall columns holding something or someone aloft have long been symbols of power in city squares. Schütte deliberately chose this square, the Harsewinkelplatz, for the placement of his work, yet *Cherry Column* has no relevance to its site. It looks uncomfortable among the parking meters and cars.

338 Rachel Whiteread, *Untitled (House)*, 1993
Building materials and plaster. Approx 10 m
(32 ft 6 in) high. 193 Grove Road, London E3,
demolished 11 January 1994

339 Thomas Schütte, *Cherry Column*, 1987. Painted cast aluminium, sandstone. Approx 600 cm (236 ¼ in) high. As installed in Harsewinkelplatz, Munster, Germany

Schütte's proposed monument for Alain Colas, *Monument for a Missing Sailor* (1989), was not realized, but Schütte intended to make a realistic figure of the yachtsman for his home town, setting it on a pedestal in a river so that at high tide the water would reach to his chin. Colas was lost at sea during an attempted crossing of the Atlantic Ocean in 1978.

An artist who likes to make arresting uncommissioned work for public spaces is Braco Dimitrijevic, who was born in Sarajevo, the city where Archduke Francis Ferdinand of Austria was assassinated in 1914, an event that indirectly led to World War I. This context led Dimitrijevic to reflect upon how historical events are presented and commemorated, as well as the way in which fame is bestowed, and how long it lasts before obscurity follows. In 1979, Dimitrijevic proposed the building of a stone obelisk with an inscription to an unknown person. When in the garden of Schloss Charlottenburg in Berlin, the artist chose an unknown passer-by, Peter Malwitz, and asked him to name a significant date. Malwitz chose 11 March, his birthday, and as a result, Dimitrijevic's stone obelisk bears this date on all four sides, plus the hopeful inscription: '11 March: This Could be a Day of Historical Importance' [340].

Maurizio Cattelan presented another kind of memorial at the Anthony d'Offay Gallery in London in 1999 -- a large black granite stele inscribed with a list of all the international football matches lost by the English national football team, thus making it a monument to failure [342]. With its polished black stone and bare lists of names, it has strong resonances of Lin's *Vietnam Veterans Memorial* in Washington, DC. Cattelan described it as a piece that 'talks about pride, missed opportunities and death'.

After the Holocaust, and terrorist bombs such as Omagh, Bali, Madrid and the World Trade Center, it seems that instead of making monuments of heroes, we now make monuments of victims. Eric Fischl unveiled his bronze *Tumbling Woman* [343] at the Cologne Art Fair in spring 2002. It was shown again at the Rockefeller Centre, New York, in August 2002 as a memorial to the World Trade Center destruction the previous year, but was swiftly removed from display. Public opinion deemed the subject too realistic and raw. *Tumbling Woman* is close in style and pose to both Rodin's *Martyr* and Maillol's *The River*, and is possibly too conventional in style and content to bear the weight of its subject.

340 Braco Dimitrijevic, *11 March -- This Could be a Day of Historical Importance*, 1979. White Carrara marble obelisk. 10 m (32 ft 10 in) high. Garden of Schloss Charlottenburg, Berlin

SCOTLAND v ENGLAND 2-1
SCOTLAND v ENGLAND 3-0
ENGLAND v SCOTLAND 1-3
SCOTLAND v ENGLAND 7-2
SCOTLAND v ENGLAND 5-4
ENGLAND v SCOTLAND 1-6
ENGLAND v WALES 0-1
SCOTLAND v ENGLAND 5-1
ENGLAND v WALES 3-5
ENGLAND v SCOTLAND 2-3
SCOTLAND v ENGLAND 1-0
ENGLAND v SCOTLAND 2-3
ENGLAND v SCOTLAND 2-3
SCOTLAND v ENGLAND 2-1
ENGLAND v SCOTLAND 1-2
SCOTLAND v ENGLAND 4-1
ENGLAND v SCOTLAND 1-2
SCOTLAND v ENGLAND 2-1
SCOTLAND v ENGLAND 2-0
IRELAND v ENGLAND 2-1
SCOTLAND v ENGLAND 3-1
ENGLAND v IRELAND 0-3
ENGLAND v WALES 1-2
ENGLAND v SCOTLAND 0-3
ENGLAND v SCOTLAND 0-1
IRELAND v ENGLAND 2-1
ENGLAND v WALES 1-2
SCOTLAND v ENGLAND 2-0
ENGLAND v SCOTLAND 0-1
ENGLAND v WALES 1-3
ENGLAND v WALES 1-2
IRELAND v ENGLAND 2-0
ENGLAND v SCOTLAND 1-5
SCOTLAND v ENGLAND 1-0
SPAIN v ENGLAND 4-3
SCOTLAND v ENGLAND 2-0
FRANCE v ENGLAND 5-2
SCOTLAND v ENGLAND 2-1
ENGLAND v WALES 1-2

CZECHOSLOVAKIA v ENGLAND 2-1
HUNGARY v ENGLAND 2-1
SCOTLAND v ENGLAND 2-0
ENGLAND v WALES 1-2
AUSTRIA v ENGLAND 2-1
BELGIUM v ENGLAND 3-2
WALES v ENGLAND 2-1
SCOTLAND v ENGLAND 3-1
ENGLAND v SCOTLAND 0-1
SWITZERLAND v ENGLAND 2-1
WALES v ENGLAND 4-2
YUGOSLAVIA v ENGLAND 2 1
SWITZERLAND v ENGLAND 1-0
ENGLAND v SCOTLAND 1-3
SWEDEN v ENGLAND 3-1
ENGLAND v REPUBLIC of IRELAND 0-2
SPAIN v ENGLAND 1-0
ENGLAND v UNITED STATES 0-1
ENGLAND v SCOTLAND 2-3
ENGLAND v HUNGARY 3-6
ENGLAND v URUGUAY 1-2
HUNGARY v ENGLAND 7-1
URUGUAY v ENGLAND 4-2
YUGOSLAVIA v ENGLAND 1-0
WALES v ENGLAND 2-1
FRANCE v ENGLAND 1-0
PORTUGAL v ENGLAND 3-1
ENGLAND v IRELAND 2-3
ENGLAND v USSR 0-1
YUGOSLAVIA v ENGLAND 5-0
BRAZIL v ENGLAND 2-0
MEXICO v ENGLAND 2-1
PERU v ENGLAND 4-1
ENGLAND v SWEDEN 2-3
HUNGARY v ENGLAND 2-0
SPAIN v ENGLAND 3-0
AUSTRIA v ENGLAND 3-1
BRAZIL v ENGLAND 3-1
ENGLAND v HUNGARY 1-2

SCOTLAND v ENGLAND 2-0
FRANCE v ENGLAND 5-2
ENGLAND v SCOTLAND 1-2
ENGLAND v ARGENTINA 0-1
BRAZIL v ENGLAND 5-1
SCOTLAND v ENGLAND 1-0
ENGLAND v AUSTRIA 2-3
ENGLAND v SCOTLAND 2-3
WEST GERMANY v ENGLAND 1-0
ENGLAND v YUGOSLAVIA 0-1
BRAZIL v ENGLAND 2-1
ENGLAND v BRAZIL 0-1
ENGLAND v WEST GERMANY 2-3
ENGLAND v WEST GERMANY 1-3
ENGLAND v IRELAND 0-1
ITALY v ENGLAND 2-0
ENGLAND v ITALY 0-1
POLAND v ENGLAND 2-0
SCOTLAND v ENGLAND 2-0
CZECHOSLOVAKIA v ENGLAND 2-1
ENGLAND v BRAZIL 0-1
ITALY v ENGLAND 2-0
SCOTLAND v ENGLAND 2-1
ENGLAND v HUNGARY 0-2
ENGLAND v SCOTLAND 1-2
ENGLAND v WALES 0-1
WEST GERMANY v ENGLAND 2-1
AUSTRIA v ENGLAND 4-3
ITALY v ENGLAND 1-0
ROMANIA v ENGLAND 2-1
ENGLAND v WALES 1-4
ENGLAND v BRAZIL 0-1
NORWAY v ENGLAND 2-1
ENGLAND v SCOTLAND 0-1
ENGLAND v SPAIN 1-2
SWITZERLAND v ENGLAND 2-1
ENGLAND v WEST GERMANY 1-2
ENGLAND v DENMARK 0-1
FRANCE v ENGLAND 2-0

ENGLAND v USSR 0-2
URUGUAY v ENGLAND 2-0
ENGLAND v WALES 0-1
ITALY v ENGLAND 2-1
MEXICO v ENGLAND 1-0
SCOTLAND v ENGLAND 1-0
ARGENTINA v ENGLAND 2-1
ENGLAND v PORTUGAL 0-1
SWEDEN v ENGLAND 1-0
WEST GERMANY v ENGLAND 3-1
ENGLAND v HUNGARY 1-3
REPUBLIC of IRELAND v ENGLAND 1-0
USSR v ENGLAND 3-1
ENGLAND v WEST GERMANY 3-4
ITALY v ENGLAND 2-1
ENGLAND v URUGUAY 1-2
ENGLAND v GERMANY 0-1
SPAIN v ENGLAND 1-0
SWEDEN v ENGLAND 2-1
ENGLAND v GERMANY 1-2
ENGLAND v HUNGARY 0-2
NORWAY v ENGLAND 2-0
UNITED STATES v ENGLAND 2-0
ENGLAND v BRAZIL 1-3
ENGLAND v GERMANY 5-6
ENGLAND v BRAZIL 0-1
ENGLAND v ITALY 0-1
ENGLAND v BELGIUM 3-4
ENGLAND v ARGENTINA 3-4
CHILE v ENGLAND 2-0
ENGLAND v ROMANIA 1-2

342 Maurizio Cattelan, *Untitled*, 1999. Granite, MDF, steel, 2700 hand-carved letters. 220 x 300 x 60 cm (86 ½ x 118 x 23 ½ in)

In comparison to America and Europe, public sculpture in the Far East has not been so well supported by commissioning bodies. During the late 1980s, the idea of public art caught on in Japan, but money for public art there comes mainly from private developers, not from the government. In China, the situation is unique. The Cultural Revolution from 1966 to 1976 abolished creative freedom, and for that decade all sculpture revolved around ideology; monumental sculptures of Mao were set up in the centres of most major cities. Then China underwent an accelerated programme of urbanization, which allowed for sculpture in the urban environment. These works focused on famous individuals in a city's history, or historical events, particularly past wars and battles -- just the subjects that were so popular in Victorian and Edwardian Britain.

At the Venice Biennale in 1999 there was a fascinating group of figures masterminded by Cai Guo-Qiang, called *Venice's Rent Collection Courtyard* [344]. This was a reconstruction of a Socialist Realist work of circa 1965, a propaganda piece containing over 100 figures, whose subject was the exploitation of personal freedom, originally made by a group of Chinese sculptors from Chongqing's Academy of Arts. Guo-Qiang brought a group of traditionally trained Chinese sculptors to Venice, and they modelled this monument anew in a large warehouse in the Arsenale. Thus a major monument of Chinese Socialist Realist sculpture was re-presented for the delectation of a Western audience. The act was so successful that Guo-Qiang won an award.

343 Eric Fischl, *Tumbling Woman*, 2001. Bronze. 94 x 188 x 127 cm [37 x 74 x 50 in]

Three recent works that propose alternative monuments, with a strong sense of whimsy, are those by Lee Bul, Jeff Koons and Paul McCarthy. In 1996, Bul exhibited a huge balloon of a Korean woman, titled *I Need You (Monument)*, which required viewers to inflate her by means of foot pumps. Bul stated: 'All monuments are, in short, collective efforts, whether we realize it or not. So the act of the audience pumping air collectively, to bring out ... what eventually became this enormous, overwhelming object, was not only to critique the monument as an object, but also to enact the processes by which all monuments come into being.'

McCarthy designed the largest-ever inflatable sculpture, *Blockhead* [326], which is over thirty-five metres high. *Blockhead* was loosely based on the character of Pinocchio, as well as monochrome minimal sculptures of the 1970s, such as those by Tony Smith. It was first conceived in 2000 to function as a pavilion selling candy bars, with the entrance-door sited between the creature's legs. The artist states: 'Inflatables create attention. And they're often product-related. Big companies make brightly coloured inflatables for big events.... Blockhead's black colour tries to subvert what is attached to commercial objects like this.'

344 Cai Guo-Qiang, *Venice's Rent Collection Courtyard*, 1999. Clay, magic lamps. Dimensions variable. As installed at 48th Venice Biennale

Blockhead is not a monument designed to last for long; it is vulnerable and has to be tethered in place by cables. And there are other artists who think this way -- Thomas Hirschhorn being one. His career started in the 1990s with his enormous and temporary room-size installations made from cheap, disposable materials such as cardboard boxes, sticky tape, aluminium foil and newspapers. He progressed to kiosks, altars and what he called 'monuments' in public spaces, such as pavements. In 2002 he made his *Bataille Monument* [348], a temporary structure dedicated to the life of the transgressive French philosopher Georges Bataille, and set in the middle of an immigrant neighbourhood in the city of Kassel. Bataille wrote about excess and notions of expenditure, and Hirschhorn's monument is made from the discarded wrappings of the consumer industry. Hirschhorn does not offer a single narrative or argument in his monuments; instead he presents an unfinished accumulation of material mirroring that which surrounds us in our daily lives.

345 Thomas Hirschhorn. *Bataille Monument*, 2002. Mixed media. Dimensions variable

346 Jeff Koons, *Puppy*, 1992. Approx. 20,000 fresh flowers, watering system, earth, wood, steel. 12 x 5 x 6.5 m [39 ft 4 in x 16 ft 5 in x 21 ft 4 in]. Guggenheim Museum, Bilbao, Spain

347 Emily Jacir, *Memorial to 418 Palestinian Villages which were Destroyed, Depopulated and Occupied by Israel in 1948*, 2001. Refugee tent, embroidery thread, mixed media, record book mounted on a pedestal, which contains a daily log of all the people who came and sewed. Dimensions variable. National Museum of Contemporary Art, Athens

Powerful and famous figures from history are often sited in front of historic buildings, but Koons overturned this precept when he placed his monumental *Puppy* in front of Arolsen Castle, Germany. *Puppy* is a 40-foot-high figure of a terrier, whose surface is made from 20,000 brightly coloured flowering plants set into soil and supported by a steel and wood armature [346]. The plants include begonias, impatiens, chrysanthemums, petunias, geraniums and lobelias, which bloom, grow and fade in their own cycles. In 1996, *Puppy* was invited by the Museum of Contemporary Art in Sydney, Australia, to appear at the harbour front as part of the commemorative anniversaries of the city, and for this showing it was refabricated as a permanent stainless-steel structure with its own integral internal irrigation system, which can accommodate up to 70,000 plants. The sculpture moved one more time, to Bilbao, Spain, where it now has a permanent home in front of the new Guggenheim Museum.

Emily Jacir wanted to create a memorial to Palestinian villages lost since 1948. In 2001, she acquired a large canvas refugee tent and pencilled onto it the names of the villages, leaving space for additional names. She started to embroider the names with thick black thread and was overwhelmed by the task she had set herself. She decided to open her studio to anyone who would help with this, and 140 people came to partake in the act of remembrance [347]. As a portable structure, the tent also calls attention to displacement and eviction.

Minimalist sculptures of the 1960s drew attention to the space and context in which they were shown, inviting the viewer into a phenomenological relationship. A more direct viewer-space relationship was initiated with the arrival of installation art in the 1970s, wherein the whole space of the gallery was activated by its contents. This relationship became even more interactive in the 1990s, when artists moved to working in spaces more associated with leisure and entertainment, such as shops, bars and city streets, and offered such things as free meals and music. The critic and curator Nicolas Bourriaud coined the phrase 'relational aesthetics' to describe this kind of art/viewer experience. By laying claim to new venues for art and producing fresh ideas about displays, artists are also functioning as curators and widening their control over the consumption of their work.

The 1980s had seen the emergence of what has been called 'institutional critique', meaning that the art gallery was no longer viewed as just a physical space. All the support systems that enabled an art institution to survive and thrive came under examination and were brought to the fore: areas like curating, sponsorship, publicity, conservation, acquisition, visitor profiles, appointment of trustees and chronological versus thematic handing of collections. Art gallery basics such as display plinths, information labels and barriers were dragged from the sidelines and set centre stage. The viewers equally came under scrutiny; they were no longer anonymous, but arrived with cultural, racial and gender baggage.

Moving from the rarefied air of the art gallery to the city streets offers fewer opportunities for the temporary or permanent placement of three-dimensional artworks. Public sculpture began to be sited in city streets in the 1960s and 1970s, and one of the most prominent places that has sought to take sculpture out of the gallery and into daily life is the German city of Munster. In 1967, the city fathers rejected the gift of a bronze sculpture by Henry Moore that was intended for an outdoor site, and in 1977 when a metal sculpture by American George Rickey was installed in one of the city's parks, there was much public disquiet. In response to this, curator Kasper König worked with the city on a sculpture exhibition that was in two parts: the first presented a chronological history of twentieth-century sculpture in the museum, while the second offered Minimalist and Post-minimalist sculptures in the open air. This was well received by both the city fathers and the populace, and König was employed again in 1987, when he invited sixty-three contemporary sculptors to create new works that reacted to the geography and history of Munster, a town that was heavily bombed in World War II and painstakingly restored in the 1950s. The 1977 show can be seen as an experiment by Munster to elevate itself into an international position in the art world, setting itself against the German city of Kassel, which every five years hosts Documenta, the largest contemporary art exhibition in the world. The experiment worked, and the sculpture world eagerly looked to Munster for its 1987 show, which did not disappoint. Some works were bought for the city and the museum, which are still in place. Nearly eighty artists made work for Munster in 1997, and thirty-five in 2007.

In contrast to the urban spaces of Munster, there have been attempts to place sculpture in city parks or more rural settings. Artists did this for themselves with Land Art in the 1960s and 1970s, but city councils had begun to organize sculpture exhibitions in their parks as early as the 1930s, Zurich being one of the first. In 1949, at Sonsbeek in Holland, and the following year at Middelheim, near Antwerp, there were open-air exhibitions of contemporary sculpture, and similar ventures later took place in Battersea Park, London. The Middelheim park was turned into a permanent venue for sculpture, and this was followed by the creation of the Kröller-Müller Sculpture Park at Otterlo, Holland, in 1961. A few years later, Isamu Noguchi designed the Billy Rose

348 Peter Fischli and David Weiss, *Room Under the Stairs*, 1993. Various full-scale objects made from carved and painted polyurethane.
As installed at Museum für Moderne Kunst, Frankfurt, Germany

349 Donald Judd, *Untitled*, 1982-6. 52 milled aluminium sculptures, each 104 x 129.5 x 183 cm (41 x 51 x 72 in). As installed in North Artillery Shed, Chinati Foundation, Marfa, Texas

Sculpture Garden in Jerusalem, and at around the same time, Storm King Art Center, an open-air sculpture park, was opened at Mountainville, in upstate New York. The two founders of Storm King claim that they were inspired to create an open-air venue for contemporary sculpture after seeing between eighty and a hundred works by David Smith, set out by the artist in his fields around his home and studio at Bolton Landing. This was one of the great marriages between sculpture and site because it was the vision of one man, their creator. But siting sculpture in a more public place comes with many problems. In the 1970s, the critic and curator Jean-Christophe Amman produced the term 'drop sculpture' to describe the arbitrary and non-specific nature of the placement of several recent outdoor public sculptures. Virtually all the Munster sculptures were site-specific, and their engagement with their site began at the very start of their production.

Site-specific interventions indoors could be said to hark back to Marcel Duchamp, followed by Yves Klein and Andy Warhol (see Introduction), and have continued to be explored by artists throughout the contemporary era. In 1968 the American artist Walter De Maria filled a gallery in Munich with 250 cubic metres of earth **(230)**, denying visitors access to the gallery. Without allowing viewers even a tiny peep inside, Daniel Buren sealed the Galerie Apollinaire, Milan, for his show there in October 1968, and Robert Barry's 1969 exhibition was called 'During the Exhibition the Gallery Will Be Closed'. Joseph Beuys and Bruce Nauman have also presented empty rooms as part of their work. The most recent museum intervention of this kind is the work of Spanish artist Santiago Sierra, who, as well as sealing off the new Lisson gallery in London on its opening night, and the Spanish Pavilion at the 2003 Venice Biennale, divested the Museum Dhondt Dhaenens in Deurle, Belgium, in 2004, of all its contents and most of its structure. The artworks were taken out, the glass was removed from the windows, and all internal features were stripped away, leaving a gaunt building open to the elements.

But the artist who could be called the progenitor of contemporary display matters, even more than Duchamp, is the Belgian Marcel Broodthaers (1924-76), who announced in 1968, only four years after becoming an artist, the opening of his own private modern art museum, the Departement des Aigles, in his own house/studio in Brussels, with himself as director. Broodthaers borrowed picture crates from an art-handling transport firm, which he stencilled with the usual warnings such as 'Handle with Care' and 'Fragile'. He showed these along with thirty museum postcards of nineteenth-century French paintings. The nineteenth century was the era of museum building, when the institutions of art and their value systems gained the upper hand, and began what Broodthaers called the 'transformation of art into merchandise', of which the postcards were a significant example.

Broodthaers's creation and control of his own museum was matched by the actions of Donald Judd, who came to believe that commercial galleries and public museums were detrimental to the viewing of art, particularly his own. He created a gallery and museum at a remote town in Texas, called Marfa, buying fifteen buildings on 350 acres of a former Army outpost, Fort Russell. The most impressive permanent installation of his work is found in the two converted artillery sheds, which between them contain 100 geometric forms made from milled aluminium, which are set out in three rows at regular intervals **(349)**. The side walls of these sheds are glazed, allowing ever-changing light conditions to play across the reflective surfaces of the sculptures. He justified his personal museum by stating: 'Somewhere a portion of contemporary art has to exist as an example of what the art and the context were meant to be. Somewhere a strict measure must exist for the art of this time and place.'

350 - 1 Martin Creed, *Work No. 227*, *The Lights Going On and Off*, 2000. Electrical times (frequency: five seconds on/five seconds off). Dimensions variable. As installed at The Museum of Modern Art, New York

The partnership of Peter Fischli and David Weiss has, since the 1990s, created a handful of gallery installations that have confused visitors, most recently at the opening of Tate Modern in 2000. They present the gallery in what looks like an untidy state, harbouring a collection of painted boards, pedestals, used paint tins, buckets, workmen's shoes and cleaning products. All the objects look real, but they are fashioned from polyurethane and hand-painted by Fischli & Weiss. These objects create the powerful impression that the gallery is in the process of being cleaned and repainted for a new installation, and that the workmen responsible have just gone off for a break [348]. Fischli & Weiss have spent their career celebrating the banality and mess of everyday existence, and these installations continue that theme, asking visitors to consider the ubiquity of the perfect white gallery space -- the 'white cube' -- and what they have come to expect from it.

The first white cube was the main gallery of the Secession building in Vienna, constructed in 1899 by a society of artists, who designed the space 'to provide a useful framework for the tasks of a modern artists' society by using the simplest possible means'. The white cube became popular in the 1970s, but was in vogue in the 1930s. Irish critic Brian O'Doherty wrote about this idea in a series of articles beginning in 1976, which were then published in book form ten years later as *Inside the White Cube: The Ideology of the Gallery Space*. This seminal book looked at how artists have developed the white space of the gallery as a constituent element of their work, rather than just thinking of it as a neutral space in which to show their art. In a further development on the empty gallery scenario, Martin Creed, for his contribution to the 2001 Turner Prize at Tate Britain, presented in a totally bare gallery *Work no. 227, The Lights Going On and Off*, which is exactly what happened every five seconds **(350-1)**.

If the visitor found the experience a little unnerving, it was nothing compared to the experience offered by Maurizio Cattelan at the Secession Gallery in Vienna in 1997, entitled *Dynamo Secession*. When the visitor ventured downstairs to a basement gallery, all was dark. But two uniformed museum guards stationed there, on hearing the footfalls of the visitor, began to pedal a pair of stationary bikes fitted with dynamos, whose power provided the energy for a 15-watt electric light bulb, which stayed illuminated as long as the visitor remained to watch.

352 Gerhard Merz, *glass/steel/concrete*, 1992. 2 glass plates, sandblasted, each 200 x 600 x 1.5 cm (78 ¾ x 236 ¼ x ½ in); four T-shaped steel beams, each 22 x 22 x 875 cm (8 ½ x 8 ½ x 344 ½ in); concrete bench, 1560 x 60 x 12 cm (614 ¼ x 23 ¾ x 4 ¾ in); seven cubes, each 36 x 36 x 36 cm (14 ¼ x 14 ¼ x 14 ¼ in). De Pont Museum of Contemporary Art, Tilburg, The Netherlands

There are some artists, predominantly German, who approach their exhibition in an art gallery in the manner of an architect or structural engineer. Rather than filling the space with small objects on pedestals, they base their work on the size and proportion of the gallery space, and make interventions that reflect this. Gerhard Merz takes control of the architecture and lighting, modifying it in a clear and rational manner. He admires the monochrome paintings of Kasimir Malevich and Barnett Newman, and the designs of Theo van Doesburg; echoes of the work of all three can be found in his mediations. For the De Pont Museum in Tilburg in 1992, he created a piece specifically geared to the gallery spaces there, *glass/steel/concrete* [352]. Between two of the vertical supports for the roof, Merz placed two large panels of sandblasted glass, held in place by steel beams. Between these he set a long concrete bench, so that the visitor could contemplate the proportions, colours and materials of the work, and the effect that the scale of the piece exerted upon them. Meanwhile, Gerwald Rockenschaub alters his gallery spaces, giving the viewer opportunities for resting while looking. For a show in Paris, he painted one wall green and installed a set of railings in front of it; in another he divided the gallery with scaffolding poles and a viewing platform. He titled his retrospective exhibition at MUMOK, Vienna, '4296m³', the volume of the galleries there, thereby turning the volume of the exhibition space into the artwork [353].

In a more aggressive manner, Richard Wilson has performed some spectacular transformations of gallery spaces, most notably his *20:50*, first shown at Matt's Gallery, London, in 1987. Recycled sump oil sits in a shelf made to fit the space of the gallery, set about chest level to the viewer, when he or she walks up a slanted, narrowing ramp. The oil reflects the surrounding architecture perfectly on its dark unruffled surface, and mirrors both the architecture of the gallery in which it is placed, and the face of the viewer. For the same gallery, two years later, Wilson made *She Came in Through the Bathroom Window* **(354)**. This involved removing a large section of the gallery's window, and realigning it so that it protruded to a considerable degree into the gallery's space. Wilson's cuts through gallery architecture recall the pioneering work executed by Gordon Matta-Clark, who, in his short career, was the first artist to make large cuts through buildings in order to alter space. He described this as 'anarchitecture', and his influence is strong today among contemporary sculptors.

Michael Elmgreen and Ingar Dragset, who live and work in Berlin, have collaborated together since 1995; their work explores the physical nature of the architecture of galleries and museums, and they are admirers of Matta-Clark. Elmgreen believes that 'New museums and McDonald's are the most standardized forms in the world.' The artists are currently engaged in a series of works called 'Powerless Structures', in which they alter and break up white-cube gallery spaces by suspending forms from the ceiling or sinking them into the ground. For the Taka Ishii Gallery in Tokyo, they made the installation *Suspended Space* **(355)**, in which they hung at odd angles four walls and a glass skylight from wires. One wall bears a 'Museum' sign, another has a green 'Exit' sign, while a third sports a fire extinguisher, the latter two being necessary items required by health-and-safety regulations in museums and galleries.

353 Gerwald Rockenschaub, (from left) *Inflatable Object*, 2000. Clear PVC sheeting. 320 x 680 x 440 cm (126 x 267 ¾ x 173 ¼ in); *Wall*, 2002. 85 clear acrylic cubes. Each 70 x 70 x 70 cm (27 ½ x 27 ½ x 27 ½ in); *Ladder*, 1993. Aluminium. 284 x 114 x 180 cm (111 ¾ x 45 x 71 in). As installed at MUMOK, Vienna

354 Richard Wilson, *She Came in Through the Bathroom Window*, 1989. Steel, glass, softboard, PVC, floodlights. Dimensions variable. As installed at Matts Gallery, London

Examining the ideologies of museums and galleries rather than their architecture has been the path followed by Joseph Kosuth, Michael Asher and Hans Haacke. Kosuth is one of the most significant exponents of Conceptual art, a movement that attempted to redefine what constitutes a work of art. He questions traditional forms of art and the assumptions that accompany them. To do this, he uses ideas and language as his material. In 1990, he made an installation at the Brooklyn Museum, New York, where he added texts around the permanent collection. He repeated this idea at Documenta 9, Kassel, in 1992, at the Neue Galerie's permanent collection, where he covered historic paintings and sculptures with pieces of black cloth and filled the galleries with printed quotations taken from Walter Benjamin's text *The Arcades Project*, examining the relationships between culture, capitalism and consumerism in nineteenth-century Paris. The viewer had to draw their own conclusions on the relationships between the texts and the works that were temporarily hidden from view.

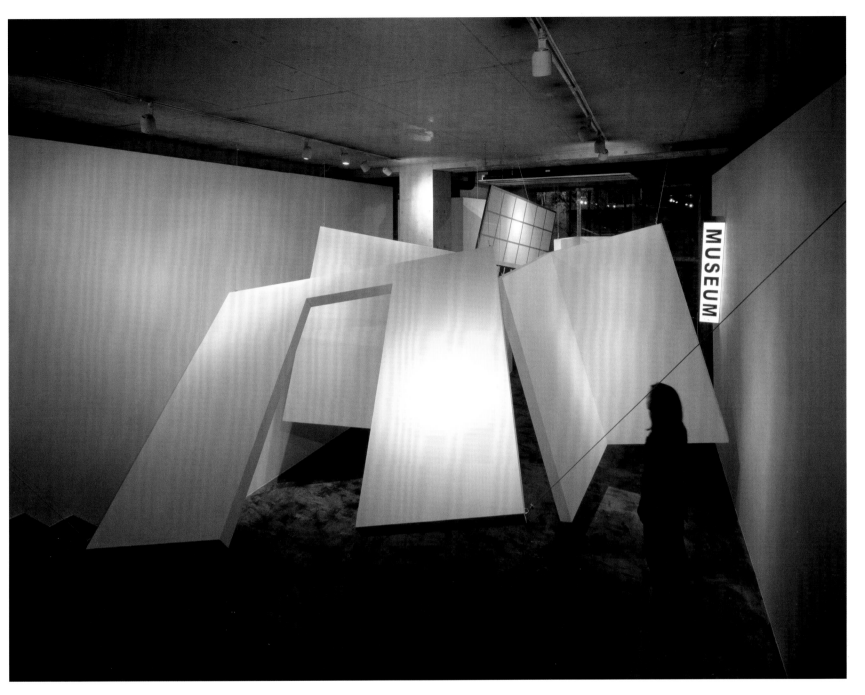

355 Michael Elmgreen and Ingar Dragset, *Suspended Space*, 2002. Plasterboard, wood, fire extinguisher, fire exit sign. Dimensions variable

Since the late 1960s, Asher has made works that investigate some of the ways in which museums and galleries present exhibitions. At the Art Institute of Chicago in 1979, he brought inside a weathered bronze sculpture from the exterior entrance of the art gallery, and in doing so raised a number of important questions about display and conservation. The bronze was a cast of Houdon's 1785 marble statue of George Washington, which had greeted visitors at the entrance of the Institute since 1925. Being outside by the main entrance it was a familiar object that could be touched, but when it was brought indoors and set in the middle of a gallery, something changed. It lost its heroic status, since the poor quality of the bronze cast and its weather-beaten look contrasted strongly with the good condition of the other eighteenth-century works of art in the gallery in which it was centrally sited. It could also not be touched. With this re-contextualizing, Asher altered the meaning, appearance and value of the sculpture.

356 Liz Larner, *Used to Do the Job*, 1987. Lead, wax, mixed materials. 123.5 x 65.4 x 62.9 cm (48 x 25 ¾ x 24 ¾ in)

357 Hans Haacke, *Helmsboro Country*, 1990. Silkscreen prints and photograph on wood, cardboard, paper. Cigarette packet 77 x 103 x 121 cm (30 ¼ x 40 ½ x 47 ½ in); cigarettes 176 cm (69 ¼ in) long, 17 cm (6 ¾ in) diameter

Haacke shares ideas with Kosuth and Asher, and is possibly the most political of all Conceptual artists. At the beginning of his career in the 1960s, he tried to get viewers physically involved, asking them to handle objects, a concept normally rejected by institutions because of the damage caused to artworks. Museums and galleries exercise power and a form of censorship in the art world by stealth, and Haacke takes this covert activity and makes it overt and often controversial. A theme he has explored is the funding of museums, either through corporate sponsorship or state grants, and on occasion he has revealed unethical investments or the bad labour practices of multi-national corporations. Money spent on cigarette advertisements has been a particular focus for Haacke, and he combined two of his bugbears in *Helmsboro Country* **(357)**. This giant wooden packet of cigarettes is modeled on the Marlboro brand, and the sides of the box are printed with pronouncements by Jesse Helms, a North Carolina Senator, on public funding for the arts. Helms opposed funding the National Endowment for the Arts, and was a supportive ally to American tobacco companies, so he fulfilled the role of villain for Haacke.

In their role as presenter and protector of art to and for the public, institutions must design suitable supports, labels, wall texts and barriers. Recent sculpture often rejects the pedestal or base and usually sits directly on the gallery floor. In 1993, Judd staked

his claim as the artist who removed the pedestal for the display of sculpture, with his work *Right angle of wood* (1962). He was not the only one thinking about pedestals in the early 1960s; in 1961 Piero Manzoni created a pedestal, made from cast iron and bronze and with the phrase *Socle du Monde* set upside down on it; Manzoni hints that the whole world, which is supported by the base, is changed into a work of art. With this seminal work, Manzoni reversed the usual relationship between pedestal and sculpture. Thirty years later, Mona Hatoum made another *Socle du Monde*, a larger wood and steel cube covered with iron filings that cling to hidden magnets. The surface is quite different from the Manzoni work, lush and organic versus his hard geometry, bringing the neglected pedestal to life (358).

Liz Larner has also investigated the power of the pedestal. Her *Used to Do the Job* (356) is a rough-looking double cube, the lower half of which is sheet lead on a metal frame, while the top half is mainly paraffin wax. But set into the wax are a variety of ingredients, including bits of metal, ores used in the casting of bronze, and explosive material utilized in the manufacture of bombs. The materials of this work are made to speak eloquently; the dimensions of the explosive wax cube would allow it to sit inside its lead coffin, which has the capacity to both muffle and stifle it.

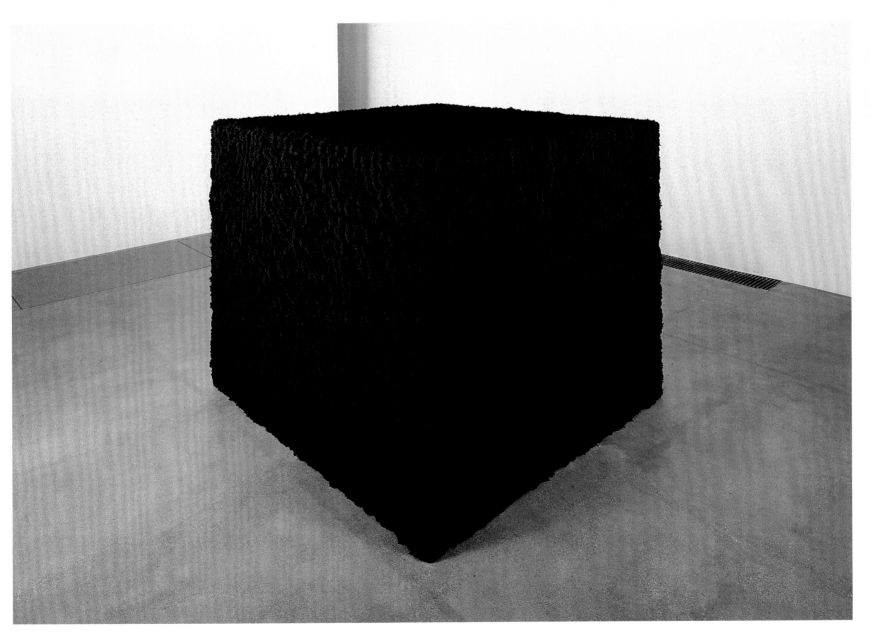

358 Mona Hatoum, *Socle du Monde*, 1992-3. Wood, steel plates, magnets, iron filings. 164 x 200 x 200 cm (64 ½ x 78 ¾ x 78 ¾ in)

359 Didier Vermeiren, *Monument to Victor Hugo*, 1998. Plaster, mixed media. 312.4 x 475 x 457.2 cm (123 x 187 x 180 in)

For nearly thirty years, Didier Vermeiren has been preoccupied with the pedestal. This has allowed him to examine the different opportunities there are for displaying sculpture, setting it in space and relating it to the viewer. He has looked particularly at the way in which three sculptors have worked with the pedestal -- Canova, Rodin and David Smith. Vermeiren has meticulously measured several of the pedestals Rodin chose for his large sculptures, noting the variety of relationships that the French sculptor employed between sculpture and pedestal, often embedding a sculpture into its plinth. Vermeiren's *Monument to Victor Hugo* **(359)**, is a reflection on Rodin's commissioned portrait of the writer, which was never realized during the French artist's liketime. Vermeiren has placed three plaster moulds on top of a conventional pedestal, and these moulds are negative versions of the positive planes of the pedestal.

Richard Deacon has also turned his attention to matters of display, and on one occasion offered an exhibition entirely of terracotta bases. In 1991, as an adjunct to the Carnegie International, Deacon was invited to 'produce an interface between the display of the Museum's permanent collection' and the temporary show of current work in the exhibition. He made three bases or 'islands' of different materials -- aluminium tread-plate, laminated and carved wood, and vinyl flooring -- onto which he placed disparate metal objects from the Museum's collection: a spoon, a table and a bronze cast by Jean-Baptiste Carpeaux (360). Meanwhile, Alison Wilding has adopted different strategies for the display of her work: she often paints a penumbra on the gallery floor around her sculptures, or includes a cast-rubber mat, which acts like a shadow.

Although he started his career as a performance artist, Fabrice Gygi now organizes gallery spaces and viewers as his materials, along with metal riot barricades and the sandbags that hold them in place, as well as tarpaulin fences, which he sites both inside and outside museums. The barricades are the kind used by police to control crowds, and also by museums to manage exhibition queues. They are deployed as a device to offer a sense of safety, and Gygi reverses this function, setting them in odd configurations (361).

Even more attentive navigation through an exhibition space is required of the viewer for the work of Fernanda Gomes, who inserts found and manufactured objects into the gallery's built fabric. Mostly she uses delicate fragments of urban detritus found around her New York studio, and her shows deal with the way in which works of art are confronted by visitors (362). She scatters specks of dirt and broken glass onto the gallery floor, as well as suspending items from visible and almost invisible threads that the visitor has to negotiate carefully. She expects her shows to alter during their duration as a result of human contact with the items.

360 Richard Deacon, *Facts*, 1991. Laminated and curved wood. Dimensions variable. As installed at Carnegie Museum of Art, Pittsburgh, Pennsylvania

361 Fabrice Gygi, *Palissades*, 2001. Galvanized metal. 16 items, each 220 x 200 x 70 cm (86½ x 78¾ x 27½ in). Fonds Régional d'Art Contemporain (FRAC), Languedoc-Roussillon, France

362 Fernanda Gomes, *Untitled*, 1999. Cigarette papers, eggshells, iron pellets, cracked plates, thread and other objects. Dimensions variable. As installed at Baumgartner Gallery, New York

Rei Naito works in much the same way as Gomes. For a show in Frankfurt in 1997, she made hundreds of tiny pillows from translucent silk organza, which were placed on the floor. Visitors were only allowed to enter the gallery alone and shoeless, and were limited to a maximum of fifteen minutes viewing. They also had to spend a meditative period preparing themselves for the experience in an adjacent room. Naito subscribes to the Japanese aesthetic of *hakanasa* -- the transitory and ephemeral, a fragile beauty **[363]**. Her 2003 installation at the D'Amelio Terras Gallery, New York, which only one person at a time could enter, consisted of a hanging circle of silk organza inside of which hung 1200 tiny glass beads on white silk threads.

363 Rei Naito, *Une Place sur la Terre*, 2003. Seven layers of translucent white silk organza, glass beads, silk thread. Dimensions variable. As installed at D'Amelio Terras Gallery, New York

Richard Wentworth once succinctly described gravity as 'our friend and enemy'. It is the most powerful force in the universe, and is so crucial an issue in the performance of matter that sculptors, who deal with mass, usually take it into account when planning and executing their work. The mass makes contact with a spot on the earth, but some sculptors have also made works that float or hover above the surface of the ground. Both kinds are held in position by the forces of gravity. It can be used in a formal, elemental way, conveying information about the weight of the material, or in an emotional way, saying something about the precarious nature of balance and the quality of a frozen movement.

One of the first artists to suspend a sculpture, rather than placing it on the ground, was Claes Oldenburg. In 1970, he hung his sewn-cotton work *Soft Three-Way Plug* from the ceiling of a New York gallery. He made a series of these plugs, using similar soft and pliable materials, which can either hang limply in space or be lowered to a sagging, semi-recumbent position on the floor. He also made a series of plugs out of sheet metal, which he entitled 'Fallen' **(366)**, and these present the illusion of having been dropped from a great height, since they appear to be embedded in the ground.

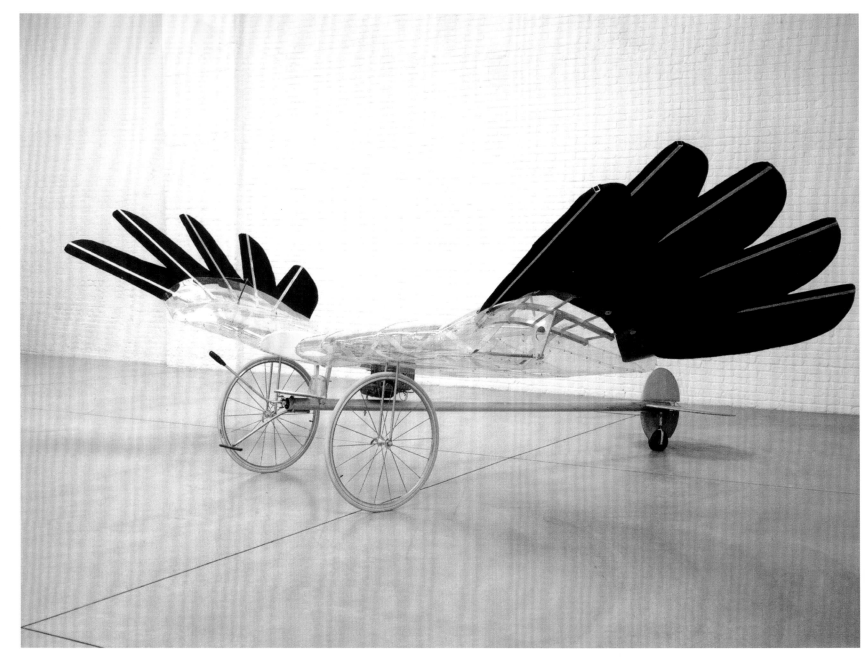

364 Panamarenko, *Raven's Variable Matrix*, 2000. Polycarbonate, aluminium, steel, felt, rubber wings, motor. Wingspan approx. 540 cm (211 in)

365 Rebecca Horn, *Concert for Anarchy*, 1990. Grand piano, metal, electric motor. 166 x 137 x 178 cm (66 ¼ x 54 x 70 in). Tate, London

366 Claes Oldenburg, *Giant Three-Way Plug*, 1971. Cor-Ten, bronze. 155 x 216 x 307.3 cm (61 x 85 x 121 in). Saint Louis Art Museum, Missouri

Robert Morris's 'Anti-Form' was a new sculptural tendency that he described in 1968 in an article in the American magazine *Artforum*, stating that 'considerations of gravity become as important as those of space'. The previous year, Morris had made some Anti-Form work: to create *Untitled (Pink Felt)* **(367)** he pinned large sheets of felt to the wall and also laid them on the floor; the materials and the gravitational pull determined the temporary shape of the form, rather than the will of the artist's hand. An even more extreme version of Anti-Form was practised by Lynda Benglis, who originally trained as a painter. In 1968 she began pouring spills of brightly coloured latex rubber and pigmented polyurethane foam directly onto the floor, letting the liquid material find its own shape.

In 1966, Henri van Herwegen invented his professional pseudonym -- Panamarenko -- an abbreviation of 'Pan American Airlines Company', and since then he has devoted himself to the exploration of flight, the relationship between mass and inertia, magnetic fields, and the force of gravity in his work. He is interested in flying machines that are worked by human effort, and this keys into the age-old dream of man being able to fly like a bird **(364)**. In 1967 he built his first aeroplane, *Flugzeug*, and spent the years from 1969 to 1971 creating his *Aeromodeller*, an airship with a 92-foot-long transparent balloon and accompanying gondola powered by four engines, which was shown at the 1972 Documenta exhibition in Kassel. More recently, Panamarenko has been working with the element of water, designing a diving suit and a submarine.

Panamarenko's intense interest in flight is matched by that of Jonathan Borofsky, who began to record his dreams during the 1970s, using them as the subject matter for his work. Many of his dreams concerned flying and the overcoming of gravity. His work comprises realistic flying figures of varying size, most of which are based on his own appearance. He, along with Antony Gormley, is the only artist in this chapter to deal with the question of gravity by consistently using the human figure, and this is probably a result of appropriating autobiographical material as his source, which is also true of Gormley. Borofsky prefers to place his flying figures in public places that involve transit of some kind. Six flying human figures entitled *I Dreamed I Could Fly* hang from the ceiling of the Civic Center Station in downtown Los Angeles, accompanied by a soundtrack of bird song. Borofsky's most defiant anti-gravitational work is *Walking to the Sky* **(368)**, where three figures at the base of a 100-foot pole watch in wonder as seven other life-size figures walk confidently upwards. Among the many associations evoked by the work, including optimism and the aspirations of the human spirit, or the ascent of the soul after death, is the biblical story of Jacob's Ladder, in which he dreamt of angels ascending and descending a ladder that stretched from earth to heaven.

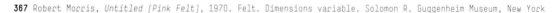

367 Robert Morris, *Untitled (Pink Felt)*, 1970. Felt. Dimensions variable. Solomon R. Guggenheim Museum, New York

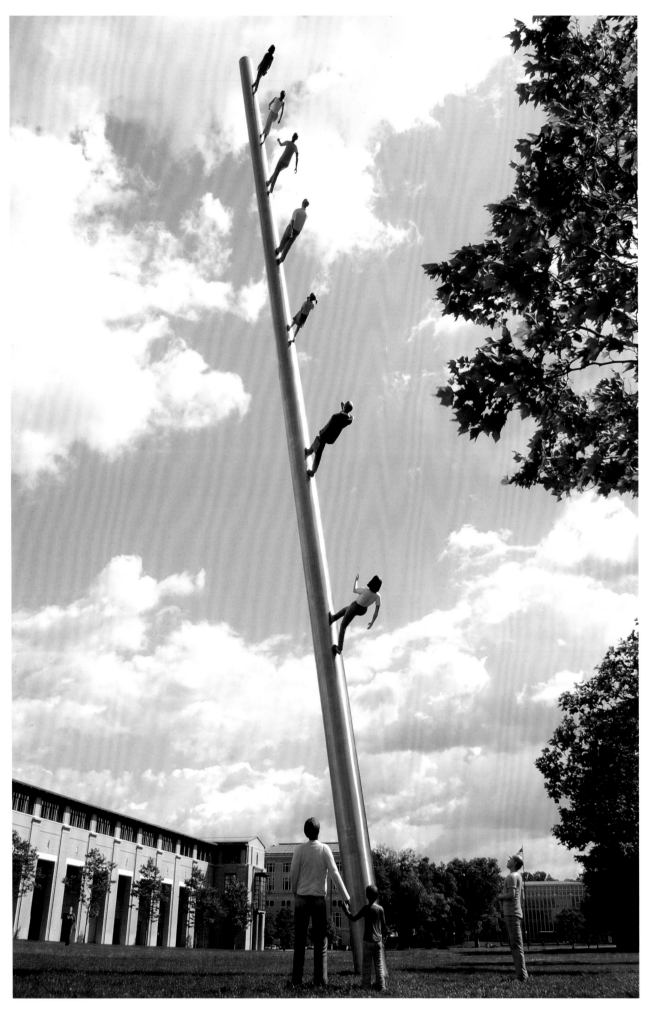

368 Jonathan Borofsky, *Walking to the Sky*, 2004. Stainless steel, fibreglass. 304.8 m (100 ft) high.
Carnegie-Mellon University Campus, Pittsburgh, Pennsylvania

369 Ayse Erkmen, *Sculptures On Air*, 1997. Helicopter, various sculptures. Dimensions variable. Suspended over the roof of Westfälisches Landesmuseum
für Kunst und Kulturgeschichte, Munster, Germany

Ayse Erkmen uses her work to examine the spaces, both real and metaphorical, that are given over to art, and this has usually resulted in architectural interventions in art galleries. However, *Sculptures On Air*, her provocative contribution to the 1977 Munster Sculpture Exhibition, was quite different. She requested that a Renaissance figure sculpture be taken out of storage from the city's main museum, the Westfälisches Landesmuseum, and tied to a helicopter with a cable and rope harness so that it hung below [369]. The helicopter made a few round tours of the city before placing the sculpture on the museum's roof. It stood there until replaced by another sculpture brought in the same manner by helicopter. The physical displacement of these sculptures allowed them to be seen in an entirely different way; firstly from below, and secondly in a new context. Since the figures were from the fifteenth and sixteenth centuries, and mostly of religious content, they added a footnote to the tradition of flying angels and spiritual messengers.

370 Chris Burden, *The Flying Steamroller*, 1996. Twelve-ton steamroller, hydraulic piston and arm, counterbalance. Dimensions variable

Chris Burden works in a variety of materials and styles. In the 1970s, he was an inventive and influential performance artist, who subjected his own body to physical risk and danger. Such experiences left him fascinated by man's basic urge to overcome barriers, to master the forces of nature, and it is therefore not surprising that he has turned his attention to gravity and suspension in air or water. In 1987, he produced a striking work comprising 625 identical cardboard models of submarines, and these stood for all the submarines ever made for the American fleet. They are displayed hanging at various levels, with their names stencilled on a nearby wall, and they look more like a shoal of fish moving through water than representations of war machines and the hidden might of one of the world's superpowers. Burden has since made more massive sculptures, such as his major work *The Flying Steamroller* **[370]**. The steamroller weighs twelve tons and is suspended from a pivoting arm, at the other end of which is a counterbalance weight. The steamroller is driven at its maximum speed and then lifted by a hydraulic piston within the pivoting arm. The combined weight of the steamroller and its counterbalance is forty-eight tons, and this causes the steamroller to continue rolling or flying for several minutes before the piston brings it back down to earth. It is a unique example of science confronting normal expectations.

In the 1960s, Bruce Nauman made small plaster casts of the spaces underneath things such as shelves and chairs, and by the beginning of the 1980s he stated that he 'had been thinking about having something hanging for quite a long time'. He went on to make a few suspended sculptures of chairs crossed by girders, and disturbing hanging carousels of taxidermied parts of dogs, wolves and deer cast in bronze. *White Anger, Red Danger, Yellow Peril, Black Death* **[371]** comprises two steel girders hanging in an X shape, with three metal chairs attached, one red, one yellow and one black. A fourth metal chair, painted white, hangs on its own and is in danger of being hit by the girders when they swing. Chairs represent a place to rest when tired, but these chairs confound that notion, and instead appear threatening, unstable and non-functional pieces of furniture.

371 Bruce Nauman, *White Anger, Red Danger, Yellow Peril, Black Death*, 1984. Steel, four painted chairs. 426.7 cm (168 in) diameter

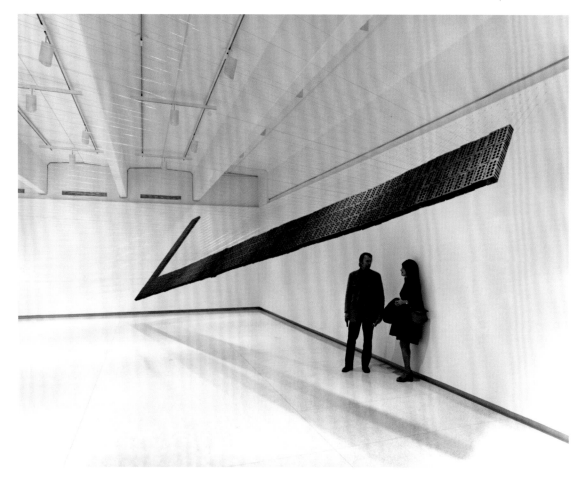

372 Loren Madsen, *L for Walker*, 1976. Red bricks, stainless steel wire. 4.57 x 18.29 x 12.19 m (15 x 60 x 40 ft). Walker Art Center, Minneapolis, Minnesota

At the beginning of the 1970s, Loren Madsen began to employ ordinary household bricks to display the properties of balance, stacking, tension and suspension. He massed his bricks together using either stiff steel rods or pliable wire, and through commissions gained the chance to work on a massive scale. His *L for Walker* **(372)**, a suspended L-shaped form of red bricks made specially for the Walker Art Center in Minneapolis, is 15 x 60 x 40 feet in dimension. Probably his most ambitious hanging piece is the one for the 1st Bank Atrium at the Pillsbury Center in Minneapolis, which consists of 12,000 pounds of black granite carved in the shape of a V, suspended on cables 83 feet above the floor.

Since the early 1980s, Nancy Rubins has been following a path similar to Madsen, suspending a variety of forms and materials from ceiling and walls. She has a penchant for using domestic appliances and worn mattresses, but her most striking works have involved stringing up an RV trailer, and hundreds of aeroplane parts. Rubins has acknowledged that her early work, which recycled discarded consumer products, was influenced by Simon Rodia's *Watts Towers* in her native Los Angeles. But when she experienced an earthquake at home, and watched the concrete walls of her apartment shake and undulate, she realized that she was interested in making sculptures that dealt with gravity and instability. Since then, she has worked on an ambitious scale, her largest work to date being *Chas' Stainless Steel, Mark Thompson's Airplane Parts, About 1,000 Pounds of Stainless Steel Wire and Gagosian's Beverly Hills Space* **(373)**. This massive suspended work, 54 feet across, is made from used aeroplane parts, and was unveiled at the Gagosian Gallery, New York, on 13 September 2001, two days after the destruction of the World Trade Center towers. The piece is intended to be a monument to latent energy held in check, but at the time of its unveiling, it would have looked uncomfortably topical.

Rebecca Horn also suspends some of her sculptures, but they are less about impressive weight and mass, and more about surprise, fragility and balance, and a stirring of emotions. Her early work of the 1970s focused on her body and its senses; she produced performances for which she made elaborate costumes, often involving feathers. In the 1980s she moved away from body-centred art to make films and mechanized sculptures. Several of her sculptures incorporate musical instruments, such as violins and cellos. One of her most arresting sculptures of this kind is her *Concert for Anarchy* [365], in which a grand piano is suspended from the ceiling by steel wires attached to its legs. Every few minutes a hidden mechanism causes the piano keys to shoot out, making a cacophonous sound, while at the same time the lid falls open, causing the keys to reverberate. Then the keys are retracted, the lid closes and the cycle, with its tension and release, starts again.

Hanging his sculptures rather than placing them on the ground has long been a strategy of Peter Shelton, who likens suspension in air to floating in water, and in several suspended sculptures has piped or dripped water over his forms. Made from bronze, *churchsnakebedbone* [374] is an amalgam of natural and cultural things. The suspended and inverted church is a detailed model of Chartres cathedral, which hangs from the bedsprings and pulls them down, creating teat-like shapes from which water drips into buckets set below. On the bed, above the cathedral, is a coiled rattlesnake, an image from Shelton's childhood in Arizona. A cast human thigh bone is wired to one of the legs of the bronze bed. Shelton sees Chartres cathedral as a kind of body -- with its load-bearing columns and daring flying buttresses as its skeleton, and its thin walls and large stained-glass windows as its skin.

373 Nancy Rubins, *Chas' Stainless Steel, Mark Thompson's Airplane Parts, About 1000 Pounds of Stainless Steel Wire, and Gagosian's Beverly Hills Space*, 2001. Stainless steel, airplane parts, stainless steel wire. 7.6 x 16.5 x 10.1 m [25 x 54 x 33 ft]. As installed at Gagosian Gallery, Beverly Hills, California

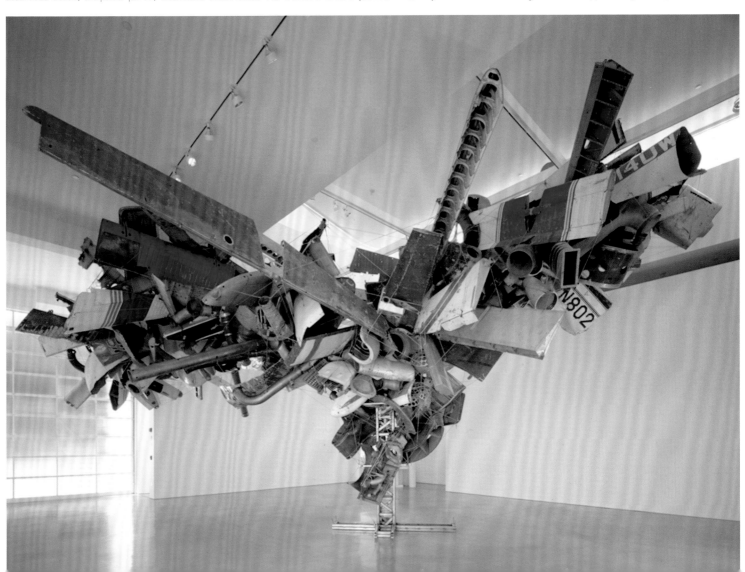

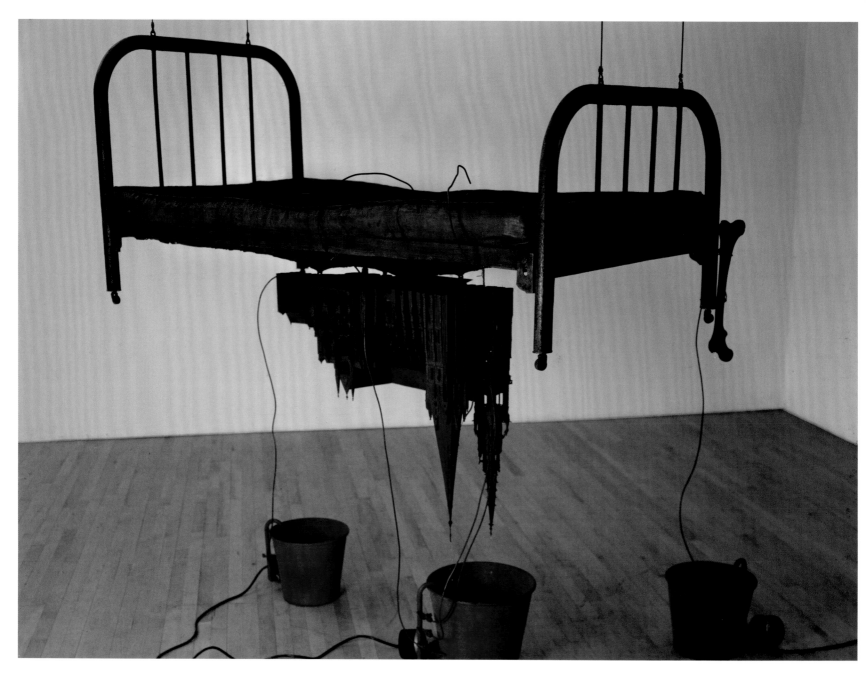

374 Peter Shelton, *churchsnakebedbone*, 1993. Cast bronze, water. 203.2 x 195.6 x 96.5 cm (80 x 77 x 38 in)

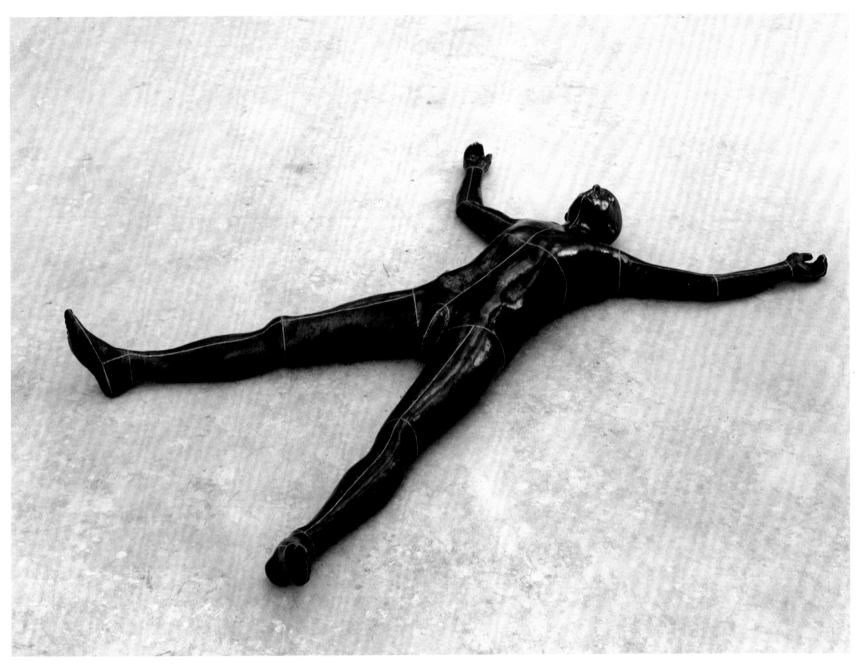

375 Antony Gormley, *Close*, 1992. Bronze. 188 cm (74 in) long

Another sculptor who links gravity with the body is Antony Gormley. As we have seen, he works exclusively with his own body, and since the late 1970s he has chosen lead, a heavy dense metal, as his preferred material. In 1984 he made *Mind*, a 14 x 9 foot amorphous lead cloud, which was hung from a gallery ceiling. It was the first time he had departed from showing his work on the gallery floor, and from making casts of his own body. The suspended work was like a stormy cloud formed from the imagination. Continuing this mental theme, for *Learning to Think* (1991), Gormley's group of five headless cast figures were not suspended from, but set into, the gallery ceiling. He described them as: 'Corporeal bodies escaping from the normal conditions of a body; they could be rising, hanging, or perhaps floating and seen from below like swimmers in a pool.' A year later, he began a small series of body cases titled *Close* [375], all of which lie on the ground with outspread limbs. The artist explained the pose as a 'body holding on for dear life', and continued: 'At this latitude we are spinning at 1,000 kilometres per hour through space. Through the figure you feel the tension between the force of centrifuge (that threatens to fling us out into deep space) and the forces of gravity; that sympathy between bodies that keeps us stuck down.'

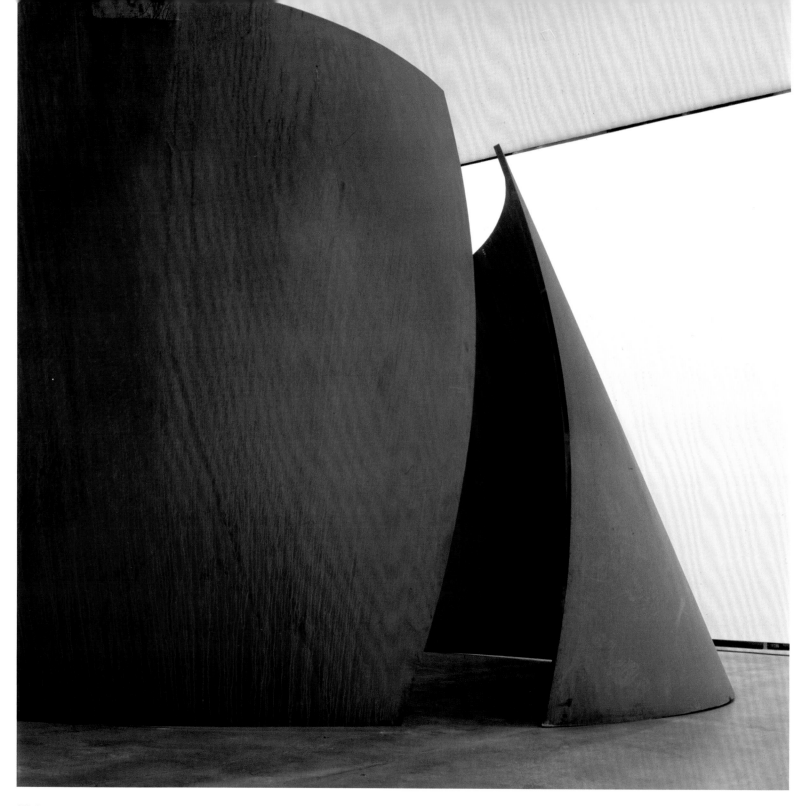

376 Richard Serra, *Torqued Ellipse*, 1997. Cor-Ten steel. Approx 411.5 cm (162 in) high. Dia: Beacon, New York

Tension of a similar kind can be found in Joel Shapiro's blocky sculptures, which veer between abstraction and figurative representation. 'I am interested in those moments when it appears that it is a figure and other moments it looks like a bunch of wood stuck together -- moments when it simultaneously configures and disfigures,' the artist stated, adding that he was also interested in moments of 'motion or dislocation'. Many of his simple block humans and animals **(377)** are found in extreme balancing acts, with some falling, losing their balance and even crashing to the ground; gravity appears to overtake them and this evokes an emotional response in the viewer.

The artist who works most imposingly with aspects of weight, matter and gravity is Richard Serra. He employs gravity as one of the most important ingredients of his work. He does not join the elements of his metal pieces by welding or bolting; instead, they are held in place by reciprocal pressure and balance. For his early works in the late 1960s, Serra began propping sheets of lead against one another, much as one does when making a house of cards. Lead is a soft and malleable material that has a tendency to sag if left unsupported, and this potential for instability was something Serra wished to introduce into his work. In the early 1970s, he changed from lead to working with large plates of hot rolled steel, which were usually wedged into the corners of gallery spaces, forcing viewers to negotiate the altered space. These pieces were flat sheets of metal, but Serra has progressed to working with curved, tilted and torqued steel plates on a massive scale; one such work is from the series *Torqued Ellipses* **(376)**. He was driven by the idea that 'a generic form, an ellipse, could be torqued on itself to produce a form not seen before.' After a long search he found a shipyard and steel-rolling mill in Maryland that was able to help him realize his idea. The resulting sculptures are unique in their spatial configurations, and quite disorientating and destabilizing for the viewer who walks among them.

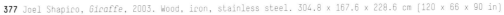

377 Joel Shapiro, *Giraffe*, 2003. Wood, iron, stainless steel. 304.8 x 167.6 x 228.6 cm (120 x 66 x 90 in)

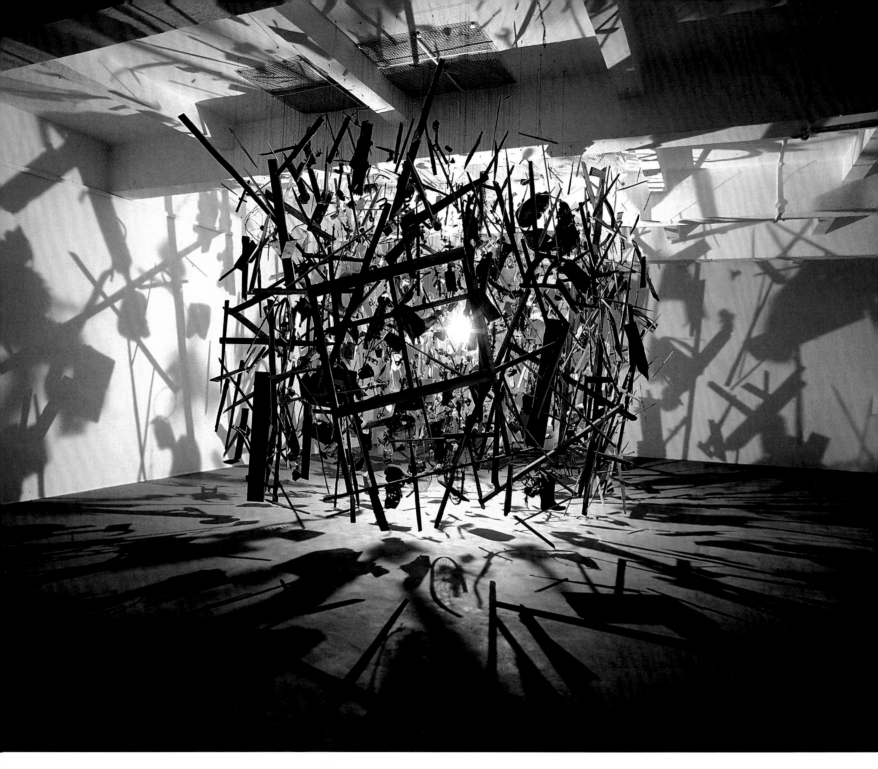

378 Cornelia Parker, *Cold Dark Matter: An Exploded View*, 1991. Mixed media. 400 x 500 x 500 cm [157 ½ x 197 x 197 in]. Tate, London

In contrast, Cornelia Parker wanted to make sculpture that had no mass or skin, and whose fragmentary, molecular structure related to recent research in astronomy and physics. She stated: 'I've never liked the fixed position of the lump.' Recently she has been collaborating with the American space agency NASA to try to send a meteorite back into space. One of her early works, *Matter and What It Means* (1989), consists of 7,000 coins, each one compressed by being run over by a train, suspended from the ceiling by metal wire. She likened this installation to our subatomic constitution and the waves and particles of light. When a viewer walks through this suspended silver world and brushes against the wires, the coins move in waves, like a shoal of silvery fish. She followed this with *Words that Define Gravity* (1992), a compilation of the words that make up the dictionary definition of gravity cast in lead, which she tossed over the White Cliffs of Dover and collected later from the beach below, in various states of damage from their fall. Her masterwork is *Cold Dark Matter: An Exploded View* **(378)**, for which she purchased an ordinary wooden garden shed and filled it with domestic objects bought from car boot sales -- Wellington boots, a lawn mower, etc. The shed was then blown up in a field by the British School of Ammunition, part of the army. All the fragments of the shed and its contents were collected together and reassembled in a London gallery, suspended from the ceiling by metal wires. At the centre of the reconstructed explosion, she placed an ordinary light bulb, which causes the fragments to cast dramatic shadows onto the gallery walls. Parker has said of the shed: 'When you cut it down it never goes up in the same way twice. It has to "die" then be "resurrected".'

Cristina Iglesias creates flying canopies and suspended ceilings that deploy the language of architecture to create spaces of the imagination. She takes her inspiration as much from modernist architecture as from Byzantine churches, Persian mosques and the *trompe l'oeil* conceits of the Baroque and the Rococo. Recently, she has produced suspended mats, which are illuminated from above and throw shadows of recondite texts onto the ground at the viewer's feet **(379)**. The viewer can either look up or down to experience the work.

379 Christina Iglesias, *Untitled (Passage II)*, 2002. Esparto grass. 300 x 119.3 x 2 cm (118 x 47 x ¾ in)

380 Giovanni Anselmo, *Untitled*, 1988. Granite stones, steel cable, canvas. Canvas 230 x 150 cm, 2 stones approx. 30 x 30 x 55 cm

381 Mikala Dwyer, *Recent Old Work*, 1996. Wood, carpet, modelling clay, wool, steel cable, casters, canvas, pins, synthetic stuffing, glass, silicone glue. Dimensions variable. Collection of Peter Fay, long-term loan to the Museum of Contemporary Art, Sydney

It is surprisingly rare to work with stone to expose the pull of gravity, but this is the path taken by Giovanni Anselmo, who during the years 1966-71 investigated elementary phenomenological experiences such as elasticity, equilibrium and the power of gravity, and also the ephemeral and invisible field of magnetic energy. In several works of this period, organic materials, such as a lettuce, were tied to or wedged between slabs of stone; the slab would fall unless the lettuce was replaced daily before shrinking or disintegrating. Like the felt pieces of Robert Morris or the steel sheets of Richard Serra, Anselmo's demonstrations revealed the forces of gravity through organic processes or through the precarious balance of sculptural forms. Since the 1980s, he has hung granite slabs over screens or on walls, suspended on strong wire, for a spare, minimal effect **[380]**.

Maurizio Cattelan does not favour the minimal effect. For his first solo show at the Galleria Massimo De Carlo, Milan, in 1993, he presented a teddy bear balanced on an electrically powered bicycle that itself was balanced on a tightrope. This was the first work in a series in which human feelings such as fear, sorrow and isolation are put into animal form. Cattelan's most famous image is his *Novecento* **[382]**, a taxidermic horse with extended legs, which is suspended from the ceiling with ropes and a leather pulley. The title is taken from Bernardo Bertolucci's film of 1976, and the work alludes to both Italian cultural history and the millennium.

Mikala Dwyer makes soft, coloured sculptures that hark back to the work of Claes Oldenburg in the 1960s and 1970s, although they do not make the same obvious references to familiar domestic objects. Many of her misshapen, irregular forms are suspended from steel cables, or present themselves in fragile balancing acts. Several of these look unfinished or vandalized, while those consisting of suspended coloured organza sheets are gentle and ethereal. Her *Recent Old Work* **[381]**, first shown at the Sarah Cottier Gallery in Sydney, is a wry comment on the pull of gravity.

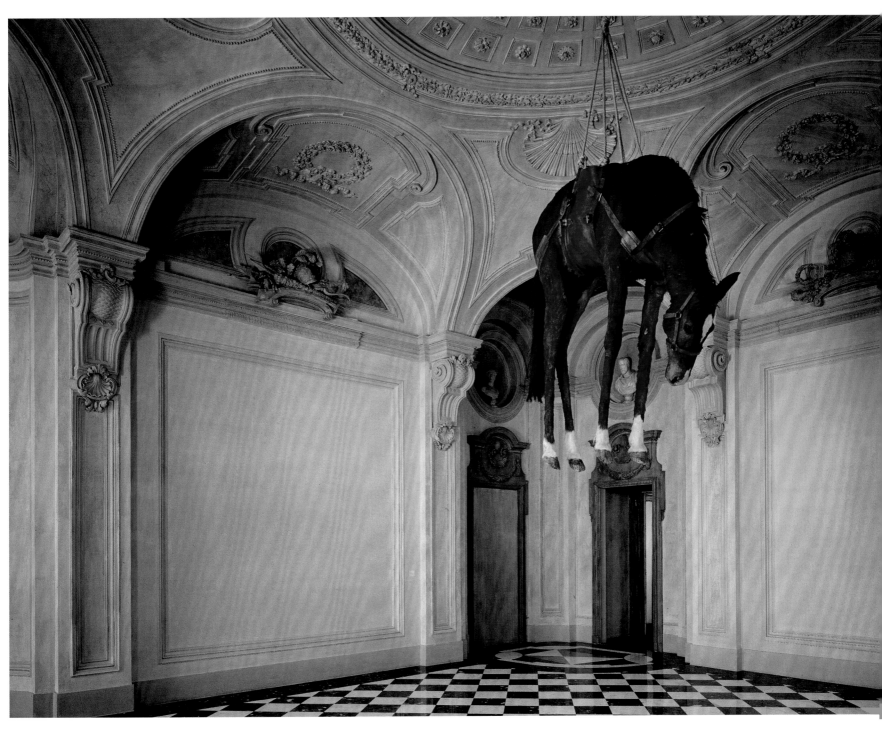

382 Maurizio Cattelan, *Novecento*, 1997. Taxidermic horse, leather saddlery, rope, pulley. 200.5 x 269 x 69.5 cm (79 x 106 ½ x 27 ½ in). As installed at Castello di Rivoli, Museo d'Arte Contemporanea, Turin

383 Richard Wentworth, *Mirror, Mirror*, 2003. Galvanized steel, laminated glass, assorted dictionaries. Dimensions variable. As installed at Felbrigg Hall, Norwich, UK

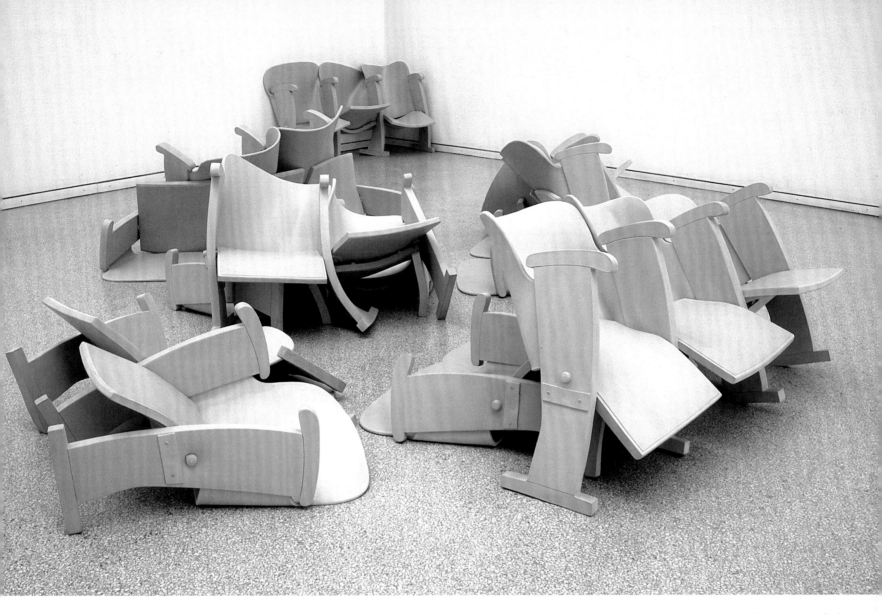

384 Loris Cecchini, *Stage Evidence (empty stalls)*, 2001. 27 elements; urethane rubber, foam, iron. Dimensions variable. Centro per l'arte contemporanea Luigi Pecci, Prato, Italy

A large, wooden platform, covered with a piece of carpet, was suspended from the gallery ceiling; the platform and carpet had a small circular hole cut out of them, which mirrored a large circular skylight in the ceiling. The excess carpet hung over its front edge, decorated by coloured woollen tassels. The platform was counterweighted by large, hanging sandbags, which tilted it at a slight angle and caused it to rest about a metre above the floor.

Familiar domestic objects are the materials used by Richard Wentworth, and these are mentioned in Chapter 4 **(108)**. From 1984, he has made a variety of sculptures, such as *Mirror, Mirror* **(383)**, that veer away from a stable vertical position and are held in what often looks like a vulnerable state. The cheerful, off-centre pieces of Dwyer and Wentworth find their ghostly equivalents in the work of Loris Cecchini, who makes casts of domestic items such as computers, bicycles, chairs and doors, in soft grey monochrome rubber, a pliable material that does not allow the forms to stand upright. Exhibitions of such work show these rubber simulacra lying on the gallery floor like dead or exhausted creatures, completely stripped of the will to hold themselves in their normal orientations **(384)**.

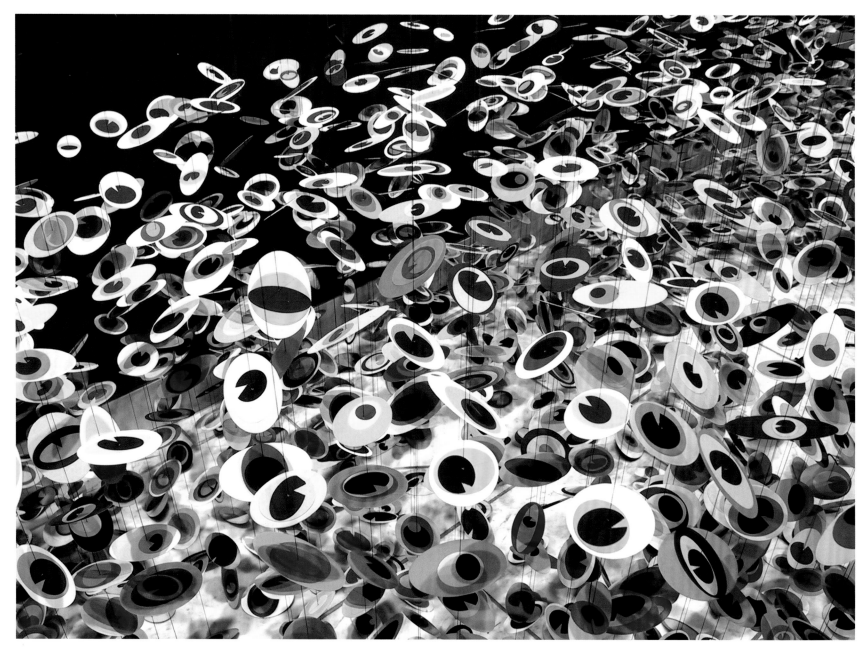

385 Pae White, *Oroscopo* (detail), 2004. Color Aid paper, thread. Dimensions variable

386 Jacob Hashimoto, *Clouds*, 2002. 3000 elements; silk, bamboo, nylon string. Dimensions variable. Studio la Città, Verona, Italy

Pae White makes cascading clouds of thousands of coloured paper forms, strung on coloured thread, to which she gives titles that usually refer to fish, birds and ships **(385)**. She acknowledges influences from the space-defining kinetic mobiles of Alexander Calder and the colour and shape combinations found in the fabrics produced in the 1960s by the Finnish firm of Marimekko. Asked why she creates such labour-intensive and attractive works, she said she liked the challenge of filling the cool white shapes of modern galleries with lyrical forms that flutter and undulate in response to the slightest movement of air. Her ambition is matched by another Los Angeles artist, Jacob Hashimoto, who makes similarly elegant multi-part mobiles that hang from ceiling to just above the floor. As befitting his Japanese heritage, Hashimoto makes his circular forms from either Japanese paper or silk stretched onto a curved bamboo frame, much in the way that kites are made in the Far East **(386)**. His works are usually white, although a handful also contain colour.

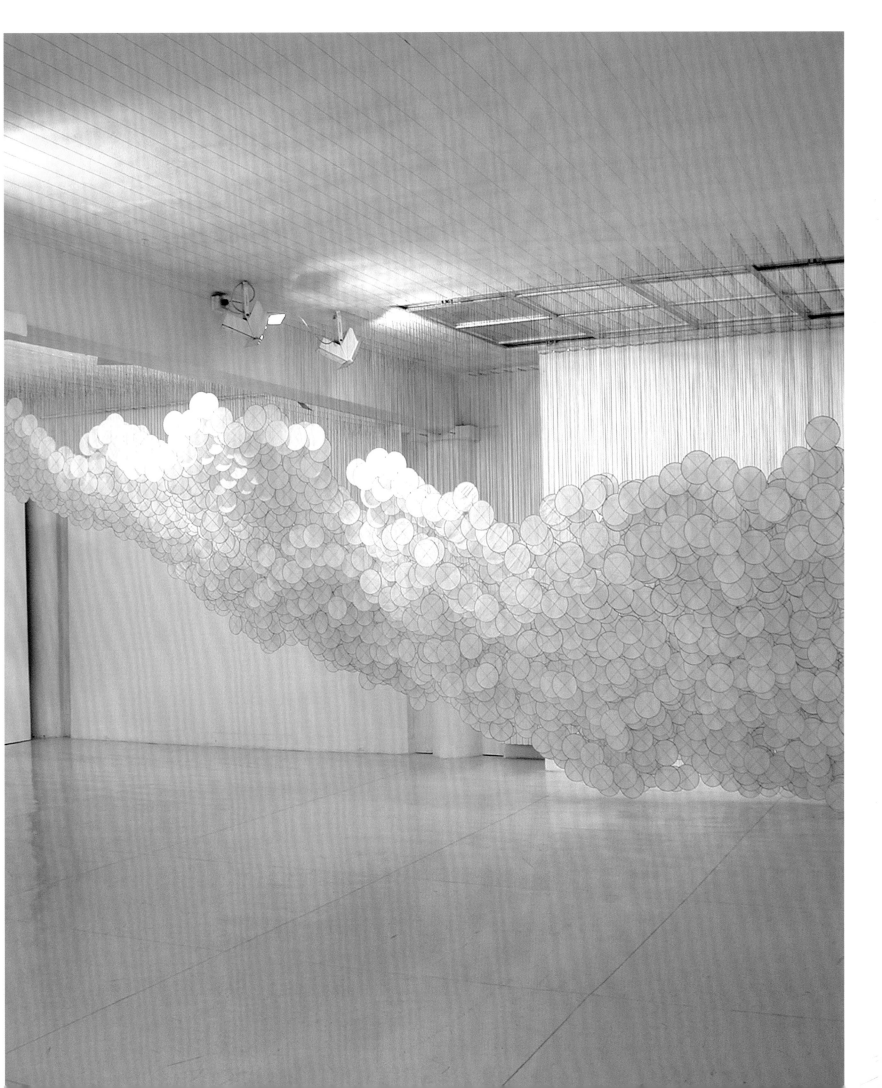

By manipulating size and scale, artists can affect viewers in a psychological way, making them feel either large or small in the context of what is displayed before them, or calling into question the accuracy and reliability of representation. The process of reducing or enlarging an object introduces issues of control, distance and how we measure things in relation to ourselves. Computers allow us the luxury of playing with scale and proportion, and artists are taking advantage of this two-dimensional virtual realm, particularly with reference to the human figure. They have noticed that experimenting with size and scale on a computer screen produces a sense of ambiguity and deception, because a digitally generated image has no scale reference.

Robert Morris considered the role of size and scale in sculpture in his seminal 'Notes on Sculpture, Part II', 1966; for him, objects that require close inspection squeeze out space: a small object or sculpture is 'essentially closed, spaceless, compressed and exclusive', because the viewer's need to get close to it diminishes their field of vision. Conversely, an increase in the object's size in relation to the human body calls for a different spatial and visual negotiation, which is more public than private.

Recently, several artists have chosen to make compressed representations of human figures. The vogue for this could relate to the ease with which computers allow us to scale things large or small, or it could be to do with the fact that today a certain constituency of artists does not wish to make large gestures and statements. Communicative tools -- cameras, televisions, phones -- are getting smaller and smaller each month, so why not sculpture? These tools feed the impulse to document every aspect of daily life, which is the content of much contemporary photography and video. However, the documentary photography is often on a grand, if impassive, scale; Thomas Ruff's huge portraits of his friends, and Rineke Dijkstra's large photographs of young bathers and new mothers are examples. Tiny human figure sculptures are at the other end of the scale, yet they share the same deadpan, even existential mood; in both photographs and sculptures, figures are usually depicted alone, wearing impassive expressions and displaying few bodily gestures.

387 Tom Sachs, *Unité d'Habitation*, 2002. Foamcore, thermal adhesive, Uniball Micro, resin, Bristol board, Wite-Out. 218.4 x 525.8 x 96.5 cm (86 x 207 x 38 in). Solomon R. Guggenheim Museum, New York

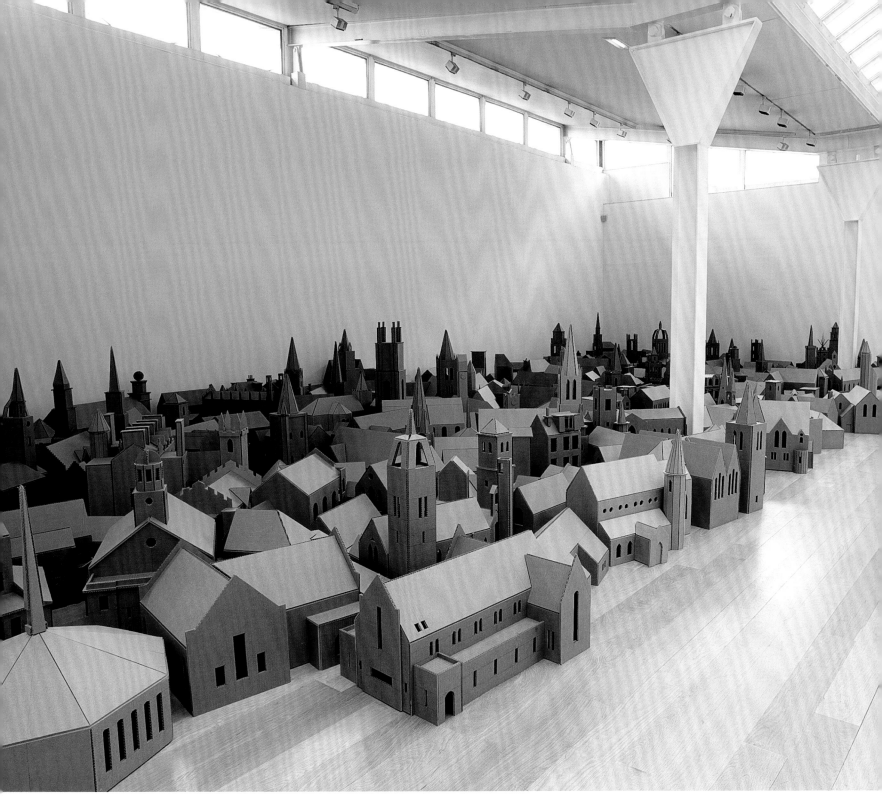

388 Nathan Coley, *The Lamp of Sacrifice, 286 Places of Worship, Edinburgh 2004*, 2004. Cardboard. Dimensions variable.
Scottish National Gallery of Modern Art, Edinburgh

389 Christina Doll, *Steffen*, 1999. Porcelain. 36.8 x 11.5 x 11.5 cm (14 ½ x 4 ½ x 4 ½ in)

Stephan Balkenhol has been carving small human figures, a few inches high, from the beginning of his career; they are casual and anonymous in character and closed in mood, seeming at home in their miniature world. Christina Doll lived in the city of Meissen in 1998, where she learnt how to work with porcelain. From this material she models small figures up to 12 inches high, and she casts them in shiny white porcelain. Portraits of friends, either clothed or nude, and accompanied by a favourite piece of their own furniture (389), they present themselves with a relaxed yet self-conscious bearing, a reflection of their status as friends, although the glossy whiteness of the porcelain tends to distance them from the viewer.

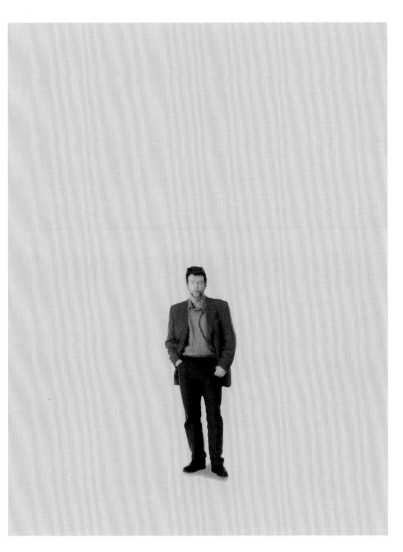

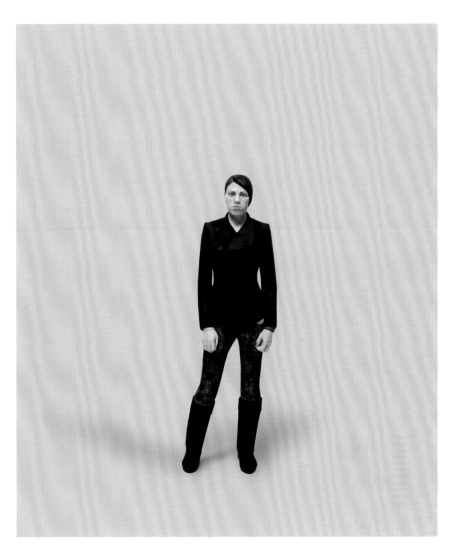

390 Karin Sander, *John Weber 1:10, 3D Bodyscan of the Living Person*, 2000. FDM (fused deposition modelling), rapid prototyping, ABS (acryl-butadien-nitryl-styrol), airbrush. 10.2 cm (4 in) high. The Museum of Modern Art, San Francisco, California

391 Tomoaki Suzuki, *Gemma*, 2004. Limewood, acrylic paint. 47 cm (18 ½ in) high

More portraits of friends and acquaintances are found in the work of Karin Sander, who presented a show in New York in 2000, called 'Scale 1:10', which comprised thirty-six miniature figurative sculptures of people in contemporary dress, including art-world associates, friends, two complete strangers, and a self-portrait in the obligatory art-world black suit. This American curator **(390)** is four inches high, and was created using a 3-D laser camera and body scanner, which read his body contours in seconds and fed them into a computer linked to an extruder machine. Over a period of thirty to forty hours, this machine built the figure, layer by layer, in acryl-nitryl-butadien-styrol on a 1:10 scale, in a process called 'fused deposition modelling'. The figure was airbrushed to give it verisimilitude to its sitter, and despite the avant-garde technology employed in its creation, it is surprising how alive he seems. Very close examination reveals the tiny ridges of the layers from which he was composed.

Tomoaki Suzuki works in a similar way to Balkenhol, carving small wooden figures in limewood and poplar, a quarter life-size, but his figures are particular portraits and are more refined in finish **(391)**. Suzuki differs from the previous three artists in that his sculptures are placed directly on the gallery floor, while theirs sit on plinths, which sets their miniature figures at eye level. To examine the detail of a Suzuki sculpture, viewers have to sink to their haunches, altering their viewing habits.

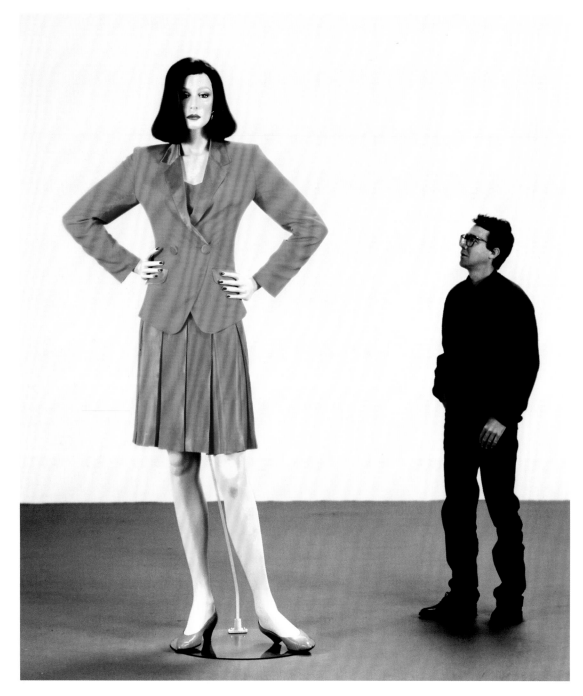

392 Charles Ray, *Fall '91*, 1992. Mixed media. 244 x 66 x 91.5 cm (96 x 26 x 36 in)

Charles Ray makes figures both tiny and huge, and his tweaking of scale first appeared with three works entitled *Fall '91* **(392)**, which are figures of women in brightly coloured power suits and high-heels, each between 8 feet and 10 feet tall. They are inspired by shop-window mannequins, but modelled with more realism. Ray sees commercial mannequins as the contemporary counterparts to ancient Greek figurative sculptures, which were similarly idealized. Instead of being an armature for displaying smart clothing, his large women take on a threatening persona. Other works by Ray share this experimentation with scale: a 6-foot tall *Boy* (1992), *Puzzle Bottle* (1995), a tiny self-portrait set inside a glass bottle, and the decidedly disturbing *Family Romance* **(393)**, described by the artist as 'a nuclear family; the dad is forty, the mother is thirty, the son is like eight, and the daughter is four'. Ray has scaled the children up and the parents down so that all four are 4 feet 6 inches tall.

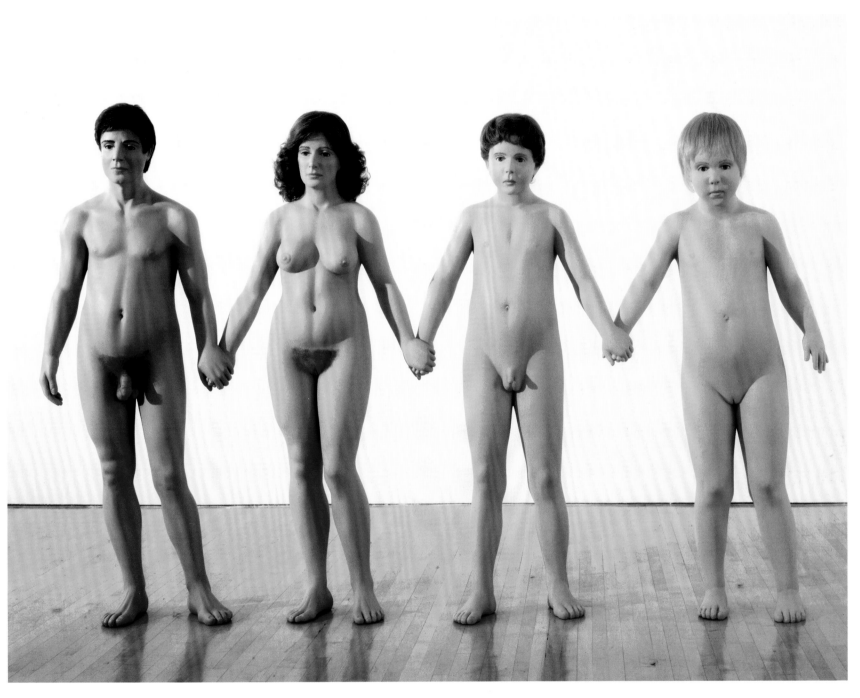

393 Charles Ray, *Family Romance*, 1993. Mixed media. 137.1 x 244 x 61 cm (54 x 96 x 24 in)

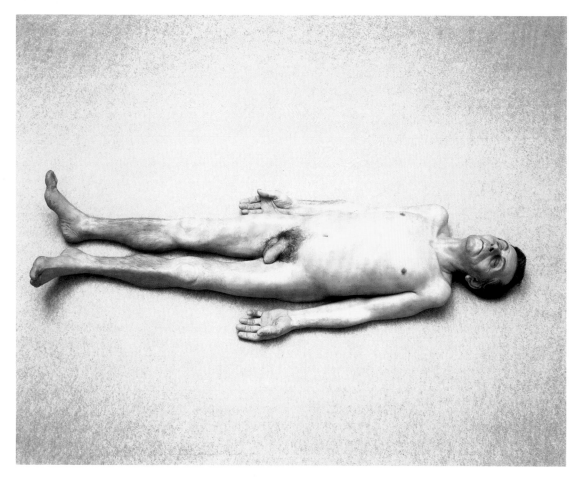

394 Ron Mueck, *Dead Dad*, 1996-7. Silicone, acrylic. 20 x 102 x 38 cm (8 x 40 ¼ x 15 in). The Saatchi Collection, London

Moving from shop-window mannequins to film props leads to Ron Mueck, who also works both large and small. He was a model-maker for films, where he had to alter scale in order to make things look real in two dimensions. His current sculpture addresses the traditional premise that imitation and verisimilitude is what art is about. However, his hyperrealism raises questions, the main one being that his figures do not look like crafted mimetic forms. They actually look real, down to the wrinkles, veins and body hair, but Mueck changes the scale, making them up to 8 feet tall, or one-third life-size, as if to remind us that the thing is a fiction. His *Dead Dad* **(394)** is a half-life-size, highly detailed rendition of his father's naked body, offered as though on a mortuary slab. It gains its eerie presence from the combination of minute detail and child-like size.

Experimenting with the scale of the human figure does not allow too much rein for imaginative feats, but for the artists who make miniature cities and dioramas, there is greater scope for visionary or disturbing narrative content, plus varying amounts of social comment. In the 1970s, Charles Simonds created his imaginary race of Little People who inhabit his miniature buildings, which are usually set in rocky or desert terrain. The Little People are never evident, since they have 'peripatetic ways' and only their buildings remain, but these are not just isolated small-scale shelters, since they relate to the scale of their maker. Early in his career, Simonds placed tiny clay dwellings on his naked chest, and he has continued to create variations on body and building, and body as building, ever since. *Circles and Towers Growing No. 5* **(398)** is one of a series of low, circular domed structures set in a hot dusty terrain, which rotate around a central hole, or navel, and suggest allusions to womb-like forms, which the title supports.

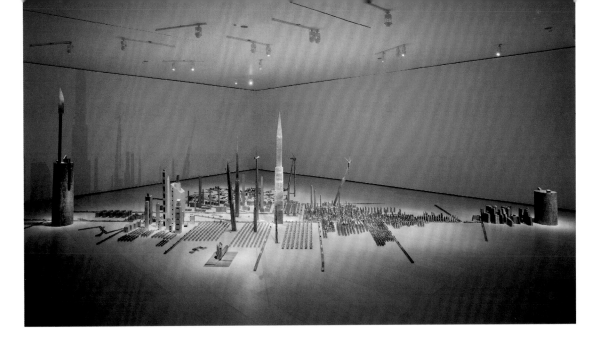

395 Miquel Navarro, *Wall City*, 1995-2000. Lead, zinc, aluminium. Dimensions variable

In the mid-1970s, Chris Burden turned his attention to models. He bought models of well-known buildings and bridges, such as London's Tower Bridge, in hobby shops and museum stores, as well as the Lego and Meccano construction kits he played with as a child. He has made facsimiles of real structures, such as a work for the Baltic gallery in Gateshead in 2002, where he showed his model of the Tyne Bridge, created entirely from Meccano parts, in a gallery that overlooked the real Tyne Bridge. Thus it was possible to see both simultaneously, the model one-twentieth the size of the original. He has also produced fantasy places, where he introduces a social content. *A Tale of Two Cities* **(396)**, made for the Orange County Museum of Art, Newport Beach, comprises an imaginative tableaux of two cities at war with one another, using over 3,000 war toys of tanks, planes and soldiers, made in the US, Japan and Europe. Burden states that the work depicts his fantasy about life in the twenty-fifth century, when he imagines the world will have returned to a system of feudal states. A pair of binoculars are provided, so that the viewer can get a better view. This work is reminiscent of the dioramas of battles and historic scenes that used to be found in local museum displays, for which many contemporary artists have expressed a sense of nostalgia, although Burden sets his battle scenes in the future.

396 Chris Burden, *A Tale of Two Cities*, 1981. Mixed media. 3.7 x 12.2 x 9.1 m (12 x 40 x 30 ft). Orange County Museum of Art, Newport Beach, California

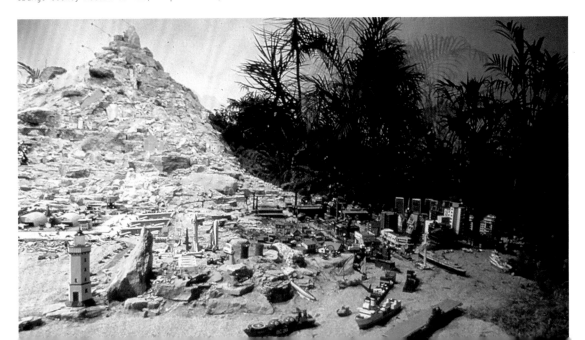

Miquel Navarro has been making model cities since 1973 using a wide range of materials, usually lead, aluminium and zinc, whose silvery sheen lends them a cold, futuristic look. The stylish, uninhabited *Wall City* (395) with its tall towers like skyscrapers, factory chimneys, roads, obelisks, large circular fortifications and rows of little box houses, sprawls across the gallery floor in an organic way, not unlike the way in which cities develop and spread across the land. Navarro states that his model cities include references to places he knows, and here there are echoes of the factories in his Spanish hometown of Mislata.

Two artists who create model cities make a point of interweaving site and material. Bodys Isek Kingelez was born in the Congo, and still lives in Kinshasa. He was employed as a restorer of traditional African masks for the Kinshasa Museum in the 1960s, but turned to making his own work in the early 1970s. His detailed and colourful models of modern cities are visionary in character, made out of paper, cardboard, plywood and other bits and pieces gleaned from discarded packaging found in the particular cities that he depicts. Thus he turns the detritus of the city's urban environment into vibrant utopian models. His first appearance in the art world was when one of his model city sculptures was included in the exhibition 'Les Magiciens de la Terre' in Paris in 1989. Since then, Kingelez has created a vision of how his home city of Kinshasa could be transformed in the future (399), and *New Manhattan City 3021* (2001-2), a model of how he would like to see downtown Manhattan look in the year 3021.

Yin Xiuzhen makes model cities that she fashions out of discarded clothing and displays in opened-up, second-hand suitcases. The clothes are found on site in the relevant cities, and thus make a strong connection between material and place. She sees people in contemporary life as having moved from 'a static environment to becoming souls in a constantly shifting transience', of which the suitcase functions as 'the life support container'. It is the transience and nomadic character of

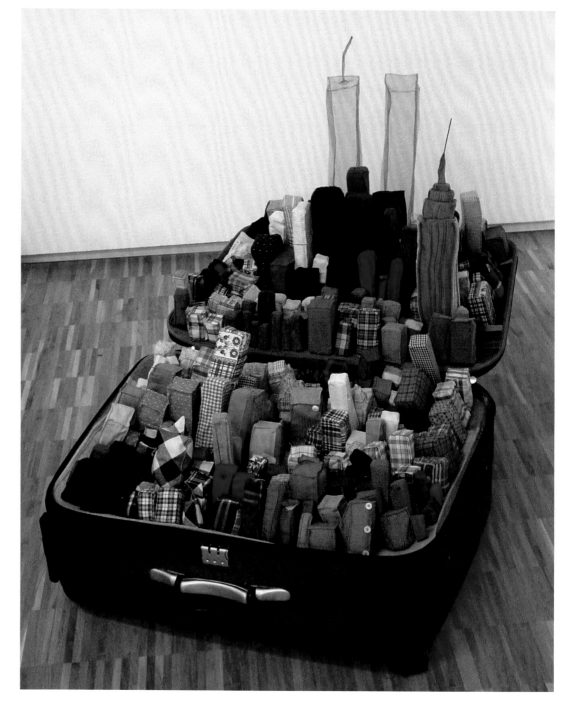

397 Yin Xiuzhen, *Portable City, New York*, 2003. Suitcase, used clothes, sound, light, map, magnifying glass. 82 x 72 x 30 cm (32 ¼ x 28 ½ x 11 ¾ in)

398 Charles Simonds. *Circles and Towers Growing No. 5*, 1978. Clay, wood. 23 x 75.5 x 75.5 cm (9 x 29 ¾ x 29 ¾ in)

399 Bodys Isek Kingelez, *Kinshasa: Project for the Third Millenium*, 1997. Wood, paper, cardboard. 100 x 332 x 332 cm (39 ⅜ x 130 ¾ x 130 ¾ in)

400 Thomas Schütte, *Studio in the Mountains II*, 1984. Cardboard, fabric. 400 x 700 cm (157 ½ x 275 ½ in)

life that provokes her to make small-scale sculptures; they can easily be packed and transported from place to place. To date, she has produced small fabric facsimiles of Guangzhou, Lisbon, Paris, San Francisco, Sydney, Wellington, New York and Hong Kong. Her brightly coloured cityscapes feature well-known landmarks that are easily identified. For her 2003 model of New York, she made the twin towers of the World Trade Center out of a transparent shimmering mesh material that gave them a tender and ghostly quality **(397)**.

There is much interest among sculptors in the making of architectural models that reflect upon the ¯utopian aspirations of iconic modernist architecture during the twentieth century, beginning with Russian Constructivist artists such as Vladimir Tatlin and continuing on to Le Corbusier, Philip Johnson and Mies van der Rohe. Architectural models appeared in the work of a new generation of German sculptors in the early 1980s, especially in the oeuvre of Thomas Schütte. He began a series of wooden models of ideal houses or artist's studios, which owe much in style to the architecture of Peter Behrens and Bruno Taut, and these he set on plain chipboard tables that are an integral part of the sculpture. *Studio in the Mountains II* **(400)** is an exception to this rule, since the striking red building with its viewing balcony is placed at the top of range of hills made from green fabric thrown over sheets of wood or cardboard. A yellow ribbon stands in for the path that the artist would take when visiting his rural retreat, ready to enjoy a spell of creative activity in what appear to be idyllic conditions. In the early 1990s, Julian Opie became interested in computer games and their graphic representation of reality, which struck him as both 'incredibly sophisticated' and 'very primitive'.

401 Julian Opie, *Imagine That It's Raining*, 1992. Plywood, gloss paint. 9 units, each 54.8 x 48.3 x 13.5 cm (21 ½ x 19 x 5 ½ in); 9 units, each 161.2 x 144 x 40.4 cm (63 ½ x 56 ¾ x 16 in); 9 units, each 502.5 x 430 x 122.4 cm (198 x 169 ¼ x 48 ¼ in)

402 Callum Morton, *Habitat*, 2002-3. Wood, acrylic paint, aluminium, sheet magnets, lights, sound. Six parts, each 74 x 110 x 130 cm (29 x 43 ¼ x 52 ¼ in); plinth 90 x 648 x 150 cm (35 ½ x 225 x 59 in)

These two phrases could also apply to his aesthetic; in the early 1990s he began to make painted-wood scale models of rural and urban buildings -- farmhouses, churches, castles, and then high-rise offices -- and these sculptures look like an amalgam of children's toys and commercial prototypes (401). In 1996 he made five full-scale, painted-wood models of popular cars, his only life-size works, and he likes the way in which they confuse the viewer with their mixture of artifice and reality, abstraction and representation.

Callum Morton studied architecture and urban planning, and this training is apparent in his elaborate models of iconic architectural masterworks, such as Philip Johnson's Glass House of the late 1940s, the Farnsworth House by Mies van der Rohe, a small cabin by Le Corbusier, and a house designed by Adalberto Libera, used as a set for a film by Jean-Luc Godard. Morton animates his complex models with narrative soundtracks and lighting effects, describing them as an integral part of 'the theatre of architecture'. His largest work is *Habitat*, a 1:50 scale model of a housing project of 158 flats built by Israeli architect Moshe Safdie in Montreal for Expo 1967 (402).

Tom Sachs works in a studio in Manhattan that was once the Allied Machinery Exchange, and which he renamed Allied Cultural Prosthetics. He worked for the architect Frank Gehry for a year and became, in his own words, 'a master carpenter'. His show 'Nutsy's' at the Bohen Foundation, New York, in 2002, was an ambitious installation of an imaginary city, covering 4,000 square feet, with an odd range of buildings and items, all made to 1:25 scale. It included a large (9 x 18 feet), detailed version of Le Corbusier's 1952 Unité d'Habitation housing-block in Marseilles [387]; a small-scale McDonald's stall; a 'modernist art park'; a 'ghetto'; and a copy of Le Corbusier's other iconic building, the Villa Savoye of 1928-31. The model city was accompanied by full-size copies of Mies van der Rohe leather chairs, which took the scale and content of the installation to another confusing level of reality. Sachs's point was that variations of the Le Corbusier buildings and the McDonald's hamburger stall can be found all round the world, and together they exemplify a kind of domination in their fields -- and in the case of the Le Corbusier, the corruption of originality. He takes this corruption one stage further in his facsimiles.

Utopian dreams, such as those designed by Kingelez, also occupy the imagination of Carlos Garaicoa, who is inspired by his home city of Havana. The styles of architecture in the city are diverse, and many buildings, through lack of funds, are decaying or lie unfinished and abandoned. A strange sight is the Capitolo, a complete replica of the Capitol Building in Washington, DC, but half-size. Garaicoa makes architectural models that propose reconstructions and inventions for the buildings of Havana, after referring to the original architect's plans to see what was intended. He speaks of giving 'continuity to projects that were never fully developed due to the state's political and economic circumstances', and his approach has a redemptive quality. He has recently made small architectural models from Japanese rice paper, which are lit from inside [403].

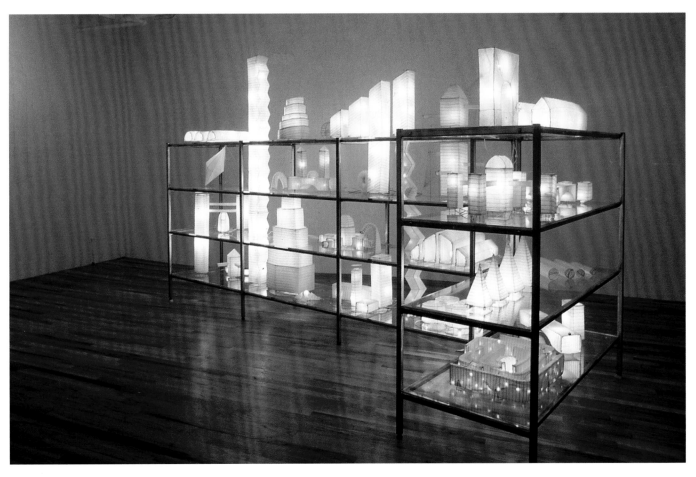

403 Carlos Garaicoa, *You Can Build Your Own City at Your Own Risk*, 2001. Metal and Plexiglas shelves,
Japanese rice paper, wire, lights. 157.5 x 61 x 406.4 cm (62 x 24 x 160 in)

Nathan Coley makes architectural models that examine how the values of a society are reflected in and determined by its built environment. His first solo exhibition in Edinburgh in 2004 consisted of a work called *The Lamp of Sacrifice, 286 Places of Worship, Edinburgh 2004* **(388)**, for which he built large-scale models from cardboard of every place of worship listed in the city's 'Yellow Pages' telephone directory. Concentrating on the beliefs evident in a city offers a different kind of map from the normal; it allows a reconfiguration of what is overlooked or familiar.

404 Rita McBride, *Mid-Rise Automobile Parking Structure*, 1994. Aluminium. 107 x 35.5 x 54.6 cm (42 ½ x 14 x 21 ½ in)

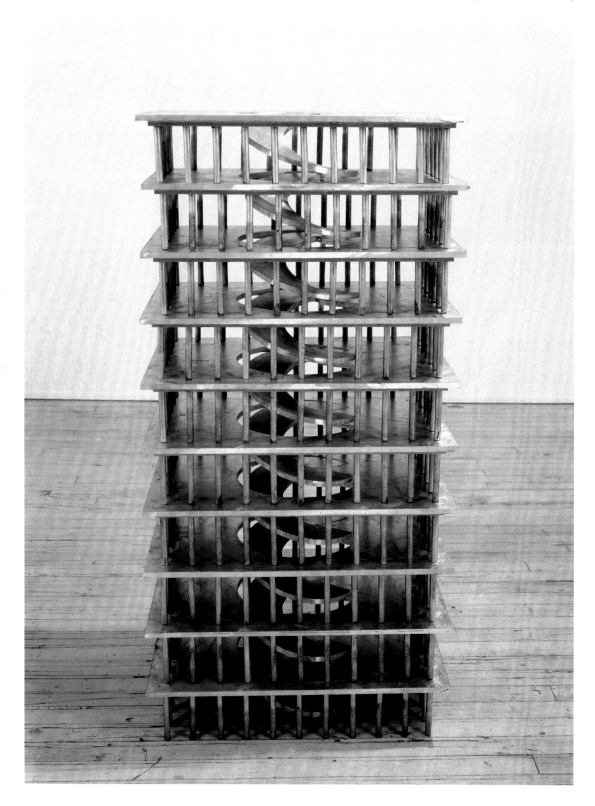

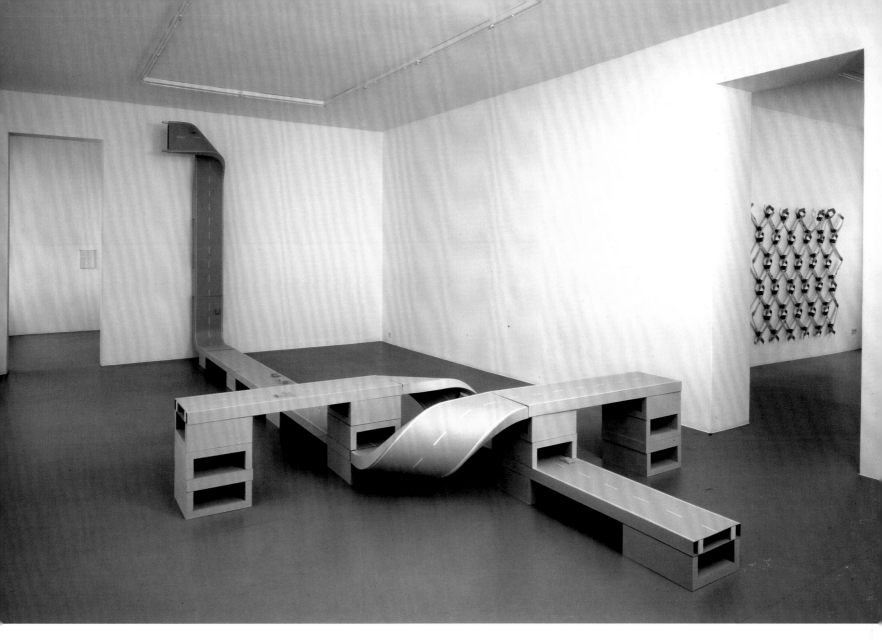

405 Thomas Bayrle, *Autostrada*, 2003. Cardboard, paint. Dimensions variable. As installed at Barbara Weiss Gallery, Berlin

The city and its architecture is the leitmotif of these small-scale sculptures, but there is another topic that has worked its way into the consciousness of contemporary sculptors: the car, with its positive and negative effects upon the quality of urban life. Rita McBride has been making a series of scale models of real multi-storey car parks since 1989, which she has cast into bronze. Devoid of their normal content, they look like minimalist sculptures (404). However, they also draw attention to the insidious influence of a nondescript type of building that demands more and more room as the car culture grows. McBride was preceded in her focus on the car by Thomas Bayrle, who has been building cardboard models of multi-lane highways and motorway intersections since the 1970s. Bayrle trained as a weaver in the 1950s and this, he states, has given him an awareness of the connections between woven fabrics and social frameworks, particularly the relationship between the individual and the community. He extends this analogy to his models of roads and their tangled junctions (405), stating that overpasses and underpasses 'were like segments of a fabric's connective tissue magnified to a great scale'.

Yutaka Sone, who trained as an architect, also turns his attention to cars and motorways, which he dignifies, like McBride, by making them in a traditional material: white marble. Stating that Los Angeles, where he lives, has no real centre or distinguishing buildings, but is experienced mostly through its car journeys on the freeways, he has created several small-scale models of motorway junctions in the area [406]. He uses aerial photographs to ensure that his models are precise and accurate; these are made in foam and cardboard and shipped to China, where experienced marble carvers make the finished sculpture. Sone's models depict nowhere places, the peripheral and the liminal.

A more dystopic view can be found in the sculpted models of Sam Durant, Michael Ashkin and Nicole Wermers. Durant, who also lives and works in Los Angeles, makes models of post-war, modernist houses built in his home city, depicted as vandalized, graffitied and burnt out [407]. Wermers makes miniature rooms less than a metre square, set on pedestals. These habitats seem abandoned but not yet empty -- like doll's houses gone awry. She favours highly detailed models of shop interiors, such as those in *Vacant Shop* [408], which look as though they have been hit by an earthquake or similar destructive force. There are no doors or windows in her small interiors, and therefore no chance of entering or exiting. The only view is from above.

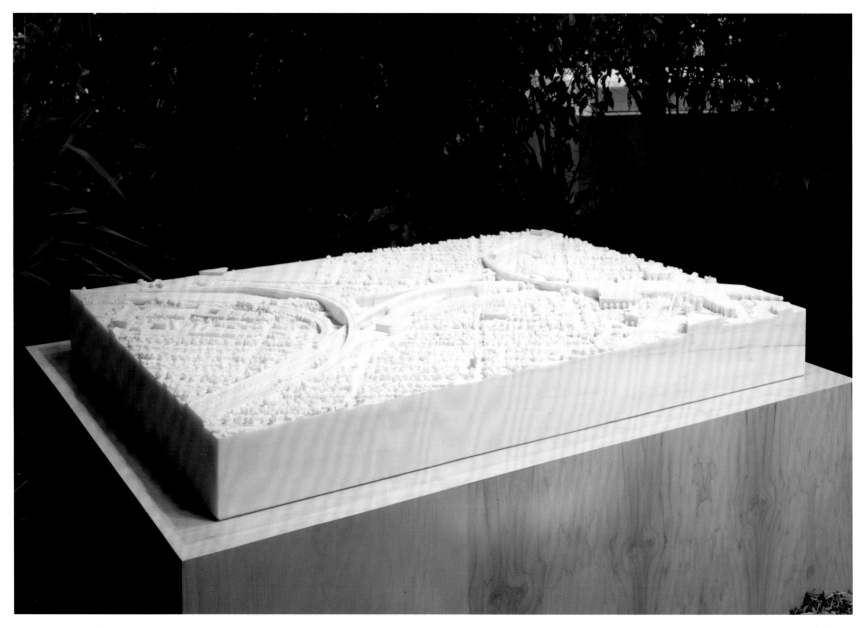

406 Yutaka Sone, *Highway Junction 405-10*, 2003. Carved marble. 22.5 x 118.3 x 161.2 cm (9 x 46 ½ x 63 ½ in)

407 Sam Durant, *Reflected Upside Down and Backward*, 1999. Wood, acrylic, asphalt, CD players. Dimensions variable

408 Nicole Wermers, *Vacant Shop*, 1999. Mixed media. 104 x 80 x 90 cm (41 x 31 ½ x 35 ½ in)

409 Michael Ashkin, *For months he lived between the billboards*, 1993. Mixed media. 132 x 104 x 86.3 cm
(52 x 41 x 34 in)

Ashkin chooses the abject, the no-place, and makes his little models from dirt, tiny sticks and fake foliage, setting them on the surface of nondescript plywood tables. It is unclear whether his industrial landscapes are imaginary or not, although he sometimes includes photographs with his models, and these record various environmental building projects in New Jersey. He showed seven tabletop tableaux at the Andrea Rosen Gallery, New York, in 1998, each of which had a barren if not apocalyptic feel. *No. 74* (1997) is a miniature landscape consisting of a yellowish flow through which tiny withered trees poke their bare branches. It speaks of a chemical spill, an ecological disaster. A poignant little tableau is his *For months he lived between the billboards* **(409)**, a section of freeway and a large billboard above a parcel of wasteland teeming with police cars and personnel. It appears that a human tragedy has occurred and the viewer is left to piece together the evidence.

410 Michael McMillen, *Mike's Pool Hall*, 1977-99. Mixed media and kinetic elements. 22.9 x 50.8 x 50.8 cm
(9 x 20 x 20 in)

411 Donna Dennis, *Deep Station*, 1981-5. Acrylic and enamel on wood, masonite, glass, metal, plastic, incandescent light, sound. 366 x 610 x 732 cm (144 x 240 x 288 in)

In contrast to these models depicting violence and ecological disasters are depictions of archetypal structures and situations. New York artist Donna Dennis makes small sculptural models that depict typical American places, made in three-quarters scale, which come accompanied by evocative soundtracks and lighting. *Deep Station* **(411)**, with its sound and light effects, conveys the experience of a city subway station, and contrasts with her *Tourist Cabin* (1976), accompanied by the sound of crickets.

The most impressive model created by Michael McMillen is his *Mike's Pool Hall* **(410)**, where the viewer is offered a tiny abandoned room with an incredible level of detail enabling the construction of an imaginative narrative; it is not surprising to learn that it was worked on over a twenty-two year span. The little room seems haunted by the long-departed ghosts of pool players and drunks, and the artist plays on feelings of nostalgia and abandonment. McMillen's astonishing facility for minute detail was honed by working as a prop maker for such movies as *Close Encounters of the Third Kind* (1977) and *Blade Runner* (1982).

412 Mariele Neudecker, *Stolen Sunsets*, 1996. Glass tanks, steel, fibreglass, enamel, food dye, salt, water, varnish. Front piece 45 x 65 x 180 cm (17 ¾ x 25 ½ x 71 in)

The natural world is also treated to scaled-down versions by a variety of artists. Utopia has been a covert theme running through some of the tiny cityscapes, but in small-scale models of rivers, trees, it becomes more overt. The grim naturalism disappears, and in its place are parodies of paradise. Mariele Neudecker makes elegantly crafted three-dimensional models based on German Romantic paintings, such as those of Caspar David Friedrich, which she sets on plinths and encloses in glass tanks filled with liquid so that she can simulate atmospheric weather conditions **[412]**. Her mountains and fir trees are made from fibreglass resin and are airbrushed with acrylic paint. She hopes to evoke the concept of the sublime evoked by the Romantic paintings, even though the sublime impresses by virtue of its overwhelming size and scale.

At the Clementine Gallery, New York, in 2002, New York artist Rob del Mar showed his miniature landscapes made from a mixture of synthetic and natural materials such as steel, plywood, flocking, stones and fungi. He creates both freestanding biospheres and wall-hung miniature landscapes (413), and his subjects are usually picture-postcard-inspired, evoking sunny holiday destinations with white sculpted clouds.

In 1996, at Sperone Westwater, New York, Charles LeDray showed several hundred tiny vases, all white, displayed in glass-shelved vitrines. He seems to revel in extreme labour-intensive activity, and for his most recent exhibition in the same gallery, the vitrine contained thousands of unique glazed ceramic vessels that he had made between 1994 and 1996 (414). It was a display of manual dexterity of the greatest virtuosity, since most of the exquisite vases were decorated, and the whole collection revealed aspects of pottery traditions from ancient times to modern. As objects for contemplation, the vitrine with its tiny treasures was almost too much to take in visually; it was hard to concentrate on any one vessel, since all its neighbours clamoured for the same attention.

Vincent Fecteau's entire oeuvre consists of models. The major function of a model is either to replicate something that once existed and is now destroyed, or to propose something to be made in the future. In his 'Matrix' show at the Berkeley Art Museum, University of California, in 2002, Fecteau showed thirteen models, all of which had been made in the previous year. At first sight, they looked as though they were models for architectural projects, but on prolonged looking it became obvious that the structures are impossible to build, which creates an unsettling appearance. Some look like miniature stage sets with odd ramps and screens, and all of them reveal a battle between form, content and scale with little hope of resolution (415-20).

413 Rob del Mar, *Autumn landscape*, 2002. Mixed media. Dimensions variable

414 Charles LeDray, *Oasis*, 1996-2003. 2000 hand-made glazed ceramic vessels, glass and steel display case. 243.8 x 91.4 x 91.4 cm (96 x 36 x 36 in)

415-20 Vincent Fecteau, *Untitled*, 2001-2. (clockwise from top) Papier mâché, acrylic, shells, rope. 22.9 x 40.6 x 41.9 cm (9 x 16 x 16 ½ in); Papier mâché, acrylic, wood, pinecones. 17.8 x 50.8 x 26.7 cm (7 x 20 x 10 ½ in); Papier mâché, acrylic, balsa wood. 25.4 x 38.1 x 49.5 cm (10 x 15 x 19 ½ in); Mixed media. 21 x 50.8 x 38.1 cm (8 ¼ x 20 x 15 in); Mixed media. 36.8 x 38.7 x 27.3 cm (14 ½ x 15 ¼ x 10 ¾ in); Papier mâché, acrylic, twigs. 30.5 x 25.4 50.8 cm (12 x 10 x 20 in)

Many of today's sculptors feel that the world is too full of things and that they do not wish to add to the clutter. Instead, they choose to recycle the mass of material encountered in daily life, bestowing new life on things that others have discarded or abandoned. Working with reprocessed rubbish often points to the voracious and endless cycles of production, consumption and rejection in the world today. Artists compulsively accumulate matter of every kind, ranging from plastic bags through soft toys and toothpicks to discarded rubber tyres and recycled plastic bottle crates.

Some sculptors work in the manner of a social historian or investigative reporter, sorting through agglomerations of stuff in order to establish new and imaginative arrangements, which often have a distinct narrative content. Others work in a more formal way, highlighting basic sculptural matters such as density, mass, composition, scale, colour and balance. There are varied and nuanced approaches to accumulations: stacking, heaping, layering, taping together and hanging. Arrangements might be scattered and chaotic, or coolly organized in a grid formation. The usual place for the display of accumulated material is the gallery floor, playing on the fact that discarded matter is usually found at one's feet.

Most of the material that artists collect for recycling is found within a close radius of their studio, although some collect similar materials from disparate parts of the world and exhibit them together, revealing how depressingly uniform many aspects of our modern world have become. A handful of artists choose to live on site in the host gallery while collecting their hoards, and they recreate the work anew each time they exhibit, making site-specific works. Most of the items collected are inert, man-made materials, but a handful of sculptors, such as Lauren Berkowitz and Simryn Gill, use natural materials that are subject to entropy and decay (see Chapter 8).

The appropriation and accumulation of discarded materials for art appeared in Europe and New York at the end of the 1950s, a time that coincided with a rise in capitalist consumerism in the Western world. In 1958-9, Robert Rauschenberg and Jasper Johns made arresting juxtapositions of urban detritus. This new category of art was named 'assemblage' by the curator William Seitz, who defined it as a 'language for impatient, hyper-critical and anarchic young artists'. He wrote: 'As element is set by element, the many qualities and auras of isolated fragments are compounded, fused or contradicted so that ... matter becomes poetry.'

In France, during the late 1950s and early 1960s, the Nouveau Réalisme group of artists was headed by Arman, who turned the detritus of everyday existence into a potent material for dealing with reality. He was also an avid collector of African tribal art, which attracted him because of the African artists' 'sense of the "accumulative"'. On a few rare occasions, he used minor items from his African collection for his accumulations, such as in *Untitled (Enfileurs de Perles)*, where he has set African masks into a wall relief and adorned them with bright patterning. His work has been described as 'the accumulation of appropriations' and this phrase is a good description of this work.

When Louise Bourgeois was asked about her choice of materials in 1986, she made an interesting comment: 'In New York everything is dumped on the sidewalk ... you find all kinds of household things, as if a whole apartment had been put on the sidewalk.... You try to save these things because they are so wonderful.... In France it is not like this. You cannot find anything on the streets. So I wouldn't have had the freedom in France to realize things that I do here.' Some of this recycled material has found its way into her room-like installations called *Cells*.

421 Leonardo Drew, *Number 80* (detail), 2002. Cast paper. Dimensions variable

422 Jason Rhoades, *Uno Momento/the theatre in my dick/a look to the physical/ephemeral*, 1996. Mixed media installation. Approx. 7.6 x 21.3 m (25 x 70 ft)

It is not surprising then to learn that many American artists work with recycled material. Two artists from Los Angeles, Jason Rhoades and Mike Kelley, harboured large-scale ambitions for their appropriated material. Rhoades assembled gallery-sized installations that often included engines, lights, music and electricity, causing wires to criss-cross the floor linking the disparate parts. There is usually an odd and noisy machine making something for the duration of the show, whose parts Rhoades acquired from DIY shops, custom-car specialists, electronic stores and factory outlets. His installations have an unfinished, provisional quality; one at the David Zwirner Gallery, New York, was disassembled as soon as it was completed. It is often hard to tell what is deliberate and what is serendipitous, due to the ever-changing physicality of his work. It is also difficult to comprehend the focus and totality of the installation, and to establish the relationships between the parts. The titles given to the installations, such as *The Purple Penis* and *the theatre in my dick*, offer little help **(422)**.

423 Penny Siopsis, *Renaissance: 1900-1997*, 1997. Found objects. Dimensions variable

424 Mike Kelley, *Dialogues*, 1991. All works blanket, stuffed animals and cassette deck. (clockwise from top left) *3 (19th Century White)*. 28 x 98 x 156 cm (11 x 38 ½ x 61 ½ in); *7 (Ambiguity and Amorphousness)*. 27 x 214 x 171 cm (10 ½ x 84 ¼ x 67 ½ in); *6 (An Example of Reflection or Absorption)*. 16 x 90 x 175 cm (6 ¼ x 35 ½ x 69 in); *4 (Written on the Wind)*. 24 x 165 x 133 cm (9 ½ x 65 x 52 ½ in); *5 (One Hand Clapping)*. 104 x 411.5 x 261.5 cm (41 x 162 x 103 in); *2 (Transparent White Glass/Transparent Black Glass)*. 26 x 140 x 168 cm (10 ¼ x 55 x 66 ¼ in)

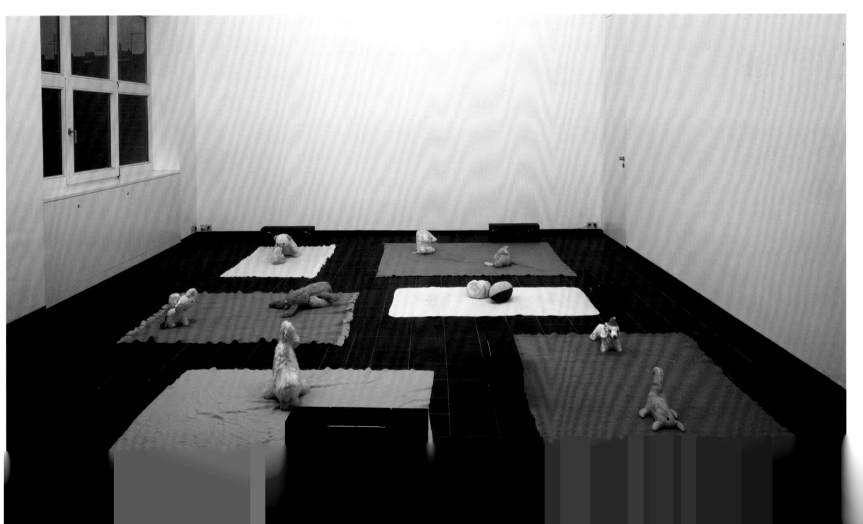

425 Tony Cragg, *Stack*, 1975. Mixed media. 200 x 200 x 200 cm (78 ¾ x 78 ¾ x 78 ¾ in). Tate, London

Kelley's practice consists of happenings, videos and sprawling, messy installations. His performances dealt with the issues of capitalist excess and psychoanalysis, and his sculptures also address those matters, as well as sexuality and gender. He favours toys and kitsch objects as his material. An installation called *Half a Man* (1987-91), shown at the Hirschhorn Museum, Washington, DC, in 1991, consisted of discarded soft toys and battered dolls placed on tatty, second-hand crocheted blankets spread on the gallery floor, accompanied by music playing from battery-powered radios. Kelley continued to develop this project, making further works with the same title and using basically the same materials, but adding worn afghan rugs. The title became more ironic with regular usage, since it called up a stereotypical view of feminine materials and handiwork: crochet and soft toys and dolls. With his *Dialogues* (424), he has placed two soft toys on each blanket, setting them in confrontational positions.

Battered and discarded soft toys are also among the scavenged material used by Penny Siopsis. She began as a painter of narratives, and more recently has turned to arranging large agglomerations of objects (423). The catalyst for this type of work was her discovery of the contents of a house found dumped in a Johannesburg street. The abandonment of these personal items could have been the result of death, or of emigration following the introduction of democracy. Siopsis wants her work to reflect something of the flavour of South African social history after apartheid, and her use of discarded personal items, her own as well as those of strangers, allows her to do this. She recognizes that such objects have resonances of memory as well as connotations of value, both material and emotional. Siopsis arranges these objects either directly on the gallery floor or piled in untidy heaps, often covered by netting. She cannibalizes her old works as material for new installations, as if to emphasize their transient nature.

In Britain, Tony Cragg worked with detritus from a different standpoint. In 1975 he made the first of a series of sculptures called 'Stack', all of which consisted of a massing of material piled tightly together in layers so as to form a large cube (425). With their horizontal emphasis, these items, mostly pieces of wood, magazines and off-cuts of building materials, called up allusions to geological strata, a connection that Cragg himself would accept. Cragg's choice of material was not random, because he wanted, right from the beginning of his career, to create a 'poetic mythology' for the industrially produced materials of our time. In his own way, he was working in the manner described by William Seitz in 1959, turning matter into poetry.

Younger British artists like David Mach and the partnership of Tim Noble and Sue Webster have turned accumulations into representations of things, but their style and chosen materials differ strongly from those of Cragg. Mach's work is not usually made from worn-out or second-hand materials, but more often from those manufactured surplus to requirements, such as magazines and newspapers. For his first solo exhibition, he made a Rolls Royce Silver Cloud car from books and periodicals in a second-hand bookshop in Hay-on-Wye, Wales, thus creating a nice link between materials and setting. In 1983, he made headline news in Britain with his *Polaris*, a large submarine modelled from discarded rubber tyres, which was set on one of the platforms on the South Bank, London. He acknowledges that it was partly a comment on the cost of the British defence budget at the time. During the 1980s and 1990s, he made large, site-specific sculptures in galleries around the world, composed of swirls and waves of glossy magazines, with ordinary objects like desks and cars caught in their eddies (426).

426 David Mach, *Fully Furnished*, 1994. Newspapers, piano, sofa, fireplace, painting, model horse. Dimensions variable. As installed at Museum of Contemporary Art, San Diego, California

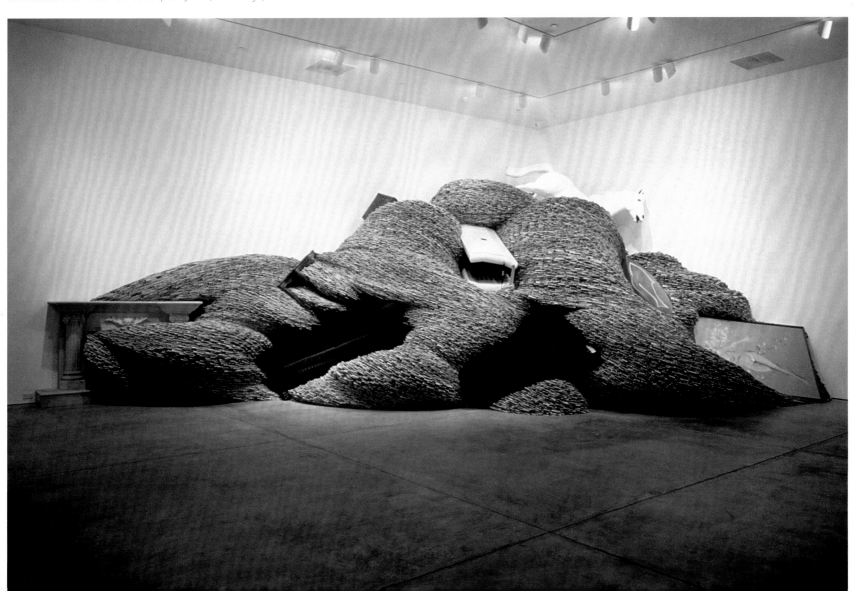

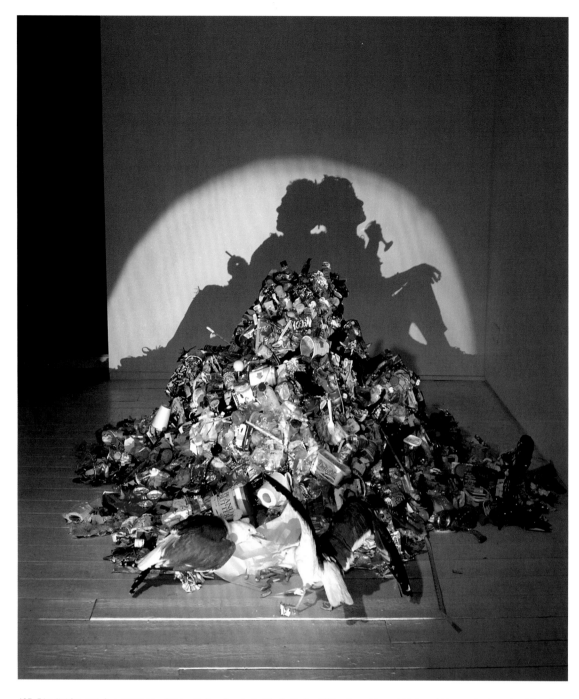

427 Tim Noble and Sue Webster, *Dirty White Trash (with Gulls)*, 1998. Domestic rubbish, slide projector, taxidermic seagulls. Dimensions variable

Noble and Webster met as art students in 1986 and have since formed a creative working partnership, manipulating a wide variety of media. They first showed in an exhibition called 'British Rubbish' at the Independent Art Space, London, in 1996, and again in 'Magic, Loneliness and Trash' at the Museum of Modern Art, Buenos Aires, in 2000. Their *Dirty White Trash (with Gulls)* **(427)** is a large pile of six months' worth of their own discarded food packaging. Two stuffed seagulls peck at the edge of the rubbish heap. Although this work looks chaotic and unordered, it is in fact very carefully arranged: when spotlit, it casts a surprising silhouetted self portrait of the artists, seated back to back, chilling out with a glass of wine and a cigarette. *British Wildlife* of 2000, a tower of taxidermic animals, also casts a shadow of their profiles. With works like these, Noble and Webster are offering a contemporary memento mori, commenting on life, decay, and the way in which society is being overwhelmed by the cumulating waste of its own consumer products.

428 Jessica Stockholder, *Installation in my Father's Backyard*, 1989. Car door, sheet rock, cloth, oil, acrylic and latex paint, orange light, yellow electrical cord, wood, hardware. Approx. 129.6 cm (51 in) high

429 Tony Feher, *Untitled (1999)*, 1999. 16 power strips, 32 25-watt ceramic green incandescent light bulbs, flasher buttons, socket plugs. Approx. 16.5 x 325.3 x 195.6 cm (6 ½ x 132 x 77 in)

Many New York based sculptors work with recycled material. Cady Noland, who is not currently making sculpture, used to present displays of mixed objects collected together in what appeared to be carefully organized randomness, which one critic described as 'aggressively inconclusive'. They mostly included found objects, but some were purchased or made by the artist. There was always a sense of confinement or enclosure, brought about by her use of aluminium scaffolding poles, and she made good use of the contrast between the silver of the poles and the colour of other items. Her work addressed the hopes and ideals of the American Dream, and the inconclusive or unfinished air of the work referred to the fact that she found the Dream unconvincing. She used a mix of popular culture and iconic American items such as the national flag, and magazines and newspapers filled with celebrity photographs as well as anti-heroes. For *This Piece Doesn't Have a Title Yet* (another example of inconclusiveness), she brought together 1,100 six-packs of Budweiser beer, Budweiser advertising banners, American flags and handtools.

In 1983, Jessica Stockholder made *Installation in my Father's Backyard* in a gallery in her hometown of Vancouver, which consisted mainly of large items taken from her father's garage. All of her succeeding work includes and expands on these autobiographical elements. She is fond of reusing a particular chest of drawers from her parents' home, as well as discarded stuff she collects from elsewhere. She recognizes that her installations of recycled material amalgamate two different artistic strands: the chance chaos of the Surrealists and the tidier geometry of Minimalism **(428)**. And having trained as a painter, she regularly uses colour in her pieces. Since these assemblages are large and somewhat unfocused, they have to be viewed from all sides. They are thus difficult both to photograph and to sell.

The processes of stacking, dangling and scattering repeated objects adopted by Tony Feher, who for a short period worked as an assistant to Scott Burton, celebrates the Minimalist work of a previous generation, by artists such as Carl Andre and Donald Judd. Focusing on ordinary things that have been discarded, such as glass jars, light bulbs, wooden crates and plastic bottles, he often uses stacked, red plastic soda cases, and arranges scatter pieces of repeated mundane domestic items. These scatter arrangements have no discernible pattern, but nevertheless convey a curious sense of order **(429)**.

Increasing the intensity of repetition a stage further is Tom Friedman, a sculptor who works with hundreds of small items in an extremely obsessive manner, so that the resulting object is a concentration of energy and material. It is obvious that Friedman's accumulative works require time, energy and painstaking attention since much of his material is fragile. He has made a starburst from thousands of toothpicks **(430)**, and he regularly uses plastic drinking cups, straws, pins, Styrofoam balls, pencils and the fluff from tennis balls to make elegant geometric shapes. His sculptures have been called 'absurd and grand', and he manages to make something riveting out of the fusion between microcosm and macrocosm.

Sarah Sze works in much the same way as Friedman; she makes large- and small-scale installations consisting of carefully arranged found objects such as toothpicks, plastic flowers, stepladders, breakfast cereal, coloured wire, match sticks, candy, aspirin and lights. The objects are intricately balanced, creating a realm that appears both ordered and chaotic. A show in 1999 at the Museum of Contemporary Art, Chicago, incorporated found materials and light, and was created on-site during a ten-day installation period **(431)**. Her work spills through rooms, balconies, staircases and closets, and she has said that she hopes viewers will 'discover a site similar to the way an archaeologist uncovers layers of objects, monuments and foundations'.

430 Tom Friedman, *Untitled*, 1995. Wooden toothpicks. 66 x 76 x 58.5 cm (26 x 30 x 23 in)

431 Sarah Sze, *Many a Slip*, 1999. Mixed media. Dimensions variable

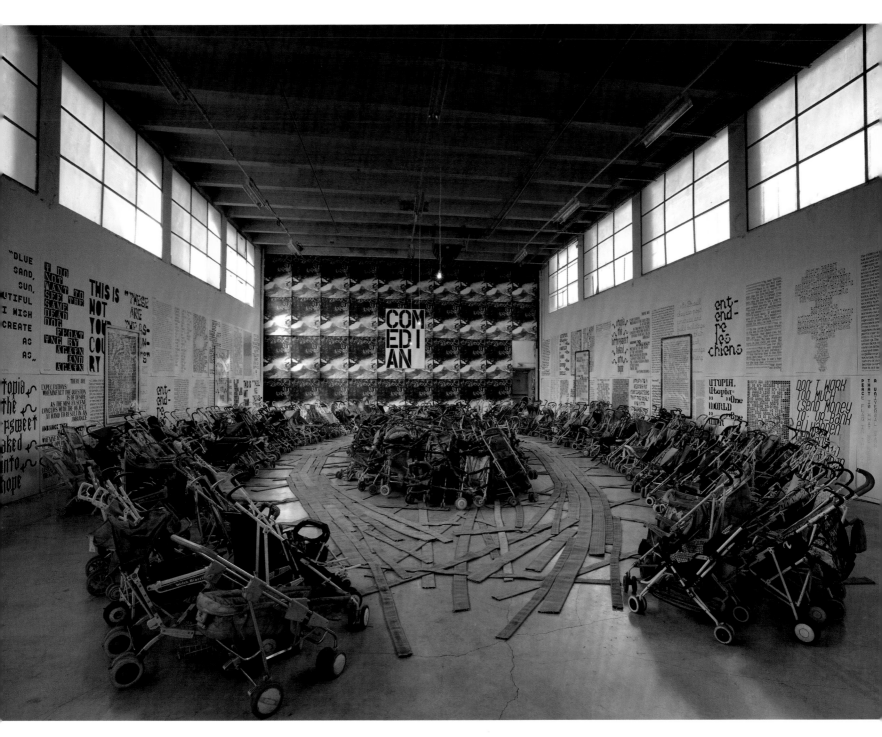

432 Nari Ward, *Amazing Grace*, 1993. 280 baby carriages, fire hose, sound. Dimensions variable

433 Tomoko Takahashi, *Line Out*, 1998. Mixed media. Dimensions variable. As installed at Neurotic Realism exhibition, The Saatchi Gallery, London, January 1999

Leonardo Drew makes large wall reliefs and freestanding forms from rows of stacked wooden boxes, canvas bags, rope and cotton bales. His choice of material for some pieces evokes the life of black cotton pickers, while other works reveal urban detritus, but all are held tight in a grid formation. Drew likes to colour and stain his massed forms, favouring white, black and rust. In a break from his usual practice, occasioned by his residency at The Fabric Workshop, Philadelphia, he made *Number 80*, a multi-part work of white paper (421). He collected discarded domestic objects, finding them in the street or buying them at local thrift shops, and with the help of staff at the museum, cast each object using white paper. The delicate casts lend the whole work an ethereal air quite unlike the strong materialist nature of the rest of his oeuvre.

Nari Ward began his career as an artist in Harlem, New York, in the early 1990s: 'Back then people were using all the empty lots as dumpsites, and I started seeing things that had been thrown out, and some things really spoke to me. I started using them in my work, trying to echo the stories behind those discarded objects.' In his dense installations, Ward responds to the social history and stories belonging to his chosen discarded objects, much in the same way as Siopsis, and, like her, tries to colour his accumulations with added emotional content. In 1993, he made the installation *Amazing Grace*, which filled an abandoned fire station, Harlem Firehouse Space (432). This consisted of baby carriages that he had found abandoned in the neighbourhood, swaddled by lengths of old fire hose and all arranged in the shape of an enormous ship hull. Meanwhile, a tape played 'Amazing Grace' sung by Mahalia Jackson.

An accumulation that takes a different angle on waste comes from Kamin Lertchaipraset, a commited Buddhist. The work has a similar look to that of Drew, because the objects are made from papier mâché, but it approaches the world from a another viewpoint. Every day for a year, Lertchaipraset selected an article about incidents in Thai society from a local newspaper. He then pulped the paper and made a small object inspired by the content of the article. The result is *Problem-Wisdom*, where all 365 objects are shown, laid out in the chronological order of their making, on a white ground. Each is inscribed in calligraphic letters with the 'wisdom' or solution to the problem.

Christoph Buchel produced the installation *Home Affairs* (434) for the Four Walls Gallery in San Francisco. This show was offered as a drop-in place for the homeless of the area: 'It was interesting to hang out with the homeless and to see what techniques they've developed to survive, and the strategies and status symbols they use to differentiate themselves from one another.' Buchel also creates piles of junk in room-like spaces that recall the homes of obsessive collectors or lonely bachelors, using second-hand beds, carpets, furniture, clothes, books, televisions, newspapers, games, food and drink, dead plants, etc.

Tomoko Takahashi is an arranger of junk. She has made installations in galleries, schools, offices, a police station and tennis courts. She immerses herself in her chosen site for a few weeks, collecting cast-off objects that relate to the site. She then weeds through and carefully arranges her jumble of found objects. In order to stay as attached to the work as possible, she lives in the space she creates, sleeping in a folding bed in the middle of things. *Line Out* (433), shown at The Saatchi Gallery, London, comprised a wasteland of islands of discarded domestic and office technology, linked by wires, cables, lamps and flickering television screens. For her installation at the UCLA Hammer Museum in Los Angeles, Takahashi arranged materials scavenged from Hollywood studio prop archives.

Lauren Berkowitz makes sculptural installations from such items as plastic bags, telephone books and magazines **(435)**, as well as natural materials like flowers, wool and salt. Her works are placed on the floor, suspended from the ceiling or propped up against walls. Art-historical references also abound in her work: references to abstraction and Minimal art with its emphasis on seriality, repetition and the grid, and to the vibrating colours of Op Art. Location has become an increasingly significant focus for Berkowitz in recent years. Created in response to particular sites, and constructed from the materials particular to them, these assemblages explore local environmental themes and concerns.

434 Christoph Buchel, *Home Affairs*, 1998. Mixed media. Dimensions variable

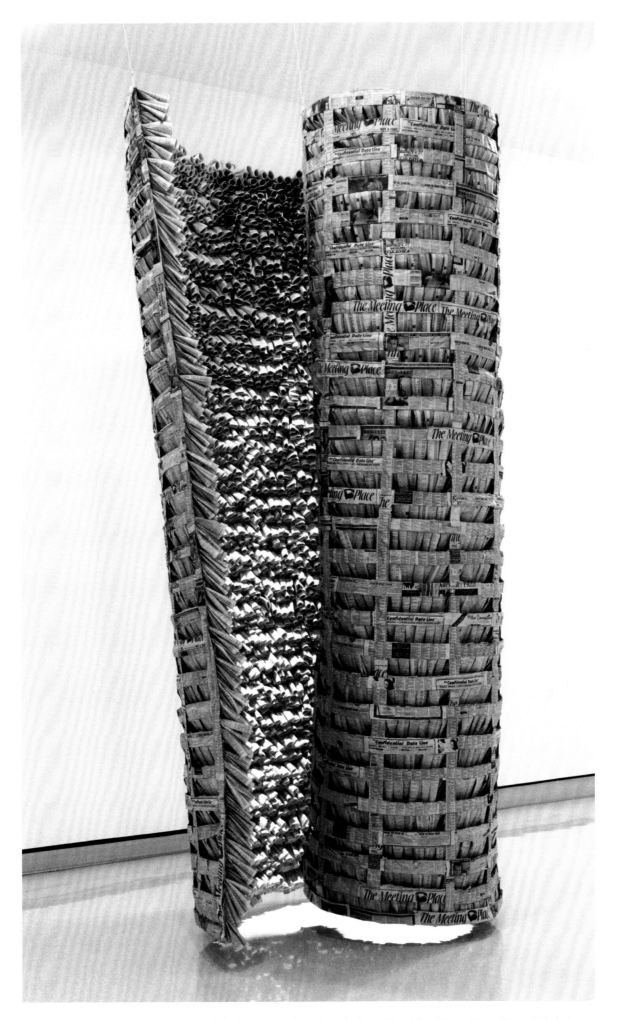

435 Lauren Berkowitz, *Buffalo Dateline*, 1995. Telephone books, wire, staples. 300 x 100 x 100 cm (118 x 39 ½ x 39 ½ in)

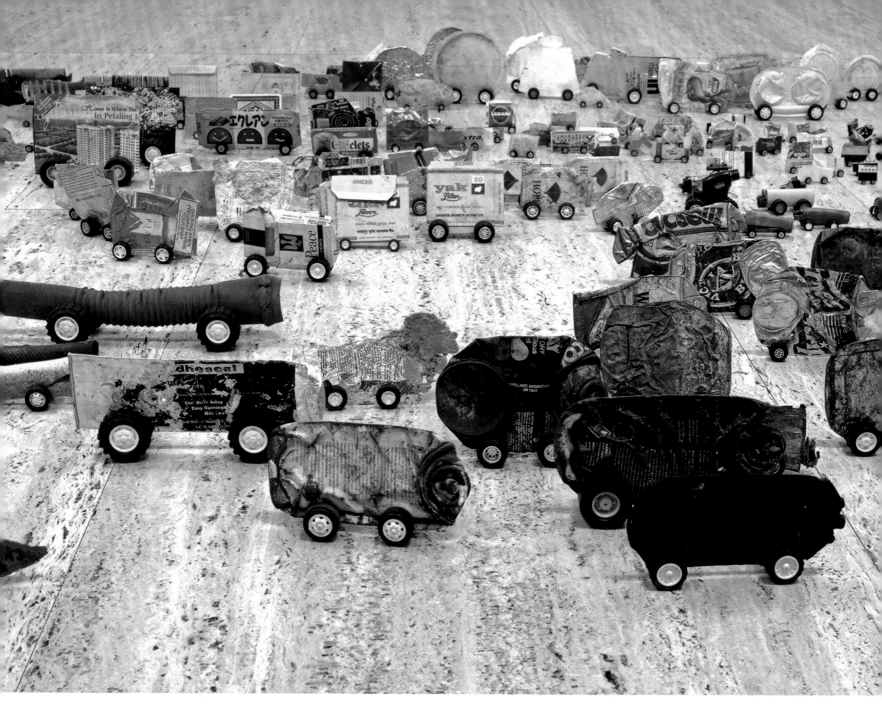

436 Simryn Gill, *Roadkill* [detail], 2000. Mixed items found on roads, toy wheels. Dimensions variable

Simryn Gill worked throughout the 1990s with objects and temporary installations that dealt with displacement and dislocation. She lived in Malaysia, Singapore, India and Britain before settling in Australia. In 1995, she made *Washed Up*, in which water-worn pieces of glass engraved with English words were laid on a gallery floor; the glass had been collected from beaches in Malaysia and the islands of Singapore. Gill said of this work: 'I was interested in the way when language leaves one place and washes up at another, something happens to it ... the meaning of words change.' In her multi-part installation *Roadkill*, at the Center for Contemporary Art, Kitakyushu, Japan, in March 2000 **(436)**, a large collection of things and fragments that had been flattened after being accidentally run over by vehicles in a wide variety of cities, including Kitakyushu, was mounted on miniature wheels.

Jac Leirner compulsively collects everyday objects such as cigarette packs, obsolete bank notes, plastic bags, envelopes, adhesive stickers -- mostly things that circulate almost unnoticed through our daily lives. She explains her choice of materials as 'already impregnated by meanings'. She has a predilection for small rectangular shapes, which evoke in their quiet way the aesthetics of Minimalism, held together by hidden polyurethane cords [438].

José Damasceno works in much the same way as Leirner, composing works that are made from repetitions of small, everyday items, such as chess pieces, pencils, compasses and hammers [437]. He has written: 'Reality, or that which is known as such, possesses countless strata, layers, dimensions, densities, kinds of porousness -- channels of a tremendous structural complexity that moves, grows, and is modified according to yet another vast universe of different viewpoints.' Neither artist makes much work that is strongly three-dimensional; they prefer work that snakes along the wall or hugs the floor.

437 José Damasceno, *A Bridge*, 1999. Blackboard erasers. 250 x 120 x 12 cm (98 ½ x 47 ¼ x 4 ¾ in)

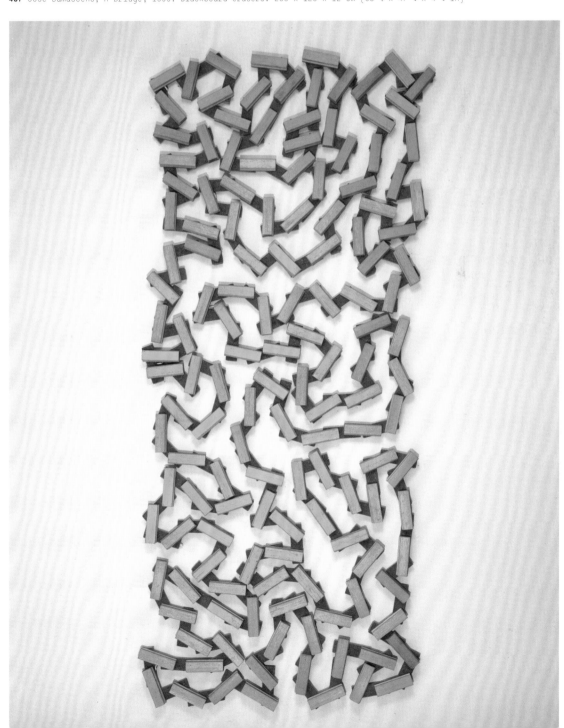

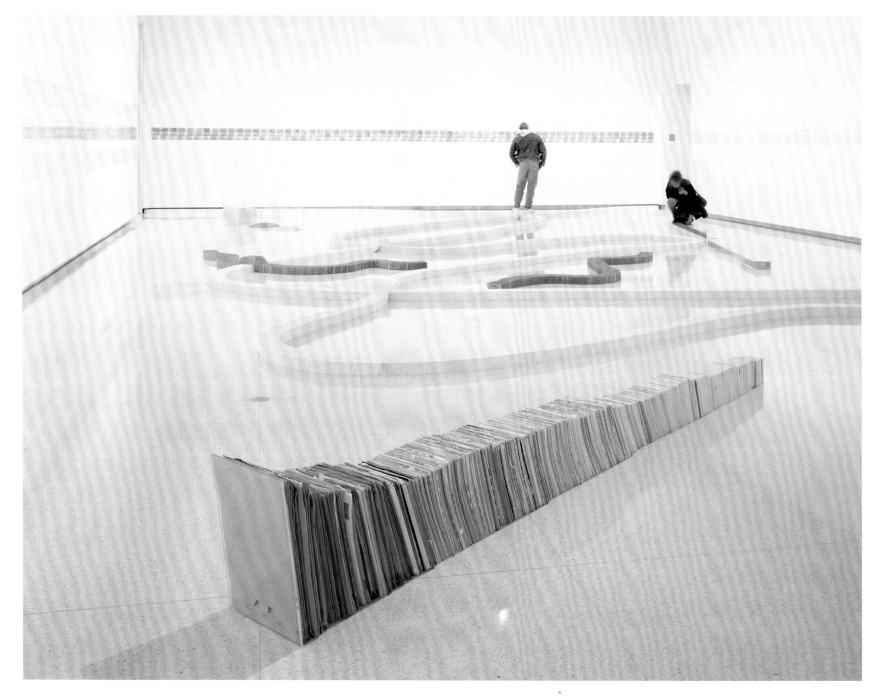

438 Jac Leirner, *To and From (Walker)*, 1991. Envelopes, steel, Plexiglas. 48 x 377 x 34 cm (19 x 148 ½ x 13 ½ in). Art Gallery of Ontario, Toronto

Pascale Marthine Tayou's appropriations and accumulations draw attention to the way in which the majority of third-world citizens have to live off the discarded and recycled flotsam and jetsam of contemporary urban life. His first solo show, 'Crazy Nomad', was in New York in 1999, and consisted of things found in the streets of cities he had visited. In 2001, Tayou was invited to make a temporary installation for the Italian town of San Gimignano, and he chose as his site the football pitch, a central public space and one of the main focuses of the town's social life. He pinned a numberless assortment of plastic bags to the wire-mesh netting that surrounds the football pitch, where they blew and billowed in the wind **(440)**. Tayou has compared himself to this object: 'I'm a plastic bag, full and empty at the same time ... it's an object in permanent transition, in movement towards other destinations ... it's a common item that belongs to the whole world, it crosses frontiers and there's something universal in its utility and in its uselessness.'

439 Shirley Tse, *Untitled*, 2003. Polyethylene, vinyl acetate sheet. 45 x 50 x 58 cm (17 ¾ x 19 ¾ x 23 in)

Another artist who deals with plastic is Shirley Tse. Her focus is narrow, choosing to work with the Styrofoam packaging that is moulded around commodities such as hi-fis, and with plastic garbage bags. She says of her material: 'Plastics are permanent in substance yet temporal in use, ubiquitous yet otherworldly, both surface and structure at once. They are prime examples of multiplicities and/or paradoxes.' Perhaps the paradox she refers to is the capacity of plastic to be both sterile and sensual. Tse arranges her plastic cast-offs into an 'integrated topographic whole', a monochromatic meld **[439]**. Tse is the niece of Eva Hesse, and is as interested as her aunt was in work that is 'non-work'.

Creating assemblages from recycled plastic bottle crates is the signature method of Winter and Horbelt, who began their artistic collaboration in 1992. Their bottle crate houses have served as information booths at the Sculpture Project in Munster in 1997, and

440 Pascale Marthine Tayou, *Plastic Bags*, 2001. Used plastic bags. Dimensions variable.
As installed at Arte all'Arte 2001, San Gimignano, Italy

441 Wolfgang Winter and Berthold Horbelt, *Tail Light Pile*, 2000. Mixed media. Dimensions variable

442 Michael Landy, *Break Down*, 2001. Mixed media. Dimensions variable. As installed at former C&A store, Oxford Street, London

as bus shelters in 1999. In 2000, at the invitation of the Pleasure Gardens at Tilburg, Netherlands, they made *Tail Light Pile*, a 2 ½ metre-high hollow column of stacked Volkswagen Lupo red plastic tail light covers, which was lit from inside, causing the structure to glow and its facets to sparkle. This was set in the middle of a pine forest and given the subtitle *Greta Gets Hansled* which enriches the content of the piece. The artists reconstructed it for their contribution to the International Triennale of Contemporary Art at Yokohama, Japan, in 2005 (441) where it stood again in all its chromatic splendour and provided the stable focus for an installation entitled *Swingerclub*.

Perhaps the most outrageous work dealing with accumulation is Michael Landy's *Break Down* (442), which took place in London over two weeks in February 2001 and was in some sense the opposite of accumulation. Landy catalogued every single thing he owned and then offered up the 7,227 objects of his life for systematic dismantling and destruction by himself and a group of twelve helpers in a disused department store in the 'consumerist mecca of Oxford Street'. Landy's list of all his worldly possessions took over a year to compile, and is now published as a catalogue. Viewers were allowed to enter the store, but many were confused by the spectacle, wondering if it was an end-of-lease sale of goods. Landy spent a major part of each day explaining his concept to the public, and to the media, who gave it generous coverage.

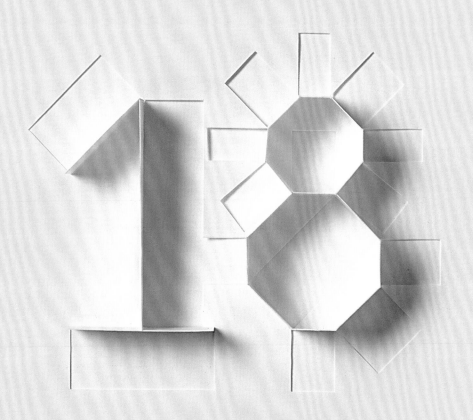

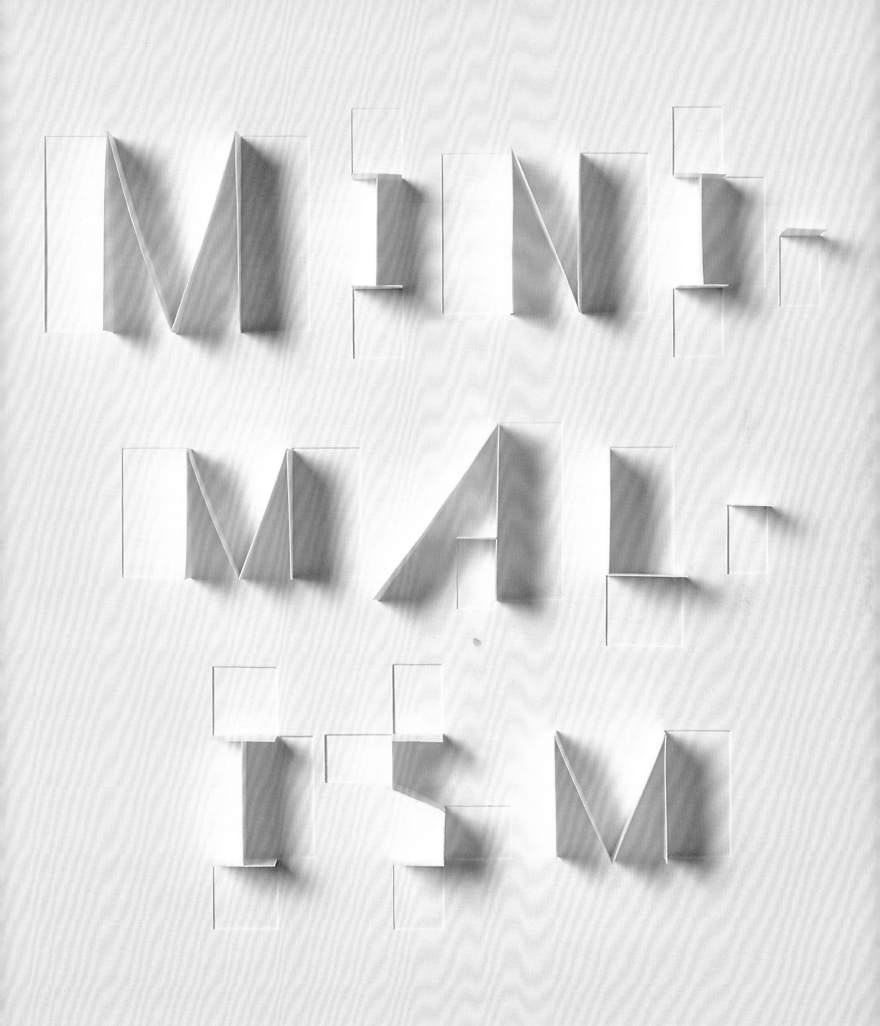

What are 'Primary Structures'? The dictionary defines them as fundamental, basic, elementary constructions or entities. The phrase was used as the title of an exhibition of young American and British sculptors at the Jewish Museum, New York, in April 1966 by American curator Kynaston McShine, which has come to be regarded as the first exhibition of Minimal art, and the one that defined its parameters. The term 'Minimal Art' had appeared twice in 1965: firstly in an article of that name by British philosopher Richard Wollheim, published in *Arts Magazine* in January, and then in an essay by American critic Barbara Rose entitled 'ABC Art', which appeared in *Art in America* in October/November. Rose was describing what she saw as a new sensibility emerging among young American painters and sculptors based in New York, such as Frank Stella, Anne Truitt, Richard Tuttle and Ronald Bladen, characterized by 'reductive tendencies' and a 'blank, neutral, mechanical impersonality', which she traced back to the Russian painter Kasimir Malevich and his *Black Square* of 1913, as well as to Duchamp and his readymades.

Donald Judd also offered a significant text in 1965; his was called 'Specific Objects' and appeared in *Arts Yearbook 8*. Judd announced that, in his evaluation of contemporary American art, the majority of 'the best new work in the last few years has been neither painting nor sculpture', but what he called 'three-dimensional work' or 'objects'. By substituting the nouns 'painting' and 'sculpture' with 'objects', Judd was signalling a break with traditional art and proposing something new, although he did not prescribe what this new work should look like. For Judd, a work like Malevich's *Black Square*, although reductive and blank in appearance, was too loaded with social, political and personal content. He disapproved of 'illusionism and of literal space, space in and around marks and colours', calling it 'one of the ... most objectionable relics of European art'. By the time the 'Primary Structures' exhibition opened in New York in spring 1966, there was a whole range of critical neologisms to describe the new art being made in that city. There were short-lived terms such as 'Rejective Art' and 'Literalism', but the one that stuck was 'Minimal'. This term should be used with care because none of the main protagonists accepted it as a designation for what they did, but it is employed here for the sake of convenience.

The essential Minimal artists were Tony Smith, Sol LeWitt, Carl Andre, Robert Morris, Dan Flavin and Donald Judd, all of whom had by 1966 restricted their formal language to simple geometric forms and allowed their materials and processes to reflect the conditions of industrial production. Industrial materials were also chosen for their basic, inexpressive qualities, and these included bricks, plywood sheets, aluminium and steel, mirrored glass, Plexiglas, light fittings and galvanized iron. Although the high period of Minimalism did not last long, it remains as a crucial precedent for artists working in a similar way today. Much contemporary art is still made via industrial processes with commonplace materials, but now such work comes with its own flavour of Minimal art history and is loaded with social and psychological content. What is apparent is that there is currently a light-hearted, hand-made approach to the minimal, a grateful and knowing look back to a body of work that still impresses through its cool, intractable presence.

When critics use the word 'Minimal' as a shorthand description, they mean work that has a strong sense of mass, is usually symmetrical, is monochrome in colour, has a high degree of simplification and self-containment, an avoidance of the pedestal, and the use of materials such as plastics and alloys. However, among the main artists, there were subtle and interesting differences in approach to questions of form, content and handling. Judd, LeWitt, Andre and Morris favoured cubes and rectangles, while Tony Smith and Ronald Bladen liked diagonals and interlocking shapes, and Bladen, like Truitt, painted his massive plywood forms by hand. He wanted his reductive sculpture to be about something; he spoke of creating 'a drama out of a minimal experience'.

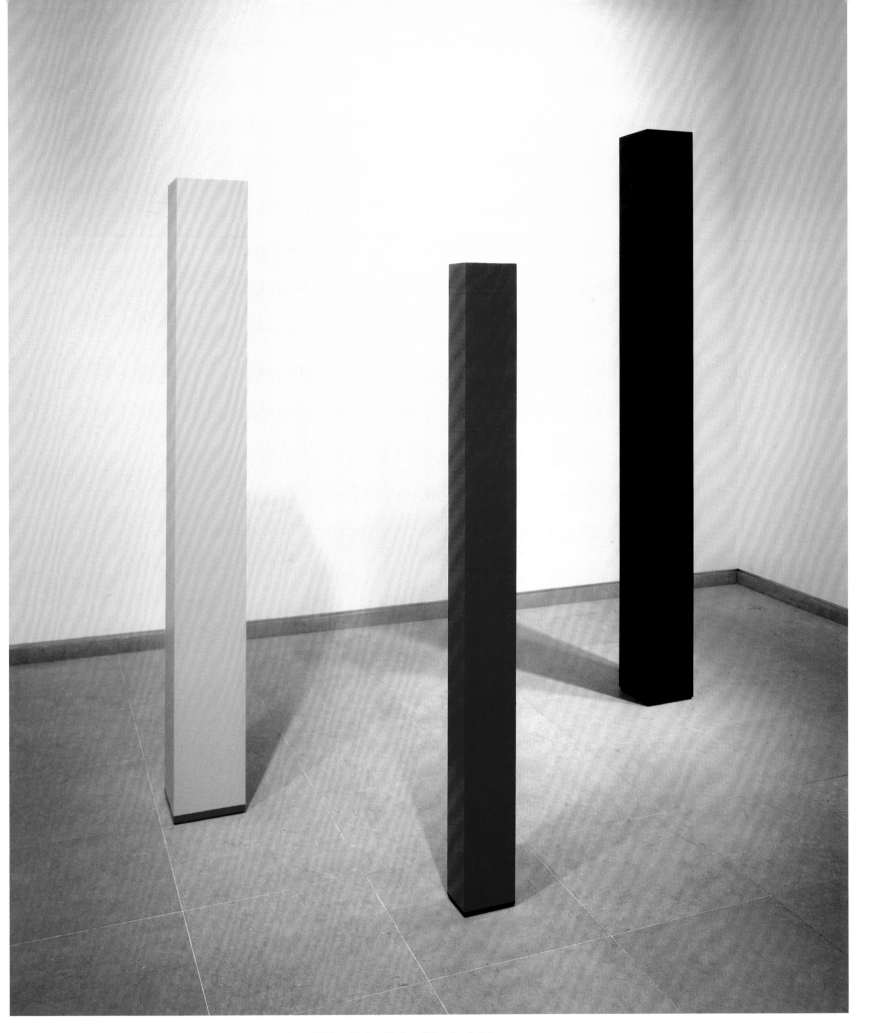

443 Anne Truitt, *Swannanoa*, 2002. Acrylic on wood. Front piece 205.7 x 20.3 x 20.3 cm (81 x 8 x 8 in)

Bladen, who was in the groundbreaking 'Primary Structures' show in 1966, was born in 1918, making him about a decade older than the others, and a precursor of Minimalism. This is also true of Anne Truitt, born in 1921. Her first solo show, at the André Emmerich Gallery, New York, in 1963, announced her simple forms, which were usually slender vertical blocks of wood, standing about 5 to 7 feet high **[443]**. She hand-painted them with a number of coats of brightly coloured paint, sanding between each application, and stated that this process rendered the colour 'as independent of materiality as I can make it'. Her lush surfaces evoked a range of allusions, evident in her titles, such as *Sea Garden* or *A Wall for Apricots*.

By the 1980s the work of Bladen and Truitt had somewhat faded from view. This has not been the case with LeWitt, Judd, Morris and Andre, whose output has remained indispensable to the development of sculpture at the end of the twentieth century and the beginning of the twenty-first. LeWitt is known for two types of work -- wall drawings and three-dimensional geometric structures, both of which are usually executed by others. For much of his career he made geometrical structures, mainly cubes; his early sculptures were closed forms, but in 1965 he decided 'to remove the skin altogether and reveal the structure. Then it became necessary to plan the skeleton so that the parts had some consistency. Equal, square modules were used to build the structures.' These square modules were made of jointed wood, painted black, but LeWitt quickly took the decision to paint them white, for two reasons. One was to 'mitigate the expressiveness' of black, and the other was to ally them more closely with white gallery walls, linking them to the architectural space in which they were shown. *12345* **[444]** is a mature modular piece by LeWitt which exemplifies his predilection for using elemental mathematical progressions for his sculptures, following universal rules rather than his own. It is easy to see that the first form on the left contains one open cube, the next has two cubes in all three dimensions, and so on to the fifth; the artist spoke of wanting to make his work to appear 'simple, basic, intelligible', and this work does just that. It is made of painted aluminium, a material he began to use around 1970 because of its durability. LeWitt stated that he was not interested in the materiality of his sculptures, and emphasized the idea that lies behind them as primary; in 1967 he proposed the term 'Conceptual Art' for his work.

Judd trained as a painter but turned to making three-dimensional geometrical forms in the early 1960s, using planks of commercially available timber and standard sheets of metals and plastics. By 1965, the year he wrote 'Specific Objects', his work, like LeWitt's, was made by others to his instructions. From then on, all of Judd's three-dimensional works were constructed from the materials of everyday urban and industrial things, such as stainless steel, copper, brass, aluminium, Plexiglas and Douglas fir plywood. Judd wrote of modern industrial materials in his 'Specific Objects' essay, describing them as 'specific' and 'aggressive', adding that there 'is an objectivity to the obdurate identity of a material'. He stands apart from the other Minimal sculptors in that he used bright colours in his works. But he ensured that his use of these colours did not descend into personal expression by simply picking them off a sample commercial colour chart. Although he praised the qualities of simplicity and wholeness, he made numerous sculptures out of repetitive parts, rather than a single unit. One of Judd's most distinctive productions is the open-box format, where thin sheets of metal, wood or Plexiglas are bolted together in a sequence (see Chapter 10).

Morris studied engineering and art history and began his career as a performance artist in New York in the late 1950s. He was one of the first sculptors to make reductive geometric structures, firstly as props for his performances, and then as autonomous objects, showing simple, painted plywood shapes at the Green Gallery, New York, as early as 1963. Looking back in 1989 at such works **[262, 367]**, he wrote how invigorating it had been

to eliminate 'transcendence and spiritual values, heroic scale, anguished decisions, historicizing narrative, valuable artefact, intelligent structure, interesting visual experience' from his work. Yet his use of modular units, which could be arranged in a different configuration at each showing, and his quartets of mirrored cubes, did create an 'interesting visual experience', since the units tested the visual memory of the dedicated viewer, and the mirrored cubes included the viewer in the work.

Horizontality is one of the signature features of Andre's work, which consists mostly of a huge variety of floor pieces. Andre challenged the conventions of sculptural presentation, since he allows his metal works to be walked on by the viewer. He has said that he wants his sculpture to be like 'a road', and *Venus Forge* **(445)** certainly looks like one. It is composed of two contrasting materials: highly polished copper plates set within dark steel ones. It is one of the more luxuriant of his floor pieces. This is confirmed by the title, which alludes to Venus, the goddess of love, who was married to Vulcan, the blacksmith and forger of thunder bolts. Besides laying metal tiles on the floor, Andre has also stacked and layered various materials, arranging them in mathematical permutations, the most famous of which are his eight different configurations of 120 firebricks called *Equivalent I-VIII*, which he showed at the Tibor de Nagy Gallery, New York, in 1966. These firebricks came from a local brickyard, and when the show was over, they were returned there. Years later, when museums and collectors realized their significance and wished to purchase them, Andre was unable to obtain the same sand-lime bricks and had to substitute another kind (ironically reinforcing the notion of equivalence).

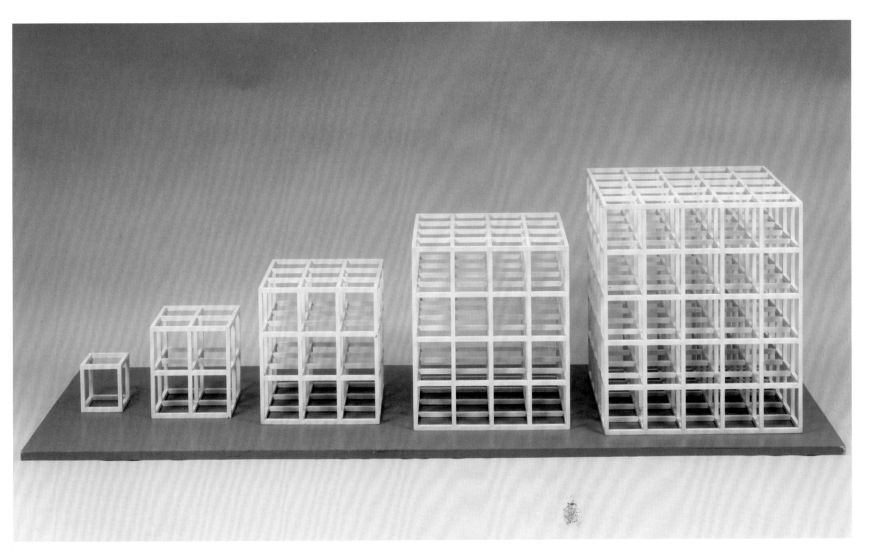

444 Sol LeWitt, *12345*, 1980. Painted aluminium. 98 x 273 x 98 cm (38 ½ x 107 ½ x 38 ½ in). Museum of Contemporary Art, Chicago, Illinois

445 Carl Andre, *Venus Forge*, 1980. Steel and copper plates. 120 x 1555 x 0.5 cm (47 ¼ x 615 x ½ in). Tate, London

LeWitt, Judd, Morris and Andre eschewed the idea of asymmetry, but subtle variations from the right angle are found in the sculptures of Ellsworth Kelly. His monochromatic paintings and painted wood sculptures of the early 1950s pre-date by a decade the reductive works of Minimalism's most famous names, and although they look similar, his aims are different. Kelly is not so interested in repetitive, serial forms, because he wants to make each of his works unique. He has also revealed that much of his source material is found in the natural world, which is not a realm of straight lines and right angles. Between the 1960s and 1980s his sculptural output increased and he turned to using large sheets of weathered steel, stainless steel and bronze, which marry elegance and strength [446].

446 Ellsworth Kelly, *Curve XXXI*, 1982. Steel. 274.5 x 265.5 x 46.5 cm (108 x 104 ½ x 18 ¼ in). Tate, London

447 Fred Sandback, *Untitled* from 'Ten Vertical Constructions', 1977. Acrylic yarn. Dimensions variable. As installed at Dia: Beacon, New York

The most minimal sculptures in terms of mass and volume were made by Fred Sandback, who, for over thirty years used coloured acrylic yarn to create his linear forms. In 1966 he traced the outline of a rectangle with string and wire on the floor, which allowed him to avoid making sculpture that has an interior and exterior. His single yarn lines and open geometric shapes live in a symbiotic relationship with the gallery space in which they are realized, and the coloured and slightly fuzzy yarn produces an almost palpable sense of volume and space **(447)**. It is even possible, with care, to walk through them. Sandback spoke of being able to be 'inside' the work, by which he means that he sets the viewer in the centre of things, in a similar way to Andre and his idea of the road.

Tony Smith, who died in 1980, was firstly a painter (and the father of sculptor Kiki Smith), and then an architect, working as an assistant to Frank Lloyd Wright for several years; his career as a sculptor only began in 1962. Smith's oeuvre overlapped and to some extent influenced Minimalism, except that he used abstract forms for something almost human, rather like Bladen and Truitt; the titles of his sculptures -- *We Lost*, *Duck*, *Cigarette*, *Willy*, *The Snake is Out* -- hint, as Smith acknowledged, that his forms were suggested by the everyday things around him or by autobiographical incidents.

By the late 1960s, when Smith and his peers had affected a transformation in the way sculpture was made and how it could look, a reaction against the rigid formalism of Minimal art was beginning to take place. The hard edges of the cube and rectangle started to soften, and to open up, and social and personal concerns began to insinuate their way into the third dimension. Morris was writing about 'anti-form' in his 'Notes on Sculpture', LeWitt was writing 'Paragraphs on Conceptual Art', and suddenly it seemed as though there was too much impassive physical concreteness around. As early as 1967, the New York-based art historian and critic Robert Pincus-Witten coined the term 'Post-Minimalism' to describe the arrival of new themes and forms, arguing in critical articles that Post-Minimalism 'actively rejects the high formalist cult of impersonality'.

448 Tony Tasset, *Wedge Bench*, 1986. Wood, leather. 53.3 x 152.4 x 48.3 cm (21 x 60 x 19 in)

At the beginning of the 1980s, many younger artists began to examine the social, economic and political conditions in which art functions, and as part of this they looked at the achievements and failures of Minimalism; two such artists, Tony Tasset and Richard Rezac, lived and worked in Chicago. Tasset kept to the kind of forms found in Minimalism, such as stacks, series and progressions, but softened their hard edges by making his objects look and feel comfortable, fashioning some out of padded leather. His *Wedge Bench* of 1986 **(448)** looks like a dysfunctional version of a neutral bench found as seating in art galleries.

449 Richard Rezac, *Untitled [95-05]*, 1995. Nickel-plated cast bronze. Each piece 27.3 x 7.5 x 5.1 cm (10 ¾ x 3 x 2 in)

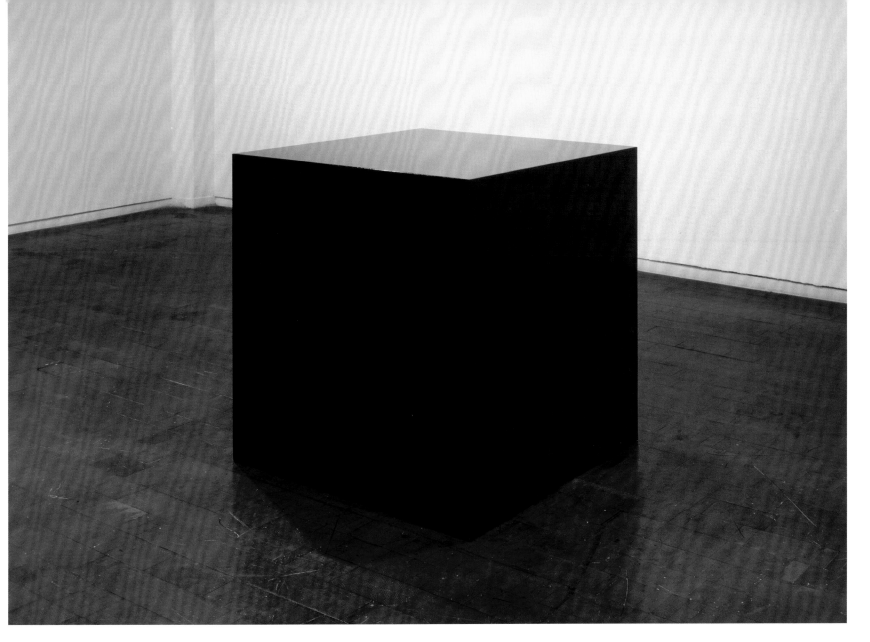

450 Charles Ray, *Ink Box*, 1986. Automotive paint on steel with printer's ink. 92 x 92 x 92 cm (36 ¼ x 36 ¼ x 36 ¼ in).
Orange County Museum of Art, Newport Beach, California

Rezac makes small, unpretentious sculptures suggesting manufactured goods that are somehow deprived of their function (449). They look flawless and machine made, and as such pay homage to the simplified forms and industrial look of Minimalism, but they are actually hard won through long hours of meticulous craftsmanship. Rezac draws inspiration for his forms from architectural details and familiar domestic items such as corbels, banisters and handles.

In Los Angeles, at the same time, Charles Ray made *Ink Box* (450), which imitates a big, glossy, black Minimal cube of the kind made by Tony Smith. This is a clever illusion, since its top section is filled with 200 gallons of black printer's ink, which if touched leaves a nasty stain on the fingers. Another Los Angeles artist, Liz Larner, felt that minimal cubes had come to symbolize stasis and a sense of security. She attacked this notion, and the form itself, by opening it up and making open cubes from coloured lengths of twisted steel and aluminium rods (451), which has the effect of making them seem unstable.

In Europe in the 1970s, Minimalism in sculpture took a different route. Ulrich Rückriem became one of the leading representatives of European Minimalism. He has been using stone in its natural, raw state since 1968, and he is perhaps the only Minimalist sculptor to work in a traditional material. He favours stone straight from the quarry, with all its natural patinas and shapes, the antithesis of the anonymous, flat, industrial surfaces preferred by the Americans. However, all these sculptors share the basic issues: size, scale, mass, volume, proportion, relationships, even colour. Rückriem has said: 'The theme of dividing a block of stone in a certain way and restoring it to its original form is still full of surprises for me and keeps me on the alert' **(180)**.

451 Liz Larner, *2 As 3 And Some Too*, 1997-8. Paper, steel, watercolour. Two elements, each 152.4 x 152.4 cm (60 x 60 in)

452 Ettore Spalletti, *Parete*, 1995. Pigments on wood, gold leaf. 247.5 x 365 x 20 cm (97 ½ x 143 ¾ x 8 in)

Ettore Spalletti is the same generation as Rückriem, but although both create forms that are cool and spare, Spalletti's work has stronger links to the cultural rather than the natural world. He freely admires the paintings of Giotto and Piero della Francesca, and the sculptures of Brancusi, and his work, which consists of flat or solid geometrical shapes, lies between the worlds of painting and sculpture. He makes painted monochromatic, mostly blue, wooden reliefs that are composed of oil paint over a plaster base **(452)**, while in his sculptures, he makes reference to functional objects such as bowls and vases in much the same way that Brancusi did.

A European artist whose work displays affinities with Minimalism, but with a more forceful presence than that of Spalletti, is Isa Genzken, who also makes photographs, videos, films and collage books. As a young artist in Dusseldorf in the early 1970s, she was aware of the powerful influence of Minimalist works coming from American soil, while in her own country, there was the dominant figure of Joseph Beuys. Trying to steer a personal path between these two approaches, she opted to produce a range of computer-generated floor pieces. Her first series, 'Ellipsoids', was created between 1976 and 1982, and these overlapped with her 'Hyperbolos', which date from 1979 to 1983 **(453)**. All were composed of painted and lacquered wood, had curved or pointed edges, and were usually between 5 and 10 metres in length. Their size meant that they often took up most of the gallery floor, but they could not be walked upon like Andre's floor pieces. Genzken then changed direction and for a few years made rough plaster and concrete forms, which she set on steel scaffolding tubes, lifting them up to the viewer's eye-level, and calling up comparisons with the built environment. Another shift in her progress through sculptural conventions led her to assemble tall columns, which have now become her signature form. These works, such as *Little Crazy Column* (2002), come in a variety of materials -- painted wood, concrete, plaster, mirrors, glass and resin, sticky tape, fibreboard and collaged photographs -- and each is unique, even though they may share decorative details. Her love of mirrored surfaces alludes to the reflective cubes of Robert Morris, and like him, her sculptures both fill and dissolve space, and include the image of the viewer.

The work of Jan Vercruysse bears similarities with that of Genzken; like her, he works predominantly in series, and shows an interest in exploring the relationship of object, space and place. In 1983, he began a group of works with the generic title of 'Chambers': large, plain structures made from wood and wood veneer that viewers could partly enter. These look both architectural and functional, and call to mind some of the wooden furniture pieces of Richard Artschwager, but they have a greater sense of being about something -- about absence and presence -- since they are both forbidding and inviting. In 1988 he began a series called 'Tombeaux', which can translate as either tomb or memorial. This *Tombeaux* **(454)** serves as a haunting monument to the absent human presence. Three beautiful and fragile blue glass chairs hang from iron pegs on an iron beam, and, by the nature of their position and their material, they are rendered non-functional. They were made for the artist in Murano, Italy, a glass-making centre famed for its formal extravagance.

Jean-Marc Bustamante makes strong references to Minimalism in his sculptures, and has said: 'It's important for me to come back to primary materials ... My reference is more Carl Andre than Donald Judd.' What he says here and what he does are not in total agreement, however, since he has not made many works with an Andre-like horizontality, and he has used bright colours on many occasions. His preference is for vertical structures, made from glass, wire mesh, painted steel, mirrors and Perspex. His titles are not the usual 'Untitled', but contain words that have emotional and psychological references, such as *Consolation* **(455)**.

In Britain, three artists have made sculpture that displays reductive tendencies: Julian Opie, Grenville Davey and Marcus Taylor. From the early 1980s, Opie has worked through a variety of styles, beginning with renderings of familiar domestic tools and utensils made from cut-out sheet metal, and painted with oils. In the late 1980s these painted fictions were abandoned in favour of minimal forms that seemed like derivations of air-conditioning units, refrigerators or office cabinets. These sculptures were autonomous, anonymous and made from industrial materials; some were freestanding and others were wall-mounted. Opie moved on from these minimal objects to an exploration of shape, colour and scale in large multi-part wooden sculptures, the titles of which -- such as *On average present day humans are one inch shorter than they were in 8000 BC* -- became increasingly inventive.

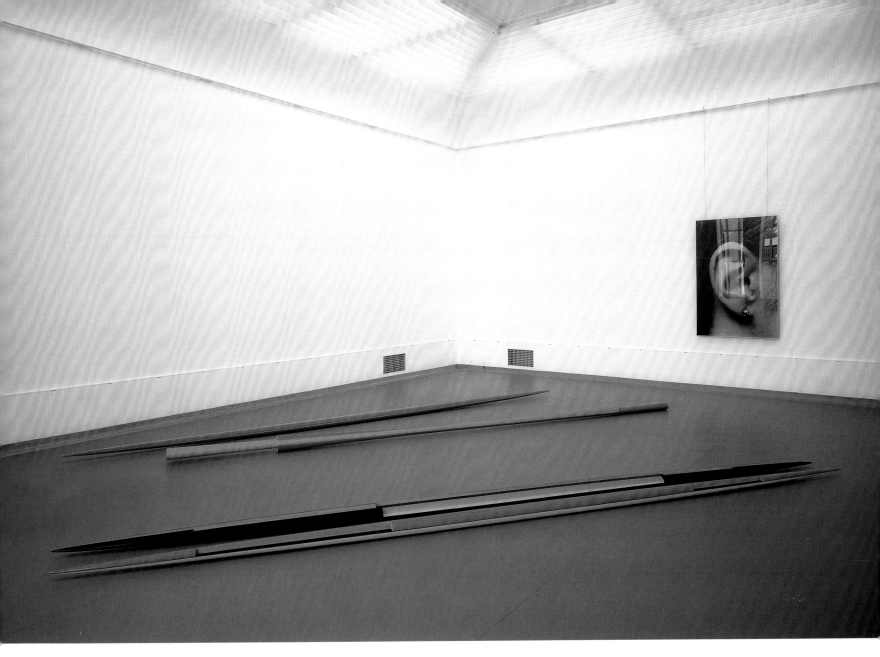

453 Isa Genzken, (from front) *Red-Yellow-Black Twin-Ellipsoid*, 1982. Wood, lacquer. Two parts, each 600 x 24 x 12 cm (236 ¼ x 9 ½ x 4 ¾ in); *Green-Orange-Grey Hyperbolo 'El Salvador'*, 1980. Wood, Lacquer. 620 x 22 x 19 cm (244 x 8 ½ x 7 ½ in); *Blue-Green-Yellow Ellipsoid 'Joma'*, 1981. Wood, lacquer. 625 x 16 x 10 cm (246 x 6 ½ x 4 in). As installed at Museum Boijmans Van Beuningen, Rotterdam, The Netherlands

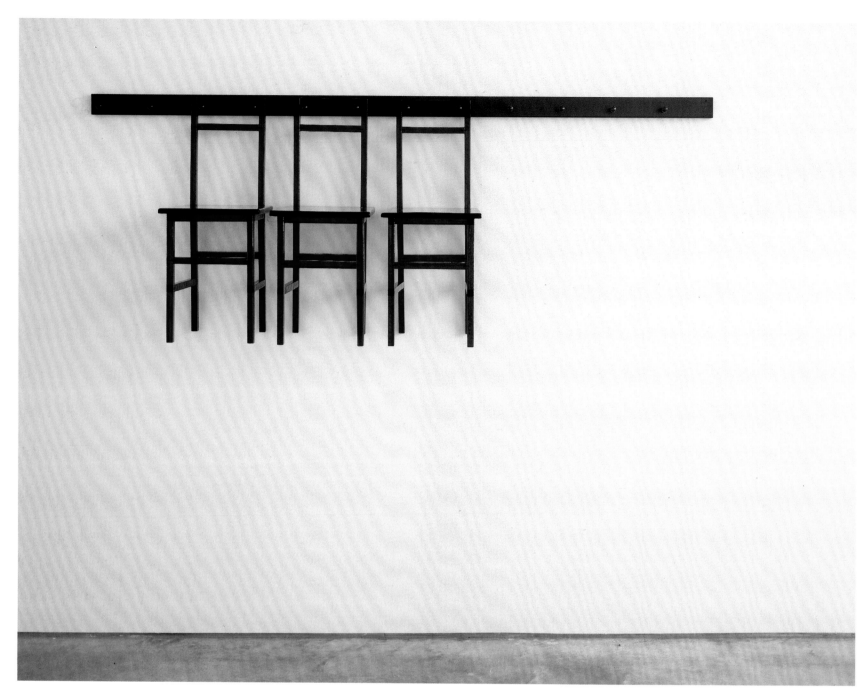

454 Jan Vercruysse, *Tombeaux*, 1991. Coloured Murano glass, iron. 191.5 x 245.1 x 37.8 cm (75 ½ x 96 ½ x 15 in). Hirshhorn Museum and Sculpture Garden, Washington, DC

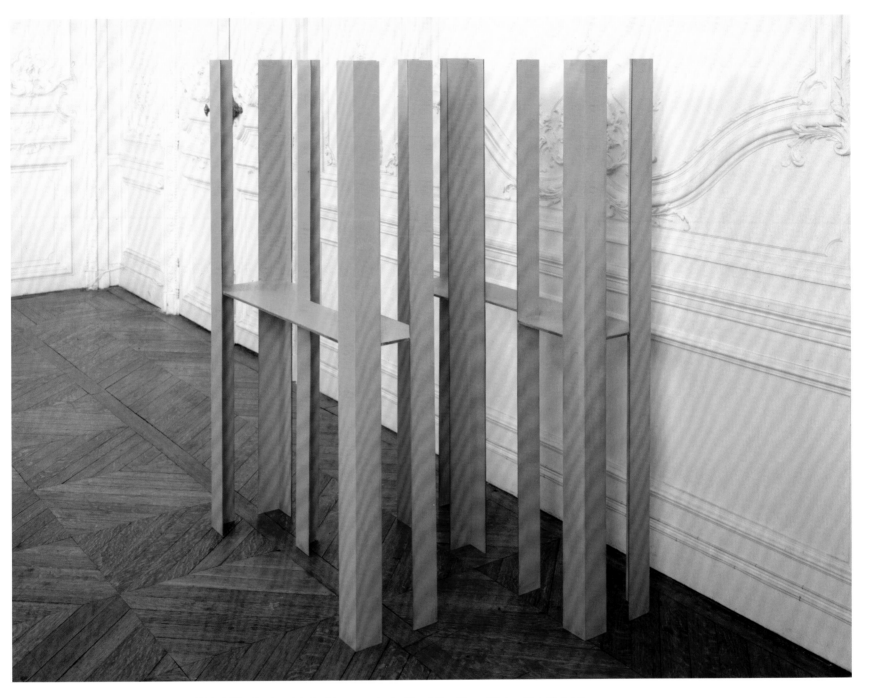

455 Jean-Marc Bustamente, *Consolation 1193*, 1992. Steel painted with orange lead. 90 x 147 x 26 cm (35 ½ x 58 x 10 ¼ in)

Grenville Davey uses industrial materials, such as steel, and the simplicity of his large forms shows an affinity with Minimalism. However, many of his works make reference to everyday objects, such as cans of drink (456), buttons and wing mirrors, which are often alluded to in his titles. Taylor shares similar aims; he has a preference for clear acrylic sheets, and he makes large, simple forms that have the look of household objects. Indeed, the subtitles of his works give a substantial clue, such as *Untitled (Model for a Diving Pool)* (1994) or *Untitled (Double Fridge)* (457). His 'Fridge' sculptures look both at Minimalism and factory mass-production, and have something of the flavour of the department store. But there is also a sense of mystery, because the forms radiate light from within, and there is a blurring between which parts are solids and which are voids.

By the beginning of the 1990s, in art-critical circles, the purity of Minimalism was hotly debated, and this was particularly stimulated by the publication of Harvard art historian Anna Chave's article, 'Minimalism and the Rhetoric of Power', in the American *Arts Magazine* in January 1990. She proposed that Minimalism was overtly masculine, and that as a consequence Minimalist art projects 'society's blankest, steeliest face; the impersonal face of technology, industry and commerce; the unyielding face of the father'.

Minimalist sculptures were said to be non-referential, lacking political, narrative or emotional content; Judd insisted that his work had nothing to do with 'society, the institutions and grand theories'. But in the 1990s, if an artist made a Minimalist object, it had everything to do with society, narrative and emotions. Mona Hatoum's *Quartered* of 1996, for example, an installation of Judd-like steel prison bunks, came with a catalogue text equating its structure with Jeremy Bentham's Panopticon design for a prison.

456 Grenville Davey, *HAL*, 1992. Steel. Two parts, each 244 (96 in) high; 122 cm (48 in) diam.

457 Marcus Taylor, *Untitled (Double Fridge)*, 1991. Acrylic sheet. 152 x 120 x 50 cm (60 x 47 ¼ x 19 ¾ in). The New Art Gallery, Walsall, UK

Rachel Lachowicz makes works that parody the icons of Minimalism created by New York sculptors of the 1960s and 1970s, but they contain a hint of tribute as well. She keeps to the simple geometric forms of the 1960s, but her parody comes through employing female gender-based materials such as lipstick and eye-shadow mixed with wax, applied to sheets of aluminium. Her *Homage to Carl Andre* (458), a configuration of thirty-six square floor tiles, is made from red lipstick and wax.

Two other Los Angeles artists, Jason Meadows and Evan Holloway, belong to the same generation and also create work that combines formal rigour with a wide range of materials. Meadows's pieces have an underlying simple geometry that is then overlaid with extra forms and some surface detailing. He uses sheets of wood and Plexiglas, materials chosen by Judd, but he shapes and interlocks them to call up issues of scale and perspective. His titles are suggestive of narratives, and from some angles his work looks as though it is a skewed representation of something, but then this disappears, leaving only a sense of ambiguity in terms of form and content.

Holloway is unusual in that he takes much of his inspiration from the natural world. *Grayscale* (462) is one of a handful of works that he has made from painted tree branches; having located a suitable tree, he breaks each branch off exactly halfway before the next branch begins, and then reattaches it at a right angle. Metal rods hold the fragile structure rigid, and the whole piece is painted in tones of grey, so that metal and wood look the same. The title refers to the scale that photographers place at the edge of their black and white prints, but could also allude to a significant exhibition in New York in 1964 called 'Black, White and Gray', which was one of the early precursors of Minimalism.

458 Rachel Lachowicz, *Homage to Carl Andre*, 1991-4. Lipstick, wax. 0.5 x 183 x 183 cm [¼ x 72 x 72 in]. Newport Harbor Art Museum, California

459 Carmit Gil, *Bus*, 2002. Aluminium, iron, wood. 3.5 x 2.5 x 12 m (11 ft 5 ¾ in x 8 ft 2 ½ in x 39 ft 4 ½ in)

460 Rachel Harrison, *Bell Tower*, 1999. Wood, wireless doorbell.
254 x 81.3 x 52.1 cm (100 x 32 x 20 ½ in)

Rachel Harrison appeared on the scene at the same time as Lachowicz, but in New York, and she too looks back to the 1960s, merging formal abstraction with a touch of kitsch, a measure of recycling and a sense of fragility. Her *Bell Tower* is a wooden structure, over 9 feet high, painted blue **(460)**. On close inspection one sees that a small plastic doorbell has been set on one of the horizontal members; if pushed, a loud tone rings in the gallery. So the sculpture has a function, but of what kind -- one that disconcerts the viewer?

Werner Feiersinger also disturbs the viewer. His clearly defined geometrical forms contain a small addition that makes them look as though they should be functional, but on further perusal clearly cannot be so. His *Two Old Men* **(461)** is an amalgam of minimal structures with a hint of narrative, which is provided by the title. The two off-white vertical monoliths seemingly cannot stand on their own without an attached, right-angled steel bar, rather like a walking stick. Paired monoliths are found in the work of Tony Smith and Anne Truitt of the early 1960s, but never with cute attachments.

Carmit Gil imbues minimal forms with her own particular flavour, which comes from living in the Middle East. In works such as *Bus* **(459)**, she looks at the structural and formal qualities of an everyday thing, and then strips it down to its barest minimum. The only clue that this work refers to ordinary life is its title, and Gil states that it refers to the buses in her home country, regularly the target of suicide bombers. Its empty, spare and elegant shape becomes rich with social and political content.

Judd predicted in 'Specific Objects' that: 'Since its range is so wide, three-dimensional work will probably divide into a number of forms. At any rate, it will be larger than painting and much larger than sculpture ... Because the nature of three dimensions isn't set, given beforehand, something credible can be made, almost anything.' And his prediction has proved correct. Sculpture today continues to offer a world of endless possibilities.

462 Evan Holloway, *Grayscale*, 2000. Tree branches, paint, metal. 198 x 76 x 254 cm (78 x 30 x 100 in)

461 Werner Feiersinger, *Two Old Men*, 1994. Polyester resin, steel, paint. Each 52 x 53 x 164 cm (20 ½ x 20 ¾ x 64 ½ in)

These biographies are intended to provide the reader with each artist's birth dates, their current place of residence, significant recent solo exhibitions that are accompanied by a catalogue, and their dealers.

ABSALON 1964-1993. Lived and worked Paris, France. Exhibitions: Villa Arson, Nice, France, 1989; Musée d'Art Moderne de la Ville de Paris, Paris, France, 1993; Kunstverein, Hamburg, Germany, 1994; Stichting De Appel, Amsterdam, The Netherlands, 1994; Tel Aviv Museum of Art, Tel Aviv, Israel, 1995; Kunsthalle Zürich, Zurich, Switzerland, 1999; The Galleries at Moore, Philadelphia, USA, 1999. Dealer: Galerie Chantal Crousel, Paris, France

GEORGES ADEAGBO born 1942. Lives Cotonou, Benin and France. Exhibitions: Musée d'Art Moderne de la Ville de Paris, Paris, France, 2000; Villa Medici, Rome, Italy, 2000; PS1 Contemporary Art Center, New York, USA, 2001; Ikon Gallery, Birmingham, UK, 2004. Dealer: Elisabeth Kaufmann, Zurich, Switzerland

JOHN AHEARN born 1951. Lives and works New York, USA. Exhibitions: Contemporary Art Museum, Houston TX, USA, 1991; Baltimore Museum of Art, Baltimore MD, USA, 1993; University Art Gallery, University of California, San Diego CA, USA, 1995; Alexander & Bonin, New York, USA, 2000 and 2001. Dealer: Alexander & Bonin, New York, USA

SUNDAY JACK AKPAN born 1940. Lives and works Ibesiko-Uyo, Nigeria. Exhibitions: Institute for Overseas Relations, Stuttgart, Germany, 1988; Horniman Museum, London, UK, 1999; Contemporanea arti e Culture, Milan, Italy, 2002; Musée d'Art Contemporain, Lyon, France, 2005

JANE ALEXANDER born 1959. Lives and works Cape Town, South Africa. Exhibitions: University of Cape Town, South Africa, 1999; Gasworks, London, UK, 2002; South African National Gallery, Cape Town, South Africa, 2003. Dealer: Linda Goodman Gallery, Johannesburg, South Africa

EDWARD ALLINGTON born 1951. Lives and works London, UK. Exhibitions: Leeds City Art Gallery, Leeds, UK, 1992; Cornerhouse, Manchester, UK, 1993; Stadtische Galerie, Goppingen, Germany, 1993; The British School at Rome, Rome, Italy, 1999; Yorkshire Sculpture Park, Wakefield, UK, 1999; Bury Art Gallery and Museum, Bury, UK, 2003. Dealer: Lisson Gallery, London, UK

DARREN ALMOND born 1971. Lives and works London, UK. Exhibitions: ICA, London, UK, 1997; The Renaissance Society, Chicago, USA, 1999; Kunsthaus Zürich, Zurich, Switzerland, 2001; Alfonsono Artiaco, Naples, Italy, 2005; Knoxville Museum of Art, Knoxville TN, USA, 2006. Dealer: White Cube, London, UK; Matthew Marks, New York, USA

PAVEL ALTHAMER born 1967. Lives and works Warsaw, Poland. Exhibitions: Kunsthalle Basel, Switzerland, 1997; Centre for Contemporary Art, Ujazdowski Castle, Warsaw, Poland, 1998; Museum of Contemporary Art, Chicago, USA, 2001. Dealer: Foksal Gallery, Warsaw, Poland

GHADA AMER born 1963. Lives and works New York, USA. Exhibitions: Villa Arson, Nice, France, 1990; Espace Karim Francis, Cairo, Egypt, 1998; Centro Andalus de Arte Contemporáneo, Seville, Spain, 1999; Institute of Visual Arts, Milwaukee WI, USA, 2000; Tel Aviv Museum of Art, Tel Aviv, Israel, 2000. Dealer: Deitch Projects, New York, USA

JAN ERIK ANDERSSON born 1954. Lives and works Turku, Finland. Exhibitions: The Baby Retrospective, Pori Art Museum, Turku Art Museum, Finland, 1990; Sara Hilden Art Museum, Tampere, Finland, 1993; Sculptor Gallery, Helsinki, Finland, 2003. Dealer: Galerie Regine Lussan, Paris, France; Galleria Allinna, Riihimaki, Finland

CARL ANDRE born 1935. Lives and works New York, USA. Exhibitions: Stadtisches Museum, Mönchengladbach, Germany, 1968; Solomon R. Guggenheim Museum, New York, USA, 1970; Museum of Modern Art, New York, USA, 1973; Kunsthalle, Bern, Switzerland, 1975; Retrospective, Laguna Gloria Art Museum, Austin TX, USA, 1978; Retrospective, Stedelijk Van Abbemuseum, Eindhoven, The Netherlands, 1987; Retrospective, Museum of Modern Art, Oxford, UK, 1996; Retrospective, Musée Cantini,

Marseilles, France, 1997; ACE Gallery, Los Angeles, USA, 2002; Gallery Yamaguchi, Osaka, Japan, 2003; Kunsthalle, Basel, Switzerland, 2005. Dealer: Konrad Fischer Galerie, Dusseldorf, Germany; Paula Cooper, New York, USA; Galerie Tschudi, Glarus, Switzerland

JAMES ANGUS born 1970. Lives and works Sydney, Australia. Exhibitions: 200 Gertrude Street, Melbourne, Australia, 1994; Australian Centre for Contemporary Art, Melbourne, Australia, 2000; Museum of Contemporary Art, Sydney, Australia, 2006. Dealer: Roslyn Oxley9 Gallery, Sydney, Australia; Gavin Brown's Enterprise, New York, USA

GIOVANNI ANSELMO born 1934. Lives and works Turin, Italy. Exhibitions: The Renaissance Society at the University of Chicago, Chicago, USA, 1997; Ikon Gallery, Birmingham, UK, 2001; Museum Kurhaus, Kleve, Germany, 2004; Ikon Gallery, Birmingham, UK, 2005. Dealer: Marion Goodman, New York, USA; Galerie Micheline Szwajcer, Antwerp, Belgium; Galerie Tanit, Munich, Germany

JANINE ANTONI born 1964. Lives and works New York, USA. Exhibitions: Sandra Gering Gallery, New York, USA, 1992; Anthony D'Offay Gallery, London, UK, 1994; Centre of Contemporary Arts, Glasgow, UK, 1995; Whitney Museum of American Art, New York, USA, 1998; Albright-Knox Art Gallery, Buffalo NY, USA, 2004. Dealer: Luhring Augustine Gallery, New York, USA

SIAH ARMAJANI born 1939. Lives and works Minneapolis MN, USA. Exhibitions: Institute of Contemporary Art, Philadelphia, USA, 1985; Kunsthalle, Basel, Switzerland, and Stedelijk Museum, Amsterdam, The Netherlands, 1987; Portikus, Frankfurt, Germany, 1988; Storm King Art Center, Mountainville NY, USA, 1993; Villa Arson, Nice, France, 1994. Dealer: Max Protetch Gallery, New York; Jiri Svestka Gallery, Prague, Czech Republic

ARMAN 1928-2006. Lived and worked Paris, France and New York, USA. Exhibitions: Retrospective, Jeu de Paume, Paris, France, 1998; Museum of Modern Art, Rio de Janiero, Brazil, 1999; Fundació La Caixa, Barcelona, Spain, 2001; Museum of Contemporary Art, Teheran, Iran, 2003; Historical Museum de la Grande Guerre, Peronne, France, 2004. Dealer: Marlborough Gallery, New York, USA; Galerie de Bellefeuille, Quebec, Canada; Marisa del Re Gallery, New York, USA

RICHARD ARTSCHWAGER born 1923. Lives and works New York, USA. Exhibitions: Whitney Museum of American Art, New York, 1988; Centre Georges Pompidou, Paris, France, 1989; The Contemporary Arts Center, Cincinnati, USA, 1998. Dealer: Marion Goodman, New York, USA; Mary Boone Gallery, New York, USA; Galerie Xavier Hufkens, Brussels, Belgium; Gagosian Gallery, New York, USA

MICHAEL ASHER born 1943. Lives and works Los Angeles, USA. Exhibitions: The Art Institute, Chicago, USA, 1979; The Renaissance Society at The University of Chicago, Chicago, USA, 1990; Museum of Modern Art, New York, USA, 1992; The Banff Centre, Alberta, Canada, 1996; Kunstmuseum, Krefeld, Germany, 2001; The Art Institute of Chicago, Chicago, USA, 2005. Dealer: Galerie Roger Pailhas, Marseille, France

MICHAEL ASHKIN born 1955. Lives and works New York, USA. Exhibitions: Peter Miller Gallery, Chicago, USA, 1992; Andrea Rosen Gallery, New York, USA, 1998; Otto Schweins Gallery, Cologne, Germany, 2002. Dealer: Andrea Rosen Gallery, New York, USA

MIROSLAV BALKA born 1958. Lives and works Warsaw, Poland. Exhibitions: Stedelijk Van Abbemuseum, Eindhoven, The Netherlands, 1994; Kunsthalle, Bielefeld, Germany, 1997; IVAM, Valencia, Spain, 1997; National Museum of Art, Osaka, Japan, 2000; Kroller-Muller Museum, Otterlo, The Netherlands, 2001; Dundee Contemporary Arts, Dundee, UK, 2002; Museum of Contemporary Art, Zagreb, Yugoslavia, 2002; Douglas Hyde Gallery, Dublin, Ireland, 2002; Foksal Gallery Foundation, Warsaw, Poland, 2003; Kunstsammlung Nordrhein-Westfalen, Dusseldorf, Germany, 2006. Dealer: Barbara Gladstone Gallery, New York, USA; White Cube, London, UK

STEPHEN BALKENHOL born 1957. Lives and works in Karlsruhe, Germany and Meisenthal, France. Exhibitions: Portikus, Frankfurt, Germany, 1988; Kunsthalle, Hamburg,

Germany, 1992; Witte de With, Rotterdam, The Netherlands, 1992; Neue Nationalgalerie, Berlin, Germany, 1994; Hirshhorn Museum and Sculpture Garden, Washington, DC, USA, 1995; Von der Heydt Museum, Wuppertal, Germany, 1998; Deweer Art Gallery, Otegem, Belgium, 2002; Sprengel Museum, Hanover, Germany, 2003; The National Museum of Art, Osaka, Japan, 2005. Dealer: Barbara Gladstone Gallery, New York, USA; John Berggruen Gallery, San Francisco, USA

LAURA ANDERSON BARBATA born 1958. Lives and works New York, USA. Exhibitions: Museum of Art, Austin TX, USA, 1998; Albright Center for the Arts, Reading PA, USA, 2001; Museo Kiscell, Budapest, Hungary, 2003; Museo de Bellas Artes, Caracas, Venezuela, 2006. Dealer: Galerie Peter Herrmann, Berlin, Germany; Galeria Ramis Barquet, New York, USA

GILLES BARBIER born 1965. Lives and works Paris, France. Exhibitions: Offenes Kulturhuas, Linz, Austria, 1996; Galerie Cokkie Snoei, Rotterdam, The Netherlands, 1997; Espai Lucas, Valencia, Spain, 1999; Henry Art Gallery, University of Washington, Seattle WA, USA, 1999; Musée de L'Abbaye Sainte Croix, Sables d'Olonne, France, 2000. Dealer: Galerie Georges-Phillipe and Nathalie Vallois, Paris, France; Rena Bransten Gallery, San Francisco, USA

LIA MENNA BARRETO born 1959. Lives and works Rio Grande do Sul, Brazil. Exhibitions: Thomas Cohn Arte Contemporanea, Rio de Janiero, Brazil, 1995; Nassauischer Kunstverein, Wiesbaden, Germany, 1998; Museum of Contemporary Art, San Diego CA, USA, 2000. Dealer: Galeria Fortes Vilaca, São Paolo, Brazil

GEORG BASELITZ born 1938. Lives and works Derneburg, Lower Saxony, Germany. Exhibitions: Kunsthalle Zürich, Zurich, Switzerland, 1990; Retrospective, Kunsthalle, Munich, Germany, 1992; Solomon R. Guggenheim Gallery, New York, USA, 1995. Dealer: Pace Wildenstein, New York, USA; Michael Werner Gallery, New York, USA and Cologne, Germany; Gagosian Gallery, New York, USA

DAVID BATCHELOR born 1955. Lives and works London, UK. Exhibitions: Curtain Road Arts, London, UK, 1995; Henry Moore Institute, Leeds, UK, 1997; The Economist Plaza, London, UK, 1998; Anthony Wilkinson Gallery, London, UK, 2000; Ikon Gallery, Birmingham, UK, 2004. Dealer: Anthony Wilkinson, London, UK

LOTHAR BAUMGARTEN born 1944. Lives and works Dusseldorf, Germany and New York, USA. Exhibitions: Solomon R. Guggenheim Museum, New York, USA, 1993; Portikus, Frankfurt, Germany, 1993; Kunsthalle, Hamburg, Germany, 2001; Kurhaus Museum, Kleve, Germany, 2006. Dealer: Marion Goodman, New York, USA

THOMAS BAYRLE born 1937. Lives and works Frankfurt, Germany. Exhibitions: Portikus, Frankfurt, Germany, 1990; Kunsthalle St Gallen, St Gallen, Switzerland, 1996; City Art Museum, Koriyama, Japan, 1997; Museum in Progress, Vienna, Austria, 2000; Kunstverein, Graz, Switzerland, 2002; Galerie Barbara Weiss, Berlin, Germany, 2003; Office for Contemporary Art, Oslo, Norway, 2007. Dealer: Barbara Weiss Gallery, Berlin, Germany

LARRY BELL born 1939. Lives and works Taos NM, USA. Exhibitions: Kiyo Higashi Gallery, Los Angeles, USA, 1999; New Directions Gallery, Taos NM, USA, 2000. Dealer: Bernard Jacobson Gallery, London, UK; Kiyo Higashi Gallery, Los Angeles, USA; Braunstein/Quay Gallery, San Francisco, USA

LUIS BENEDIT born 1937. Lives and works Buenos Aires, Argentina. Exhibitions: Striped House Museum, Tokyo, Japan, 1982; Fundación San Telmo, Buenos Aires, Argentina, 1988; Retrospective, Museo Nacional de Bellas Artes, Buenos Aires, Argentina, 1996. Dealer: Ruth Benzacar Gallery, Buenos Aires, Argentina; Arthus Gallery, Brussels, Belgium

LYNDA BENGLIS born 1941. Lives and works New York and Santa Fe LA, USA. Exhibitions: Gihon Foundation, Sand City CA, USA, 2002; Retrospective, Cheim & Read, New York, USA, 2004. Dealer: Toomey/Tourell, San Francisco, USA; Cheim & Read Gallery, New York, USA

LAUREN BERKOWITZ born 1965. Lives and works Melbourne, Australia. Exhibitions: Karyn Lovegrove Gallery, Melbourne, Australia, 1994; Canberra Contemporary Art Space, Canberra, Australia, 1998; Jewish Museum of Australia, Melbourne, 2002. Dealer: Sherman Galleries, Melbourne, Australia

JOSEPH BEUYS 1921-1986. Lived and worked Dusseldorf, Germany. Exhibitions: Solomon R. Guggenheim Museum, New York, USA, 1979; Kunstsammlung Nordrhein-Westfalen, Dusseldorf, Germany, 1991; Tate Modern, London, UK, 2005; Museum Kunst Palast, Dusseldorf, Kunstmuseum, Bonn, Museum Hamburger Bahnhof, Berlin, Germany, 2006. Dealer: Ronald Feldman Fine Arts, New York, USA; Gagosian Gallery, New York, USA

XU BING born 1955. Lives and works New York, USA. Exhibitions: Elvehjem Museum of Art, Madison WI, USA, 1991; North Dakota Museum of Art, Grand Forks ND, USA, 1992; Bronx Museum of New York, New York, USA, 1994; Arthur M. Sackler Museum of Art, Washington, DC, USA, 2001. Dealer: Ethan Cohen Fine Art, New York, USA

RONALD BLADEN 1918-1988. Lived and worked New York, USA. Exhibitions: San Francisco Museum of Modern Art, San Francisco, USA, 1992; The Weatherspoon Art Gallery, The University of North Carolina, Greensboro NC, USA, 1996; Kunsthalle, Bielefeld, Germany, 1998; PS1 Contemporary Art Center, New York, USA, 1999; Danese Gallery, New York, USA, 2004. Dealer: Danese Gallery, New York, USA

NAYLAND BLAKE born 1960. Lives and works New York, USA. Exhibitions: New Langton Arts, San Francisco, USA, 1985; Center for Contemporary Art, Ujazdowski Castle, Warsaw, Poland, 1992; Contemporary Arts Museum, Houston TX, USA, 1996; Brooklyn Academy of Music, Brooklyn NY, USA, 1997; Tang Museum and Art Gallery, Skidmore College, Saratoga Springs NY, USA, 2003. Dealer: Matthew Marks, New York, USA; Gallery Paule Anglim, San Francisco, USA

CHRISTIAN BOLTANSKI born 1944. Lives and works Paris, France. Exhibitions: Kemper Museum of Contemporary Art, Kansas City MO, USA, 1998; Museum of Fine Arts, Boston, USA, 2000; The Centre for Contemporary Art, Warsaw, Poland, 2001; The Jewish Museum, San Francisco, USA, 2001; South London Art Gallery, London, UK, 2002; Kunsthalle, Hamburg, Germany, 2003; Museo d'Arte Contemporanea, Rome, Italy, 2006. Dealer: Marion Goodman, New York, USA

MONTIEN BOONMA 1953-2000. Lived and worked Bangkok, Thailand. Exhibitions: Retrospective, Asia Society, New York, USA, 2004; National Gallery of Australia, Canberra, Australia, 2004. Dealer: Deitch Projects, New York, USA

JONATHAN BOROFSKY born 1942. Lives and works Venice CA, USA. Exhibitions: Whitney Museum of American Art, New York, USA, 1984; Rose Art Museum, Brandeis University, Waltham MA, USA, 1997; Kunstmuseum, Basel, Switzerland, 1999; Musée Departmental de Gap, Marseilles, France, 2001; Rockfeller Center, New York, USA, 2004. Dealer: Paula Cooper, New York, USA; Rudolf Budja Gallery, Vienna, Austria

LOUISE BOURGEOIS born 1911. Lives and works New York, USA. Exhibitions: Retrospective, The Museum of Modern Art, New York, USA, 1982; Museo de Arte Contemporáneo, Monterrey, Mexico, 1995; Retrospective, Deichtorhallen Hamburg, Hamburg, Germany, 1996; Tate Modern, London, UK, 2000; Contemporary Museum, Baltimore MD, USA, 2006. Dealer: Robert Miller Gallery, New York, USA; Galerie Karsten Greve, Paris, France and Cologne, Germany

BERLINDE DE BRUYCKERE born 1964. Lives and works Ghent, Belgium. Exhibitions: de Brakke Grond, Amsterdam, The Netherlands, 2001; MUKHA, Antwerp, Belgium, 2001; Galleria Continua, San Gimignano, Italy, 2003; Hauser & Wirth, Zurich, Switzerland, 2004; De Pont Museum for Contemporary Art, Tilburg, Switzerland, 2005; DA2 Domus Artium, Salamanca, Spain, 2007. Dealer: de Brakke Grond, Amsterdam, The Netherlands; Galleria Continua, San Gimignano, Italy; Galerie Hauser & Wirth, Zurich, Switzerland

CHRISTOPH BUCHEL born 1966. Lives and works Basel, Switzerland. Exhibitions: TBA Exhibition Space, Chicago, USA, 1998; Kunstmuseum, St Gallen, Switzerland, 2000;

Palace of the People, Bucharest, Romania, 2003. Dealer: Maccarone Inc, New York, USA; Hauser & Wirth, Zurich, Switzerland

LEE BUL born 1964. Lives and works Seoul, South Korea. Exhibitions: New Museum of Contemporary Art, New York, USA, 2002; Centre for Contemporary Art, Glasgow, UK, 2003; Museum of Contemporary Art, Sydney, Australia, 2004. Dealer: IL Gallery, Seoul, South Korea; Galerie Thaddaeus Ropac, Salzburg, Switzerland

CHRIS BURDEN born 1946. Lives and works Topanga CA, USA. Exhibitions: BALTIC Centre for Contemporary Art, Gateshead, UK, 2005; Galerie Krinzinger, Vienna, Austria, 2005; Galleria Massimo de Carlo, Milan, Italy, 2006; South London Gallery, London, UK, 2006. Dealer: Gagosian Gallery, New York, USA; Ronald Feldman Fine Arts, New York, USA

SCOTT BURTON 1939-1989. Lived and worked New York, USA. Exhibitions: Max Protetch, New York, USA, 2000; Wexner Center for the Visual Arts, Columbus OH, USA, 2001; Albion, London, UK, 2006; Berkeley Art Museum, University of California, Berkeley CA, USA, 2007. Dealer: Max Protetch, New York, USA

JEAN-MARC BUSTAMENTE born 1952. Lives and works Paris, France. Exhibitions: Musée d'Art Moderne de la Ville de Paris, Paris, France, 1990; Stedelijk Van Abbemuseum, Eindhoven, The Netherlands, 1992; Kunstmuseum, Wolfsberg, Germany, 1994; New Museum of Art, Lucerne, Switzerland, 2001; Deichtorhallen, Hamburg, Germany, 2001; Centro de Arte, Salamanca, Spain, 2003; Galerie Karlheinz Mayer, Karlsruhe, Germany, 2003. Dealer: Galerie Xavier Hufkens, Brussels, Belgium; Matthew Marks, New York, USA; Galerie Thaddaeus Ropac, Paris, France

JAMES LEE BYARS 1932-1997. Lived and worked Venice, Italy. Exhibitions: IVAM, Valencia, Spain, 1994; Museum of Contemporary Art, Chicago, USA, 1996; Stedelijk Museum, Amsterdam, The Netherlands, 1996; City Art Gallery, Wellington, New Zealand, 1996; Henry Moore Institute, Leeds, UK, 1996; Retrospective, Fundação de Serralves, Porto, Portugal, 1997; Kestner Gesellschaft, Hanover, Germany, 1999; Museum Ludwig, Cologne, Germany, 2001; Centre Georges Pompidou, Paris, France, 2003; Schirn Kunsthalle, Frankfurt, Germany, 2004; Institute of Contemporary Art, Philadelphia, USA, 2004; Whitney Museum of American Art, New York, USA, 2004; Barbican Art Gallery, London, UK, 2005; Baldwin Gallery, Aspen CO, USA, 2005. Dealer: Galerie Michael Werner, Cologne, Germany and New York, USA

PIER PAOLO CALZOLARI born 1943. Lives and works Fossombrone, Italy. Exhibitions: Studio Bocchi, Rome, Italy, 1991; Galerie de France, Paris, France, 2001. Dealer: Studio La Citta, Verona, Italy

LUIS CAMNITZER born 1937. Lives and works New York, USA. Exhibitions: Retrospective, Lehman College Art Gallery, New York, USA, 1991; El Museo del Barrio, New York, USA, 1996. Dealer: Carla Stellweg Gallery, New York, USA

ANTHONY CARO born 1924. Lives and works London, UK. Exhibitions: Tate Gallery, London, UK, 1991; Retrospective, Trajan Market, Rome, Italy, 1992; Retrospective, Museum of Contemporary Art, Tokyo, Japan, 1994; Kettle's Yard Gallery, Cambridge, UK, 1994; Kenwood, London, UK, 1994; Museum of Contemporary Art, Tokyo, Japan, 1995; National Gallery, Athens, Greece, 1996; Venice Biennale, Venice, Italy, 1999; Museo de Bellas Artes, Bilbao, Spain, 2000; Yorkshire Sculpture Park, Wakefield, UK, 2001; Frederik Meijer Sculpture Park, Grand Rapids MI, USA, 2003; Museum of Art, Seoul, South Korea, 2004; Retrospective, Tate Britain, London, UK, 2005. Dealer: Annely Juda Fine Art, London, UK; Mitchell-Innes & Nash, New York, USA

MAURIZIO CATTELAN born 1960. Lives and works New York, USA. Exhibitions: Musée d'Art Moderne de la Ville de Paris, Paris, France, 1994; Secession, Vienna, Austria, 1997; The Museum of Modern Art, New York, USA, 1998; Kunsthalle, Basel, Switzerland, 1998; Migros Museum, Zurich, Switzerland, 2000; Museum Boijmans Van Beuningen, Rotterdam, The Netherlands, 2001; Museum Ludwig, Cologne, Germany, 2001; Museum of Contemporary

Art, Chicago, USA, 2001; Museum of Contemporary Art, Los Angeles, USA, 2003; Musée du Louvre, Paris, 2004. Dealer: Marion Goodman, New York, USA; Massimo de Carlo, Milan, Italy; Emmanuel Perrotin, Paris, France

LORIS CECCHINI born 1969. Lives and works Milan, Italy. Exhibitions: Contemporary Art Centre, Siena, Italy, 1998; Gallego Centre for Contemporary Art, Santiago da Compostela, Spain, 2000. Dealer: Galleria Continua, San Gimignano, Italy

HELEN CHADWICK 1954-1996. Lived and worked London, UK. Exhibitions: ICA, London, UK, 1986; City Museum and Art Gallery, Birmingham, UK, 1987; Museum of Modern Art, Oxford, UK, 1989; Banff Arts Center, Alberta, Canada, 1991; Serpentine Gallery, London, UK, 1994; Folkwang, Essen, Germany, 1994; The Museum of Modern Art, New York, USA, 1995; Retrospective, Barbican Art Gallery, London, UK, 2004; Manchester City Art Gallery, Manchester, UK, 2004. Dealer: Zelda Cheatle, London, UK

JOHN CHAMBERLAIN born 1927. Lives and works Shelter Island, New York, USA. Exhibitions: Staatliche Kunsthalle, Baden-Baden, Germany, 1991; Dia Center for the Arts, New York, USA, 1991. Dealer: Waddington, London, UK; Pace Wildenstein, New York, USA

JAKE and **DINOS CHAPMAN** born 1962, born 1966. Live and work London, UK. Exhibitions: Institute of Contemporary Arts, London, UK, 1996; Gagosian Gallery, New York, 1997; Tate, Liverpool, UK, 2007. Dealer: White Cube, London, UK; Gagosian Gallery, New York, USA; Galerie Daniel Templon, Paris, France

DALE CHIHULY born 1941. Lives and works Seattle WA, USA. Exhibitions: Seattle Art Museum, Seattle WA, USA, 1992; Tower of David Museum, Jerusalem, Israel, 2000; Garfield Park Conservatory, Chicago, USA, 2001; Racine Art Museum, Hamilton NJ, USA, 2002; Tacoma Art Museum, Tacoma WA, USA, 2003; Kew Gardens, London, UK, 2005. Dealer: Marlborough Gallery, New York, USA

EDUARDO CHILLIDA 1924-2002. Lived and worked Zabalaga, Spain. Exhibitions: Retrospective, Hayward Gallery, London, UK, 1990; Retrospective, Martin-Gropius-Bau, Berlin, Germany, 1991; Retrospective, Royal Palace, San Sebastian, Spain, 1992; Retrospective, Schirn Kunsthalle, Frankfurt, 1996; Museo Nacional Centro de Arte Reina Sofia, Madrid, Spain, 1998; Yorkshire Sculpture Park, Wakefield, UK, 2004. Dealer: Galeria Colon XVI, Bilbao, Spain

MEL CHIN born 1951. Lives and works North Carolina, USA. Exhibitions: Menil Collection, Houston TX, USA, 1991; Colorado State University, Fort Collins CO, USA, 1995; Station Museum of Contemporary Art, Houston TX, USA, 2006. Dealer: Frederieke Taylor Gallery, New York, USA

CHOI JEONG HWA born 1961. Lives and works Seoul, South Korea. Exhibitions: Asia Society, Grey Art Gallery, New York, USA, 1996; Wolverhampton Art Gallery, Wolverhampton, UK, 2007. Dealer: Galerie 02, Paris, France; Galerie Jean-Luc & Takako Richard, Paris, France

WILLIE COLE born 1955. Lives and works New York, USA. Exhibitions: University of Wyoming Art Museum, Laramie WY, USA, 2005; Sheldon Memorial Art Gallery, Lincoln NE, USA, 2006. Dealer: Alexander and Bonin, New York, USA

NATHAN COLEY born 1967. Lives and works Dundee, UK. Exhibitions: Galerie Rudiger Schottle, Munich, Germany, 2000; The Fruitmarket Gallery, Edinburgh, UK, 2004; Haunch of Venison, London, UK, 2005; Mount Stuart, Isle of Bute, UK, 2006. Dealer: Doggerfisher, Edinburgh, UK; Haunch of Venison, London, UK

NICOLA COSTANTINO born 1964. Lives and works Buenos Aires, Argentina. Exhibitions: Galeria Ruth Benzacar, Buenos Aires, Argentina, 1999; Museum of Fine Arts, Buenos Aires, Argentina, 2000; Miro Foundation, Barcelona, Spain, 2000. Dealer: Galerie de Arte, Buenos Aires, Argentina; Galeria Animal, Santiago, Chile

STEPHEN COX born 1946. Lives and works Shropshire, UK. Exhibitions: Museum of Egyptian Modern Art, Cairo, Egypt, 1994; Henry Moore Institute, Leeds, UK, 1995; Dulwich Picture Gallery, London, UK, 1997; Jesus College,

Cambridge, UK, 1999; Bristol City Museum & Art Gallery, Bristol, UK, 2006

LIZ CRAFT born 1970. Lives and works Los Angeles, USA. Exhibitions: Centrum für Gegenwartskunst Oberosterreich, Linz, Austria, 2001; Public Art Fund, New York, USA, 2002; Halle für Kunst, Luneberg, Germany, 2006. Dealer: Sadie Coles HQ, London, UK; Marianne Boesky Gallery, New York, USA

TONY CRAGG born 1949. Lives and works Wuppertal, Germany. Exhibitions: Museum of Contemporary Art, Rome, Italy, 2003; Museu Serralves, Porto, Portugal, 2004; The Central House of Artists, Moscow, Russia, 2005; Neues Museum, Nuremberg, Germany, 2006. Dealer: Lisson Gallery, London, UK; Galerie Thaddaeus Ropac, Paris, France; Konrad Fischer Galerie, Dusseldorf, Germany

MEG CRANSTON born 1960. Lives and works Venice CA, USA. Exhibitions: Carnegie Museum of Art, Pittsburgh PA, USA, 1993; Witte de Witte Center for Contemporary Art, Rotterdam, The Netherlands, 1998. Dealer: Galerie Kapinos, Berlin, Germany; 1301PE, Los Angeles, USA; Galerie Praz-Delavallade, Paris, France; Rosamun Felsen Gallery, Santa Monica CA, USA

MARTIN CREED born 1968. Lives and works London, UK. Exhibitions: Southampton Art Gallery, Southampton, UK, 2000; Camden Arts Centre, London, UK, 2001; Kunsthalle, Bern, Switzerland, 2003; Johnen Galerie, Berlin, Germany, 2004; Galerie Rudiger Schottle, Munich, Germany 2005; Hauser & Wirth, Zurich, Switzerland 2006. Dealer: Cabinet Gallery, London, UK; Johnen + Schottle, Cologne, Germany; Gavin Brown's Enterprise, New York, USA

JAMES CROAK born 1951. Lives and works New York, USA. Exhibitions: Hudson River Museum, New York, USA, 1989; Survey Show, Contemporary Art Center of Virginia, Virginia Beach VA, USA, 1999. Dealer: Stux Gallery, New York, USA; Galerie de la Tour, Amsterdam, The Netherlands

BRYAN CROCKETT born 1970. Lives and works Brooklyn NY, USA. Exhibitions: Fotouhi Cramer Gallery, New York, USA, 2001; Lehmann Maupin, New York, USA, 2002. Dealer: Lehmann Maupin, New York, USA

DOROTHY CROSS born 1956. Lives and works Dublin, Ireland. Exhibitions: Camden Arts Centre, London, UK, 1993; Arnolfini Gallery, Bristol, UK, 1996; Museum of Contemporary Art, Taipei, Japan, 2002; Irish Museum of Modern Art, Dublin, Ireland, 2005. Dealer: Kerlin Gallery, Dublin, Ireland

ABRAHAM CRUZVILLEGAS born 1968. Lives and works Mexico City, Mexico. Exhibitions: Foundation for Contemporary Art, Mexico City, Mexico, 1993; Contemporary Arts Museum, Houston TX, USA, 2003. Dealer: Kurimanzutto, Mexico City, Mexico; Jack Tilton Gallery, New York, USA

ALEXANDRE DA CUNHA born 1969. Lives and works London, UK. Exhibitions: Galeria Luisa Strina, São Paolo, Brazil, 2002; Museu du Arte da Pamphula, Belo Horizonte, Brazil, 2005. Dealer: Galeria Luisa Strina, São Paolo, Brazil; Vilma Gold, London, UK; Jack Tilton Gallery, New York, USA

ZHANG DALI born 1963. Lives and works Beijing, China. Exhibitions: Courtyard Gallery, Beijing, China, 1999; Chinese Contemporary, London, UK, 2002. Dealer: Chinese Contemporary, Beijing, China; Base Gallery, Tokyo, Japan

JOSE DAMASCENO born 1968. Lives and works Rio de Janiero, Brazil. Exhibitions: Centro de Artes Calouste Gulbenkian, Lisbon, Portugal, 1994; Centro Cultural, São Paolo, Brazil, 2001; Culturgest, Porto, Portugal, 2003; Museu de Arte Moderna, São Paolo, Brazil, 2005; Museum of Contemporary Art, Chicago, USA, 2005. Dealer: Galeria Fortes Vilaca, São Paolo, Brazil; Thomas Dane Gallery, London, UK

GRENVILLE DAVEY born 1961. Lives and works London, UK. Exhibitions: Chisenhale Gallery, London, UK, 1992; Kunsthallen Brandts, Odense, Denmark, 2003. Dealer: Lisson Gallery, London, UK; Galleria Lia Rumma, Naples, Italy

JOHN DAVIES born 1946. Lives and works London, UK. Exhibitions: Whitworth Art Gallery, Manchester, UK, 1996; University Art Gallery, Newcastle-upon-Tyne, UK, 1999;

Museo de Bellas Artes de Bilbao, Bilbao, and Institut Valencia d'Art Modern, Valencia, Spain, 2004-2005. Dealer: Marlborough Fine Art, London, UK

E.V. DAY born 1967. Lives and works New York, USA. Exhibitions: Whitney Museum of American Art, New York, USA, 2001; Santa Barbara Contemporary Arts Forum, Santa Barbara CA, USA, 2006. Dealer: Deitch Projects, New York, USA; Galerie Hans Mayer, Dusseldorf, Germany

RICHARD DEACON born 1949. Lives and works London, UK. Exhibitions: SCAI the Bathhouse, Tokyo, Japan, 1998; Dundee Contemporary Arts, Dundee, UK, 2001; PS1 Contemporary Art Center, New York, USA, 2001; Museum Ludwig, Cologne, Germany, 2003; Louisiana Museum of Modern Art, Humlebaek, Denmark, 2004; Tate, St Ives, UK, 2005. Dealer: Lisson Gallery, London, UK; Marian Goodman Gallery, New York, USA; Galerie von Bartha, Basel, Switzerland; Galerie Thaddeus Ropac, Paris; SCAI the Bathhouse, Tokyo, Japan

JOHN DE ANDREA born 1941. Lives and works New York, USA. Exhibitions: Retrospective, Kunsthaus, Vienna, Austria, 1994; Denver Art Museum, Denver CO, USA, 1996. Dealer: O K Harris, New York, USA

WIM DELVOYE born 1965. Lives and works Ghent, Belgium and London, UK. Exhibitions: Castello di Rivoli, Turin, Italy, 1991; Open Air Museum of Sculpture, Middleheim, Belgium, 1997; MUKHA, Antwerp, Belgium, 2000; Migros Museum, Zurich, Switzerland, 2001; Manchester City Art Gallery, Manchester, UK, 2002; Centre for Contemporary Art Luigi Pecci, Prato, Italy, 2003. Dealer: Galerie Micheline Szwajcer, Antwerp, Belgium; Sperone Westwater, New York, USA

ROB DE MAR born 1965. Lives and works New York, USA. Exhibitions: The Vermont Studio Center, Johnson VT, USA, 1997; Skowhegan School of Sculpture & Painting, Skowhegan ME, USA, 1998; PS.122, New York, USA, 2002. Dealer: Clementine Gallery, New York, USA; Inman Gallery, Houston TX, USA

WALTER DE MARIA born 1935. Lives and works New York, USA. Exhibitions: Museum für Moderne Kunst, Frankfurt, Germany, 1991; Kunsthaus Zürich, Zurich, Switzerland, 1999; Fondazione Prada, Milan, Italy, 1999. Dealer: Gagosian Gallery, New York, USA

AGNES DENES born 1931. Lives and works New York, USA. Exhibitions: Retrospective, Herbert F. Johnson Museum, Cornell University, Ithaca NY, USA, 1992. Dealer: Joyce Goldstein Gallery, New York, USA

DONNA DENNIS born 1942. Lives and works New York, USA. Exhibitions: Sculpture Center, New York, USA, 1993; Holly Solomon Gallery, New York, USA, 1998; Dayton Art Institute, Dayton OH, USA, 2003. Dealer: Shark's Ink, Lyons CO

ISABEL DE OBALDIA born 1957. Lives and works Panama. Exhibitions: Museo de Arte Contemporáneo, Ancon, Panama, 1993; Centro Wifredo Lam, Havana, Cuba, 1995. Dealer: Galeria Arteconsult, Panama; Mary-Anne Martin Fine Art, New York, USA

BRACO DIMITRIJEVIC born 1948. Lives and works Paris, France. Exhibitions: Tate Britain, London, UK, 1985; Museum Moderner Kunst-Stiftung Ludwig, Vienna, Austria, 1994; The Israel Museum, Jerusalem, Israel, 1994; Hessishes Landesmuseum, Dusseldorf, Germany, 1995; Kunsthalle, Dusseldorf, 1997; Pori Art Museum, Pori, Finland, 2000; Ikon Gallery, Birmingham, UK, 2001; State Russian Museum, St Petersburg, Russia, 2005; Fondazione Mudima, Milan, Italy, 2005. Dealer: Galerie de Paris, Paris, France; Pat Hearn Gallery, New York, USA

MARK DION born 1961. Lives and works Beach Lake PA, USA. Exhibitions: Wexner Center for the Arts, Columbus OH, USA, 1998; Tate, London, UK, 1999; The Museum of Modern Art, New York, USA, 1999; The Smart Museum of Art, University of Chicago, Chicago, USA, 2000; Stadtische Galerie, Karlsruhe, Germany, 2000; Frederick R. Weisman Art Museum, Minneapolis MN, USA, 2001. Dealer: Tanya Bonakdar, New York, USA; Georg Kargl, Vienna, Austria; Galerie Christian Nagel, Cologne, Germany

MARTIN DISLER 1949-1996. Lived and worked Geneva, Switzerland. Exhibitions: Museum Folkwang, Essen, Germany, 1985; Retrospective, Kunsthalle, Emden, Germany, 1995; Retrospective, Kunsthaus, Aargauer, Switzerland, 2006. Dealer: Galerie Karl Pfefferle, Munich, Germany; Galerie Elizabeth Kaufmann, Zurich, Switzerland

IRAN DO ESPIRITO SANTO born 1973. Lives and works São Paolo, Brazil. Exhibitions: Irish Museum of Modern Art, Dublin, Ireland, 2006. Dealer: Sean Kelly, New York, USA; Galeria Fortes Vilaca, São Paolo, Brazil

CHRISTINA DOLL born 1972. Lives and works Cologne and Meissen, Germany. Exhibitions: Forderkoje Art, Cologne, Germany, 2000. Dealer: Galerie Michael Janssen, Cologne and Berlin, Germany

HERI DONO born 1960. Lives and works Yogyakarta, Indonesia. Exhibitions: Museum für Volkerkunde, Basel, Switzerland, 1991; Canberra Contemporary Art Space, Canberra, Australia, 1993; Museum of Modern Art, Oxford, UK, 1996; Walsh Gallery, Chicago, USA, 2006. Dealer: Base Gallery, Tokyo, Japan; Gajah Gallery, Singapore, Asia

LEONARDO DREW born 1961. Lives and works New York, USA. Exhibitions: Museum of Contemporary Art, San Diego CA, USA, 1995; St Louis Art Museum, St Louis MO, USA, 1996; Hirshhorn Museum and Sculpture Garden, Washington, DC, USA, 2000; The Fabric Workshop, Philadelphia, USA, 2002; Palazzo Delle Papesse, Siena, Italy, 2006. Dealer: Mary Boone, New York, USA; Sikkemajenkinsco, New York, USA

ORSOLYA DROZDIK born 1948. Lives and works Budapest, Hungary and New York, USA. Exhibitions: Retrospective, Ludwig Museum, Budapest, 2001; Budapest Gallery, Budapest, 2007. Dealer: Hans Knoll Galerie, Vienna, Austria; APA Gallery, Budapest, Hungary

MARCEL DUCHAMP 1887-1968. Lived and worked in Paris, France and New York, USA. Exhibitions: Arts Club of Chicago, Chicago, USA, 1937; Tate Gallery, London, UK, 1966; Philadelphia Museum of Art, Philadelphia, USA, 1973; Musée National d'Art Moderne, Paris, France, 1977; Fundació Joan Miro, Barcelona, Spain, 1984; Philadelphia Museum of Art, Philadelphia, USA, 1987; Palazzo Grassi, Venice, Italy, 1993

SAM DURANT born 1961. Lives and works Los Angeles, USA. Exhibitions: Kapinos, Berlin, Germany, 1999; Tomio Koyama Gallery, Tokyo, Japan, 2000; Museum of Contemporary Art, Los Angeles, USA, 2002; Kunstverein, Dusseldorf, Germany, 2003; Govett-Brewster Art Gallery, New Plymouth, New Zealand, 2003; Massachusetts College of Art, Boston, USA, 2006. Dealer: Blum & Poe, Santa Monica CA, USA; Paula Cooper Gallery, New York, USA

JIMMIE DURHAM born 1940. Lives and works Berlin, Germany. Exhibitions: Palais des Beaux-Arts, Brussels, Belgium, 1993; Módulo Centro Difusor de Arte, Lisbon, Portugal, 1995; The Banff Centre, Banff, Canada, 2005; Cornerhouse Gallery, Manchester, UK, 2006. Dealer: Galerie Micheline Szwajcer, Antwerp, Belgium

MIKALA DWYER born 1959. Lives and works Sydney, Australia. Exhibitions: Australian Centre of Contemporary Art, Melbourne, Australia, 1995; Museum of Contemporary Art, Sydney, Australia, 2000; Chapter Arts Centre, Cardiff, UK, 2000; National Gallery of Australia, Canberra, Australia, 2002. Dealer: Sarah Cottier Gallery, Sydney, Australia; Anna Schwartz Gallery, Melbourne, Australia

KEITH EDMIER born 1967. Lives and works New York, USA. Exhibitions: University of South Florida Contemporary Art Museum, Tampa FL, USA, 1997; Douglas Hyde Gallery, Dublin, Ireland, 1998. Dealer: Sadie Coles HQ, London, UK; Friedrich Petzel Gallery, New York, USA; Neugerriemschneider, Berlin, Germany

OLAFÜR ELIASSON born 1967. Lives and works Berlin, Germany. Exhibitions: Malmo Museum, Malmo, Sweden, 1996; Kunsthalle, Basel, Switzerland, 1997; Galerie für Zeitgenössische Kunst, Leipzig, Germany, 1998; Dundee Contemporary Arts, Dundee, UK, 1999; Kunstverein, Wolfsburg, Germany, 1999; The Art Institute of Chicago, Chicago, USA, 2000; Saint Louis Art Museum,

St Louis MO, USA, 2000; Tate Modern, London, UK, 2004. Dealer: Tanya Bonakdar, New York, USA; Neugerriemschneider, Berlin, Germany

MICHAEL ELMGREEN and **INGAR DRAGSET** born 1961, born 1969. Live and work Berlin, Germany. Exhibitions: Reykjavik Art Museum, Reykjavik, Iceland, 1998; Galerie für Zeitgenössische Kunst, Leipzig, Germany, 2000; Statens Museum für Kunst, Copenhagen, Denmark, 2001; Fondacio La Caixa, Barcelona, Spain, 2002; Tate Modern, London, UK, 2004; Serpentine Gallery, London, UK, 2006. Dealer: Galerie Helga Aldevar, Madrid, Spain

TRACEY EMIN born 1963. Lives and works London, UK. Exhibitions: White Cube, London, UK, 1994; Neues Museum Weserburg, Bremen, Germany, 1997; Moo Gallery, Helsinki, Finland, 1997; Sagacho Exhibition Space, Tokyo, Japan, 1998; Gesellschaft für Aktuelle Kunst, Bremen, Germany, 1998; Cornerhouse Gallery, Manchester, UK, 2000; Haus der Kunst, Munich, Germany, 2002; Stedelijk Museum, Amsterdam, The Netherlands, 2002; Art Gallery of New South Wales, Sydney, Australia, 2003; Contemporary Art Center, Istanbul, Turkey, 2004. Dealer: White Cube, London, UK; Lehmann Maupin, New York, USA

AYSE ERKMEN born 1949. Lives and works Istanbul, Turkey and Berlin, Germany. Exhibitions: Museum Fredericianum, Kassel, Germany, 1999; Secession Gallery, Vienna, Austria, 2002; Kunstmuseum St Gallen, St Gallen, Switzerland, 2003; Schirn Kunsthalle, Frankfurt, Germany, 2004; Ikon Gallery, Birmingham, UK, 2005. Dealer: Macka Sanat Gallery, Istanbul, Turkey; Galerie Barbara Weiss, Berlin, Germany

JAN FABRE born 1958. Lives and works Antwerp, Belgium. Exhibitions: Schirn Kunsthalle, Frankfurt, Germany, 1991; Museo Pecci, Prato, Italy, 1994; Ludwig Museum, Budapest, Hungary, 1996; Arnolfini Gallery, Bristol, UK, 1997; Museum of Contemporary Art, Warsaw, Poland, 1999; The Natural History Museum, London, UK, 2000; Stedelijk Museum, Ghent, Belgium, 2002; Musée d'Art Contemporain, Lyon, France, 2004. Dealer: Deweer Art Gallery, Otegem, Belgium; Galerie Daniel Templon, Paris, France

LUCIANO FABRO born 1936. Lives and works Milan, Italy. Exhibitions: Retrospective, Museum of Modern Art, San Francisco, USA, 1993; Portikus, Frankfurt, Germany, 1995; Centre Georges Pompidou, Paris, France, 1996; Castello di Rivoli, Turin, Italy, 1998. Dealer: Barbara Gladstone, New York, USA; Simon Lee, London, UK

VINCENT FECTEAU born 1969. Lives and works San Francisco, USA. Exhibitions: Berkeley Art Museum, Berkeley CA, USA, 2002; Van Abbemuseum, Eindhoven, The Netherlands, 2004. Dealer: Gallery Paule Anglim, Los Angeles, USA; Greengrassi, London, UK; Galerie Daniel Buchholz, Cologne, Germany

TONY FEHER born 1956. Lives and works New York, USA. Exhibitions: Worcester Art Museum, Worcester MA, USA, 2002; The Chinati Foundation, Marfa TX, USA, 2005. Dealer: D'Amelio Terras Gallery, New York, USA; Anthony Meier Fine Arts, San Francisco, USA

WERNER FEIERSINGER born 1966. Lives and works Vienna, Austria. Exhibitions: Galerie Annick Ketele, Antwerp, Belgium, 1993; Galerie Martin Janda, Vienna, Austria, 2005. Dealer: Galerie Martin Janda, Vienna, Austria

KEN FEINGOLD born 1952. Lives and works Los Angeles, USA. Exhibitions: Grossman Gallery, Museum of Fine Arts, Boston, USA, 2004; ACE Gallery, Los Angeles, USA, 2005. Dealer: Postmasters Gallery, New York, USA

CARLEE FERNANDEZ born 1974. Lives and works Los Angeles, USA. Exhibitions: Henry Duarte, Los Angeles, USA, 2000; Acuna-Hansen, Los Angeles, USA, 2002. Dealer: Acuna-Hansen, Los Angeles, USA

IAN HAMILTON FINLAY 1925-2006. Lived and worked Dunsyre, Lanarkshire, UK. Exhibitions: Landesmuseum, Mainz, Germany, 1998; Joan Miro Foundation, Barcelona, Spain, 1999; Scottish National Gallery of Modern Art, Edinburgh, UK, 2001; Tate, St Ives, UK, 2002; The Arts Club of Chicago, Chicago, USA, 2004; Royal Botanic Garden, Edinburgh, UK, 2005. Dealer: Victoria Miro, London, UK; Ingleby Gallery, Edinburgh, UK

URS FISCHER born 1973. Lives and works Zurich, Switzerland. Exhibitions: Institute of Contemporary Arts, London, UK, 2000; Santa Monica Museum, Los Angeles, USA, 2002; Kunsthaus Zürich, Zurich, Switzerland, 2004; Fondazione Nicola Trussardi, Milan, Italy, 2005; Camden Arts Centre, London, UK, 2005. Dealer: Sadie Coles HQ, London, UK; Gavin Brown's Enterprise, New York, USA

ERIC FISCHL born 1948. Lives and works New York, USA. Exhibitions: Louisiana Museum of Modern Art, Humlebaek, Denmark, 1991; Museum für Moderne Kunst, Frankfurt, Germany, 1999; Kunsthalle, Mannheim, Germany, 2003; Museum Wolfsburg, Wolfsburg, Germany, 2004; Delaware Center for the Contemporary Arts, Wilmington DE, USA, 2006. Dealer: Mary Boone, New York, USA; Gagosian Gallery, New York, USA

PETER FISCHLI and **DAVID WEISS** born 1952, born 1946. Live and work in Zurich, Switzerland. Exhibitions: Centre Georges Pompidou, Paris, 1992; Walker Art Center, Minneapolis MN, USA, 1996; Kunsthaus Zürich, Zurich, Switzerland, 1997; Museum of Modern Art, San Francisco, USA, 1998; Tate Modern, London, UK, 2006; Swiss Institute, New York, USA, 2007. Dealer: Pace Wildenstein, New York, USA; Matthew Marks, New York, USA; Sprüth Magers, Cologne, Munich and London

DAN FLAVIN 1933-1996. Lived and worked New York, USA. Exhibitions: The Museum of Contemporary Art, Chicago, USA, 1989; Fundación Proa, Buenos Aires, Argentina, 1998; Solomon R. Guggenheim Museum, New York, USA, 1999; Serpentine Gallery, London, UK, 2001; Retrospective Tour 2005-7, started at National Gallery of Art, Washington, DC, USA. Dealer: Pace Wildenstein, New York, USA

SYLVIE FLEURY born 1961. Lives and works Geneva, Switzerland. Exhibitions: Migros Museum, Zurich, Switzerland, 1998; Villa Merkel, Galerie der Stadt Esslingen, Esslingen, Germany, 1999; Moderna Museet, Stockholm, Sweden, 2000; Museum für neue Kunst, Karlsruhe, Germany, 2001. Dealer: Monika Spruth, Cologne, Germany; Hauser & Wirth & Presenhuber, Zurich, Switzerland; Chouakri brahms, Berlin, Germany

LAURA FORD born 1961. Lives and works London, UK. Exhibitions: Spacex Gallery, Exeter, UK, 1996; Camden Arts Centre, London, UK, 1998; Salamanca Centre of Contemporary Art, Salamanca, Spain, 2002; De La Warr Pavilion, Bexhill-on-Sea, UK, 2002; Aberystwyth Arts Centre, Aberystwyth, UK, 2003. Dealer: Houldsworth Fine Art, London, UK

TOM FRIEDMAN born 1965. Lives and works Northampton MA, USA. Exhibitions: Stephen Friedman, London, UK, 1998; Galeria Foksal, Warsaw, Poland, 1999; Museum of Contemporary Art, Chicago, USA, 2000; Stedelijk voor Actuele Kunst, Ghent, Belgium, 2001. Dealer: Feature Inc, New York, USA; Stephen Friedman, London, UK; Tomio Koyama Gallery, Tokyo, Japan

KATHARINA FRITSCH born 1956. Lives and works Dusseldorf, Germany. Exhibitions: Dia Center for the Arts, New York, USA, 1993; Museum of Modern Art, San Francisco, USA, 1996; Museum für Gegenwartskunst, Basel, Switzerland, 1997; Kunsthalle, Dusseldorf, Germany, 1999; Museum of Contemporary Art, Chicago, USA, 2001; Tate Modern, London, UK, 2002. Dealer: Matthew Marks, New York, USA; White Cube, London, UK

KATSURA FUNAKOSHI born 1951. Lives and works Tokyo, Japan. Exhibitions: Andre Emmerich Gallery, New York, USA, 1995; Hiroshima Museum of Contemporary Art, Hiroshima, Japan, 2004. Dealer: Annely Juda Fine Art, London, UK; Galerie Michael Hass, Berlin, Germany

GIUSEPPE GABALLONE born 1973. Lives and works Milan, Italy. Exhibitions: Musée d'Art Moderne de la Ville de Paris, Paris, France, 1997; FRAC Limousin, Limoges, France, 1999; Castello di Rivoli, Turin, Italy, 2000; Witte de With Centre for Contemporary Art, Rotterdam, The Netherlands, 2001; Hara Museum, Tokyo, Japan 2001; Museum of Contemporary Art, Chicago, USA, 2002. Dealer: Greengrassi, London, UK

ANYA GALLACCIO born 1963. Lives and works London, UK. Exhibitions: Lanarkshire House, Glasgow, UK, 1999; Kunsthalle, Bern, Switzerland, 2000; Tate Britain, London, UK, 2002; Ikon Gallery, Birmingham, UK, 2003; Palazzo delle Papesse, Siena, Italy, 2005; Sculpture Centre, New York, USA, 2006. Dealer: Stephen Friedman, London, UK; Thomas Dane, London, UK; Lehmann Maupin, New York, USA

CARLOS GARAICOA born 1967. Lives and works Havana, Cuba. Exhibitions: Kulturhuset Toldkammeret, Helsingborg, Sweden, 2000; Sonsbeek, Arnhem, The Netherlands, 2001; Fundació La Caixa, Barcelona, Spain, 2003; Palazzo delle Papesse, Siena, Italy, 2004; Yorkshire Sculpture Park, Wakefield, UK, 2006. Dealer: Galleria Continua, San Gimignano, Italy; Lombard-Freid Fine Arts, New York, USA

GUIDO GEELEN born 1961. Lives and works Tilburg, The Netherlands. Exhibitions: Stedelijk Museum, Gouda, The Netherlands, 1994; De Pont Museum for Contemporary Art, Tilburg, The Netherlands, 1996; Ecole des Beaux-Arts, Valenciennes, France, 2000; Stedelijk Museum, Amsterdam, The Netherlands, 2000. Dealer: Galerie Rob Jurka, Amsterdam, The Netherlands; Paul Andriesse Gallery, Amsterdam, The Netherlands

ISA GENZKEN born 1948. Lives and works Berlin, Germany. Exhibitions: The Renaissance Society at the University of Chicago, Chicago, USA, 1992; Lenbachhuas, Munich, Germany, 1993; Generali Foundation, Vienna, Austria, 1996; INIT Kunsthalle, Berlin, Germany, 1998; Kunstverein, Frankfurt, Germany, 2000; Kunsthalle Zürich, Zurich, Switzerland, 2003; Camden Arts Centre, London, UK, 2005; Secession, Vienna, 2006. Dealer: Lucas Schoormans Gallery, New York, USA; Hauser & Wirth, Zurich, Switzerland

JOCHEN GERZ and **ESTHER SHALEV-GERZ** born 1940, born 1940. Live and work Paris, France. Exhibitions: Cornerhouse, Manchester, UK, 1992; Vancouver Art Gallery, Vancouver, Canada, 1994; Gallery of Contemporary Art, Warsaw, Poland, 1995; Kunstmuseum, Dusseldorf, Germany, 1997; Bolzano Museum, Bolzano, Italy, 1999; Centre Georges Pompidou, Paris, France, 2002; Akademie der Kunste, Berlin, Germany, 2004. Dealer: Galerie Anselm Dreher, Berlin, Germany

CARMIT GIL born 1976. Lives and works Tel Aviv, Israel. Exhibitions: Galerie Frank Elbaz, Paris, France, 2004 and 2005. Dealer: Galerie Frank Elbaz, Paris, France

SIMRYN GILL born 1959. Lives and works Sydney, Australia. Exhibitions: Kiasma Museum of Contemporary Art, Helsinki, Finland, 1998; Bluecoat Gallery, Liverpool, UK, 1999; Ikon Gallery, Birmingham, UK, 2000; Galeri Petronas, Kuala Lumpur, Malaysia, 2001; Art Gallery of New South Wales, Sydney, Australia, 2002. Dealer: Roslyn Oxley9 Gallery, Sydney, Australia

ROBERT GOBER born 1954. Lives and works New York, USA. Exhibitions: Dia Center for the Arts, New York, USA, 1992; Serpentine Gallery, London, UK, 1993; Museum für Gegenwartskunst, Basel, Switzerland, 1995; The Museum of Contemporary Art, Los Angeles, USA, 1997; Walker Art Center, Minneapolis MN, USA, 1999; Retrospective, Schaulager, Basel, Switzerland, 2007. Dealer: Matthew Marks, New York, USA

ANDY GOLDSWORTHY born 1956. Lives and works Cumbria, UK. Exhibitions: The Natural History Museum, London, UK, 1989; Retrospective, Leeds City Art Gallery, Leeds, UK, 1990 + tour; Setagaya Art Museum, Tokyo, Japan, 1994; Aspen Art Museum, Aspen CO, USA, 1995; Anchorage Museum of Art, Anchorage AK, 1996; Scottish National Gallery of Modern Art, Edinburgh, UK, 1998; Barbican Centre, London, UK, 2000; Museum of Contemporary Art, San Diego CA, USA, 2003; National Gallery of Art, Washington, DC, USA, 2005; Yorkshire Sculpture Park, Wakefield, UK, 2007. Dealer: Michael Hue-Williams, London, UK; Galerie Lelong, New York and Paris

FERNANDA GOMES born 1960. Lives and works Rio de Janiero, Brazil. Exhibitions: Ursula Blickle Stiftung, Kraichtal, Germany, 2000; Adam Art Gallery, Wellington, New Zealand, 2002; Museo de Arte Contemporáneo Español, Valladolid, Spain, 2005; Museu Serralves, Porto, Portugal, 2006. Dealer: Baumgartner Gallery, New York, USA; Galeria Luisa Strina, São Paolo, Brazil

STEVEN GONTARSKI born 1972. Lives and works London, UK. Exhibitions: White Cube, London, UK, 2000; Le consortium, Dijon, France, 2003; Gandy Gallery, Prague, Czech Republic, 2004; Groninger Museum, Groningen, The Netherlands, 2005; pkm Gallery, Seoul, South Korea, 2006. Dealer: White Cube, London, UK; Karyn Lovegrove Gallery, Los Angeles

FELIX GONZALEZ-TORRES 1957-1996. Lived and worked New York, USA. Exhibitions: The Museum of Modern Art, New York, USA, 1992; Magasin 3, Stockholm Konsthall, Stockholm, Sweden, 1992; The Fabric Workshop, Philadelphia, USA, 1994; Touring show starting at The Museum of Contemporary Art, Los Angeles, USA, 1994; Solomon R. Guggenheim Museum, New York, USA, 1995; Sprengel Museum, Hanover, Germany, 1997; Museum Moderner Kunst Stiftung Ludwig, Vienna, Austria, 1998. Dealer: Andrea Rosen Gallery, New York, USA

ANTONY GORMLEY born 1950. Lives and works London, UK. Exhibitions: Stroom, Den Haag, The Netherlands, 1999; Galerie Norenhake, Berlin, Germany, 2001; Centro Gallego de Arte Contemporánea, Santiago de Compostela, Spain, 2002; National History Museum, Beijing, China, 2003; BALTIC Centre for Contemporary Art, Gateshead, UK, 2003; Fundação Calouste Gulbenkian, Lisbon, Portugal, 2004; Hayward Gallery, London, UK, 2007. Dealer: White Cube, London, UK; Galerie Thaddaeus Ropac, Paris, France

DAN GRAHAM born 1942. Lives and works New York, USA. Exhibitions: Wiener Secession, Vienna, Austria, 1992; The Galleries at Moore, Philadelphia, USA, 1993; Museum für Gegenwartskunst, Basel, Switzerland, 1996; Centro Gallego de Arte Contemporáneo, Santiago da Compostela, Spain, 1997. Dealer: Hauser & Wirth, Zurich, Switzerland; Lisson Gallery, London, UK

RENÉE GREEN born 1959. Lives and works New York, USA, and Vienna, Austria. Exhibitions: Clocktower Gallery, New York, USA; Museum of Contemporary Art, Los Angeles, USA, 1993; Stichting De Appel, Amsterdam, The Netherlands, 1996; Wiener Secession, Vienna, Austria, 1999; Fondation Antoni Tapies, Barcelona, Spain, 2000. Dealer: Galerie Christian Nagel, Cologne, Germany; Pat Hearn Gallery, New York, USA; Galleria Emi Fontana, Milan, Italy

VICTOR GRIPPO 1936-2002. Lived and worked Buenos Aires, Argentina. Exhibitions: Centro de Arte y Comunicación, Buenos Aires, Argentina, 1977; Ikon Gallery, Birmingham, UK, 1995; Camden Arts Centre, London, UK, 2006. Dealer: Ruth Benzacar-Galeria de Arte, Buenos Aires, Argentina

ASTA GROTING born 1961. Lives and works Berlin, Germany. Exhibitions: Hagia Sophia Museum, Istanbul, Turkey, 1992; Stichting De Appel, Amsterdam, The Netherlands, 1995; Center for Contemporary Art, Ujadowski Castle, Warsaw, Poland, 1997. Dealer: Galerie Isabella Kacprzak, Cologne, Germany

THOMAS GRUNFELD born 1956. Lives and works Cologne, Germany. Exhibitions: Galerie Jousse Seguin, Paris, France, 1992; Galerie im Taxispalais, Innsbruck, Austria, 1995; Kolnischer Kunstverein, Cologne, Germany, 1997; Karsten Schubert, London, UK, 2003. Dealer: Marianne Boesky Gallery, New York; Galerie Jousse Seguin, Paris, France; Sprüth Magers, Cologne, Munich and London

CAI GUO-QIANG born 1957. Lives and works New York, USA. Exhibitions: Louisiana Museum of Modern Art, Humlebaek, Denmark, 1997; The Museum of Modern Art, New York, USA, 2002; Tate Modern, London, UK, 2003; Deutsche Guggenheim, Berlin, Germany, 2006. Dealer: Michael Hue-Williams, London, UK

FABRICE GYGI born 1965. Lives and works Geneva, Switzerland. Exhibitions: Swiss Institute of Contemporary Art, New York, USA, 2001; DKM Stiftung, Duisburg, Germany, 2002; MAMCO, Geneva, Switzerland, 2004; Kunstmuseum St Gallen, St Gallen, Switzerland, 2005; Magasin 3, Konsthall, Stockholm, Sweden, 2006. Dealer: Galerie Chantal Crousel, Paris, France; Art & Public, Geneva, Switzerland

HANS HAACKE born 1936. Lives and works New York, USA. Exhibitions: Tate, London, UK, 1984; The New Museum of Contemporary Art, New York, USA, 1986; Centre Georges

Pompidou, Paris, France, 1989; Portikus, Frankfurt, Germany, 2000; National Museum of Art, Osaka, Japan, 2004. Dealer: Paula Cooper Gallery, New York, USA

FIONA HALL born 1953. Lives and works Adelaide, Australia. Exhibitions: National Gallery of Australia, Canberra, Australia + tour, 1994; Institute of Modern Art, Brisbane, Australia, 1998; Gallery 706, Colombo, Sri Lanka, 1999; Queensland Art Gallery, Brisbane, Australia, 2005. Dealer: Roslyn Oxley9, Sydney, Australia

ANN HAMILTON born 1956. Lives and works Columbus OH, USA. Exhibitions: Walker Art Center, Minneapolis MN, USA, 1992; Tate, Liverpool, UK, 1994; Wexner Center for the Arts, Columbus OH, USA, 1996; Contemporary Arts Museum, Houston TX, USA, 1997; Miami Art Museum, Miami FL, USA, 1998; Vancouver Art Gallery, Vancouver, Canada, 1999. Dealer: Sean Kelly, New York, USA

DAVID HAMMONS born 1943. Lives and works New York, USA. Exhibitions: Retrospective, Institute of Contemporary Art, New York, USA, 1991; William College Museum of Art, Williamstown MA, USA, 1993; Kunstverein, Salzburg, Austria, 1995; Kunsthalle, Bern, Switzerland, 1998; Museo Nacional Centro de Arte Reina Sofia, Madrid, Spain, 2000; ACE Gallery, New York, USA 2003. Dealer: White Cube, London, UK; Hauser & Wirth, Zurich and London

DUANE HANSON 1925-1996. Lived and worked Florida, USA. Exhibitions: Brown University Art Museum, Providence, Rhode Island NY, USA, 1990; Kunsthalle, Tubingen, Germany, 1990 + tour; Museum of Fine Arts, Montreal, Canada, 1994; Diamaru Museum of Art, Tokyo, Japan, 1995; Museum of Art, Fort Lauderdale FL, USA, 1998; Retrospective tour 2002-3, starting at Padiglione d'Arte Contemporanea, Milan, Italy. Dealer: Hanson Collection, Davie FL, USA

SIOBHAN HAPASKA born 1963. Lives and works London, UK. Exhibitions: Institute of Contemporary Arts, London, UK, 1995; Oriel Gallery, Cardiff, UK, 1997; Sezon Museum of Modern Art, Tokyo, Japan, 1999. Dealer: Kerlin Gallery, Dublin, Ireland; Tanya Bonkdar Gallery, New York, USA

RACHEL HARRISON born 1966. Lives and works New York, USA. Exhibitions: Arena Gallery, Brooklyn NY, 1996; Milwaukee Art Museum, Milwaukee WI, USA, 2002; Kunsthall, Bergen, Norway, 2003; Camden Arts Centre, London, UK, 2004; Museum of Modern Art, San Francisco, USA, 2004. Dealer: Greene Naftali Gallery, New York, USA; Galerie Arndt & Partner, Berlin, Germany

JACOB HASHIMOTO born 1963. Lives and works Los Angeles, USA. Exhibitions: Museum of Contemporary Art, Chicago, USA, 1998; Galleria La Nuova Pesa, Rome, Italy, 1999; Finesilver Gallery, San Antonio TX, USA, 2001; Tacoma Art Museum, Tacoma, Washington, DC, USA, 2004; Rice Gallery, Rice University, Houston TX, USA, 2005. Dealer: Studio La Citta, Verona, Italy; Ann Nathan Gallery, Chicago, USA

MONA HATOUM born 1952. Lives and works London, UK. Exhibitions: Centre Georges Pompidou, Paris, France, 1994; Museum of Contemporary Art, Chicago, USA, 1997; Museum of Modern Art, Oxford, UK, 1998; Kunsthalle, Basel, Switzerland, 1998; Museum van Hedendaagse Kunst, Antwerp, Belgium, 1999; Tate Britain, London, UK, 2000. Dealer: White Cube, London, UK; Alexander & Bonin, New York, USA

TIM HAWKINSON born 1960. Lives and works Los Angeles, USA. Exhibitions: Contemporary Art Center, Cincinnati, USA, 1996 + tour; Armoury Center for the Arts, Pasadena CA, USA, 1996; Akira Ikeda Gallery, Taura, Japan, 1999; The Power Plant Contemporary Art Gallery, Toronto, Canada, 2000; Hirshhorn Museum and Sculpture Garden, Washington, DC, 2001; Akira Ikeda Gallery, Berlin, Germany, 2004; Whitney Museum of American Art, New York, USA, 2005. Dealer: White Cube, London, UK; Jablonka Gallery, Cologne, Germany; ACE Contemporary Exhibitions, Los Angeles, USA

MATHILDE TER HEIJNE born 1969. Lives and works Amsterdam, The Netherlands. Exhibitions: Migros Museum, Zurich, Switzerland, 2002; Thyssen-Bornemisza Art Contemporary, Vienna, Austria, 2005. Dealer: Galerie Martina Detterer, Frankfurt, Germany

JOSE HERNANDEZ-DIEZ born 1964. Lives and works Caracas, Venezuela and Barcelona, Spain. Exhibitions: Galeria Camargo Vilaca, São Paolo, Brazil, 1995; Galeria Elba Benitez, Madrid, Spain, 1997; Sala Mendoza, Caracas, Venezuela, 1998. Dealer: Sandra Gering Gallery, New York, USA; Galerie Enrique Guerrero, Mexico City, Mexico

GEORG HEROLD born 1947. Lives and works Cologne, Germany. Exhibitions: Bawag Foundation, Vienna, Austria, 1998; Kunsthalle Zürich, Zurich, Switzerland, 1999; The Centre for Contemporary Art, Warsaw, Poland, 1999; Kunsthalle, Nuremberg, Germany, 2000; Kunstverein, Hanover, Germany, 2005; Staatliche Kunsthalle, Baden-Baden, Germany, 2005. Dealer: Galerie Gisela Capitain, Cologne, Germany; Anthony Reynolds, London, UK; Friedrich Petzel Gallery, New York, USA

OLIVER HERRING born 1964. Lives and works New York, USA. Exhibitions: Kunstverein, Mannheim, Germany, 1993; The Museum of Modern Art, New York, USA, 1996; Camden Arts Centre, London, UK, 1997; Institute of Visual Arts, Milwaukee WI, USA, 2001; Palm Beach Institute of Contemporary Art, Palm Beach FL, USA, 2002; Frye Art Museum, Seattle WA, USA, 2005; Hirshhorn Sculpture Museum and Garden, Washington, DC, USA, 2006. Dealer: Max Protetch, New York, USA

EVA HESSE 1936-1970. Lived and worked New York, USA. Exhibitions: Memorial Exhibition, Solomon R. Guggenheim Museum, New York, USA, 1972; Whitechapel Art Gallery, London, UK, 1979; IVAM, Valencia, Spain, 1993; Tate Modern, London, UK, 2002. Dealer: Hauser & Wirth, Zurich, Switzerland

ROGER HIORNS born 1975. Lives and works London, UK. Exhibitions: Corvi-Mora, London, UK, 2001; Marc Foxx, Los Angeles, USA, 2003; Galerie Nathalie Obadia, Paris, France, 2006; Milton Keynes Gallery, Milton Keynes, UK, 2006. Dealer: Corvi-Mora, London, UK; Marc Foxx, Los Angeles, USA

THOMAS HIRSCHHORN born 1957. Lives and works Paris, France. Exhibitions: Solomon R. Guggenheim Museum, New York, USA, 1998; Musée d'Art Moderne de Saint-Etienne, Saint-Etienne, France, 1999; Museum of Contemporary Art, Chicago, USA, 1999; Whitechapel Art Gallery, London, UK, 2000; Museu d'Art Contemporani, Barcelona, Spain, 2001; Institute of Contemporary Art, Boston, USA, 2005; Kestner Gesellschaft, Hanover, Germany, 2006; Museu Serralves, Porto, Portugal, 2006. Dealer: Arndt & Partner, Berlin, Germany; Stephen Friedman Gallery, London, UK; Barbara Gladstone Gallery, New York, USA

DAMIEN HIRST born 1965. Lives and works Devon, UK. Exhibitions: Bruno Bischofberger, Zurich, Switzerland, 1997; Southampton Art Gallery, Southampton, UK, 1998; Gagosian Gallery, New York, USA, 1999; Kunsthaus Zürich, Zurich, Switzerland, 1999; Gagosian Gallery, New York, USA, 2000; Museum of Contemporary Art, Los Angeles, USA, 2001; The Saatchi Gallery, London, UK, 2003; Hilario Galguera Gallery, Mexico City, Mexico, 2006. Dealer: White Cube, London, UK; Gagosian Gallery, New York, USA; Bonakdar Jancou Gallery, New York, USA

EVAN HOLLOWAY born 1967. Lives and works Los Angeles, USA. Exhibitions: Xavier Hufkens, Brussels, 2002 and 2005; Museum of Modern Art, San Francisco, USA, 2004. Dealer: Marc Foxx, Los Angeles, USA; The Approach, London, UK

MARTIN HONERT born 1953. Lives and works Dusseldorf, Germany. Exhibitions: Museum für Moderne Kunst, Frankfurt, Germany, 1992; Norwich Gallery, Norwich, UK, 1993; Arnolfini Gallery, Bristol, UK, 1996; Museu d'Art Contemporani, Barcelona, Spain, 1997; Gemäldegalerie Neue Meister, Albertinum, Dresden, Germany, 2000. Dealer: Matthew Marks Gallery, New York, USA; Johnen & Schottle, Cologne, Germany

REBECCA HORN born 1944. Lives and works Hanover, Germany. Exhibitions: Solomon R. Guggenheim Museum, New York, USA, 1993; Kestner Gesellschaft, Hanover, Germany, 1997; Die Neue Kunsthalle, Mannheim, Germany, 2002; Gallery Trisorio, Naples, Italy, 2003; K2 Kunstsammlung, Dusseldorf, Germany, 2004; Kunstmuseum, Stuttgart, Germany, 2005; Fundação Centro Cultural de Belem, Lisbon, Portugal, 2005; Retrospective, Martin-Gropius-Bau, Berlin, Germany, 2006. Dealer: Marion Goodman, New York, USA

RONI HORN born 1955. Lives and works New York, USA, and Reykjavik, Iceland. Exhibitions: The Museum of Contemporary Art, Los Angeles, USA, 1990; Museum für Gegenwartskunst, Basel, Switzerland, 1995; Whitney Museum of American Art, New York, USA, 2000; De Pont Museum for Contemporary Art, Tilburg, The Netherlands, 2001; PS1 Contemporary Art Center, New York, USA, 2005; Kunstmuseum, Bonn, Germany, 2007. Dealer: Matthew Marks Gallery, New York, USA; Jablonka Galerie, Cologne, Germany; Xavier Hufkens, Brussels, Belgium

SHIRAZEH HOUSHIARY born 1955. Lives and works London, UK. Exhibitions: British Museum, London, UK, 1997; Tate, Liverpool, UK, 2000; SITE, Santa Fe NM, USA, 2002. Dealer: Lisson Gallery, London, UK; Lehmann Maupin, New York, USA

CRISTINA IGLESIAS born 1956. Lives and works Madrid, Spain. Exhibitions: The Renaissance Society at the University of Chicago, Chicago, USA, 1997; Solomon R. Guggenheim Museum, New York, USA, 1997; Whitechapel Art Gallery, London, UK, 2003. Dealer: Donald Young, Chicago, USA; Galerie Tanit, Munich, Germany

ROBERT IRWIN born 1928. Lives and works California, USA. Exhibitions: Retrospective, Museum of Contemporary Art, Los Angeles, USA, 1993; Retrospective, Kunstverein, Cologne, Germany, 1994; Retrospective, Museo Nacional Centro de Arte Reina Sofia, Madrid, Spain, 1995; Museum of Contemporary Art, San Diego CA, USA, 1997; Dia Center for the Arts, New York, USA, 1998. Dealer: Pace Wildenstein, New York, USA

JIM ISERMANN born 1955. Lives and works Los Angeles, USA. Exhibitions: Chicago Fine Arts Club, Chicago, USA, 1997; Institute of Visual Arts, University of Wisconsin, Milwaukee WI, USA, 1998 + tour; Camden Arts Centre, London, UK, 1999; Portikus, Frankfurt, Germany, 2000; UCLA Hammer Museum, Los Angeles, USA, 2002; Palm Springs Art Museum, Palm Springs CA, USA, 2006. Dealer: Circus Gallery, Los Angeles, USA; Corvi-Mora, London, UK

EMILY JACIR born 1970. Lives and works Ramallah, Palestine and New York, USA. Exhibitions: OK Center for Contemporary Art, Linz, Austria, 2003; The Khalil Sakakini Cultural Centre, Ramallah, Palestine, 2003; Royal College of Art, London, UK, 2004. Dealer: Alexander & Bonin, New York, USA; Anthony Reynolds, London, UK

ANN VERONICA JANSSENS born 1956. Lives and works Brussels, Belgium. Exhibitions: Neue National Galerie, Berlin, Germany, 2001; Ikon Gallery, Birmingham, UK, 2002; Open Art Museum, Middelheim, Antwerp, Belgium, 2003; Galeria Antoni Tapies, Barcelona, Spain, 2004. Dealer: Galerie Micheline Szwajcer, Antwerp, Belgium; Esther Schipper, Berlin, Germany

SUI JIANGUO born 1956. Lives and works Beijing, China. Exhibitions: Hannart Gallery, Taipei, Taiwan, 1994; New Delhi Cultural Centre, New Delhi, India, 1995; Victoria College of Arts, Melbourne, Australia, 1997. Dealer: Galerie Loft, Paris/Hong Kong; Ethan Cohen Fine Arts, New York, USA; Red Gate Gallery, Beijing, China

KATARZYNA JOZEFOWICZ born 1959. Lives and works Danzig, Poland. Exhibitions: Galerie im Taxipalais, Innsbruck, Austria, 2003; Neue Kunsthalle St Gallen, St Gallen, Switzerland, 2005; The Centre for Contemporary Art, Warsaw, Poland, 2006. Dealer: Gallery Foksal, Warsaw, Poland

DONALD JUDD 1928-1994. Lived and worked Marfa TX, USA. Exhibitions: Museum Wiesbaden, Wiesbaden, Germany, 1993; Galerie Gmurzynska, Cologne, Germany, 1994; The Menil Collection, Houston TX, USA, 1998; The Museum of Modern Art, Saitama, Japan, 1999; Sprengel Museum, Hanover, Germany, 2000 + tour; Kunsthalle, Bielefeld, Germany, 2002; Tate Modern, London, UK, 2004 + tour. Dealer: Pace Wildenstein, New York, USA; Paula Cooper, New York, USA

BRIAN JUNGEN born 1970. Lives and works Vancouver, Canada. Exhibitions: Dunlop Art Gallery, Regina, Saskatchewan, Canada, 2000; Solo Exhibition Space, Toronto, Canada, 2000; Art Gallery, Calgary, Alberta, Canada, 2001; Secession, Vienna, Austria, 2003; New Museum, New York, USA, 2005; Vancouver Art Gallery, Vancouver, Canada, 2006;

Witte De With, Rotterdam, The Netherlands, 2007. Dealer: Catriona Jeffries Gallery, Vancouver, Canada

ILYA KABAKOV born 1933. Lives and works New York, USA and Paris, France. Exhibitions: Centre Georges Pompidou, Paris, France, 1995; Satani Gallery, Tokyo, Japan, 1997; Museum of Contemporary Art, Antwerp, Belgium, 1998; State Hermitage Museum, St Petersburg, Russia, 2002. Dealer: Barbara Gladstone Gallery, New York, USA; Galerie Thaddaeus Ropac, Paris, France

ANISH KAPOOR born 1954. Lives and works London, UK. Exhibitions: National Gallery of Canada, Ottowa, Ontario, Canada, 1993; Hayward Gallery, London, UK, 1998; CAPC Musée d'Art Contemporain, Bordeaux, France, 1999; BALTIC Centre for Contemporary Art, Gateshead, UK, 2000; Turbine Hall, Tate Modern, London, UK, 2002; Kunsthaus, Bregenz, Austria, 2003; Museo Archeologico Nazionale, Naples, Italy, 2003. Dealer: Lisson Gallery, London, UK; Barbara Gladstone, New York, USA

MIKE KELLEY born 1954. Lives and works Los Angeles, USA. Exhibitions: Kunsthalle, Basel, Switzerland, 1992; ICA, London, UK, 1993; Whitney Museum of American Art, New York, USA, 1993; Migros Museum, Zurich, Switzerland, 2000; Jablonka Galerie, Cologne, Germany, 2001; Metro Pictures, New York, USA, 2002; Tate, Liverpool, UK, 2004; Gagosian Gallery, New York, USA, 2005. Dealer: Gagosian Gallery, New York, USA; Galerie Ghislaine Hussenot, Paris, France

ELLSWORTH KELLY born 1923. Lives and works New York, USA. Exhibitions: Retrospective, Whitney Museum of American Art, New York, USA, 1982; Retrospective, Solomon R. Guggenheim Museum, New York, 1996 + tour to Los Angeles, London and Munich; Museum of Modern Art, San Francisco, USA, 2003; Tate, St Ives, UK, 2006. Dealer: Matthew Marks, New York, USA; Barbara Krakow Gallery, Boston, USA

STEFAN KERN born 1986. Lives and works Hamburg, Germany. Exhibitions: Kunstlerhaus, Hamburg, Germany, 1995; Frankfurter Wohnung, Frankfurt, Germany, 1997; Ernst Barlach Museum, Wedel, Germany, 1999; Portikus, Frankfurt, Germany, 2000; Kunstverein, Hamburg, Germany, 2002. Dealer: Sprüth Magers Lee, Cologne, Germany; Andres Kreps Gallery, New York, USA

CLAY KETTER born 1961. Lives and works Malmo, Sweden. Exhibitions: Konsthall, Lund, Sweden, 2002; Moderna Museet, Stockholm, Sweden, 2002; Galleri Specta, Copenhagen, Denmark, 2004. Dealer: White Cube, London, UK; Sonnabend Gallery, New York, USA; Galerie Nordenhake, Stockholm, Sweden

ANSELM KIEFER born 1945. Lives and works Barjac, France. Exhibitions: National Galerie, Berlin, Germany, 1991; Museo Correr, Venice, Italy, 1997; Royal Academy of Arts, London, UK, 2001; Fondation Beyeler, Basel, Switzerland, 2001; Museum für Moderne Kunst, Ostende, Belgium, 2003; Museo Archeologico Nazionale, Naples, Italy, 2004; The Aldrich Contemporary Art Museum, Ridgefield CT, USA, 2006; The Hirshhorn Museum and Sculpture Garden, Washington, DC, USA, 2006. Dealer: Gagosian Gallery, New York, USA; White Cube, London, UK

EDWARD KIENHOLZ 1927-1994. Lived and worked Los Angeles, USA. Exhibitions: Retrospective, BALTIC Centre for Contemporary Art, Gateshead, UK, 2005; The Museum of Contemporary Art, Sydney, Australia, 2005. Dealer: LA Louver, Los Angeles, USA

BODYS ISEK KINGELEZ born 1948. Lives and works Kinshasa, Congo. Exhibitions: Fondation Cartier, Paris, France, 1999; Kunstverein, Hamburg, Germany, 2001; Contemporary Arts Museum, Houston TX, USA, 2005. Dealer: Galerie Peter Herrman, Berlin, Germany

PER KIRKEBY born 1938. Lives and works Copenhagen and Arnasco, Denmark. Exhibitions: Palais des Beaux Arts, Brussels, Belgium, 1998; Stadtische Galerie, Karlsruhe, Germany, 2000; Museum Ludwig, Cologne, Germany, 2002; Aargaouer Kunsthaus, Aarau, Switzerland, 2005; Kunsthaus, Kiel, Germany, 2005. Dealer: Galleri Bo Bjerggard, Copenhagen, Denmark; Galerie Michael Werner, Cologne, Germany

YVES KLEIN 1928-1962. Lived and worked Paris, France. Exhibitions: Gagosian Gallery, New York, USA, 2002; Centre Georges Pompidou, Paris, France, 2006

JEFF KOONS born 1955. Lives and works New York, USA. Exhibitions: Deste Foundation, Athens, Greece, 1999; Papal Palace, Avignon, France, 2000; Deutsche Guggenheim, Berlin, Germany, 2000; Guggenheim Museum, Bilbao, Spain, 2001; Kunsthaus, Bregenz, Switzerland, 2001; Musée d'art Contemporain, Nimes, France, 2002; Kunsthalle, Bielefeld, Germany, 2002; Museo Archeologico, Naples, Italy, 2003; Retrospective, Astrup Fearnley Museet für Moderne Kunst, Oslo, Norway, 2004; Retrospective, Helsinki City Art Museum, Helsinki, Finland, 2005. Dealer: Sonnabend Gallery, New York, USA; Gagosian Gallery, New York, USA

JOSEPH KOSUTH born 1945. Lives and works New York, USA and Brussels, Belgium. Exhibitions: Chiba City Museum of Art, Chiba City, Japan, 1999; Kunstmuseum, Ittingen, Switzerland, 1999; Isabella Stewart Gardner Museum, Boston, USA, 2000; Collegium Artisticum, Sarajevo, Bosnia-Herzogovenia, 2000; Van Abbemuseum, Eindhoven, The Netherlands, 2004; Contemporary Art Center, Copenhagen, Denmark, 2005. Dealer: Sean Kelly, New York, USA; Galeria Lia Rumma, Milan, Italy

JANNIS KOUNELLIS born 1936. Lives and works Rome, Italy. Exhibitions: Retrospective, Ionion Boat, Piraeus Harbour, Greece, 1994; Museo Nacional Centro de Arte Reina Sofia, Madrid, Spain, 1997; Kunststation St Peter, Cologne, Germany, 2001; Centro per l'Arte Contemporanea, Prato, Italy, 2001; Stedelijk Museum voor Actuele Kunst, Ghent, Belgium, 2002; Kunstraum, Innsbruck, Austria, 2003; Louisiana Museum of Modern Art, Humlebaek, Denmark, 2004; Villa Massimo Rome, Italy, 2004; National Museum of Contemporary Art, Athens, Greece, 2004; Scottish National Gallery of Modern Art, Edinburgh, UK, 2005; Kunstmuseum, Vaduz, Liechtenstein, 2006. Dealer: Marion Goodman, New York, USA; ACE Gallery, New York, USA

TANIA KOVATS born 1966. Lives and works London, UK. Exhibitions: Riverside Studios, London, UK, 1991; Laure Genillard Gallery, London, UK, 1995; British School at Rome, Rome, Italy, 1997; New Art Centre, Roche Court, Salisbury, UK, 1999. Dealer: Asprey Jacques, London, UK

BRIGITTE KOWANZ born 1957. Lives and works Vienna, Austria. Exhibitions: Architekturforum, Innsbruck, Austria, 1996; Hochschule für angewandte Kunst, Vienna, Austria, 1998; Kunsthaus, Murzzuschlag, Austria, 1999; Max Planck Gesellschaft, Munich, Germany, 2000; Shanghai Art Museum, Shanghai, China, 2001; Zentrum für Internationale Lichtkunst, Unna, Germany, 2005; Kunsthalle, Krems, Germany, 2007. Dealer: Galerie Fortlaan, Ghent, Belgium

GABRIEL KURI born 1970. Lives and works Mexico City and Brussels, Belgium. Exhibitions: MUKHA, Antwerp, Belgium, 2003; Gallery Kurimanzutto, Mexico City, Mexico, 2006. Dealer: Gallery Kurimanzutto, Mexico City, Mexico; Galerie Chez Valentin, Paris, France

RACHEL LACHOWICZ born 1964. Lives and works Los Angeles, USA. Exhibitions: Shoshana Wayne Gallery, Santa Monica CA, USA, 1993; Pittsburgh Center for the Arts, Pittsburgh PA, USA, 1994; Dogenhaus Galerie, Berlin, Germany, 1997. Dealer: Shoshana Wayne Gallery, Santa Monica, USA; Patricia Sweetow Gallery, San Francisco, USA

WOLFGANG LAIB born 1950. Lives and works Hochdorf, Germany. Exhibitions: The Henry Moore Studio, Leeds, UK, 1993; De Pont Museum for Contemporary Art, Tilburg, The Netherlands, 1993; Camden Arts Centre, London, UK, 1994; Sprengel Museum, Hanover, Germany, 1995; The Arts Club of Chicago, Chicago, USA, 1998; Retrospective, Hirshhorn Museum and Sculpture Garden, Washington, DC, USA, 2000 + tour; Dallas Museum of Art, Dallas TX, USA, 2001; Sprengel Museum, Hanover, Germany, 2001; Folkwang, Essen, Germany, 2002; San Diego Museum of Contemporary Art, San Diego CA, USA, 2002; Toyota Municipal Museum of Art, Toyota, Japan, 2003; Kunstmuseum, Bonn, Germany, 2005; Retrospective, Fondation Beyeler, Basel, Switzerland, 2005; Museo Nacional Centro de Arte Reina Sofia, Madrid, Spain, 2007. Dealer: Anthony Meier Fine Arts, San Francisco; Sperone Westwater, New York, USA; Galerie Lelong, Paris, France

MICHAEL LANDY born 1963. Lives and works London, UK. Exhibitions: Tate Britain, London, UK, 1995; C&A Store, Oxford Street, London, UK, 2001; Tate Britain, London, UK, 2004. Dealer: Thomas Dane, London, UK

ABIGAIL LANE born 1967. Lives and works London, UK. Exhibitions: Karsten Schubert, London, UK, 1997; Victoria Miro Gallery, London, UK, 1998; Milton Keynes Gallery, Milton Keynes, UK, 2001. Dealer: Victoria Miro Gallery, London, UK; Eyestorm, New York, USA

LIZ LARNER born 1960. Lives and works Los Angeles, USA. Exhibitions: Regen Projects, Los Angeles, USA, 1998, 2001 and 2005; Museum of Contemporary Art, Los Angeles, USA, 2001. Dealer: Regen Projects, Los Angeles, USA

CHARLES LEDRAY born 1960. Lives and works New York, USA. Exhibitions: Villa Arson, Nice, France, 1993; Jay Gorney Modern Art, New York, USA, 1995; Institute of Contemporary Art, University of Pennsylvania, Philadelphia, USA, 2000 + tour. Dealer: Sperone Westwater, New York, USA

JAC LEIRNER born 1961. Lives and works São Paolo, Brazil. Exhibitions: Institute of Contemporary Art, Boston, USA, 1991; Hirshhorn Museum and Sculpture Garden, Washington, DC, USA, 1992; The Bohen Foundation, New York, USA, 1998; Sala Mendoza, Caracas, Venezuela, 1998; Museu de Arte Moderna, São Paolo, Brazil, 1998 and 2001; Miami Art Museum, Miami FL, USA, 2004. Dealer: Galerie Camargo Vilaca, São Paolo, Brazil

ZOE LEONARD born 1961. Lives and works New York, USA. Exhibitions: The Renaissance Society at The University of Chicago, Chicago, USA, 1993; Museum of Contemporary Art, North Miami FL, USA, 1997; Philadelphia Museum of Art, Philadelphia, USA, 1998; Centre for Contemporary Art, Ujazdowski Castle, Warsaw, Poland, 1999; Wexner Center for Contemporary Art, Columbus OH, USA, 2003. Dealer: Paula Cooper Gallery, New York, USA

KAMIN LERTCHAIPRASENT born 1964. Lives and works Bangkok, Thailand. Exhibitions: The Art Gallery, Silpakorn University, Bangkok, Thailand, 1992; Tadu Contemporary Art, Bangkok, Thailand, 1997; Gallery Art U, Osaka, Japan, 2002. Dealer: Walsh Gallery, Chicago, USA; Valentine Willie Fine Art, Kuala Lumpur, Malaysia

SOL LEWITT 1928-2007. Lived and worked USA. Exhibitions: The Museum of Modern Art, New York, USA, 1996 + tour; Retrospective, Museum of Modern Art, San Francisco, USA, 2000; The Metropolitan Museum of Art, New York, USA, 2005; Retrospective, Allen Memorial Art Museum, Oberlin OH, USA, 2007. Dealer: Marion Goodman, New York, USA

WON JU LIM born 1968. Lives and works Los Angeles, USA. Exhibitions: Russel Gallery, University of California, San Diego CA, USA, 1999; Kunstlerhaus Bethanien, Berlin, Germany, 2000. Dealer: Patrick Painter Inc, Santa Monica CA, USA

MAYA LIN born 1960. Lives and works New York, USA. Exhibitions: Henry Art Gallery, Seattle WA, USA, 2002. Dealer: Gagosian Gallery, New York, USA

RICHARD LONG born 1945. Lives and works Bristol, UK. Exhibitions: Tate Britian, London, UK, 1990; Hayward Gallery, London, UK, 1991; Kunstsammlung Nordrhein-Westfalen, Dusseldorf, Germany, 1994; Setagaya Art Museum, Tokyo, Japan, 1996; Contemporary Arts Museum, Houston TX, USA, 1996; Bristol City Museum and Art Gallery, Bristol, UK, 1997; Museum Kurhaus, Kleve, Germany, 1999; Museo Guggenheim, Bilbao, Spain, 2000; Museu Serralves, Porto, Portugal, 2001; Tate, St Ives, UK, 2002; Synagoge, Stommeln, Germany, 2004. Dealer: Anthony d'Offay, London, UK

ANTONIO LOPEZ-GARCIA born 1936. Lives and works Madrid, Spain. Exhibitions: Marlborough Monaco, Monte Carlo, Monaco, 2002 and 2003. Dealer: Galeria Marlborough, Madrid, Spain; Galerie Claude Bernard, Paris, France

LOS CARPINTEROS: Dagoberto Rodriguez born 1969, Marco Castillo born 1971, Alexandre Arrechea, born 1970. Live and work Havana, Cuba. Exhibitions: Casa del Joven Creador, Havana, Cuba, 1992; Galeria Angel Romero, Madrid, Spain, 1995; Castillo de los Tres Reyes del Morro, Havana, Cuba, 1996; Convento de San Francisco de Asis, Havana, Cuba, 1997; The New Museum of Contemporary Art, New York, USA, 1998; San Francisco Art Institute, San Francisco, USA, 2001; BALTIC Centre for Contemporary Art, Newcastle, UK, 2002; Contemporary Art Center, University of South

Florida, Tampa FL, USA, 2006. Dealer: Galeria Moleiros, San Francisco, Panama

SARAH LUCAS born 1962. Lives and works London, UK. Exhibitions: Portikus, Frankfurt, Germany, 1996; Museum Ludwig, Cologne, Germany, 1997; Freud Museum, London, UK, 2000; Tate Modern, London, UK, 2002; Milton Keynes Gallery, UK, 2003; Kunsthalle Zürich, Zurich, Switzerland, 2005. Dealer: White Cube, London, UK; Barbara Gladstone, New York, USA

RITA McBRIDE born 1960. Lives and works New York, USA. Exhibitions: Des Moines Art Center, Des Moines, USA, 1992; Witte de With, Rotterdam, The Netherlands, 1997; Kunstverein, Munich, Germany, 1999; Staatliche Kunsthalle, Baden-Baden, Germany, 2000; De Pont Museum for Contemporary Art, Tilburg, The Netherlands, 2001; Secession, Vienna, Austria, 2002; Kunstmuseum, Vaduz, Liechtenstein, 2002; Institut d'Art Contemporain, Villeurbanne, France, 2002. Dealer: Alexander & Bonin, New York, USA

PAUL McCARTHY born 1945. Lives and works Altadena CA, USA. Exhibitions: Kunstlerhaus Bethanien, Berlin, Germany, 1995; Museum of Contemporary Art, Los Angeles, USA, 2000; Villa Arson, Nice, France, 2001; New Museum of Contemporary Art, New York, USA, 2001; The National Museum of Contemporary Art, Oslo, Norway, 2003; Van Abbemuseum, Eindhoven, The Netherlands, 2004. Dealer: Luhring Augustine Gallery, New York, USA; Hauser & Wirth, Zurich, Switzerland; Patrick de Brock Gallery, Knokke, Belgium; Galerie Asbaek, Copenhagen, Denmark

ALLAN McCOLLUM born 1944. Lives and works New York, USA. Exhibitions: Serpentine Gallery, London, UK, 1990; Rooseum Center for Contemporary Art, Malmo, Sweden, 1990; Sprengel Museum, Hanover, Germany, 1995; Retrospective, Musée d'Art Moderne, Villeneuve, Lille, France, 1998; Konstmuseum, Boras, Sweden, 1999; San Diego State University, Calexico CA, USA, 2000; Grand Arts, Kansas City MO, USA, 2003; Musée d'art moderne et contemporain, Geneva, Switzerland, 2006. Dealer: John Weber, New York, USA; Galerie Xavier Hufkens, Brussels, Belgium; Barbara Krakow Gallery, Boston, USA; Friedrich Petzel Gallery, New York, USA

JOHN McCRACKEN born 1934. Lives and works Los Angeles, USA. Exhibitions: Kunsthalle, Basel, Switzerland, 1995; Miami Art Museum, Miami FL, USA, 1997; SITE, Santa Fe NM, USA, 1999; Centre Georges Pompidou, Paris, France, 2000; SMAK, Ghent, Belgium, 2004. Dealer: LA Louver, Los Angeles, USA; David Zwirner, New York, USA; Hauser & Wirth, Zurich, Switzerland

JOSIAH McELHENY born 1966. Lives and works New York, USA. Exhibitions: The Henry Art Gallery, University of Washington, Seattle WA, USA, 1999; The Isabella Stewart Gardner Museum, Boston, USA, 1999; Yerba Buena Center for the Arts, San Francisco, USA, 2001; Centro Galego de Arte Contemporanea, Santiago de Compostela, Spain, 2002. Dealer: Brent Sikkema, New York, USA; Donald Young, Chicago, USA

DAVID MACH born 1956. Lives and works London, UK. Exhibitions: Tate Britain, London, UK, 1996; Contemporary Arts Center, Cincinnati, USA, 1998. Dealer: Jill George Gallery, London, UK; Galerie Jerome de Noirmont, Paris, France

ALEXIS LEYVA MACHADO born 1970. Lives and works Havana, Cuba. Exhibitions: Galeria Arte Contemporáneo, Mexico City, Mexico, 1993; Museum of Contemporary Art, Los Angeles, USA, 1997; The Israel Museum, Jerusalem, Israel, 1997; Museo Nacional Centro de Arte Reina Sofia, Madrid, Spain, 2000. Dealer: Juan Ruiz Galeria, Maracaibo, Venezuela; Galeria Moleiros, San Francisco, Panama; Barbara Gladstone, New York, USA

ROY McMAKIN born 1956. Lives and works Seattle WA, USA. Exhibitions: La Jolla Museum of Contemporary Art, La Jolla CA, USA, 1987; Seattle Art Museum, Seattle WA, USA, 1999; Feature Inc, New York, USA, 2001; Marc Selwyn Fine Art, Los Angeles, USA, 2004; San Diego State University, San Diego CA, USA, 2005. Dealer: Matthew Marks, New York, USA; James Harris Gallery, Seattle WA, USA

MICHAEL McMILLEN born 1946. Lives and works Los Angeles, USA. Exhibitions: Armoury Center for the Arts, Pasadena CA, USA, 2002; University of Wyoming Art Museum, Laramie WY, USA, 2003; De Saisset Museum, Santa Clara CA, USA, 2006. Dealer: LA Louver, Los Angeles, USA

LOREN MADSEN born 1943. Lives and works New York, USA. Exhibitions: University of Florida, Gainesville FL, USA, 1991; J.R. Kinshicho Project, Tokyo, Japan, 1997; University Art Gallery, SUNY, New York, USA. Dealer: McKee Gallery, New York, USA

ANNA MARIA MAIOLINO born 1942. Lives and works São Paolo, Brazil. Exhibitions: Gallery 4, New York, 2002; Miami Art Central, Miami FL, 2006. Dealer: Raquel Arnaud, Rio de Janiero, Brazil

MARK MANDERS born 1968. Lives and works Arnhem, The Netherlands, and Ronse, Belgium. Exhibitions: Van Abbemuseum, Eindhoven, The Netherlands, 1994; Staatliche Kunsthalle, Baden-Baden, Germany, 1998; Stedelijk Museum, Amsterdam, The Netherlands, 2000; The Renaissance Society at the University of Chicago, Chicago, USA, 2003. Dealer: Greene Naftali Gallery, New York, USA

INIGO MANGLANO-OVALLE born 1961. Lives and works Chicago, USA. Exhibitions: The Henry Art Gallery, Seattle WA, USA, 2000; Cranbrook Art Museum, Bloomfield Hills MI, USA, 2001; Orange County Museum of Art, Newport Beach CA, USA, 2003; Art Institute of Chicago, Chicago, USA, 2005. Dealer: Max Protetch, New York, USA

PIERO MANZONI 1933-1963. Lived and worked Milan, Italy. Dealer: Piero Manzoni Archive, Milan, Italy

MAREPE born 1970. Lives and works Salvador da Bahia, Brazil. Exhibitions: Galeria Luisa Strina, São Paolo, Brazil, 2002; Anton Kern Gallery, New York, USA, 2004; Centre Georges Pompidou, Paris, France, 2005. Dealer: Galeria Luisa Strina, São Paolo, Brazil; Anton Kern Gallery, New York, USA

TERESA MARGOLLES born 1963. Lives and works Mexico City, Mexico. Exhibitions: Kunsthalle, Bregenz, Austria, 2003; Kunsthalle, Vienna, Austria, 2003; Museum für Moderne Kunst, Frankfurt, Germany, 2004. Dealer: Peter Kilchmann, Zurich, Switzerland; Yvonamor Palix, Paris, France; Galeria Enrique Guerrero, Mexico City, Mexico

RAYMOND MASON born 1922. Lives and works Paris, France. Exhibitions: Retrospective, Centre Georges Pompidou, Paris, France, 1985; Birmingham Museum and Art Gallery, Birmingham, UK, 1989; Rupertinum, Salzburg, Austria, 1994; Retrospective, Fondation Dina Vierny, Musée, Maillol, Paris, France, 2000. Dealer: Marlborough Gallery, London, UK

TONY MATELLI born 1971. Lives and works New York, USA. Exhibitions: Kunstraum, Dorbin, Germany, 2004; Kunsthalle, Vienna, Austria, 2004; Swiss Institute for Contemporary Art, New York, USA, 2004. Dealer: Basilico Fine Arts, New York, USA; Lora Reynolds Gallery, Austin TX, USA

GORDON MATTA-CLARK 1943-1978. Lived and worked New York, USA. Exhibitions: Museo Nacional Centro de Arte Reina Sofia, Madrid, Spain, 1997; PS1 Contemporary Art Center, New York, USA, 1998; Mudimadrie Galerie Gianluca Ranzi, Antwerp, Belgium, 2004. Dealer: David Zwirner Gallery, New York, USA

JASON MEADOWS born 1972. Lives and works Los Angeles, USA. Exhibitions: Room 702, Los Angeles, USA, 1997; Studio Guenzani, Milan, Italy, 2000; Krinzinger Projekte, Vienna, Austria, 2002. Dealer: Corvi-Mora, London, UK; Marc Foxx, Los Angeles, USA; Tanya Bonakdar Gallery, New York, USA

CILDO MEIRELES born 1948. Lives and works Rio de Janiero, Brazil. Exhibitions: Capp Street Project, San Francisco, USA, 1994; IVAM, Valencia, Spain, 1995; Laumier Sculpture Park, Saint Louis MO, USA, 1995; Espaco Cultural Sergio Porto, Rio de Janiero, Brazil, 1996; Institute of Contemporary Art, Boston, USA, 1997; Kiasma Museum of Contemporary Art, Helsinki, Finland, 1999; New Museum of Contemporary Art, New York, USA, 1999 + tour. Dealer: Gallery Lelong, New York, USA

ANA MENDIETA 1948-1985. Lived and worked New York, USA. Exhibitions: Retrospective, New Museum of Contemporary Art, New York, USA, 1987; Kunsthalle, Dusseldorf, Germany, 1996 + tour. Dealer: Gallery Lelong, New York, USA

MATHIEU MERCIER born 1970. Lives and works Paris, France. Exhibitions: Museum of Modern Art, Ljubljana, Slovenia, 2003; Hermes Shop, Brussels, Belgium, 2004; Kunsthaus Bethanien, Berlin, Germany, 2004. Dealer: Jack Hanley, San Francisco, USA; Galerie Chez Valentin, Paris, France

GERHARD MERZ born 1947. Lives and works Berlin, Germany and Pescia, Italy. Exhibitions: Deweer Art Gallery, Otegem, Belgium, 1995; Freight Depot, Hanover, Germany, 2000; Kunstsammlung Nordrhein-Westfalen, Dusseldorf, Germany, 2002; Kunsthaus, Bregenz, Austria, 2003. Dealer: Galerie Tanit, Cologne, Germany

MARIO MERZ 1925-2003. Lived and worked Turin, Italy. Exhibitions: Solomon R. Guggenheim Museum, New York, USA, 1989; Wilhelm Lehmbruck Museum, Duisburg, Germany, 1996; Fundacão de Serralves, Porto, Portugal, 1999; Fundación Proa, Buenos Aires, Argentina, 2003; Mario Merz, Turin, Italy, 2003. Dealer: Barbara Gladstone, New York, USA; Sperone Westwater, New York, USA

ANNETTE MESSAGER born 1943. Lives and works Paris, France. Exhibitions: Musée d'Art Moderne de la Ville de Paris, Paris, France, 1995; Museum of Contemporary Art, Miami FL, USA, 1997; Museo Nacional Centro de Arte Reina Sofía, Madrid, Spain, 1999. Dealer: Marion Goodman, Paris, France; Monika Sprüth Galerie, Cologne, Germany

OLAF METZEL born 1952. Lives and works Munich, Germany. Exhibitions: Kunsthalle, Hamburg, Germany, 1992; Wilhelm Lehmbruck Museum, Duisburg, Germany, 1996; Haus am Waldsee, Berlin, Germany, 1999; Villa Arson, Nice, France, 1999; Institut Mathildenhohe, Darmstadt, Germany, 2001; Kunstraum, Munich, Germany, 2002; Pinakothek der Moderne, Munich, Germany, 2001. Dealer: Galerie Bernd Kluser, Munich, Germany

JASON MIDDLEBROOK born 1966. Lives and works New York, USA. Exhibitions: Public Art Fund, New York, USA, 1999; Welcome Trust, London, UK, 2001; New Museum of Contemporary Art, New York, USA, 2001; Museum of Art, Santa Monica CA, USA, 2001; Palazzo Delle Papesse, Siena, Italy, 2003; Aldrich Contemporary Museum of Art, Ridgefield CT, USA, 2004; Sheldon Memorial Art Gallery, University of Nebraska, Lincoln NE, USA, 2006. Dealer: John Berggruen Gallery, San Francisco, USA; Sara Meltzer Gallery, New York, USA

YUE MINJUN born 1962. Lives and works Beijing, China Exhibitions: Chinese Contemporary, London, UK, 1998 and 2000; One World Art Center, Beijing, China, 2002; Soobin Art Gallery, Singapore, 2002; Miele Gallery, Switzerland, 2003; Schoeni Art Gallery, Hong Kong, China, 2004. Dealer: Galerie Urs Meile, Lucerne, Switzerland; Chinese Contemporary, London, UK

ROBERT MORRIS born 1931. Lives and works New York, USA. Exhibitions: Retrospective, Centre Georges Pompidou, Paris, France, 1995; Nuova Icona, Venice, Italy, 1997; Pietro Sparta Gallery, Chagny, France, 1997; Le Musée d'art contemporain, Lyon, France, 1999. Dealer: Sonnabend Gallery, New York, USA; Leo Castelli Gallery, New York, USA

CALLUM MORTON born 1965. Lives and works Melbourne, Australia. Exhibitions: Artspace, Sydney, Australia, 1996; Govett-Brewster Art Gallery, New Plymouth, New Zealand, 1997; Museum of Contemporary Art, Sydney, Australia, 2003; Chandigarh Museum and Art Gallery, Chandigarh, India, 2004; Perth Institute of Contemporary Art, Perth, Australia, 2007. Dealer: Roslyn Oxley9 Gallery, Sydney, Australia; Anna Schwartz Gallery, Melbourne, Australia

REINHARD MUCHA born 1950. Lives and works Dusseldorf, Germany. Exhibitions: Anthony d'Offay Gallery, London, UK, 1997; Luhring Augustine, New York, USA, 1998 and 2002. Dealer: Luhring Augustine, New York, USA; Galerie Philip Nelson, Paris, France

RON MUECK born 1958. Lives and works London, UK. Exhibitions: Anthony d'Offay Gallery, London, UK, 1998 and 2000; National Gallery, London, UK, 2003; Scottish National Gallery of Modern Art, Edinburgh, UK, 2006. Dealer: Anthony d'Offay, London, UK; James Cohan Gallery, New York, USA

JUAN MUNOZ 1953-2001. Lived and worked Madrid, Spain. Exhibitions: The Renaissance Socieety at the University of Chicago, Chicago, USA, 1990; Museum für Gegenwartskunst, Zurich, Switzerland, 1996; Louisiana Museum of Modern Art, Humlebaek, Denamrk, 2000; Hirshhorn Museum and Sculpture Garden, Washington, DC, USA, 2004 + tour. Dealer: Marion Goodman, New York, USA; Galeria Massimo Minini, Brescia, Italy

TAKASHI MURAKAMI born 1962. Lives and works Tokyo, Japan, and New York, USA. Exhibitions: Nagoya Parco Gallery, Nagoya, Japan, 1999; Museum of Contemporary Art, Tokyo, Japan, 2001; Museum of Contemporary Art, New York, USA, 2001. Dealer: Marianne Boesky, New York, USA; Tomio Koyama Gallery, Tokyo, Japan; Blum & Poe, Santa Monica CA, USA

REI NAITO born 1961. Lives and works New York, USA. Exhibitions: The National Museum of Art, Osaka, Japan, 1995; Gallery Koyanagi, Tokyo, Japan, 1996; The Carmelite Cloisters Gallery, Frankfurt, Germany, 1997; Naoshima Contemporary Art Museum, Japan, 2001; Kunsthalle, Erfürt, Germany, 2003. Dealer: D'Amelio Terras, New York, USA; Galerie Jennifer Flay, Paris, France

YOSHITOMO NARA born 1959. Lives and works Tokyo, Japan. Exhibitions: SCAI The Bathhouse, Tokyo, Japan, 1995; Museum of Contemporary Art, Chicago, USA, 2000; Yokohama Museum of Art, Yokohama, Japan, 2001; Center for Contemporary Art, Cleveland OH, USA, 2003. Dealer: Marianne Boesky Gallery, New York, USA

DAVID NASH born 1945. Lives and works Blaenau Ffestiniog, UK. Exhibitions: Serpentine Gallery, London, UK, 1990; Mappin Art Gallery, Sheffield, UK, 1991; Asahikawa Museum of Art, Hokkaido, Japan, 1994; MUKHA, Antwerp, Belgium, 1996; New Art Centre, Roche Court, Salisbury, UK, 2003; Tate, St Ives, UK, 2004. Dealer: Annely Juda Fine Art, London, UK

BRUCE NAUMAN born 1941. Lives and works New Mexico. Exhibitions: Walker Art Center, Minneapolis MN, USA, 1993; Museum für Gegenwartskunst, Berlin, Germany, 1993; Kunstmuseum, Wolfsburg, Germany, 1997; Dia Center for the Arts, New York, USA, 2002; Deutsche Guggenheim, Berlin, Germany, 2003. Dealer: Zwirner & Wirth, New York, USA; Douglas Young Gallery, Chicago, USA

MIQUEL NAVARRO born 1945. Lives and works Valencia, Spain. Exhibitions: Museo Guggenheim, Bilbao, Spain, 2004; IVAM, Valencia, Spain, 2005; Museo Batha, Fez, Morocco, 2005. Dealer: Galerie Colon XVI, Bilbao, Spain; Galeria Saro Leon, Las Palmas, Gran Canaria

ERNESTO NETO born 1964. Lives and works Rio de Janiero, Brazil. Exhibitions: Contemporary Arts Museum, Houston TX, USA, 1999; ICA, London, UK, 2000; Waxner Center for the Arts, Columbus OH, USA, 2000; University Art Museum, Berkeley CA, USA, 2001. Dealer: Tanya Bonakdar, New York, USA; Galerie Yvon Lambert, Paris, France; Galeria Fortes Vilaca, São Paolo, Brazil

MARIELE NEUDECKER born 1965. Lives and works Bristol, UK. Exhibitions: Chapter Arts Centre, Cardiff, UK, 2002; Museum of Contemporary Art, Sydney, Australia, 2003; City Gallery, Prague, Czech Republic, 2004; Kunstmuseum, Krefeld, Germany, 2004; Tate, St Ives, UK, 2004. Dealer: Galerie Barbara Thumm, Berlin, Germany

RIVANE NEUENSCHWANDER born 1967. Lives and works Belo Horizonte, Brazil. Exhibitions: New Museum, New York, USA, 1998; SITE, Santa Fe NM, USA, 1999; Douglas Hyde Gallery, Dublin, Iceland, 2000; ArtPace, San Antonio TX, USA, 2001; Walker Art Center, Minneapolis MN, USA, 2002; Palais de Tokyo, Paris, France, 2003. Dealer: Galeria Fortes Vilaca, São Paolo, Brazil; Stephen Friedman, London, UK

OLAF NICOLAI born 1962. Lives and works Leipzig and Berlin, Germany. Exhibitions: Migros Museum, Zurich, Switzerland, 2001; Kunstmuseum, Thun, Germany, 2004; Altenburg Museum, Altenburg, Germany, 2004. Dealer: Galerie Erna Hecey, Brussels, Belgium; Galerie Eigen + Art, Berlin and Leipzig, Germany

TIM NOBLE and **SUE WEBSTER** born 1966, born 1967. Live and work London, UK. Exhibitions: DESTE Foundation, Athens, Greece, 2000; Milton Keynes Gallery, Milton Keynes, UK, 2002; PS1 Contemporary Art Center, New York, USA, 2003; Museum of Fine Arts, Boston, USA, 2004; Centro de Arte Contemporanea, Malaga, Spain, 2005. Dealer: Modern Art, London, UK; Gagosian Gallery, London, UK; Deitch Projects, New York, USA

CADY NOLAND born 1956. Lives and works New York, USA. Exhibitions: Museum Boijmans Van Beuningen, Rotterdam, The Netherlands, 1998; Migros Museum, Zurich, Switzerland, 1999. Dealer: Paula Cooper Gallery, New York, USA

CLAES OLDENBURG born 1929. Lives and works New York, USA. Exhibitions: Northen Centre for Contemporary Art, Sunderland, UK, 1989; Correr Museum, Venice, Italy, 1999; Fundacão de Serralves, Porto, Portugal, 2001; Metropolitan Museum of Art, New York, USA, 2001; Frederick Meijer Gardens, Grand Rapids MO, USA, 2002; Whitney Museum of American Art, New York, USA, 2002; Konrad Fischer Galerie, Dusseldorf, Germany, 2004. Dealer: Pace Gallery, New York, USA; Paula Cooper Gallery, New York, USA; Konrad Fischer Galerie, Dusseldorf, Germany

JAN VAN OOST born 1961. Lives and works Ghent, Belgium. Exhibitions: Galerie Xavier Hufkens, Brussels, Belgium, 1994; Galleria Persano, Turin, Italy, 1996; Groeninge museum, Bruges, Belgium, 1999; Galerie Dhondt-Dhaenens, Duerle, Belgium, 2002. Dealer: Galerie Piece Unique, Paris, France

JULIAN OPIE born 1958. Lives and works London, UK. Exhibitions: Ikon Gallery, Birmingham, UK, 2001; Neues Museum, Nuremberg, Germany, 2003; Selfridges Department Store, Manchester, UK, 2003. Dealer: Lisson Gallery, London, UK; Galerie Barbara Thumm, Berlin, Germany

DENNIS OPPENHEIM born 1938. Lives and works New York, USA. Exhibitions: Retrospective, Stadesmuseum, Pori, Finland 1993; Kunstsammlung Tumulka, Munich, Germany, 1995; Kunstverein, Mannheim, Germany, 1996; Museum voor Moderne Kunst, Arnhem, The Netherlands, 1999; Ludwig Forum, Aachen, Germany, 2001; Irish Museum of Modern Art, Dublin, Ireland, 2001; The Contemporary Museum, Honolulu, 2002; Whitney Museum of American Art, New York, USA, 2003; Nevada Museum of Art, Reno NV, USA, 2003; Arizona State University Art Museum, Tempe AZ, USA, 2004; Mam Mario Mauroner Contemporary Art, Vienna, Austria, 2005; Neuberger Museum of Art, New York, USA, 2006. Dealer: Stux Gallery, New York, USA; Haines Gallery, San Francisco, USA

GABRIEL OROZCO born 1962. Lives and works in Mexico and New York, USA. Exhibitions: The Museum of Modern Art, New York, USA, 1993; Kunsthalle Zürich, Zurich, Switzerland, 1996; Musée d'Art de la Ville de Paris, Paris, France, 1998; Museum of Contemporary Art, Los Angeles, USA, 2000; Kurimanzutto, Mexico City, Mexico, 2002; Serpentine Gallery, London, UK, 2004. Dealer: Marion Goodman, New York, USA; Galerie Chantal Crousel, Paris, France

LUCY ORTA born 1966. Lives and works Paris, France and London, UK. Exhibitions: Musée d'Art Contemporain, Bordeaux, France, 1995; Museum of Contemporary Art, Sydney, Australia, 1998; Secession, Vienna, Austria, 1999; Museum of Contemporary Art, Tokyo, Japan, 1999; Art Gallery of Western Australia, Perth, Australia, 2000; Musée des Arts Decoratifs, Lausanne, Switzerland, 2000; Frauen Museum, Bonn, Germany, 2001; Angel Row Gallery, Nottingham, UK, 2002; Barbican Art Gallery, London, UK, 2006.

DAMIAN ORTEGA born 1967. Lives and works Mexico City, Mexico. Exhibitions: Institute of Contemporary Art, Philadelphia, USA, 2002; Kunsthalle, Basel, Switzerland, 2004; Kurimanzutto, Mexico City, Mexico, 2005; Museum of Contemporary Art, Los Angeles, USA, 2005; DAAD Galerie, Berlin, Germany, 2007. Dealer: D'Amelio Terras, New York, USA; Galeria Art & Idea, Mexico City, Mexico

PEPON OSORIO born 1955. Lives and works Philadelphia, USA. Exhibitions: El Museo del Barrio, New York, USA, 1991; Cleveland Institute of Art, Cleveland OH, USA, 1993; The Newark Museum, Newark NJ, USA, 1996; Otis College of Art and Design, Westchester CA, USA, 1997; Museo Nacional Centro de Arte Reina Sofia, Madrid, Spain, 1998; El Museo del Barrio, New York, USA, 1999; Museo de Arte Contemporáneo, San Juan, Puerto Rico,

2000; Institute of Contemporary Art, Philadelphia, USA, 2004. Dealer: Bernice Steinbaum Gallery, Miami FL, USA; Ronald Feldman Gallery, New York, USA

TOM OTTERNESS born 1952. Lives and works New York, USA. Exhibitions: IVAM, Valencia, Spain, 1991 + tour; The Carnegie Museum of Art, Pittsburgh PA, USA, 1993; Gallery of Contemporary Art, Krannert Art Museum, Champaign IL, USA, 1994; Museum of Contemporary Art, Palm Beach FL, USA, 1998. Dealer: Marlborough Gallery, New York, USA; John Berggruen Gallery, San Francisco, USA

GAY OUTLAW born 1959. Lives and works San Francisco, USA. Exhibitions: Museum of Modern Art, San Francisco, USA, 1999; University Art Museum, Long Beach CA, USA, 2001; University of Virginia Art Museum, Charlottesville VA, USA, 2003; Mills College Art Museum, Oakland CA, USA, 2005. Dealer: Gallery Paule Anglim, San Francisco, USA

ROXY PAINE born 1966. Lives and works New York, USA. Exhibitions: Musée d'Art Americain, Giverny, France, 1998; Museum of Contemporary Art, North Miami FL, USA, 2001; SITE, Santa Fe NM, USA, 2002; Rose Art Museum, Brandeis University, Waltham MA, USA, 2002. Dealer: Ronald Feldman Gallery, New York, USA; James Cohan Gallery, New York, USA

MIMMO PALADINO born 1948. Lives and works Paduli, Italy. Exhibitions: Museu de Arte Moderna, Rio de Janiero, Brazil, 1992; Forte di Belverdere, Florence, Italy, 1993; Museo Diego Aragona Pignatelli Cortes, Naples, Italy, 1995; South London Gallery, London, UK, 1999; Retrospective, Lenbachhuas, Munich, Germany, 1999; Centro per l'arte contemporanea Luigi Pecci, Prato, Italy, 2002. Dealer: Sperone Westwater, New York, USA; Galerie Michael Haas, Berlin, Germany

PANAMARENKO born 1940. Lives and works Antwerp, Belgium. Exhibitions: Fondation Cartier, Paris, France, 1998; Hayward Gallery, London, UK, 2000; Jean Tinguely Museum, Basel, Switzerland, 2000; Dia Center for the Arts, New York, USA, 2001; Kewenig Gallery, Cologne, Germany, 2003; Deweer Art Otegem, Belgium, 2004; Hangar 7, Salzburg, Austria, 2004. Dealer: Liliane & Michel Durand-Dessert, Paris, France

GIULIO PAOLINI born 1946. Lives and works Turin, Italy. Exhibitions: Villa Medici, Rome, Italy, 1996; Neue Galerie am Landesmuseum Joanneum, Graz, Switzerland, 1998; Castello di Rivoli, Turin, Italy, 1999; Fundación La Caixa, Madrid, Spain, 2000; Rhona Hoffman Gallery, Chicago, USA, 2005. Dealer: Marion Goodman, New York, USA; Studio Marconi, Milan, Italy

JORGE PARDO born 1963. Lives and works Los Angeles, USA. Exhibitions: Kunstverein, Hamburg, Germany, 1993; Museum Boijmans Van Beuningen, Rotterdam, The Netherlands, 1997; Museum of Contemporary Art, Los Angeles, USA, 1998; Dia Center for the Arts, New York, USA, 2000; pkm Gallery, Seoul, South Korea, 2002; Dia Center for the Arts, New York, USA, 2003; Kunstmuseum, Aarhus, The Netherlands, 2005. Dealer: Friedrich Petzel Gallery, New York, USA; pkm Gallery, Seoul, South Korea; 1301PE, Los Angeles, USA

CORNELIA PARKER born 1956. Lives and works London, UK. Exhibitions: Ikon Gallery, Birmingham, UK, 1988; Cornerhouse Gallery, Manchester, UK, 1999; Chisenhale Gallery, London, UK, 1991; Serpentine Gallery, London, UK, 1995; Gallery 102, Dusseldorf, Germany, 1995; Chapter Arts Centre, Cardiff, UK, 1996; ArtPace San Antonio TX, USA, 1997; ICA, Philadelphia, USA, 2000; Galleria d'Arte Moderna e Contemporanea, Turin, Italy, 2001; Kunstverein, Wurttemberg, Germany, 2005; Yerba Buena Center for the Arts, San Francisco, USA, 2005; Bronte Parsonage Museum, Haworth, UK, 2006. Dealer: Frith Street Gallery, London, UK

JENNIFER PASTOR born 1966. Lives and works El Segundo CA, USA. Exhibitions: Richard Telles Fine Art, Los Angeles, USA, 1994; Museum of Contemporary Art, Chicago, USA, 1996 + tour; Whitney Museum of American Art, New York, USA, 2004. Dealer: Barbara Gladstone Gallery, New York, USA; Regen Projects, Los Angeles, USA

EVAN PENNY born 1953. Lives and works Toronto, Canada. Exhibitions: The Power Plant Contemporary Art Gallery,

Toronto, Canada, 2002; Glenbow Museum, Calgary, Canada, 2004; Hudson Valley Center for Contemporary Art, Peekskill NY, USA, 2005. Dealer: Sperone Westwater, New York, USA

GIUSEPPE PENONE born 1947. Lives and works Turin, Italy. Exhibitions: Museo de Arte Moderno, Buenos Aires, Argentina, 1997; The Douglas Hyde Gallery, Dublin, Ireland, 1999; Synagoge Stommeln, Pulheim-Stommeln, Germany, 2000; Centre Georges Pompidou, Paris, France, 2004. Dealer: Marion Goodman, New York, USA; Rudolf Zwirner, Cologne, Germany

MANFRED PERNICE born 1963. Lives and works Berlin, Germany. Exhibitions: Musée d'Art Moderne de la Ville de Paris, Paris, France, 1998; Portikus, Frankfurt, Germany, 2000; Witte de With, Rotterdam, The Netherlands, 2000. Dealer: Anton Kern, New York, USA; Mai 36 Galerie, Zurich, Switzerland; Galerie Neu, Berlin, Germany

PATRICIA PICCININI born 1965. Lives and works Melbourne, Australia. Exhibitions: Contemporary Art Centre of South Australia, Adelaide, Australia, 1996; Tolarno Galleries, Melbourne, Australia, 1999; Centro de Artes Visuales, Lima, Peru, 2001; Museum of Contemporary Art, Sydney, Australia, 2002; Hara Museum of Contemporary Art, Shinagawa, Tokyo, Japan, 2003; City Gallery, Wellington, New Zealand, 2006. Dealer: Roslyn Oxley9 Gallery, Sydney, Australia; Robert Miller Gallery, New York, USA

RONA PONDICK born 1952. Lives and works New York, USA. Exhibitions: Landessammlungen, Salzburg, Austria, 1999; Galleria d'Arte Moderna, Bologna, Italy, 2002; Groninger Museum, Groningen, The Netherlands, 2002; DeCordova Museum and Sculpture Park, Lincoln MA, USA, 2002; Museum of Contemporary Art, Cleveland OH, USA, 2004. Dealer: Jose Freire Gallery, New York, USA; Sonnabend Gallery, New York, USA

MARJETICA POTRČ born 1953. Lives and works Ljubljana, Slovenia. Exhibitions: Solomon R. Guggenheim Museum, New York, USA, 2001; Nordenhake Gallery, Berlin, Germany, 2003; List Visual Arts Center, Massachusetts Institute of Technology, Cambridge MA, USA, 2004; De Appel Foundation for Contemporary Art, Amsterdam, The Netherlands, 2004. Dealer: Max Protetch Gallery, New York, USA; Nordenhake Gallery, Berlin, Germany

MARTIN PURYEAR born 1941. Lives and works Accord NY, USA. Exhibitions: Museum of Fine Arts, Boston, USA, 1990; Retrospective, Art Institute of Chicago, Chicago, USA, 1991 + tour; Fundación La Caixa, Madrid, Spain, 1997; The Contemporary Arts Center, Cincinnati OH, USA, 1999; Virginia Museum of Fine Arts, Richmond VA, USA, 2001 + tour; BALTIC Centre for Contemporary Art, Gateshead, UK, 2003. Dealer: McKee Gallery, New York, USA; Donald Young Gallery, Chicago, USA; Margo Leavin Gallery, Los Angeles, USA

JON PYLYPCHUK born 1972. Lives and works Los Angeles, USA. Exhibitions: Andrea Rosen Gallery, New York, USA, 2005; Museum of Contemporary Art, Cleveland OH, USA, 2006; China Art Objects, Los Angeles, USA, 2006. Dealer: Friedrich Petzel Gallery, New York, USA; China Art Objects, Los Angeles, USA

MARC QUINN born 1964. Lives and works London, UK. Exhibitions: Tate Britain, London, UK, 1995; Kunstverein, Hanover, Germany, 1999; Fondazione Prada, Milan, Italy, 2000; Tate, Liverpool, UK, 2002; Irish Museum of Modern Art, Dublin, Ireland, 2003; Groninger Museum, Groningen, The Netherlands, 2006; MACRO, Rome, Italy, 2006. Dealer: White Cube, London, UK; Gagosian Gallery, New York, USA

EGLE RAKAUSKAITE born 1967. Lives and works Vilnius, Lithuania. Exhibitions: Centre for Contemporary Art, Vilnius, Lithuania, 2000; XL Gallery, Moscow, Russia, 2002; National Center for Contemporary Arts, Moscow, Russia, 2003; Tallin Art Hall, Tallin, Estonia, 2004. Dealer: Skuc Gallery, Ljubljana, Slovenia; P74 Gallery, Ljubljana, Slovenia

CHARLES RAY born 1953. Lives and works Los Angeles, USA. Exhibitions: Rooseum Center for Contemporary Art, Malmo, Sweden, 1994; Whitney Museum of American Art,

New York, USA, 1998; The Museum of Contemporary Art, Los Angeles, USA, 1998; Museum of Contemporary Art, Chicago, USA, 1999. Dealer: Donald Young Gallery, Chicago, USA; Regen Projects, Los Angeles, USA

ERWIN REDL born 1963. Lives and works New York, USA. Exhibitions: Kunsthalle, Krems, Austria, 1989; Galerie Stadtpark, Krems, Austria, 2000; Calvin Klein Store, Madison Ave., New York, USA, 2002; Plug-In Institute of Contemporary Art, Winnipeg, Canada, 2005. Dealer: Galerie Stadtpark, Krems, Austria; ACE Gallery, Los Angeles, USA

TOBIAS REHBERGER born 1966. Lives and works Frankfurt, Germany. Exhibitions: Museum Fridericianum, Kassel, Germany, 1995; Portikus, Frankfurt, Germany, 1996; Sprengel Museum, Hanover, Germany, 1998; Moderna Museet, Stockholm, Sweden, 1999; The Museum of Contemporary Art, Chicago, USA, 2000; Museum für Neue Kunst, Karlsruhe, Germany, 2002; Whitechapel Art Gallery, London, UK, 2004; Museo Nacional Centro de Arte Reina Sofia, Madrid, Spain, 2005. Dealer: Galerie Micheline Szwajcer, Berlin, Germany; Friedrich Petzel Gallery, New York, USA

PEDRO CABRITA REIS born 1956. Lives and works Lisbon, Portugal. Exhibitions: Magasin 3 Konsthall, Stockholm, Sweden, 2001; Kestner Gesellschaft, Hanover, Germany, 2002; Kunsthalle, Bern, Switzerland, 2004; Camden Arts Centre, London, UK, 2004; Galerie Nelson, Paris, 2005; Giorgio Persano, Turin, Italy, 2005. Dealer: Mai 36 Galerie, Zurich, Switzerland; Tracy Williams Ltd, New York, USA

THOMAS RENTMEISTER born 1964. Lives and works Berlin, Germany. Exhibitions: Stadtisches Museum Abteiberg. Monchengladbach, Germany, 1995; Kunstverein, Cologne, Germany, 2001; Hamburger Bahnhof, Berlin, Germany, 2002; Kunsthalle, Nuremberg, Germany, 2004; Haus am Waldsee, Berlin, Germany, 2007. Dealer: Otto Schweins Gallery, Cologne, Germany

RICHARD REZAC born 1952. Lives and works Chicago, USA. Exhibitions: Museum of Contemporary Art, Chicago, USA, 1990; Shoshana Wayne Gallery, Santa Monica CA, USA, 1991; Cedar Rapids Museum of Art, Cedar Rapids IA, USA, 1993; Rhona Hoffman Gallery, Chicago, USA, 2006. Dealer: Feature Inc, Los Angeles, USA; Marc Foxx, Los Angeles, USA

JASON RHOADES 1965-2006. Lived and worked Los Angeles, USA. Exhibitions: Kunsthalle, Nuremberg, Germany, 1998; Stedelijk Van Abbemuseum, Eindhoven, The Netherlands, 1998; Museum of Contemporary Art, Los Angeles, USA, 2001; Portikus, Frankfurt, Germany, 2001. Dealer: David Zwirner, New York, USA; Hauser & Wirth, Zurich, Switzerland; Galeria Helga de Alvear, Madrid, Spain

GERWALD ROCKENSCHAUB born 1952. Lives and works Vienna, Austria. Exhibitions: Villa Arson, Nice, France, 1992; Kunstverein, Hamburg, Germany, 1993; Secession, Vienna, Austria, 1994; Kunstverein, Hamburg, Germany, 1999; Retrospective, Museum of Modern Art, Vienna, Austria, 2004. Dealer: Hauser & Wirth, Zurich, Switzerland

UGO RONDINONE born 1964. Lives and works Zurich, Switzerland and New York, USA. Exhibitions: Kunsthaus Zürich, Zurich, Switzerland, 1994; Le Consortium, Dijon, France, 1997; Stedelijk Museum, Amsterdam, The Netherlands, 1998; Kunstmuseum, Aarhus, Denmark, 2000; Sommer Contemporary Art, Tel Aviv, Israel, 2000; Whitechapel Art Gallery, London, UK, 2006; Galeria Civica, Modena, Italy, 2006; Musée d'Art Contemporain, Lyons, France, 2007. Dealer: Matthew Marks Gallery, New York, USA; Hauser and Wirth and Presenhuber, Zurich, Switzerland; Schipper & Krome, Berlin, Germany

NANCY RUBINS born 1952. Lives and works Topanga CA, USA. Exhibitions: Museum of Contemporary Art, Los Angeles, USA, 1992; ArtPace, San Antonio TX, USA, 1998; Fondation Cartier pour l'art contemporain, Paris, France, 2003. Dealer: Gagosian Gallery, New York, USA; Paul Kasmin Gallery, New York, USA

ULRICH RUCKREIM born 1938. Lives and works Clonegal, Ireland. Exhibitions: Kunstmuseum, Winterthur, Switzerland, 1991; Kirkstall Abbey, Leeds, UK, 1993; Egyptian Museum, Berlin, Germany, 1994; Lenbachhaus,

Munich, Germany, 1995; Stedelijk Museum, Amsterdam, The Netherlands, 1997; Neue Nationgalerie, Berlin, Germany, 1998; Kunstverein, Dortmund, Germany, 1999; Neues Museum, Nuremberg, Germany, 2000; Contemporary Art Centre, Vilnius, Lithuania, 2000; Kunstmuseum, Bonn, Germany, 2002; Yorkshire Sculpture Park, Wakefield, UK, 2003; Gemeentemuseum, The Hague, The Netherlands, 2003; Wilhelm Lehmbruck Museum, Duisburg, Germany 2004. Dealer: Nohra Haime Gallery, New York, USA; Galerie Nordenhake, Berlin, Germany

URSULA VON RYDINGSVARD born 1942. Lives and works New York, USA. Exhibitions: Retrospective, Storm King Art Center, Mountainville NY, USA, 1992; Nelson Atkins Museum of Art, Kansas City MO, USA, 1997 + tour; Yorkshire Sculpture Park, Wakefield, UK, 1997; Madison Art Center, Madison WI, USA, 1998; Neuberger Museum of Art, New York, USA, 2002; Centre for Architecture, New York, USA, 2005. Dealer: Galerie Lelong, New York, USA

TOM SACHS BORN 1966. Lives and works New York, USA. Exhibitions: SITE, Santa Fe NM, USA, 1999; The Bohen Foundation, New York, USA, 2002; Deutsche Guggenheim, Berlin, Germany, 2003; Sammlung Goetz, Munich, Germany, 2004; Fondazione Prada, Milan, Italy, 2006. Dealer: Sperone Westwater, New York, USA; Galerie Thaddeus Ropac, Paris, France

DORIS SALCEDO born 1958. Lives and works Bogota, Colombia. Exhibitions: The New Museum of Contemporary Art, New York, USA, 1998; Museum of Modern Art, San Francisco, USA, 1999; Tate, London, UK, 1999; Camden Arts Centre, London, UK, 2001. Dealer: Alexander and Bonin, New York, USA; White Cube, London, UK

FRED SANDBACK 1943-2003. Lived and worked New York, USA. Exhibitions: Kunsthaus Zürich, Zurich, Switzerland, 1985; Yale University Contemporary Arts Museum, New Haven CT, USA, 1991; Dia Center for the Arts, New York, USA, 1996; Zwirner & Wirth, New York, USA, 2004; Kettle's Yard Gallery, Cambridge, UK, 2005. Dealer: Barbara Krakow Gallery, Boston, USA; Zwirner & Wirth, New York, USA; Lawrence Markey Gallery, New York, USA

KARIN SANDER born 1957. Lives and works Stuttgart, Germany. Exhibitions: Stadtisches Museum Abteiberg, Monchengladbach, Germany, 1992; The Museum of Modern Art, New York, USA, 1994; Sprengel Museum, Hanover, Germany, 1995; Kunsthalle, Goppingen, Germany, 1999; Staatsgalerie, Stuttgart, Germany, 2002; Centro Gallego de Arte Contemporanea, Santiago de Compostela, Spain, 2003; Centre d'art contemporain, Geneva, Switzerland, 2005. Dealer: D'Amelio Terras, New York, USA; Galerie Helga de Alvear, Madrid, Spain; Galerie Mueller-Roth, Stuttgart, Germany

MICHAEL SANDLE born 1936. Lives and works London, UK. Exhibitions: Retrospective, Whitechapel Art Gallery, London, UK, 1988; Galerie Carla Stutzer, Cologne, Germany, 1999. Dealer: The Drawing Gallery, London, UK

BOJAN SARCEVIC born 1974. Lives and works Paris, France. Exhibitions: Kunsthalle, Lophem, Belgium, 1999; Gesellschaft für Aktuelle Kunst, Bremen, Germany, 2000; Modern Institute, Glasgow, UK, 2000; Stedelijk Museum, Amsterdam, The Netherlands, 2001. Dealer: Galerie Carlier Gebauer, Berlin, Germany; Galerie BQ, Cologne, Germany; Pinksummer, Genoa, Italy

JOE SCANLAN born 1961. Lives and works Brooklyn NY, USA. Exhibitions: Ikon Gallery, Birmingham, UK, 2002; Van Abbemuseum, Eindhoven, The Netherlands, 2006; K21, Dusseldorf, Germany, 2006. Dealer: D'Amelio Terras, New York, USA; Micheline Szwajcer, Antwerp, Belgium

KATY SCHIMERT born 1963. Lives and works New York, USA. Exhibitions: The Renaissance Society at the University of Chicago, Chicago, USA, 1997; Art Museum, University of California, Berkeley CA, USA, 1999. Dealer: David Zwirner Gallery, New York, USA

THOMAS SCHUTTE born 1954. Lives and works Dusseldorf, Germany. Exhibitions: De Pont Museum for Contemporary Art, Tilburg, The Netherlands, 1998; Dia Center for the Arts, New York, USA, 1999; Sammlung Goetz, Munich, Germany, 2001; Folkwang Museum, Essen, Germany, 2002;

Kunstmuseum, Winterthur, Switzerland, 2003. Dealer: Marion Goodman, New York, USA

ALAIN SECHAS born 1955. Lives and works Paris, France. Exhibitions: Fondation Cartier, Paris, France, 1997; Kunstmuseum, Bonn, Germany, 1999; Musée d'Art Moderne et Contemporain, Strasbourg, France, 2001; Le Consortium, Dijon, France, 2001; Palais de Tokyo, Paris, France, 2005. Dealer: Baronian-Francey, Brussels, Belgium; Galerie Charlotte Moser, Geneva, Switzerland

GEORGE SEGAL 1924-2000. Lived and worked South Brunswick NJ, USA. Exhibitions: Retrospective, Jewish Museum, New York, USA, 1998. Dealer: Sidney Janis, New York, USA

BEVERLY SEMMES born 1952. Lives and works New York, USA. Exhibitions: Southampton City Art Gallery, Southampton, UK, 1994; The Museum of Contemporary Art, Chicago, USA, 1995; Irish Museum of Modern Art, Dublin, Ireland, 1996; Hirshhorn Museum and Sculpture Garden, Washington, DC, USA, 1996; Wexner Center for the Arts, Columbus OH, USA, 1997; Kunstverein, Ulm, Germany, 1999; The Fabric Workshop and Museum, Philadelphia, USA, 2000; Kunsthallen Brandts, Odense, Denmark, 2004. Dealer: Leslie Tonkonow, New York, USA; Shoshana Wayne Gallery, Los Angeles, USA

RICHARD SERRA born 1939. Lives and works New York, USA, and Nova Scotia, Canada. Exhibitions: Retrospective, Museo Nacional Centro de Arte Reina Sofia, Madrid, Spain, 1992; Tate Britain, London, UK, 1992; Dia Center for the Arts, New York, USA, 1997; Museo Archeologico, Naples, Italy, 2004; Guggenheim Museum, Bilbao, Spain, 2005; The Museum of Modern Art, New York, USA, 2007. Dealer: Gagosian Gallery, New York, USA

GIL SHACHAR born 1965. Lives and works Bremen, Germany. Exhibitions: The Artist's Studio Gallery, Tel Aviv, 1996; Wilhelm Lehmbruck Museum, Duisburg, Germany, 1998; Von-der-Heydt Museum, Wuppertal, Germany 1999. Dealer: Julie M. Gallery, Tel Aviv, Israel; Galerie Lohn, Monchengladbach, Germany

JOEL SHAPIRO born 1941. Lives and works USA. Exhibitions: Haus der Kunst, Munich, Germany + tour, 1998; Yorkshire Sculpture Park, Wakefield, UK, 1999; Museum of Fine Arts, Boston, USA, 1999; National Gallery of Canada, Ottowa, Canada, 2000; Metropolitan Museum of Art, New York, USA, 2001; Denver Art Museum, Denver, USA, 2001. Dealer: Pace Wildenstein, New York, USA

PETER SHELTON born 1951. Lives and works Los Angeles, USA. Exhibitions: Des Moines Art Center, Des Moines IA, USA, 1988; Dean Clough Henry Moore Sculpture Trust, Halifax, UK, 1998; Contemporary Arts Museum, Houston TX, USA, 1998. Dealer: LA Louver, Los Angeles, USA

YINKA SHONIBARE born 1962. Lives and works London, UK. Exhibitions: Ikon Gallery, Birmingham, UK, 1999; Camden Arts Centre, London, UK, 2000; The Andy Warhol Museum, Pittsburgh PA, USA, 2002; Moderna Museet, Stockholm, Sweden, 2004; Boijmans Van Beuningen Museum, Rotterdam, The Netherlands, 2004. Dealer: Stephen Friedman Gallery, London, UK

WIEBKE SIEM born 1954. Lives and works Hamburg and Berlin, Germany. Exhibitions: Kunstraum Neue Kunst, Hanover, Germany, 1991; Portikus, Frankfurt, Germany, 1994; Kunstverein, Bonn, Germany, 1996; Kunsthalle, Bern, Switzerland, 1997; Henry Moore Institute, Leeds, UK, 2001. Dealer: Galerie Johnen & Schottle, Cologne, Germany; Galerie Rudiger Schottle, Munich, Germany; Galerie Rudiger Schottle, Paris, France

SANTIAGO SIERRA born 1966. Lives and works Mexico City, Mexico. Exhibitions: Ikon Gallery, Birmingham, UK, 2002; Kunsthalle, Vienna, Austria, 2002; Palais de Tokyo, Paris, France, 2003; Kunsthaus, Bregenz, Austria, 2004. Dealer: Lisson Gallery, London, UK; Galerie Peter Kilchmann, Zurich, Switzerland; Galeria Enrique Guerrero, Mexico City, Mexico

ROMAN SIGNER born 1938. Lives and works St Gallen, Switzerland. Exhibitions: Survey, Bonnefantenmuseum,

Maastricht, The Netherlands, 2000; Camden Arts Centre, London, UK, 2001; Centro Gallego de Arte Contemporanea, Santiago de Compostela, Spain, 2006. Dealer: Hauser & Wirth, Zurich, Switzerland

JEANNE SILVERTHORNE born 1950. Lives and works New York, USA. Exhibitions: Studio La Citta, Verona, Italy, 1995; Institute of Contemporary Art, Philadelphia, USA, 1996; Whitney Museum of American Art, New York, USA, 1999; Williams College Art Museum, Williamstown MA, USA, 2001; Gallery Seomi, Seoul, South Korea, 2006. Dealer: McKee Gallery, New York, USA

CHARLES SIMONDS born 1945. Lives and works New York, USA. Exhibitions: Corcoran Gallery, Washington DC, USA, 1988; Retrospective, La Caixa, Barcelona, Spain, 1994; Centre Hospitalier, St. Anne, Paris, France, 1995; Denver Art Museum, Denver CO, USA, 2000; Retrospective, IVAM, Valencia, Spain, 2003. Dealer: Marianne Boesky Gallery, New York, USA

PENNY SIOPSIS born 1953. Lives and works Johannesburg, South Africa. Exhibitions: Adelson Galleries, New York, USA, 1996. Dealer: Linda Goodman Galleries, Johannesburg, South Africa

DAVID SMITH 1906-1965. Lived and worked Bolton Landing, USA. Exhibitions: Storm King Art Centre, Mountainville NY, USA, 1998 and 1999; Metropolitan Museum of Art, New York, USA, 2000; IVAM, Valencia, Spain, 2004; Solomon R. Guggenheim Museum, New York, USA, 2006; Centre Georges Pompidou, Paris, France, 2006; Tate Modern, London, UK, 2007. Dealer: Gagosian Gallery, New York, USA

KIKI SMITH born 1954. Lives and works New York, USA. Exhibitions: Whitechapel Art Gallery, London, 1995; Irish Museum of Modern Art, Dublin, Ireland, 1997; Kestner Gesellschaft, Hanover, Germany, 1998; Hirshhorn Museum and Sculpture Garden, Washington DC, USA, 1998; The Museum of Modern Art, New York, USA, 2003; The Fabric Workshop and Museum, Philadelphia, USA, 2003; Whitney Museum of American Art, New York, USA, 2006; Contemporary Arts Museum, Houston TX, USA, 2006. Dealer: Pace Wildenstein, New York, USA

TONY SMITH 1912-1980. Lived and worked New York, USA. Exhibitions: Retrospective, The Museum of Modern Art, New York, USA, 1998. Dealer: Matthew Marks, New York, USA; Mitchell-Innes & Nash, New York, USA

VALESKA SOARES born 1957. Lives and works New York, USA. Exhibitions: Musuem of Modern Art, San Francisco, USA, 2001; Museo Rufino Tamayo, Mexico City, Mexico, 2003; The Bronx Museum of the Arts, New York, USA, 2003. Dealer: Galeria Fortes Vilaca, São Paulo, Brazil

YUTAKA SONE born 1965. Lives and works Los Angeles, USA, and Tokyo, Japan. Exhibitions: Mito Art Tower, Mito, Japan, 1993; Hiroshima Contemporary Art Museum, Hiroshima, Japan, 1997; Sogetsu Art Museum, Tokyo, Japan, 1999; ArtPace, San Antonio TX, USA, 2000; The Museum of Contemporary Art, Los Angeles, USA, 2001. Dealer: David Zwirner, New York, USA

KIM SOOJA born 1957. Lives and works New York, USA. Exhibitions: Gallery Seomi, Seoul, South Korea, 1994; Centre d'Art Contemporain Nationale, Grenoble, France, 1997; CCC, Kitayushu, Japan, 1999; Sprengel Museum, Hanover, Germany, 2001; PS1 Contemporary Art Center, New York, USA, 2001; Kunsthalle, Vienna, Austria, 2002; The Zacheta Gallery of Art, Warsaw, Poland, 2003; Museum Kunst Palast, Dusseldorf, Germany, 2004. Dealer: Peter Blum, New York, USA

ANTONIO SOSA born 1952. Lives and works Seville, Spain. Exhibitions: Galeria Berini, Barcelona, Spain, 1991; Torre de los Guzmanes, Seville, Spain, 1992. Dealer: Galeria Rafael Ortiz, Seville, Spain; Galerie Zellermayer, Berlin, Germany; Galerie Tomas March, Valencia, Spain; Galeria Alonso Vidal, Barcelona, Spain

MONICA SOSNOWSKA born 1972. Lives and works Warsaw, Poland. Exhibitions: Kurimanzutto, Mexico City, Mexico, 2003; Basis Voor Actuele Kunst, Utrecht, The Netherlands, 2004; De Appel Gallery, Amsterdam, The Netherlands, 2004;

Serpentine Gallery, London, UK, 2004. Dealer: Gallery Foksal, Warsaw, Poland; Laura Pecci, Milan, Italy

OUSMANE SOW born 1935. Lives and works Paris, France. Exhibitions: City Museum, Dakar, Senegal, 1987; Pont des Arts Outdoor exhibition, Paris, France, 1999. Dealer: Le Petit Jardin, Paris, France

ETTORE SPALLETTI born 1940. Lives and works Cappelle Sultavo, Italy. Exhibitions: Portikus, Frankfurt, Germany, 1990; South London Gallery, London, UK, 1995; Museum van Hedendaagse Kunst, Antwerp, Belgium, 1996; Henry Moore Institute, Leeds, UK, 2005. Dealer: Studio La Citta, Verona, Italy; Xavier Hufkens, Brussels, Belgium

PIA STADTBAUMER born 1959. Lives and works Hamburg, Germany. Exhibitions: Sprengel Museum, Hanover, Germany, 1999; Kunstmuseum, Bonn, Germany, 2000; Kunstverein, Ulm, Germany, 2001; Produzentgalerie, Hamburg, Germany, 2006. Dealer: Sean Kelly Gallery, New York, USA

HAIM STEINBACH born 1944. Lives and works New York, USA. Exhibitions: Witte de With, Rotterdam, The Netherlands, 1992; Solomon R. Guggenheim Museum, New York, USA, 1993; Castello di Rivoli, Turin, Italy, 1995; Tel Aviv Museum, Tel Aviv, Israel, 2000. Dealer: Sonnabend Gallery, New York, USA; Galleria Lia Rumma, Milan and Naples, Italy

FRANK STELLA born 1936. Lives and works New York, USA. Exhibitions: Waddington Galleries, London, UK, 2005; Harvard University Art Museums, Cambridge MA, USA, 2006. Dealer: Jacobson Howard Gallery, New York, USA

JANA STERBAK born 1955. Lives and works Montreal, Canada. Exhibitions: Fundación La Caixa, Barcelona, Spain, 1993; Louisiana Museum, Humlebaek, Denmark, 1993; Museum of Contemporary Art, Chicago, USA, 1998; The Fabric Workshop and Museum, Philadelphia, USA, 1999; Art Gallery of Sudbury, Sudbury, Ontario, Canada, 2002; Malmo Konsthall, Malmo, Sweden, 2002; Kunsthallen Bradts, Odense, Denmark, 2004; Centre Culturel Canadien, Paris, France, 2006; Palazzo delle Papesse, Siena, Italy, 2006; Carre d'Art, Nimes, France, 2006. Dealer: Donald Young Gallery, Chicago, USA; Galeria Toni Tapies, Barcelona, Spain; Barbara Gross Galerie, Munich, Germany

JESSICA STOCKHOLDER born 1959. Lives and works New Haven CT, USA. Exhibitions: Kunsthalle Zürich, Zurich, Switzerland, 1992; Dia Center for the Arts, New York, USA, 1995; Kunstnernes Hys, Oslo, Norway, 1997; Open Air Museum of Sculpture, Middelheim, Antwerp, Belgium, 1998. Dealer: Jay Gorney Modern Art, New York, USA; Galerie Nathalie Obadia, Paris, France

YOSHIHIRO SUDA born 1969. Lives and works Tokyo, Japan. Exhibitions: Megro Museum of Art, Tokyo, Japan, 1999; Ujazdoswki Castle, Warsaw, Poland, 2000; Hara Museum, Tokyo, Japan, 2000; The Museum of Modern Art, Gunma, Japan, 2002; Dundee Contemporary Arts, Dundee, UK, 2002; Art Institute of Chicago, Chicago, USA, 2003; Shiseido Gallery, Tokyo, Japan, 2004. Dealer: D'Amelio Terras, New York, USA; Gallery 360, Tokyo, Japan

DO-HO SUH born 1962. Lives and works New York, USA. Exhibitions: PS1 Contemporary Art Center, New York, USA, 2000; Serpentine Gallery, London, UK, 2002; Seattle Art Museum, Seattle WA, USA, 2002; Art Sonje Centre, Seoul, South Korea, 2003; Hermes Department Store, Tokyo, Japan, 2005; The Fabric Workshop and Museum, Philadelphia, USA, 2005. Dealer: Lehmann Maupin Gallery, New York, USA

TOMOAKI SUZUKI born 1972. Lives and works London, UK. Exhibitions: Michael Janssen Gallery, Cologne, Germany, 2001; Northern Centre for Contemporary Arts, Sunderland, UK, 2004. Dealer: Corvi-Mora, London, UK

RICKY SWALLOW born 1974. Lives and works Melbourne, Australia, and London, UK. Exhibitions: National Gallery of Australia, Canberra, Australia, 2000; Museum of Contemporary Art, Sydney, Australia, 2001; Stedelijk Museum voor Actuele Kunst, Ghent, Belgium, 2001; Public Art Gallery, Dunedin, New Zealand, 2001; Gertrude Contemporary Art Spaces, Melbourne, Australia, 2004. Dealer: Darren Knight Gallery, Sydney, Australia; Andrea Rosen Gallery, New York, USA

ERICK SWENSON born 1972. Lives and works Dallas TX, USA. Exhibitions: Diverse Works Art Space, Houston TX, USA, 1996; Museum of Contemporary Art, Sydney, Australia, 2001; Villa Stuck, Munich, Germany, 2002; UCLA Hammer Museum, Los Angeles, USA, 2003; Scottsdale Museum of Contemporary Art, Scottsdale AZ, USA, 2004. Dealer: Angstrom Gallery, Dallas TX, USA; James Cohan Gallery, New York, USA

SARAH SZE born 1969. Lives and works New York, USA. Exhibitions: ICA, London, UK, 1998; Fondation Cartier, Paris, France, 1999; Museum of Contemporary Art, Chicago, USA, 1999; Museum of Contemporary Art, San Diego CA, USA, 2001; Museum of Fine Arts, Boston, USA, 2002; Walker Art Center, Minneapolis MN, USA, 2002; Whitney Museum of American Art, New York, USA, 2003; Fondazione Davide Halevim, Milan, Italy, 2004; Malmo Konsthall, Malmo, Sweden, 2006. Dealer: Marianne Boesky Gallery, New York, USA

TOMOKO TAKAHASHI born 1966. Lives and works London, UK. Exhibitions: Riverside Studios, London, UK, 1995; Hales Gallery, London, UK, 1997; Atlanta Contemporary Art Center, Atlanta GA, USA, 2000; Clissold Park, London, UK, 2000; Craft Museum, New Delhi, India, 2002; New Museum of Contemporary Art, New York, USA, 2003; Mori Art Museum, Tokyo, Japan, 2004; Kunsthalle, Kiel, Germany, 2004; Kunsthalle, Bern, Switzerland, 2005; Serpentine Gallery, London, UK, 2005. Dealer: Hales Gallery, London, UK

TONY TASSET born 1960. Lives and works Chicago, USA. Exhibitions: Karsten Schubert, London, UK, 1987; Shedhalle, Zurich, Switzerland, 1992; Kolnischer Kunstverein, Cologne, Germany, 1997; Institute of Visual Arts, University of Wisconsin, Milwaukee WI, USA, 1998; The Contemporary Arts Center, Cincinnati OH, USA, 2000; Illinois State University, Normal IL, USA, 2003; PS1 Contemporary Art Center, New York, USA, 2006. Dealer: Rhona Hoffman Gallery, Chicago, USA; Christopher Granes Gallery, Santa Monica CA, USA

MARCUS TAYLOR born 1964. Lives and works London, UK. Exhibitions: White Cube, London, UK, 1993; PACE, Edinburgh, UK, 2000. Dealer: White Cube, London, UK

PASCALE MARTHINE TAYOU born 1967. Lives and works Brussels, Belgium. Exhibitions: Galerie Peter Herrmann, Stuttgart, Germany, 1999 and 2001; Portikus, Frankfurt, Germany, 2002; MARTA Herford, Germany, 2005. Dealer: Lombard Freid Fine Arts, New York, USA; Galleria Continua, San Gimignano, Italy

ROBERT THERRIEN born 1947. Lives and works Los Angeles, USA. Exhibitions: The Eli Broad Family Foundation, Los Angeles, USA, 1994; Saidye Bronfman Centre for the Arts, Montreal, Canada, 1996; The Contemporary Arts Center, Cincinnati OH, USA, 1997; Kemper Museum of Contemporary Art, Kansas City MO, USA, 2000; Los Angeles County Museum of Art, USA, 2000 + tour; The Eli Broad Art Foundation, Santa Monica CA, USA, 2003. Dealer: Gagosian Gallery, New York, USA; Lora Reynolds Gallery, Austin TX, USA

RIRKRIT TIRAVANIJA born 1961. Lives and works New York, USA and Berlin, Germany. Exhibitions: Kolnischer Kunstverein, Cologne, Germany, 1996; The Museum of Modern Art, New York, USA, 1997; Migros Museum, Zurich, Switzerland, 1998; Kunsthalle, Oslo, Norway, 2001; Secession, Vienna, Austria, 2002; Ikon Gallery, Birmingham, UK, 2003; Galerie für Zeitgenössische Kunst, Leipzig, Germany, 2003; Boijmans Van Beuningen, Rotterdam, The Netherlands, 2004; ARC, Paris, France, 2004. Dealer: Gavin Brown's Enterprise, New York, USA; Gallery Side 2, Tokyo, Japan; Neugerriemschneider, Berlin, Germany

MOMOYO TORIMITSU born 1967. Lives and works New York, USA. Exhibitions: Swiss Institute of Contemporary Art, New York, USA, 2004; Momentaart, Brooklyn, New York, 2005. Dealer: Deitch Projects, New York, USA; Galerie Xippas, Paris, France

SHIGEO TOYA born 1947. Lives and works Saitama, Japan. Exhibitions: Satani Gallery, Tokyo, Japan, 1995; Shugoarts, Tokyo, Japan, 2003, 2004 and 2006. Dealer: Kenji Taki Gallery, Tokyo and Nagoya, Japan; Shugoarts, Tokyo, Japan

ROSEMARIE TROCKEL born 1952. Lives and works Cologne, Germany. Exhibitions: Museum of Contemporary Art, Chicago, USA, 1991; Museum Ludwig, Cologne, Germany, 1992; City Gallery, Wellington, New Zealand, 1993; Hamburger Kunsthalle, Hamburg, Germany, 1998; Whitechapel Art Gallery, London, UK, 1998; Stadtische Galerie im Lenbachhaus, Munich, Germany, 2000; Sammlung Goetz, Munich, Germany, 2002; Museum für Moderne Kunst, Frankfurt, Germany, 2003; Museum Ludwig, Cologne, Germany, 2005 Museum für Moderne Kunst, Duisburg, Germany, 2006. Dealer: Barbara Gladstone, New York, USA

ANNE TRUITT 1921-2004. Lived and worked Washington, DC, USA. Exhibitions: The Corcoran Gallery of Art, Washington DC, USA, 1974; Georgia O'Keeffe Museum, Sante Fe NM, USA, 2002; Danese Gallery, New York, USA 2001 and 2003. Dealer: Danese, New York, USA; Andre Emmerich, New York, USA

SHIRLEY TSE born 1968. Lives and works Los Angeles, USA. Exhibitions: MFA Gallery, College of Design, Pasadena CA, USA, 1996; MacLennan Gallery, St Louis University, St Louis MO, USA, 2000; Para/Site Art Space, Hong Kong, China, 2000; Pomona College Museum of Art, Claremont CA, USA, 2004. Dealer: Shoshana Wayne Gallery, Los Angeles, USA

GAVIN TURK born 1967. Lives and works London, UK. Exhibitions: New Art Gallery, Walsall, UK, 2002; White Cube, London, UK, 2004. Dealer: White Cube, London, UK

JAMES TURRELL born 1943. Lives and works Flagstaff AZ, USA. Exhibitions: Nagoya City Museum, Japan, 1998; National Gallery of Art, Washington, DC, USA, 2002; Mattress Factory, Pittsburgh PA, USA, 2003; Sonoma County Museum, Sonoma CA, 2003; pkm Gallery, Seoul, South Korea, 2003; Centre national d'art et du paysage, Vassiviere en Limousin, France, 2004. Dealer: Pace Wildenstein, New York, USA

CY TWOMBLY born 1928. Lives and works Rome, Italy. Exhibitions: Retrospective, Kunsthalle, Bern, Switzerland, 1973; Retrospective, Whitney Museum of American Art, New York, USA, 1979; Retrospective, Museum Haus Lange, Krefeld, Germany, 1982; Retrospective, The Museum of Modern Art, New York, USA, 1994; Kunstmuseum, Basel, Switzerland, 2000; Pinakothek der Moderne, Munich, Germany, 2002; Serpentine Gallery, London, UK, 2004. Dealer: Gagosian Gallery, New York, USA

PALOMA VARGA-WEISZ born 1966. Lives and works Dusseldorf, Germany. Exhibitions: Kunstverein, Bremerhaven, Germany, 2001; Castello di Rivoli, Turin, Italy, 2002; Museum Kurhaus, Kleve, Germany, 2004; Kunsthalle, Dusseldorf, Germany, 2004. Dealer: Sadie Coles HQ, London, UK; Konrad Fischer Galerie, Dusseldorf, Germany; Gladstone Gallery, New York, USA

XAVIER VEILHAN born 1963. Lives and works Paris, France. Exhibitions: Fundació Joan Miro, Barcelona, Spain, 2001; Barbican Centre, London, UK, 2002; Centre Georges Pompidou, Paris, France, 2004; Fondation Vasarely, Aix-en-Provence, France, 2004. Dealer: Galerie Jennifer Flay, Paris, France; Galeria Fac Simile, Milan, Italy; Galerie Martin Janda, Vienna, Austria

JAN VERCRUYSSE born 1948. Lives and works Brussels, Belgium. Exhibitions: Van Abbemuseum, Eindhoven, The Netherlands, 1997; Palais des Beaux-Arts, Brussels, Belgium, 1999; Museum Dhondt-Dhaenens, Deurle, Germany, 2003. Dealer: Xavier Hufkens, Brussels, Belgium; Tracy Williams Ltd, New York, USA

DIDIER VERMEIREN born 1951. Lives and works Brussels, Belgium. Exhibitions: Xavier Hufkens, Brussels, Belgium, 2000; Van Abbemuseum, Eindhoven, The Netherlands, 2003. Dealer: Xavier Hufkens, Brussels, Belgium; Galerie Ghislaine Hussenot, Paris, France

HENK VISCH born 1950. Lives and works Eindhoven, The Netherlands and Stuttgart, Germany. Exhibitions: Groninger Museum, Groningen, The Netherlands, 1984; Stadtische Galerie, Nordhorn, Germany, 1986; Kunstraum, Wuppertal, Germany, 1990; Produzenten Galerie, Hamburg, Germany, 1994; Open Air Museum of Sculpture, Middelheim, Antwerp, Belgium, 1996; Sprengel Museum, Hanover, Germany,

1998; Kunstverein, Bremerhaven, Germany, 2001; De Pont Museum for Contemporary Art, Tilburg, The Netherlands, 2005; Moriyama House, Tokyo, Japan, 2006. Dealer: Produzentengalerie, Hamburg, Germany

MARK WALLINGER born 1959. Lives and works London, UK. Exhibitions: Grey Art Gallery, New York, USA, 1991; ICA, London, UK, 1991; Ikon Gallery, Birmingham, UK, 1995; Deweer Art Gallery, Otegem, Belgium, 1997; Delfina, London, UK, 1998; Portikus, Frankfurt, Germany, 1999; Museum für Gegenwartskunst, Basel, Switzerland, 1999; Secession, Vienna, Austria, 2000; Retrospective, Tate, Liverpool, UK, 2000; Tate Britain, London, UK, 2007. Dealer: Anthony Reynolds, London, UK

ZHAN WANG born 1962. Lives and works Beijing, China. Exhibitions: Central Academy of Fine Arts, Beijing, China, 2003; Jardin des Tuileries, Paris, France, 2004; House of Shiseido, Tokyo, Japan, 2004; Museum of Contemporary Art, Chicago, USA, 2005. Dealer: Shanghart Gallery, Beijing, China; Courtyard Gallery, Beijing, China

NARI WARD born 1963. Lives and works New York, USA. Exhibitions: Isabella Stewart Gardner Museum, Boston, USA, 2002; Walker Art Center, Minneapolis MN, USA, 2002; Addison Gallery of American Art, Andover MA, USA, 2002. Dealer: Deitch Projects, New York, USA

ANDY WARHOL 1928-1987. Lived and worked New York, USA. Exhibitions: Retrospective, The Museum of Modern Art, New York, USA, 1989

REBECCA WARREN born 1965. Lives and works London, UK. Exhibitions: Maureen Paley Interim Art, London, UK, 2000; The Saatchi Gallery, London, UK, 2003; Kunsthalle Zürich, Zurich, Switzerland, 2004. Dealer: Maureen Paley Interim Art, London, UK; Matthew Marks, New York, USA; Donald Young Gallery, Chicago, USA

GARY WEBB born 1973. Lives and works London, UK. Exhibitions: MW Projects, London, UK, 2002; Migros Museum, Zurich, Switzerland, 2003; Chisenhale Gallery, London, UK, 2004; Kunsthaus, Glarus, Switzerland, 2005; Bortolami Dayan, New York, USA, 2006. Dealer: The Approach, London, UK

MEG WEBSTER born 1944. Lives and works San Francisco, USA. Exhibitions: Contemporary Arts Museum, Houston TX, USA, 1993; PS1 Contemporary Art Center, New York, USA, 1998; Aspen Art Museum, Aspen CO, USA, 1999; Centro de Arte de Salamanca, Spain, 2001; COPIA, Napa CA, USA, 2003; Queens Museum of Art, Queens NY, USA, 2005. Dealer: Morris Healy, New York, USA; Paula Cooper Gallery, New York, USA

RICHARD WENTWORTH born 1947. Lives and works London, UK. Exhibitions: Serpentine Gallery, London, UK, 1993; Stedelijk Museum, Amsterdam, The Netherlands, 1994; Galleri Wang, Oslo, Norway, 1999; Irish Museum of Modern Art, Dublin, Ireland, 2003; Tate, Liverpool, UK, 2005. Dealer: Lisson Gallery, London, UK

NICOLE WERMERS born 1971. Lives and works Hamburg, Germany and London, UK. Exhibitions: Museum Ludwig, Cologne, Germany, 2001; Kunstverein, Bonn, Germany, 2001; Delfina Gallery, London, UK, 2003; Migros Museum, Zurich, Switzerland, 2004; Secession, Vienna, Austria, 2004. Dealer: Stephen Friedman Gallery, London, UK; Produzentgalerie, Hamburg, Germany; Tanya Bonkdar Gallery, New York, USA

FRANZ WEST born 1947. Lives and works Vienna, Austria. Exhibitions: Stadtisches Museum, Monchengladbach, Germany, 1996; The Museum of Modern Art, New York, USA, 1997; The Renaissance Society at the University of Chicago, Chicago, USA, 1999; Berlin Projects, Berlin, Germany, 2002; Whitechapel Art Gallery, London, UK, 2003; Kunsthaus, Bregenz, Austria, 2003; Mass MOCA, North Adams MA, USA, 2003; Kunsthaus, Bregenz, Austria, 2003. Dealer: Gagosian Gallery, New York, USA; Galerie Barbel Grasslin, Frankfurt, Germany; Hauser & Wirth and Presenhuber, Zurich, Switzerland

PAE WHITE born 1963. Lives and works Los Angeles, USA. Exhibitions: UCLA Hammer Museum, Los Angeles, USA,

2004; La Salle de Bains, Lyon, France, 2004; Centre d'Art Contemporain, Delme, France, 2004; neugerriemschneider, Berlin, 2005. Dealer: 1301PE, Los Angeles, USA; Skestos Gabriele Gallery, Chicago, USA; greengrassi, London, UK

RACHEL WHITEREAD born 1963. Lives and works London, UK. Exhibitions: Chisenhale Gallery, London, UK, 1990; Stedelijk van Abbemuseum, Eindhoven, The Netherlands, 1992; Kunsthalle, Basel, Switzerland, 1994; Tate, Liverpool, UK, 1996; Museo Nacional Centro de Arte Reina Sofia, Madrid, Spain, 1997; Public Art Fund, New York, USA, 1998; Deutsche Guggenheim, Berlin, Germany, 2001; Serpentine Gallery, London, UK, 2001; Victoria & Albert Museum, London, UK, 2003; Museu de Arte Moderna, São Paolo, Brazil, 2004; Tate Modern, London, UK, 2005. Dealer: Anthony D'Offay/Haunch of Venison, London, UK; Gagosian Gallery, New York, USA

ALISON WILDING born 1948. Lives and works London, UK. Exhibitions: Moderna Galerija, Ljubljana, Slovenia, 1989; Tate, Liverpool, UK, 1991; Henry Moore Sculpture Trust Studio, Dean Clough, Halifax, UK, 1991; Newlyn Art Gallery, Penzance, UK, 1993; Tate, St Ives, UK, 1993; Mattress Factory, Pittsburgh PA, USA, 1994; Angel Row Gallery, Nottingham, UK, 1995; Douglas Hyde Gallery, Dublin, Ireland, 1996; The Edmonton Art Gallery, Edmonton, Canada, 1997; Northern Gallery for Contemporary Art, Sunderland, UK, 1998; The Henry Moore Foundation Studio, Dean Clough, Halifax, UK, 2000; Peter Pears Gallery, Aldeburgh, UK, 2003. Dealer: Karsten Schubert, London, UK

HANNAH WILKE 1940-1993. Lived and worked New York, USA. Exhibitions: Retrospective, University of Missouri, St Louis MO, USA, 1989; Helsinki City Art Museum, Helsinki, Finland, 1989; Nikolay Contemporary Art Center, Copenhagen, Denmark, 1995; Santa Monica Museum of Art, Santa Monica CA, USA, 1996; Retrospective, Neue Gesellschaft für bildende Kunst, Berlin, Germany, 2000. Dealer: Ronald Feldman Fine Arts, New York, USA

FRED WILSON born 1954. Lives and works New York, USA. Exhibitions: The Contemporary and Maryland Historical Society, Baltimore MD, USA, 1992; Seattle Art Museum, Seattle WA, USA, 1993; Museum of Contemporary Art, Chicago, USA, 1996; The Ian Potter Museum of Art, The University of Melbourne, Australia, 1998; Fine Arts Museum of San Francisco, USA, 1999; Survey, Center for Art and Visual Culture, University of Maryland, Baltimore County MD, USA, 2002 + tour. Dealer: Pace Wildenstein, New York, USA; Rena Bransten Gallery, San Francisco, USA

RICHARD WILSON born 1953. Lives and works London, UK. Exhibitions: Arnolfini Gallery, Bristol, UK, 1989; Mito Art Tower, Mito, Japan, 1993; Museum of Contemporary Art, Los Angeles, USA, 1995; Serpentine Gallery, London, UK, 1996; Stadtisches Museum, Zwickau, Germany, 1998; Taipei Fine Arts Museum, Taipei, Taiwan, 2001. Dealer: Matts Gallery, London, UK

WOLFGANG WINTER and **BERTHOLD HORBELT** born 1960, born 1958. Live and work Frankfurt, Germany. Exhibitions: Hanoi City Tea House, Hanoi, Vietnam, 1999; Rice University Gallery, Houston TX, USA, 2000; South Bank Museums, Frankfurt, Germany, 2001; Folkwang Museum, Essen, Germany, 2003; Yorkshire Sculpture Park, Wakefield, UK, 2004; Museum für Moderne Kunst, Frankfurt, Germany, 2004; Schlosspark Kassel Wilhelmshohe, Kassel, Germany, 2005. Dealer: Galerie Voges & Partner, Frankfurt, Germany; Nusser & Baumgart Contemporary, Munich, Germany

KRZYSZTOF WODICZKO born 1943. Lives and works New York, USA. Exhibitions: Galerie Lelong, New York, USA, 1996; Generali Foundation, Vienna, Austria, 2002. Dealer: Galerie Lelong, New York, USA

BILL WOODROW born 1948. Lives and works London, UK. Exhibitions: Oriel Gallery, Cardiff, UK, 1995; Camden Arts Centre, London, UK, 1995; Tate Britain, London, UK, 1996; Mestna Galerija, Ljubljana, Slovenia, 1997; New Art Centre Sculpture Park, Roche Court, UK, 2000; South London Gallery, London, UK, 2001; Snape Maltings, Snape, UK, 2005; Plymouth City Museum and Art Gallery, Plymouth, UK, 2006. Dealer: Lisson Gallery, London, UK; Galerie Sabine Wachters, Brussels, Belgium

ERWIN WURM born 1954. Lives and works Vienna, Austria. Exhibitions: Secession, Vienna, Austria, 1991; Kunstverein, Hamburg, Germany, 1993; Villa Arson, Nice, France, 1993; Museum Moderner Kunst Stiftung Ludwig, Vienna, Austria, 1995; Institute of Visual Arts, University of Wisconsin, Milwaukee WI, USA, 1998; Neue Galerie, Graz, Austria, 2002; Yerba Buena Center for the Arts, San Francisco, USA, 2004; Museum der Moderne, Salzburg, Austria, 2005; Ludwig Forum für Internationale Kunst, Aachen, Germany, 2006 + tour. Dealer: Galerie Zellermayer, Berlin, Germany; Jack Hanley Gallery, San Francisco, USA; Galerie Krinzinger, Vienna, Austria

AH XIAN born 1960. Lives and works Sydney, Australia. Exhibitions: Beijing Teachers University, Beijing, China, 2000; Queensland Art Gallery, Brisbane, Australia, 2000; Asia Society, New York, USA, 2002; Frankfurt Museum, Frankfurt, Germany, 2002

YIN XIUZHEN born 1963. Lives and works Beijing, China. Exhibitions: Contemporary Art Museum, Beijing, China, 1995; Capital Normal University Museum, Beijing, China, 1996; Manchester Craft Centre, Manchester, UK, 1998; Gertrude Front Gallery, Melbourne, Australia, 2000; Anna Schwartz Gallery, Sydney, Australia, 2002; McMaster University, Art Gallery of Hamilton, Hamilton, Canada, 2004; Town Hall, Friedrichshafen, Germany, 2004. Dealer: Alexander Ochs Galleries, Berlin, Germany and Beijing, China; Ethan Cohen, New York, USA

YUKINORI YANAGI born 1959. Lives and works New York, USA and Okayama City, Japan. Exhibitions: Ars Futura, Zurich, Switzerland, 1993; The University Art Museum, University of California at Santa Barbara CA, USA, 1995; Wadsworth Atheneum, Hartford CT, USA, 1995; Chisenhale Gallery, London, UK, 1997; Art Gallery of New South Wales, Sydney, Australia, 2006. Dealer: Peter Blum Gallery, New York, USA; Maru Gallery, Tokyo, Japan

DAISY YOUNGBLOOD born 1945. Lives and works New Mexico. Exhibitions: University Gallery, University of Massachusetts, Amherst MA, USA, 1996; DC Moore Gallery, New York, USA, 2000; Survey, The Contemporary Museum, Honolulu, USA, 2003. Dealer: McKee Gallery, New York, USA

LIM YOUNG-SUN born 1959. Lives and works Seoul, South Korea. Exhibitions: Kumho Museum of Art, Seoul, South Korea, 1989; Total Museum, Changhueng, Korea, 1992; Seoul Arts Center, Seoul, South Korea, 1996; Liebman Magnan Gallery, New York, USA, 2000; University of Wyoming Art Museum, Laramie WY, USA, 2002. Dealer: Park Ryu Sook Gallery, Seoul, South Korea; Stux Gallery, New York, USA

CHEN ZHEN 1955-2000. Lived and worked Paris, France. Exhibitions: The New Museum of Contemporary Art, New York, USA, 1994; Center for Contemporary Art, Kitayushu, Japan, 1998; National Maritime Museum, Stockholm, Sweden, 1998; Museum of Art, Tel Aviv, Israel, 1998; Museum of Contemporary Art, Zagreb, Croatia, 1998; Espace Culturel Francois Mitterand, Perigueux, France, 1999; Serpentine Gallery, London, UK, 2001; PS1 Contemporary Art Center, New York, 2003; Kunsthalle, Vienna, Austria, 2007. Dealer: Galleria Continua, San Gimignano, Italy

ANDREA ZITTEL born 1965. Lives and works Los Angeles, USA. Exhibitions: Museum of Modern Art, San Francisco, USA, 1995; Museum für Gegenwartskunst, Basel, Switzerland, 1996; Deichtorhallen, Munster, Germany, 1999; Public Art Fund, New York, USA, 1999; Ikon Gallery, Birmingham, UK, 2001. Dealer: Andrea Rosen, New York, USA; Sadie Coles HQ, London, UK

GILBERTO ZORIO born 1944. Lives and works Turin, Italy. Exhibitions: Retrospective, Kunstverein, Stuttgart, Germany + tour, 1985; Centro per l'Arte Contemporanea Luig Pecci, Prato, Italy, 1992; Galleria Civica d'Arte Moderna, Trento, Italy, 1996; Dia Centre for the Arts, New York, USA, 2002; Galleria Giorgio Persano, Turin, Italy, 2006. Dealer: Galeria Luis Adelantado, Valencia, Spain; Salvatore Ala Gallery, Milan, Italy; Sonnabend Gallery, New York, USA

1975

Death of Dame Barbara Hepworth
Anthony Caro exhibition, MOMA, New York
General Franco dies in Spain
Fall of Saigon -- end of Vietnam War
Baader-Meinhof trial in *Stuttgart*

1976

Claes Oldenburg's *Clothespin* unveiled in Philadelphia
Tate purchases Carl Andre's *Equivalent VIII*
Richard Long at the British Pavilion, Venice Biennale
Christo's *Running Fence*, Sonoma and Marin Counties,
 California
Jimmy Carter becomes US President
Founding of P.S.1, New York

1977

'Contemporary Women: Consciousness and Content',
 Brooklyn Museum, New York
Gilbert and George give up their roles as
 'living sculptures' and start to make
 photo pieces
Walter de Maria *Lightning Field*, New Mexico
Opening of Centre Georges Pompidou in Paris
First cases of AIDS diagnosed in New York
Death of Mao TseTung
Documenta 6 held in Kassel, West Germany

1978

George Segal's Memorial for Kent State University
 rejected
First test-tube baby born in UK
Death of Gordon Matta-Clark
Francis Ford Coppola's film *Apocalypse Now*

1979

Rosalind Krauss's essay 'Sculpture in the expanded field'
 published in *October* magazine
Gino de Dominicis 'Invisible Statues' exhibition at
 Mario Pieroni Gallery, Rome
Margaret Thatcher becomes Conservative Prime Minister of UK
Joseph Beuys retrospective exhibition, Guggenheim Museum,
 New York
Jean-Francois Lyotard's book *The Post-Modern
 Condition* published

1980

Bice Curiger's Zurich exhibition 'Saus und Braus.Stadtkunst'
Georg Baselitz shows wooden sculpture, German Pavilion,
 Venice Biennale
Green Party founded in West Germany
Mugabe becomes Prime Minister of Zimbabwe
Ronald Reagan becomes US President
Gulf War, Iraq invades Iran

1981

Tony Cragg's first solo show at the Whitechapel
 Gallery, London
Richard Serra's *Tilted Arc* unveiled in Federal Plaza,
 New York
Objects and Sculpture exhibition, ICA Gallery, London

1982

Maya Lin's *Vietnam Veterans Memorial*, Constitution
 Gardens, Washington DC
Joseph Beuys's *7000 Oaks* project at Documenta 7, Kassel
Agnes Denes *Wheatfield: A Confrontation*, Battery Park,
 New York
Issey Miyake outfit on the cover of February edition
 of *Artforum* magazine
Falklands War between UK and Argentina
Hans Hollein's Städtisches Museum at Monchengladbach opens
Documenta 7 held in Kassel, West Germany

1983

'The New Art' exhibition, Tate, London
Compact discs first marketed
Green party wins seats in German Bundestag
Lech Walesa awarded Nobel Peace Prize
Cruise missiles arrive at Greenham Common, UK

1984

First Turner Prize award at Tate Gallery, won by
 Malcolm Morley
James Stirling and Michael Wilford -- Stuttgart
 Neu Staatsgalerie opens
Primitivism in 20th century Art, exhibition, MOMA,
 New York

1985

Christo wraps the Pont Neuf, Paris
Charles Saatchi opens London gallery to house
 his growing collection
Jeff Koons 'Equilibrium' exhibition, New York
President Gorbachev elected in USSR
WHO declares AIDS an epidemic
Gordon Matta-Clark retrospective exhibition,
 MOCA, Chicago

1986

Clore Gallery opens at Tate
'Damaged Goods. Desire and the Economy of the Object'
 exhibition, New York
Jochen and Esther Gerz unveil their *Monument against
 Fascism*, Harburg, Germany
Helen Chadwick's 'Of Mutability' exhibition at the
 ICA Gallery, London
Death of Henry Moore
Death of Joseph Beuys
Death of Ana Mendieta
Opening of the Reina Sofia Gallery, Madrid
Opening of Museum Ludwig, Cologne
Opening of MOCA, Los Angeles
Chernobyl nuclear accident in USSR
'Endgame: Reference and Simulation in Recent Painting
 and Sculpture' Exhibition in Boston

1987

Richard Wilson's *20/50* shown at Matts Gallery, London
Jana Sterbak exhibits *Vanitas, Flesh Dress of an Albino
 Anorectic*, at The Ydessa Gallery, Toronto, Canada
Richard Deacon wins the Turner Prize
Skulptur Projekte, City of Munster
Richard Serra's *Fulcrum* sited at Broadgate,
 City of London
Death of Andy Warhol
Martin Kippenberger incorporates a painting by
 Gerhard Richter into a coffee table
Stock market crash on 'Black Monday'
'Art Against Aids' exhibitions at 72 New York galleries
Documenta 8 held in Kassel, West Germany

1988

Start of the Channel Tunnel between Britian and France
Tony Cragg at the British Pavilion, Venice Biennale
'Freeze' exhibition, curated by Damien Hirst,
 in a warehouse in Surrey Docks, East London

1989

Antony Gormley's *Field for Mexico*
Richard Long wins the Turner Prize
Opening of IVAM, Valencia
Berlin Wall comes down
Removal of Richard Serra's *Tilted Arc*, from
 Federal Plaza, New York
'Magiciens de la Terre' exhibition, Pompidou Centre
 and La Vilette, Paris
Massacre of protesters, Tiananmen Square, Beijing

1990

'High and Low, Modern Art and Popular Culture'
 exhibition, MOMA, New York
'Viral Infection: The Body and its Discontents' exhibition,
 Hallwalls Contemporary Art Center, Buffalo
Nelson Mandela released from jail, South Africa
Reunification of Germany

1991

Anish Kapoor wins the Turner Prize
Dislocations (installation) exhibition, MOMA, New York
Cornelia Parker's Cold Dark Matter: An Exploded View
 exhibited, at Chisenhale Gallery, London
Opening of Museum of Contemporary Art, Frankfurt
Mel Chin plants Revival Field in Saint Paul, Minnesota
Gulf War, Iraqi forces removed from Kuwait
Boris Yeltsin becomes Russian President. Dissolution of USSR
Start of civil war in Yugoslavia
Donna Haraway's book A Cyborg Manifesto: Science,
 Technology and Socialist-Feminism in the late
 Twentieth Century published

1992

Grenville Davey wins the Turner Prize
Ilya Kabalov's The Toilet at Documenta 9, Kassel
Bill Clinton becomes US President
Fred Wilson presents Mining the Museum in Baltimore
Documenta 9 held in Kassel, Germany

1993

Rachel Whiteread's House, and she wins the Turner Prize
Louise Bourgeois at American Pavilion, Venice Biennale
Abject Art exhibition, New York
Beginning of the Internet
Damien Hirst shows Mother and Child, Divided --
 a bisected cow and calf -- at the Venice Biennale

1994

Antony Gormley wins the Turner Prize
Demolition of Whiteread's House
Andy Warhol Museum established in Pittsburgh
Nelson Mandela elected President of South Africa,
 the end of White Rule
Channel Tunnel opens

1995

Damien Hirst wins the Turner Prize
'The Maybe', Cornelia Parker's exhibition at the Serpentine
 Gallery, London
Opening of MACBA, Barcelona
'Identity and Alterity: Figures of the Body 1895/1995'
 exhibition, Venice Biennale
Human/Nature exhibition, New Museum, New York
Christo wraps the Reichstag, Berlin
Bosnia peace accord signed in Dayton, Ohio

1996

Rachel Whiteread awarded commission for the Austrian
 Holocaust Memorial in Vienna
Opening of Daniel Liebeskind's Jewish Museum, Berlin
Oleg Kulik arrested for his performance as a dog at the
 private view of 'Interpol -- a global network from Stockholm
 and Moscow', Centre for Contemporary Art, Stockholm
Inception of Hugo Boss Prize at the Guggenheim, New York
 -- won by Matthew Barney

1997

'Sensation' exhibition at the Royal Academy, London
Rachel Whiteread at the British Pavilion, Venice Biennale
Skulptur Projekte, City of Munster
Opening of the Guggenheim Museum, Bilbao
Opening of the J. Paul Getty Center, Los Angeles
Tony Blair becomes Labour Prime Minister

Death of Diana, Princess of Wales
Documenta 10 held in Kassel, Germany

1998

'Wounds: Between Democracy and Redemption in
 Contemporary Art', exhibition at Moderna Museet,
 Stockholm
US President Bill Clinton accused of perjury over
 alleged sexual impropriety
Unveiling of Antony Gormley's Angel of the North near
 Gateshead, England
Retrospective exhibition of Piero Manzoni (1933-63)
 at Serpentine Gallery, London
Germany announces it will pay $110 million over 5 years
 to Holocaust survivors in Eastern Europe

1999

Cai Guo Qiang's Rent Collection Courtyard at the
 Venice Biennale
Opening of Museu de Serralves, Oporto, Portugal
Louise Bourgeois awarded Golden Lion achievement award
 at Venice Biennale
Gabriel Orozco's Parking Lot exhibition at Galerie
 Micheline Swajcer, Antwerp, offering desperate
 drivers a place to park

2000

Opening of Tate Modern
Sarah Lucas exhibition at the Freud Museum, London
Unnatural Science exhibition, Massachussetts MOCA
Wim Delvoye exhibits Cloaca at MUKHA, Antwerp
Marjetica Potrc wins the Hugo Boss Prize, New York

2001

Opening of Baltic, Gateshead
Takashi Murakami designs handbags for Louis Vuitton
Destruction of Bamiyan Buddhas by Taleban regime,
 Afghanistan
Destruction of World Trade Center, New York, by terrorists

2002

Martin Creed wins the Turner Prize
Iraq war
looting of National Museum, Baghdad
Documenta 11 held in Kassel, Germany, curated by a team
 led by Nigerian Okwui Enwezor
Anish Kapoor's sculpture Marsyas fills the Turbine Hall
 at Tate Modern

2003

ICA, London appoints a scientist-in-residence
At the Venice Biennale, Utopia Station and Zone of
 Urgency sections
Schaulager exhibition venue opens, Basel, Switzerland,
 designed by Herzog & De Meuron
Contemporary Art Center, Cincinnati, USA, opens,
 designed by Zaha Hadid
Elmgreen & Dragset dismantled the collection of the
 Museum Kunst Palast, Dusseldorf, drove it round
 the block on trucks, and reinstalled it

2004

British Imperial War Museum appoints Langlands & Bell
 as official war artists in Afghanistan
Fire at MOMart warehouse, London, UK, destroyed numerous
 contemporary works of art, including pieces by Damien
 Hirst, Tracey Emin and the Chapman brothers.
Donald Judd retrospective at Tate Modern, London, UK,
 curated by Nicholas Serota
21st century Museum of Contemporary Art, Kanazawa,
 Japan, opens
Madrid train bombs

2005

Marc Quinn's marble sculpture of Alison Lapper,
 installed on Fourth Plinth, Trafalgar Square,
 London, UK
Venice Biennale curated by two Spanish women, Maria
 Corral and Rosa Martinez
Harald Szeeman, the curator who produced the seminal
 1969 exhibition 'When Attitudes become form' dies
Walker Art Center, Minneapolis, unveils new galleries
 designed by Herzog & De Meuron
Christo presents 'The Gates' in Central Park, New York
Richard Serra installs A matter of time, the biggest
 sculptural installation ever, in the Guggenheim
 Museum, Bilbao, Spain

2006

Marcel Duchamp voted most influential artist in UK
 survey of art students
Broad Foundation, Los Angeles, buys a collection of
 570 works by Joseph Beuys
A new museum for ancient and contemporary ethnic art,
 the Musee du Quai Branly, designed by Jean Nouvel,
 opens in Paris
Yorkshire Sculpture Park unveils James Turrell's
 Skyspace, a permanent installation in a historic
 deer shelter
Death of Jason Rhoades

2007

Olympic Sculpture Park opens in Seattle, USA
Judd Foundation opens the artist's SoHo home in New York
 to the public
Death of Sol LeWitt
Damien Hirst shows his diamond-encrusted skull, valued
 at £50 million, at White Cube Gallery, London

BIBLIOGRAPHY

GENERAL

Bachelard, Gaston, *The Poetics of Space*, Boston, 1994
Barthes Roland, *Mythologies*, New York, 1972
Buskirk, Martha, *The Contingent Object of Contemporary Art*, Cambridge MA, 2003
Cabanne, Pierre, *Dialogues with Duchamp*, New York, 1979
Causey, Andrew, *Sculpture Since 1945*, Oxford, 1998
Danto, Arthur C., *After the End of Art: Contemporary Art and the Pale of History*, Princeton NJ, 1997
Duby, Georges, and Jean-Luc Duval, *Sculpture from Antiquity to the Present Day*, Taschen, 2002
Esche, Charles, et al., *East Art Map*, London, 2006
Foster, Hal, *The Return of the Real*, Cambridge MA, 1996
Fried, Michael, *Art and Objecthood*, Chicago and London, 1998
Harper, Glenn, and Twylene Moyer, eds, *A Sculpture Reader: Contemporary Sculpture since 1980*, Washington, DC, 2006
Kraus, Chris, Jan Tumlir and Jane McFadden, *LA Artland -- Contemporary Art from Los Angeles*, London, 2005
Krauss, Rosalind, *Passages in Modern Sculpture*, New York and London, 1977
Krauss, Rosalind, *The Originality of the Avant-Garde and other Modernist Myths*, Cambridge MA, 1984
Kwon, Miwon, *One Place After Another: Site-Specific Art and Locational Identity*, Cambridge MA, 2002
McEvilley, Thomas, *Sculpture in the Age of Doubt*, New York, 1999
Maraniello, Gianfranco, *Art in Europe 1990-2000*, Milan, 2002
Masheck, Joseph, *Marcel Duchamp in Perspective*, New York, 2002
Meyer, Ursula, *Conceptual Art*, New York, 1992
Morris, Robert, *Continuous Project Altered Daily*, New York, 1993
Nuridsany, Michael, *China Art Now*, Paris, 2004
Obrist, Hans Ulrich, *Interviews, Volume 1*, Milan, 2003
Potts, Alex, *The Sculptural Imagination: Figurative, Modernist, Minimalist*, New Haven and London, 2000

THE FIGURE

Abject Art: Repulsion and Desire in American Art, exhib. cat., Whitney Museum of American Art, New York, 1993
Bloom, Michelle E., *Waxworks: a cultural obsession*, Minneapolis and London, 2003
Buchsteiner, Thomas, and Otto Letze, eds., *Duane Hanson: More Than Reality*, Ostfildern-Ruit, Germany, 2001
Gaudibert, Pierre, *Art Africain Contemporain*, Paris, 1992
Georg Baselitz, exhib. cat., Solomon R. Guggenheim Museum, New York, 1995
Posner, Helene, *Kiki Smith*, Boston, 1998
Royle, Nicholas, *The Uncanny*, Manchester, 2003
Second Skin: Historical Life Casting and Contemporary Sculpture, exhib. cat., Henry Moore Inst., Leeds, 2002

THE BODY FRAGMENTED

Bourgeois, Louise, *Destruction of the Father/ Reconstruction of the Father, Writings & Interviews, 1923-1997*, Cambridge MA, 1998
Le corps en morceaux, exhib. cat., Musee d'Orsay, Paris, 1990
Nochlin, Linda, *The Body in Pieces: The Fragment as a Metaphor of Modernity*, London, 1994

STRANGE CREATURES

Haraway, Donna, *Symians, Cyborgs, and Women: The Reinvention of Nature*, New York, 1991

POST-POP OBJECTS

Baudrillard, Jean, *The System of Objects*, London and New York, 1996
British Sculpture Now, exhib. cat., Kunstmuseum, Lucerne, 1982
Eco, Umberto, *Faith in Fakes: Travels in Hyperreality*, London, 1986
Endgame. Reference and Simulation in Recent Painting and Sculpture, exhib. cat., Institute of Contemporary Art, Boston, 1986
A Forest of Signs, exhib. cat., Museum of Contemporary Art, Los Angeles, 1990
Hughes, Anthony, and Erich Ranfft, eds, *Sculpture and its Reproductions*, London, 1997
Koons, Jeff, *The Jeff Koons Handbook*, London, 1992
Nittve, Lars, ed., *Allan McCollum*, Malmo, 1990
Thompson, Jon, et al., *Richard Deacon*, London, 1995
Warner, Marina, *Richard Wentworth*, London, 1994

ARCHITECTURE & FURNITURE

Bloemink, Barbara, and Joseph Cunningham, *Design/ Art: Functional Objects from Donald Judd to Rachel Whiteread*, London and New York, 2004
Bruderlin, Markus, ed., *ArchiSculpture: Dialogues between Architecture and Sculpture from the Eighteenth Century to the Present Day*, Ostfildern-Ruit, Germany, 2004
Mario Merz, exhib. cat., Solomon R Guggenheim Museum, New York, 1989
Marjetica Potrc: Urgent Architecture, exhib. cat., Palm Beach Inst. of Contemporary Art, Lake Worth FL, 2004
Schafaff, Jorn, and Barbara Steiner, eds, *Jorge Pardo*, Baden-Wurttemberg, 2000

CULTURAL DIVERSITY

Camnitzer, Luis, *New Art of Cuba*, Austin, Texas, 1994
Corrin, Lisa, et al., *Mark Dion*, London, 1997
Finkelpearl, Tom, *David Hammons*, Cambridge MA, 1991
Flam, Jack D., ed., *Primitivism and Twentieth Century Art: A Documentary History*, Berkeley, California, 2003
Herkenhoff, Paulo, et al., *Cildo Meireles*, London, 1999
Magiciens de la Terre, exhib. cat., Centre Georges Pompidou, Paris, 1989
Mulver, Laura, et al., *Jimmie Durham*, London, 1995

TRADITIONAL MATERIALS

Bronze: The Power of Life and Death, exhib. cat., Henry Moore Institute, Leeds, 2005
Levi, Primo, *The Periodic Table*, New York, 1984
Penny, Nicholas, *The Materials of Sculpture*, London and New Haven, 1993
A Primal Spirit: Ten Contemporary Japanese Sculptors, exhib. cat., Los Angeles County Museum of Art, Los Angeles, 1990
Tony Cragg -- Signs of Life, exhib. cat., Kunst und Ausstellungshalle der Bundesrepublik Deutschland, Bonn, 2003

EPHEMERAL EFFECTS

Ana Mendiata: a Retrospective, exhib. cat., The New Museum of Contemporary Art, New York, 1992
Celant, Germano, ed., *Piero Manzoni*, London, 1998
Christov-Bakargiev, Carolyn, ed., *Arte Povera*, London, 1999
Crow, Thomas, *Gordon Matta Clark*, London, 2003
Friis-Hansen, Dana, et al., *Cai Guo-Qiang*, London, 2002
Lippard, Lucy, *Eva Hesse*, New York, 1992
Moure, Gloria, ed., *Kounellis*, New York, 1990

INSPIRED BY NATURE

Bann, Stephen, *Ian Hamilton Finlay: A Visual Primer*, London, 1985
Beardsley, John, *Earthworks and Beyond Contemporary Art in the Landscape*, New York, 1984
Enclosed and Enchanted, exhib. cat., Museum of Modern Art, Oxford, 2000
Fuchs, Rudi, *Richard Long*, New York and London, 1986
Tiberghien, Gilles, *Land Art*, London, 1995
Utopia Post Utopia: Configurations of Nature and Culture in Recent Sculpture and Photography, exhib. cat., The Institute of Contemporary Art, Boston, USA, 1988

COLOUR, SURFACE & LIGHT

Adcock, Craig, *James Turrell: The Art of Light and Space*, Berkeley, California, 1990
Batchelor, David, *Chromophobia*, London, 2000
Celant, Germano, *Anish Kapoor*, Milan, 1995
Colour After Klein: Rethinking Colour in Modern and Contemporary Art, exhib. cat., Barbican Art Gallery, London, 2005
Dan Flavin: The Architecture of Light, exhib. cat., Solomon R. Guggenheim Museum, New York, 1999
Elger, Dietmar, ed., *Donald Judd: Colorist*, Hanover, 2000
Neri, Louise, et al., *Roni Horn*, London, 2000
Robert Irwin, exhib. cat., The Museum of Contemporary Art, Los Angeles, 1993

MEMORY

Ann Hamilton: Mneme, exhib. cat., Tate, Liverpool, 1994
Blume, Anna, *Zoe Leonard*, Vienna, 1997

Cacciari, Massimo, and Germano Celant, *Anselm Kiefer*, Milan, 1997
Doubletake: Collective Memory and Current Art, exhib. cat., Hayward Gallery, London, 1992
Gumpert, Lynne, *Christian Boltanski*, Paris and London, 1992
Martin Honert, exhib. cat., Matthew Marks Gallery, New York, 2004
Martin, Jean-Hubert, Boris Groys, et al., *Ilya Kabakov: Installations 1983-1995*, Paris, 1995

CLOTHING

Charles LeDray, Sculpture 1989-2002, exhib. cat., Institute of Contemporary Art, University of Pennsylvania, Philadelphia, 2002
Lucy Orta: Body Architecture, exhib. cat., University of South Florida Contemporary Art Museum, 2001
Untragbar: Mode als Skulptur, exhib. cat., Museum für Angewandte Kunst, Cologne, 2001

MONUMENTALITY

Balkin Bach, Penny, *Public Art in Philadelphia*, Philadelphia, 1992
Lingwood, James, ed., *Rachel Whiteread, House*, London, 1995
Webster, Sally, *Critical Issues in Public Art: Content, Context and Controversy*, New York, 1992
Weyergraf-Serra, Clara and Martha Buskirk, eds, *The Destruction of Tilted Arc: Documents*, Cambridge MA, 1991
Young, James, *The Texture of Memory: Holocaust Memorials and Meaning*, New Haven and London, 1993

INSTALLATION

Asher, Michael, *Writings 1973-1983 on Works 1969-1979*, Halifax, Nova Scotia, 1983
Crimp, Douglas, *On the Museum's Ruins*, Cambridge MA, 1993
Haacke, Hans, *Unfinished Business*, Cambridge MA, 1986
Mack, G., *Art Museums into the 21st Century*, Basel, 1999
Marcel Broodthaers, 1924-1976, exhib. cat., Galerie Nationale du Jeu de Paume, Paris, 1991
Newhouse, Victoria, *Art and the Power of Placement*, New York, 2005
O'Doherty, Brian, *Inside the White Cube: The Ideology of the Gallery Space*, Berkeley CA, 1999
de Oliveira, Nicholas, Nicola Oxley and Michael Petry, *Installation Art*, London, 1994

GRAVITY

Peter Shelton: bottlesbonesandthingsgetwet, exhib. cat., Los Angeles County Museum of Art, 1994
Richard Serra: Weight and Measure, exhib. cat., Tate, London, 1992
Richard Serra: Torqued Ellipses, exhib. cat., Dia Center for the Arts, New York, 1997

SIZE & SCALE

Tom Sachs: Cultural Prosthetics, exhib. cat., Gian Enzo Sperone, Rome, 1997

ACCUMULATION

The Art of Assemblage, exhib. cat., Museum of Modern Art, New York, 1961
Scanlan, John, *On Garbage*, London, 2005
Vergine, Lea, *When Trash Becomes Art*, Milan, 2007

MINIMALISM

Andre, Carl, and Hollis Frampton, *12 Dialogues 1962-1963*, Halifax, Nova Scotia, 1981
Battcock, Gregory, *Minimal Art: A Critical Anthology*, New York, 1968
Berger, Maurice, *Labyrinths: Robert Morris, Minimalism and the 1960s*, New York, 1989
Judd, Donald, *Donald Judd, Complete Writings, 1959-1975*, Halifax, Nova Scotia, 1975
Meyer, James, *Minimalism: Art and Polemics in the Sixties*, New Haven and London, 2001
Sol LeWitt: A Retrospective, exhib. cat., San Francisco Museum of Modern Art, 2000
Zelevansky, Lynne, *Sense and Sensibility: Women Artists and Minimalism in the Nineties*, New York, 1994

Courtesy 1301PE, LLC., Los Angeles 2006/Photo: Fredrik Nilsen: 384; Courtesy the artists and Ace Gallery: 82, 204, 272-3; Courtesy the artist and Acuna-Hansen Gallery: 89t; Courtesy Albright-Knox Art Gallery, Buffalo, NY/Photo: Tom Loonan: 283; Courtesy Alexander and Bonin, New York: 36r, 125, 160, 163t, 207b; Courtesy Alexander and Bonin, New York and verna & mai 36 project, Zürich/Photo: Bill Orcutt: 402; ● Allen Memorial Art Museum, Oberlin College: 152, 366; Courtesy the artist/Anderson Gallery, Buffalo and Sherman Galleries: 429; ● Angelos/Photo: Attilio Maranzano: 313; Courtesy the artist and Gallery Paule Anglim, San Francisco/Photo: Gay Outlaw: 210; Private collection, courtesy Annely Juda Fine Art, London: 28; Courtesy The Approach, London: 253; The Arman Studio Archives/Photo: Shunk Kender: 9t; Courtesy Gallery Arndt & Partner/Photo: 74 FBM-Studio: 26t; Courtesy the artists and Art & Public, Geneva: 112, 306; ● And courtesy the artist: 23, 24, 43, 49, 62, 85, 88, 130, 156, 157, 191, 193, 218, 231r, 233t, 236, 285br, 304, 314, 321b, 368, 388, 405b, 417b; Courtesy the artist/Photo: Andrew Miksys: 209; Photo: Edward Woodman: 105; Photo: Jens Ziehe: 269, 275; Photo: Jörg Hejkal: 208b; Photo: Peter Mauss/ESTO: 407; Photo: Terry Rishel: 195; Photo: Woodley & Quick: 408; Photo: Wolfgang Träger: 434b; ● The artist/State Art Collection, Western Australia Art Gallery: 361; Courtesy Collection of Charles Asprey and Galerie NEU: 134t; Courtesy Athens National Museum of Contemporary Art, Inv. No. 514/04: 343; Courtesy the artist and Luhring Augustine, New York: 208t; Marieluise Hessel Collection on permanent loan to the Center for Curatorial Studies, Bard College, Annandale-on-Hudson, New York: 270l; ● Barford Sculptures Ltd/Photo: John Riddy: 131; ● The artist/Courtesy Galeria Ramis Barquet: 154; ● Georg Baselitz/Photo: Martin Müller, Berlin: 16; Courtesy Baumgartner Gallery, New York: 260; Courtesy Elba Benitez Gallery, Madrid: 116l; Courtesy the artist and Blum & Poe, Los Angeles, CA/Photo: Joshua White: 405t; Courtesy Marianne Boesky Gallery, New York: 90bl, 424; ● The artist/Courtesy Bolsa de Arte de Porto Alegre/Photo: Egon Kroeff Neto: 285t; Courtesy the artists and Tanya Bonakdar Gallery, New York: 441, 238; Courtesy of Tanya Bonakdar Gallery, New York and Alexander Gray Associates, New York/Photo: Jorge Colombo: 308(1); Courtesy Louise Bourgeois Studio: 59, 280, 302r; Bridgeman Art Library: 331; Courtesy the British Council: 229; Courtesy the artist and Gavin Brown's enterprise/Photo: Tom Powel Imaging. Inc.: 350:1; Courtesy Buchholz Gallery: 451; Calais Musée des Beaux-Arts et de la Dentelle/Photo ● F. Kleinefenn: 257b; Courtesy the artist and Galerie Gisela Capitain, Cologne: 290b; Courtesy the artist/ Cass Sculpture Foundation: 186; Courtesy carlier gebauer/ Photo: Joachim Fliegner: 308r; ● Bodys Isek Kingelez/ Photo: André Morin/Courtesy Fondation Cartier: 397b; Courtesy Central Park Conservancy: 377; Courtesy Galerie Chez Valentin: 113; ● Chicago Museum of Contemporary Art: 441, 445; Courtesy Museo Chillida-Leku: 188, 190t; Courtesy the Chinati Foundation, Marfa, Texas. Photograph by Florian Holzherr, 2002: 293, 348; Courtesy Chinese Contemporary: 53, 81; Courtesy Opas Chotiphantavanont: 290tr; Photo ● Studio la Città: 385, 449; Courtesy the City of Chicago and Gladstone Gallery, New York/Photo: Patrick Pyszka: 264-5 Courtesy Clementine Gallery, New York: 409l; Courtesy James Cohan Gallery, New York: 96t, 240, 241, 394; Courtesy James Cohan Gallery, New York and Stephen Friedman Gallery, London: 301; ● The artist/Courtesy Sadie Coles HQ, London: 41; ● Courtesy Sadie Coles HQ, London/Jay Jopling/The artist: 72; Photo ● Giorgio Colombo, Milano: 294t; Courtesy Galleria Continua, San Gimignano - Beijing: 67, 383, 434t; Courtesy the artist and Paula Cooper Gallery, New York: 57, 320; ● The artists/Courtesy Corvi-Mora, London: 203, 391r, 123; Courtesy the artist and Sarah Cottier Gallery, Sydney: 380b; Courtesy CP Foundation/Collection Queensland Art Gallery, Brisbane: 153t; Courtesy Galerie Chantal Crousel: 70, 137b, 190b, 257; Courtesy de l'artiste & Galerie Chantal Crousel/ ● Alain Séchas - ADAGP: 89b; ● The artist/Courtesy Thomas Dane, London and Alexander and Bonin, New York: 213, 435; ● Estate of Anne Truitt/Courtesy Danese, New York: 439; Courtesy Daros-Latinamerica Collection, Zurich/Photo: Zoé Tempest, Zurich: 158; De Pont Museum of Contemporary Art, Tilburg/Photo: Henk Geraedts, Tilburg: 352; Courtesy the artists and Deitch Projects: 80, 311, 312; Courtesy Studio Wim Delvoye: 31, 215; ● Dia Art Foundation: 228, 444; Archive Braco Dimitrijevic: 337; ● Documenta Archiv/Photo: Dieter Schwerdtle: 232. 302l; Courtesy the artist and doggerfisher, Edinburgh: 389 Courtesy Galerie EIGEN + ART Leipzig/Berlin: 39; Courtesy the artist and Galerie Frank

Elbaz, Paris: 357t; Courtesy Elmgreen & Dragset GbR: 355; ● Vincent Fecteau/Photo: Oren Slor: 410-11; Courtesy Ronald Feldman Fine Arts, New York/Photo: Tony Velez: 159; Ian Hamilton Finlay, Little Sparta/Photo: Andrew Lawson: 233b; ● Paloma Varga Weisz/Courtesy Konrad Fischer Galerie, Dusseldorf and Gladstone Gallery, New York: 84; Courtesy Konrad Fischer Galerie, Düsseldorf/Photo: Dorothee Fischer: 134b, 295b; Courtesy Foksal Gallery Foundation: 27, 141, 142; Courtesy Galeria Fortes Vilaça, São Paulo: 129, 290tl, 431; Courtesy Frac Bourgogne/Photo: André Morin, Paris: 359b; Frankfurt am Main Museum für Moderne Kunst/Photo: Axel Schneider: 50; Courtesy Stephen Friedman Gallery, London: 17, 220; Courtesy Stephen Friedman Gallery, London and Gladstone Gallery, New York/Photo: Werner Maschmann: 341; Courtesy Stephen Friedman Gallery, London and Tomio Koyama Gallery, Tokyo: 287; ● The artist/Courtesy Frith Street Gallery: 378; ● The artists/Courtesy Gagosian Gallery, New York: 217, 267, 295tl, 334, 370, 373, 395b, 423; Courtesy Gent S.M.A.K. Stedelijk Museum voor Actuele Kunst/Photo: Dirk Pauwels: 162, 201, 202; ● Miroslaw Balka/ Courtesy Gladstone Gallery, New York: 26br, 289; ● The Felix Gonzalez-Torres Foundation. Courtesy of Andrea Rosen Gallery. Photograph James Franklin: 291; Courtesy The Goodman Gallery: 417t; Courtesy the artists and Marian Goodman Gallery, New York/Paris: 69, 169, 239, 270, 338, 380t, 153b, 230; Courtesy Marian Goodman Gallery, New York and Castello do Rivoli, Museo d'Arte Contemporanea/Photo: Attilio Maranzano: 381; Courtesy Greengrassi, London: 222-3; Groninger Museum/Photo: John Stoel: 181, 416; ● By DACS/ detail, 1994, by Thomas Grünfel/Photo: Lothar Schnepf: 87; Courtesy Studio Guenzani: 165t; ● FMGB Guggenheim Bilbao Museoa/Photo: Erika Barahona-Ede: 342, 376, 395t; The Solomon R. Guggenheim Foundation, New York/Photo: David Heald: 102, 367; Courtesy Murray Guy, New York and Shoshana Wayne, Santa Monica : 433; Courtesy the artist and Hales Gallery/Photo: Steve White: 426; Courtesy the artist and James Harris Gallery, Seattle/Photo: Tom Van Eynde: 446; ● Richard Long/Courtesy Haunch of Venison, London/● Tate, London 2006: 177; Hauser & Wirth Collection, Switzerland: 26blCourtesy the artist and Hauser & Wirth, London & Zürich: 199, 263b, 428; ● The Estate of Eva Hesse/Courtesy Hauser & Wirth, London & Zürich: 9b; Courtesy the artist and Herald St, London: endpaper; Courtesy Galerie Max Hetzler Berlin: 135; Hirshhorn Museum and Sculpture Garden, Smithsonian Institution, Joseph H. Hirshhorn Purchase Fund, Holenia Purchase Fund 2000: 310; Courtesy Workshop Rebecca Horn/Photo: Attilio Maranzano: 365; Courtesy the artist and Houldsworth Gallery: 285bl; Courtesy Xavier Hufkens/Photo: Vincent Everarts: 349; Courtesy the Douglas Hyde Gallery, Dublin: 227; Courtesy Instituto Valenciano de Arte Moderno, Spain. The Estate of James Lee Byars: 212r; Courtesy Jablonka Galerie, Cologne: 339; Courtesy Bernard Jacobson Gallery, London/Photo: Thom Vinetz: 258; Courtesy the artist and Alison Jacques Gallery, London: 97; Courtesy Galerie Martin Janda, Vienna: 64t, 458; Courtesy Galerie Michael Janssen, Cologne: 155, 390; Courtesy Catriona Jeffries Gallery, Vancouver and Casey Kaplan Gallery, New York: 163b; Photo ● Jerusalem, The Israel Museum: 295tr; Courtesy jointadventures.org and Gallery Elisabeth Kaufmann, Zurich/Photo: Werner Maschmann: 167; ● The artist/Courtesy Annely Juda Fine Art: 8b, 180t, 183; Courtesy the artists and Sean Kelly Gallery, New York: 165b, 284; ● Wit McKay, New York/Courtesy Sean Kelly Gallery, New York: 179; Courtesy the artist and Leo Koenig: 51t; Jeff Koons LLC: 101; Courtesy the artist and Gallery Koyanagi, Tokyo/Photo: Naoya Hatakeyama: 361; Courtesy the artist and Galerie Krinzinger, Vienna: 321t; Courtesy the artist and kurimanzutto, Mexico city: 115; Courtesy Wolfgang Laib: endpaper; ● The artists/ Courtesy Galerie Lelong, New York: 138b, 181; Courtesy Marcus Leith/Tate Photography: 248; Courtesy Lisson Gallery, London: 21, 103t, 106, 108, 109, 184-5, 256, 266t, 359t, 382, 399, 418, 452, 454, endpaper; Courtesy Lisson Gallery, London/photo Helge Mundt: endpaper ● The artist/Courtesy Lombard-Freid Projects: 401; ● The artists/Courtesy of L.A. Louver Gallery, Venice, CA: 274, 281, 406b; Courtesy Lyon Musée d'Art Contemporain/● Blaise Adilon: 29; Courtesy Gallery Tomas March: 288; ● The artists/Courtesy Matthew Marks Gallery, New York: 110, 124, 211, 254-5, 282t, 317, 347, 443; ● The artist/Courtesy Marlborough Fine Art: 325b; Courtesy Marseille [mac]/Photo: W. Squitieri: 114; Courtesy of Mary-Anne Martin/Fine Art, New York/Photo: Manuel Heilbloom: 66; ● The artist/Courtesy Matts Gallery, London: 354; Courtesy the artist and Lehmann Maupin Gallery, New York/Collection of Whitney Museum of American Art, New York/Photo George Hirose: 305; Courtesy McCarthy Studios: 51b, 79, 323; Courtesy McKee Gallery, New York:

63, 92, 93, 180b, 372; ● John DeAndrea/Courtesy Louis K. Meisel Gallery: 351; ● Olaf Metzel/Photo: Ulrich Görlich, Zürich: 333; Courtesy Mitchell-Innes & Nash, New York: 421t; ● The artist/Henry Moore Foundation Studio/photo: Roderick Coyne: 266b; ● The artist/Photo Masanobu Moriyama: 221, 340; ● Courtesy Murderme/Sadie Coles HQ, London: 73; Courtesy Greene Naftali Gallery, New York: 357b; ● Simryn Gill/Photo: Jenni Carter/Art Gallery of New South Wales: 430; Courtesy Orange County Museum of Art, California: 447; Courtesy YIN XIUZHEN and ALEXANDER OCHS GALLERIES BERLIN/BEIJING: 396; Courtesy Studio Orta: 307; Courtesy Tom Otterness and Marlborough Gallery/Photo: Mark Luttrell: 324b; Courtesy the artist and Roslyn Oxley9 Gallery, Sydney: 168; ● The artists/Courtesy PaceWildenstein: 25, 60, 61, 83, 91, 250, 259; Courtesy Palais de Tokyo; ● Florian Kleinefenn: 425; Courtesy Maureen Paley, London: 192; ● Panamarenko: 364; ● Mark Segal/ Photo Panoramic Images: 328-9; Courtesy Friedrich Petzel Gallery, New York: 128; Courtesy Galerie Karl Pfefferle: 18r; ● Jan Van Oost/ Courtesy Galerie Pièce Unique Paris: 32; Courtesy PKM Gallery: 77; ● The artist/Courtesy Galerie Eva Presenhuber, Zurich: 40b, 216; Courtesy the artists and Max Protetch Gallery, New York: 122, 140b, 243, 315 ; Courtesy Public Art Fund, New York/Photo: Donna Svennevik: 231l; Queensland Art Gallery: 52; Courtesy the artist and Regen Projects, Los Angeles: 237, 356l, 448; ● The artist/ Courtesy Anthony Reynolds Gallery, London: 15; Coll. Jean-Luc Richard, Paris: 116r; Photograph John Riddy: 187; Courtesy Galerie Thaddaeus Ropac: 453; ● Andrea Zittel/ Courtesy Andrea Rosen Gallery, NY: 138t; ● The artist/ Photo: James Austin/Robert and Lisa Sainsbury Collection, UEA, Norwich: 20; ● 1994 David Mach/San Diego Museum of Contemporary Art/Photo: Philip Scholz Rittermann: 419; Courtesy Studio Karin Sander: 391l; ● 2005. Photo Art Resource/Scala, Florence: 251; ● 2007. Digital Image, The Museum of Modern Art, New York/Scala, Florence: 248; ● 2007. Photo The Jewish Museum/Art Resource/Scala, Florence: 330; Courtesy the artist and Anna Schwartz Gallery, Melbourne: 137t, 400; ● Ricky Swallow/Photo: Karl Schwerdtfeger/ Courtesy Darren Knight Gallery, Sydney and Stuart Shave/ Modern Art, London: 282b; Courtesy Stuart Shave/Modern Art, London: 420; Courtesy Shugoarts, Tokyo/Photo: Tadasu Yamamoto: 182; Courtesy Sikkema Jenkins & Co.: 415, 432; ● Charles Simonds: 397t; Courtesy Sonnabend Gallery: 90t, 127, 200; ● Béatrice Soulé: 30; Courtesy the artists and Galerie Monika Sprüth/Philomene Magers, Köln, München, London: 246, 262b, 270b; Courtesy Galerie Monika Sprüth/ Philomene Magers, Köln, München, London/● the artist, VG-Bild Kunst, Bonn/Photo: Bernhard Schaub, Cologne: 90br, 303; Courtesy the artist and Sprüth Magers Projekte: 133; ● Jana Sterbak: 64b, 309; Courtesy the artist and Galeria Luisa Strina/Photo: Eduard Fraipont: 117, 143; Courtesy Stux Gallery: 96b; ● The artists/Courtesy Galerie Micheline Szwajcer, Antwerp: 111, 126, 175; Courtesy Galerie Micheline Szwajcer and Ann Veronica Janssens: 274; ● Tate, London 2006: 11t, 42, 68, 78, 107, 173, 178, 326, 442; ● Marcus Taylor/Courtesy of the artist: 455; Courtesy the artist and D'Amelio Terras, New York: 421b; Courtesy the artist and the Tobu Museum Tokyo/● Jane Alexander: 95; Courtesy Emily Tsingou Gallery, London: 406t; ● James Turrell/ Photo: Florian Holzer: 234, 261; Courtesy Galerie GP & N Vallois, Paris: 40t; ● Didier Vermeiren, A.D.A.G.P: 358; ● The artists/Courtesy Waddington Galleries, London/ Photo: Prudence Cuming Associates, London: 19; Courtesy The Wanås Foundation/Photo: Anders Norrsell: 132, 262t; ● 2007 Board of trustees, Washington National Gallery of Art: 9m; Courtesy Shoshana Wayne Gallery: 456; Frederick R. Weisman Foundation, Los Angeles, California: 34, 35r; Courtesy Galerie Barbara Weiss: 369, 403; Courtesy Michael Werner Gallery, New York and Cologne/● The Estate of James Lee Byars: 174; Courtesy Michael Werner Gallery, New York and Cologne: 71; Archiv Franz West/Photo: Melissa Goldstein: 121; Courtesy Sperone Westwater Gallery, New York: Front endpaper, 205, 257t, 316, 409r; ● The artists/Courtesy Jay Jopling/ White Cube, London: 33, 44r, 45, 47, 48, 65, 86, 147, 189, 194t, 207t, 214, 235, 292, 294b, 296, 297, 327, 375; Whitney Museum of American Art, New York: 150-51, 161; Photo ● Wien, MUMOK, Museum Moderner Kunst Stiftung Ludwig : 353; Courtesy the artist and Wilkinson Gallery, London: 271; ● Wolfsburg Kunstmuseum/Photo: H. Mundt: 58; Courtesy Won Ju Lim: 139; Courtesy Yanagi Studio: 219; Courtesy Donald Young Gallery, Chicago: 38, 37, 103b, 176, 379, 392, 393; Courtesy Donald Young Gallery, Seattle: 268; Courtesy Zeno X Gallery: 194b; ● The artists/Courtesy David Zwirner, New York: 249, 263t, 404

Turrell, James 235, 247, 258, 260
 Catso, Red 260, *261*
 Roden Crater 234, 235, 260
 Skyspaces 260
Tuttle, Richard 438
Twombly, Cy 296
 Thermopylae 295

'uncannyness' 22, 33
USA 7-11, 14, 16, 22, 24, 27, 31, 33,
 35-7, 44, 60, 62-3, 67, 76, 78, 80-1,
 94, 100, 102, 104, 110, 120, 123-7,
 133, 141, 146, 148-9, 154, 157, 161-4,
 166, 181, 188-9, 203, 211, 226, 228-33,
 235, 238, 240, 242, 258, 260, 264, 267,
 289, 291-2, 296, 302, 306, 315-16, 320,
 323, 326-8, 349, 354-5, 364, 366-7,
 372, 379, 384, 391, 401, 404, 406-7,
 409, 414, 416, 418, 422, 427, 438,
 440-1, 445-7, 458, *see also individual
 artists*
 African-Americans 149, 161
 Art-in-Architecture programme 320, 323

van der Rohe, Mies 120, 398, 400-1
van Doesburg, Theo 352
van Herwegen, Henri *see* Panamarenko
van Oost, Jan 30
 Black Figure in Corner 30, *32*
Varga-Weisz, Paloma 83
 Bumpman sick 83, *84*
Veilhan, Xavier *285*, 286
 The Republican Guard 285, *286*
Vercruysse, Jan 450
 Tombeau 1991 452
Vermeiren, Didier 358
 Monument to Victor Hugo 358, *358*
videos 6, 27, 76, 80, 220, 317, 418
Vietnam 326-7
Visch, Henk 18-19
 Untitled 1981 18
von Rydingsvard, Ursula 182
 Doolin, Doolin 181, *182*

wall drawings 440
wall-hanging sculptures 56, 60, 198, 315,
 318, 366, 372, 428
Wallinger, Mark 46

Ecce Homo 15, 46
Ward, Nari 427
 Amazing Grace 425, 427
Warhol, Andy 10, *10-11*, 46, 100, 116, 349
 Silver Clouds 10
 Campbell's Soup Cans 10
Warren, Rebecca 191
 Teacher (M.B.) 191, *192*
waste 107, 414-35
water 39, 242, 367, 430
wax 16, 24, 27, 33-4, 40, 45-6, 56, 62-3,
 172, 191, 193, 240, 357
Webb, Gary 252
 Miami Gold 253
Webster, Meg 231
 Glen 231
 Kitchen Garden 231, *231*
Webster, Sue 419-20
 British Wildlife of 2000 (Noble and
 Webster) 420
 Dirty White Trash (with Gulls) (Noble
 and Webster) 420, *420*
Weiss, David 11, *347*, 350
Wentworth, Richard 100, 108, 114, 364
 Mirror, Mirror 382, *383*
 Shrink 108, *108*
Wermers, Nicole 404
 Vacant Shop 405
West, Franz *121*, 123, 133
 Rest 133
 Test 121
White, Pae 384
 Oroscopo 384
Whiteread, Rachel 267, 331-2
 The Holocaust Memorial 333
 Untitled (House) 332, *333*
 Water Tower 267
Wilding, Alison 267, 359
 Assembly 266, 267
 Receiver 267
Wilke, Hannah 58-60
Wilson, Fred 146, 149
 Guarded View 149, *150-1*
Wilson, Richard 353
 She Came In Through The Bathroom Window
 353, *354*
 20:50 353
Winter, Wolfgang 433, 435
 Swingerclub (Winter and Horbelt) 435
 Tail Light Pile (Winter and Horbelt)
 434, 435
wire 46, 60, 161, 330, 372, 450
Wodizcko, Krzysztof 141
 Homeless Vehicle 138, 141
Wollheim, Richard 438
Won Ju Lim 139
 Elysian Fields North 139, *139*
wood 8, 16-19, 22, 27, 29, 83, 94,
 102, 111, 126-8, 134, 137, 154,
 160, 166, 172, 179, 181-3, 186-7,
 237, 242, 247, 252, 258, 267,
 317, 330, 356, 359, 398, 419,
 422, 427, 440, 450, 456
Woodrow, Bill 107-8, 116
 *Car Door, Ironing Board, Twin Tub
 and North American Headdress* 107, *107*
wool 27, 69, 428
Wright, Frank Lloyd 445
Wunderkammern 146, 148
Wurm, Erwin 318
 Untitled 318, *319*

Xu Bing 216
 Panda Zoo 216, *218*

Yin Xiuzhen 396, 398
 Portable City, New York 396
Yinka Shonibare 306
 Three Graces 301
Yoshiro Suda 242
 Weed 227
Yoshitomo Nara 286
 Dogs from Your Childhood 286, *287*
Youngblood, Daisy 93, *93*, 94
 Romana 92, 94
 Tied Goat 93, 94
Yue Minjun 80, *81*
Yukinori Yanagi 218, *219*
 One Dollar 218, *219*

Zhan Wang 242
Zhang Dali 50
 Chinese Offspring 53
Zittel, Andrea 139
 A-Z Comfort Unit 139
 *A-Z Management and Maintenance Unit
 Model 003* 138
Zorio, Gilberto 201
 Acidi 200

Many sculptors, curators and dealers have helped me with ideas and information about contemporary sculpture, far too many to mention personally, so this can only be a general expression of my gratitude. Three people at Phaidon Press have been of special assistance: David Anfam; Emmanuelle Peri, for tracking down the most recondite illustrations; and Julia Rolf, forester extraordinaire, who stayed calm when all about her was agitated. The biggest thank you goes to Barbara Lloyd, for walking every step of the way with me.

Judith Collins

Phaidon Press Limited
Regent's Wharf
All Saints Street
London N1 9PA

Phaidon Press Inc.
180 Varick Street
New York, NY 10014

www.phaidon.com

First published 2007
Reprinted 2008
© 2007 Phaidon Press Limited

ISBN 978 0 7148 4314 8

A CIP catalogue record for this book is available
from the British Library

Designed by Sonya Dyakova
with Bianca Wendt and Ingrid Arnell

Typeset in *Paper Alphabet* (designed by Sonya Dyakova)
and *Simple* (designed by Norm)

Paper Alphabet photographed by Edward Park

Printed in China

ENDPAPERS

Wolfgang Laib, *Pollen from Hazelnut*, 1993. Pollen
from hazelnut tree. 320 x 360 cm (138 x 141 ¾ in)

Alexandra Bircken, *Gewachs*, 2005. Plaster, wool,
wood, stones, fabric, plastic, thread. 130 x 80 x 64 cm
(51.5 x 31.5 x 25 in)

Eva Rothschild, *Diamond Day*, 2003. Powder coated steel,
wood. 200 x 200 x 200 cm (78 ¾ x 78 ¾ x 78 ¾ in)

Richard Deacon, *What Could Make Me Feel This Way 'A'*, 1993.
Bent wood, cable ties, screws. 28.6 x 56 x 48.3 m
(93 ft 10 in x 183 ft 9 in x 158 ft 5 in).
Sprengel Museum, Hannover

All works are in private collections unless otherwise stated